THE OXFORD HISTORY OF
CLASSICAL ART

THE OXFORD HISTORY OF

CLASSICAL ART

EDITED BY

JOHN BOARDMAN

OXFORD UNIVERSITY PRESS

Oxford University Press, Walton Street, Oxford OX2 6DP

Oxford New York Toronto
Delhi Bombay Calcutta Madras Karachi
Kuala Lumpur Singapore Hong Kong Tokyo
Nairobi Dar es Salaam Cape Town
Melbourne Auckland Madrid

and associated companies in
Berlin Ibadan

Oxford is a trade mark of Oxford University Press

Published in the United States
by Oxford University Press Inc., New York

British Library Cataloguing in Publication Data
Data available

Library of Congress Cataloging in Publication Data
The Oxford history of classical art / edited by John Boardman
Includes bibliographical references and index.
1. Art, Classical. I. Boardman, John, 1927–
N5610.084 1993 709'.38—dc20 93–6825
ISBN 0–19–814386–9

10 9 8 7 6 5 4 3

Datacapture by Alliance Typesetters, Pondicherry, India
Typeset in Adobe Minion by Oxuniprint, Oxford
Printed in Great Britain
on acid-free paper by
Butler & Tanner Ltd.
Frome, Somerset

EDITORIAL PREFACE

THIS volume has been designed as a companion to *The Oxford History of the Classical World*, to serve a public interested in classical antiquity both for its own sake and for its legacy to the western world, however slightly this may still be perceived or appreciated. The aim has been less to provide a historical narrative or categorization of the arts with pictures attached than to engage the reader's attention more directly by pictures of objects and monuments. Through these we hope to lead him or her to an understanding of their meaning and of their relevance to the development of an idiom in which change was a constant factor. Each author was accordingly invited to introduce his or her chapter with a survey of the social and historical background to the period covered, and of the function and fortunes of its arts, patrons, and artists; thereafter, to use a broad choice of illustration as a basis for demonstration. The editor has to thank his collaborators for their patient acceptance of this scheme; the Press for the management of a difficult format and assemblage of illustration (notably Hilary O'Shea, Bob Elliott, and Gill Metcalfe); and many museums, collectors, and agencies for provision of pictures.

CONTENTS

LIST OF COLOUR PLATES

LIST OF MAPS

1 INTRODUCTION

JOHN BOARDMAN

THE blushing Venus standing in her tiny temple that graces both the sculpture hall of the Walker Art Gallery in Liverpool and our first colour plate stands also to demonstrate many of the popular conceptions and misconceptions about classical art which, over the last 200 years, have conditioned our own view of it. The statue was made by John Gibson in the middle of the last century for a Liverpool couple. The artist had been caught up in the world of neo-classicism, befriending its greatest exponents in Britain and Europe—Flaxman, Canova, and Thorwaldsen. He went to study and work in Rome, which is where he saw the Parthenon marbles—in plaster casts. His approach to his work was not quite that of his contemporary classicists. He studied anatomy, not simply the nudes of the life class and the classical marbles of the major collections; and he was inspired by life as much as by the antique: his statue group of an Amazon thrown from her horse was inspired by seeing an accident in a circus. This led him to experiment with colouring his marbles, whence this blonde, blue-eyed Venus, rosy-skinned from her bath. But she is not so much a study from life as in the tradition for such figures that began in fourth-century BC Greece and was fostered by the hundreds of copies of the Roman period which stood in public and private collections, which had been tirelessly copied for gardens and country houses, and which can be bought as concrete casts in garden centres today. The type was known from ancient texts to have been invented by Praxiteles and displayed in a temple at Cnidus, designed so that her naked charms could be appreciated from all angles; and this inspired the original and the present-day architectural setting for Gibson's figure. Such a statue may seem a banality beside what can now be appreciated of classical art, and to ignore many qualities which scholarship has come to recognize as essential to its message, but the goddess's realism in form and colour and her function as a divinely erotic symbol carry accurate indications of some aspects of classical art, even as it was understood in Gibson's day.

Gibson knew classical art from engravings in books; then, when he went to Rome, from Roman copies of Greek statues, Roman statuary, and from the finds at Pompeii and in the cemeteries of Etruria. Italy was still the major source, revealing Greek art mainly in Roman translation, while even the Greek vases from the cemeteries were commonly taken as Etruscan, not Greek. Greece and Turkey were beginning to reveal original Greek sculpture to western eyes, notably the Parthenon marbles and other groups brought to western collections in London, Paris, Munich, and Berlin, and to stock the many private-house collections, especially in Britain. Classical architectural forms, again mainly in their Roman form, had survived well enough above ground to have remained in the live architectural tradition of Italian artists. The Renaissance view of antiquity, colourless in its classicizing statuary but vivid and vigorous in its narrative arts, had presented such a brilliant and coherent image of the past that

it positively hindered perception of the truth. The less monumental arts of antiquity were becoming known from excavations in Italy and the Roman provinces, while finds in Greek colonies on the north shores of the Black Sea which were taken to St Petersburg considerably widened scholars' experience of the other arts in Greece. Scholars and collectors had long been preoccupied with ancient coins and gems which served as portable and original displays of ancient myth and portraiture. Plaster casts of anything from statues and architectural mouldings to gem impressions were collected by artists and gentlemen, and there were times when the collections of casts were valued even more highly than the originals, since the pristine whiteness of the plaster seemed a positive enhancement, and the range of types that could be collected was not limited by the market in original works. Charles Townley, at home in Westminster with his collection of classical marbles, mainly Roman copies (**Colour Plate II**), could feel that he had achieved communion with the essence of Greek antiquity. His collection was bought for the British Museum in 1805 for £20,000. Within ten years the museum was contemplating acquisition of the Elgin marbles from the Parthenon, and the difference in quality was apparent even to a select committee of the House of Commons.

Attitudes to antiquity acquired from literary sources had their effect on attitudes to classical art. The heroic, the philosophical, and the ideal played their part in presenting classical antiquity as a paradigm for the self-judged high civilization of nineteenth-century imperialism and thought. The reluctance to recognize Greece's own debt to other cultures dies hard. In art history it was probably artists rather than scholars who saw the true worth and read the true message of classical art, until the later nineteenth century when the sturdy scholarship of Germany put order and professionalism into a subject long subjected to the wholly romantic view—a view propagated so well by the reconstructions of antiquity offered by western painters, who presented the ancient world and even its art market in terms acceptable and familiar to their contemporaries (**Colour Plate III**). Serious excavation, especially in Greece itself, provided a wider range of raw material for the scholar's attention, and classical art ceased to be monopolized by consideration of languid nudes, bearded philosophers, and a variety of classical landscapes with figures. Gibson's Tinted Venus now raises a smile rather than awe, yet in the history of our subject her place is assured and deserved.

It would be foolish to think that by now we have 'got it right'. Each age will read classical art differently; some will attempt to press it into anthropological moulds and structures, or will decry its achievements and influence, or will subject it to the service of ideologies bred by modern concerns with race, gender, and psychology. The best that has emerged is the recognition that it has to be expounded in terms of the societies for which it was created, that we should judge it on its own terms, of what was possible and intended, and not on our terms. But even a 'factual approach' is not immune from such pressures, nor should it be. The writers of these chapters cannot define or explain everything or even most of what has survived and what they have chosen to illustrate, but they hope they can help the reader exercise his eyes and understanding. So the remainder of this introduction is given over to a summary indication of factors, influences, and trends that might assist appreciation of what follows.

Greek art was the creation of the Greeks, but not the creation of the Greek state, in the way that monumental Egyptian art was the creation and expression of the Egyptian royal house and state religion. There was no Greek state, but many small city-states (*poleis*) which were frequently at war with each other and could barely combine even in the face of a common threat. The unity was of language and religion, and presumably of other ethnic qualities which determined a certain unity in the cities' sometimes diverse artistic efforts. Even after Alexander the Great had introduced to Greeks the idea of

empire, the one part of his realm which failed to cohere was the Greek homeland. Rome was dramatically more successful in forging a unity out of different races and cultures and over enormous distances; more successful too in creating a 'world art' which might be recognized as readily in Britain as in Persia. Greeks liked to behave as individuals, Romans as a team, in government or the battlefield. The former makes for liveliness in the arts, the latter guarantees their survival and dispersal. So we shall move gradually from consideration of the art of the individual, of small communities, to the art of a world power.

To describe classical art in terms of a Rise and Fall would miss the point of virtually every stage in its history. There is indeed plenty of 'poor art', by any standards, but when it is relatively abundant this reflects on the size of a receptive market low on the social and economic scale, rather than the skills of the period. At every stage classical art must be judged capable of producing the best possible, given the constraints of technique and material. Differences lie in change which need not always be interpreted as progress. It was rather determined by a variety of factors: changing patronage—public or private, royal or democratic; changing attitudes to the function of art—to display wealth and power, to publish propaganda, to express faith; changing economic circumstances of the many different cities involved in its production, since even under the Roman Empire there was never any one dominant centre which dictated fashion.

Change was rapid too. This was probably a result of the character of classical society. It had to be determined by the artists, naturally, and artists who were not bound to serve a dominant dynasty or priestly caste had more freedom of choice. This is why the arts of the empires of Mesopotamia and Egypt changed relatively slowly, barely perceptibly for some centuries, partly because the incentive for change was lacking in the patrons and could not be exercised independently by the artisans, partly because the idiom was found to serve its limited purpose satisfactorily. Indeed, there was positive merit in a conservatism that gave an impression of permanence; in classical art we meet this mainly in coinage, where it is a matter of conservatism promoting confidence in value. Nor is it wholly illusory that works of quality, even in cheap materials, were more widely distributed through classical communities than they were in the empires of the east. It is ironic that in later centuries totalitarian states in the west seem to have turned instinctively to classical art (or to their misconception of it) to express their ideals.

The Bronze Age arts of the classical world find no place in this volume. The Minoans of Crete were not Greek-speakers and their brilliant palatial arts are closer to the traditional idioms of the east than to what was to develop in Greece in later centuries. The Mycenaeans of the Greek mainland *were* Greek-speakers but their art forms derive almost wholly from the Minoan, although it may be possible to discern in them qualities which distinguish the arts of their successors. And the pre-Roman arts of Italy are intelligible in terms either of the cultures of Europe, or of the influx of Greek styles through import to Etruria (which we also have to ignore here) or to the Greek colonies of south Italy and Sicily, who made their own contribution.

The twelfth century BC saw the collapse of the Bronze Age societies of Greece followed, in Greece, by a measure of depopulation or at least dispersal from the palatial centres, some of it across the Aegean and to Cyprus, and notable changes in life-style and social behaviour. In these Dark Ages, no longer quite so obscure thanks to archaeology, down to the eighth century, Greek society began to re-form into independent communities, replacing the network of palace-dependent centres, and this new order was to be the basis for the classical world. The arts, expressed for us most fully in pottery decoration,

depended very little on what had gone before, although awareness of a 'heroic' past was expressed through the creation and oral transmission of epic stories about that past, when gods and heroes walked and fought with men, culminating with Homer's poems and the beginning of western literature, and it must also have been quite apparent in the remains left in and on the ground—castles like the citadel of Mycenae, attributed to the hands of giants. Decoration was abstract, 'geometric', applied with delicacy and precision. 'Geometric' is more than an apt description of such mainly linear pattern, for it evokes the mathematical basis, dictating proportion and balanced composition, that was to determine the development of the arts in classical Greece, even in periods when realism might seem to untutored eyes to have been the main intention.

In the Dark Ages power lay with local families or kings, but we need not exaggerate their effect in communities which were hardly bigger than hamlets, and in the arts they are responsible mainly for some rather grander pottery grave monuments and the appearance of some foreign exotica. A long coastline encourages maritime activity, and the search for materials (mainly metal, probably) led Greek adventurers to the eastern shores of the Mediterranean, soon answered by the reciprocal interest and voyages of the Levantine Phoenicians. The Greeks, mainly of Euboea and the islands, encouraged a flow of goods, mainly from Mesopotamia via north Syria rather than Phoenicia, and this was to effect the first major change in the appearance of Greek art. The orientalizing revolution broke the Geometric style, although its essence was never lost. Figure decoration of a very formal and restricted type had been admitted in the Geometric but it now developed new strains and subjects, and began to be used in the interests of narrative and the expression of contemporary life and behaviour. In its way Geometric art was a pure and local phenomenon. With the arrival of the oriental, Greek art became perceptibly little more than an extension of an idiom long established in the east, even if expressed with a peculiarly Greek interest in matters ignored in the homelands of these foreign styles. Immigrant artists taught new techniques, but their studios were soon taken over by Greeks and the eastern patterns were deployed for new purposes, often of fairly trivial ornament for relatively cheap goods, like painted pottery, which was not an important medium in the east, but which fortunately (since it is virtually indestructible) pleased Greek eyes and pockets. There were new functions too—not so much for the aggrandizement of the ruling families, except indirectly through the building of temples for city gods and their embellishment with handsome votive offerings. This was, after all, one way of making a statement about power and authority, through the bought patronage of the gods. Not all the gifts from the east were productive. Some new techniques tended to stereotypes (the Daedalic style in sculpture, incising 'black-figure' techniques in vase-painting). Progress could be uneven and out of step in different centres, since this is *par excellence* the age of diversity in Greek art and of strong regional styles. The Greeks lacked much real sense of nationhood, and their arts did little to reinforce the unity of speech and religion.

Greek art retains this orientalizing aspect through the sixth century, absorbing new ideas from Egypt also, notably affecting styles in sculpture and architecture, and all the time the new idiom was being developed in a manner that carried it even further from its record of use in the east or Egypt. This is the Greek Age of Tyrants, which means no more than that local rulers might not be just influential landowning families, but strong men who relied more on popular support but were not beyond establishing dynasties of their own. They recognized the need to demonstrate power visually, though not to the point of constructing great palaces on the eastern model; they were not that wealthy nor in command of such resources of manpower, and what they had was more often than not expended on what we would judge public works, like the water supply. Gift exchange with what were certainly wealthier eastern rulers could soon develop into a matter of being bought by Persian gold, but real trade, rather than piracy or exchange, had grown with the establishment of ports of trade in the east, Egypt, and

Italy. This was furthered by the wave of colonization which had started in the eighth century, seeking new markets and more living space for a growing population. It carried Greeks, Greek art and life, to the shores of Italy, France, North Africa, and the Black Sea. The Mediterranean world was becoming 'classical' and the arts disseminated by the newcomers from the Aegean were beginning to establish a common style recognized and often copied beyond their own new territories.

Regionality in Archaic Greek art begins to break down in the sixth century with the freer movement of people and artists, and with the fifth century the sense of 'being Greek' is strengthened by the need to respond to a common threat, the Persian invasions. By this time, in Athens at least where the record is clearest, social organization is changing to a form of democracy which, in the arts, means that the state can become as important a patron as a ruling family or wealthy individual. The lessons of the east had been totally absorbed and the oriental idiom Hellenized. What follows is the most profound of the revolutions in Greek art, the 'Classical'. By the end of the fifth century art, together with literature, history-writing, and philosophy, had acquired a new aspect and aim that set it apart from the record of all other early cultures. The central interest in man, and in divinities of mortal aspect and behaviour, transformed both style and subjects. The realization that the artist could effectively improve on nature through realistic representation, rather than rely on conceptual formulas through which to express the natural world—which is what all earlier art had amounted to—occurred in Greece for the first time in the history of man, and dictated the future course of the arts in the Mediterranean, and then most of the rest of the western world. Yet it was not mere realism *per se*, rather than a shrewd combination of observation and of that long dominant interest in design and proportion, that effected the change. When a sculptor wrote a book about his work it described the principles of achieving the ideal human figure and must have relied more on mathematics than anatomy.

Patronage was still strongly regional. Interstate warfare was the norm and interstate rivalry could be demonstrated in the arts and in the manipulation of narrative art (generally for temple decoration) to make political statements. This use of art for something more subtle than a demonstration of human or divine power is another new feature of the use of the arts which is owed to Greece. It began in the Archaic period and is but another aspect of the way Greeks used their myth history as a commentary on contemporary affairs, as they did also in their literature and theatre. This way of treating the present in terms either of the past or of idealizing generalities tended to inhibit expression of the individual, both of identity (portraiture) and of emotion, except in very formal ways, until the fourth century.

When Alexander the Great resolved to avenge the Persian treatment of Greeks by reducing their empire, and proceeded to effect his aims with astonishing speed, Greece might have become another imperial, palace-centred power on the oriental model. This did not happen because the homeland states remained nearly as independent and no less quarrelsome than they had been before; and because after Alexander's early death his empire was broken into smaller regions, in the non-Greek areas, each of which exercised its own dynastic ambitions and the arts that served them, though in a common 'Hellenistic' style. (In English 'Hellenistic' describes the period of what in German is called *Hellenismus*, which we cannot translate as Hellenism since we use this word more broadly.) The changes in Hellenistic art need not, then, be explained in terms of profound political change, although the major centres, in Alexandria and Pergamum, developed an idiom for a form of imperial art that was to serve Rome very well. What rather happened was that the confident command of an idealized realism developed into a deeper interest in portraying the individual; portraiture, though often of a highly idealized nature, flourished, and the expression of emotion, through face and physique, could at times be carried to extremes. The arts of the west were carried yet another stage further away from the formality of Mesopotamia and Egypt; nature was not merely imitated but improved upon and artists

sought to stir the emotions not through the subjects of figures or stories but through their expression of physical forms. Man remained the centre of interest, but now man in his environment also, and another of the perhaps puzzling omissions in Classical art was rectified, that of an interest in landscape.

In 146 BC the Romans sacked Corinth and in the next hundred years came to control almost all Greek lands. In Italy the Roman state had begun to emerge as a powerful entity in the sixth century BC, but at that time was still in terms of the arts no more than an extension of Etruria, whose own arts were almost wholly dependent on Greek example. Roman exposure to Greek art was furthered by contacts with purer sources, in the colonies established in south Italy, which Roman armies also overran. Under the Roman Republic, down to the death of Julius Caesar in 44 BC, the arts display a muted Hellenistic mode, but Rome itself was being enriched with plundered art from Greece which inspired new but at first somewhat indiscriminate patronage. The Hellenistic kingdoms provided a model for an imperial art, and general admiration of all things Greek made the way easy for a strong revival of Greek art of the high Classical style under the early Empire, and encouraged the widespread copying of Greek models in sculpture and painting, to which we owe much of our knowledge of the lost originals. Greek literature and art together provided an idiom for the expression of the New Order which imperial Rome could offer the Mediterranean world. The models, in Classical Athens, had served similar ends on a far smaller scale and with less self-consciousness. What emerges is a version of classical art, eclectic in its sources of inspiration, from the Greek Archaic on, and most heavily affected by the Hellenistic since immigrant Greek artists were responsible for much of the work provided for the early Empire. In new hands and with new patrons Roman art developed an expression of near-baroque theatricality that well suited its philosophers' views on rhetoric in the arts. At the same time, for a wider and less ambitious market, it provided decorative styles which, with no little measure of humanity and wit, match anything in the later history of western art.

Roman art, however, is not a mere pastiche of Greek art. For Roman patrons, imperial and private, the artists of Greek and Roman birth created a style which has a clear individuality whatever its origins. Moreover, it was practised in a wider range of media than hitherto, and there was much added which is of Roman inspiration and which made no lesser contribution to the classical legacy. Indeed, since it was devised for a world power and international religion, it could the more readily be adapted to the needs of comparable cultures in later centuries. For the first time classical art provided an international language, recognized, understood, and practised from Celtic Britain to the Semitic east. Imperial patronage fortunately did not create the passive conservatism we remarked in the older empires of the east, though it is true to say that the tempo of change was slower. In some ways there was a more conscious creativity and building for posterity. In the decorative arts the principal Roman contributions are in realistic portraiture and in narrative arts devoted to contemporary history rather than myth history, recording the achievements of emperors who could be treated as gods, just as they were often portrayed as gods. Art could be used as readily as literature to propagate the ideals of Roman rulers, to demonstrate the benefits of Roman rule. Possession and display of an imperial portrait became a link with the seat of power, however distant. In funerary arts myth could serve still, as it had in the Greek world, to reflect mortality and, more often now, hopes of immortality. On these qualities the arts of early Christianity were fostered. In this volume we stop short of considering the way in which the translation was made, except in passing. The subject is too large to be treated summarily.

In architecture the innovations were more profound and influential. They stem from technical progress, with arch, vault, and the use of brick and concrete, occasioned by new needs in society. They created new attitudes to the use of space and light, and principles of design which went far beyond the

PLATE I

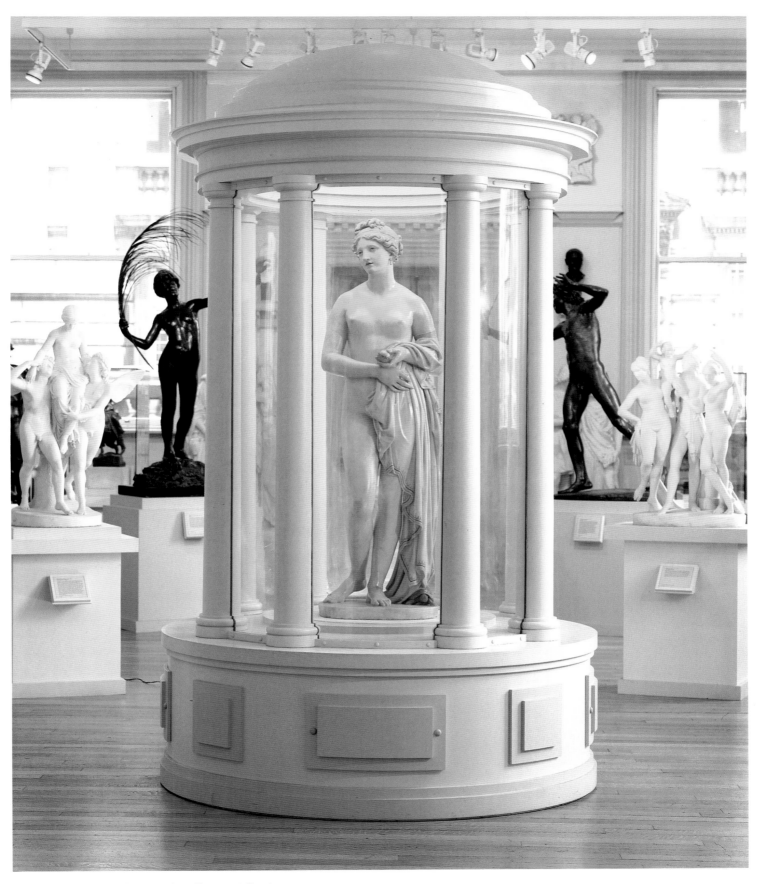

Venus, by John Gibson (Liverpool, Walker Art Gallery)

PLATE II

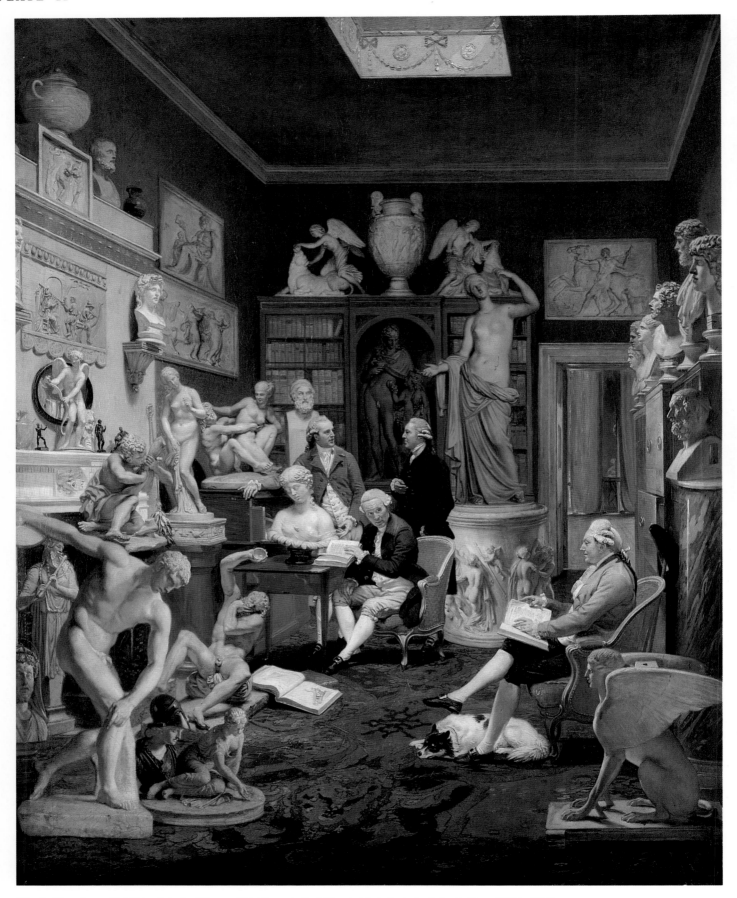

Charles Townley and his Friends in the Library of his House in Park Street, Westminster by John Zoffany (1733–1810)
(Townley Hall Art Gallery, Burnley)

PLATE III

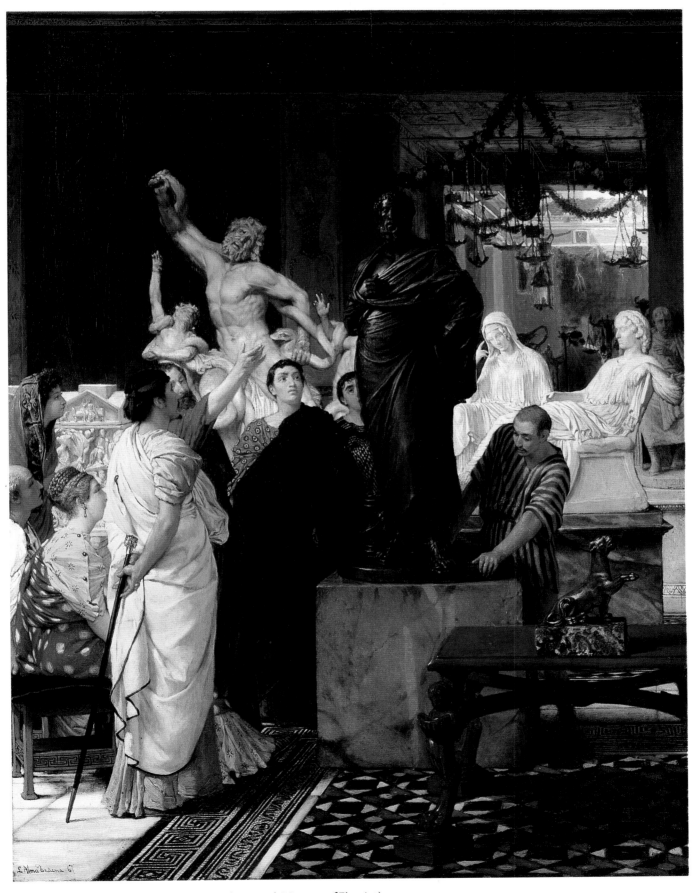

A Dealer in Statues by L. Alma-Tadema, 1867 (Montreal, Museum of Fine Art)

PLATE IV

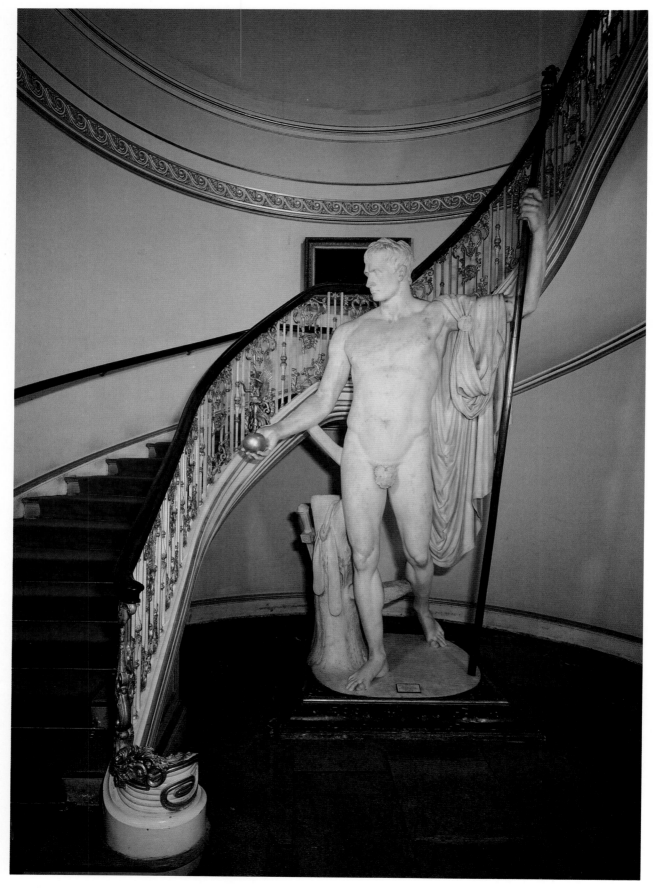

Napoleon, by Antonio Canova, 1803–5 (Apsley House, London)

more limited ambitions of the Greek world, where any needs for the colossal were met by simple magnification of the norm.

With the last period considered here the Empire begins to disintegrate. Rome no longer holds the centre stage. Imperial power proved vulnerable to both the arms and the religion of the barbarian. In the arts there is a perceptible retreat from classical rules, and a return to modes of expression which depend on something beyond the blend of realism and proportion which had sustained Greek art and which under Rome had been made subservient to other needs. It is expressed in a stiffening of forms, in what seems a deliberate turning away from perfection of form and composition to a mixture of ruthless expressionism on the one hand, and an almost puppet-like formality which was but a whisker away from abstraction. The requirements of a new, uneasy world, too diverse perhaps to survive as a political and cultural unit, may have called for a version of the classical style less self-contained, more emphatic and reassuring, but no less firmly rooted in its classical past.

'The Arts' today comprise music, dancing, various types of literature, each of which in antiquity enjoyed the protection and inspiration of a Muse. For the visual arts, even for architecture, there was no Muse. The only divine patron that might be claimed was Hephaestus (Vulcan), the smith god who was also something of a wizard and made various mechanical toys and traps. We have the term 'arts and crafts' but in Greek there was one word only, which we should translate as 'craft'—*techne*, the root of our word 'technology'. In Latin the word is *ars*, whence our 'art', and although it was used mainly of what we would call the applied arts, it could also embrace broader cultural pursuits. *Ars artis causa*, Art for Art's sake, was not a concept of any significance in antiquity although it is today the motivating force for all artists whose work is not functional or applied, but created for galleries or collectors. There is, therefore, something of a problem for a volume such as this, in isolating 'Art' from all the other functions of ancient life. It cannot be so isolated, and the development that we trace in concept, pattern, and style was a more vital expression of the ancient societies in which it was motivated than it is for much of the history of art, especially from the Renaissance to the present day.

Art collectors began to appear in antiquity in the years of the later Roman Republic and early Empire, apparently under the stimulus of the flow of objects from Greece, as loot or by purchase, and we hear of collections of gems and even the borrowing of statuary for special exhibitions. This must have stimulated some production by artists for the art market, even if not quite in the terms envisaged by the nineteenth-century artist (**Colour Plate III**). It is better expressed in the imperial commissions for sculptural groups and paintings to adorn palaces and pleasure gardens, though even there it may be possible to detect an element of functionality in the religious or mythological motifs chosen.

In a cultural environment in which a person whom we would call an artist might be treated as no better than a plumber, and paid by the hour, it might not seem very likely that pride in performance would play any role, and without such pride where is the stimulus for the rapid progress and invention in the visual arts which are the theme of much of this volume? That there was such pride is clear, though it is puzzlingly apparent in fairly restricted periods. Artists' signatures, even on quite humble objects, begin to appear almost as soon as the Greeks learned to write, and generally we have no reason to believe that signatures at all enhanced the value of the works. By the fourth century BC there are appreciably fewer signatures, and thereafter they are rare, although makers' stamps appear quite commonly on mass-made materials—moulded vases and the like. Most of the masterpieces of Hellenistic and Roman art own no named maker, and although several Hellenistic statue bases carry their sculptor's name, the practice soon died out. It is not that the names were unimportant, and they were remembered in the few

texts from antiquity that address such subjects, though with decreasing evidence for the later centuries BC on.

A skilful or well-connected modern artist can become very rich—his dealer even richer. The masons who carved the marble figures for the Classical Erechtheum on the Acropolis at Athens were paid the equivalent of ordinary day wages. But at about this time leading artists do seem to have been able to attract rich contracts for state projects, either for major cult statues or for architectural designs. Money, as ever, conveyed status probably more readily than perceived artistic ability. Under Rome the sheer expense of some works excited the disapproval of the rather puritanical Elder Pliny. Much of the expense seems to have been generated by the exotic character of the materials used but we must imagine that there were some very wealthy artists, or at least workshop-owners. At all periods, much of the hard work in the studio, and quite possibly no little of the design, was probably undertaken by slaves. Women are barely mentioned, except for a few painters, though weaving and embroidery were traditionally in their hands and we know that their works could be decorated with mythological scenes.

Finally, as we have explained the word Hellenistic, so we should explain the word Classical. In this form (capital C) and in this volume it is applied to the arts of the fifth and fourth centuries BC, though other writers may give it narrower boundaries more closely associated with the period and style of the Parthenon. As 'classical' we use it to refer more generally to the style which was created in the fifth century but which then determined and is apparent in the work of the rest of Greek and Roman antiquity, at least into the first or second century AD. It is in this broader definition that classical art can be seen to have permeated so much of the non-Greek and non-Roman world. This is a phenomenon of antiquity, beginning almost as soon as Greek art takes shape in the Geometric period, and continuing well into the Roman Empire, which created its own new artistic ambience. Some aspects of this diffusion in antiquity are dwelt on and illustrated in Chapter 7, which accordingly ranges from Britain to China.

It is not too difficult to describe what we mean by classical art when it comes to its diffusion and its legacy, but the word itself conceals a deeper meaning which may help understanding of what it was that proved so durable and so influential. It implies qualities that are apparent in other non-visual arts of antiquity, and in other aspects of ancient society. There is a determination to confront the world in terms of man rather than of the divine or supernatural. It is less a matter of the gods being given exceptional powers and forms than of their essentially human behaviour being expressed in human terms, being used to explore human ambitions and problems, and being depicted in word or image to serve as an ideal for human behaviour. Here perhaps the classical may even meet the romantic, but there has been a tendency over the last 200 years for European tyrannies to turn to their own strange versions of classical art to express their aims and impress their followers. Canova's portrait statue of Napoleon is a colossal marble nude, in Greek pose, holding Victory on his outstretched hand like the Athena in the Parthenon, but consigned now to the stairwell of his conqueror's home at Hyde Park Gate in London (**Colour Plate IV**).

The Latin word *classicus*, whence our classical or classic, implied anything or anyone of high class or ranking; it was applied to ancient authors, and so by extension ('unthinking and unanalysed' as the *Oxford English Dictionary* describes it) to Greek and Roman antiquity in general. But it implies order as well as quality. The 'classical orders' of architecture carry connotations of fixed rules and forms which, however, as study shows, were not blindly followed as a pattern-book, but which served as models within which subtleties of design and proportion could be exercised. In 'classical art' there are rules too, including a certain agreement to observe realistic rendering of the human figure, but generally in terms

of ideal forms which might be rendered with as great precision as the architectural forms, and yet leave the artist the fullest scope for individual expression. What the neo-classicists did not realize was that idealization and a degree of truth to nature were not incompatible, and had been successfully reconciled in the Classical period. It was not necessary to believe, with Winckelmann, that the Greeks had no wrinkles! This was the message of the Parthenon marbles. In some ways there were more rules in classical art than in arts of other cultures, but they were not restrictive. Indeed, they provided a basis for the development of the widest range of expression, both formal and humane. They guaranteed continuity without stifling change, and herein must lie their strength and durability, the reason why time and again artists have returned to them for inspiration and guidance.

2 PRE-CLASSICAL GREECE

ALAN JOHNSTON

FOR most people the Phoenix is the bird that rose from its own ashes, a creature of myth. To the Greeks Phoenix was rather the founder of the Phoenician race, a mythological-cum-historical figure. Both resurrection and Phoenicians loom large in the story of Greek art of the period between 1100 and 500 BC, and while it is not the case that a totally new start had to be made from the ashes of the Mycenaean palace-based civilization of the late Bronze Age, it is palpable that influences from the eastern seaboard of the Mediterranean in the eighth and seventh centuries are central to the transformation of the arts and technologies of Greece, including its literature.

An attempt will be made here to explain the mechanisms, influences, and impetus behind such transformations, which changed architecture from mud-brick huts with reed roofs and rough stone foundations into marble temples with precisely cut blocks and elegant decorative features, sculpture from small, lumpy terracotta figurines into over-life-size statues of marble or bronze, replete with observed detail, and painting from strips of purely linear design into large-scale figure-compositions of considerable refinement.

Throughout we will be hampered by being able to consider only what has been preserved, and aided only by the occasional report in ancient authors of now lost monuments. The inevitable result of such a state of affairs is considerable dispute about many aspects of the subject, not least the extent of survivals from the Mycenaean period or of that wave of influence from the Near East, and one might add the problems concerning the role played by free painting and other art forms now almost wholly lost.

Art is produced within a social setting and we must keep in mind the general development of Greek society in the centuries with which we are dealing, however difficult it may be to trace that development in detail, whether from archaeological or written sources. In the archaic period there arose a network of small states (*poleis*, singular *polis*), in which a body of free males varying in number and social status wielded military, religious, and political power. The *poleis* too varied in size; in the smallest any political change would have taken place within a close-knit group of families with their retainers, while even in the larger, such as Attica and Laconia, centred on Athens and Sparta, personal links between rivals would normally have existed. Sparta expanded its area of influence by military conquest of agricultural lands and the enslavement of the bulk of the inhabitants. At some time in our period Athens too expanded to control the whole of Attica, which included towns equivalent in size to some independent *poleis*; these may have retained some local control, but after 510 BC a new form of political structure was introduced for the whole of the territory, based on a number of democratic principles, a solid foundation for the democracy of Classical Athens.

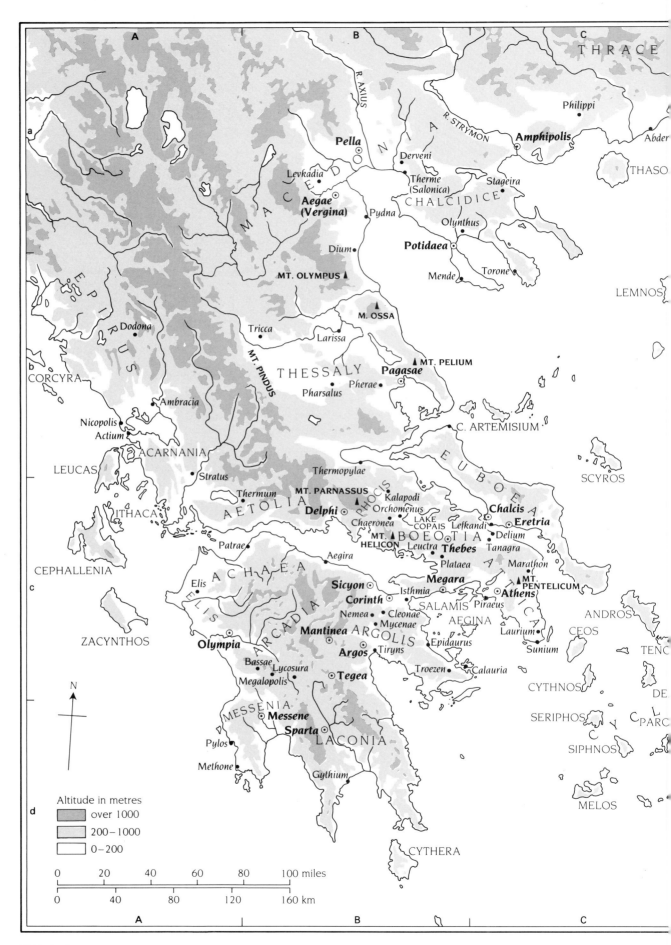

THRACE

R. AXIUS

R. STRYMON

Philippi

Pella ⊙

Amphipolis ⊙

Abder

Derveni

THASO

Levkadia

Therme
(Salonica)

Stageira

M A C E D O N I A

Aegae
(Vergina) ⊙

CHALCIDICE

Pydna •

Olynthus •

Dium •

Potidaea ⊙

LEMNOS

MT. OLYMPUS ▲

Mende •

Torone •

E P I R U S

Dodona •

M. OSSA ▲

Tricca •

Larissa •

MT. PELIUM ▲

MT. PINDUS

THESSALY

Pagasae ⊙

b

CORCYRA

Pharsalus •

Pherae •

Ambracia •

Nicopolis •
Actium •

C. ARTEMISIUM

ACARNANIA

SCYROS

LEUCAS

Stratus •

Thermopylae •

E U B O E A

Thermum •

MT. PARNASSUS ▲

Kalapodi •

ITHACA

A E T O L I A

Delphi ⊙

PHOCIS

Orchomenus •

Chalcis ⋀

Eretria ⊙

Chaeronea •

LAKE
COPAIS

Lefkandi •

Delium •

CEPHALLENIA

Patrae •

MT. ▲
HELICON

B O E O T I A

Tanagra •

Leuctra • Thebes •

Aegira •

Plataea •

Marathon •

A C H A E A

MT. ▲
PENTELICUM

c

Elis •

Megara •

A T T I C A

ZACYNTHOS

E L I S

Sicyon ⊙

Isthmia •

Athens ⊙

ANDROS

Corinth ⊙

SALAMIS

Piraeus •

CEOS

A R C A D I A

Nemea • Cleonae •

AEGINA

Laurium •

Mantinea ⊙

Mycenae •

A R G O L I S

TEN

Olympia ⊙

Argos ⊙ Tiryns •

Epidaurus •

Sunium •

Bassae • Lycosura •

Troezen •

Calauria •

CYTHNOS

DE

Megalopolis •

Tegea ⊙

SERIPHOS

PARC

N

SIPHNOS

MESSENIA

Messene ⊙

SPARTA ⊙

Pylos •

LACONIA

Methone •

Gythium •

Altitude in metres

over 1000

200–1000

0–200

d

MELOS

CYTHERA

0 20 40 60 80 100 miles

0 40 80 120 160 km

MAP 1. THE AEGEAN WORLD

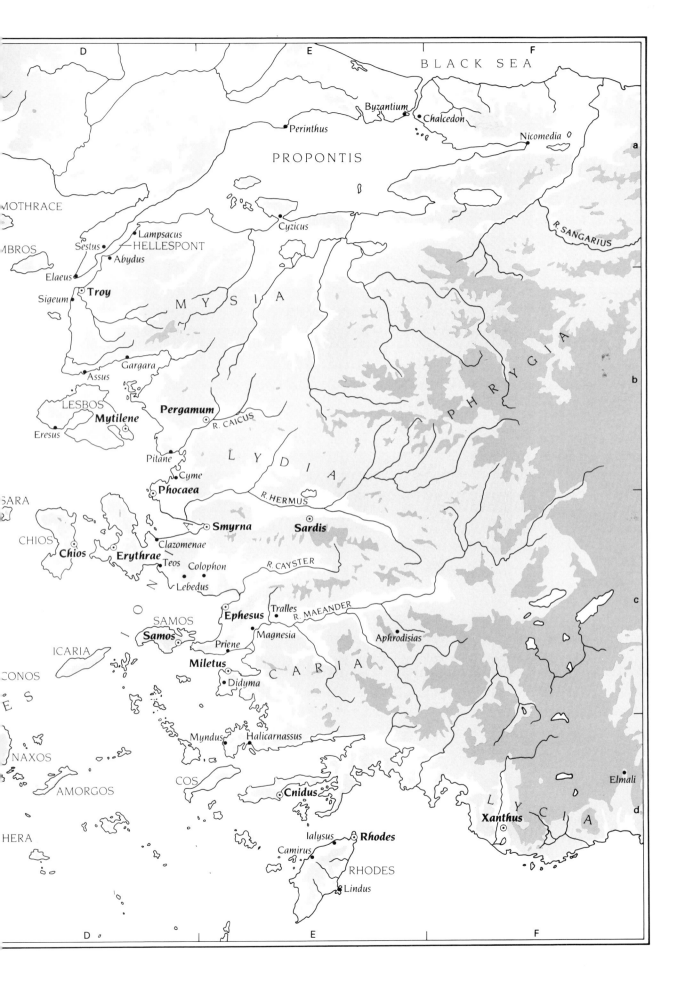

BLACK SEA

Byzantium
Chalcedon
Nicomedia

Perinthus

PROPONTIS

R. SANGARIUS

Cyzicus

MOTHRACE

MBROS

Lampsacus
Sestus HELLESPONT
Abydus

Elaeus

Troy

Sigeum

M Y S I A

P H R Y G I A

Gargara

Assus

LESBOS

Mytilene

Pergamum
R. CAICUS

L Y D I A

Eresus

Pitane

Cyme

Phocaea

R. HERMUS

SARA

Smyrna

Sardis

CHIOS

Clazomenae

Chios

Erythrae

Teos

Colophon

R. CAYSTER

Lebedus

Tralles

c

Ephesus

R. MAEANDER

ICARIA

SAMOS

Magnesia

Aphrodisias

Samos

Priene

CONOS

Miletus

C A R I A

Didyma

E S

NAXOS

Myndus

Halicarnassus

Elmali

AMORGOS

COS

L Y C I A

HERA

Cnidus

Ialysus

Rhodes

Xanthus

Camirus

RHODES

Lindus

Population as a whole seems to have increased markedly from the eighth century onward, though actual figures are harder to judge, and local fluctuations can be seen. Much of the population would have been reliant on agriculture for all or most of their subsistence, not least in areas with good land and restricted access to the sea, such as Boeotia and Laconia. Few *poleis* had substantial wealth in exploitable natural resources other than the land, but we may note the precious metals to be found in southern Attica, and on the islands of Thasos and Siphnos; all yielded also a less valuable mineral, but one used to great effect, marble. The true rock of the economy remained crops and husbandry, with an increase in corn and olive oil production. Only a few *poleis* relied on trade, whether production, carrying, or piracy, for a significant percentage of wealth-creation; Aegina, Samos, and Miletus are examples. Nor should we overlook the role of slavery in the Greek economy; it was an institution that took many forms, from indigenous serf labour to bought foreign captives, and is of disputed extent during the Archaic period; but we do at least have good evidence that menial or hard labour was often performed by slaves or prisoners of war.

The *polis* system encouraged interstate rivalry, especially at the level of the élite. It is best seen in the institution of the major Greek athletic and music festivals, most of them in the early sixth century. Accordingly, the favoured method of showing one's wealth was to decorate the sanctuaries in which those festivals took place, with both architecture and a large variety of variously prestigious offerings. The character of such dedications might differ from place to place—more marble statuary in the islands, more bronzework on the mainland, especially at Olympia—but overall it amounted to an increasing mass of displayed wealth. Reasons for offerings vary, and in many cases, though the dedicator writes his name (and often that of the maker of the offering), a specific reason is not given: 'a tenth of his production', 'from the enemy' are far more frequent than 'because of his son's recovery in health' or 'from the Corinthians'. Such competitive piety, some would say self-advertisement, naturally gave employment to many artists, as we shall see.

From about 1100 to 800 BC we must assume a society in which relatively small groups were engaged largely in attaining self-sufficiency, with external contacts, especially from non-Greek areas, a somewhat occasional event. Craft specialists existed, especially in larger centres, but many may only have been part-time smiths or potters. In this period our material record is almost confined to pottery and to figurines or utensils in bronze; architectural remains are for the most part undistinguished, to the extent that there is genuine debate about which are houses for mortals and which for gods, if indeed such distinctions then existed. Offerings in graves are our main source of material; from them we can note that metals were in short supply, indeed that iron was used because copper alloys became unavailable, rather than for its intrinsic qualities. The few figures that appear in terracotta and bronze in the period before about 900 BC, especially on Crete, relate more to a lingering tradition from the Bronze Age than to any fresh start. In pottery basic skills were retained, with products little changed from what went before, save that in the tenth century there is a marked improvement, both in potting and for the brushwork, in tautness of line. Metal was reserved mainly for functional objects, the most decorative being pins of bronze, which develop a variety of mouldings for their heads.

These beginnings are worth stressing. Such foundations persist for centuries to come; for example, the little pin-head mouldings become ever more elaborate and, joined by elements borrowed from the Near East and Egypt, are enlarged to form the basis of very many later Greek architectural features.

Pottery was widely used and so quantitively of greatest use to us when we seek the development of decorative ideas in these centuries. The art styles are termed Protogeometric and Geometric after their major aspect and chronological order. Gradually pots became the vehicle for ever more elaborate panels and friezes of linear decoration, based on the circle, triangle, lozenge, wavy line, and meander. We may

hazard influences from basketry and woodwork. Figures appear hesitantly in this repertoire, and are drawn in the same silhouette manner as the ornament, with the same brush and 'glaze' slip. Among the first manifestations, in the tenth century, are two archers on a tiny water jug from Lefkandi on Euboea and the occasional horse, symbol of wealth, on Attic funerary jars. By the later ninth century a greater variety of animals is found, in part inspired from designs punched on gold headbands used to wreathe the dead, and themselves influenced by Near Eastern metalwork.

It is in this century that contact with the east, never totally lost, begins to gain pace. Our record tells us that luxury goods were imported, ivories, faience, and precious metals, but no doubt perfumes, spices, and textiles came too. Lefkandi seems to have been precocious in such contacts, and it is there that a precociously ambitious architectural complex of about 1000 BC has recently been excavated [3], to the discomfort of earlier 'steady-state' theories about the development of Greek architecture.

During these centuries, within the fairly close limits of the Geometric style we can discern different repertoires of ornament and types of artefact in the various areas of Greece. Athens' influence can be seen early on, and again around 850–800 BC. Crete almost strays outside these limits; here we find in the ninth century an outburst of motifs, floral and faunal, borrowed from Phoenicia and North Syria, in pottery and metalwork; immigrants may have accompanied them. Even here, though, there follows a reversion to the Geometric style disseminated from Athens.

The Cretan pots have a few figured scenes [4], but a school of such painting develops in mid-eighth-century Athens. Here and elsewhere it was a practice to mark the tombs of the élite with large vases [5], and it is on these that figured scenes first regularly appear. The pictures either refer directly to the funeral proceedings, or, we may conclude, reflect the lives, sometimes heroized, of the deceased. The style is as regimented as the ornament in which the scenes are entombed.

The eighth century also sees a dramatic increase in the number and size of the offerings made to the gods, *agalmata*, another powerful generator of works of art in the Greek world. Impressive size is seen not so much in buildings, though there is some growth there, but in individual offerings, notably bronze tripods with cauldrons. Originally the actual utensils were offered in thanks to the gods, but they were replaced by overblown, flimsily made substitutes, to which were attached an interesting variety of solid-cast bronze figurines. These, with their free-standing brothers (few sisters), form an important group of three-dimensional plastic works, illustrating the possibilities of the Geometric style. Among them some group compositions have an all-round aspect not to be seen again in Greek art for many centuries. These are small objects (such pieces are rarely taller than 25 cm. and are cast solid in bronze after wax models), yet there are hints that at this same period were made the first large-scale statues, cult figures in wood or bronze sheet beaten around a wooden frame. They were intended to confront the worshipper, a frontality of view which long dominates Greek sculpture. And on virtually the humblest level, the adoption of the mould from the Near East around 700 BC also impressed frontality, for more technical reasons, on terracotta votive figurines.

Along with the mould came the style of the figures themselves, a mixture of Egyptian, Hittite, Assyrian, and other elements that is found in the arts of Phoenicia and the North Syrian states in the ninth and eighth centuries, not only in terracotta, but also in stone sculpture as well as minor works of ivory, faience, and precious metals. There was no deep Greek tradition in these arts, and we can note how much more directly non-Greek styles were imitated in them. In painting the adaptation was slower, and resulted in an amalgam of home-grown and imported elements that becomes truly Greek.

Many of these elements will be picked out in the commentary on the illustrations; in the pictorial arts a new repertoire of floral patterns, especially the palmette, lotus, and petal (or ray), together with intertwining tendrils, predominate, while various animals too find a home, especially the lion family,

including the sphinx. The human form of Near Eastern bronzes and ivories is also translated into Greek ceramic painting.

This process of assimilation has been dubbed 'orientalizing', a somewhat misleading term which covers a wide variety of origins and a lengthy time span; it was no overnight change. The appearance of Near Eastern motifs in Cretan pottery of the ninth century is an early manifestation, the adoption of some Egyptian architectural and sculptural ideas in the years around 600 BC among the latest. Such contacts also brought the alphabet and aspects of eastern astronomy and mythology. The desire to express pictorially these and their own myths and legends was a further major stimulus for Greeks towards the production of figured works of art. In the seventh century we find a steady, if slow, increase in the number of myths shown, in various media, and in the frequency of their appearance. Not all experiments were successful; some monsters based on Near Eastern types are more or less stillborn. Yet animal fables are in great favour at this period, succumbing eventually to the more cautionary and didactic side of Greek mythology, the interplay of god, hero, and mortal.

While interchange between Greek and eastern (and other) arts did not cease in the earlier sixth century—witness for example gem-engraving, the adoption of coinage from Lydia, and Greek masons working for Persian kings at Pasargadae—such an 'orientalizing period' can reasonably be isolated.

Perhaps the most striking aspect of seventh-century art is the adoption of a new facial type from the Near East, melded with a linear strictness inherited from Geometric art. We see heavy, overlarge features in a U- or V-shaped face with horizontal brow, a far cry from the round, uptilted heads that went before. We call the style Daedalic, after the legendary Cretan artisan; and it is on Crete that it finds its best expression, although it takes root in many areas of the Greek world. That world was now beginning to embrace a number of outposts or colonies settled in Italy, North Africa, the north Aegean, and the Hellespont.

In many of these areas Greek work was sooner or later to have a profound effect on local populations, as will be seen in Chapter 7. Such settlement in foreign lands was driven by various motives,

 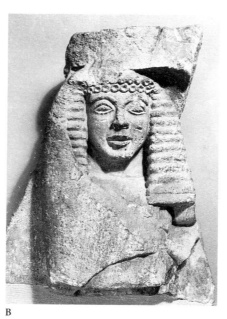 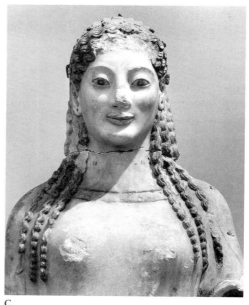

A B C

Heads showing typical features of the eighth, seventh, and sixth centuries. A bronze Geometric statuette of a male warrior (Olympia Museum); B Daedalic-style female head, veiled, on a limestone relief from Mycenae (Athens, National Museum); C marble head of a later sixth-century kore (Athens, Acropolis Museum)

land hunger, domestic strife, and trading opportunity apparently to the fore. This expansion of a Greek world provided, whatever else, a larger market for manufactured goods and decorated wares from the homeland, as well as spawning local, colonial production.

In vase-painting the strait-jacket of the silhouette style was broken by the introduction of a variety of new techniques. Outline is much favoured, with the use of more colour—red, yellow, brown. The use of engraved detail, as employed by bronzesmiths, was also imported into painting; we term the style black-figure, and its wholesale adoption at Corinth in the early seventh century and in the 630s in Athens ensured its considerable success. Outline and polychrome techniques were largely confined to less productive ceramic workshops, though our meagre evidence is just sufficient to show that they were also regularly employed for large-scale work on terracotta, plaster, and wood.

The use of frieze composition had already posed problems of spatial juxtaposition and movement. The occasional Geometric horse would raise its legs or a charioteer lean forward, and a sophisticated if naïve manner of showing depth had evolved; but the broader range of subject-matter which was now attempted demanded more variety. We could say that artists were slow to take up the challenge, since for over a century little changed—the profile view predominates—while a combination of profile head and legs with frontal body, together with a healthy dose of expressive gesticulation, served to create flow and movement. A desire to fill as much space as possible, *horror vacui*, is seen in earlier cultures and persists now, with tall figures knocking their heads against the upper frame, and often a thick soup of filling decoration, whose changing nature can be a useful dating criterion.

The Daedalic style also permeates our earliest preserved Greek stone figures, which differ markedly from the bronze statuettes of earlier generations. On Crete a number of limestone pieces decorated temples that owe much to Near Eastern design; the figures too have strong affinities with the east—sphinxes and nude female figures akin to representations of a range of Near Eastern goddesses such as Astarte and Kubaba. At Olympia a set of figures of beaten bronze, perhaps made on Crete, even incorporated decorated sheets imported from Syria. Marble statuary first appears in the Cyclades, where Paros and Naxos are rich in the stone and still supply it to modern workshops. The standing, frontal male and female figures, kouroi and korai, become standard types as votives or tomb monuments for the next 150 years, though their particular development is a matter of high interest. They do not cling statically to accepted canons of measurement, like Egyptian statuary; Greek sculptors show a keen interest in developing a more natural rendering of detail and structure, some of course with more success than others. From an early period a good proportion sign their works, as do artisans in a number of other crafts. It can be argued that very early marble pieces show little Egyptian influence, but at least the male type has by the end of the seventh century many undeniable Egyptian echoes; by then Greeks had settled, as mercenaries and traders, in the lands of the delta.

The development of Greek sculpture did not reside in these two types alone, but they do predominate in the statistical record, and their employment in compositions in temple pediments shows something of their stock character. The Greek temple is very much rooted in developments of the seventh century; some aspects of earlier structures hint at what is to come, such as a line of posts to support ceiling timbers, or concentration on the architectural enhancement of one end where the entrance lay, but many particular characteristics only appear now. Not all the steps can be demonstrated in actuality, but it is around 625–600 BC that buildings with upper parts substantially in stone, not merely mud-brick and timber, first appear. Such underpinnings were needed not least to support the weight of the large clay tiles that first appear around 675 BC in the Greek world. All such buildings are of sacral use. It was not normal for the performances of religion to be held within a building, but at and around an altar; temples were generally placed to the west of the altar, within the sacred precinct,

Syrian bronze horse frontlet from the sanctuary of Hera, Samos (Samos Museum)

temenos. On these early buildings we first see some of the peculiar details of the Doric order (though others do not appear in our preserved record until the sixth century). A major feature is the colonnade surrounding the central room, cella; it is of disputed origin, but its purposes may have been as much to offer shade or protection for the mud-brick walls as to add elegance, since it appears also as an independent structure, the stoa, a Greek invention, used first to afford shelter for spectators at sacred rites and festivals.

The Archaic and Classical periods demonstrate the increasing attention paid to the embellishment of the temenos; rarely before the fifth century are purely civic buildings so treated. The changes can be seen clearly in numerous sanctuaries where the increasing size of the temple and number of ancillary buildings are demonstrated by excavation. Few of the big Classical temples are without a more modest seventh- or sixth-century predecessor [24]. The importance to ruling groups of providing major deities of the city with ever more imposing homes is obvious; the increasing number of references to slaves in preserved texts is an indication of what type of work-force was employed, at least in part. Competition in impressiveness is best seen perhaps in the building programmes in the western colonies in the late Archaic period, at Selinus, Acragas (Agrigentum), Metapontum, and Syracuse; and it is noteworthy that in most of these places single military rulers were in command. Regrettably, though, we have little direct evidence concerning the funding of any of these projects.

We do, however, have some reliable reports that these dictators ('tyrants') were patrons of the arts on the Greek mainland as well. Pisistratus at Athens certainly promoted poetry and music, and commissioned many building projects. The competitive nature of inter-city life meant, however, that in

most larger states, whatever form their government took, aristocratic or dictatorial, the sixth and early fifth centuries generally saw considerable architectural and other artistic development. None the less, it cannot be stressed too much that our contemporary records are overall very thin, and that references to the period in later authors are often suspect, being tailored to, or simply conditioned by, contemporary patterns of thought and exegesis. The approach is also seen in earlier times. Nowhere in Archaic Greek art can one demonstrate a deliberate attempt to place scenes in period; contemporary clothes, armour, architecture, and gestures convey the stuff of myth and legend, and this remains true in Greek art of later years.

From the large number and variety of sacred places a number emerge as of particular significance, whether because of their strategic location, for example on the borders of two or more powerful states, or through the alleged and advertised powers of their guardian deities, notably oracles. These sanctuaries could attract devotees and offerings from even beyond the Greek world, from as early as the eighth century. The best known are those where the great Panhellenic games were later held—Olympia, Delphi, Isthmia, Nemea—growing out of local (or regional) competitions. But a large number of other 'national' sanctuaries also attracted rich offerings, known from excavation or historical report— Athena's on the Acropolis of Athens and at Ialysus and Lindus on Rhodes, Hera's in her extra-urban temenos at Argos and on Samos, Artemis' at Ephesus, Zeus' in his oracular shrine at Dodona, and Apollo's in his at Didyma, near Miletus.

Demand for votive gifts and architectural adornment of such sanctuaries was the principal spur for artisans' production and experiment in our period. In the seventh century the Greek world in general saw a considerable falling off in the number and value of goods offered to the dead. Perhaps the most striking survivals from the sanctuaries are the numbers of metal objects, mostly bronze: the armour and weaponry captured from foreign or Greek enemies, much of it worth consideration as works of art; or the personal adornments of male and female adorants; or offerings made specifically for dedication, such as statuettes representing the deity or animals connected with sacrifice. Pottery, too, and figurines in terracotta were frequently dedicated. We know that sometimes manufacture of such votives took place in the temenos itself, although other objects were no doubt dedicated specifically as exotic rarities. The inscribed catalogue of treasures dedicated to Athena at Lindus lists, along with some offerings allegedly made by characters from myth, a wide range of gifts from foreign potentates, and the writings of Herodotus and later authors add to the picture.

Common offerings of stone, especially in the eastern Aegean, are little limestone statuettes, most made on Cyprus. Limestone was more easily worked than marble, and widely used for buildings as well as for large sculptures in some parts of the Greek world. Where stone of reasonable quality was lacking, as in Italy, clay was worked into large-scale figures. An important feature of sculpture in all these materials was the addition of decoration in paint. It is indeed unfortunate that so few of the big painted terracotta figures now survive in anything more than pitiful fragments.

Marble too was painted. The use of Cycladic, Ionian, and Attic marble spread throughout the sixth century; some pieces in semi-finished state were transported considerable distances. Marble invaded those areas previously occupied by wood, terracotta, and mud-brick, an invasion best seen in the development of temple architecture. A striking feature of the upper parts of Archaic shrines is the richly coloured terracotta cladding (revetment) of wooden beams, which affords protection from the elements. When local stone replaced wood such cladding was often retained; and by the end of the period in a number of areas the stone and terracotta unit was replaced by a single marble block, carved with a variety, albeit a restricted variety, of decorative mouldings.

In much of the Greek world the temples so developed conform to a quite closely definable type

(though variety of detail is more frequent than may appear). We call it the Doric order (see [109]), since it is normal in those areas inhabited by Dorian Greeks. Perhaps the controlling feature of the order is the unusual frieze that is found above the architrave which tops the columns. There is a very strict alternation of plain, squarish panels (metopes) with a triple-grooved element (triglyph), ordered in such a way that triglyphs abut each other at the ends of each side. It is a simple device, but the repercussions in purely architectural design were enormous, and seem to have absorbed the interest of ancient architects, and most certainly of modern interpreters, for generations. By the end of our period Doric temples were being built with carefully planned ratios of parts, observing the fall of joints between courses of stones, even between stones and roof-tiles above. At an early stage desire for symmetry led to a false porch (*opisthodomos*) being added to balance the true porch at the east end, although in Sicily a contrasting preference is seen for enhancing the true porch by making it deeper and more imposing. This emphasis is almost certainly borrowed from non-Doric temples built in Ionia, in places such as Samos and Ephesus. The Ionic order is much less limiting architecturally (and less well preserved in our record today). It was used for some of the largest buildings ever erected in the Greek world; the temple of Artemis at Ephesus measured about 55 × 115 m. Most of these structures were left largely unroofed, save for their broad and lofty colonnades with their forests of columns. The order admits many more purely decorative features than Doric, and distinct varieties can be found in the Cyclades, on Samos, and at Ephesus.

A by-form, based on a capital with a vertical axis, was used for a few temples in northern Ionia and Aeolis [29 A]. Many representations and occasional finds tell us that this type of capital was far more widespread on furniture, not least on couch legs, and both this and the Ionic capital may derive from eastern furniture. The couch was by the late sixth century the place to find the upper-class Greek male, eating, drinking, conversing, and politicking. Rooms in private houses were by then being specifically designed to accommodate such *chaises-longues* around their walls. But we have little sign in residential areas of the sort of extravagance seen in temple architecture; mud-brick and timber, or local stone where it was plentiful, prevail. Painted plaster on the walls and mosaics on the floor have yet to be found, and it is unlikely that they will be.

Outside the temenos, major architectural efforts were expended on the construction of fortifications, or terracing walls; the finest are in a sophisticated style of polygonal masonry, a shape suitable to the volcanic stone often employed, and are works of art in themselves. Overall town planning goes back even earlier, to western colonies of the late eighth century, when there is already evidence of a central civic area being reserved, to become the *agora*, the assembly and market-place [32]. Long strips of housing blocks were laid out on regular alignments all round. The colonial settlements may originally have been single-room huts with a market-garden, laid out along a street grid. At one site which has been fully accessible for excavation, Megara Hyblaea in Sicily, these shacks eventually grew to take up much of the urban area, fronting these streets, although larger houses looked inwards, around a central court, as they would continue to do through the Classical and Hellenistic periods. The western colonies also provide our most significant examples of communal buildings, heralding, in unusual form, the theatre that became one of the glories of Hellenistic architecture. The use of perishable materials, wood and mud-brick, has made our task in reconstructing its history difficult—and of course in making a theatre larger you would normally remove all traces of any predecessor. Other public buildings probably have some kind of origin—functional or architectural—in the chieftain's hut of the early Iron Age, a community centre, audience and debating chamber, and festival site; its hearth became the perpetual flame of the goddess Hestia, often housed in the Classical period in a town's *prytaneion*, *Hôtel de ville*.

Temples were not left unadorned, and the Archaic period sees enormous developments in their

sculptural decoration. The major medium is marble, but simple painted slabs of terracotta or stone can demonstrate the development from two to three dimensions. Major sources of such sculpture are the Acropolis of Athens and the sanctuary of Apollo at Delphi; it is normally found in specific parts of the building, in the frieze of the Ionic order, and the metopes of the Doric, while it can appear in the triangular pediments at the short ends of the temple in both orders, though rare in Ionic. Some early tiled temples have hipped roofs, without any pediment, and we may assume that the standard later form was deliberately chosen for architectural and decorative effect.

Each space to be filled required tailoring of subject-matter, which in turn could be more or less relevant to the particular cult or, politically, to the town in question. Pediments provided the opportunity to put on a colourful display to impress or awe the approaching visitor and to watch over the rites performed in front. Filling the triangle led to various expedients; regularly a snaky monster or a fallen or falling warrior was used; and scale was more or less subtly altered to accommodate figures. By the early fifth century pedimental figures were cut in the round, not attached to the background in high relief. Friezes were often of terracotta, made from moulds, and so favoured a repetitive procession in which longer elements, notably the horse, played a large part. In contrast, the almost square metope highlighted single frames of action, and we find in them experiments of both composition and subject-matter. And atop the pediment there were regularly placed floral or figured acroteria, above the decorated revetments.

Sculptors would have supported themselves from contracts for such work, in addition to any private commissions for kouroi and korai and the like; in many parts of the Greek world stelai, tall slabs with relief carving, were popular for funerary or votive use. Towards the end of our period literary sources tell of the first dedications of statues by victors in the games, and the concept of the statuary group begins to develop from its origins as a string of standard types or a composition as it were brought down from a pediment. Even so there is little three-dimensional in their appearance, even if an occasional head or torso in three-quarter view breaks up the stricter frontality or profile.

Of great significance is the development of the technique of hollow-casting large bronzes. The basic method is attested from the early seventh century, but it was not tried out on life-size works until over a century later. A major problem seems to have been the fluidity of the molten bronze entering the mould; in fact no major bronze of the ancient world was ever cast in one piece; several sections were welded together. However, once the technique was mastered artisans quickly took up the opportunities offered by lighter weight and freedom from the constraints of the marble block. The Classical period saw the full force of this development, especially in male figures in action. It is to be regretted that we have no record of the comparative cost of marble and bronze, but the latter must have been substantially more expensive, even with a skin less than half a centimetre thick. Preserved pieces are rare indeed, even fragments are not numerous; but we do have many stone bases with attachments for bronze, not marble, figures, and literary sources amply confirm the arrival of bronze statuary in the late sixth century.

We are fortunate to possess signatures of a number of artists who add their home town, and it is clear that they were mobile, ready to work, often with materials they knew well from their birthplace, for rich patrons far away; the Athenian Acropolis has, for example, yielded bases for statues in bronze or marble signed by men from Paros, Miletus, and even Sparta, as well as a few Athenians themselves. It is often difficult to detect in such a cosmopolitan world any trends in art that reflect political shifts, alliances, and demise. Sparta is a case in point. Her notorious military austerity was to come; during our period the arts there flourished as much as in many another leading city, with outsiders being commissioned and local schools, more or less distinguishable in style, of pottery and bronzeworking. Degrees of local

independence in matters of style and subject-matter vary from one art form to the other, not surprisingly in a world where artistic mobility is so apparent.

We should not forget the small. A great variety of objects carried decorative features, whether floral or figured. The technique of raising the walls of vessels of bronze from an original cake (by alternately hammering the metal cold and hot, to preserve elasticity) was mastered in the seventh century. This allowed a range of metal containers to be produced, some of imposing size. Weaponry and armour were also decorated; stamped panels on the bronze strips attached to the inside of shields are an important source of iconographical material. Jewellery in bronze and particularly silver and gold is at times highly intricate. Egyptian technique, motifs, perhaps even staff are attested in a faience industry set up in the later seventh century on Rhodes and elsewhere; the same is true of the renewed Greek production of coloured glass, though here Lydia may have been as influential a source. At the same time the more home-grown arts of casting bronze figurines and moulding terracottas flourished, and we can do much to isolate regional styles.

We will note the importance of the technical study of the moulds to fashion terracottas and their 'generations' of use. Such technical study of moulds is equally significant for a totally new type of artefact: small lumps of precious metal were weighed out and stamped with designs cut on moulds. We call them coins, and they first appear in Lydia in the later seventh century. At first an alloy of gold and silver was used, electrum, and the Greek cities of Ionia (or perhaps individual Ionian Greeks) soon borrow the Lydian invention. Silver coins first appear in the Greek world around 550–525 BC, normally of a much rounder shape than the bean-like electrum lumps. Initially only one side would bear a design or type, punched on to it from a mould or die, over which the blank was placed, but in due course the punch itself was cut with a type. These designs tend to echo current favourites, not least animals, but by the fifth century Greek silver coins were regularly the vehicle for exceptionally fine studies. A closely related craft is that of gem-cutting and ring-engraving; a few studios worked in soft-stone and ivory in the seventh century, but the sixth saw the renewal of hardstone-engraving, notably in east Greece, where we may ponder the relationship between gem engravers and die cutters of coins. The good range of gem-stones and some delicate detailed work, together with a surprising variety of subject-matter, make them an important area of study.

A few coin issues can be precisely dated. Some sets of architectural sculpture can be given approximate dates from literary texts, notably Herodotus; and a modest number of archaeological strata can be dated through similar references. Yet for the period in question dating often depends heavily on judgements of development of style, in the broadest sense: pot x is later than pot y because its shape has changed in a 'later' direction, and its figures or decoration are drawn in a 'later' way; and of course other factors, such as the lettering of an inscription, the context of the find-spot, or the popularity or rendering of a myth, can be called in evidence.

Dating in this way is perhaps easier in the Archaic and Early Classical periods than later, since we do not appear to have the mixtures of progressive and classicizing, ideal and individual, that are found then. Much material, though by no means as much as we would like, has been found in excavation, near to its presumed place of manufacture; and an additional bonus for this period is that the Greek states tended to use individual varieties of the alphabet, and so any text on or associated with a work of art can give important clues as to its origin, or that of its maker. Such texts are naturally immensely useful on objects that travel far, such as coins and gems.

Artistic styles evolved slowly through much of the Archaic period. In some areas the Daedalic style in sculpture lingers into the sixth century, but overall there is a tendency to depict both bodies and heads in more natural proportions. Such changes can best be studied in the series of kouroi and korai; yet the

figures remain very much four-sided throughout. In painting, change occurs, but tends to be slow; for example, only towards the end of the period do we see attempts at rendering the eye in profile in a profile head; the forceful, frontal eye had sufficed. The frontal head is used for an interesting range of figures, many of which may be termed demonic, especially the Gorgons. However, in some areas, notably Crete and Sicily, frontality seems to have been considered a more immediate, almost theatrical method of presentation, although one might more mundanely see in some such heads merely the influence of mould-made terracotta figures. The most active years of stylistic change in our period were at Athens around 525 BC, when the best vase-painters, whose trade was flourishing enormously as a result of overseas demand, reversed their technique, from figures in black with incised detail, on an orange-red ground (black-figure), to ones in red, with brushwork detail, on a dark ground (red-figure). And soon after, in a competitive burst of invention, early red-figure painters experiment with a range of daring new three-quarter, frontal, and rear-view poses; experiments which are taken up with somewhat more sobriety in the following generation. Inspiration undoubtedly came from observation of life in Athens, not least in the theatre and gymnasium, or, one should say, in those areas used for exercise and performance, only later to be graced by new architectural forms.

1050–750 BC: THE SLOW DEVELOPMENT OF NEW SCHOOLS OF ART

1 Pottery is virtually the only surviving material evidence for the art of the period 1050–900 BC (the so-called Protogeometric period) after the economic collapse of the Mycenaean palace system and the concomitant loss of specialist skills. The pots are largely of Mycenaean shapes, with some additions seemingly imported from Greeks now living in Cyprus. Decoration is restricted to designs based largely on circles, triangles, and rectangles—that is, where there is not an ever-degenerating dependence on inherited designs such as plain zigzag and wavy line. The pieces here illustrate the commonest shapes, the round-bodied two-handled amphora and the *skyphos*, a drinking-bowl on an elegant high foot, though the decoration of both is slightly more elaborate than the average (and that on the amphora unusually asymmetric). Both are of Attic manufacture, from the major Athenian cemetery of this period. The circles are drawn with a multiple brush fixed to a compass. Herein lies an important aspect of Protogeometric style at its best, the control exercised over free-hand pattern that had predominated in the Mycenaean period—the compass rules and the ruler encompasses. The basic appearance is of a light ground with added decoration. The paint used is variously called 'black', 'gloss', 'glaze'; it consists of a solution of very fine particles of the same clay as the body of the vase. It fires black because of the chemical change of the iron oxides in the clay; the coarser body of the vase takes in oxygen in a final phase of firing, and the iron in it changes to orange-red ferric oxide, but the finer particles of the 'paint' form a sealed layer into which the air cannot penetrate and its ferrous oxide remains the black colour created in the previous stage of firing, with a kiln starved of air. The same technique will be used for almost all Greek decorated wares in the ensuing centuries.

2 (**Colour Plate V**) While most prestigious finds from the Protogeometric period are heirlooms from the past or imports from the east (rare as they are), terracotta is used for a few more exotic objects than mere vases. The most unusual is this centaur, from Lefkandi on Euboea, found in fact in two graves, head and torso. The decoration on the piece sets the pattern for much modelled work by Greek potters, since it is painted with purely conventional designs, such as were used to deck out vases. On the other hand, attention is paid to faunal detail; the monster is known in the Bronze Age and recurs later, but is to our knowledge unknown at the period in Greece apart from this example. It has a gash on the knee, suggesting a wound, perhaps sustained in a battle, such as is known from Homer, and has six fingers—error or monstrous sign? The piece nicely illustrates the difficulties under which our interpretation of Greek art labours when written sources are absent, and even artisanal products hinting at folklore or legend are extremely rare. Interest in, or ability to show, detail is not such that we can be sure how much of the creature is human, how much animal. Centaurs later normally have arms, suggesting a more human nature than armless sphinxes, but the artist had to depict a hostile hybrid (though there was the odd friendly centaur), and that was not easy without giving it arms.

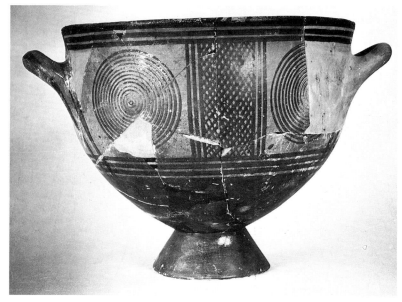

1 B Athenian *skyphos* from Athens (Athens, Kerameikos Museum)

1 A Athenian amphora from Athens (Athens, Kerameikos Museum)

3 The building of which a reconstructed drawing is shown was also at Lefkandi, and after its construction became the centre of an extremely rich cemetery. It was clearly an important site before it was deserted in the later eighth century; the material of the tenth century imported from the Near East and Egypt is scarcely paralleled anywhere else in Greece or the western Mediterranean. Caution is perhaps needed since many other sites cannot be recovered because of later over-building, and others may yet be found. The materials of this structure are those common in the Dark Ages, stone foundations, mud-brick walls, and timbers. It is the size, external appearance, and probably function that are, to date, unique for the period, around 1000 BC. Within, two rich burials, with horses,

suggest an exceptional, royal occasion, and it would seem that the building was erected after the interment as a place of heroic worship; certainly the graves of later generations of the local élite cluster round it. 10 × 45 m. is large even by much later standards, though the basic form, a long rectangle with an apsidal end, is favoured in the period down to the seventh century. The surrounding 'colonnade' is puzzling; the timbers were rectangular, fixed in the ground, not on bases as in later Greek architecture. Tiles were not yet used in Greece, and so a thatched roof is likely. The substantial difference in the nature of the roofing must be borne in mind when this building is compared with later, tiled structures of like size.

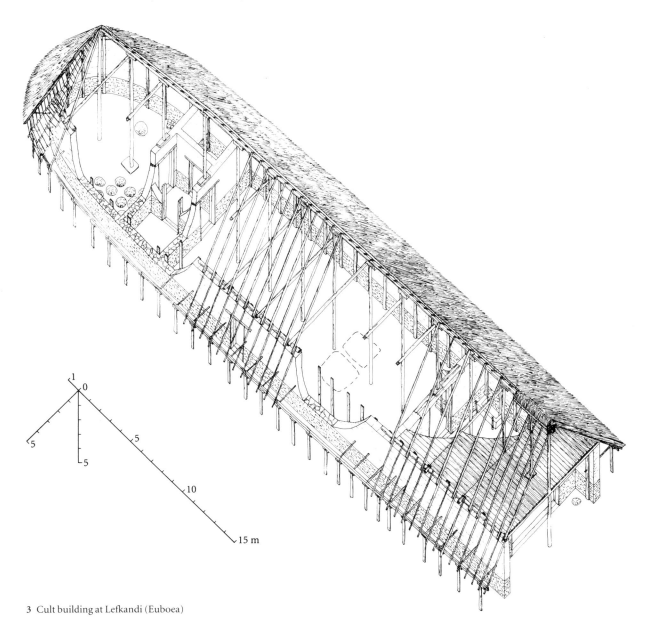

3 Cult building at Lefkandi (Euboea)

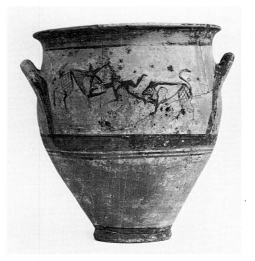
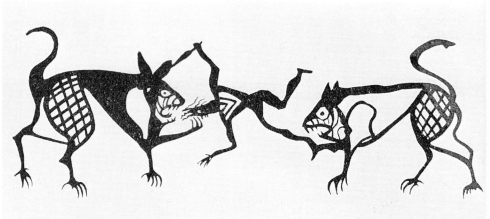

4 Cretan burial urn from Knossos (Heraklion Museum)

4 This urn is a Cretan shape typical of the period, and often found used for the interment of cremated remains. At Knossos, where this example was found, communal tombs are normal, and often the 'crypts' of Bronze Age families were reused. They had practised inhumation and we are uncertain of their Greekness, but the later Iron Age inhabitants were certainly Dorian Greeks. This was made about 850 BC. It is a good example of a restricted number of known ninth-century pots bearing decoration by way of flora and fauna, including humans, which anticipates similar advances in Greece in the next century, but has little ceramic following on Crete itself. The figured scenes appear to have a blend of inspiration, from existing or rediscovered Minoan artefacts and from Near Eastern works of art being brought to the island. Overall the designs are in silhouette with a modicum of outline; the side not shown depicts two 'proto-sphinxes' with cross-hatched bodies, like our man's torso, facing each other—a heraldic form of composition borrowed from Near Eastern arts and highly favoured in Greek painting and sculpture. Here we see a man, *in extremis*, between two 'proto-lions'; the vacant space on all sides is exceptional in later Greek art, but the structure of the bodies is typical of figured work of the Geometric period. The inspiration, given the lack of Cretan lions, is likely to be from imported works of art, or possibly a local tradition derived from such a source.

5 It is at Athens that the most complex and at the same time controlled examples of the Geometric style in pottery are to be found. Movement of population into the Attic countryside still left most of the élite in the area of Athens in the eighth century, as far as we can judge from the comparative richness of burials. Tombs were marked by large vases, craters for men, amphorae for women; they stood above the actual burial pit in which the remains (normally cremated) and other offerings were placed. It is to be noted that a good number were found in excavations in the nineteenth century, mostly ill recorded. The crater shown (about 750 BC, 123 cm. high) has bands of ornament over most of the body, with the broadest fitted to the more significant parts. Varieties of meander are staples in the Late Geometric style, not only at Athens. The eye is almost deluded by other geometrically crafted shapes in the broader friezes, humans and horses. The style of such highly patterned figure-work was developed around 760 BC by one particular painter, dubbed the Dipylon Painter after the alleged place of recovery of some of these giant pots. The representations depict funerals, either lying-in-state (*prothesis*) or procession (*ekphora*), as well as probably associated activities, ranging from games to rather heroized echoes of the military activities of the deceased. Most scenes lack any features that specify the context, and it is possible that some are attempting to render in pictorial form stories told by bards about the heroic past, not least the *Iliad* and *Odyssey* (see [12]). Later, such scenes are often identified by written labels for characters, or by specific attributes given to heroes, such as Heracles' club. Two particular aspects of the form of representation are worth noting: the accent put on the important parts of the body—eye, chest, muscular legs, and a desire to show all that the painter knew was there—all the legs of a chariot team, all the wheels of carts and chariots—in a sense, the third dimension brought to the surface.

6 A similar approach to the figure can be seen in three-dimensional works, of which this is one of the most complex of the period. Such bronzes were cast solid and are rarely as much as 25 cm. high. The great majority have been found dedicated in sanctuaries, where they are the main evidence of cult in the eighth century, often before any structures are found. Ours is from about 700 BC. Most

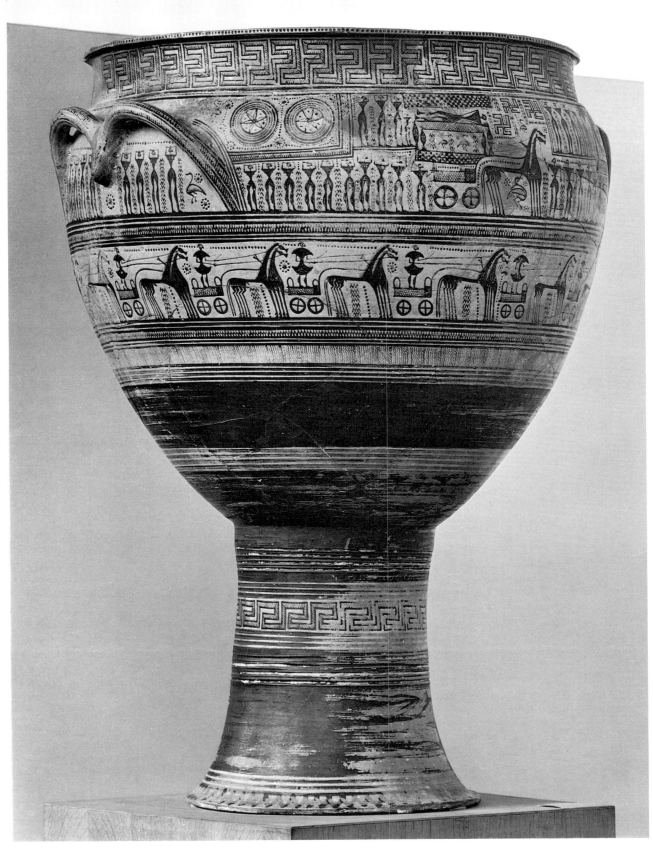

5 Athenian crater: funeral scenes (Athens, National Museum)

6 Bronze statuette: helmet-maker (New York, Metropolitan Museum of Art)

bronzes depict animals, usually representing those either sacrificed (oxen) or prized (horses). Human figures are usually male and can often be regarded as divine, especially the helmeted figure of Zeus at Olympia. Groups are often families of animals, or hunting scenes, with feline creatures probably inspired by Near Eastern art. Here a seated man works on a helmet placed on a form. The model for casting would have been in wax and shows a degree of three-dimensionality, attained no doubt by the maker turning the model in his hands, which disappears from the Greek plastic arts in the seventh century, to re-emerge only centuries later. While such bronzes were manufactured in many centres, to judge from find-spots and styles, it is very likely that itinerant smiths also worked at the emerging inter-regional sanctuaries such as Olympia and Delphi. The relatively small and rounded head is typical of the eighth century.

7 The most prestigious bronzework of the eighth century comes in the shape of cauldrons on three legs, tripod bowls, assembled in one piece from cast and hammered elements. Again they are best known as dedications at sanctuaries, especially at Olympia, where some 500 are known from the period 800–650 BC. The earliest are relatively small and functional, but they soon take on a purely decorative aspect and grow in size. The largest, mainly hammered pieces could never have stood any actual use. We know such tripods were now and later presented as prizes at games and were probably one form of currency, or at least a form of stored wealth and ostentation. Decoration of a Geometric type is regularly applied to the legs and handles, while bronze figurines often topped or flanked the handles. Again horses and armed males predominate. Illustrated is a fragmentary cast leg with two scenes preserved in square panels. Below, heraldic rampant lions face each other over a poorly preserved floral;

7 Leg of bronze tripod (Olympia Museum)

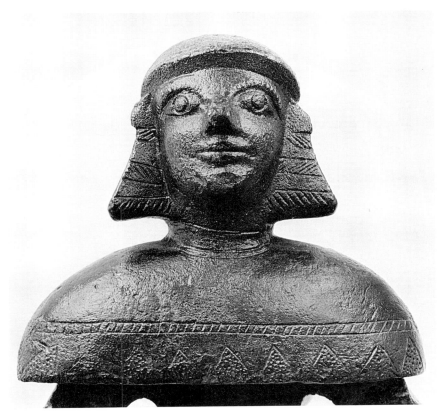

8 B Bronze cauldron attachment: winged female (Athens, National Museum)

8 A Bronze cauldron and stand (Olympia Museum)

this was no doubt one of the newly imported Near Eastern varieties, perhaps the 'Tree of Life'. Above, helmeted warriors in typical Geometric posture each grasp the leg of a tripod (of similar shape no doubt to that of the piece itself). Later the theme is used to represent a struggle between Heracles and Apollo for control of Delphi (represented by the tripod which was associated with the oracle). While the iconography is related, there is little to support a similar identification of it here, not least because of the dedication of the object at Olympia, at a time when the repute of the Delphic shrine was still much in its infancy.

8 The substantial changes that took place in many aspects of Greek life, thought, and art in the seventh century (and which began well back into the eighth) are perhaps best illustrated by a new type of cauldron, first found in Greece in the late eighth century. Here bowl and stand are separate parts, and the bowl is decorated with creatures unknown to the Geometric repertoire, busts of winged males and females, and eagle-like heads on snaky necks. Finds from the Near East clearly show that the inspiration came largely from Syria and eastern Anatolia, while the decoration on the stand in this reconstructed drawing is heavily Assyrianizing. Exports from the Near East are found scattered through Greece, and further west among the emerging élite in Etruria. The cast heads present a mixed Syrian–Phoenician set of details; variants of such a head type are also found in other bronzes and in ivories also exported to Greece. This style, or range of styles, profoundly influenced the approach of Greek artisans in all branches of craft, who turned away from the perky, rounded, and small heads of the indigenous tradition and adopted a generally tauter and more linear version of the fleshy, large-featured, and essentially frontal eastern heads [B]. We call the Greek winged figures sirens, since soon we find whole figures with bird bodies reminiscent of the busts. Similarly, the eagle-heads are termed griffins. They are not used to decorate cauldrons in the east (save on Cyprus), and were perhaps always added later to the original bowls. Early examples are hammered from sheet bronze, later ones cast. The eagle-headed lion was well known in the arts of Mycenaean Greece, but disappears from our view throughout the Dark Ages. Some new versions follow Bronze Age types and may well owe their form to rediscovered or retained gems of Minoan Crete (cf. [22 A]), but the cauldron attachments owe their appearance to a variety of different influences, not least the desire of bronzesmiths to work with sharp contours and clear, symmetrical pattern.

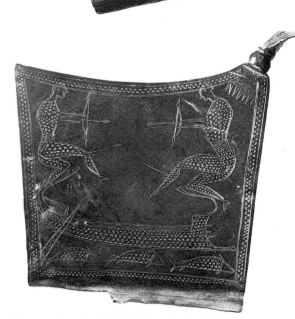

9 The extent to which functional objects carry elaborate decoration varies from civilization to civilization, period to period. The Greeks were profuse with not only abstract and floral ornament, but also figured work. Here is a large bronze safety-pin or fibula (gold and silver examples are also known), one of a large number made mostly in the eighth and early seventh centuries which were specifically given large flat areas on which figures could be incised. The style is very close to that of contemporary pottery, although Boeotia seems to have been the major centre and was not a producer of much figured pottery. The engraver here gives us one scene apparently from everyday life and one interpreting a mythological tale; in both he adopts a falling-back pose to denote forward movement, and is at pains to indicate the wounds of battle through its weapons (see [17]). As often, the sea is also indicated by a part, fish, while we are left to hazard the circumstances in which the archers do battle, noting only the difficulties found in these early representations of activity in successfully depicting shoulders. Battle between a man and a set of Siamese twins appears relatively often in the art of the period, but not later, and opinions vary as to whether the hybrid can be an early version of what is regularly later the *three*-bodied opponent of Heracles, Geryon [21], or a more shadowy hybrid mentioned by Homer (or neither!).

THE IMPACT OF NEAR EASTERN ART: THE SEVENTH CENTURY

10 Geometric art, as practised by the Dipylon Painter and his followers, had nowhere to go, it was a finished product. Athenian painting did indeed develop out of this strait-jacket, but it is at Corinth that the main changes in technique first appear. Few figures are seen on Corinthian Geometric pottery (and fine linear design will remain a Corinthian forte), and few large vases were made. Far more common (and by about 725 BC widely exported) were small jugs of various kinds, cups, and pots like this, rounded flasks rarely above 8 cm. in height; they must have carried perfumed oils, which would in part have been

9 Bronze safety-pin (fibula) (Athens, National Museum)

imports from the Near East, as also are elements of the decoration on these *aryballoi*. The old silhouette style is enlivened by some flecks scratched on the surface; a forerunner of the black-figure technique—see [45], in which all linear detail is incised on the black silhouette to show the pale ground through. Other figures have areas painted in outline, perhaps the more natural painting technique. The use of incision could well have been inspired by its use in metalwork, both local and imported. The frieze here is

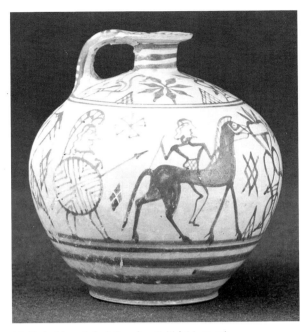
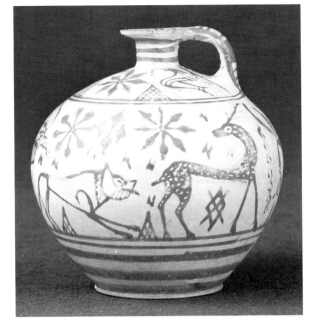

10 Corinthian oil-flask (London, British Museum)

the most varied figured display of what is termed the Early Protocorinthian period (about 720–690 BC). Other *aryballoi* have more repetitive rows of animals. Here a warrior and rider, part of the Greek tradition, are joined by a deer, a lion, and a floral tree, all elements brought from further east. The painter may have intended to depict a single scene which he envisaged, but we have difficulties interpreting such a juxtaposition of closely placed and seemingly disparate figures. The painter certainly does not, and presumably was unable to, show by depth, overlapping, or gesture any intended association.

11 The seventh century saw major changes in the decoration of pottery. While some schools long retained Geometric motifs ('sub-geometric'), elsewhere we see much experiment with new ways of representing figures and with the subject-matter chosen. In particular there is a greater emphasis on mythological scenes, inspired by a variety of oral tradition, and on animal friezes, with a large imported component, especially of creatures of legend and folklore, such as the sphinx, siren, and griffin. A compendium of these changes appears on this sack-shaped decanter (*olpe*) painted in Corinth around 640 BC, and exported to Veii, north of Rome; a similar piece has been found at Erythrae on the Izmir peninsula in Turkey. The Chigi vase displays a range of colour in its main frieze that is rare in earlier and later vase-painting (but see [73]) before the mid-fifth century [98]. It also has friezes in white on the black bands. The representation of two lines of battle clashing also has no parallel outside the painter's own works; it is an early and impressive record of this rel-

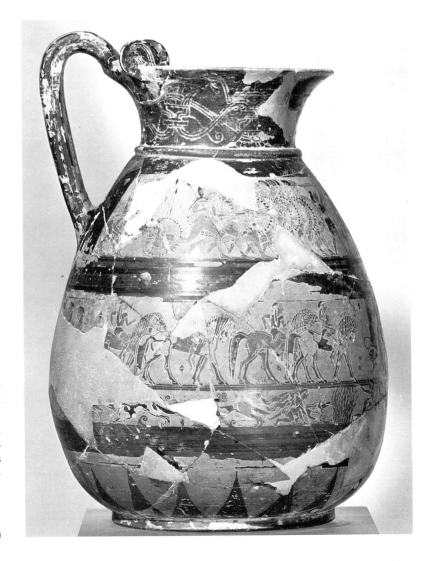

11 Corinthian jug (Rome, Villa Giulia)

atively new tactic of organized, massed onslaught. As often, animal violence echoes the human in a lower frieze, where we find the fullest version of a lion-hunt, with a beast copied from Assyrian art; the more Greek hare-hunt (again, the fullest) lurks below. Not seen here and presumably painted somehow as an afterthought, though in the main frieze, is a scene of five standing figures below the handle; they are given slightly different attributes (apart from sex) and also labels in large letters, to indicate that we have here our earliest representation of the Judgement of Paris.

12 (also **Colour Plate V**) The most adventurous painting on Attic vases remains on large jars, normally used as tomb markers in the old tradition; decoration other than plain work is regularly confined to a single side. This amphora was used for a child's burial at Eleusis, perhaps not its intended function. It stands 1.42 m. high, the main frieze over half a metre. The outline technique reaches its peak here in Attic painting, soon to be supplanted by black-figure incised silhouettes, which indeed appear sporadically throughout the century at Athens, witness the lion and boar on the shoulder. Violence also above and below (see [**11**]), and all around a luxuriant foliage born of a variety of Near Eastern floral arrangements. Much additional white, clay-based, is used, typical of this period, although it continues to be applied more sparingly in ensuing generations. Both scenes show a hero combating monsters. Above, a seated giant is about to be blinded; the *Odyssey* gives the story of Polyphemus, made drunk by Odysseus in his cave. The white has worn from Odysseus' body; he kneels on his opponent like a Pharaoh. Features are large and angular, a few being incised. On the body her sisters abandon a horizontal, headless Medusa to pursue Perseus, who is protected by Athena, blocking the way. These are the earliest known full Gorgon figures in Greek art, and unlike later ones, based on a frontal lion mask, are constructed around a cauldron-based head, replete with protomes [**8**]; the running pose too is not the excessively kneeling stance of later years, but a gentle prance.

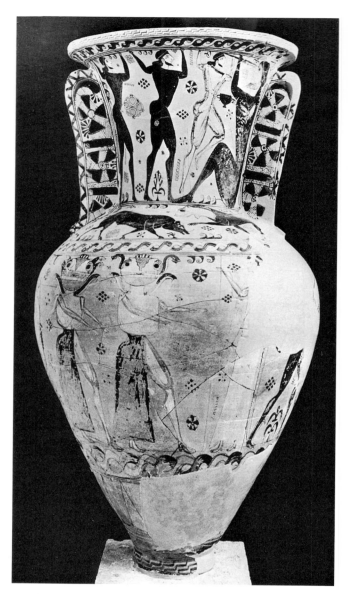

12 Athenian amphora: Polyphemus and Perseus (Eleusis Museum)

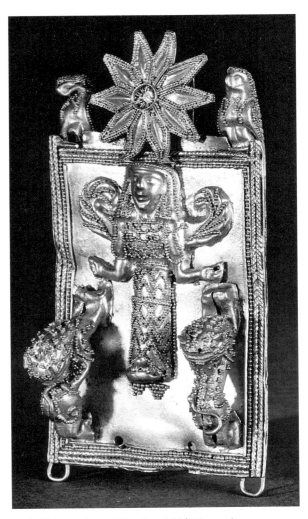

13 Gold plaque: Artemis (London, British Museum)

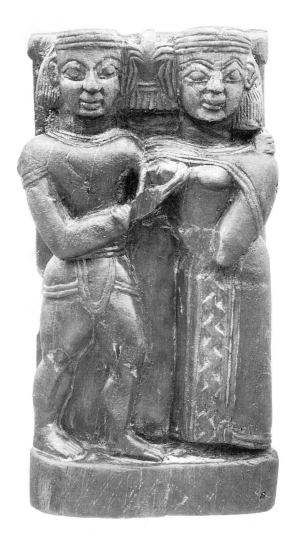

14 Wooden relief: Zeus and Hera, from Samos (lost)

13 While finds of gold and silver jewellery from Greek lands are rather scarce in the sixth century, we possess good quantities from the seventh, notably from a work-shop on the island of Rhodes. The technique, practised earlier in Greece, is basically pressing gold sheet over a matrix with the pattern. Now we find added the use of granulation, patternwork in small grains of gold soldered to the surface (a technique best seen in Etruscan jewellery of the period). The style is also radically changed, with the adoption of Near Eastern heads (see [8]) and motifs. Here we see the 'Mistress of Animals', a winged deity subduing two lions (often held by the tail); the theme is purely Near Eastern, but is applied to Greek cults, especially that of Artemis, who sports wings more often than any other major Greek deity. Other plaques show a similar figure with the body of a bee, another facet of the worship of Artemis, especially at Ephesus. Frontality and symmetry are hallmarks of the so-called Daedalic style, as are a long torso and chequer-patterned robe. The most frequent

vehicle for the style is the cheap terracotta votive figurine found in many areas of the Greek world. They are now made from moulds, a technique introduced from Syria in the early seventh century; the simplest mould form is one-piece, into which the clay is pressed, and naturally the frontal aspect of the figure is the usual one to be presented. The mould remains the standard production method for the wide range of votive types in baked clay that ensued [**54**].

14 A forgotten factor in Greek art is the use of wood. Only about a dozen pieces of figure-work are known for the Archaic period, most of them from the marshy seaside sanctuary of Hera in the plain west of the city of Samos. Ancient authors give us more or less reliable reports of other wooden pieces, many of life size, and of a variety of woods used. Not all are of early date, and the use of wood

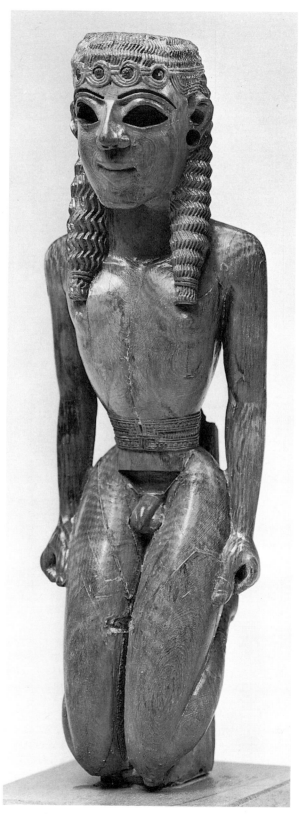

15 Ivory figurine from lyre frame (Samos Museum)

was clearly not a phenomenon merely confined to the infancy of Greek sculpture. This piece is of moderate size (about 18 cm. high), and is the most complex of the figured pieces from the Samian Heraeum, although one must add that some of the carpentry is also highly elaborate. It must date from around 620 BC and depicts Zeus and Hera. The central motif resembles the floral bundle certainly later used to denote Zeus' thunderbolt, but is more likely a bird, perhaps the cuckoo seen later with Hera; Zeus' clothing would be unusual, since he regularly wears either very little or a voluminous himation (wrap) elsewhere. The gesture denotes the sexuality of their relationship, and is again borrowed from the eastern repertoire. The carving of the heads is particularly close to Syrian models, and we may wonder about the training of the maker.

15 Among the finest pieces dedicated at the Samian Heraeum is this ivory figure of a kneeling youth. It clearly formed part of a larger object, and it has been thought to be the arm of a lyre, though not all would accept this view. The craft of ivory-carving returns to Greece in the eighth century, and products often closely follow Near Eastern types and styles. Ivory naturally had to be worked with the tusk-size as base, as did cheap bone imitations. The superb carving of this piece includes details, such as in the ear, that do not recur for some generations in our preserved record. The basic structure, however, and the archaeological context, clearly indicate a date of about 650–630 BC. Inlay for details was presumably in stone. The carving of the musculature is particularly noteworthy, especially since few other nude male figures of the period, in whatever medium, are as well preserved. While the torso retains the triangular upper part and rather sausage-like legs of the Geometric period, the indication of pectoral muscles, clavicles, and stomach find closer parallels in stone sculpture of the early sixth century. Naturally there has been much debate about where the piece was made; its singularity has made any decision difficult.

16 It is unfortunate that our earliest known marble statue from Greece is not in good surface condition, even if it is largely in one piece. It was found in the sanctuary of Artemis on Delos, and bears an inscription cut on the body (as often in Greek plastic arts) recording that it was a dedication to Artemis by Nikandre, from a prominent Naxian family; she may well have officiated in the cult. The statue is in many senses a small terracotta writ large. It also clearly betrays the original rectangular shape of the block, from which a minimal amount of stone has been cut. The marble is local, from Naxos, and no doubt another famed Naxian product, emery, was used to smooth its now lost surface before paint was applied. Few toolmarks remain, but we can safely assume the use of the point and chisels to work the hard stone. It is likely that the holes in the hands

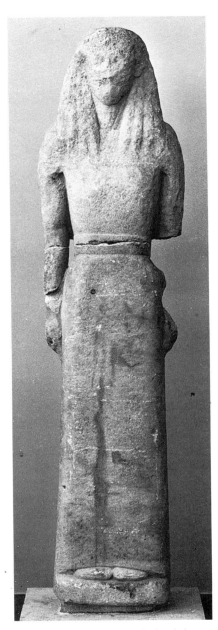

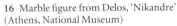

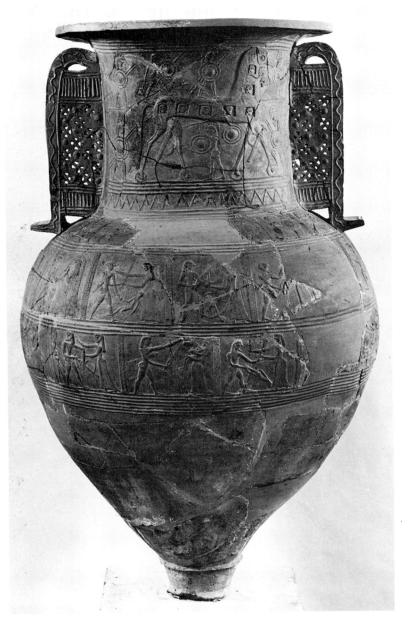

16 Marble figure from Delos, 'Nikandre' (Athens, National Museum)

17 Clay storage jar: sack of Troy (Mykonos Museum)

were for the attachments of accessories, perhaps animals, which would make this a representation of Artemis (see [13]). The predominance of females in seventh-century plastic arts is in striking contrast with male-dominated Geometric figure-work, and should be ascribed partly to the influx of largely female figurines from the east and partly to cult reasons, with a rise in popularity of dedications at the sanctuaries of Hera, Artemis, and Athena; there is, however, no accompanying falling off in the popularity of Olympia or Delphi, devoted to the gods Zeus and Apollo.

17 Large clay storage jars are common features of ancient civilizations. In Greece they are often decorated, to a greater or lesser degree; in some areas figured work is often applied, and a number of schools can be identified. Most of this material is of the seventh and sixth centuries, and Crete and the Cyclades are the leading producers; in both areas animals, fabled or, more rarely, actual, form the basis of the repertoire, but myth scenes also appear. The figures are usually modelled separately, either by hand or from moulds, and applied to the roughened surface; paint is known to have been added to some Cretan pieces. The jars

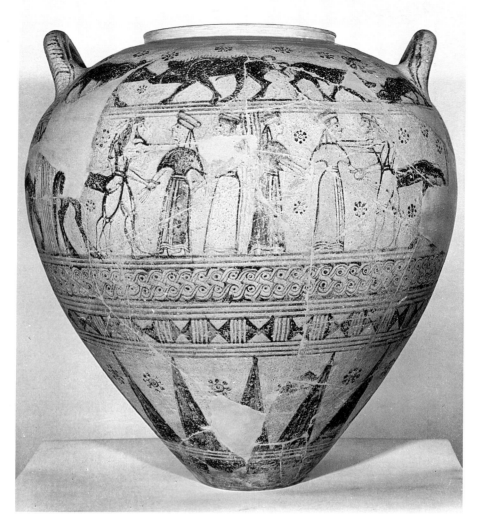

(termed pithoi or amphorae) add considerably to our knowledge of mythological representation in the period. Here there are numerous panels showing scenes from the Sack of Troy by the Greeks. The jar was used for a burial on the island of Mykonos and dates from around 675 BC. The main scene gives our earliest representation in art or literature of the Wooden Horse with its armed cargo; a fragment of a similar jar shows a wheel attached to the hoof, a hint of the dilemma felt by the artisans. One is struck by the harsh violence of the repeated scenes of killing of women and children, while a single panel depicts the (successful) attempt of Helen to disarm her Greek husband, Menelaus, by revealing her charms. Again, no such forthright depiction is found in later generations, though the piquancy of the story, known from a literary source of uncertain date, was termed 'too modern' for the Archaic period by one scholar, before this piece was found in 1961.

18 One myth that finds frequent pictorial expression in the seventh and sixth centuries is the killing of the Minotaur by Theseus, the sole adventure of the Athenian hero

that appears in this period (contrast [**79, 80**]). An early example is on the reverse of this jar made probably in Sicily around 650–625 BC. The shape is more common in plainer pottery than decorated, while the painting style is a mix of the older silhouette of the animals on the shoulder with the use of outline drawing found in many of the short-lived vase-painting schools of the seventh century (see [**12**]). Here we can discern a mixture of influence from outside Sicily, not least, in the subsidiary decoration, from the east Greek world. Figured work with humans is, as often at this period, confined to the major zone, where two panels are laid out on each side. There is considerable symmetry of design, an echo of the heraldic method of presentation currently much favoured. Two women are accosted by a centaur, who grasps the wrist in a possessive manner known from many other scenes. Here, however, we lack evidence for a clear interpretation; in Greek literature centaurs carried off individual girls, but here the spirit of pictorial representation reduplicates their number. Centaurs are now men with the rear part of a horse (contrast [**2**]), with the consequential anomaly of silhouette horse and

19 Clay metope from Thermum: Chelidon (Athens, National Museum)

outline fore-quarters, found not only on this piece. The painter corrected the pose of one leg, but did not, or could not, remove his original lines.

19 Few large-scale paintings on flat surfaces ('free' painting) survive from the Greek world. Small scraps of stuccoed limestone panels on the walls of the temple of Poseidon at Isthmia, about 650 BC, exist, and about a generation later the temple of Apollo at Thermum at the west end of the Corinthian Gulf was decorated with a frieze which included square terracotta metopes (98 × 87 cm.). The decoration was fired in the kiln in the same manner as that on vases, and the technique used is broadly similar to that on the far smaller Corinthian pots such as the Chigi vase [11]. A range of myth is portrayed; connections with the deity worshipped are tenuous, if existent at all. This scene is of a myth rarely depicted at any period of Greek art, Procne and Chelidon (the better-preserved figure, shown here) with the body of Itys, the result of a tale of lust and infanticide that ended with the transformation of the cast into birds, including the swallow, Chelidon, her

tongue cut out to prevent her telling the tale. The other preserved metopes portray a wide range of unrelated scenes; a few, like this one, tell us who the characters are, in a script that is an unusual mix of Corinthian and local Aetolian. The temple stood a long time and one wonders how intelligible the labels were in the Classical period, when some of the metopes show signs of refurbishment.

20 Decorative metalwork is as significant in the art history of Greece as in that of many other civilizations. Here is a good example of Cretan-inspired work on armour. The piece was found at Olympia, where it was dedicated to Zeus Olympius, along with thousands of other metal objects, not least weapons and armour captured from the enemy, Greek and barbarian alike. Most of the sheet bronze is worked from the rear, repoussé, and given surface detail by the chisel. A typical range of later seventh-century figures and florals decorates the cuirass—heraldically arranged pairs of lions, bulls, sphinxes, and panthers, palmette and lotus chains, and below, balanced trios of humans. One set is led by a lyre-player, who

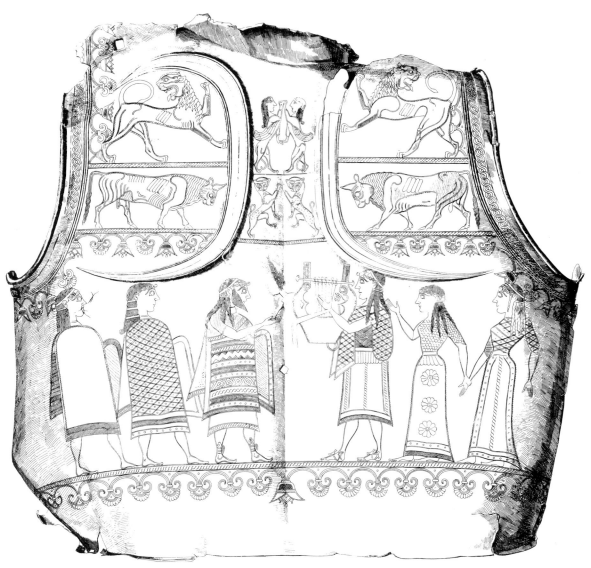

20 Bronze cuirass (Athens, National Museum)

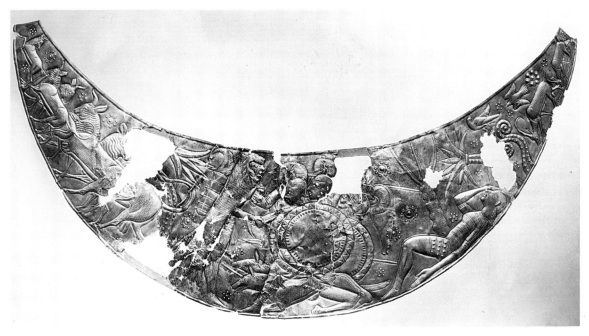

21 Bronze horse pectoral: Heracles and Geryon (Samos Museum)

A

might well be intended as Apollo, while the shoes and beard of his opposite number mark him out as a figure of distinction. We note in particular the attempt to render cloaks wrapped round the body. Holes in the metal point to use in battle, and the same is found on other highly decorated items of defensive armour; they were no parade pieces.

21 The purpose of this bronze sheet, of about 625 BC, is less clear, but it was probably a horse collar. It comes from the sanctuary of Hera on Samos, which we have found to be a rich source of Greek and imported material of these centuries. Pieces in similar style are known from Olympia and most carry scenes of high interest. Here we see a very full and early depiction of Heracles, now wearing his lion-skin, attacking the triple-bodied Geryon, reeve of the sun god, whose cattle Heracles has come far west to rustle; the watch-dog too is monstrous, while the herdsman lies on the right, already dispatched by the hero. The format of the scene will change little over the next century, though here we have a Geryon with only two, not six, legs, and some goats and the filling ornament have been brought in from contemporary Samian vase-painting, or perhaps textiles. Note the diminishing scale of the figures which fit the established shape of the artefact, a solution to be adopted by the designers of pedimental sculpture in later years. Grasping an opponent by the hair, even the horse-hair of his helmet crest, will also remain a standard motif.

22 The art of gem-cutting revived fitfully in eighth- and seventh-century Greece. Bone and ivory seals are well attested from the Peloponnese, though there is no good evidence for their use to seal documents or boxes. The same applies to a series of softstone gems, mainly of the seventh century, cut in the Cyclades, especially on Melos. Two excellent examples and one more run-of-the-mill are illustrated here. The grey steatite amygdaloid (almond-shaped) stone with the rendering of a goat [A] is clearly inspired by bodies in torsion cut centuries before by Minoan artists, though here the legs are more curiously treated. The double-sided round (lentoid) green steatite piece [B] demonstrates how these cutters added to the range of hybrid creatures so popular in all the arts of the period; the contorted winged horse is a striking conceit, well suited to the round object. Four impressions from a small cube of green steatite found on the Acropolis of Athens are shown as [C]. The same technique is used, with simple cuts an important element, but the highly linear effect is more typical of the series as a whole than is the fine work of [B]. Animals predominate, though the scene of two goats at a bush is uncommon. The scene of intercourse has parallels, not least (and curiously) in the earliest stamps found on tiles, of much the same date.

B

B

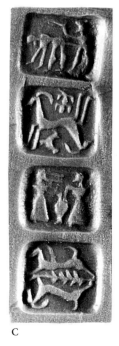

C

22 Stone seals (**A** London, British Museum; **B** New York, Metropolitan Museum of Art; **C** Athens, National Museum)

ARCHITECTURE: TEMPLE, POLIS, AND HOME

23 This remarkable house model was found in the tomb of a woman on the island of Thera; it was kitted out with a set of miniature vessels. A number of models of temples or houses (the difference is rarely clear) are known from finds at sanctuaries of the eighth and seventh centuries; this is a far larger (38 cm. high) and more elaborate piece, decorated with vase-painting motifs of about 650–625 BC. The decorator has added his own and the owner's name on the portal in flowing rounded letters in keeping with the painting style, but at odds with the generally angular letters of most contemporary inscriptions. A leading question is to what extent the model reflects actual housing of the period; at least the benches round the walls are a common feature of Greek, and especially Cycladic, houses, used for sitting, sleeping, and storage. We shall see that in vase-painting houses of heroes tend to be on the scale of contemporary temples, though the earlier models mentioned above appear more in keeping with actual architecture. The owner's inscription points to this being a house rather than a temple, but the capitals of Aeolic form [**29**] do not to our knowledge appear in domestic architecture. Here they face the porch, not the exterior. As often in Greek art the monumental and serious is given a touch of

life, with two cavorting figures, perhaps apes, painted on the lower side wall.

24 The sanctuaries of the Greek world were a focus of civic attention, and we shall note their increasing monumentalization as competition between city-states increases. Often an earlier structure is replaced with one more up-to-date, and usually larger. Replacement was often occasioned by the destruction, by whatever agency, of an earlier shrine. Recent excavations at the modern site of Kalapodi, near ancient Hyampolis (Phocis, central Greece) have revealed such a sequence of structures at the sanctuary (temenos) dedicated to Apollo and Artemis, to be identified perhaps with Apollo's famous oracular seat of Abae. The Persians destroyed the shrine in 480 BC and a makeshift altar was in use until a new building was provided around 450–425 BC. Earlier there were two temple buildings, both thatched, side by side, and their excavation has given valuable evidence for the history of Greek architecture; they belong to the seventh century. One has an irregular form of porch, two columns between spur walls; the tall lowest course was of stone, set in mortar, with mud-brick walls above. The other had a broad, four-column porch, and bases, for ceiling support, were set against the inside of the walls, together with a central row of posts; the walls were made of two colours of brick, deliberately patterned. After a destruction about 575 BC, the two were

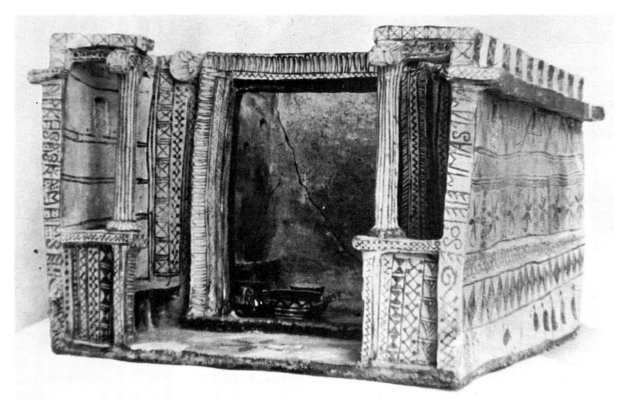

23 Clay house model (Thira Museum)

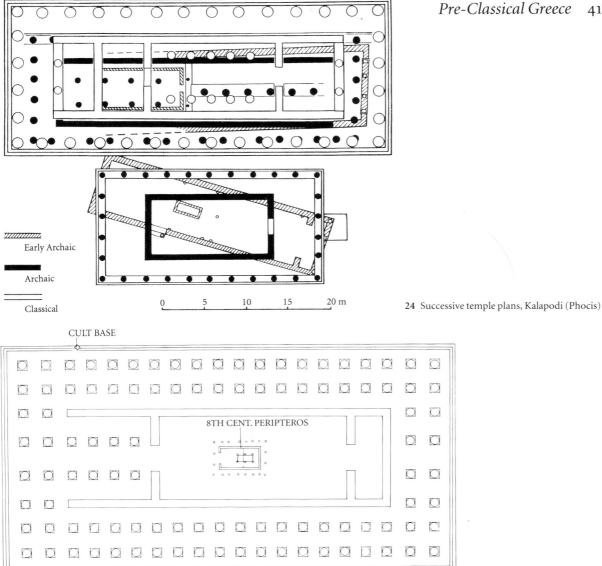

Early Archaic

Archaic

Classical

0 5 10 15 20 m

24 Successive temple plans, Kalapodi (Phocis)

CULT BASE

8TH CENT. PERIPTEROS

N

0 10 20 30 40 50 m

25 Early temples of Artemis at Ephesus

replaced with two equally differing structures. To the north was built a long temple with eighteen columns down the side and two internal rooms, a format with several contemporary parallels. The southern structure had an abbreviated eleven columns and no porch, a much rarer variant of the basic temple design. One of the two has been shown by careful excavation of *pisé* fragments to have had logs, not squared timbers, for its ceiling beams.

25 An equally interesting sequence of structures has been located at the temple of Artemis at Ephesus, one of the Seven Wonders of the World, according to a list first drawn up by chroniclers of the Hellenistic period. That temple was built in the fourth century and replaced a similar huge Ionic temple constructed over a long period from the mid-sixth century onward. There were also earlier structures; recently a low water-table has enabled excavation in the central part of that temple to reach levels of the eighth century. A rectangular building has been found (8.50 × 13.50 m.) of good stone work, with a colonnade of posts or columns. With some modifications it remained in use for a lengthy period, eventually being embodied in the substructure of the central shrine of the sixth-century building. The early temple is at present unique in our record of Greek buildings, though it must be regarded as a direct predecessor of the marble temples. The first of these, of the mid-sixth century, can be closely compared with rivals erected to Hera on Samos and Apollo at Didyma, south of Miletus. These all have two sets of surrounding columns (dipteral), with more columns in a deeper porch.

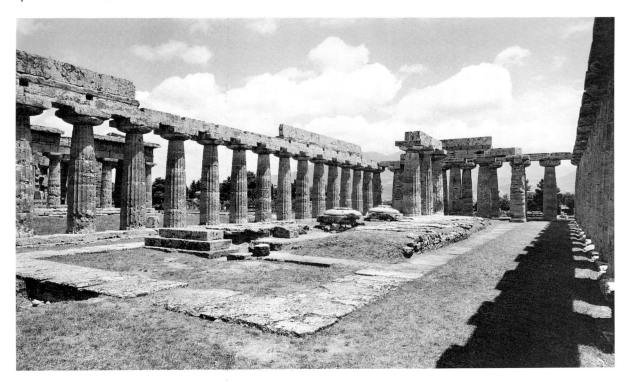

26 Temple of Hera, Paestum

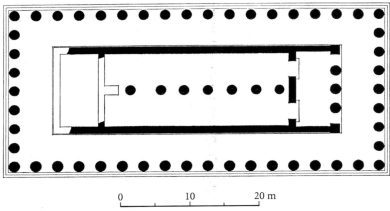

0 10 20 m

The order is recognizably Ionic, with significant local variations in such things as the treatment of column bases and the architrave, as well as in the most distinctive detail of the order, the capital.

26 A few Greek temples still stand relatively well preserved, although some others can be better restored on paper from their fallen members. For the Archaic period our prime example of the former category is undoubtedly the temple at Paestum in Italy dubbed in the eighteenth century 'the Basilica'. A temple dedicated to Hera, it is aligned to the grid plan of the colony of Posidonia/Paestum and was built about 550–525 BC. It is of the Doric order but with additional features of a more decorative type than found in the Greek mainland [27]. The cigar-shaped columns show at its extreme the vertical curvature normally used in the Doric order, and the squashy lower part (echinus) of the capital together with the narrow neck below is also typical of Archaic Doric. Above, the entablature is sandwiched with ornamental mouldings in sandstone, not found in Greece. Many of the echini were also lightly modelled and painted with floral designs, perhaps also used on other Doric buildings. The plan, with its central row of full-size columns (see [24]), is not unparalleled, but is unusual in this later period. Two deities may have been the object of cult here, but it may only have been for more practical reasons that two doors were included at the east end. The temple's upper works, of stone, had nailed on to them brightly painted terracotta revetments (see [30]).

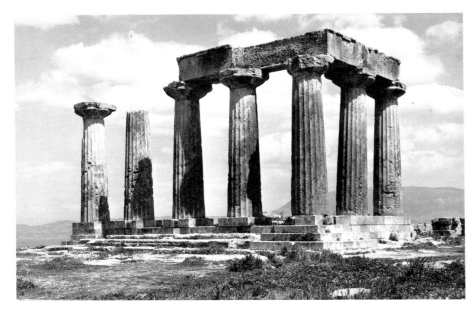

27 Temple of Apollo, Corinth

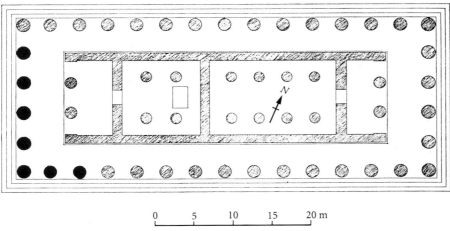

0 5 10 15 20 m

27 Of much the same period as [26] is the temple of Apollo at Corinth, the only Greek structure to survive the sack of the city by L. Mummius in 146 BC, although it required heavy repairs. Four of its monolithic columns survive, while much of its plan can be read in the cuttings for foundations in the bedrock of the hill on which it stands. Scattered blocks demonstrate the existence of a predecessor of the earlier seventh century. The plan (as [24]) shows two rooms, each with its own entrance; we have no information as to the reason for this doubling. The columns in one piece of locally quarried stone (very locally—much of the surrounding rock is cut away) are not unusual in the Archaic period, and must have been raised by the Egyptian method of ramps and haulage (by slaves?). The Doric order here has the heaviness of tall architrave and thick columns of most Archaic temples; the columns taper typically to a thin neck. Again, as normal in the period, the side columns are slightly closer set than those at the front. The architect has faced up to the problem of 'angle contraction' by adopting a compromise: triglyphs have to meet at the corners of the Doric frieze, beyond their natural position directly over the columns; this increases the length of the frieze from the corner to the centre of the second column in, an increase which can be accommodated either by simply broadening the metopes or by placing the corner capital closer to its neighbours. Here we find a bit of both, but on the mainland closer setting of columns at the corners prevails, presenting architects of Doric temples with a difficult problem of basic planning, which was to cause problems with such buildings for centuries to come.

28 The best-known building of the Archaic period in the Ionic order (even if little remains standing) is a small store-house, a treasury, built in the sanctuary of Apollo at Delphi by the men of Siphnos in the Cyclades. Fortunately

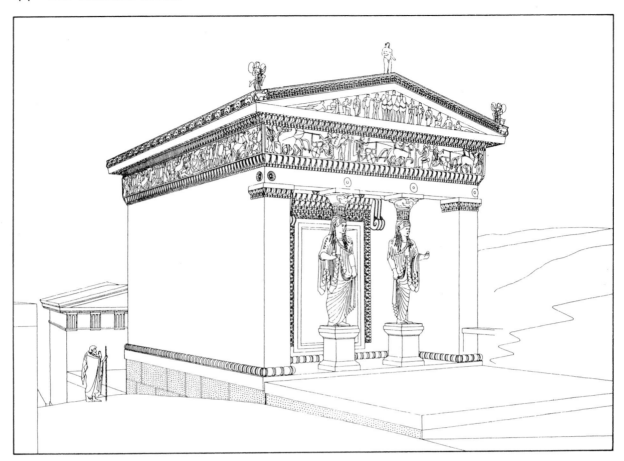

28 Treasury of the Siphnians, Delphi

the text of Herodotus gives us a good idea of its date, in the early 520s BC. The sanctuary contained a number of such small buildings, as did other major cult centres, where they tended to be built in rows, a method scarcely possible on the terrain of Delphi. The order chosen was normally that in vogue in the home town, and materials could also be imported to the site; in this case it is island marble. The simple room-plus-porch plan is general, though here the overall treatment is far from simple, showing Archaic Ionic at its most exuberant, with rich amounts of carved and painted floral and figured decoration. We note the large mouldings at the wall base and on either side of the sculpted frieze, and the elaborate frame and console for the door. Most striking are the symmetrically posed female figures in lieu of columns between the *antae*—not the first such architectural use in Greece, and one relatively common in smaller objects such as furniture. We must view them as participants in the cult at Delphi. Similar architecture is found in the Cycladic islands, not least the use of a frieze (see [35]), whether figured or not, above the architrave, not a feature of the Archaic Ionic order further east.

29 The variety of approach to architecture in the east Greek world is apparent from extant remains. Column bases at Ephesus and Didyma bear sculpted friezes of cult processions. At Didyma Gorgons and lions guard the temple, carved on the architrave. Altars grew to large dimensions. At Smyrna a curious set of colonnades was being built in about 610 BC when the Lydian King Alyattes sacked the town. That set was based on capitals in the rare Aeolic order (see on [23])—in essence with the volutes sprouting vertically from the shaft rather than from a horizontal cushion as in Ionic [A]. The type is found on square pilasters in the Near East as well as widely on Greek furniture legs and the like. Architecturally it is largely confined to the north-east Aegean, with one temple in the hinterland of Lesbos as its main exemplar. The use of single Aeolic columns as supports for monumental dedications was rather more widespread, and may have led to the invention of the Corinthian capital in the fifth century. To the south, the island of Chios affords a range of Ionic delicacies (even if the *size* of its major temple, at Phana in the south of the island, was not so far short of those of Ephesus and Samos). Richly decorated mouldings are combined with a particular penchant for using lion's paw feet for

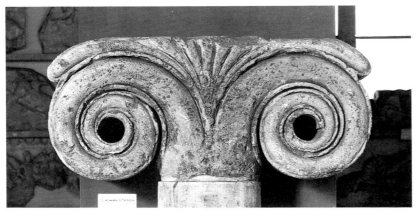

29 A Aeolic capital (Istanbul Museum)

29 B Lion's paw wall-footing (Chios Museum)

30 Clay gutter revetment from Morgantina, Sicily

details such as door-posts [B], again a motif regular in minor works, especially tables, writ large.

30 It is rare to find the painted decoration surviving on stones of temples. Ample compensation for the loss comes in the form of terracotta revetments, which were widely used on the upper parts of Greek buildings in the Archaic period and later. Their function was originally to protect vulnerable wooden structural members, and they first appear along with the clay tile, which appears to have been reintroduced to Greece in the early seventh century. We may note that such clay cladding was retained in decorative use after many of the parts to be protected had changed from wood to stone. Figured work was relatively common on these cover tiles in the later Archaic period, and we show a highly ornamental revetment from Mor-

31 'Theatre', Metapontum

gantina, here in a restored drawing. The site is in the hinterland of Sicily, but the style is purely Greek, with particular connections with Ionia. Two types of Gorgon head alternate with palmettes, while an elaborate meander is painted on the flat surface below, the straight lines echoing the flatness of the moulding; such fit of design to profile is increasingly frequent in Archaic architecture and has repercussions in Classical sculpture with its 'modelling line'. The lower part, extended over the top of the wall, is typical of west Greek revetments, and where it appears on the mainland we can explain it as an import, for example in the treasuries built by western colonies at Olympia.

31 Architectural attention was focused on the sanctuary in the Archaic period and other types of structure remain more humble. Water works could be impressive and ornamental, and some attention was paid to public meeting-places. The theatre was little developed at this time, as far as our source material allows us to judge; often a simple hillside would have sufficed an audience. Where no hillside was readily available other provision was needed, and two notoriously flat sites, the west Greek colonies of Metapontum and Posidonia/Paestum, have yielded interesting remains of such attempts. At the former it would appear that a simple wooden stand was erected in the seventh century, burnt down before 550 BC, and replaced with an impressive embanked circular structure with a broad passage running through it, widening at the centre to form a rectangular stage; the seats, as ever, would have been wooden. We note that this 'amphitheatre' was replaced by a more normal Greek theatre in the fourth century, and we may assume continuity of purpose. The original building was far too large for merely the enfranchised males of the community and must have served as a general meeting-place. In the similar round structure of the fifth century at Posidonia the entrance passages do not point to the centre of the circular stage but to a rostrum at one side of it, more suggestive perhaps of a political assembly building.

32 Many colonial foundations of the Greeks in the seventh century or earlier have now yielded evidence of rectilinear town plans, in sharp contrast to the haphazard agglomeration of small units found in homeland cities. There, for example, the central meeting-place (agora) at Athens was initially laid down in the later sixth century in an area used earlier for housing and burials. Colonial

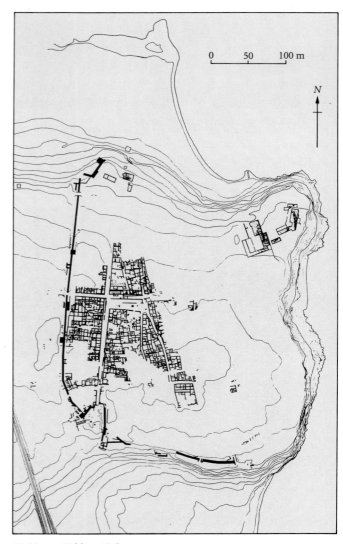

32 Megara Hyblaea, Sicily

plans, as far as can be seen, left an area vacant for use as an agora, and buildings were erected for public use as and when possible. The primary need was housing for the colonists, and this was laid out normally in strips, divided into equal units, back to back and fronting on to long streets; a few major streets would run in the other direction. Our best evidence comes from Sicilian sites, where single units, expressed in terms of ancient feet, vary around a mean of about 50 × 50. The earliest such plan known is at Megara Hyblaea, where single-room cabins

were first erected in the centre of market-garden-sized plots; only later, when the houses grew in size, if not in pretension, did the walls reach the roadsides, with their carefully laid kerbs. Here and at other sites the large slabs of housing blocks did not all run precisely at right angles to each other, though it was not the lie of the land that appears to have been the major controlling factor in any such variations.

SCULPTURE AND CULT BUILDINGS IN THE ARCHAIC PERIOD

33 Models show us that the roof of early Greek temples was normally pitched at the main, entrance end. Although not universal, this feature remains normal in subsequent architecture. The adoption of heavy tiled roofs and the

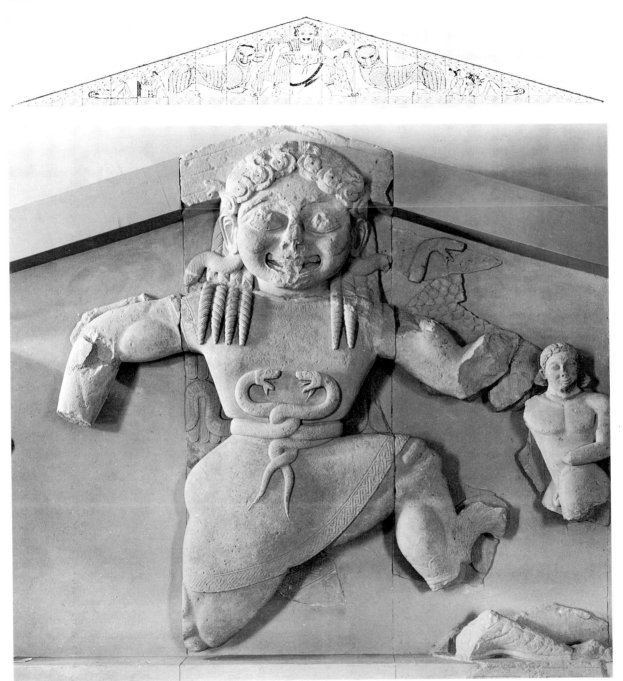

33 Pediment of temple of Artemis (Corfu Museum)

B

34 Metopes of 'Treasury', Foce del Sele (Paestum Museum). **A** Clytemnestra; **B** Sisyphus

necessary strong stone support led to a low-angled gable, at about 14 degree pitch. This triangular field was prominent to the visitor and so was very often given decoration. The earliest pediments that are preserved are of painted stone or terracotta; some may have been of bronzework nailed to a wooden backing. The increased use of stone, and its established employment for relief sculpture in other contexts, resulted in the adoption of three-dimensional decoration in pediments. The earliest, and a large-scale example of this technique, comes from the otherwise poorly preserved temple of Artemis built around 580 BC on low-lying land by the acropolis site of Corcyra, modern Corfu. The low relief is carved on the individual blocks that support the eaves and roof. We have already seen the method of accommodating figures to a triangular space, by simply reducing the scale [21], although even there dead and dying figures were found to be suitable corner-fillers. Several decorative elements are blended in this once richly painted composition, and agreement is far from full on a number of aspects. The massive Gorgon, Medusa, in the centre, appears on Sicilian pediments often just as a head, clearly with a view to giving a supernatural aura to the building; but here she is also presented as the Mistress of Animals, with two fine panthers, a role which the cult deity, Artemis, regularly plays [13]. Additionally, she is surrounded by her children, Pegasus and Chrysaor, giving a dimension of myth or folktale to the whole, even though they will only be born when Perseus severs her head. The smaller groups to either side almost certainly depict other mythological tales, but the only surely identifiable figure is Zeus, whose thunderbolt is preserved as he attacks to the right. The designer gives us other clues—a tree lightly cut on the background on the right, and the throne, or more likely altar, on which the older man (Priam?) sits on the left, threatened by an attacker now lost, but wielding a massive spear.

34 We are fortunate to have a good amount of architectural sculpture of the Archaic period. A temple of Hera north of Posidonia (Paestum), at the mouth of the Sele River, a boundary between areas of Greek and Etruscan influence, was decorated with at least thirty-six figured metopes cut, normally in one with a triglyph, from local sandstone. A wide range of myths is depicted, not all directly associable with the cult. Some of the metopes are unfinished with the figures merely blocked out [A]. The long limbs and large heads are typical of the period, a little after the middle of the sixth century, while the roundness of the skull and receding forehead suggest work influenced by east Greek style. The finished piece [B] also shows pronounced renderings of musculature, though still largely unintegrated with the bodies as a whole. The myth here is not common, and is treated uniquely; the Underworld, Tartarus, is the scene, with Sisyphus, one of the notorious Greek sinners, condemned to push a stone uphill for eternity. The natural environment is shown in an abbreviated manner, almost symbolically, as often in Greek art before late Classical, while interest centres on the figures, including here a male sphinx, a death demon further discomforting Sisyphus. The other, unfinished, piece gives us our earliest example of Clytemnestra being restrained from assisting her paramour Aegisthus, who is about to be killed by her son Orestes on what must have been the adjoining metope on the right. We note in particular the spread-eagled pose used to denote the rushing figure with her axe.

35 Very fine friezes are to be found in Classical and later sculpture, but for the Archaic period we have only scraps preserved, few of great distinction, apart from that which decorated the Siphnian Treasury [28] at Delphi. More commonly found are mould-made terracotta frieze slabs, very often with chariot scenes repeating themselves along the building. Horses remain *de rigueur* in frieze composi-

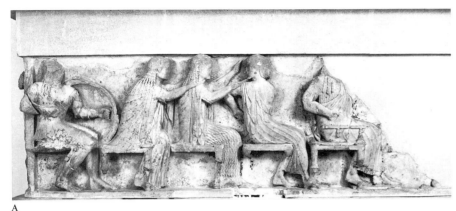

A

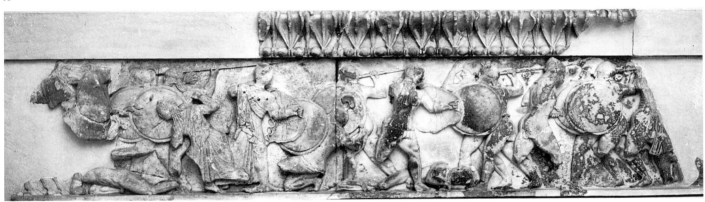

B

35 Frieze of Treasury of the Siphnians (Delphi Museum).
A Olympian gods; B gods fight giants

tion, appearing on all four sides of the treasury, in four different myths. A signature is part-preserved on the splendid battle of gods and giants on the north side, flanking the path up to the temple of Apollo; but the name is lost and the rest curiously defaced. Two schools of carving are clearly discernible: on the north and east the surfaces are fully rounded and the composition complex, while south and west figures have sharply cut-back contours and tend to be isolated; drapery too is differently treated. The marble is Cycladic, the teams of sculptors perhaps also from the islands. Names painted on the background or on the moulding below the frieze assist the interpretation of scenes, though where none are preserved, doubts remain. The south side for example shows the abduction of a female amidst a mixed cavalcade by an altar, and the west most probably a Judgement of Paris, but one where, uniquely, the three goddesses are shown being brought to or taken from Mount Ida on chariots. On the east [A] deities on Olympus are in agitated discussion on the left, while in the right half a battle takes place at Troy; the inscriptions tell us that the souls of Achilles and Memnon are being weighed before Zeus, in his grander throne, and that the combatants are the same two heroes, attended by other Greek and Trojan warriors. The gods present a typical range of hairstyles and drapery treatment; Ares on the left does not join in conversations, but next to him Eos, the

Dawn, argues for her son Memnon's life, joined by Artemis and Apollo as advocates of the Trojans. In the section of the gigantomachy shown [B] we see a typical use of depth by the use of overlapping into and out from the background, and of the uniting horizontals of spears and contorted fallen bodies. Unusually here one goddess turns left to dispatch her opponent, so introducing a triangular pedimental composition near the centre of the long frieze. As in much other stone sculpture many details were pegged on separately; most would have been of metal.

36 A similar composition is found in the pediment of probably Parian marble from the east end of the temple of Athena built on the Acropolis of Athens around 520 BC. Here, however, the figures are fully in the round, independent of the rear, structural, wall of the pediment. The central role of Athena, probably here alongside Zeus, in the gigantomachy was no doubt inspired by the woven scenes on the robe, now lost, made every four years for the cult statue in the same building, on the occasion of the Great Panathenaea festival. This practice probably commenced in 566 BC. The rebuilding of the large temple of Athena was undertaken during the dictatorship (tyranny) of Pisistratus and his sons at Athens, and is one of a series of major structural works in Attica attributable to this period of one-man rule. In the pediment we see figures virtually to a

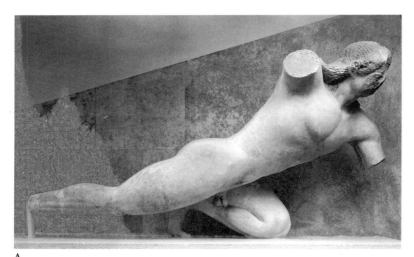

A

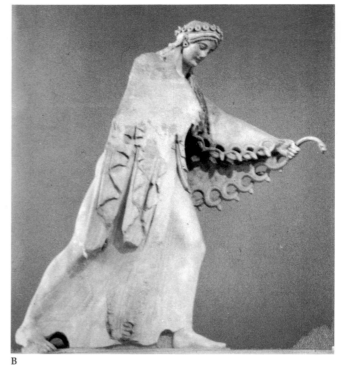

B

36 Pedimental figures of temple of Athena (Athens, Acropolis Museum). A giant; B Athena

single, massive, scale throughout, with collapsed giants in the wings and falling ones beside them; regrettably only four figures of perhaps an original eleven are preserved. While all the figures are either in movement or in contorted poses, the Archaic sculptor renders little of the muscular movement needed to sustain such positions, despite the excellent quality of carving and finish. The youthful, unbearded giants are nude; one has fairly short hair, a trend in male coiffure that becomes normal in the next generation. Athena holds out in her left hand one of the snake-fringes of her aegis as she attacks her opponent. The eyeballs, hanging nearly vertically from the head, are a clear concession to the high positioning of the figure.

37 One of the best-preserved buildings at Delphi, repaired and re-erected in 1903–6, is the little Treasury of the Athenians, possibly built as a thank offering for the victory at Marathon in 490 BC. Architecturally it resembles a small Doric temple without colonnade. The Doric frieze of triglyphs and metopes is continued around the whole

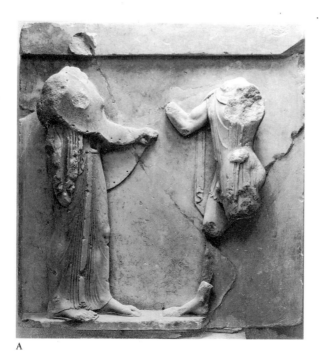

A

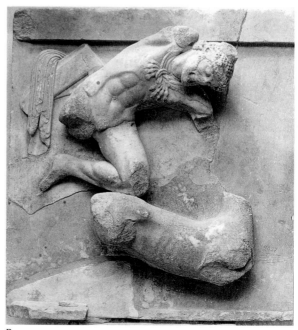

B

37 Metopes of Treasury of the Athenians (Delphi Museum). A Theseus and Athena; B Heracles

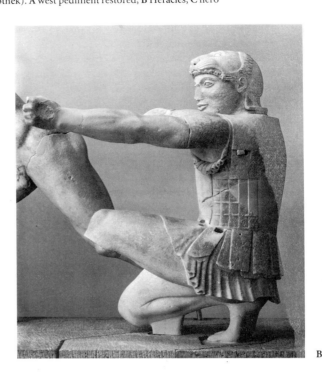

38 Pedimental figures from temple of Aphaea, Aegina (Munich Glyptothek). A west pediment restored; B Heracles; C hero

building, an optional treatment for such buildings, and each metope is sculpted, as were the pediments. The metopes are small, a mere 67 × 63 cm., and many are cruelly battered. Enough survives to demonstrate that they represent the deeds of Heracles as well as the more recently promoted Athenian hero, Theseus. Shortly before 500 BC we first find represented in art, possibly prompted by a newly composed poetic work, the cycle of feats performed by Theseus as he returned home to Athens from his childhood foster-home at Troezen on the other side of the Saronic Gulf. These are among the earliest 'serial' representations in Greek art; even Heracles' deeds are not surely strung together in such sequence in earlier works. Shown here are two well-preserved metopes, demonstrating two radically different methods of filling the square. In [A] Theseus quietly faces his protector, Athena, while in [B] Heracles leaps on to the back of the gold-antlered hind from Cerynia in Arcadia, having chased it 'for many leagues' (the number increases in the telling); the whole forms a bravura circular composition. Among details we may note the greater competence than in [35] or [36] in the rendering of musculature, notably of the arms and legs.

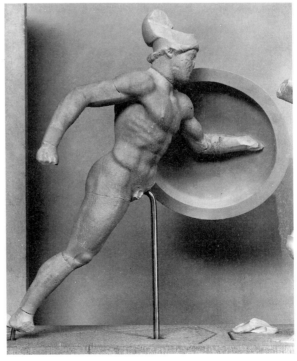

38 The most complete series of pedimental sculpture of the late Archaic period comes from the Doric temple of Aphaea, built around 500 BC, in an already well-established sanctuary above a bay at the north-east corner of the island of Aegina. Aphaea was originally a Cretan deity, and a cult certainly existed at the site in the Bronze Age; the centre of population, Aegina town, was some fifteen kilometres away on the west coast. A curiosity yet to be fully explained is that three, or probably four, sets of pedimental sculpture were cut for the temple, two of which were very soon thrown down or replaced. A clear difference in style, and probably date, can be seen in the two sets that survived and are now largely in the Glyptothek, Munich. Though the work is in Parian marble, we can see in details such as the sharpness of line and the plethora of added metal the strong influence of bronzework, and can note the importance of Aegina as a bronzeworking centre at the time, to judge from reports in later literature and preserved bases with signatures. The pediments have Athena, not the resident deity, as the central figure in the midst of fighting between hoplite soldiers and archers [A]. One archer is represented as Heracles, and it is persuasively argued that the battles are at Troy, in successive mytholog-

B

C

ical generations; Aeginetan heroes were involved in both. In the more advanced east pediment there are fewer and larger figures, with the action rather more complex, not simply fanning out to the corners as in the west, though both employ the sequence of kneeling, collapsing, and fallen figures in the corners, a sequence confirmed by the cuttings on the pediment floor to accommodate the individual statues. The Heracles and the hero to Athena's right from the east pediment are depicted here [**B, C**]. We may note the smooth contours of the face and the heavy rounded chin, while the musculature is both pronounced and mildly responsive to the violent action.

FREE-STANDING SCULPTURE IN THE ARCHAIC PERIOD

39 A generation or more after marble figures were first sculpted in Greece we have our first well-preserved male statues. They are datable to the years around 600 BC, largely on the evidence of stylistic comparison with figurines or similar figures in two dimensions on pottery (which is found in closer archaeological context). A number of pairs of these kouroi (youths) were found in a pit near the temple of Poseidon at Sunium in Attica; Poseidon was regularly represented with a beard and so the figures are unlikely to represent the known inhabitant of the shrine. Marble from the Cyclades is used, as for much work in Greece of the Archaic period. To judge from slabs abandoned in the quarries, much of the preliminary shaping was done *in situ*, and certainly in early figures use was made of a gridded surface to block out such details. The influence of Egyptian large-scale stone figures, both in the use of a grid and in monumental size, is clear, though the Greek figures are nude and make do without the back pillar support used in Egypt. Dedicatory inscriptions are often cut on statue or base, and we may suspect that many such texts were painted but are now lost. Male figurines were part of the Greek tradition of dedication; when writ large they redound all the more to the glory of the deity, and not least of the dedicator(s). In the sequence of figures shown here and in the following pictures, the framework of the figures remains much the same—a very four-sided piece (nobody is tempted to walk round a kouros) in a nearly frozen stance—but the manner of cutting details changes substantially, and in different ways in different parts of Greece (as far as we can detect from the patchy nature of preserved material). In general, contours become less angular, details cut with less use of regular grooves and ridges, and the three-dimensional aspect of both the whole and the myriad details are better understood. In the early pieces there is much use of mere patternwork to denote musculature and in particular ears and hair. This Attic piece has a breadth in the shoulder that is

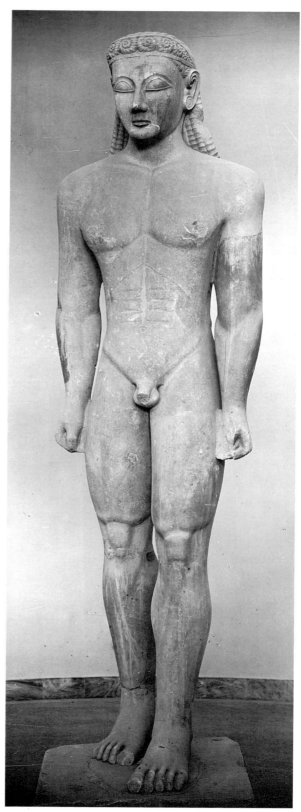

39 Kouros, from Sunium (Athens, National Museum)

40 Colossal kouros (Samos Museum)

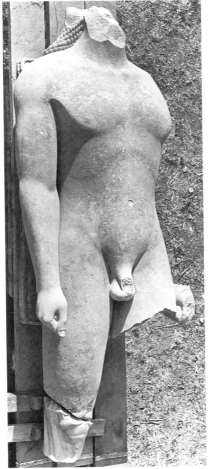

typical of later work from the area. Its monumental size, a little over 3 m., allows the sculptor to introduce even more such ornamentality of detail than we find in smaller contemporary pieces.

40 Monumental sculpture persisted from the later seventh century well into the sixth, and was never totally abandoned thereafter. The series of kouroi, however, shows a preference for the gigantic in the first half of the sixth century. The example here (4.75 m. high) is one of the latest such figures, a kouros excavated recently in the sanctuary of Hera on Samos; again we have a figure that cannot represent the deity, but rather an idealized adorant. The dedicator's inscription was cut on the thigh, perhaps some time after the figure was set up along the sacred way that led from the city to the temple across the plain. Isches is the name, but we know that his was not the first colossus to be offered to the goddess, and already groups of statues had also been given as tokens of aristocratic respect [50]. The sculpture of the east Greek world has a more readily distinguishable artistic style than that of other areas, and even within it some local variants can be perceived. Here we find a very typical treatment of bodily detail, very much on the surface and softly rounded, while distinctly east Greek traits in a typically brachycephalic head are the lack of hairband, receding chin and forehead, and fleshy features.

41 In strong stylistic contrast to [40] is this kouros from south Attica of a slightly later date. It was found near the village of Anavyssos, and was clearly set up as a memorial over a tomb; it can be associated with the three-stepped base which bears an epitaph to one Kroisos, bidding the passer-by (cemeteries often lined the roadside) to pause and grieve for the death of one whom fierce Ares had killed in the front line of battle. Various considerations point to Kroisos being a member of the powerful Alcmeonid clan, and the battle probably that in Attica when Pisistratus finally installed himself as tyrant in about 545 BC. The monument may not have been set up until the clan returned to favour a decade or more later. Kouroi used for funerary monuments differ in no way from the rest. Here we see a tendency to massiveness of proportion, especially in shoulders and thighs, that is particularly Attic, while the modelling of muscle and bone is fuller than in east Greek work such as [40]. None the less there is a strong generic connection between such works in the general fleshiness of features and ornamental treatment of hair (it is disputed whether Kroisos wears a cap or whether the head hair was merely painted). If one compares the statue with [39] a host of changes, one may say advances, in detail can be discerned. The overall concept is still basically four-sided, and while the arms are cut almost free from the body the original shape of the block is still apparent.

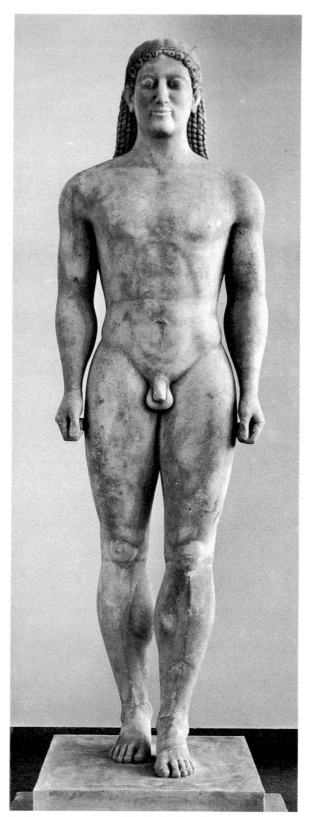

41 Kouros, grave marker of Kroisos (Athens, National Museum)

42 A major achievement of metalworkers in the mid-sixth century was the mastering of the technique to cast hollow-cast, large pieces of bronze. Small-scale works had been so cast since the first half of the seventh century, but larger works required much greater care and expertise. All large-scale Greek bronzework, figures or objects, is made up of parts joined with a hard solder of bronze. The individual parts were cast in moulds set in sand-pits, with the molten metal channelled in. An early example of this procedure comes from the excavations of the Athenian Agora, where broken fragments of mould were found abandoned in a pit. The fragments are of a rather small kouros (about 1 m. high), perhaps for the cult-statue of Apollo Patröus, whose sanctuary lay hard by the pit. Ancient literary sources seem to place the first statues of bronze in approximately the period indicated by the style of these fragments, around 550 BC. Earlier, a few large-scale bronze (and silver) statues were made of sheets of metal beaten over a wooden core (*sphyrelaton*). Rhoecus and Theodorus of Samos are said by Pausanias to have 'melted bronze first and cast statues', although in another passage he credits Theodorus with first casting statues of iron, an extremely unlikely feat at that period; he seems to have garbled the statement made by Herodotus, in the fifth century, that Glaucus of Chios was the first to *solder* iron. This and other distortions of the literary tradition warn us to look very hard before taking the words of writers of the Roman period too literally when they are writing about early Greek art.

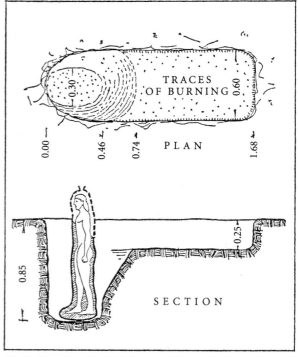

42 Casting pit and mould fragments for bronze statue (Athens, Agora Museum)

PLATE V

2 Clay centaur from Lefkandi (Eretria Museum)

12 Athenian amphora: Polyphemus (Eleusis Museum)

45 Corinthian amphora: Tydeus and Ismene (Paris, Louvre)

PLATE VI

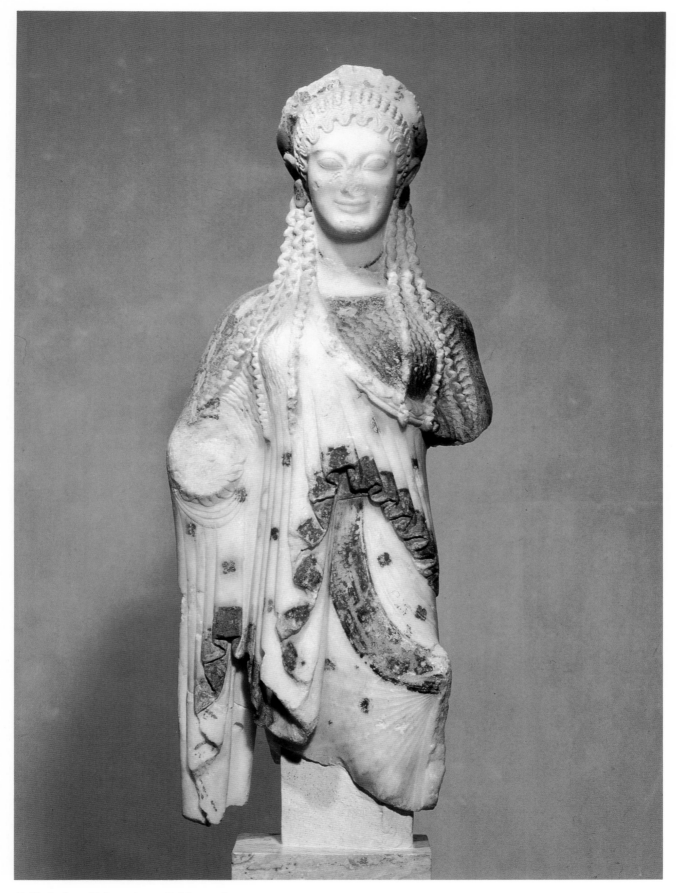

48 Votive kore (Athens, Acropolis Museum)

PLATE VII

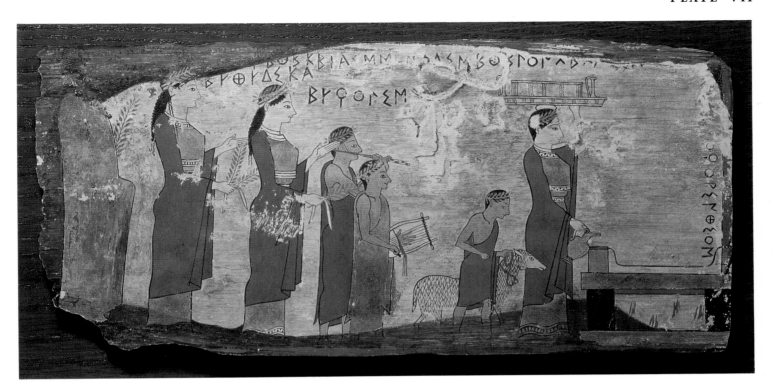

64 Painted wooden tablet from Pitsa: sacrificial procession (Athens, National Museum)

71 Caeretan water-jar: Perseus (?) (Küsnacht, private collection)

PLATE VIII

A

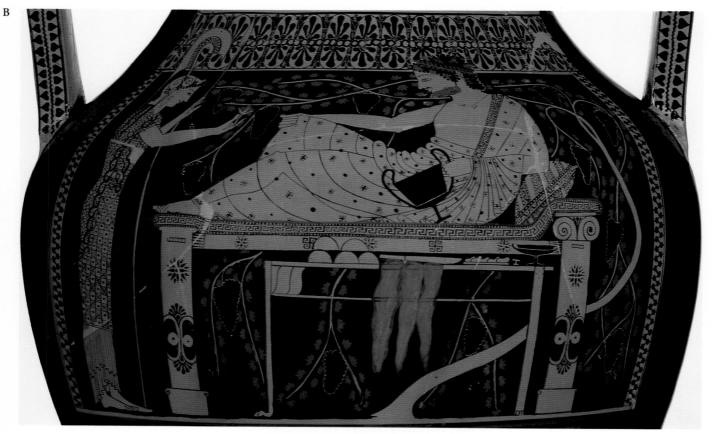

B

73 Athenian amphora, black- and red-figure: Heracles (Munich, Antikenmuseum)

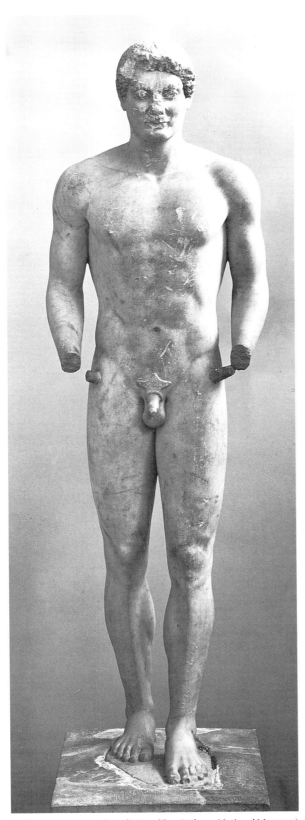

43 Kouros, grave marker of Aristodikos (Athens, National Museum)

43 One of the latest works to retain the traditional kouros stance was found in the area of Mount Olympus— the one in Attica—in 1944. Its base proclaims it the statue of Aristodikos, and its find-spot that it too marked a grave. The damage to the face is unfortunate, but merely adds to an impression of physical brutality that has earned this piece an equivocal repute. The heavy-bodied tradition of the Anavyssos kouros [41] is continued; the beefy Attic shoulders are now horizontal and there is no trace of the pinched Archaic waist; the legs remain similar though, with nearly equine knees below bulky thighs; the apparently separate plaque of pubic hair is a borrowing from bronzeworking technique. It is this stage of development that we next see in figures that break free from the kouros stance (p. 88), losing the strict symmetricality and daring to invade the space around them. The use of the statue as a funerary marker (no doubt alongside one of the main ways leading from the local village) of itself determines the traditional rigidity. One may also speculate how far economy of carving from a single block of marble played a part in the retention of such figures; as ever throughout the kouros series, the front plane is extraordinarily flat, even if the arms are nearly free from the body and smaller details such as eyes and ears more fully modelled in three dimensions.

44 The seated figure was another standard sculptural type, although with variants, in the Archaic period. Generally the seat denotes status, and the most elaborate thrones are reserved for Zeus. Simple seats are provided for the more active among the gods, such as Ares [35], and among mortals for heroes at rest [70] or 'clerks'—a statuary type at Athens and Cnidus borrowed from Egypt and used, to our knowledge, to commemorate officials in charge of the embryonic public records, a prestigious post. In east Greece the enthroned figure, another species with close Egyptian parallels, is popular, especially at Miletus and the nearby sanctuary of Apollo at Didyma. An inscription gives us precious information on one of the Didyma pieces here, 'I am Chares, the *archos* [leader/ruler] of Teichioussa'; the statue then represents a local aristocrat of about 575 BC from the Milesian dependency in which the sanctuary lay. The massiveness of the original block remains, despite the attempt to break up the surface with drapery folds. He wears a large wrap (himation) over a full-length chiton (sleeved dress). The sculptor could not resist giving as many pleats to the skirt of the chiton as toes peeping out from under it.

45 (Colour Plate V) Pot-painters at Corinth produced masses of animal-frieze vases, mainly small scent-containers or *skyphoi* throughout the period after [11], down to around 550–525 BC. They are generally anonymous, both literally, since painters very rarely signed their work, and artistically. A more ambitious figured school is seen in a far more restricted number of larger pots, also widely

44 Marble figure of Chares from Didyma (London, British Museum)

The couch is more normally found in scenes of the symposium, where the dog is also more at home.

46 The female version of the kouros we term 'kore'. Early examples show much greater variety in basic conception—rectangular or cylindrical body—and in treatment of detail, notably the dress, than do the kouroi. Yet they were used for the same purposes, as gifts to the gods [16] and markers over tombs. The well-preserved piece here is the earliest known from Attica and almost certainly stood over a tomb; much of the original paint can still be traced. There are many reminiscences of earlier Attic kouroi, especially the large features cut with grooves and ridges, though some details, the scalloped hair and the incipient pleated folds of the ends of the shawl, are later touches; a date of about 575 BC may be suggested. The body is awkwardly rendered under the dress, with typical broad Attic shoulders. The gestures are normal for korai of the period—one hand thought of as extended, holding an offering, here a pomegranate, the other to the breast in a manner derived from Near Eastern figurines of the goddess Astarte. The hair is here worn unusually tied in a bun at the back, with no tresses falling over the shoulders. Apart from the arms the piece is highly symmetrical; korai stand and do not adopt the Egyptian walking pose seen in the males.

47 Some half-century later this remarkable piece was dedicated on the Athenian Acropolis; excavated in 1886 it still retained good amounts of its painted decoration, now somewhat dulled. Sadly we cannot associate it with any inscribed base, to discover the name of dedicator or sculptor—a state of affairs that applies to most of the large number of korai from the Acropolis (see [48]). Most of these wear the finer chiton only, but our piece, dubbed the Peplos Kore, has the heavier peplos as her main garment; none the less she wears a chiton, visible at elbow and ankle, below. An apparent lack of modelling is just that—apparent, since the complexity of the hairstyle, a certain sensitivity to the body below, and especially a few developed drapery folds point to a date of the 520s BC or just earlier.

48 (**Colour Plate VI**) Two substantial series of votive korai are known, from the Heraeum on Samos and from the Athenian Acropolis. Some at least were dedicated by men, and so we must view such figures as idealized votaries of the female deities worshipped at the sanctuaries (on Samos both Hera and Aphrodite are mentioned as recipients, as well as the neutral 'goddess'). Most korai from both places wear the sleeved chiton, of finer material than the peplos, with a cloak worn diagonally over it, beneath the left arm but over the right; in all but the early examples further asymmetry is added by pulling aside the skirt with one hand, while the other carries its offering. The tightened drapery allows the sculptor to model the legs more

exported, but with a concentration in Etruria. This amphora is a typical piece of the Late Corinthian period, 575–550 BC. Imitation of metal rivets is rendered in purple and white, the colours which are also liberally applied to the figured scene, where dark and light are deliberately balanced. The scene here is extremely rare and not directly attested in any written form (except perhaps for the very names painted here, rather untidily, as often). Tydeus is threatening Ismene, who has been clearly caught *in flagrante* with the hastily departing Periclymenus: a good example of the expressive use of full gestures. The scene must be set in Thebes, and the episode a minor one during the attack by the Seven; Polynices led them against his brother Eteocles, who was refusing to yield up the throne as he had promised. Tydeus, Diomedes' father, acted as their ambassador on a mission inside the walls of the city.

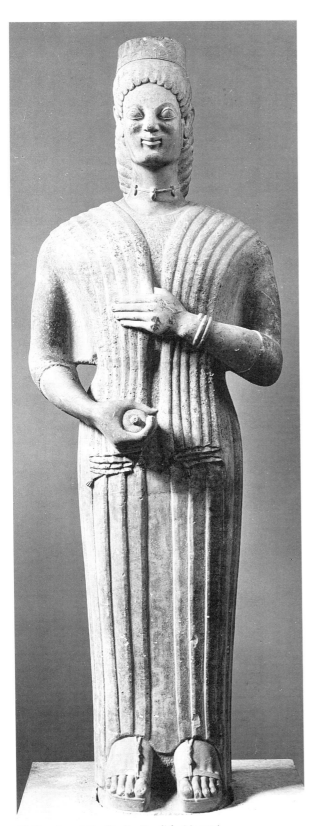

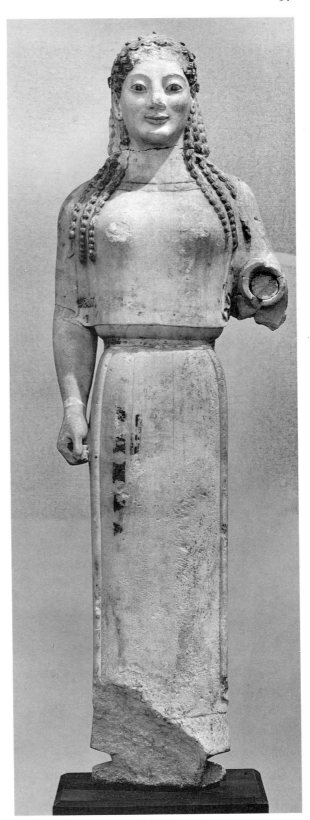

46 Kore from Attica (Berlin, Staatliche Museen)

47 Votive kore (Athens, Acropolis Museum)

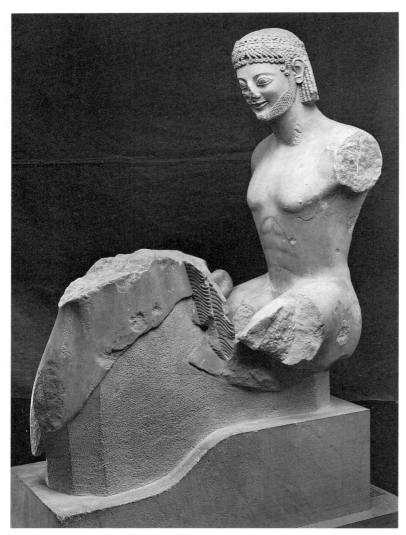

49 Marble 'Rampin' rider (Athens, Acropolis Museum with cast of head; Paris, Louvre Museum)

for expensive dedications and their makers. The signatures are often found on the flutes of columns which served as high pedestals for the korai figures, whose downward gaze is thereby explained. The treatment of the rear of such statues varies, though it is rarely as detailed as the front; ours is unusually plain, as is once more [41] the top of the head.

49 The sculpture from the Archaic Acropolis at Athens was smashed by the Persians under Xerxes in autumn 480 BC. When the Athenians returned they began to tidy up the mess, though new buildings did not rise till after 450 BC. Pockets of dumped sculpture were located in the excavations of the 1880s; the fresh condition of many pieces can be contrasted with Archaic sculpture from most other sites, where the material was exposed to the elements much longer. A few pieces were found before these excavations and joining fragments then came to light. A head of about 560 BC in the Louvre, called the Rampin head, was clearly turned to our right, and the new join showed why: it belonged to an equestrian figure, whose head turns to break total symmetry. Because inscriptions on the bases of equestrian statues were regularly on the short end, we must imagine the statue facing the principal view of the onlooker. A scattering of chariots and ridden horses are found in Archaic sculpture in the round; here the horse is wretchedly preserved, while the rider's torso shows little, and that superficial, modelling. Eyes and lips (with a painted moustache) are summary compared with the richly ornamented hair, though the rendering of the planes is more subtle than may appear. A peculiarity is the wreath that is worn; while hairbands, garlands, and wreaths of some kind are almost *de rigueur*, this is made of oak leaves and may well indicate a victor in the Pythian games at Delphi, instituted less than a generation earlier. Fragments of a similar piece, however, raise the strong possibility of a group of two horsemen, perhaps the Dioscuri, Castor and Pollux; the symmetry of such a group, heads facing left and right, would be fully in keeping with Archaic practice, more so than a single, asymmetric statue.

50 An important percentage of dedications in later periods comprises groups of statues, occasionally impressive numbers of them, though rarely physically combined in any joint action. While pairs of kouroi and korai appear earlier (see on [39]), our earliest known multi-figured group is from the sanctuary of Hera on Samos and dates to about 560 BC. It in fact comprises a simple sequence, set in series, of already standard types, kouros, kore, seated and reclining figure. The sculptor's name, Geneleos, is preserved, as well as the names of some of the individuals; the dedication is unfortunately worn, and we cannot be sure whether the dedicator was male or female. Such uncertainty naturally affects our view of the purpose of the

(sometimes very) prominently, much as he would do for a kouros figure. On the rather small piece of about 520 BC (55 cm. high) shown here, the right arm was actually held out, but it was worked in a separate piece and dowelled on, a procedure that is relatively frequent in this and later periods. The overall treatment is highly decorative, with a sense of bravura in the elaboration of the hair and the depth of cutting of the folds of drapery; we should not forget the balance that would have been added by the drapery now lost at the right. The face is softly modelled in rounded masses; this together with the slimness of the body suggests non-Athenian work, and the island of Chios has been proposed as the home of the artist. Many signatures are known from the Acropolis, though none can be assuredly connected with a statue; the artists represented, however, come from a wide range of areas outside Attica, suggesting that Athens of about 550–480 BC was a magnet

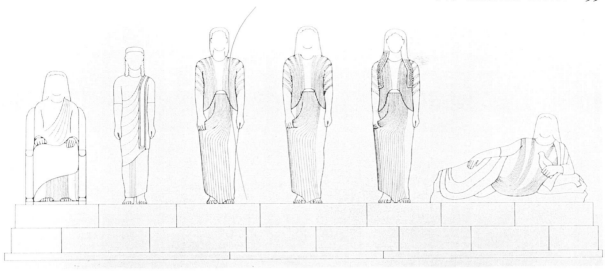

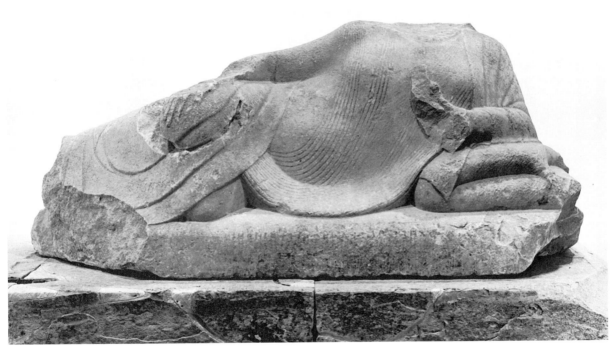

50 Marble group by Geneleos (Samos Museum; and Berlin, Staatliche Museen)

group and the relationship between its members; we may suppose they were all from one priestly family. In particular, the sex of the reclining figure is disputed. This pose is normal for males at the symposium, reclining on couches, and enters the iconographic repertoire early in the sixth century; females in such company tend to be nude courtesans (*hetaerae*). Dress and body forms of the figure have been seen as female, but in east Greece males regularly wear a long chiton, unbelted as here, and mantle above.

The developed pectorals are rather fuller than the breasts of undoubted female figures, including those in the group, and find parallels in other male representations from the east Greek world, both in the round and in painting. The korai figures, Philippe and Ornithe, present early examples of the skirt-pulling motif; the regular, shallow folds of drapery too are typical of Samian work of the first half of the century. The group was set up in a prominent position along the sacred way, as was [40].

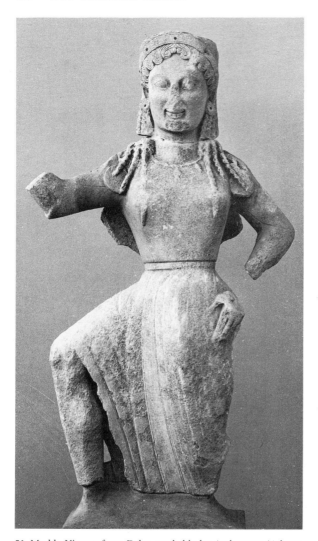

51 Marble Victory from Delos, probably by Archermus (Athens, National Museum)

Archaic sculpture would not in any case have encouraged the curious to investigate. Whether the rear view was easily visible is disputed. A strong case can be argued to associate the piece with a battered inscribed base; it seems to name a Chian Archermus as sculptor and a Parian as dedicator. Archermus is known from bases found on the Athenian Acropolis, and also from Pliny's writings on sculpture, where his alleged Chian family tree is cited, as well as from a comment on a play of Aristophanes, where he is said to have made the earliest statue of Nike with wings. The temptation to associate all these strands of evidence is strong, but there are difficulties in associating the cutting on the base with the statue, and many would prefer to see the figure atop a temple, as an acroterial figure, a favourite position for winged figures of later generations.

52 We have seen vases and sculpture in the round used as tomb markers. Another form of monument, which indeed becomes the most common type, is a stone slab (stele) decorated with relief sculpture, or merely painted decoration. We know of highly elaborate examples, notably of the mid-sixth century from Attica, and from Athens again in the later fourth. Most Archaic stelai are tall and slim, and from their inception around 600 BC, down to around 530, the series becomes ever taller and more elaborate. There may well have been legislation passed to curb such excess; we certainly have evidence for limits to expenditure on funerals at various times and places in the Greek world. The so-called Brother-and-Sister stele (the fragment with the sister's head is in Berlin) is the best preserved of this elaborate type, comprising base with inscription (fragmentary, but the youth may have been a Megacles, a name confined to the Alcmeonid family [41]), shaft sculpted in low relief, finial, here in the form of a double range of volutes, and a crowning figure of a crouching sphinx; all of course once brightly painted. The sphinx, lion, or later siren is often used to guard tombs, perhaps a reflection of Egyptian custom; one inscription from Thessaly calls the sphinx 'the dog of Hades', though in most of Greece *the* dog of Hades, Cerberus, merely has triple heads to mark his important status and does not appear in funerary art. On the stelai the main decoration normally consists of a single figure, facing right (as 'winners' generally do in Greek art); warriors, athletes, and older, cloaked males predominate. Here a second smaller figure of the young sister is added, where later the faithful dog of the dead man is often carved. Such low relief is artistically more comparable with painting than with sculpture in the round, and would suggest a date in the 530s BC for this piece.

51 The winged figure of Nike (Victory) served to commemorate many a success in war and more peaceful contests. In sculptural form our earliest known Nike comes from the area of the temple of Artemis on the island of Delos. It is not a large piece, and the lowest parts are unfortunately lost. Enough remains, however, to show that she was in the Archaic running pose, with spread-eagled limbs, head turned to the viewer. By the end of the Archaic period we find a more graceful upright pose in use, to culminate in the great sweeping creations of the Classical and Hellenistic periods [192]. Details of the very decoratively treated head suggest a date in the mid-sixth century, which would also fit the awkward twist (or lack of twist) of the body at the waist. Sculptors found various ways of dealing with winged ladies wearing dresses; here the wings are merely appended to the back; the four-sided nature of

53 While most statues were erected on plain bases, on which a text was often inscribed, a few were given plinths decorated in low relief. Like other squared stones they were pressed into service by Themistocles when he hastily rebuilt the walls of Athens in 479/8 BC; indeed, they were

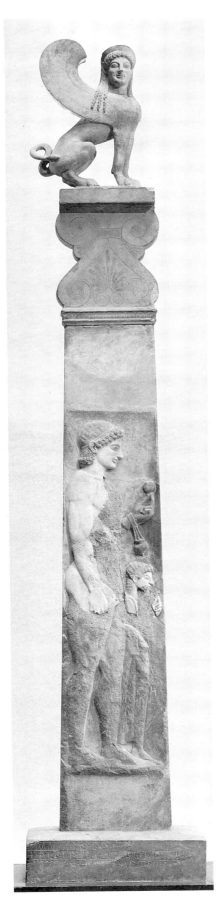

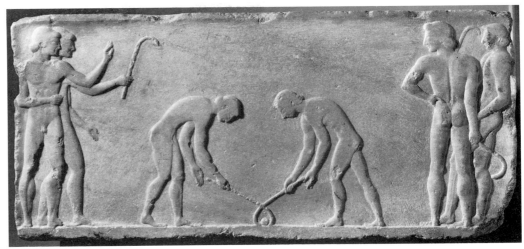

A

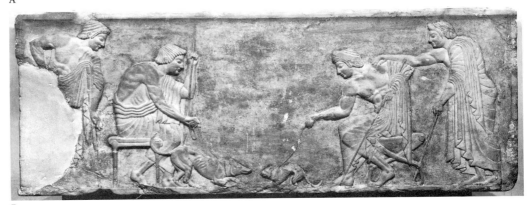

B

53 A, B Marble bases
(Athens, National
Museum)

52 Attic tomb marker
(Athens, National
Museum; Berlin,
Staatliche Museen; New
York, Metropolitan
Museum)

preferred—cemeteries traditionally being just outside the walls (though this point raises problems with regard to the early fortifications of Athens). We may reflect that the monuments may have stood only for thirty years or so before their demolition. These two have cuttings above for seated figure and kouros respectively, both now lost, while they also have a cutting below, showing that they were raised on a pillar. The paint is well preserved in places, giving a dark red ground for generally paler figures on which traces of a metal foil have been located; it is a contrast that puts one in mind of contemporary early red-figured vases, although from the scraps or echoes of free painting that we have from this time it is clear that a variety of colour combinations were in use, all within the framework of strongly outlined figure-work. Also reminiscent here of early red-figure are some of the poses employed: figures in rear and frontal view and stances with legs and feet more strongly differentiated than before. The two players on the left on [A] are forerunners of two typical 'attackers', exemplified by the Tyrannicides of 477 BC [81]. The game, we must note, is shown nowhere else in Greek art and not clearly mentioned in literature. Like other good artists the sculptor leaves much open air in the centre of both these compositions. [B] is a particularly fine panel composition with the focus sweeping down from the corners to the cat and dog of the youths-about-town at the centre; the earlier vase by Exekias [70] has a closely similar, varied composi-

tion. The youths relax after their athletic exercise, two in leaning poses that will also have a vogue in later generations.

METALWORK AND THE MINOR ARTS

54 From the tenth century onwards terracotta figurines are among the commonest types of dedication at a broad range of Greek sanctuary sites. The coming of the mould in the seventh century facilitated the manufacture of such cheap votives on a large scale. It is possible to trace moulds through generations of use: the original becomes worn, and a new mould is made from a figurine made from it, with details touched up as necessary. Since clay shrinks in firing the second-generation mould may be 10 per cent or so smaller than the first. Figures of females predominate in the Archaic period; while the standing type is the most popular, seated figures remain frequent, notably in Attica [A]. Rarely are details so specific as to render the figures

usable for offering only to a single deity, and so we find such figures given to a variety of them. Most striking is the standing Boeotian 'pappas' [B], named from the cylindrical hat like that of an Orthodox priest, of which male and female versions are known; the body is a board, the head either well modelled, from a mould, or pinched from a ball of clay and bird-like. They were decorated either in vase-painting technique or with a broader range of colours; the latter was normal for these figurines, but the colour is very rarely well preserved, since it was often applied after firing. Frequently the figures carry offerings, therefore they are miniature versions of the ideal adorant seen in the marble korai, not a representation of any deity. In Sicily a favourite offering is a piglet [C]; the animal was connected in particular with the popular cult of the harvest deity Demeter.

55 The combined use of exotic materials is an unusual but ever-present aspect of Archaic and Classical Greek art, although what is preserved is pitiful compared with what our sources record. Significant in this respect is a rich find of votive material buried under the path leading up to the

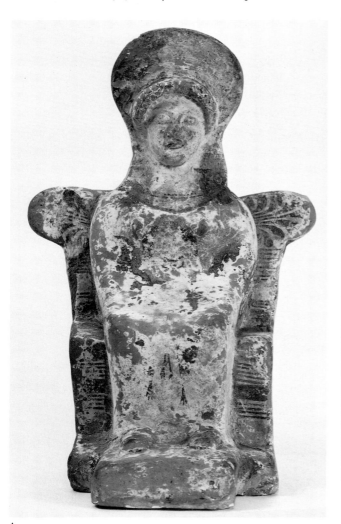
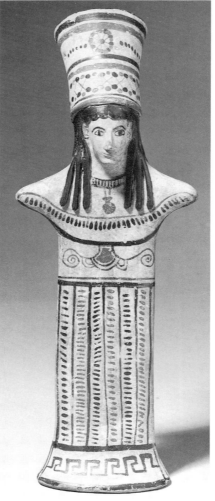

A B C

54 Clay statuettes (**A Berlin, Staatliche Museen;** B London, British Museum; C Gela Museum)

55 Ivory and gold head (Delphi Museum)

temple of Apollo at Delphi. It had been cleared up after a fire, no doubt one which destroyed the building in which it had been housed. Ivory inlay from a chest, a near life-size bull of beaten silver with gold foil trimmings, and several parts of statues of gold and ivory are among the finds. Three heads of ivory, the largest 21 cm. high, are preserved in fair condition, as well as decorated gold sheeting, from the hair and dress of the figures, probably likenesses of Apollo. Our literary record tells us that cult statues of the two materials were being made in the later Archaic period—Pausanias talks of 'extremely old' figures of deities at Olympia. There is some debate as to the place of manufacture of the Delphi statues; it is possible that they stood in the Treasury of the Corinthians, known to have been destroyed by fire, and one is plausibly Corinthian in style; the other two have features more at home in east Greece.

56 In the sixth century bronze figurines continue to be made both as parts of larger ensembles and as individual items. A good proportion of the latter represent deities, though genre subjects, especially athletes, are noteworthy. Styles can be tentatively isolated. The fine Zeus [A] is Pelo-

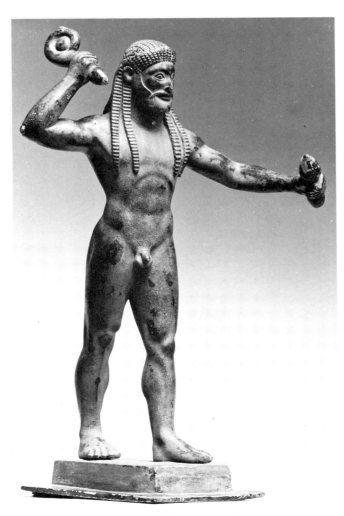

56 A Bronze statuette: Zeus (Munich, Antikensammlungen)

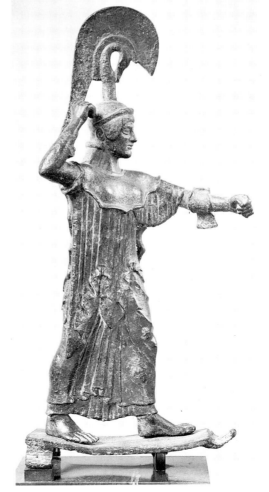

56 B Bronze statuette: Athena (Athens, National Museum)

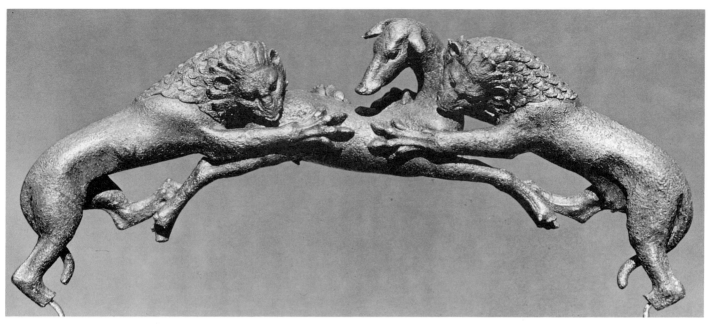

57　Bronze bowl handle (Olympia Museum)

ponnesian, perhaps Corinthian of about 530 BC, contemporary with the Attic kouros [41]. He holds out the thunderbolt in his left hand and raises an enigmatic (but not unique) curved object in his right. A purposeful stride is weakly reflected in a slight turn of the heavy torso. The other attacking figure is unmistakably Athena [B], and in fact was found on the Athenian Acropolis. We have seen the large marble counterpart in the pediment from her temple there [36], and the type may reflect an actual cult statue.

57　The quality of workmanship of bronze vessels of the Archaic period is often very high. This is a cast handle, one of a pair originally decorating a tripod-basin, dumped in a disused well at Olympia around 450 BC, about a generation after its dedication. It may have been made in Athens. The composition of the two lions attacking a young deer is admirably adapted to the required curve of the handle; the actual attachments by which the handle was riveted to the rim of the bowl (probably in the shape of palmettes, to judge from the rare parallels) are lost. It is a composition with a pedigree at Athens going back to the later seventh century, while the lion-attack is found even earlier; at least two pediments on the Acropolis had lions attacking bulls, while single lions on bull, deer, or boar were the coin types of three mints in the Chalcidice (northern Greece) from the late sixth century on. While the lion represents the dominance of strength and is used as an analogy for human victory and control, the pitting of human against lion can also be used to demonstrate the superiority of man; both ideas can be seen in earlier Near Eastern art. Certainly, few Greeks could have had personal experience

of such felines. The suppleness of the modelling here, together with details of musculature and body structure, point to a date late in the Archaic period.

58　We have already noted a readiness to decorate items of armour in the seventh century, and the practice continues into the sixth. A rich source of mythological scenes is the series of bronze shield-bands found as dedications at many sanctuaries, especially Olympia. They were fixed to the inside of the shield and included the 'sleeve' (*porpax*) through which the left arm was put [A]. The bands are decorated with a sequence of panel compositions; they were

A

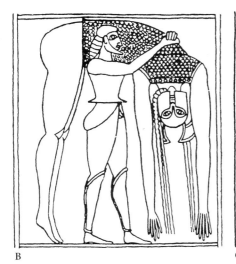

B C D

58 Bronze shield-band panels (Olympia Museum). **A** interior; **B** Ajax and Achilles; **C** ransom of Hector; **D** Heracles in Underworld

transferred by hammering from an original matrix. The characters are sometimes named, as on vases and sculpture, and alphabetic evidence shows Corinth and in particular Argos as centres of manufacture. The range of scenes is wide, with a proportion of purely animal compositions typical of Archaic Greek art. Shown here are two Trojan episodes and one much rarer theme. The Trojan War, together with the deeds of Heracles, is heavily represented in the series. On an early band [**B**], about 600 BC, Ajax carries the huge body of Achilles, the scene filling as much space as possible; the head of Achilles is seen frontally. The second panel [**C**] shows Priam, supported by Hermes, supplicating Achilles for the return of the body of his son Hector. Gestures are standard—the touching of the beard and the arm over the head, in death or sleep. The third piece [**D**] presents a very rare scene, where gestures are of greeting—the names tell us that it is Heracles approaching the seated figures of Theseus and Pirithous, imprisoned in

Hades during an abortive mision to seize Persephone. One of the variant literary accounts has it that only one can be released; it will be Theseus. Overall, the scenes on the bands demonstrate a wide range of violent activity, including that of the wild animals; we should not however conclude that they were specifically chosen because of the military use of the objects, since there is little to distinguish them from the subject-matter of art in general during the period.

59 The shield-band panels are about 6 cm. square. The bronze volute crater (for the shape see [**66**]) here is 164 cm. high, with a capacity of some 1,200 litres. The body is made from a single sheet of bronze and the other parts are separately cast; each Gorgon-decorated handle weighs 46 kg. Herodotus tells us that a Laconian crater was made at Sparta as a gift to King Croesus of Lydia; it had a frieze of animal figures on the neck and held 7,500 litres (a very sus-

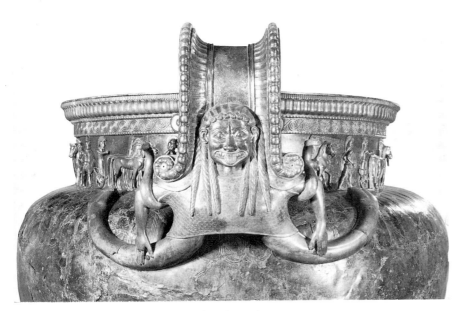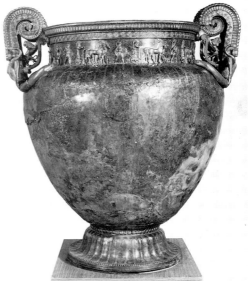

59 Bronze crater from Vix (Châtillon-sur-Seine Museum)

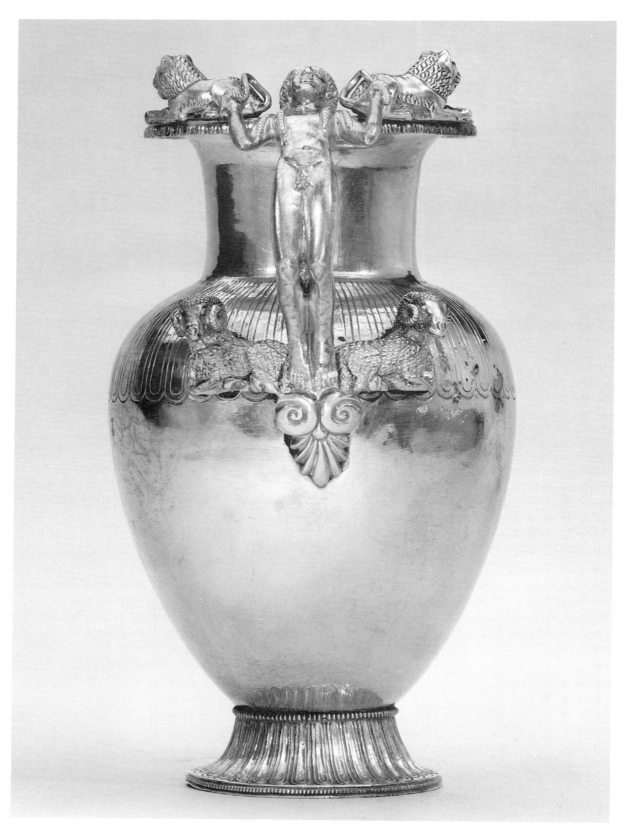

60 Silver jug with gilt details (New York, Metropolitan Museum of Art)

pect amount). Elsewhere there exist some figures from neck friezes, with flat back and rivet holes, which are larger than the warriors on this crater. The prestige vases were made largely or wholly for export; this piece was found in a rich female burial of the local Hallstatt culture at Vix, near the source of the Seine, together with Attic vases of about 520 BC. Related pieces have been found near Stuttgart and at sites in the northern Balkans. The figure-work presents here little that is unusual; the procession of hoplite soldiers and chariots is a standard frieze composition, while the Gorgon is frequently found, along with other animals, in subordinate decorative positions; the female on the lid is more intriguing and difficult to interpret, and can be considered alongside a running girl figure, probably from the rim of such a lid, found at Prizren, Kosovo province, in the former Yugoslavia. Running females are more common in Spartan art than elsewhere, and together with the evidence of Herodotus have led many to take this and other pieces as Laconian work. Marks made to assist reassembly of the neck figures on the vase go some way to support that conclusion, though there is a school of thought that prefers to see here products of workshops in the Greek colonies of south Italy, Tarentum (Taranto) or Sybaris.

60 Precious metals rarely escape the attentions of later generations, and few gold and silver objects are preserved from our period. While the crater for Croesus mentioned above [59] is likely to have been of gilded bronze (pure gold would not have been structurally stable or strong enough), we have a few smaller items of gold and rather more of silver. A hoard looted from a Lydian tomb near Uşak, western Turkey (100 miles east of Sardis), consisted of scores of silver and gilded silver vessels, many of Greek workmanship. This jug, which has many bronze brothers, adopts the conceit of a kouros figure as its handle. It weighs 623 g. (compare the coins [63]); the body is hammered from a single sheet and the foot and handle added separately after being cast. Decoration of the foot and body, with tongues of varying size, is regular in such work and the short beaded tongues on the edge of the lip become an extremely common form of minor decoration on clay vases. The format of the handle is also regular; a simple palmette regularly terminates plain handles below, and at the lip the handle normally bifurcates, to be riveted on to the lip. Such bifurcation can take figural form, as here, and an added nuance is the 'Master of Animals' motif of the figure grasping the tails. The rams below balance the beasts on the lip. The style of the youth's head and hair points to an east Greek origin of 550–525 BC.

61 We have noted ivory-carving as a technique re-borrowed from the Near East in the later eighth century. Some other skills took a little longer to reappear in the Greek world, such as the working of faience and glass, and

61 Faience perfume flask (Berlin Staatliche Museen)

the cutting of hardstone gems [62]. Glass and faience are related materials, made from minerals, essentially quartz or silica, to various recipes. The techniques involved are skilled. In faience work the basic paste was modelled by hand, normally around a core of material that would be burned away, or with the help of moulds. Colour could be controlled by the addition of various minerals. It was a technique especially popular in Egypt, and when production starts in Greece, quite probably through immigrant workmen, the objects made and their iconography are very much influenced from that area. Some of the most attractive pieces are figured vases, the confections reaching great elaboration at times; the hybrid forms recall those found on contemporary gems, which were cut in the same east Greek milieu in which the faience was produced. Here we see two Eros figures, their heads forming the two handles, hugging a flask with modelled heads on either side. The heads are in the broad and fleshy east Greek style of the middle of the sixth century or a little later.

62 The sixth century saw the reintroduction of gem-cutting in hard stone in the Greek world. Inscriptions on these gems point to east Greece, the islands, and Cyprus as centres of production. A broad range of stones is used, and the favoured shape is the scarab, beetle-backed, with the device cut on the oval base. The surviving material can be numbered in hundreds. Curiously we have no assured example of the use of these gems as seal-stones, although a few inscriptions indicate such a purpose—'I am the sign of Thersis; do not open me.' Figure-work has affinities with

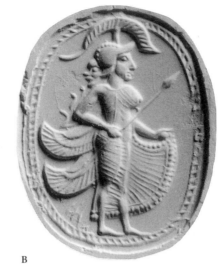
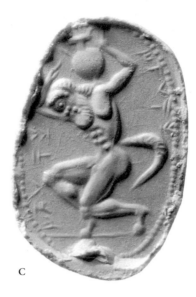

A B C

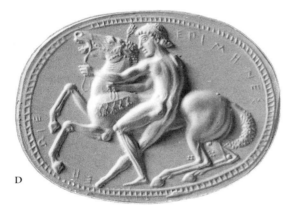

D

62 Hardstone gems (**A** St Petersburg; **B** London, British Museum; **C** Athens, Numismatic Museum; **D** Boston, Museum of Fine Arts)

types on coins. Animal studies are very frequent, but we also find a broad range of mythological and human scenes. The technique demanded much use of the bow drill. Here we have late Archaic gems in four different stones. On [**A**] we see a complex design of a winged youth on horseback. The view is essentially from the rear, but heads are in profile and little attempt is made to mask the transition. Yet there is an enquiring interest in composition, shared by cutters of ability now and later. On a piece from Amathus in Cyprus [**B**] a satyr head masquerades as the head of Medusa at the back of the neck of the winged Athena, a rare east Greek conceit; Athena draws aside her skirt like a kore, though more often her left hand is used to hold out her aegis [**36**]. The satyr lifting a jug on his shoulders [**C**] is a fine study of pose, boldly cut; the Archaic running stance is here pleasingly adapted; the inscription, perhaps cut at the time of carving, is in Cypriot syllabic script. The fourth piece [**D**], with the signature of the maker Epimenes, one of the few known artists' names on Archaic gems, was found in the Nile delta; the script of the signature is puzzling, but likely to be of a Cycladic islander.

Here again we find a keen interest in pose; the position of the legs of the youth is akin to that of many contemporary representations of archers. Archers and chariots are among the first subjects on which three-quarter views and foreshortening are attempted.

63 Silver coins were first minted in the Greek world about 550 BC. The normal weight ranged between 6 and 17 g., though fractional issues were often less than 1 g.; interestingly the type on fractions was commonly a part of the whole—one horse instead of a chariot, indicating pictorially the relative value. These pieces, all of the period 500–480 BC, display a range of the types used. At Athens, the famous 'owl' coinage appears about 520–510 BC, with the head of the patron deity accompanied by the reverse type of an owl [**A**]; the legend ATHE tells us the issuing city, though such information is by no means normal at this period (compare early British stamps without any indication of origin beyond the queen's head). A notorious feature of the Athena heads is their resistance to stylistic change. At Corinth [**B**] the head of Athena the Bridler

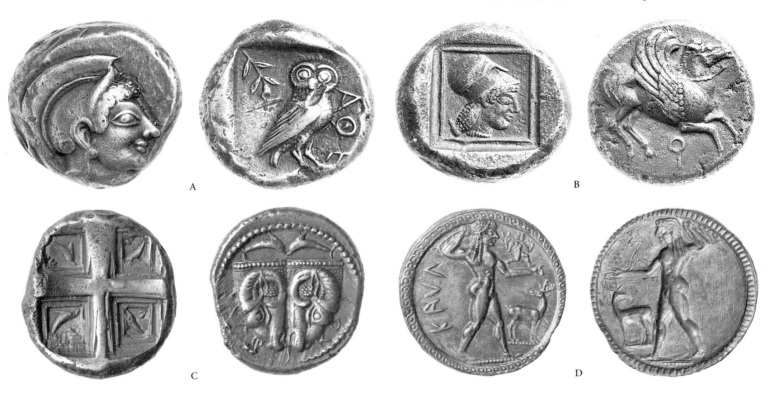

63 Silver coins of Athens, Corinth, Delphi, and Caulonia

accompanies the basic type of the horse Pegasus, who was tamed by Bellerophon at Corinth with Athena's help. Coins can be better dated than many other types of artefact, and it is clear that while Athens persisted with the 'good old' Athena, probably to instil confidence in the purity of her silver, Corinthian die-cutters let their Athena move with the stylistic times. The use of patterned reverse punches is given its most elaborate form in issues at Delphi around 480 BC [C], where the quartered punch is tricked out as a coffered ceiling, perhaps reflecting that of the newly rebuilt temple of Apollo; on the obverse two silver drinking horns in the shape of rams' heads may possibly refer to booty captured from the Persians in 480 BC. The fourth piece [D] illustrates the great variety of technique and type used in early silver coinage. It is a wafer-thin silver sheet, struck by two dies, but surely in imitation of repoussé work; the two dies had to be carefully aligned to avoid puncturing the sheet; it is about 2·5 cm wide and weighs 8 g., while [A] weighs 17 g. The type on either side is a relatively rare full figure, here Apollo, who supports a further figure and stands on a base. There can be little doubt that there is an association between type and the myth or cult of the issuing state, Caulonia, an Achaean colony in the toe of Italy. This particular technique of coining is confined to colonies in southern Italy and in the Straits of Messina.

POTTERY AND PAINTING

64 (**Colour Plate VII**) It is a matter of regret that the Greek climate is not suitable for the preservation of wood, since we have ample evidence that it was used both for large-scale sculpture and for panel painting in our period. Some poor scraps of wooden sculpture of the sixth century survive. For paintings we look for clues more to the Greek-inspired scenes on the walls of Etruscan sixth-century tombs than to the meagre remnants that have come to light in Greece itself. The most striking of these are four plaques, 30 × 15 cm. approximately, found at a sanctuary of the Nymphs in a cave above Corinth. The best preserved (length about 30 cm.), perhaps the earliest, presents a scene of a sacrificial procession not far removed from what we find on a few Attic black-figure vases; the technique is very much one of contours defining space, and the colours a restricted palette, mainly white, red, and blue. The inscriptions are more careful than those found on contemporary Corinthian pots, but they serve similar functions, to identify characters in particular, and invade the scene in a similar way. The colour of female flesh is an indoors white (contrast the use of 'sunburnt' red paint on the heads of early black-figure males). The ages of the participants are clearly denoted by their size; children and youths are also given their names. The sheep is a far more

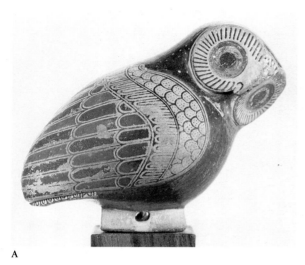
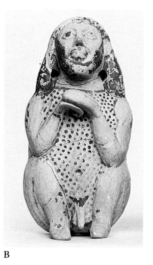
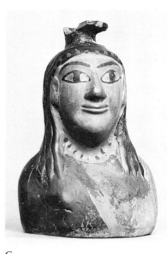

A B C D

65 A, B Corinthian clay figure-vases (Paris, Louvre; London, British Museum) 65 C, D East Greek clay figure-vases (London, British Museum)

frequent offering to the gods than the much-pictured bull, which was beyond the actual means of many individuals or even communities. The contrast of colours is strongly reflected in the use of white, red, and black in Late Corinthian vase-painting of much of this period, about 575–550 BC.

65 We have already seen a moulded 'plastic' vase made of faience [**61**]. This type of figured work is commonly found in ceramic form; added decoration is often in pottery technique as well, though the matt colours of the terracotta workshop could also be used. The main centres of production of these vases (they are all actual containers) are Corinth and east Greece; clay analysis suggests that Ephesus and Miletus were the eastern workshops, though it is clear that figure-vases were made occasionally in most known potteries. Most are of the later seventh and sixth centuries. Corinthian types can often be distinguished by their clay, and unlike eastern examples do not have a prominent mouth, merely a hole for pouring. Many shapes are found, with a degree of copying between producing areas. Animals come mostly from the general stock of the real and the monstrous—the owl [**A**] is among the most successful of Corinthian products, and the dotted reveller [**B**] may be a performer not unrelated to the satyr. The most common east Greek type is the female bust [**C**]; this suits well the presumed use of the containers for perfumed oil, until we note that the helmeted male head comes second in frequency. The features are typical of central Ionian work of about 575–550 BC. Other parts of the human body are also made, always from moulds, in contrast to the thrown examples from Corinth. Illustrated is a leg [**D**], more coy than some parts. The pieces are useful evidence for contemporary footwear, especially the fittings. It is said to have been found on Samos.

66 The black-figure technique of decorating vases prevails in most Greek workshops in the late seventh and sixth centuries. Technically methods remain much the same, although styles do change, with increasing rapidity as the sixth century passes. This Attic volute-crater, a very rare ceramic version of the shape at the period, was made around 570 BC and exported to Etruria, where an increasingly large percentage of Athenian pots are now sent. It is called the François vase after its finder. Both potter, Ergotimos, and painter, Kleitias, signed it; signatures are added sporadically to vases as to other artefacts, being particularly frequent at Athens in the later sixth century. We know of other signed work by both our artisans. Kleitias also painted labels for virtually all the figures, and not a few of the objects, in the many friezes; not that most figures do not already have attributes of some kind by which we could recognize them without the names, whose addition is more in the spirit of exuberant display (see [**35**]). As also on [**35**] the horse (or sometimes as here a centaur) forms an important building block in the filling of friezes, though here we also have a ship performing a similar function. The vase presents a compendium of myth, to a large extent connectable with the story of Achilles, though any fully programmed structure can be doubted from our fragmentary knowledge of Kleitias' other large works. Lip friezes recall the manner of decoration of metal craters [**59**], while the main, high frieze is as ever near the top of the body of the vase, where the gods arrive in procession to the (temple-like) house of the newly wed Peleus and Thetis, Achilles' parents-to-be. We are fortunate in possessing two earlier examples of this procession on Attic vases to compare and contrast, both as regards style and iconography and with relevance to the purpose and significance of the vases. At this period many pots were painted with friezes consisting only of animals; Kleitias here

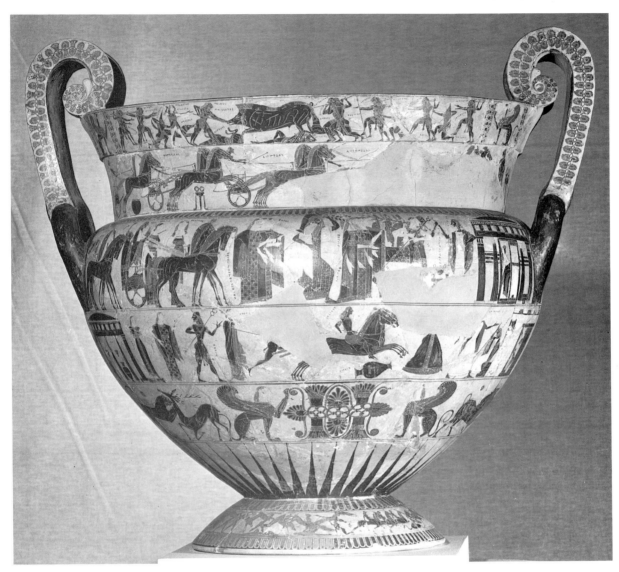

66 Athenian black-figure volute-crater, the François vase (Florence Museum)

restrains himself to one such frieze, still drawn with his superbly controlled brush and graver.

67 One of the commonest shapes in Attic black-figure ware is the neck-amphora, a jar potted from separate body and neck. They were particularly common exports in the later sixth century. This piece has the standard syntax of subsidiary decoration in its floral bands, though the scenes are highly unusual. Everyday life, especially of the common man, is rarely pictured in the Archaic period. On this amphora we see on one side two oxen pulling a plough, while on the other birds are limed on a tree and fall to the ground, while the decoy owl does his job and the landowner and his friend hide behind the 'bushes' constituted by the floral patterns at the handles. There is a good

deal of light background to the scenes, while figures and florals are enlivened by the addition of red and white pigments. The drawing and incision is relatively simple but clearly by a practised hand. The vase is not signed, but works by the same hand have been identified; we give *ad hoc* names to such painters, and this one is dubbed the Bucci Painter, after a one-time owner of one piece. No other work attributed to him has any similar scene. The lid pictured here is too small to belong, but may have been acquired during the life of the pot, which we assume was found in an Etruscan tomb before appearing on the art market.

68 Cups were also decorated in large numbers and widely exported from Athens. The development of the

67 Athenian black-figure amphora: ploughing, bird-liming (New York, private collection)

shape demonstrates an increasingly tall stem and ever more shallow bowl. Cups of the sixth century, wherever made, tend to have a lip set off from the body; despite the offset, at Athens the decoration can happily cover both areas, as here (alternatively, lip and bowl can be given separate treatment). We call this type the Siana cup after one find-spot, on Rhodes; many, as ours, come from Tarentum, a Spartan colony, and it may not be an accident that cups of a related shape were among the few Laconian pottery exports of the period. The frieze technique can be paralleled in the approach to crater decoration; cups and craters were essential equipment of the symposium, the major social function of Greek (male) life. This cup can be attributed to one of the major painters of Attic black-figure, Lydos (= Lydian), a man with a non-Greek origin, one assumes, but little trace of any non-Greek, even non-Attic, style in his work. The interest in animals is retained in shield blazon and winged horses. On one side a man attempts to stop two warriors duelling, with their white-haired fathers and others in attendance; nothing indicates whether Lydos had any particular episode from mythology in mind, and the addition of bystanders to fill space is a common feature of frieze, and even panel painting. Similar, rather inconsequential groups flank the readily identifiable figures on the other side; Athena strides in her Promachos pose behind the divine chariot on which Hermes brings Heracles to Olympus. As usual heads reach the

same height in the frieze, whether of figures on foot or on board the chariot.

69 The use of defined panels for scenes on vases has a long history, though eclipsed at times by the frieze, especially in the seventh century. Neck-amphorae have unbounded panels [67], other large vases have more formally restricted frames; the preservation of plaques of terracotta, and much more rarely wood [64], reminds us of more important panel painting. On this hydria of the late sixth century we find a scene from the *Iliad*, the dragging of Hector's corpse past the tomb of Patroclus by Achilles. It is a scene that has a brief vogue in Athens at this period, and is only known in art from one earlier vase. The panel is crowded with activity, time and space collapsed within its frame; even so the painter adopts a popular conceit, 'porthole' composition—more often found in the tondos of cups—by cutting off the chariot team to the right, together with much of Patroclus' white burial mound, above which the named little *psyche* (soul) of Patroclus hovers. The winged female may well be the gods' messenger Iris, who takes an active part in the later ransom of Hector's body; that episode is also presaged by the presence of his parents, Priam and Hecabe, within their palace on the left. The wide-stepping figure of Achilles is borrowed from the already established depiction of him bounding from ambush to capture Troilus [66], while Iris' balancing pose

68 Athenian black-figure cup, by Lydos (Taranto Museum)

to the right is taken from the dance floor. We may note the pleating of the drapery, a hint, among many, of the comparatively late date of the work, which can be attributed to a workshop termed the Leagros group, specializing in hydriae and amphorae for the Etruscan market.

70 The most able of Attic black-figure artists was Exekias, who signed a number of his works, of various shapes, and to whom some thirty vases can be attributed. He was both potter and painter, as seen in his signatures on this large amphora with panel decoration found at Vulci. We must imagine the piece in rather better condition than its present worn surface presents. The scene shown here illustrates not merely Exekias' remarkable control over incised line, but also his innovations in composition and subject-matter. Inscriptions tell us that it is Ajax and Achilles who are playing a board game, with armour and weapons either worn or to hand. It is the earliest of many such scenes, unexplained in our written record, but no doubt set during the lull in fighting at Troy, for which the inventor Palamedes provided new forms of recreation. No other example has the subtleties of composition that Exekias has here; many artists, perhaps for reasons of narrative rather than composition, introduce a central figure of Athena, which breaks the play of diagonals that pre-

dominates here, diagonals that are also used to create depth, as in the spears and feet. Incision allows us a glimpse of now lost embroidery and perhaps leatherwork in the corslets and sumptuous mantles; the former are thick enough for the mantles to bulge out over them at the back. Exekias incises his best, large eyes, equips his heroes with thigh-guards, and Achilles with arm-protectors and skull-cap under the helmet. No less admirable are the two views of the hands, and the neat, highly decorative use of small-lettered inscriptions. Style, shape of vase, and the praise of Onetorides (*kalos*) all point to a date in the 530s BC.

71 (Colour Plate VII) Among black-figure schools outside Athens, the most vigorous is undoubtedly that dubbed Caeretan, after Caere (Cerveteri) in Etruria, where its products have for the most part been found. Some fifty pieces, mainly hydriae like this, are known, made in the years around 540–520 BC, and placed in Caeretan graves alongside Attic and other imports. The colourful style with rather old-fashioned thick-set, large-headed figures finds echoes in contemporary and earlier work in the Greek east; one piece has inscriptions in Greek, and we may assume that a settler from Ionia, or an Ionian colony, set up the shop. Etruscan art of the period owes much to such in-

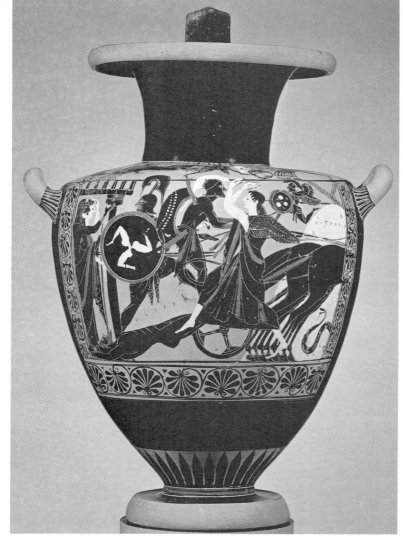

69 Athenian black-figure water-jar: Achilles with body of Hector (Boston, Museum of Fine Arts)

fluences [356, 359]. Here, hairstyles and floral types are particularly Ionian; musculature and the drapery of a hunter on the reverse betray a later date than the general style might suggest, being akin to Attic work of the 520s BC. The hydriae present varied and sometimes unusual mythological scenes; this one is unique, with a hero (one assumes he will prevail despite his position on the right) facing a huge sea-monster and his playmates with rock and sickle. The seal on the left strongly suggests a possible origin for the painter; in Greek it is *phoke*, and Phokaia was a city in Ionia closely involved in opening up the western Mediterranean to Greek trade. It was captured by the Persians in the later 540s BC and many of its inhabitants fled to Italy.

72 Pot-painters in Laconia also produced an individual black-figure style, much dependent for technique and subject-matter on Corinth, but with intriguing local ingredients. While Sparta is the main centre of Laconia, we do not know as much as we would like about the location of the pottery workshops and the status of their staff. There can be no doubt that the art of Laconia was furthered by professional workers quite up to the general standards of quality in Greece during the sixth century. The military training and increasing isolation of the true-born Spartan élite is not reflected in such production. Craters and cups are the main pot shapes made, along with a few plain oil(?) jars. While many of the widely exported craters are also plain black, a few have figured decoration and cups are quite often figured. Here we have an extreme and quite early example of the porthole method of decoration which we saw on [69]. The ferocious dog is not by itself; its three heads and snaky coat and tail would also alert us to a specific canine. It is Cerberus, the guardian of the Underworld, a vision so well known at the period that the painter, of about 550 BC, can suppress most of Heracles to the right, showing merely his club and the chain by which he controls his fiercesome captive, and of Hermes to the left, winged sandal in evidence. Laconian artists delight in animals, however heavily drawn, and here, as often, subsidiary birds are added. Red and incision are almost prodigally used.

73 (**Colour Plate VIII**) Andocides signed this amphora, graffito, on the foot. Its shape is a decade or more later than Exekias' larger vase [70]. The basic scene is common, if detailed—a man reclining on a couch at a feast (symposium) with a loaded table beside him. The slightly more elaborate drapery and musculature of [A] again points to a later date than [70] though the styles are related. The personnel involved and especially the technique of [B], provide the interest. It is no ordinary feast, but special to Heracles, his armour suspended from the wall, attended by Athena and Hermes; he holds Dionysus' wine cup and the god's vine fills the background. The location is perhaps on earth rather than in Olympus after Heracles' admission there, since he is often attended by Dionysus and his satyrs. The technique of [B] shows the reverse of black-figure; the background is painted in, while the figures are left the colour of the clay (reserved), and decorated with black together with some red paint. We may note the difficulties, and differences of approach, that the new technique engenders—the treatment of Athena's skirt, the cakes on the table, the vine stem by the leg of the table, and black objects on a black ground. It was probably the painter of this scene who introduced this reversed technique to the Athenian Potters' Quarter around 525 BC. We call him the Andocides Painter, though it is possible that he is the same man as the one who painted the black-figure panel and many other black-figure vases (and whom we term the Lysippides Painter). Very few amphorae are painted in this dual technique (bilinguals), even fewer with the same scene on either side as here, and these very few are not among the earliest red-figure vases. Technically, we note

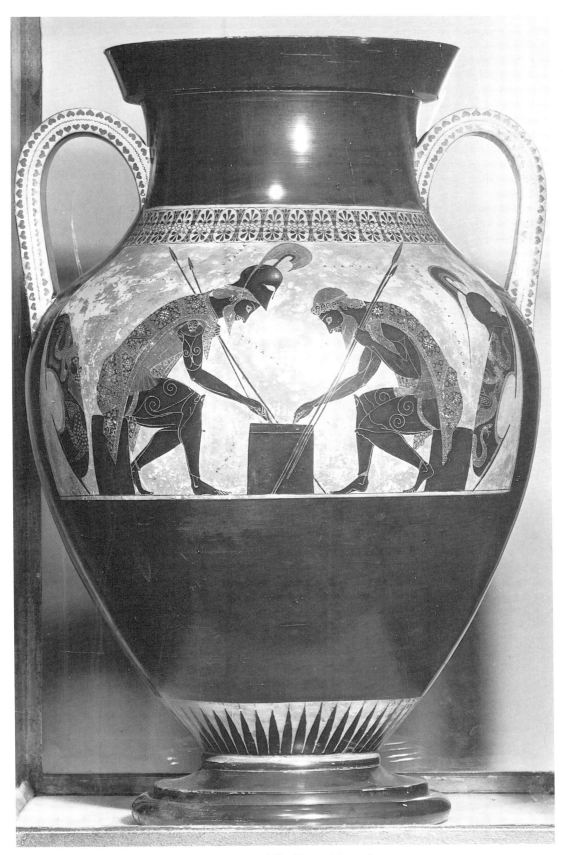

70 Athenian black-figure amphora, by Exekias: Ajax and Achilles (Vatican Museum)

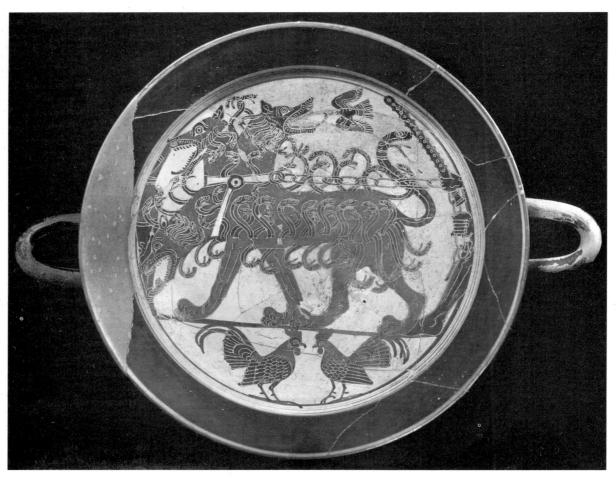

72 Laconian cup: Cerberus (private collection)

the occasional retained use of incised lines (bunch of grapes). The details are painted here in both brushwork and a thicker, wiry line (the 'relief line'), which was used in Archaic red-figure for much of the outline and the heavier details of anatomy and dress. Its method of application on to a vase is still a matter of dispute.

74 A little later than [73] we find a group of vase-painters who explore more fully the potentials of the new technique, notably in figure drawing, while discarding most remaining legacies of the black-figure approach. Euphronios was the most powerful of this group, dubbed the Pioneers. This vase, of about 510 BC, is among his fine calyx-craters, a shape known first from Exekias, and here signed by Euxitheos as potter. *Leagros kalos* (Leagros is handsome) is inscribed, in admiration of a local youth who was later to become a general. The shape, with its exaggerated lip, affords a broad canvas which the eye can take in at once. Most such vases have clearly an A and a B side; here there are warriors arming on the reverse, while on A Death and Sleep remove the body of Sarpedon from the field at Troy, supervised by Hermes, holding his herald's staff. As ever on more ambitious work the detail is rich, but basic advances in the use of the technique can be seen in treatment of both bodies and drapery; notable is

the use of a lighter brown for finer detail, a dilute solution of 'glaze'. It is found here for washes as well as lines. By contrast, most of the black lines are now drawn with the wiry relief line noted above [73]. Euphronios likes to display his anatomic virtuosity; here the frontal left foot of the vast body of Sarpedon is an example of the exciting experiments with pose made by the Pioneers, and in the left lower arm we see a rare, but probably deliberate, foreshortening.

75 The more elaborate volute-crater returns to favour in the ceramic repertoire of Athens in the late sixth century and is the vehicle for much high-quality work thereafter. The method of decoration of a number of early pieces in this series mimics that of the far more expensive metal counterparts [59]. This vase is the best preserved of half a dozen by a leading painter of the period after the Pioneers, the Berlin Painter, who had a long and regrettably declining career lasting from about 500 BC into the 460s. Like most leading artists who painted larger vases he also decorated small pieces, unlike the specialist cup-painters [76]. The theme here is an old one; on both sides warriors battle between interested spectators. However, the Berlin Painter is not only an excellent draughtsman, he also makes his details tell, not least by allowing himself more

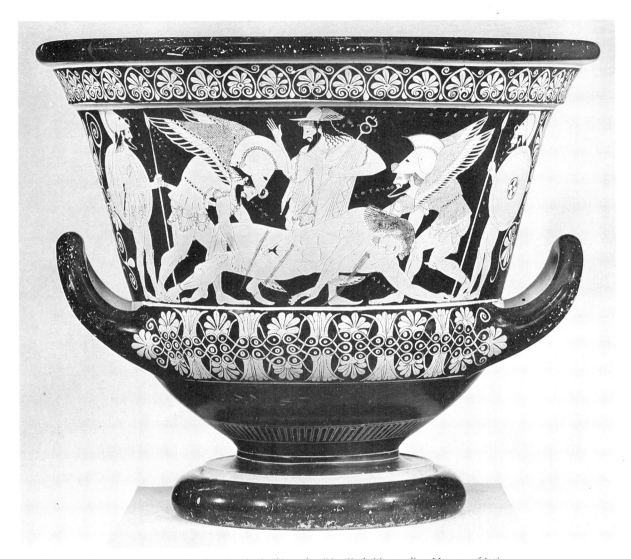

74 Athenian red-figure calyx-crater, by Euphronios: death of Sarpedon (New York, Metropolitan Museum of Art)

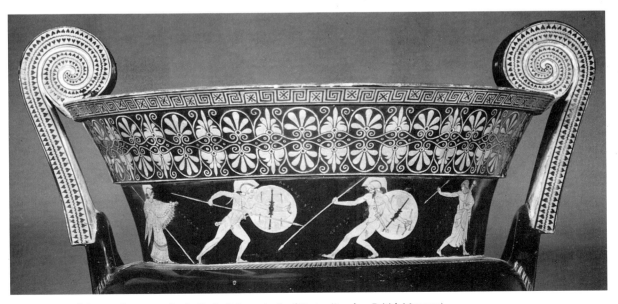

75 Athenian red-figure volute-crater, by the Berlin Painter: death of Hector (London, British Museum)

space between figures here, pointing up the individual renderings. We are at Troy, still a source of inspiration; it is Homer's text that is illustrated in depth, with the figure of Achilles about to triumph over the defeated Hector. Athena encourages her protégé, while Apollo, the Trojan's divine helper, signals his acceptance of the will of Zeus by walking away; yet he turns, displaying his arrow, auguring Achilles' death from the bow of Paris. The composition is a fine play of diagonals, and there is much rich detail of musculature in dilute paint; such detail can be rarely captured in photographs, but, apart from giving clues as to the identity of the painter (and the Berlin Painter's work is particularly consistent in this respect), it tells us much about the artist's attitude to anatomy and its rendering in two dimensions.

76 Among the most impressive early red-figure works are a number of large 'parade' cups, elaborately and fully decorated. This example was painted by Onesimos probably in the 490s BC. Despite its fragmentary state, the scenes are rich with detail. It is one of many known pieces (see also [**74**]) to have been repaired during its life; in addition, an Etruscan graffito under the foot not only confirms

its export from Athens, but probably indicates that it was dedicated to the Etruscan Hercle (Heracles). The stories told, though, are of Troy; on the outside Briseis is removed from Achilles' possession and brought to Agamemnon. Inside (and inner friezes are sporadically found in more ambitious work throughout the history of the cup) Troy is taken; the central feature is fittingly in the tondo, with Neoptolemus attacking the old King Priam using his grandson Astyanax as a club, while Polyxena tears her hair in the background; the altar on which Priam sits is boldly labelled 'of (Zeus) Herkios'. Sacrilege is emphasized by the placing of Ajax's rape of Cassandra immediately above; she clutches Athena's statue in vain and the painter adds Apollo's tripod to emphasize the sanctuary which she seeks. Opposite, we may note Menelaus dropping his sword, as Helen rushes to him, aided by a hovering figure of young Eros. There is much to admire in the variety of poses here also, as the armed Greeks attack virtually defenceless Trojans.

77 The number of scenes of Dionysiac activity, involving humans or the god and his train, on pots of the late sixth and fifth centuries is more extensive than our selection

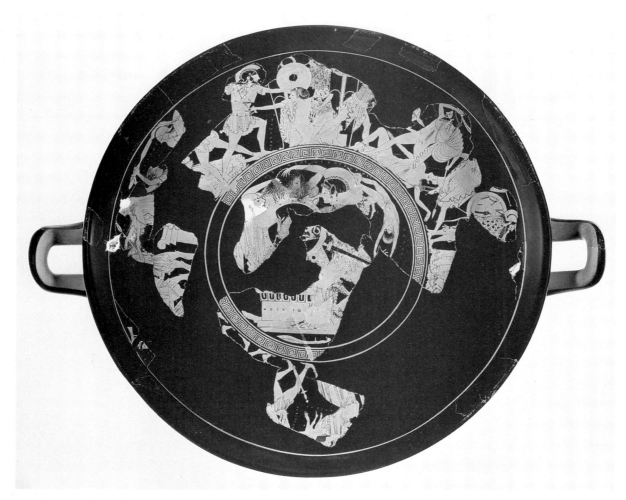

76 Athenian red-figure cup, by Onesimos: sack of Troy (Malibu, J. Paul Getty Museum)

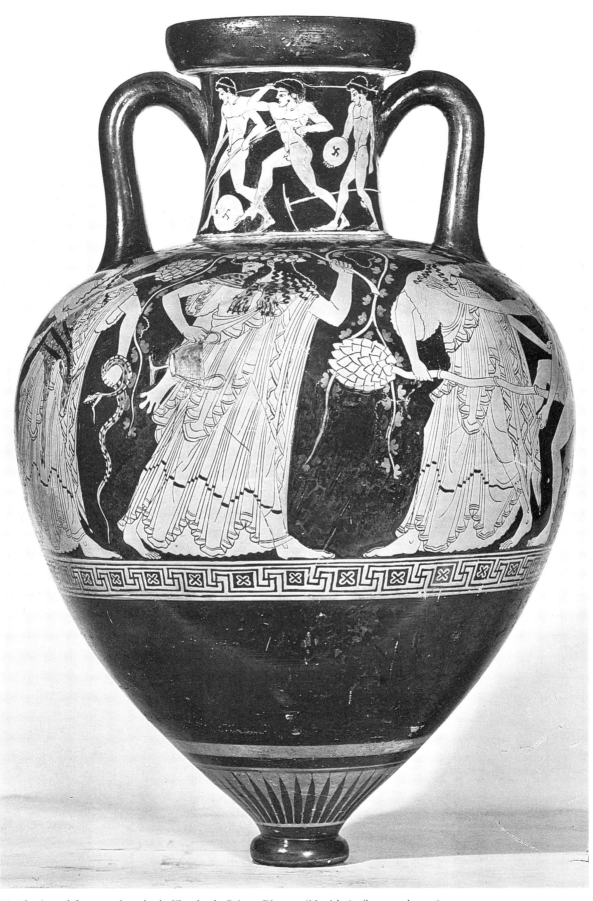

77 Athenian red-figure amphora, by the Kleophrades Painter: Dionysus (Munich, Antikensammlungen)

78 Athenian red-figure
skyphos, by the Brygos Painter:
carousal (Paris, Louvre)

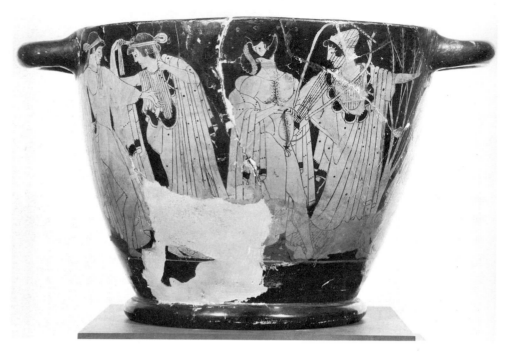

may suggest. This remarkably finely composed and painted frieze is placed on a shape of jar borrowed from the wine-merchant—the storage amphora with its pointed foot; rare in figured ware, they are common in plain fabrics and were made in various places. About twenty black- and red-figure versions are known. This one, of about 490 BC, is by the Kleophrades Painter, to whom are attributed some 115 pieces, of a range of shapes similar to that of his major artistic rival and contemporary, the Berlin Painter [74]. Clearly a pupil of Euthymides, a companion of Euphronios, he retains an interest in large vigorous figures and well-populated scenes. The scenes of athletes on the neck underline that tradition. Below, Dionysus has his typical attributes—bearded, with an ivy wreath and long chiton and mantle, holding a large *kantharos* and vine (compare [73]). The large figures of maenads turn away from him—a centrifugal composition widely used at this period—to repel impish satyrs, smaller for being crouched under the handles. The highly ornamental drapery, with leg outlines drawn underneath and the further hem well visible, can be compared with some contemporary sculpture. The extensive use of a wash of dilute glaze is striking, for the animal skins, the snake, and the hair of a blonde maenad charmed by a flute-playing satyr, on the reverse.

78 Human merriment often appears on the stout drinking-cups known as *skyphoi* and made in small numbers by the specialist cup-painters of the late Archaic period. Here we see cavorting in the streets of Athens after the symposium has finished. A slave-boy carries further supplies of drink in the subordinate position below the handle, while bearded and heavily garlanded men are paired with courtesans in the main field. One raises his head in song, accompanying himself on the lyre, while the painter ably captures the unsteadiness of another. We call the artist the Brygos Painter, after a potter with whom he frequently works, and over 200 pots, mainly cups, have been attributed to him. There are also a number of imitators and followers of his distinctive style, with its tubular folds of drapery, hairy chests, elegant nostrils and lips. In the eye the pupil is well forward and the inner end is almost open. We are perhaps into the 480s BC. It is a very light vase, like many of its fellow *skyphoi*, and the first sketch needed to be accurate to avoid the application of too much of the black paint which forms the background.

79 A contemporary and rival of the Brygos Painter was Douris, perhaps a Samian by origin, whose career lasted into the 470s BC, when his workshop colleagues and pupils continued his rather elegant and solid style. This piece, found like so many others in Etruria, is an example of the cycle of deeds performed by the new Attic hero Theseus, as he returned to his true home, around the danger-infested coast of the Saronic Gulf. These scenes first appear in the 510s BC and may reflect a work of literature in which Theseus was claimed as the model hero of Attica. His struggle with the Minotaur, the one deed widely seen in earlier art, is on the tondo; here we see four of his other exploits. Athena stands by him (see [37 A]), as she had done by Heracles. Near the Isthmus of Corinth Theseus encountered the fierce sow owned by an old lady at Crommyon, a rather

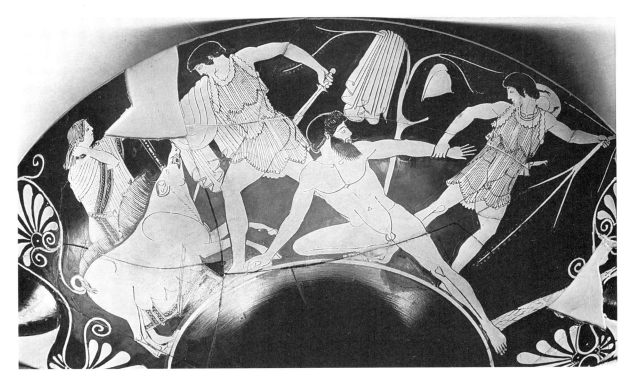

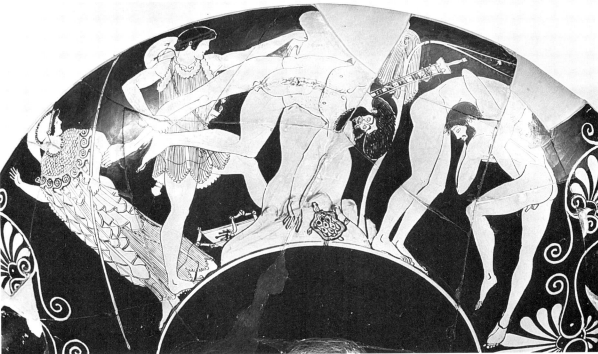

79 Athenian red-figure cup: Theseus' deeds (London, British Museum)

pale echo of Heracles' hunt of the boar of Calydon, though Theseus takes the precaution of adopting the attacking pose of the tyrannicide Aristogeiton [81]. To tie Sinis to the tree from which he was wont to project passers-by,

Theseus hangs his travelling hat and cloak on a suitable peg; his body here is thick-set but tall in proportion to the head, an indication of a date nearing 480 BC. The head of his next opponent, Sciron, is in three-quarter view, one of

the early and still rather unsuccessful attempts in Greek art; a turtle waits to devour him as he plunges into the sea from the Scironian cliffs—his own trick again turned against him. Finally, a wrestling match with Cercyon at Eleusis, this time with his chiton on the peg. While there is little novel in the iconography, treatment of detail is full and the line admirably controlled.

80 This half-life-sized marble is one of a number of fragmentary works from the Athenian Acropolis which clearly formed part of larger compositions. The figure stretches his right arm up, surely holding a weapon with which he threatens another who grasps his left shoulder; a small fragment of his bearded head, with a hand to its throat, survives. It may perhaps be the pair of Theseus and Procrustes; this is one of the deeds of Theseus not depicted on the later cup, [79], but perhaps the best known of them because of the Procrustean solution which Theseus turns on his host, cutting him down to size to fit the bed offered. That bed is normally depicted on vases, but it is debatable whether such a *mise-en-scène* was included in this early group in the round. The figure presents a largely frontal kouros-like body, twisted a little at the waist, more at the shoulders. The contours of the lower body suggest a date no later than 510 BC, making this an early illustration of Theseus' deeds, if indeed this is what it is.

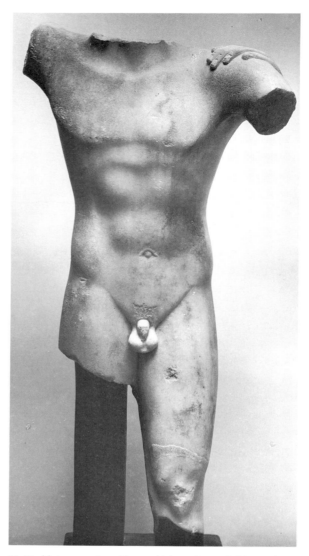

80 Marble torso, perhaps Theseus (Athens, Acropolis Museum)

3 THE CLASSICAL PERIOD

JOHN BOARDMAN

THE fifth and fourth centuries BC, the 'Classical period' in the narrower sense of the words, were militarily the most illustrious for the Greek nation. In 479 BC the Persians were finally driven from the Greek homeland, and in 323 BC Alexander the Great died in Babylon, having overrun the whole of the Persian Empire with his armies, from Egypt to India. Not that 'nationhood' was a concept easily admitted by the Greeks. They had a bond of language and religion and so could, with some difficulty and incomplete accord, combine to defeat the Persians in Greece; but when it came to taking the battle into Persia itself it required the ruthless drive of a peripheral Greek, Alexander, to weld together an effective fighting and administrative force. Between-whiles they behaved, as they long had and long would, as independent city-states, fiercely proud of their local allegiances and often engaged in fighting each other. Indeed, the historical centrepiece of this Classical period was the Peloponnesian War, which divided Greece and brought about the fall of Athens and dissolution of the league-cum-empire with which she had carried the fight to the Persians.

Fifth-century Athens saw the first democracy—limited in its practice to male citizens and economically dependent to some extent on the services of slaves. The rulers of Athens were now chosen by vote and lot, although rich families were still influential, as they were still in many other Greek states, even where roughly democratic constitutions had been introduced. Wealth helped—loot from Persians or neighbours, and in Athens' case local silver mines. But Greece had no great natural wealth and had already in the Archaic period been forced to look overseas for resources. The effects of democracy and of wealth were apparent to all, but an élite class of intellectuals was exercising a different freedom, of thought and invention. The poets of Athens brought to the public stage plays which were based on Greece's myth-history, but which they used to explore such eternal human problems as loyalty, the conflict of civil and moral law, sin and retribution, in a manner which laid the foundations of western theatre and is influential still today. In comedy the poet could comment more directly on contemporary figures and faults, and eventually (in Middle and New Comedy) produce a Comedy of Manners spun round the fortunes of the stock characters of everyday life rather than of heroes and gods. Intellectual curiosity about the world and its ways had been stimulated in the Archaic period. Now it was extended to consider the world as something other than a creation of the gods, to explore the working of man's mind, of the powers of speech (all-important in the democratic assembly), and of visual images that might render reality, transcend it, or counterfeit it.

Amid this intellectual and political activity—all of it exposed to common gaze except for what took place in the philosophy schools—there was much that finds an echo in the visual arts. Contemporary problems no less than military successes can be explored and celebrated in art as well as in poetry. An age

of rationalization—of gods, of concepts, of behaviour—inspires a readiness to generalize or idealize what was already the Greek artist's prime subject, the human form. This is Classicism in its narrower sense, attempting to perceive patterns, to set standards. In this the playwrights, philosophers, and politicians of the fifth and fourth centuries BC achieved no little success. So did the artists.

In their expression of these new attitudes to the world and to their neighbours artists were not creating *their* new Classicism at the specific request of their patrons. It depended rather on the development of their craft, sometimes even on technical advances, as well as on a different view of their function and the stimulus provided by the expectations of their customers and of state or individual patronage. The reasons for change and its mechanism can be studied internally, in each craft, but the way in which it was expressed depended now more than ever on the mood of the society the artists served.

In Archaic Ionia the colossal temples dominated the city landscapes like French cathedrals, demonstrations of power as much as of piety. In Classical Greece the temples were more modest, though still imposing, no less statements of power and piety, though also sometimes of state propaganda. A tyrant can coerce forced labour for such projects more readily than a democracy that has to pay at least subsistence to its labourers, who may be freemen or slaves. We can judge this from the accounts for the great building programme for Athens, inaugurated by Pericles in the mid-fifth century, to replace the buildings destroyed by the Persian invasions of 480–479 BC, now that Athens had finally 'freed' Greece of the Persian aggressor. Money, which was readily available, could attract skilled hands but could not create them. By then the elaboration of monumental marble architecture was no longer monopolized by temple building, but gradually came to determine the appearance of public administrative buildings, and eventually of theatres and assembly halls. There was, as it were, a levelling up of architectural ambition in the city. (We concentrate on Athens in this chapter because, for the fifth century at least, it was the most powerful state in Greece and, in terms of what has survived, artistically the most prolific. In the fourth century the centre of political power shifts north, to Macedonia.)

Major architecture depended on state patronage, whether commissioned by its magistrates or, for temple projects, by the priestly families. The state could also commission major sculptural dedications, at home or in national sanctuaries, to celebrate military success and to honour individuals. Thus, to celebrate the battle of Marathon, the Athenian state started a new temple to Athena on the Acropolis, and later paid Phidias to make a forty-foot bronze Athena to stand there, as well as a bronze group of gods, heroes, and generals to stand at Delphi, where it might remind all Greeks of Athens' role in securing their freedom. Propaganda begins to get the upper hand over simple piety. Individual citizens too could sponsor major public works. In Athens the general Cimon and his family and friends appear to have commissioned several buildings, a new temple for the Athenian hero Theseus (Cimon seems to have fancied himself as a second Theseus) and the Painted Stoa, decorated with a mural showing the battle of Marathon.

Archaic cult statues could often be very simple, indeed primitive affairs, acquiring their sanctity from their alleged origins, helped often by their obvious antiquity. New cult statues for new or rebuilt Classical temples might be of bronze or marble, of a scale commensurate with the building but not usually excessive. With the Parthenon, though, a forty-foot Athena (matching the height of the bronze that stood outside) was made by Phidias [106] of gold for the dress and ivory for the flesh, and this fashion was followed for a very few other cult statues in Greek temples. Ostentatious wealth in a cult statue was not an inevitable signal of piety, though even the simplest of them could be decked out with embroidered clothes and jewellery for festivals. So this was a new way of saying something more about the motives of the state patron. In this as in other respects the Parthenon can be seen to have been

designed to be as much a statement of civic pride in the city's present power and past achievement, as a thanks-offering to a guardian deity. The notion is abetted by the choice of sculpture for the building, as we shall see. Democracies could be as much concerned about their image at home or in national centres, such as the sanctuaries at Olympia and Delphi, as could any tyrant or king, and the visual arts served this interest in a more direct and permanent form than did speeches or poems.

Other statues of marble or bronze were commissioned by individuals to celebrate success, in games or business, to stand in sanctuaries or public spaces (the market-place—agora). The subjects were not even vaguely portraits of the donors, but an athlete would dedicate an athlete statue, successful generals might be shown and identified by the grateful state (but usually only after their deaths, in the fifth century at least), and a mythical group of appropriate content could be chosen to commemorate any occasion—from a battle to a successful play. Graves were not commonly marked by statues now but, at best, by marble relief gravestones (stelai), and in Classical Athens not even by these until after about 430 BC since the Archaic practice had been abandoned in the early fifth century. Funeral mores in Classical Greece say at least as much about the aspirations of the survivors as they do about the merits of the dead.

We hear (but sadly do not see) more of major painting in the fifth century, mainly panel-friezes for temples and public buildings, with 'programmatic' themes of mythical or semi-historical content (such as the battle of Marathon), serving much the same purpose as the complexes of sculpture decorating temples. Again, a major and new art form seems to be serving more than piety.

The last paragraphs have dwelt mainly on the function of the major arts in the fifth century. After Athens' defeat, down to the days of Alexander the Great, there were some shifts of emphasis and different sources of patronage emerged. Greek artists had long been ready to work for foreign kings, notably their neighbours in Asia Minor (Turkey). These kingdoms were now within the Persian Empire but their rulers remained rich and independent. Some of the major works of Greek fourth-century architecture and sculpture which have survived were commissioned by the rulers of Caria and Lycia in south-west Asia Minor. Comparable wealth in the western Greek colonial area of Sicily and south Italy also promoted major projects in city-states still mainly ruled by kings or tyrants. The renewed importance of this type of individual or family patronage goes hand in hand with other demonstrations of self-importance through the arts, such as the growing interest in portraiture, by now for the living and not just for the long or recently dead. As the power of Macedonia grew and the ambitions of Philip II and his son Alexander to be the accepted leaders of the Greek nation against Persia began to be realized, the northern dynasts provided a new patronage for the major arts, backed by considerable wealth. They were more ready than most Greek city-states had been to glorify the individual and his family.

Classical Greece was a far wealthier place than Archaic Greece, though it is doubtful whether the standard of living for most people was much improved. Persian loot brought with it manufactured goods of exotic forms, most of them familiar already through contacts in Asia Minor, and none of them now influential for artists, who were wholly self-sufficient in their crafts and innovative in their design, with no further need of vital inspiration from overseas. A few luxury borrowings can be observed, but they are trivial. Much of the precious metal was converted into coin by the state (the silver), but there was more gold and silver available for works of art, though little enough has survived. Much silver, for instance, was stacked as bullion in the form of plain silver dishes (*phialai*) in the state treasuries. We have to imagine landowners or merchants (probably the wealthiest of the community apart from military men fattened on loot) having their bullion converted into plate or jewellery, rather than think that artists kept large stocks of precious material to work for the open market.

In all this the artist was serving still the comparatively narrow interests of the state, whether a democracy or monarchy, of wealthy individuals, or of enterprising merchants who sought manufactured goods to satisfy foreign customers in the east or in areas of non-Greek Italy. The results in architecture and sculpture were visible to all, but we have to ask what motivation there could have been in the humbler arts, and to what extent the artist's eye and skill were exercised in the service of more modest customers. It is noticeable that even the simpler objects and utensils of bronze or clay seem to carry something of the finer quality of major arts. The homogeneity of the 'Classical style' regardless of medium or scale ensured a level of design quality through a remarkably wide range of artefacts in the community, so far as they can be judged from extant examples—for woodwork and textiles we can merely guess. But even the poorest clay figurines, mass-produced in moulds and brightly coloured, share something of the more ambitious style of major works. Even in the severely practical matter of minting coins major artists could be employed to make the dies and some even signed their work. In many Greek states the coins were, by any standards, works of art, yet the only value added by the quality of the dies was aesthetic.

Fortunately, the Archaic delight in elaborately figure-decorated pottery did not abate until near the end of our period. The main difference is that Athens virtually monopolized production until the later fifth century, when studios set up in different parts of the western colonial world began to supply local markets with pots decorated in a style originally derived from Athens. Pots decently decorated with about five or six figures cost about two or three days' wages—which is not altogether cheap but did not put them beyond the range of the ordinary household (which used them, as we can judge from excavations). These are the vases which nowadays will fetch £10,000 at auction. On overseas markets they were sufficiently profitable for merchants to risk the carriage of these breakables by sea and land, and this was certainly a stimulus to production in Athens far beyond the requirements of the local market.

The vase-painters decided the subject-matter for most vases—this is clear enough; how far this choice was influenced by public taste or had moulded public taste already is hard to say. Major art of the day is only faintly influential, and the vase scenes are decidedly not simply extracts or sketches of murals or major panel paintings such as were made for public buildings. The range of subjects tells us little about this. There are myth scenes, some of them expressing the same themes as major works of the day, and therefore sharing with them the more profound messages they could carry about politics, life, and religion. There was a discreet range of domestic and religious scenes, with an increasing interest in the life of women as time goes on, and none whatever in civic behaviour. While the major monuments shunned any direct identification of contemporary figures and events, but commented on them through myth or generically, the pot scenes could be a little more explicit, but never to the point of the illustration of famous events or famous people in action, or at least not until they had acquired an aura of myth.

Even summary inspection of the pictures that accompany this chapter will reveal the novelties of the Classical period, or at least their superficial characteristics. Architecture remains fairly conservative, but we shall discover that it can be subtly refined, and there are both new decorative patterns and a wider range of use for the major orders. It is in sculpture particularly that the new spirit can be seized, and the innovations and dominant features are to a large degree shared by the other arts, including the graphic. This is a period in which foreign influence and foreign techniques were of minimal importance, which is a notable difference from what was true of the preceding three centuries.

The human figure, whether representing god or man, remains the most significant image, and it is presented in an increasingly realistic manner. But this simple observation suppresses a profound variety

PLATE IX

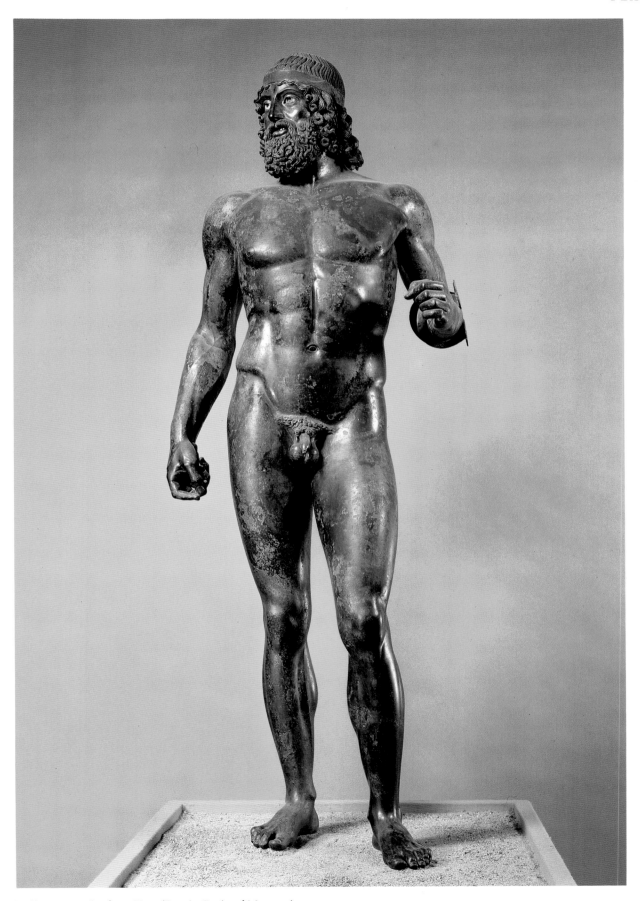

87 Bronze warrior from Riace (Reggio, Regional Museum)

PLATE X

98 B Athenian white-ground cup: satyr and maenad (Taranto, National Museum)

139 Athenian red-figure vase by the Meidias Painter: Aphrodite and Phaon (Florence, National Museum)

PLATE XI

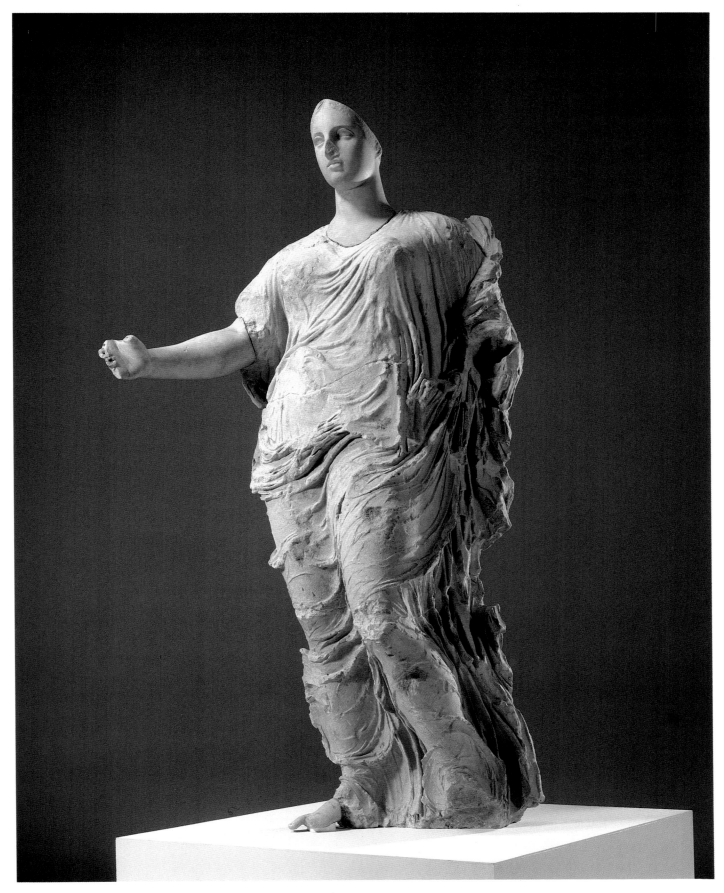

125 Marble and limestone goddess (Malibu, J. Paul Getty Museum)

PLATE XII

147 Cloth from tomb of Philip II (Thessaloniki Museum)

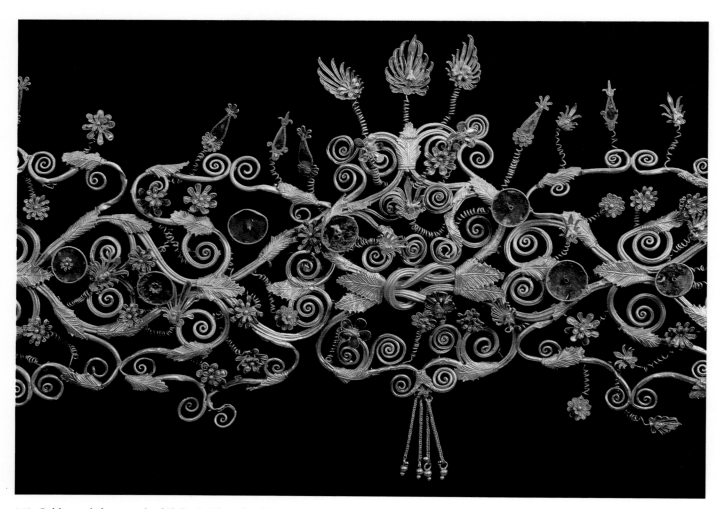

148 Gold wreath from tomb of Philip II (Thessaloniki Museum)

of other intentions on the part of the artists, some of them by no means secondary. Realism had not been pursued by the Archaic artist for its own sake, but the conventions of Archaic art were gradually adjusted towards the realistic in the interests of creating a more effective image, and some quite basic elements, such as the frontal eye in a profile face, were preserved simply because their impact was more effective than any more realistic treatment of the feature could have been. In the Classical period we may begin to suspect that realism *was* being pursued, or at least admitted, for its own sake. There is certainly a great deal more close observation from life—in drawing, the profile eye in the profile face, and in sculpture far more accurate recording of details of superficial musculature and veining. More important than these superficialities, however, was observation of structure, and an understanding of the human figure as more than an assemblage of realistic superficial details and patterns.

The earliest explicit example of the new style is the so-called Kritian boy, who is to some extent misleading in being both incomplete and of marble, not bronze. The sculptor has succeeded in breaking with the Archaic convention of rigid symmetry, exemplified by even the most advanced and 'realistic' of the kouroi [43]. The boy's weight is carried by his straight left leg. The right leg is slack, and the thigh is carried forward. There is a corresponding tilt to the pelvis, slackening of the right buttock, and the shoulders and head are lightly inclined. It is closer to being a 'real', relaxed figure than anything in earlier art, anywhere. The factors which effected this truly revolutionary change are various. This is unquestionably a more effective image of man, even if a shade less imposing than his predecessors to our eyes. To his contemporaries the impression such figures made must have been dramatic. The desire to improve the effect of the image may well have been considerably helped by new techniques also. To conceive such a realistic pose the body needs to be understood from within, with some comprehension of the role of bone and muscle; and to achieve it in sculpture it needs to be created from within. It is an innovation that could only be realized in a modelling technique, one that built up the body on armatures, adding muscle and flesh in clay. There is no easy path to this new style from a purely carving technique, starting from sketches on the outside of the block in the older Egyptian and Archaic Greek manner. Modelling was familiar to sculptors already, but mainly for small works to be fired in clay or cast in bronze. Larger works in bronze are new to the late Archaic period, and the modelling required in preparation for them offered the opportunities for the type of experiment that could lead to figures like the Kritian boy. But he is in marble. His bronze brothers, alas, are lost, but there are plenty of intimations of them, from bases and from copies of them made in later periods. We must imagine that most if not all major works in marble from this time on depended on original clay models, probably at life size, which were then translated into stone. This is by far the simplest explanation of the phenomenon, and explains better the functions of master sculptors (who prepared the models) and workshop apprentices (who then copied and carved them). Archaic sculpture was essentially carved: Classical sculpture is essentially modelled. The German language expresses the difference in the use of the two terms, *Glyptik* and *Plastik*, although the distinction is not strictly observed in modern literature.

The result, however, is not mere realism. We can see the body becoming better understood and the sculptors' varying treatment even of such a basic pose as the standing relaxed figure. There is progress from the still flat-footed Riace bronzes [87], through the figures with withdrawn foot and raised heel (associated with Polyclitus [93]), to fourth-century figures whose weight is partly carried by a pillar beside them [129]; and by now too, in figures that were designed for the all-round view [134] rather than the frontal, which dictated the appearance of most earlier standing male statues. Yet when a sculptor such as Polyclitus wrote a book about his 'model' figure, the *Kanon*, it dwelt on proportion (*symmetria*, the commensurability of parts) and not anatomy. Famous painters wrote treatises on the same subject. Measurement and the human body had long been closely linked. Egyptians and Greeks measured in

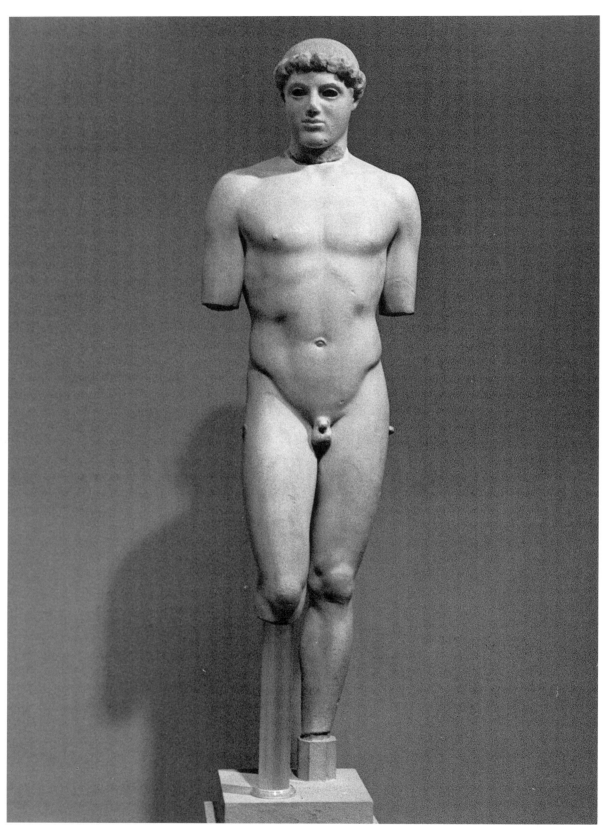

'The Kritian boy' (Athens, Acropolis Museum)

terms of fingers, palms, feet, cubits (forearms), fathoms (arms-spread). The units were related as they are in the human body, but when they are tied to absolute measurements they may not exactly resemble any average human body. An expression of the ideal figure, which is what Polyclitus and others were attempting, might be better achieved by statements of proportion. The artist's view of the human figure remained in its way a mathematical exercise, just as did his view of the composition of figures in groups, and just as did the architect's in the laying out of a temple building, observing rules of proportion throughout, from details of mouldings to whole ground-plans. The Classical artist sought to achieve an equilibrium between the almost opposed interests of absolute proportion and anatomical realism. Like his fellow playwrights and philosophers he sought a way of reconciling the variety of human experience and appearance with absolute rules or forms. And the Classical 'ideal' figures of Greek art express this desire no less than the essays of poets and philosophers, studying the general through the particular in plays, or enquiring into the existence of absolute standards of behaviour, of right and wrong, good and bad, beautiful and ugly. The balance and reconciliation of opposites is a vital and inspiring force in Greek thought and religion, and in Greek art of the Classical period.

The naked male seems to have emerged as the paradigm of the Classical style. This is not an altogether false impression, although the naked male had been popular enough in the Archaic period too. The preoccupation with such figures is in part explained by Greek interest in the human, in all the arts, rather than in the demonic; in part it is an exaggeration of life, since it was recognized by foreigners in antiquity that the Greeks had an odd, indeed shameful, readiness to go naked, and not only for athletics; and in the Archaic period it also attracted the artist's interest in anatomy pattern. To some degree it too is an idealizing trait, but it is not a signal of rank or heroic status; the concept of 'heroic nudity' derives from it but has no role in the Classical period itself.

Clothing had also attracted the Archaic artist, also for its pattern-potential and primarily on women. On Early Classical works much the same motive inspired the series of more austere peplos-wearing figures, whose different dress dispensed with the fussy splendour of Archaic folds and pattern. But after the mid-century dress too was rendered yet more realistically, and yet again with an ulterior motive in the best works, to help emphasize the forms of the body beneath. Think of this again in terms of a modelling technique, adding dress to a basically naked form, and it is clear why dress too should follow the line of development observed with the naked figures. By the end of the fifth century, and indeed in the latest sculpture placed on the Parthenon [105], the dress barely concealed the body's contours and there developed a 'windblown' or 'wet' look of a profoundly sensuous character. A further stage, developed in the succeeding period, gave dress virtually a life of its own, bunched and swirling over limbs and torso.

The female nude, a potent image in later western art, came late on the scene, in the fourth century. It had been used before mainly for pathetic effect. Now it is more openly erotic and it is likely that the fleshy appearance of white marble was being deliberately exploited. Earlier statues were generally as comprehensively, if perhaps less emphatically, painted as they had been in the Archaic period: a concept very difficult for modern viewers to accept, conditioned as we are by the Renaissance's view of Classical art—as colourless as it was when excavated, and purged of its colour by burial. We seriously underestimate colour in all Greek art. In architecture the patterned mouldings were picked out in different colours and even the marble column shafts and walls may have been tinted, in part to relieve the reflecting glare of a Mediterranean sun. The bronze statues too we have to imagine with a pale, brassy, or golden surface, nearer a natural suntan than the dark chocolate familiar from most museum displays, and deliberately rendered by Renaissance artists for much the same reasons as they left their marbles white. The Classical bronzes could be picked out with red copper details for lips and nipples,

silver teeth, realistic inlaid eyes of glass or stone, and inlaid patterns on dress. It may well be too that more colour was admitted to dress on the bronzes than could be achieved with inlays of different materials.

Pose, anatomy, dress are the superficialities. Later writers dwelt on the ethos of Classical works. Expression of mood and emotion might have been expected to follow naturally on any more realistic expression of the appearance of the body. Previously this had been managed by the conventions of gesture and pose, and these, subtly adjusted, remained of greater importance than the casual viewer might realize. The shortcomings of our reliance on copies of Classical sculpture are exposed in the face of originals, such as the Olympia temple sculpture and Early Classical bronzes, which show how far sculptors could go. But it may have been a trend that militated against that more dominant interest in idealization, and the ethos of Olympia gave way to a no less telling attitude in the design of the Parthenon sculptures a generation later. It was the same tendency that worked against realistic portraiture for so long. We may find the result rather chilly through our over-exposure to much later (to the present day) classicizing versions by artists who have lost or never understood the motives of the creators of the Classical style.

The physical appearance of the arts of fifth- and fourth-century Greece may be their most obvious claim on our assessment of the artists' achievement, but the subjects are no less important, not only for their function in the society they served, but in their legacy to later western art. Story-telling in single tableaux had been an essential element in the Archaic artist's expression of narrative. The Classical artist continued to shun telling stories by a succession of images, or by repeating the figure of a protagonist in a single composition to indicate progression in the narrative. Both time and space are disregarded, where need be, to achieve an accomplished narrative in a single composition. Basically this remained a common practice in western art until the camera and film rendered possible the record of momentary action, though other ancient cultures had already adopted the device of repetition in successive scenes (like a strip cartoon) or within one scene. The Greek solution required some co-operation on the part of a viewer who both knew the essential narrative from other sources, and could be expected to understand the conventions of pose or gesture or dress through which novel presentations could be interpreted. In the fifth century there was further refinement for major narrative monuments, such as the Parthenon frieze or the painting of the battle of Marathon in the Painted Stoa. On these, it seems, limited movement in both space and time is accommodated without repetition of figures or the device of using separate fields for successive events.

We have mentioned 'the artist' without so far considering his status and place in society. Most Greek art of the Classical period was still the product of family businesses within which crafts were passed on from father to son. They were professionals, and we have no good reason to think that they plied their craft only seasonally and were dependent on working also on a family farm for basic sustenance, though it is likely that the wealthier were landowners of more than the space of their studios or kilns. The great names of the period, in sculpture and architecture, seem to have enjoyed high social status, and were wealthy. While the artisan seems to have received no more than the average day wage for copying sculptor's models, whatever the skills involved, the designer seems to have been well rewarded. But although we have the sums awarded for some commissions it is not always clear whether, for instance, these were just for supplying models (specified in some cases) or for the whole operation, involving acquisition of material and employment of studio staff. Where a major and expensive state project was involved, the state provided the materials; we have some of the accounts for the gold and ivory for the cult statue in the Parthenon, and for the sale of surplus material. That responsibility for such materials might lead to suspicions about the artist's honesty is understandable, and Phidias was suspected of

embezzling some of gold for the Parthenos, which, it was alleged, he could answer because he made the gold sheets removable so that their weight could be checked.

Pride in achievement is indicated by the continuing practice of signing work, although not architectural sculpture, it seems, for which we rely on later reports in encyclopaedists and guidebooks. Even painted vases are still signed, though not always the best (to our eyes) or by the best artists, and the practice died out at the end of the fifth century. But even potters could make money, die wealthy, and receive their meed of honour from the state. A fifth-century poet reflects Athens' especial pride in her pottery, which is rather surprising given our view of the prime achievements in the other arts of this period in Athens. Sculptors' signatures became more modest, if anything, but might still occupy the same field as the dedication naming the donor. The artist is still regarded as basically a gifted craftsman rather than raised above ordinary humanity, like a poet or philosopher.

In a period of such intense intellectual activity we might expect a comparable flow of energy and inspiration in the visual arts. This seems to have been true and the worth of the artists' contribution may be judged by the survival and influence of their work far beyond the borders of the Greek world and into later centuries, to the present day. If we ask what it could have meant to the fifth-century Greek we may be less at a loss than when we ask a comparable question about his response to and understanding of, say, a play by Euripides. The image can speak across centuries sometimes more directly than words, though the grammar of the Classical arts, their conventions and potential message, demand an empathy with the period that is not easily realized. The Classical Athenian's conception of the appearance of his gods, their majesty, and the expression of their concern for mankind must have been in terms of something like the east pediment of the Parthenon, where the gods stand or sit, colossal and physically elevated, flanked by the rising and declining chariots of the Sun and Moon. The philosopher Plato expressed reservations about arts which could counterfeit life. When he described the human soul's struggle towards Truth in terms of a charioteer's effort to ascend the heights of heaven where the twelve gods command their teams, he may not have been thinking of a Parthenon pediment, but he was expressing his parable in terms of an image which took all its force from the conventions and imagery of the arts of the fifth century. No doubt the Greek could respond as readily, albeit at different levels of comprehension, to the new world of images and forms that his artist contemporaries had fashioned. Probably in no other period of classical antiquity was he so close to and engaged by the products of artists' skills and imagination.

THE NEW SCULPTURE

81 Harmodios and Aristogeiton killed the Athenian tyrant Hippias in 514 BC, and were themselves slain. The story went that they were lovers and the assassination the result of family jealousy rather than a matter of political liberation (which was not, at any rate, achieved for some years). But once the new democracy was established in 510 BC the Athenians erected a statue group to them as liberators, the first of such commemorative dedications that, in a way, heroized the recent dead. We do not know what the group was like because the Persian King Xerxes took it away to Persepolis when he sacked Athens in 480 BC, and

although one of Alexander the Great's successors returned it, the group seems not to have attracted the attention of later copyists, our prime source of information about the appearance of such famous statues. Possibly this is because it was not an action group but simply two standing, kouros-like figures. After the defeat of the Persians the Athenians had a new group made, by the sculptors Kritios and Nesiotes ('islander'), who had collaborated on other works (and recall the 'Kritian boy', above, p. 88). It is this later group, of the 470s, that was copied for the Roman market and to adorn the gardens of emperors. It is shown here in the version preserved in Naples [A]. (The head of the older man, Aristogeiton, is restored from another copy.)

The group is novel, since it is an action group in the round, and it is incomplete inasmuch as the victim is not shown but imagined, roughly in the position of the viewer. The slashing gesture of the youth and the protective, stolid pose of the older man were used as evocations of their heroic behaviour by artists later in the century, who applied them to other Athenian heroes such as Theseus or his companions. Notice, for instance, the figure to the left of Apollo in the Olympia pediment [82]. The novelty of this representation of a historical event might be explained if we take the original group to have been relatively anony-

B

81 Tyrannicides group. **A** copy (Naples, National Museum);
B plaster cast of head of Aristogeiton (Baiae Museum)

A

A

mous in its appearance, and no more closely related either
to the men or to what they did than a kouros is to the man
whose grave he marks; but that the need to replace them
came when an action group seemed more appropriate,
and when enough time had passed for close identity
(though not true portraiture) of the two men to be accept-
able, since the event had already become 'heroic'. We shall
find other examples of this artistic shyness where recent
events are concerned; it is in a way an example of the Greek
preference for the general rather than the particular.

The tree trunks by the forward legs of the two figures are
the Roman copyist's additions, to make more stable
figures which, in the original bronze, would not have
required such oddly inappropriate props. There are many
other ways in which copies in marble must deviate from
their bronze originals, but in this case we are offered a
most unusual opportunity to make a direct comparison.
In 1952 at Baiae on the Bay of Naples fragments of ancient
plaster casts made from original Greek statues were exca-
vated. They must be from a copyist's studio, and he had
imported casts from Greece to serve as models. Among
them was part of the head of Aristogeiton [**B**] and this can
show us what the original was like. The eyelids look lumpy
because, when the mould was made from the original, the
fine bronze-wire eyelashes had been covered over with
clay to avoid damaging them. We can see that the locks of
the beard and moustache were delicately incised, a fine
detail which copyists in marble were seldom able to repro-
duce.

82 The Temple of Zeus at Olympia received its marble
architectural sculpture about a quarter of a century later
than Aphaea [**38**]. It is the fullest and most varied original
expression we have of the 'Severe Style' in sculpture—a
term applied to Early Classical sculpture and reflecting on
its sobriety after Archaic elaboration. The rather static east
pediment in fact recalls a story which, at one level, relates
to the founding of the Olympic Games—the chariot race
won by Pelops—and at another level puts in the viewer's
mind the sequence of events provoked by perjury before
Zeus at this moment before the race, leading to recurring

B

82 Temple of Zeus at Olympia. **A** west pediment; **B** metope:
Heracles and Athena (Olympia Museum)

disaster for generations of the family of Pelops. The other
pediment [**A**] shows Apollo (the rule of law) umpiring the
fight of Greeks and centaurs, the defeat of the unruly and
barbaric at the hands of the civilized. And the metope slabs
that decorate the porches at each end of the temple show
the Labours of Heracles. These relate to Olympia, in that
the hero was the son of Zeus and was thought to have laid
out the stadium there, but they also demonstrate how a
mortal hero could attain immortality through courage
and piety towards the gods. The example shown [**B**] has a
youthful Athena receiving the slain Stymphalian birds
from the hero, a muted and relaxed version of a story told
hitherto in terms of violent action. So the artist and his
patrons are using the narrative to communicate different

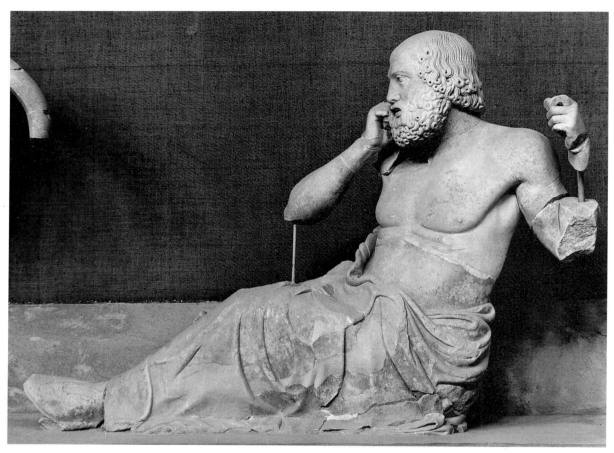

82 C Temple of Zeus at Olympia. Seer from the east pediment (Olympia Museum)

messages, historical, religious, and moral, at different levels, as well as others perhaps that we are unable to catch.

The action figures, the relaxed standing males, the austere women, typify the Early Classical. The figures are lifelike without being totally realistic; indeed, there are several serious errors and incongruities in the compositions of both figures and dress. More importantly, there is a genuine attempt to characterize age (flabby old men, sleek youths and girls) and expression (foreboding for the seer [C], pain in the fighters, tension and weariness in Heracles). The Olympia Master had taken the Greek sculptor's concern for creating ideal, standard figures into realms of expression where few artists were to follow until the fourth century.

83 Zeus carried off the Trojan prince Ganymede to be cupbearer of the gods and his catamite (a word derived, via Etruscan and Latin, from Ganymede's name). The deed was not shameful and this group which shows the rape was displayed in the god's sanctuary at Olympia. The boy is holding a cock—a lover's gift; and Zeus his knobbly walking stick. It is a little earlier than the temple sculpture [82] but made of fired clay, about half life-size. We assume it to

have been a dedication and not part of a structure (where clay sculpture might be admitted), despite the oddly shaped base which gives a sort of lift to the group. A sculptor who had modelled figures at this scale might have cast them in bronze or had them copied in marble. The cheapest option was to fire the group, though this was a process requiring considerable technical skills. There are other, even life-size, clay sculpture groups in Greece of this period but the technique was even more in favour in areas where fine white marble was not available, such as Italy. The style is the finest, Early Classical, but the fact that the colour too was fired on and thereby preserved tells us how a painted marble of this date might have appeared: yellowish bodies, deep red for Zeus' cloak, blue-black and brown for details of hair.

84 The second-century AD author Lucian describes a statue by the sculptor Myron of an athlete 'stooping in the pose of one preparing to throw, turning towards the hand with the discus and gently bending the other knee, as ready to rise and cast'. This enables us to recognize a number of copies of the original bronze (supported in marble by the usual tree trunk), of which this is the most complete.

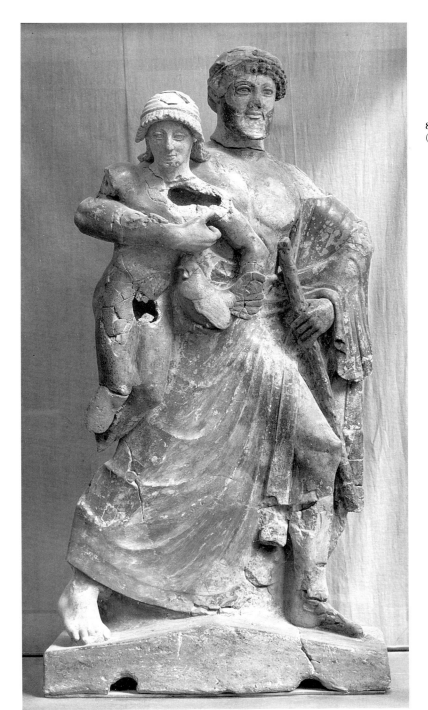

83 Clay group: Zeus and Ganymede (Olympia Museum)

Other authors tell us more about Myron and suggest that he was born in Attica and worked around the mid-fifth century. He had a reputation for extreme realism in animal sculpture—a bronze cow on the Acropolis real enough to be mistaken for flesh and bone—and for figures caught in an instant of action—a runner on tiptoes, and this discus-thrower (Discobolus). In ancient Greece the discus was thrown 'straight', without the pirouetting we see today. The figure recalls some of the more ambitious action figures in pediments [38] and is in fact conceived mainly in one plane, like a relief with no background. The cap-like treatment of the hair is characteristic for such an early bronze and a touch Archaic (compare [85]); notice the knobs in the hair where the copyist's machine fitted. This athlete-in-action inspired dozens of neo-classical versions and has served as a symbol of the Greek athletic ideal. In 1938 Hitler requested the 'gift' of this copy to Germany. It was sent, and displayed in Munich, then returned to Rome after the war.

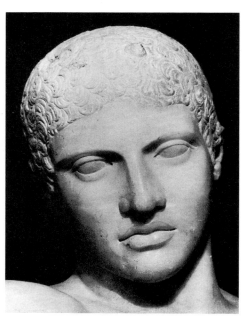

84 Discobolus of Myron, copy (Rome, National Museum)

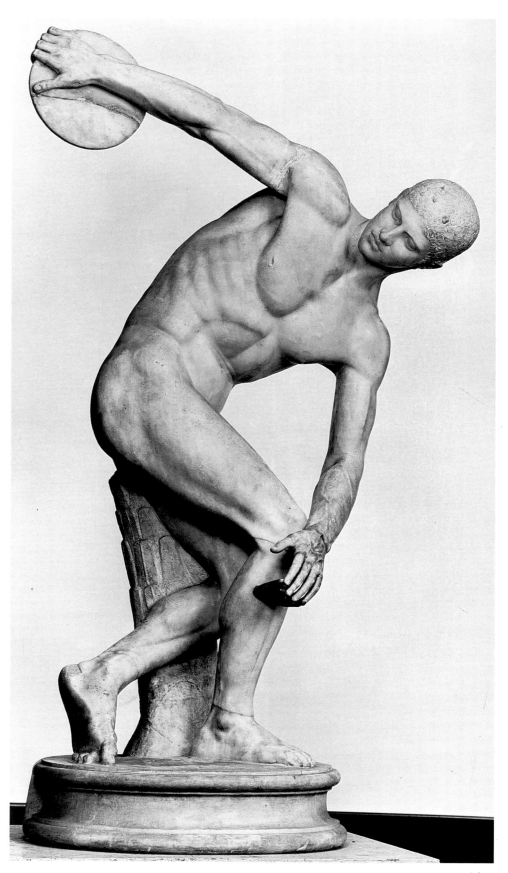

85 The famous bronze charioteer from Delphi well demonstrates the problems of viewing surviving Greek art out of context. The figure stood in the car of a four-horse chariot, with a groom on foot beside it, to celebrate the victory of a Sicilian ruler, Polyzalus, in the Games of 478 or 474 BC. So it was not the most eye-catching figure, and parts that we admire—the feet—were out of view. Its rather austere verticality, in pose and pattern, must have been set off by the rounded forms of the great chariot team, and for us to view it in isolation does little justice to the concept of its nameless sculptor. Charioteers wear long dresses; theirs is a windy profession. And the dress needs strapping down over the shoulders to stop it billowing. His eyes were inlaid with glass and stone, his lips in copper, and his headband picked out in silver. It is not often that major bronzes are found in excavations on land. This owes its survival to an earthquake that dropped it, out of sight and mind, into an ancient drain.

86 The bronze found in the sea off Artemisium (the north cape of the island of Euboea) is rather over life size (2.09 m.), as befits a god: compare the mortal charioteer [85], who stands 1.80 m. It must be from an ancient wreck, more likely *en route* south, even to Italy, than north, and so it should be from a northern Greek sanctuary. It may have been a dedication rather than a cult statue—these are usually static. Its watery source should not predispose us to identify the figure as Poseidon, the sea god, and restoration of a trident to his raised right hand is unhappy. A thunderbolt goes better, giving us Zeus in a characteristic pose, threatening but without an adversary. His hair is tied by a plait, a feature of statues of this date (around 460 BC); the rest is sublime nudity. This total nakedness for the divine or heroic is an extension of the Greeks' acceptance of nudity in life, especially sport, and the artist's exploitation of it. The sculptor suggests rather than portrays with any anatomical accuracy (the arms are too long!) both the athletic balance and divine power.

87 (**Colour Plate IX**) Two bronze statues were found in the sea off Riace (on the 'toe' of Italy) in 1972. We show statue A. They were in like pose, to be restored with shield and spear, and in like style though probably modelled by different artists. The style is of about 450 BC but there has been some scholarly distress over relative date and origin, probably because we are unused to finding work of such quality, and reluctant to credit stylistic differences between figures designed by different artists within a single workshop and for a single group. Each figure demonstrates superbly the new command in portraying a body in repose, but at the same time conveying tension in limbs and expression. They were probably looted from some Greek site for a Roman destination, but we do not know where they stood in Greece and can have no reason to believe that they must be mentioned in some ancient sur-

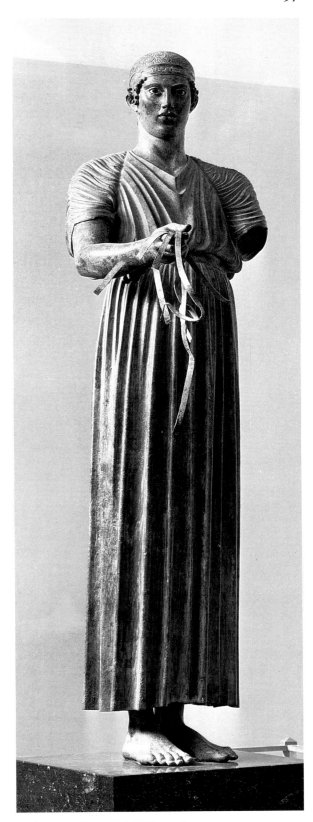

85 Bronze charioteer (Delphi Museum)

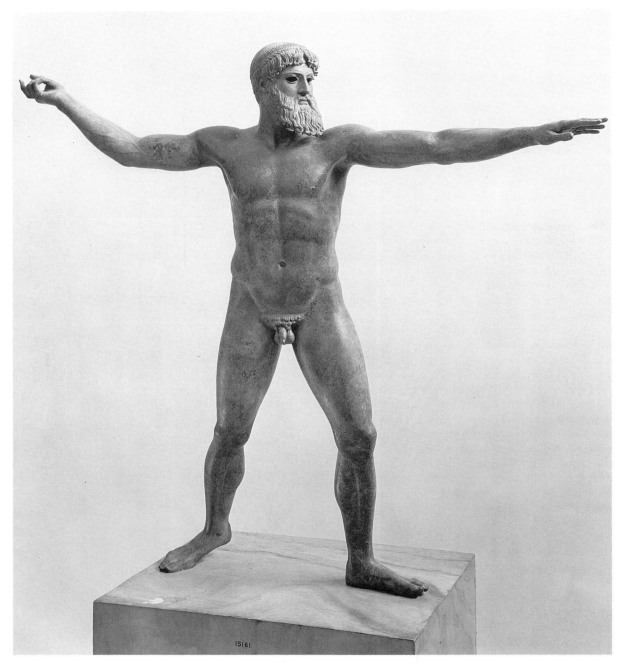

86 Bronze Zeus from Artemisium (Athens, National Museum)

viving source. Nor can we know their artists, although Phidias is often mentioned in connection with them by optimistic scholars. It seems likely that they are from a group, showing heroes or heroized mortals. Candidates include the dedication by Athens of a group of heroes, generals, and gods at Delphi to commemorate the victory at Marathon and made by Phidias.

The modern viewer is struck by their bold, almost sensual, nudity (some women allege the back views to be espe-

cially moving), and, in a museum setting, by the way they seem to dominate the space in which they are displayed. If they are from a group, which seems likely, they would have stood side by side, to quite a different effect. And the addition of the geometric forms of straight spear and large round shield may well have been a most effective foil to the realism of the bodies—another aesthetic factor we miss in their present state.

Statue A had copper lips, silver teeth, and wore a wreath

or helmet. He stands a shade under 2 m. high. Close technical analysis has taught us much about how such statues were made. The artist modelled the figure in clay with most of the surface detail, except for locks of hair, beard, and accessories. Piece-moulds were taken from the model, and these were coated inside with wax before being reassembled (usually in major parts—head, torso, arms) and filled with a new clay core. Compare the Archaic [42]. When the moulds were removed the wax surface could be worked over in detail and solid wax added for locks of hair to complete the figure. Parts that may have been difficult to fit in later were cast and inserted separately (the lips of this statue, for example). Then the major parts of the figure were coated with a clay mantle. The wax was melted out and replaced by molten bronze, the mantle broken off, and the core scooped out. The parts could then be soldered together and the surface patched and polished. The statues were fitted to their stone bases by bronze tenons set in lead, or lead alone (as here). The whole process was one that called for patience as well as technical virtuosity.

88 Original marble statuary of the Classical period, other than architectural sculpture, is almost as rare as major bronzes. This life-size marble was found in the Phoenician island-city of Motya, at the western end of Sicily. It is of imported marble, as is all the statuary marble of the area in this period. Is the figure itself an import from the Greek homeland? Probably not, though the artist may have travelled from the east. The working of marble requires somewhat different skills from that for limestone. All the Archaic and Classical marble sculptures from Italy and Sicily have to be judged either imported, or made from imported marble, which was then used sparingly for flesh parts of figures in other material (see [125]). But major works may have been completed in the west by sculptors who travelled to execute special commissions.

The young man's head looks 'Severe', Early Classical (compare [84]); his body, strong and sinuous with its clinging dress, looks somewhat later, yet in the view of many not unthinkable by the mid-century. And if this is a prime and original work by a major artist a degree of non-conformity with our expectations (which are of no more than the highest common factor of what we have, copies and all) should be admissible. The long dress and odd chest-band suggest a charioteer, yet he seems a free-standing figure of individual importance. The odd dress has also been thought appropriate for a Phoenician priest, and it is from a Phoenician city. It might, of course, have been looted from a Greek city in Sicily, and so require no Phoenician explanation or patronage. We are unused to original works of such high quality, and when they appear (as with the Riace bronzes [87]) they invariably present problems that challenge received ideas.

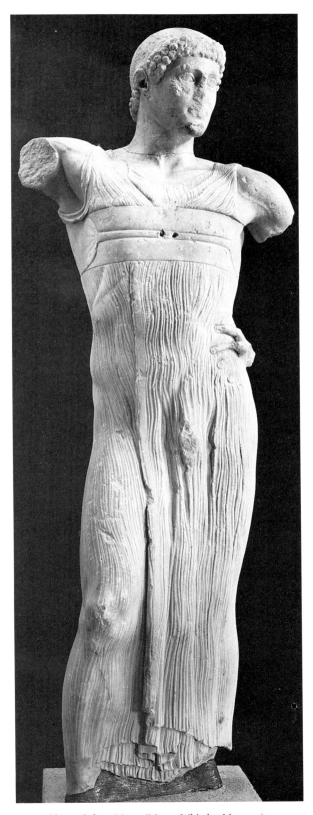

88 Marble youth from Motya (Motya, Whitaker Museum)

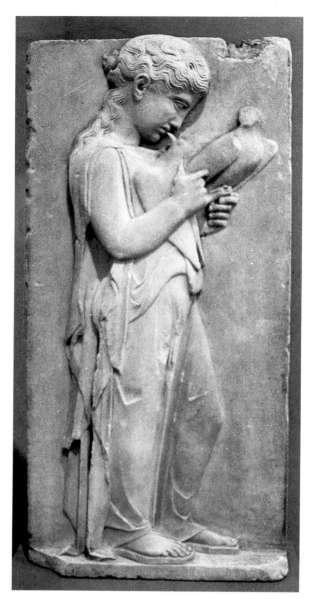

89 Gravestone (New York, Metropolitan Museum)

89 The relief of a girl with her pet doves decorated a gravestone set up in one of the Greek islands, perhaps Paros, about 450 BC. The gap in production of relief gravestones in Athens from early in the century to about 430 BC is made good by examples from other parts of Greece, where we find similar tall slabs for single figures as well as broader ones for seated figures or groups, and a greater range of subjects than there had been in the sixth century. The simple, ungirt dress and 'Severe' head seem to our eyes appropriate to the subject, but notice the new freedom with the hair, and the way the relaxed pose of the figure conceived in the round is successfully conveyed and executed in very shallow relief.

90 Realistic portraiture emerged more slowly than realistic anatomy in Greek sculpture, probably because interest in the ideal militated against concentration on the particular. Early 'portraits' too are generally of the long or recently dead and must usually be characterizations rather than likenesses. We know them mainly from later copies of the heads alone, set on 'herms'. These are square pillars which derive from early cult images of a head or mask of Hermes, set on a pillar decorated with an erect phallus, a common roadside monument in Classical Greece. The late herms with portrait heads often carry the name of the 'sitter', but not always the right name! Greek portraits were usually of whole figures—nude warrior generals, dressed poets and philosophers. We shall see more lifelike portraits later [195–8, 213–17].

[A] Themistocles, Athenian commander at the battle of Salamis, ended his days (462 BC) as governor of a Persian province in Asia Minor. This bust, inscribed as of Themistocles, was found at Ostia, the port of Rome. It seems in a style appropriate to his last years and is not without what appear to be individual traits. The east Greek world seems to have led Greece in realistic and individual renderings of human subjects, and this may derive from a portrait said to have been set up at Magnesia, where Themistocles died.

[B] Anacreon was an Ionian poet and bon viveur who spent many years in Athens at the turn of the sixth–fifth centuries BC. There was a statue of him on the Athenian Acropolis, described in antiquity as 'of a man singing when he is drunk'. This must be a copy of that statue, made about 440 BC, long after his death. We can recognize him also from his head on a labelled herm. He is shown as a naked party-goer, playing a lyre (missing), the features appropriate to his reputation rather than realistic.

[C] The sculptor Cresilas made a portrait of the Athenian leader Pericles, of which this is most probably a copy. The original must have been made after the stateman's death in 429 BC, but it presents an ideal head without individuality, and identification must have depended on an inscription. The original was probably a naked warrior figure, life size. Pericles had an unusually high crown to his head, but the way the helmet is worn here is the usual 'at ease' position pushed to the back of his head exposing the face—how else create a warrior portrait, realistic or not?

91 Roman loot from Greece included not only freestanding statues from Greek sanctuaries and cities but whole pedimental groups which were installed on Roman temples. This marble group [A], showing Heracles' and Theseus' fight against the Amazons, supervised by a central Athena, was set on the temple of Apollo Sosianus in the Roman forum. Some of the figures were reworked, and the Theseus [B] was given new bronze locks (not shown here). The style is of about 450–440 BC but its original home is

90 A Portrait of Themistocles, copy (Ostia, Archaeological Museum)

90 B Portrait of Anacreon, copy (Copenhagen, Ny Carlsberg Glyptotek)

90 C Portrait of Pericles, copy (London, British Museum)

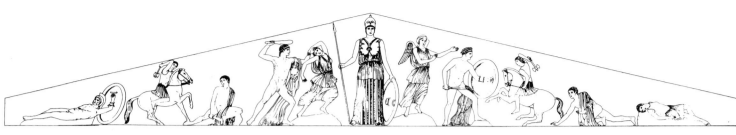

91 A Amazonomachy pediment (Rome, Conservatori Museum)

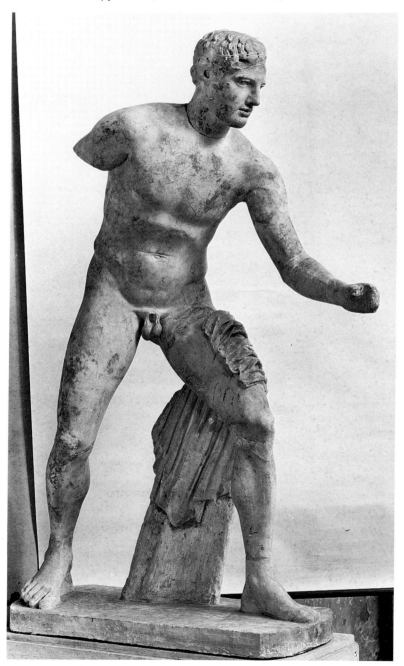

91 B Theseus from Amazonomachy pediment (Rome, Conservatori Museum)

not known. Eretria has been suggested, since the size is right and a figure from the Archaic pediment on its temple of Apollo was certainly taken to Rome in antiquity. It represents the best style in pedimental sculpture intermediate between Olympia [82] and the Parthenon [103–5].

92 The bare-headed Athena contemplating her helmet is a copy of a mid-fifth-century Greek original. The dress is still 'Severe', with the heavy, straight-falling peplos robe, while the style of the head verges on the Classical of the Parthenon period. The stance is in contrast with the almost casual gesture and the aegis slung across her body. (The aegis is a divine protective goat-skin worn by the goddess, blazoned with a Gorgon head.) Many have thought this a copy of a bronze made by Phidias for the colonists of Lemnos (who left Athens about 450 BC), a statue whose beauty was remarked by ancient viewers, while another scholar has associated it with the Riace bronzes [87] and the Phidian group for Delphi. The eagerness to detect, even in copy, early work of Phidias, the master of the Parthenon, may not be entirely misplaced.

93 Polyclitus worked mainly in the third quarter of the fifth century, while the Parthenon was being built, but he was no Athenian and represents the rather different sculptural tradition of southern Greece; he was born in Argos. There has been call already to remark the fifth-century Greek sculptor's interest in proportion as well as in anatomical accuracy. Polyclitus carried this to the point of writing about the principles of his work, his *Kanon*; this work has not survived but we know it was concerned not with pure anatomy but with *symmetria*, the commensurability of parts of the human body—its ideal proportions. He embodied these principles in a statue of a spear-bearer, the Doryphorus, which we recognize in many copies. One of the most complete is shown here [A], alongside a fragmentary copy in basalt [B] which catches something of the surface appearance of the original bronze. We see a somewhat stockier figure than those of the Parthenon, relatively larger-headed, and from these features we might be able to begin to deduce something about what the Polyclitan principles of proportion were. However, the finer points of mensuration have probably been lost through copying and we are left with this distinctive but generalized impression only. The relaxed stance has moved on a stage from the Riace bronzes [87]. The slack leg, withdrawn,

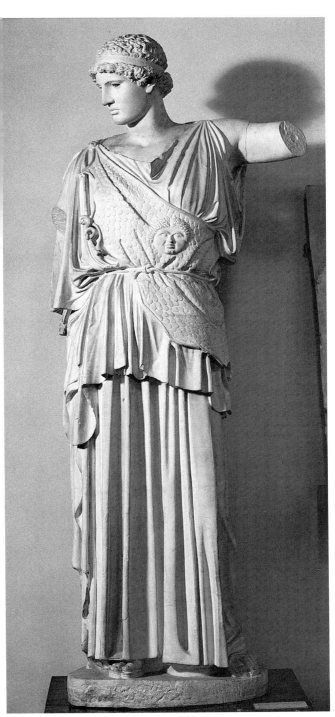

94 Pliny tells a story about a competition at Ephesus between the most famous sculptors of the high Classical period, to create a statue of an Amazon, the winner to be judged by the artists themselves. They each put themselves first, Polyclitus second; the latter was thus judged winner. This sounds like a good guidebook tale and need have no truth in it at all, but there are three major wounded Amazon types [A] that are of the right period and can be associated with Ephesus, and it does seem that a major group of these figures was set up there in about the 430s BC. The types are known only from copies (and had been cast for the Baiae copyist's studio; see on [81 B]) and could well be from different hands but one studio. The differences are slighter than those between the two Riace bronzes. The poses are broadly Polyclitan and the physiques rather masculine, which is partly because of their subject—warrior women—partly an indication that the Greek sculptor had not yet found call to assert femininity in studies of the female nude. The example shown [B] is a copy of one of the better-known types (the 'Lansdowne'). She was wounded below the left breast and wears a broken rein as her belt. The way her balance is shifted partly on to a pillar support looks forward to new problems and solutions for standing figures in Greek sculpture.

THE NEW PAINTING I

95 The second quarter of the fifth century saw a revolution in major painting, yet the closest we can get to it is through vase-painting and descriptions in later authors, leading to such uninspiring reconstructions as this (which is better than most, by no means up-to-date, but possibly giving a better general impression of the original composition). Earlier painting on wooden panels involved fairly simple, unified scenes, so far as we can judge. They served as architectural decoration or independent votives and it is hard to say how common they may have been (see [64, 372]). Now there are major friezes, probably on wooden panels, which were used as major decoration for the interior walls of public buildings. The figures on them were at least half life size, and were set up and down the field, not on a single ground line. This was not to give any impression of perspective, nor to relegate less important figures to the distance of the top register (indeed, this was often reserved for the gods). It did, however, open up the possibilities of expressing the space in which the figures acted, and interrelationships which could go far beyond the restrictions of the frieze on a single ground line, with, at best, overlapping figures to suggest depth. It was probably most effective in battle scenes, to judge from the way the device was later used by vase-painters, but the earlier paintings, as described to us, seem to have been fairly static. The prime artist was Polygnotus of Thasos, who

92 Athena Lemnia of Phidias, copy (Dresden Albertinum and Bologna, Civic Museum)

rests on the toes alone, and the whole body is composed in a balance of straight and bent, relaxed and tense limbs, with the contrasted movement of head and body—the *contrapposto* so admired in Classical art by Renaissance artists.

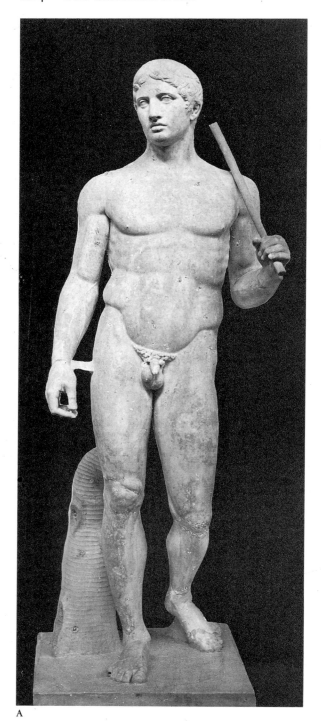

A

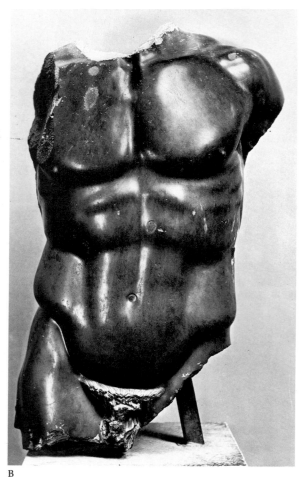

B

93 Doryphorus of Polyclitus, copies (A Naples, National Museum; B Florence, Uffizi Gallery)

very much dependent on the hope that Pausanias (or his source) left nothing out. In Athens Polygnotus, or his companion Micon, painted a *Battle of Marathon* for the Painted Stoa in the Agora. The style, so far as we can judge it, was roughly like that of the larger contemporary vases [96, 97], on a pale ground and coloured, with some novelty of pose but no shading or rotundity of figure and with minimal interest in landscape detail.

These big paintings answered the demand for major, programmatic themes of a different character from those chosen for the sculptural decoration of temples: myth-historical events which carried contemporary messages of success (defeats of the Persian-like Amazons, gods killing giants) and even near-contemporary mortal battles, such as Marathon, which had already taken on a heroic flavour for the Athenians. The genre lasted for a generation only, and although it was much written about in later centuries, it never attracted the attention of copyists as did its successors of the late fifth century on, to which we shall return.

96 This shows the reverse of the name vase of the Niobid Painter. It is Athenian work of about 460 BC, contempor-

worked in Delphi, Athens, and elsewhere. His work at Delphi, for the Cnidian clubhouse, is described, figure by figure, by the second-century AD writer Pausanias, and the reconstruction of Polygnotus' *Sack of Troy* is based on this,

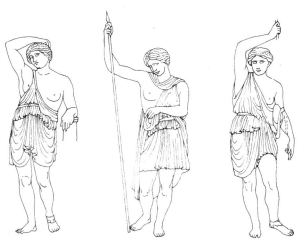

94 A Amazon statues at Ephesus

ary with the wall-paintings of Polygnotus and obviously
inspired by the new compositions which have just been
described. The figures are set up and down the field, which
is roughly 1½ figures high (probably the proportions of
the panel paintings), and not even in level registers but on
varying and irregular ground-lines; which is why the scene
is shown here in a drawing, because the white of the lines is
invisible in photographs, and we need to see all the figures.
This is an unusually early version of the new composition
on vases and possibly closer to the appearance of the wall-
paintings, but for the black ground, than most later vase
scenes in which the painters adjusted the composition to
the medium, with more rigid registers. The figures are
motionless, interrelated by glance and pose; notice the way
one is cut off by the ground-line, top left, as though emerg-
ing or arriving on the scene—this is one of the novelties of
the wall-paintings, to judge from descriptions of them.
The subject, as so often with masterpieces, is obscure. Her-
acles is the central figure, watched by his patroness Athena.
The two below him are likely to be Theseus and his com-
panion Pirithous, caught in the Underworld, from which
Heracles will release one (compare [58 D]). But the rest are
hardly Underworld figures—more probably heroes—and
it might be that this is an assembly of gods and heroes
before Marathon, where gods and heroes fought beside the
mortal Athenians, including both Heracles and Theseus,
summoned up for the occasion. The round-hatted figures
in the wings might then be the Dioscuri, who are usually
associated with Sparta; and the Spartans arrived too late to
fight at Marathon. But other explanations are regularly on
offer. For the drawing, observe the relaxed pose of the
seated figures, the faces drawn in three-quarter view, the
foreshortened shield: all notable advances in draughts-
manship since the Archaic period.

We call the artist of the vase the Niobid Painter. Readers
will have noticed in this and the preceding chapter similar
sobriquets for artists whose real names are unknown. A
small minority of vase-painters signed their work, neither
always the best painters nor the best works. Close stylistic

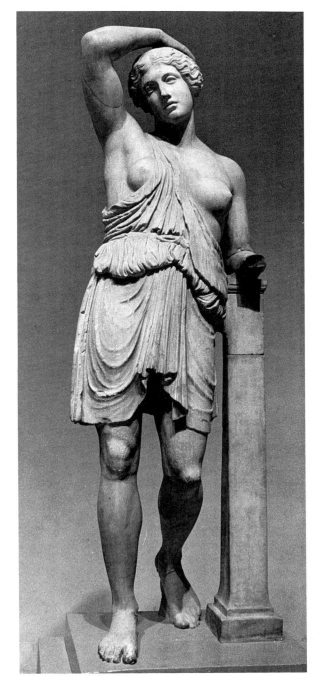

94 B Wounded Amazon, copy (New York, Metropolitan Museum)

analysis, dwelling on the details of draughtsmanship that
are more automatic or unconscious than deliberate (like
handwriting), has enabled scholars to assemble works by
single hands, and then invent names for them, prompted
by the subject of one of their vases (as here), or a potter for
whom they worked and whose name is known, or the loca-
tion of a masterpiece, or an owner, or an oddity of style.
The attributions are reinforced by consideration of orna-
ment, shape, and subject. One scholar, Sir John Beazley,

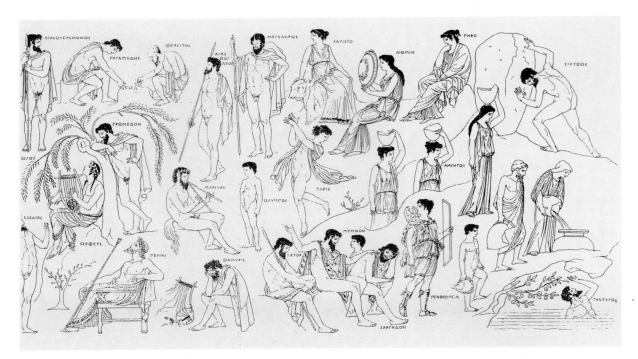

95 Reconstruction of a painting by Polygnotus

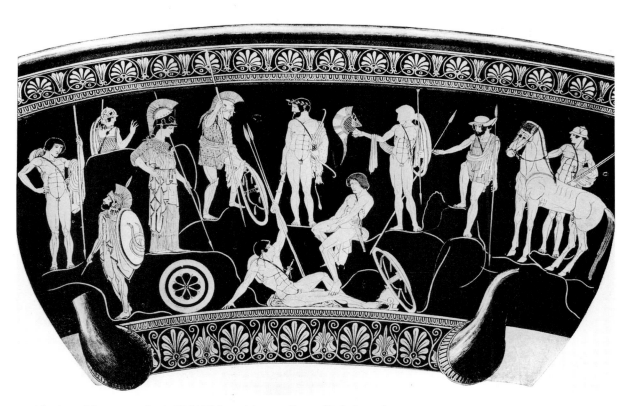

96 Athenian red-figure crater, by the Niobid Painter: Athena and heroes (Paris, Louvre)

who died in 1970, discerned and named almost all the painters now acknowledged by modern scholarship in this area: an almost superhuman task which required the application of a single mind with phenomenal visual memory and acute perception of style and detail.

97 The big Amazonomachy on this Athenian red-figure vase (a volute-crater) has its figures disposed up and down the field in the manner of the wall-paintings of the day, and the subject was one which we know the muralists also executed. So this may give us an idea of the appearance of the

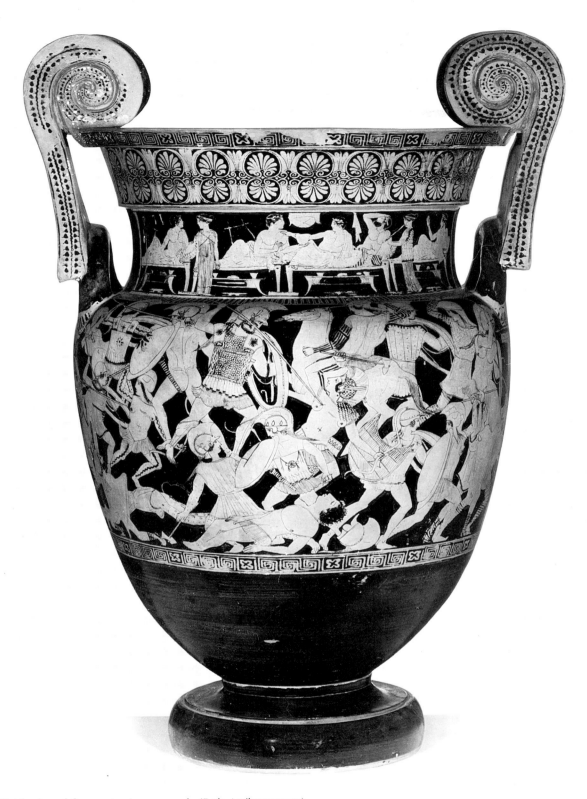

97 Athenian red-figure crater: Amazonomachy (Basle, Antikenmuseum)

action scenes on walls, but it is unlikely that it even roughly copies any particular monumental painting, rather than disposes stock groups of combatants in the new fashion. Although vase-painters must have been well aware of the developments in the monumental arts there are virtually no examples of direct copying. If there had been we would expect replicas of whole scenes on the vases, and all we have is repetition of standard groups in different combina-

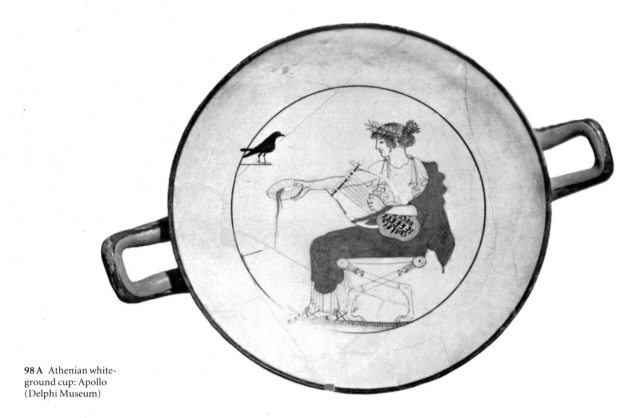

98 A Athenian white-ground cup: Apollo (Delphi Museum)

tions. This can also be judged well enough from the many surviving major works of sculpture which find no close echo on any of the thousands of surviving vases, although here and there we can see that a sculptural composition has given a hint of how a particular episode might be depicted. On this vase, a tall one, 73 cm. high, we see already a tendency to range the figures in two registers, and lesser painters find this an easy way to admit the larger cast of actors. But this manner remains exceptional and not even always the choice of the better artists.

The story of the Athenian repulse of the Amazons from their city was being used as a parable for the Athenian defence against the Persians earlier in the century. Soon the Amazons will be shown in Persian dress, though here they are still equipped like Greek warriors, except for the patterned sleeves and trousers of the archer Amazon at the left. Hers is a dress earlier adopted for heroic archers from other orientals—Scythians. The subsidiary scene on the neck shows a mortal drinking-party, more closely related to the use of the vase (for mixing wine and water) than is the heroic composition on the body.

98 The red-figure technique on vases presents the figures reserved in a rather austere black background. A white ground for painting had been used even for some black-figure, and in the fifth century it appears in Athens for some special classes of vase, or in special positions. The finest examples are in large cup interiors and for some tall cylindrical oil-vases (*lekythoi*) which commonly served the cult of the dead. The white ground and the amount of added colour permitted on these vases (where the red-figure vases are basically bichrome red and black) must be affected by the appearance of painted wall panels, and we can fairly look to the vases for an idea of the muralist's art.

[A] White-ground cup interiors often show single deities and were probably made specially for dedication. This one showing Apollo, of about 480 BC, was found at Apollo's sanctuary at Delphi. The god holds his lyre and pours a libation from a *phiale* cup, attended by his raven. He wears a red cloak and details of his lyre are picked out in low relief, probably once gilt.

[B] (**Colour Plate X**) A more elaborate cup interior, some twenty years later than [A], has a satyr attacking a maenad—an ecstatic follower of Dionysus, often subjected in art to such assaults. This too has gilt relief details for beads and bracelets, but the colour is more varied on the red dress and spotted animal skin. We are also better able to appreciate the effect of using a thinned mix of the ordinary 'glaze' paint, to produce after firing a paler, honey colour for the hair mass and minor anatomical detail. Although the main effect is still of line and silhouette, these details add a painterly touch which is not altogether natural to the medium but highly effective as a complement to the fine linear detail.

have carried much more detail. The larger *lekythoi* regularly have false interiors, making them elaborate packaging for comparatively small quantities of precious perfumed oil; not an unfamiliar phenomenon today.

99 When Heracles visited the Ethiopian King Busiris, who intended to sacrifice him, the Greek hero turned the tables on his host, attacking him and his African followers. On this vase by the Pan Painter, of about 450 BC, a fine pyramidal composition matches the bellying shape of the pot (a *pelike*), which itself reflects its intended contents—perfumed oil. The artist conveys more than the mere vigour of the encounter beside the altar where the hero was to be slaughtered. The neat coiffure and taut strength of the Greek is deliberately contrasted with the flabby physique of his opponents, their (to Greek eyes) ugly circumcision and ungainly poses, though one at least is fighting back with a mallet. Greek artists were quite familiar with African and negroid features but dark skins are rather a challenge to the red-figure technique and the painter has settled for showing them with snub noses and shaved heads. Greeks and Greek artists were not always so dismissive of the behaviour of foreigners, but this is a special and heroic situation, and by this time their views of the un-Greek, the barbarian, whose forces they had repelled and defeated, might have encouraged this approach.

100 Most Greek drinking-cups, the shallow *kylikes*, are up to about one foot across, but there are occasional larger, less practical examples which we may suspect of being show-pieces of drawing rather than vessels for use. The one shown here is 43 cm. across and its interior is filled with a big-figure scene of a Greek killing an Amazon, generally identified as Achilles and Penthesilea at Troy, with another live Greek and a dead Amazon. In the story Achilles falls in love with the Amazon queen as he kills her, but here Achilles is impassive although Penthesilea supplicates, helplessly and hopelessly. The identification has given the painter a name—the Penthesilea Painter. The group looks as though it has been borrowed from a panel and crammed into a circle. Better to look at the individual figures and observe the finesse of draughtsmanship and many of the details of gilt relief and colour masses (the Greek's cloak) that are commoner on the white-ground vases. This perhaps means that the group owes rather more to major painting in detail than most presented in the red-figure technique.

The exterior (not shown) is quite simply painted with youths and horses, though by the same man, who had both a grand and a pedestrian style. It seems that he belonged to a group of painters who shared the work on a big series of fairly simple cups, some doing the inside, some the outside, rather like a production line, reflecting in an interesting way on the staffing and procedures of a large potter's studio in mid-fifth-century Athens.

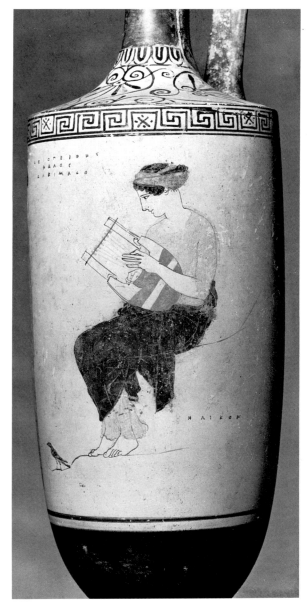

98 C Athenian white-ground *lekythos*: Muse (Munich, Antikensammlungen)

[C] Many of the best of the white-ground *lekythoi* are the earliest, and though destined for the tomb, do not carry explicit funerary scenes. This one, by a master of the genre (the Achilles Painter), is of about 440 BC and shows Muses on Mount Helicon (the rock is labelled with the name). There is a greater range of colour here, some thinned to give a transparent effect, some overlaid with dress lines. The neat inscription praises a handsome youth—'Deiopeithes, son of Alkimachos, is beautiful'—written in neatly ranged letters like those on stone inscriptions. The figure is about 15 cm. high, much smaller than those on murals, but it is doubtful whether the latter need

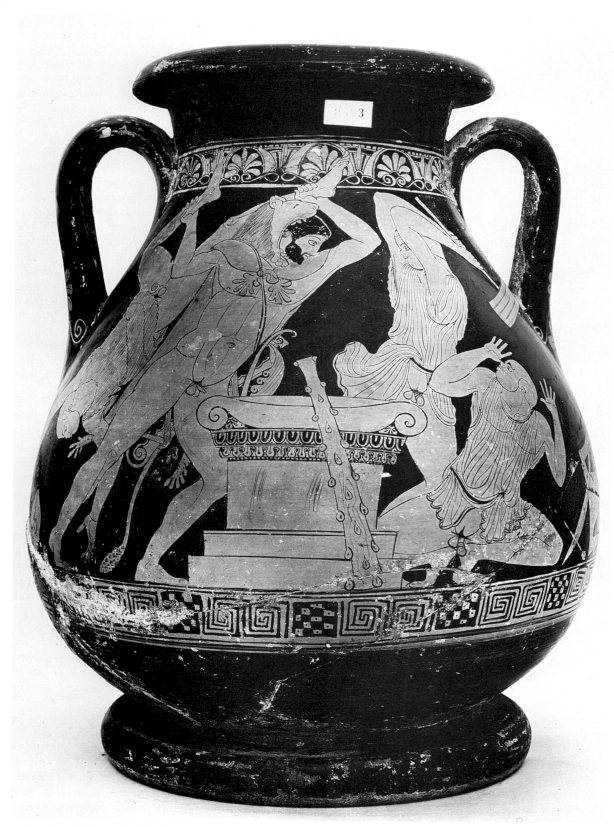

99 Athenian red-figure *pelike*: Heracles and Busiris (Athens, National Museum)

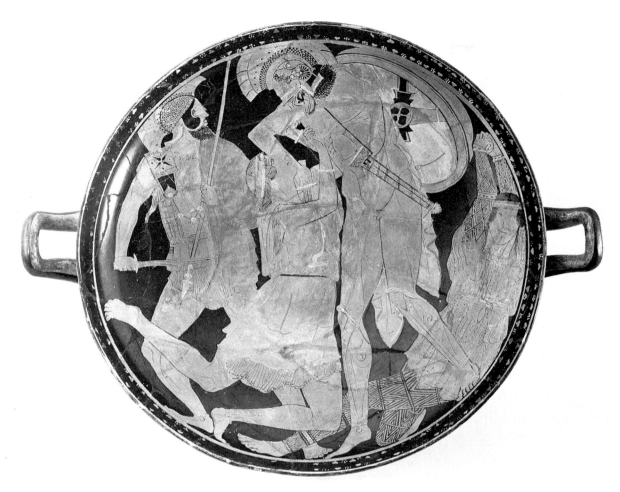

100 Athenian red-figure cup: Achilles and Penthesilea (Munich, Antikensammlungen)

IMPERIAL ATHENS

After the final defeat of the Persians in the Greek home-land, at Plataea in 479 BC, the Greek states agreed (perhaps formally in the so-called Oath of Plataea) not to rebuild the temples destroyed by the Persians but to leave them as a memorial to the barbarian invasion. Athens and Attica had suffered most. Athens went on to lead a League of Greek states against the Persians. By the mid-century this had become more like an empire, with the 'contributions' amounting to tribute, and its treasury moved from neutral Delos to Athens itself. The Persian problem and threat had been solved and the Athenian statesman Pericles thought it fitting that the temples should be rebuilt and League funds used for the purpose. The justice of the decision was questioned but it brought work to Athenians and answered the citizens' new self-confidence. There was an influx to Athens of artists and masons. On the Acropolis,

in the city, and in the countryside there arose new marble temples, lavishly decorated with architectural sculpture devoted to subjects which seem to reflect on the city's new dignity and her claim to be the leader and school of Greece. Though a democracy, Athens displayed all the arrogance of an imperial power, even in the comparatively tiny cock-pit of Greece, and the mood is well displayed in the art and architecture with which she adorned herself—'like a wan-ton woman', as some contemporaries are said to have complained.

101 The Athenian Acropolis had been devoted to the service of the gods, especially the city goddess Athena, since before the mid-sixth century, although the tyrant family may have found a haven there for a while. It carried a fine temple of Athena, a gateway, and little else monu-mental that we can distinguish; the walls were still those built in the Late Bronze Age. After the battle of Marathon, in 490 BC, there seems to have been a plan to build another

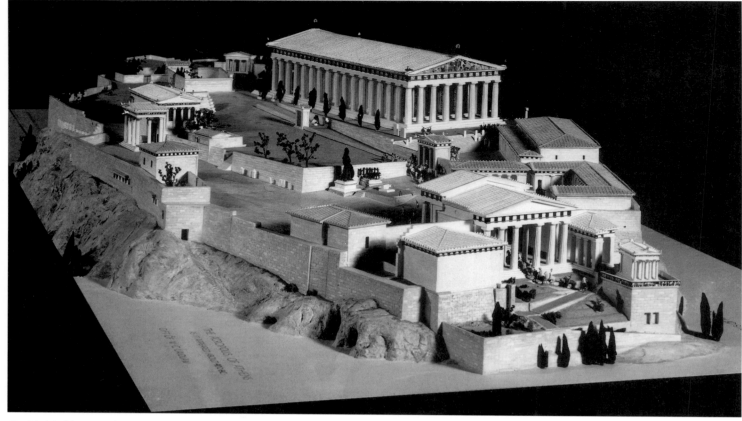

101 Model of the Acropolis, Athens (Toronto, Royal Ontario Museum)

Athena temple, aborted by the Persian sacks of 480–479. This building's foundations, adjusted, were used by Pericles' architects for the definitive temple of Athena, the Parthenon. It was dedicated in 438 BC, with its cult statue, and properly completed with its sculptured pediments in place six years later. It was followed by the building of the monumental entrance to the Acropolis, the Propylaea, which had no sculpture but housed a picture gallery; the Erechtheum north of the Parthenon; and the temple of Athena Nike (Victory) on the bastion south of the entrance. Other new buildings had less monumental pretensions but the appearance of the citadel was transformed into an architectural show-piece unparalleled in Greece outside the sanctuaries of Delphi or Olympia. Planning was partly determined by the ground and by structures being replaced, but there was a near-theatrical progress created for visitors through the Propylaea, past the 40-foot bronze Athena which celebrated Marathon, before the west façade of the Parthenon could be admired (it was not clear to the view as it is today). And this great Doric structure, traditional in its plan and decoration, was set off by the irregular, innovative, and decorative Erechtheum in the more feminine (as antiquity came to regard it) Ionic order.

102 It is incredible that so much of the Parthenon and its decoration have survived: various mishaps and plunderings in antiquity, conversion to a Christian church, then to a mosque, a shattering explosion in 1687, incorporation in a Turkish village with depredation by foreigners, notably Lord Elgin—which of all the disasters was the only salutary one since it has preserved what, as we can see, would otherwise have been eroded by industrial atmosphere, general neglect, and some unhappy restoration. At the eleventh hour a programme of conservation and restoration on the building by skilled Greek scholars may secure the architecture for our enjoyment and appraisal as successfully as much of the sculpture has been. It was not quite a typical Classical Doric temple. The plan shows the main hall (cella) which housed the cult statue [106] but also an unconventional square room behind instead of simply a false porch. The room was a treasury, which rather reflects on the building's history and status. The façades are wider than usual—eight columns, not six—lending a reassuring breadth which is enhanced by the way its proportions then seem to match those of the broad citadel on which it stands. The Doric detail is conventional enough, picked out in colour. This is totally contrary to most people's expectations of a 'Classical building'. There is extreme subtlety too in the barely perceptible curves of the floor, the column profiles, the way they lean slightly in, while the upperworks lean slightly out. All this conduces to a lightening of what might otherwise appear a very four-square, earthbound structure. To say that it seems to soar is extravagant, but it could so easily have seemed to squat.

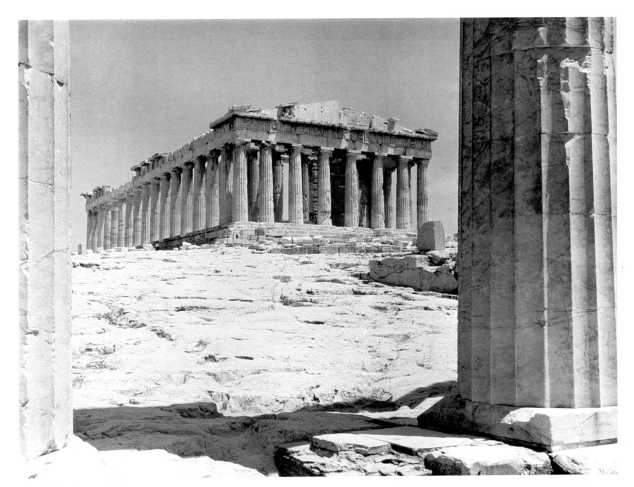

102 The Parthenon, Athens

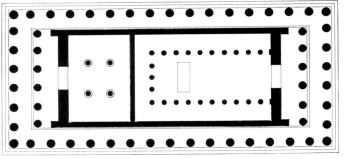

N

103 The metope panels on the upperworks of the Parthenon are carved in high relief, the figures virtually in the round, some of them almost leaping from the background of the slabs and defying the restrictive frame. Add colour to the dress and admire how the naked body of the youth on [A] must have been displayed. He is fighting a centaur, which is the subject of most of the metopes along the south side of the building. On other sides the gods fight giants, Athenian heroes fight Amazons (for the message of which see on [97]), and Troy is sacked. All but the south metopes were badly defaced by Christians, but at the north-west corner, beside the Trojan scenes, there is one well-preserved slab with two goddesses [B], probably Athena and Hera. It has been thought that this was spared because it might be construed as an Annunciation.

104 A novelty of the Parthenon was the 160-m.-long frieze that ran around the outside of the central block, at the wall top just inside the outer colonnade. It showed a version of the procession to Athena, with horsemen [A] and chariots for the main part, led by ministrants of the intended sacrifices, into the presence at the front of the temple of the heroes of the Athenian tribes [B] and the Olympian gods themselves [C]. [B] shows some of the heroes and two marshals of the procession, in an old cast of the relief which has since been largely destroyed; [C] shows Poseidon, Apollo, Artemis, Aphrodite, and Eros, leaning on his mother's knee, holding a parasol. Eros and much of his mother are painted in here because the original figures are known only from an old cast, and have since been destroyed.

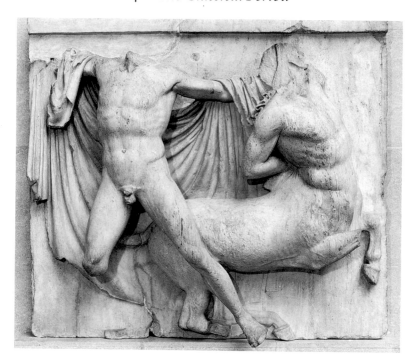

103 A Metope from the Parthenon, south: Greek and centaur (London, British Museum)

103 B Metope on the Parthenon, north

This unique decoration for a temple seems to carry in it hints of heroization for the Athenian cavaliers, parading for the gods, and probably alluding to successes by Athenians against Persians earlier in the century. The dead at Marathon were already worshipped as heroes and this could be the message of the frieze. The Classical Athenian in the procession, passing the building and looking up at the frieze, would have identified it as an Athenian occasion, but heroic, with chariots and horses that were no part of the procession once it had reached the Acropolis rock, and in the presence of gods and heroes. The proud identification was with the immediate past, glorious and heroic, not the present.

The whole figures give a clear impression of the 'Parthenon style', commonly and probably rightly associated with the name of the sculptor Phidias, who seems to have been designer and artistic adviser to Pericles for the project. The figures are slighter than the Polyclitan [93], less expressive and emotional than those at Olympia a generation earlier [82], but more deliberately seeking to express an ideal and generalized view of the human subject. The frieze, perhaps the best-known work of Classical sculpture today, was never mentioned in antiquity, even in Pausanias' guidebook of the second century AD, which does mention the pediments. It was, of course, relatively inconspicuous and to be glimpsed only between the outer columns of the temple and intermittently, from a very steep angle of view. Its original meaning may well have been lost in a period which was well used to sacred buildings being decorated with processional and sacrificial scenes, but this was not the case in the fifth century BC.

105 The west pediment of the Parthenon [A, B] showed the struggle between Athena and Poseidon for the land of Athens. Most of the figures are missing but they had been drawn in the seventeenth century and with the help of surviving fragments the reconstruction is made possible. It is shown here both on the model of the temple and in the reconstruction that has been made in the Cast Gallery at Basle, using casts of the original pieces, made up with carved plastic so that problems of attribution of fragments (still vexed), pose, and composition could be explored at full size. This gives a good idea of the new, more crowded compositions admitted to pediments in the Classical period. The central pair of struggling gods are flanked by watching heroes and kings of Attica with their families. The east pediment depicted the birth of the goddess from the head of her father Zeus (but she was shown postnatally standing before him) attended by the Olympian gods. The centre of the pediment was wrecked by making the apse for a Christian church, and we are not even sure whether the central Zeus was seated or standing. But seven other figures are preserved near-complete (though with only one head) and several fragments. The massive statues are the best examples we have of original Classical marbles,

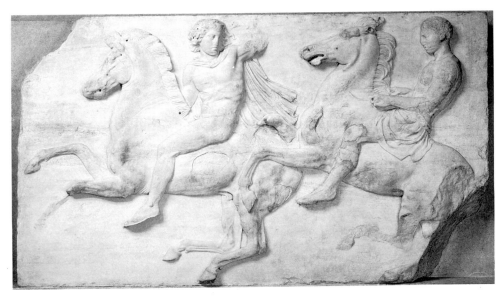

104 A Parthenon west frieze (London, British Museum)

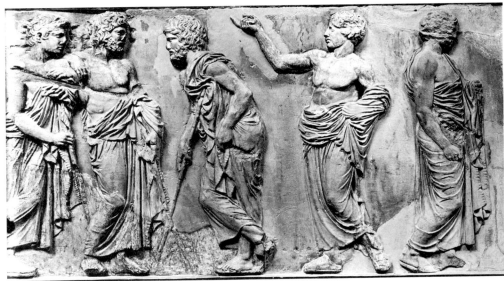

104 B Parthenon east frieze: heroes (cast in London, British Museum)

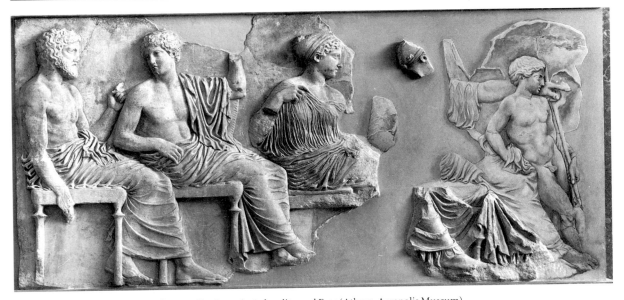

104 C Parthenon east frieze: Poseidon, Apollo, Artemis, Aphrodite, and Eros (Athens, Acropolis Museum)

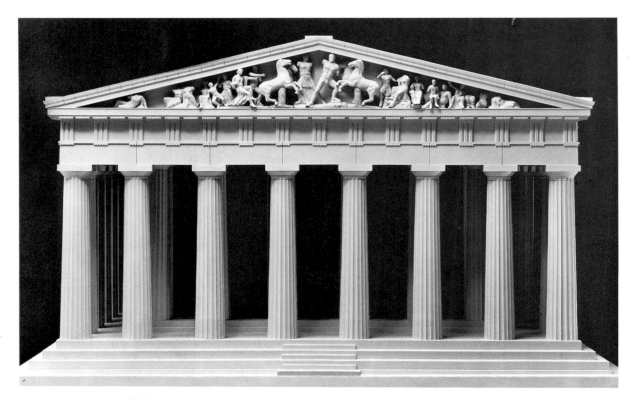

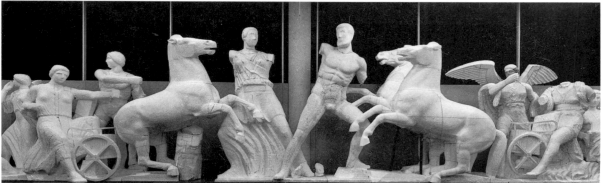

105 A, B Parthenon west pediment (Basle, Cast Gallery)

but they were the latest to be placed on the building, and therefore show an advanced stage of the Parthenon style. We show the reclining nude Dionysus [C], a masterly study in realistic relaxation. The other figure [D], yet more relaxed and in a way even nakeder, is Aphrodite. Her dress clings to her body revealing more than it conceals. Both figures announce new attitudes in sculpture, away from the greater formality and idealizing of the metopes and frieze, and closer to the power and sensuality conveyed by later Classical works. It is difficult to see how they could have been made except from life-size clay models, worked by the master sculptor, and then copied in marble by masons and apprentices, probably with a finishing touch from the master, and finally painting.

The Aphrodite is shown in a photograph of a cast, not of the original, and from an angle at which she was never viewed in antiquity. The study of sculpture through plas-ter casts, which eliminate the stains of time and can be manipulated more readily for photography and compara-tive study, if necessary with works whose originals are far distant, has always been valued by scholars and artists. From the seventeenth century on they were the normal furniture of artists' studios, while in some museums they were regarded as even more valuable for display than ori-ginal works, since the choice of subject was broader and their whiteness was thought to lend them a positive advan-tage. This was before it was realized that the originals were commonly painted; but casts too can be restored with painting; and the study of modelling and form is generally managed better without such distraction. A cast gallery is still the best place for a full comparative study of classical sculpture. There are rich and accessible galleries in Oxford and Cambridge, in Britain; and yet richer ones in other European cities (notably, Paris, Bonn, Munich).

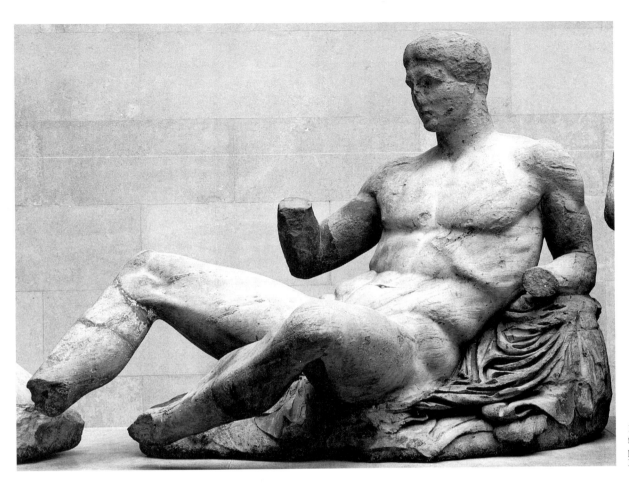

105 C Dionysus from Parthenon east pediment (London, British Museum)

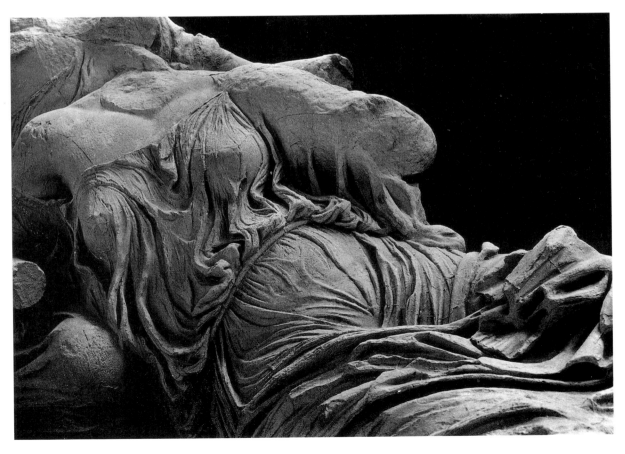

105 D Aphrodite from Parthenon east pediment (Oxford, Cast Gallery)

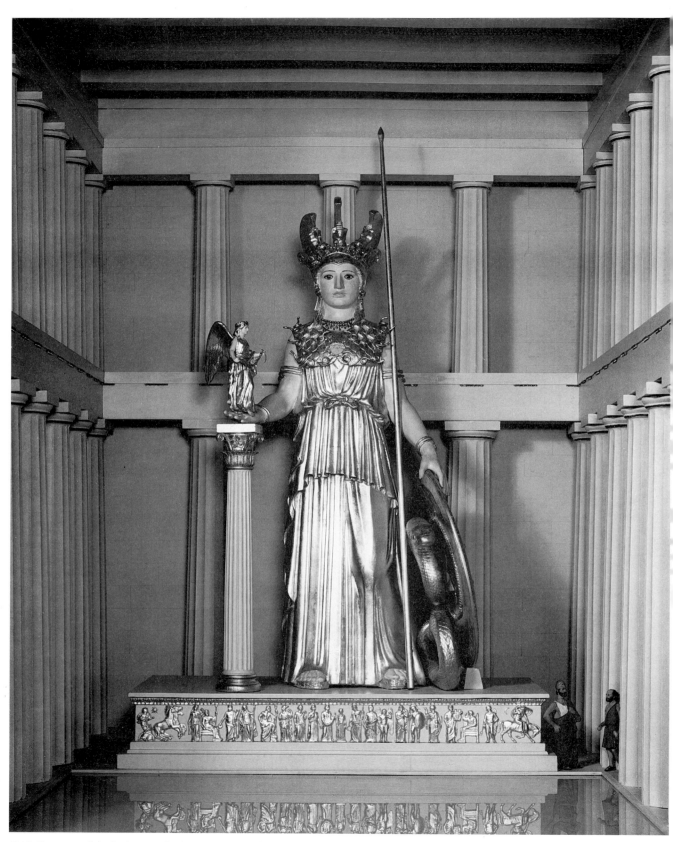

106 A Reconstruction of Athena Parthenos (Toronto, Royal Ontario Museum)

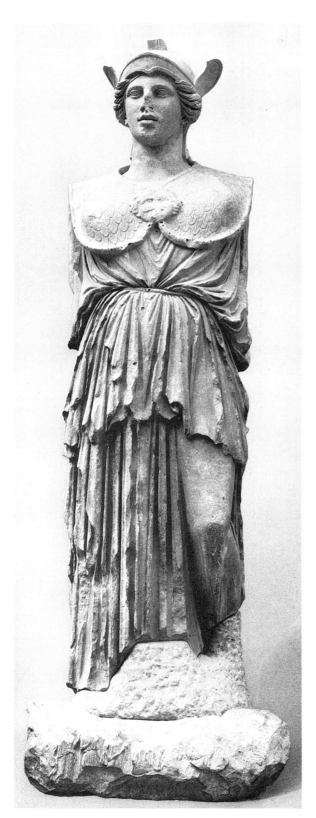

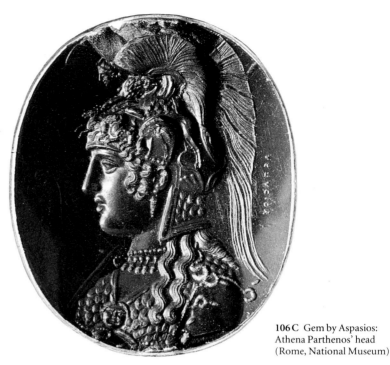

106 C Gem by Aspasios:
Athena Parthenos' head
(Rome, National Museum)

106 The cult statue within the Parthenon, the work of Phidias, stood some 40 feet high. The flesh parts were of ivory, and the dress made of gold plates fitted over a wooden core: an extravagant demonstration of wealth in a building that itself housed a treasury and was a statement of the wealth and power of its city. It was described and often copied, at various scales, in antiquity. A model of its probable appearance in its setting, framed by the double colonnade and with a shallow pool of water before it which reflected light from the doorway on to it, is shown in [A]. [B] shows a rather free reduced copy of it in marble which was made for the rulers of Pergamum in the Hellenistic period; and [C] an early Roman gem-stone which gives a detailed view of her head (as does the gold pendant [118A]).

Cult statues in a temple symbolize the presence of the deity at sacrifices in her honour. But sacrifices took place at an altar outside the temple and the Parthenon had no new altar of its own. The Athena Parthenos seems more a statement of civic pride (or arrogance) than piety, just as the building and its decoration seem to combine an expression of imperialism with a claim on the patronage of the Olympians and not just Athena alone, and even with some of the functions of a war memorial.

107 The Erechtheum was built after the Parthenon, just to its north and partly overlapping (probably deliberately) the still visible ruined foundations of the older Athena temple which had been destroyed by the Persians. Its odd

106 B Athena Parthenos, free copy from Pergamum (Berlin, Pergamum Museum)

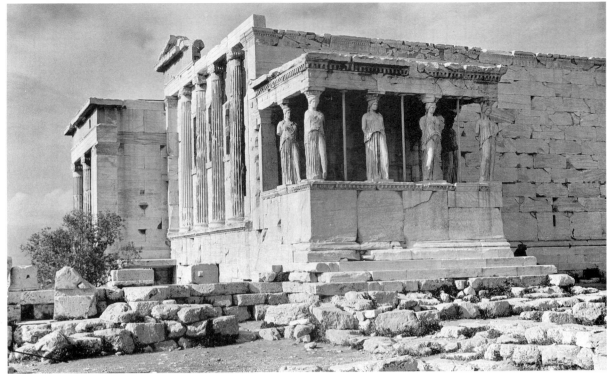

107 A Erechtheum, Athens Acropolis

plan was probably an attempt to accommodate different cults in the same building—for Athena, for Poseidon, and for Erechtheus—so it was no ordinary temple. The old wooden cult statue of Athena was probably kept in it. The Ionic order is classic, but ornate [109 D] in the decoration of its capitals and elaboration of door mouldings, which have been the model for dozens of classicizing buildings of the Roman period and in the last 200 years. The sculptured frieze around it was composed of white marble figures set against a black marble backing. Accounts for the sculpture tell us that the going rate for copying one human figure or horse was 60 drachmas (two months' average pay for a workman). The names are of citizens or immigrant 'metics', not then of known master sculptors but of skilled masons, who would have worked from full-sized models supplied by the master studio. The strange false porch facing the Parthenon is supported by six statues of women ('Caryatids'; compare the Archaic [28]), an odd eastern conceit soon popular in Greece [B] and much copied in later years. The heavy body forms and the fluting folds of their skirts lend them a certain architectonic quality as well as reflecting a ritual function. They held *phiale* cups in their hands, to judge from copies, and so were perceived as ministrants in the sacrifice to Athena and, to a degree, a welcome to processions passing between them and the Parthenon towards the altar.

108 The architectural splendours of Athens were not confined to its Acropolis. The old assembly and market area (Agora) in the lower town had begun to attract administrative and sacred buildings in the Archaic period.

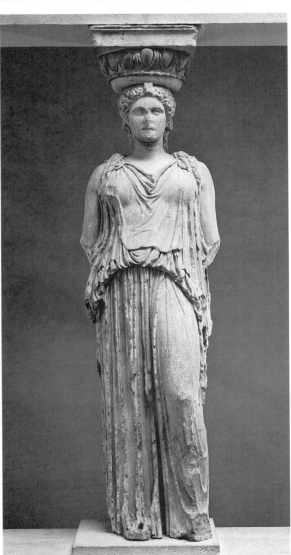

107 B Caryatid from the Erechtheum (London, British Museum)

108 A Model of the Athens Agora, west side (Athens, Agora Museum)

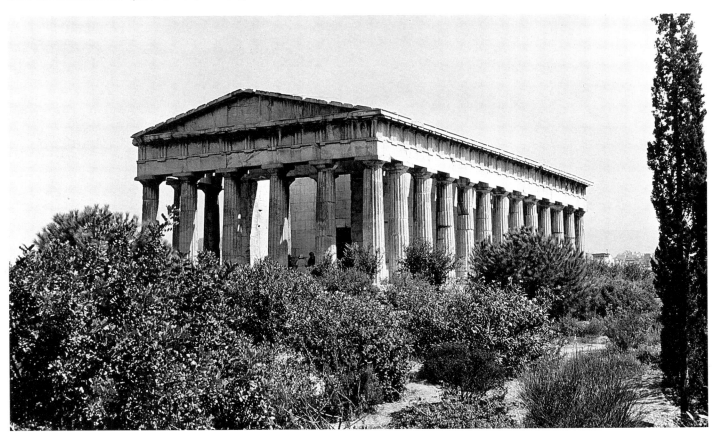

108 B Temple of Hephaestus, Athens

The fifth-century appearance of the west side is shown in the model [A]. The circular building (Tholos) in the foreground is a magistrates' clubhouse. The importance of the colonnade is apparent in other buildings—for the façade beyond the Tholos, which is the facing for a series of administrative offices with a Council House behind; then a small temple, and the Stoa of Zeus which is not a temple in the ordinary sense but a long covered colonnade with projecting wings, sacred to Zeus but also serving as a meeting-place and gallery of paintings. Above and behind is the temple of Hephaestus [B], the first of the new temples of the mid-century. It gives a very good idea of a Classical Doric building of modest size, owing its excellent preservation to its conversion to a Christian church. But it lacks the subtlety of the Parthenon and that building's commanding situation.

ARCHITECTURE

109 The appearance of Greek temples and most other public buildings is strictly defined by the principal 'orders', which are most obviously expressed in the treatment of colonnades and their upperworks, but which extend to other, slighter details of architectural ornament. These have all contributed to the classical tradition in architecture and are still observed in classicizing works, or have been adopted (as they were in antiquity) for other decorative work of carpentry or moulded relief. This is particularly true of the mouldings such as bead-and-reel. The Doric order [A] had developed as a stone translation of the carpentry patterns of wooden buildings in the seventh century BC. The columns have no bases and their capitals are splaying discs that acquire straighter profiles with time. The architrave above is plain, but topped by metope panels, divided by vertical triglyphs. These derive from the pattern of beam ends and the openings between them. The order was always most popular in the Greek homeland, where it was first developed. In the Ionic order [B] the columns more closely resemble enlarged wooden furniture and the type is basically orientalizing, of the later seventh and sixth centuries BC. The rings of leaves at the tops of columns acquire volute 'cushions' to become the conventional Ionic capital; the bases recall the feet of turned wooden furniture. In the upperworks the

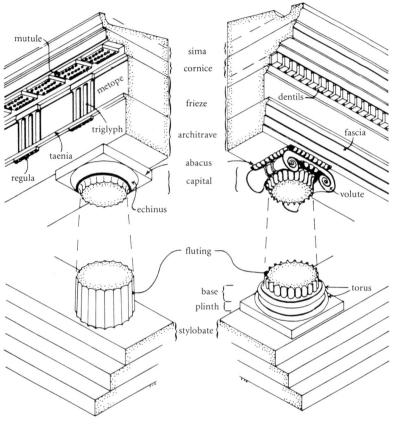

109 A, B The Doric and Ionic orders

109 C Corinthian capital (Epidaurus, Archaeological Museum)

109 D Painted coffers and capital, the Erechtheum, Athens

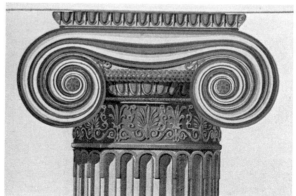

architrave is divided into three horizontal bands, like overlapping boards, and above there may be a frieze, sometimes with carved figures, or just of dentils ('little teeth'), which are the pattern of protruding roof beams. The order was developed in east Greece but seen in Treasury buildings at Delphi in the Archaic period. In the fifth century it is introduced to Athens, where it is cunningly used as a foil to the Doric in adjacent buildings (Parthenon and Erechtheum) or in the same building (the Propylaea, where the taller Ionic columns flank the rising central way and Doric is used on the façades).

Unlike Doric, the Ionic capital has a front and a back. Before the end of the fifth century a new capital type was invented to accompany other elements of the Ionic order, the Corinthian. The volutes are reduced and set at the corners, springing from a basket-shaped core decorated with rings of acanthus leaves. This spiky, curling foliage becomes an important element from this time on in various architectural settings as well as in other arts. [C] is a fine example from Epidaurus, and appears to have been the model provided by the architect to be copied by masons for the capitals of the Tholos, a round building of the mid-fourth century.

Other patterned mouldings in architecture were readily transferred to minor arts, and owe their origin to eastern floral and leaf patterns. The most familiar are egg-and-dart and leaf-and-dart. The profile of the moulding itself always reflects its decoration; thus, the 'egg' appears on ovoid mouldings, the incurving 'leaf' on S-shaped mouldings, while the rectilinear meander goes on flat bands.

Colour was no less important on architecture than it was on sculpture. Recent study has suggested that even walls and column shafts on the Parthenon were treated with a very pale reddish-ochre which would have mitigated the glare and perhaps protected the surface. One recalls the red sometimes added to the surface of fine black- and red-figure vases to deepen the natural orange colour of the fired clay. It has long been known that the mouldings and ceilings of Classical buildings were painted. This was the result of the careful inspection of them by scholars and architects in the nineteenth century and much more has been detected since. Our conception of the pristine gleam of marble temples is as inaccurate as older views about pure white statues. [D] shows some of the painted decoration which was detected on the Erechtheum—in ceiling coffers and on the capitals. The principal elements are in red, blue, green, yellow, and gold, while the 'eyes' of the capitals were gilt, and the cable pattern inlaid with glass. Colour contrasts in stone, however, were rare and it was for the Romans to exploit the coloured marbles of the Mediterranean world. But on the Erechtheum too a darker stone from Eleusis was used as the backing for the (painted) white marble figures of the frieze, and there is occasional use of dark stone to articulate parts of buildings elsewhere in this period.

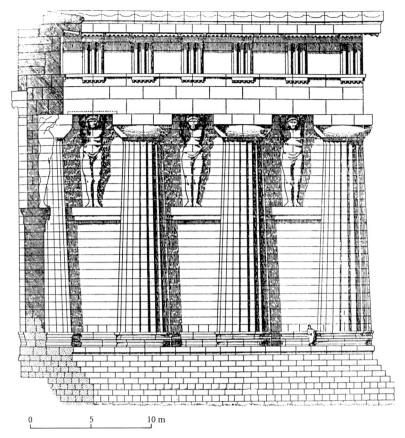

110 Temple of Zeus, Acragas

110 The western Greek colonies of Sicily and south Italy were wealthy and undemocratic, and their rulers disposed to making a display architecturally. The preferred order was the Doric. Theron, tyrant of Acragas (Agrigentum), planned the largest of all Doric temples to celebrate his defeat of the Carthaginians in 480 BC, and dedicated it to Olympian Zeus. It was still incomplete in 406, when the city was sacked by Carthage. The outer colonnade was closed by screen walls, and between the columns (4 m. thick at their bases) stood giant figures (atlantes) appearing to support the architrave. These were nearly 8 m. high; the whole building more than 40 m. longer than the Parthenon. Such massive projects seemed to the taste of Greek monarchs (Archaic tyrants or Sicilian kings), rather than democracies—few of whom, other than Athens, could have afforded them. Western Greek temples, like most of their sculpture [125], were not of marble but of the local limestone that had to be stuccoed over to provide a smooth, marble-like surface and to disguise the courses of building blocks. In all their arts the Greeks took pains to 'hide the joins'!

111 Town planning and domestic design in the Classical period were determined by considerations of economy of

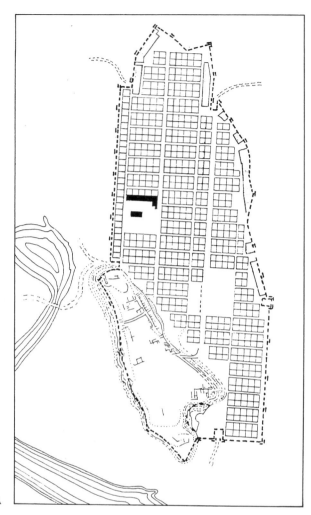

A

space, defence, and basic comfort. In the towns, where any planning was possible, such public spaces as there were had severely practical functions, for assembly or market, and the courtyards of the better houses were for light and air. There might be a small bathroom in each home, but provision for the disposal of body and other waste is not apparent, and not all streets could accommodate two-way wheeled traffic.

Most early Greek cities 'just grew' unplanned except where they were new foundations, but we find a grid plan as early as eighth-century Smyrna. The architect Hippodamus of Miletus (late fifth century) was credited with influential new theories of town planning, based on the grid, and in the later fourth century Priene [151] probably reflects his influence. For a Classical town we turn to Olynthus, in north Greece. The old town lay on a low acropolis (bottom left in [A]) with the town theatre on its slopes and its houses and street plan apparently as haphazard as any hill town in Tuscany. In 432 BC a considerable influx of population prompted the laying out of a New Town which the walls were extended to embrace, to the north. The severe grid of back-to-back houses is clear from the plan, with one fairly wide main street, and two open areas—one for a sanctuary, the other the market-agora. The town was destroyed in 348 BC and has been well excavated, thereby leaving us a more comprehensive view of Classical town life than any other site so far.

The houses, in reconstruction [B], seem as uninspiring as any urban development in the present century. From their plans ([C], of typical north-facing and south-facing houses) we can see that owners could exercise consider-

111 Olynthus. A town plan; B models of houses; C house plans

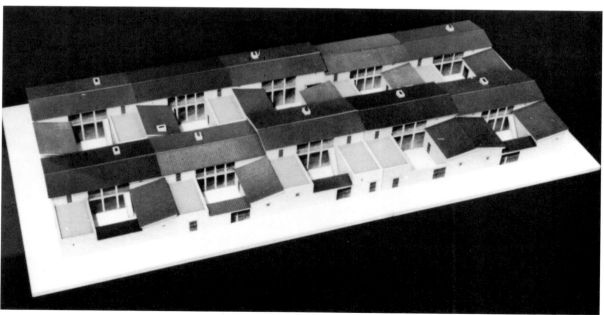

B

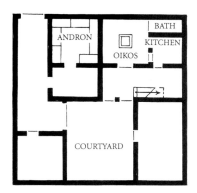 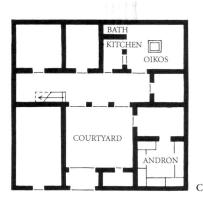

able individuality in plan, but the traditions of domestic life dictated nothing more than variations on the assembly of the few basic rooms. If we forget how the houses are jammed together with just an alley behind and narrow road in front, each house may seem desirably well planned. They are roughly 17 m. (less than 60 feet) square. The entrance led into a court with a shady colonnade on one side, facing south (*pastas*). Over this north half of the house an upper storey accommodated bedrooms and the women's work- or play-room (*gynaikonitis*). Downstairs is the living room, with hearth (*oikos*), and bathroom and kitchen attached in 'open plan'; store rooms; and the men's room (*andron*) sized and laid out to accommodate usually seven couches (*klinai*) on which a dinner and symposium could be conducted in the usual reclining position. The mixing bowl for the wine would have stood in the anteroom. But we should not think that a symposium-feast was a daily event in downtown Olynthus, however important the occasion may seem to be in Greek literature and society. Variants on this general theme and plan informed most Mediterranean domestic architecture before the days of central heating and air conditioning, and are echoed in most modern middle-class houses in the western world: display rooms (the *andron*) directly accessible from the street door or court; smelly and noisy activities (children, cooking) more remote. There was no access from the back alley. One larger out-of-town villa at Olynthus which has one has been taken to show that slaves and women had their own subordinate entrance, which was obviously not the case in the town nor the probable intention in the villa. Walls were of mud-brick, sometimes over a stone socle. Floors were clay, but some could be laid with pebbles or even patterned mosaic (notably the *andron*). Roofs carried large clay tiles (about 22 × 95 cm.)

What is perhaps most remarkable about the town is the uniformity. In the fourth century some plans were changed to allow rooms for industry, while here and there two were put together for a grander residence, and these might have a court with a colonnade on all four sides (peristyle) like the finer Hellenistic (and, later, Roman) houses. Were all the poorer citizens in the Old Town? Domestic slaves must have lived in. The superficial classlessness

must be illusory. But there was enough room in the Olynthus houses to deploy good furniture, and they imply a standard of life and use of fine objects and materials that suggest wide enjoyment of reasonable comfort and appreciation of whatever the craftsmen or merchants could provide. There was a good potential clientele here to occupy the local artisan and artist, and we do not need to imagine that fine works had a strictly limited distribution in the community, here or in most other Classical towns of Greece.

112 The model shows the sanctuary of Zeus at Olympia in the later fourth century. The basic elements are the altar (an ash mound to the left of the temple at the centre), the temple to house the cult statue (the temple here replaced the older one further right, then dedicated to Hera), and a boundary wall to limit the sacred area (temenos). Further planning in this as in any other Greek sanctuary depended on the traditional placing of these elements. The Games were an important factor in worship at Olympia and in the fifth century the end of the stadium came close to the temple front, but the sacred area was later more clearly defined by the stoa (foreground), and the stadium moved a little away (the entrance bottom left). Treasuries dedicated by rich Greek states, here especially the western Greek, were ranged on a terrace overlooking the approach to the Classical stadium (right); when built, most of them overlooked the finishing line itself. The rest of the sanctuary area was well populated with statues and monuments, commemorating successes in the Games or in wars, even with fellow Greeks. The effect must have been bewilderingly crowded, but at the same time a show-place of the best Greek art. Other buildings outside the temenos wall are administrative, or exercise grounds, and the shed-like structure behind the temple was the studio in which Phidias made the gold and ivory cult statue of Zeus. The little round building (top right) was built by Philip II, father of Alexander, to house statues of his family worked in gold and ivory—like gods! The treasury dedications of states had given place to dynastic displays by imperial families.

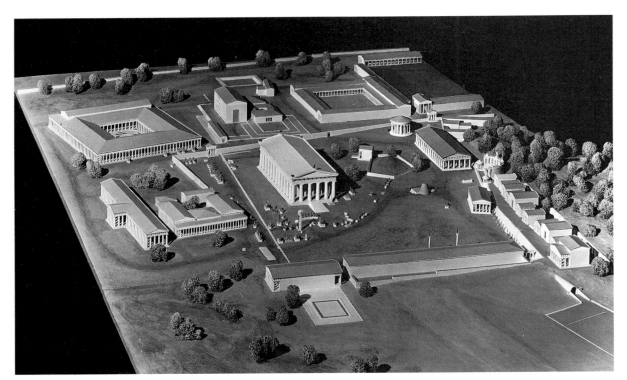

112 Model of the sanctuary,
Olympia

113 Reconstruction of the Mausoleum

113 A combination of dynastic pretensions and the heroizing of the dead led to the creation of monumental tombs that shared something of the appearance if not function of temples. King Mausolus of Caria, in south-western Asia Minor, was a semi-independent vassal of the Persian king but living in a strongly Hellenized environment. His queen Artemisia planned a heroic tomb for him, completed only after both their deaths soon after the mid-fourth century. It gives its name to all subsequent 'mausolea'. It looks like a square temple raised on a high base and with a pyramidal roof. The idea of above-ground burial was familiar in Asia Minor, but here the tomb chamber was beneath the monument, which seems rather to exalt its occupier and his family to divine status. Tradition had it that four prominent Greek sculptors were employed to decorate the tomb. The placing of the sculpture and indeed the whole appearance of the building depend on a rather vague ancient description and excavation of the slight remains on the ground. Many blocks and pieces of relief sculpture had been built into the nearby Crusader castle (in modern Budrum), whence most of the surviving sculpture was removed to the British Museum in the last century [131]. The appearance of the tomb, real or imagined, influenced the construction of comparable *heroa* in antiquity, and many later tombs and war memorials (e.g. that in Melbourne, Australia).

ARTS OF LIVING AND LUXURY

114 Our knowledge of Greek furniture derives almost wholly from representations on vases and reliefs. The more important types were for beds, which served also as symposium couches (as on [73]) and even biers; thrones, which were unlikely to have been so common in everyday life; stools and footstools. Many of these forms derived from the massive and ornate furniture of Egypt and the Near East and exhibit elaborately carved or lathe-turned legs and inlaid detail in ivory or coloured glass and amber. In the fifth century, however, lighter, simpler, and more graceful carved forms begin to appear, and these seem to be of purely Greek design. The most striking are chairs with splaying legs and shaped backrests. The vase scene shown here has Heracles' brother Iphicles with their music-master Linus. He is sitting on one of these elegant chairs while his pupil is on a stool. Such scenes can tell us much about the realia of everyday life even when the 'actors' are heroic or divine. Notice the detailing of the lyres, the instrument hanging above (a *phorminx*), the crossed cases for writing implements top right, and below them a bag for knucklebones—a typical schoolboy's gear.

115 Modelled and especially moulded (and so mass-produced) clay attachments and minor objects provided

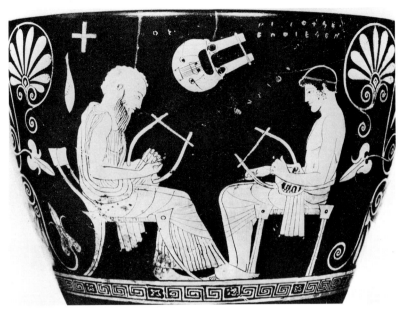

114 Athenian red-figure *skyphos*: music lesson (Schwerin, Staatliches Museum)

popular and cheap decoration and could serve as substitutes for work in more valuable materials. The fired clay was normally painted and could be gilt. [A] is a small cut-out which could be attached to furniture or caskets, and belongs to a series which seems to have been made in the island of Melos in the Early Classical period and later. This example shows the hunt of the Calydonian boar, with the beast attacked by heroes and the heroine-huntress Atalanta. Clay relief plaques were alternatives to the wooden offerings, carved or painted, and to more valuable dedications in stone. A fifth-century series from various sites in the west, but especially Locri in south Italy, are in effect icons with sacred subjects. The one shown here [B] depicts Hermes and Aphrodite in a chariot drawn by two Erotes. Statuettes in the round resemble the more valuable examples in bronze but seem to have a far greater range in subject-matter. [C] shows the rustic god Pan in his common Classical form, human-bodied with goat-legs and a goatish head. Fine reliefs in metal could be cast in clay (and later plaster) and serve as decorative attachments or models for other craftsmen. [D] is an ancient cast from a metal belt ornament, made about 430 BC, and shows a resting or mourning warrior, possibly Odysseus.

116 The quality of die-cutting for Classical Greek coins went far beyond the call of identification of a state or mint. There was a tendency to favour conservatism in types since familiarity bred confidence, but some cities seem to have gone to some trouble to offer both variety and quality, and the style of rendering traditional subjects would be updated. Heads were a common subject for the obverses, representing local gods where in the succeeding period we

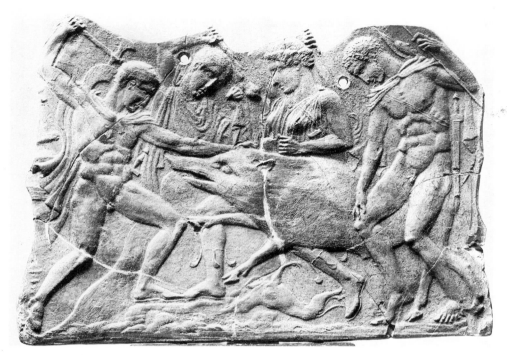

115 A Clay relief plaque: Calydonian boar hunt (Berlin, Staatliche Museen)

115 C Clay Pan (Berlin, Staatliche Museen)

115 B Clay relief plaque from Locri: Aphrodite and Hermes (Taranto, National Museum)

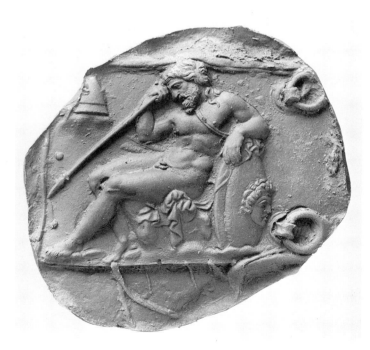

115 D Clay relief: Odysseus (Athens, Agora Museum)

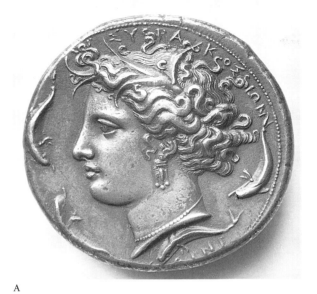

A

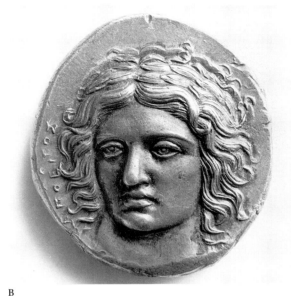

B

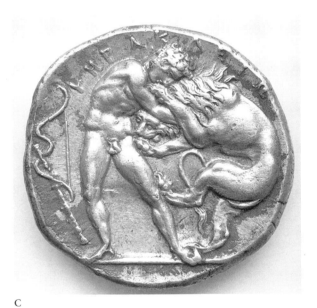

C

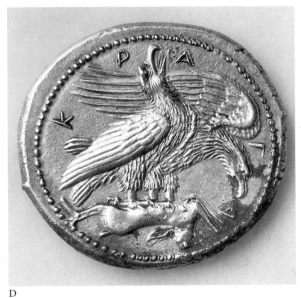

D

116 A–D Silver coins of Syracuse, Clazomenae, Heraclea, and Acragas

see the heads of rulers. [A] has the nymph Arethusa on a coin of Syracuse, signed by the die cutter Euainetos (part of the signature below the head). Facing heads, as that of Apollo [B] on a coin of Clazomenae (in east Greece), tend to invite damage through wear to the projecting nose but are not avoided. Reverses may have figure groups, like the Heracles and lion [C] on a coin of Heraclea in south Italy, or symbolic figures like the eagles on a hare on a coin of Acragas in Sicily [D]. These are all silver coins. The Classical Greeks seldom struck gold, but bronze coinage for lesser denominations was beginning.

117 Engraved gems of the Classical period were generally larger than the Archaic [62], with simpler cut backs, eventually omitting the patterned border to the device, so that the figures are given more space and the compositions are less obviously confined and determined by the shape of the stone. Four stones signed by Dexamenos of Chios have survived, made in about the third quarter of the fifth century; they are also the finest of the period. [A] has the head of a man, carefully characterized by his incipient baldness and rather wispy beard, but not necessarily a portrait. There is exceptionally fine detailing of eyelashes and locks

117 A, B Engraved gems by Dexamenos (Boston, Museum of Fine Arts; St Petersburg, Hermitage)

117 C Engraved gem: Nike (London, British Museum)

117 D Engraved gold ring: goddess (London, Victoria and Albert Museum)

on the stone, which is only 2 cm. high. [B] is one of two signed Dexamenos gems that show herons. The hard stones required cutting with the drill, probably set on a fixed horizontal lathe, but the finer detailing of feathers on the birds was rendered painstakingly by hand, and the subject reminds us that Classical artists were no less adept at observing and rendering wildlife forms than human ones. Perhaps a century later is [C], a half-naked Nike (Victory) building a trophy. Enlargement does nothing to impair

appreciation of the quality of the cutting, which can compare with the finest relief sculpture of the day (it is 3.3 cm. high). This must be the work of a major artist, and we are indeed told of sculptors (including Phidias) who also turned their hands to miniaturist work of this type, as did Renaissance artists. Finger rings of precious metal also carry intaglios, although they were probably more often worn as jewellery than used for the serious business of sealing property or documents. It is easier to cut into metal than the hard stone, but finer rings, as [D], with a goddess (Hera or Aphrodite), can compare with the hardstone gems in quality.

118 A Gold pendant: Athena Parthenos' head (St Petersburg, Hermitage)

118 B Gold ear-ring pendant: Nike in chariot (Boston, Museum of Fine Arts)

118 The Classical goldsmith had mastered the arts of filigree and granulation, and tended to the ornate in the creation of fine jewellery for wealthy women. He did, however, eschew the use of other materials which would have added colour to his work, such as precious stones or cloisonné enamelling, until the end of the fifth century (for a later example, see [182]). Generally he, and his customers, admired the gold alone. We show two highly ornate pieces: [A] a pendant found in a south Russian grave, the disc of which carries a version of the head of the Athena Parthenos [106], and the pendant of an ear-ring rendered as a Nike (Victory) driving a four-horse chariot, the whole object measuring only 5 cm. high [B].

119 Classical mirrors were bronze discs, generally silvered. These may be supported on stands in the form of columns or of figures of women, or they may have hinged lids, rather like powder compacts. The latter can be decorated in relief on the outside and with an incised scene inside. [A] is an exterior on which the drunken Heracles seeks to assault a nymph, or possibly the priestess Auge. This erotic use of the female nude accompanies the greater interest in the genre for representations of Aphrodite (as on [B]) or Nike [117 C], and in major statuary [130]. The buxom Aphrodite on [B] is from the inside of a mirror cover. She is playing jacks (five-stones) with Pan, who seems accusing, while Eros leans at her hip and offers advice. The goddess of love had already in the fifth century been admitted in Greek art to scenes of mortal occasions, such as preparations for marriage, and it was natural to allow her the sort of terrestrial relaxation implied in this scene, especially with the decidedly rustic Pan and omnipresent Eros. The finely incised lines would have appeared dark on the brassy surface, but we commonly have to view such scenes in reverse, with chalk-filled lines on the patinated bronze. Both these examples are fourth century.

120 South Russia has proved an important source for Classical Greek art in precious materials. The Greek cities on the Black Sea shores were rich and their tombs were well furnished. Their neighbours, the Scythians of the Ukraine and north of the Caucasus, were also good customers for expensive Greek jewellery [118 A], but this market was served also by works which had been specifically designed for them. This we judge from the shapes of the objects (as [365]) or the character of the decoration, often representing the Scythians themselves or related peoples. Much of this work may have been done in the nearby Greek colonies. The gold comb shown here was found in a burial on the Dnieper, well north of the Crimea. The figures on the handle, less than 5 cm. high, are rendered wholly in the round. They represent a local encounter with long-haired Scythians, wearing Greek armour and a leather tunic, but trousered and carrying

119A Bronze mirror cover: Heracles and Auge (Athens, National Museum)

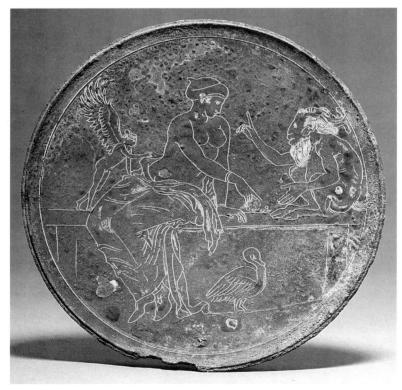

119B Bronze mirror back: Aphrodite, Eros, Pan (London, British Museum)

light shields, and a horseman, also sleeved and trousered under his chain-mail corselet.

121 Greek silver vessels were seldom as highly decorated as the Near Eastern, but the south Russian market again provided an opportunity for the display of elaborate techniques. These are views of a large silver vase found in a burial not far from the find-spot of [120]. The decoration is in low relief and the figures and flowers are gilt, a common combination of materials. It would have been unnatural to disguise the brilliant reflective properties of silver (here somewhat tarnished by age) with anything other than the yet more valuable and versatile gold. The lifelike rendering of the birds contrasts with the rather formal and geometric treatment of the unrealistic florals. But these, in a barely altered form, are to become important decorative elements in Classical art, appearing on objects of any scale and medium, from architecture to jewellery.

122 The dearth of fine metal vases decorated in relief is partly mitigated by the survival of clay imitations of them, although on many the potter and vase-painter can make his own contribution to the generally exotic effect (while others are simply rather poor copies, sometimes casts). Xenophantos the Athenian thought fit to sign the vase shown here, a work of the early fourth century. Some of the figures are in painted relief, others in the usual red-figure technique, and the vessel is otherwise shaped and treated as a painted vase of the period. Significantly, perhaps, it too was found in south Russia, but in a Greek colonial cemetery in the Crimea: a case of imported fine ware for Greeks in this region, while there was local production in precious metal [120–1] for their northern neighbours.

SCULPTORS AND STYLES

123 The winged goddess of Victory alights to crown success on the battlefield, Zeus' eagle hovering beneath her feet. The wind on her dress bares a breast and a leg, it presses the cloth against her body, as though it too were bare, and makes it billow in deep folds behind her legs. The expressive, semi-nude effect has been glimpsed already on the Parthenon [105 D] and will be a hallmark of sculptures of women in the last quarter of the fifth century. This figure is the work of the sculptor Paeonius, a north Greek, but working in Olympia, where it was set on a triangular pillar some 10 m. high. It celebrated the success of Messenians and Naupactians, supporting Athenians against Spartans in the fighting at Sphacteria (Pylos) in 425 BC. The dedication does not mention the Spartans, probably because Olympia depended much on Sparta's patronage, but the viewer would know what the occasion was. A

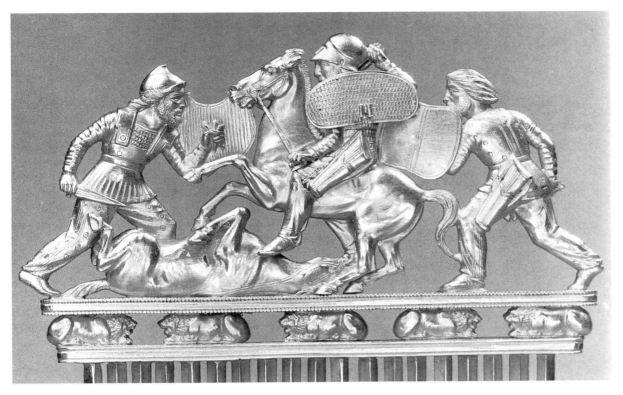

120 Handle of gold comb (St Petersburg, Hermitage)

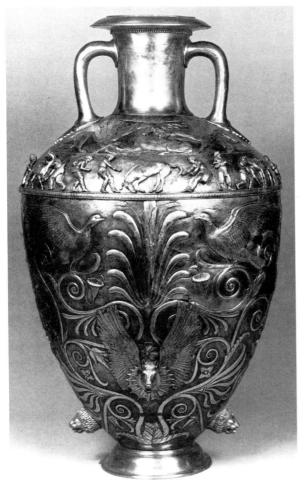

121 Gilt silver amphora and detail (St Petersburg, Hermitage)

122　Athenian clay relief vase (St Petersburg, Hermitage)

123　Nike by Paeonius (Olympia Museum)

Greek memorial of success against other Greeks in a sanctuary where inter-Greek competition was otherwise athletic says much about both the often strained neutrality of Olympia and city pride. Artistic pride too is accommodated, since Paeonius signed, though in smaller letters, on the dedication block, and took the opportunity to refer to his own success in the competition for the commission to make the acroterial statues for the temple of Zeus.

124 One of the last projects of rebuilding on the Acropolis was the little Ionic temple to Athena as Victory (Athena Nike) which the visitor today sees restored on the bastion to the right of the entrance. Around it, at pavement level and facing out, was a balustrade decorated in relief with figures of Victories, with sacrificial animals and trophies, and of Athena. This Victory, binding on her sandal, displays a further stage in the sculptor's use of dress to

enhance rather than conceal the naked body. It is difficult to imagine what the effect of bronze figures in this style might have been, with the bright metal detailing all the forms of the body, the dress hardly more than a lacework of line and shadow; difficult too to judge how much would have been clearly seen of these painted marble figures from viewpoints far below on the Acropolis slopes.

125 (Colour Plate XI) The Malibu goddess is the only near-complete stone cult statue of the Classical period to have been found so far. It is over life size, 2.20 m. high, and must be from a sanctuary somewhere in south Italy or Sicily. This we judge mainly from its material, which is white marble for the flesh parts, limestone for the body. 'Acrolithic' (with stone extremities) statues are a feature of western Greek sculpture, since white marble was not available locally, so bodies were made of wood or, as here, softer stone. But they were still lavish affairs, and the wood or stone could be gilt or painted. We may suspect that this is the work of a homeland Greek artist, commissioned by one of the wealthy western cities whose architectural pretensions we have already observed [110]. The restless and heavy folds of the dress do nothing to conceal the body forms, and this almost emotive use of drapery looks forward to styles which will succeed the 'wet' look of figures like [124]. Yet it is conceived in the same spirit, with the forms of the body clearly understood and modelled, and the dress added (in the original clay model) either to veil it lightly or, as here, to emphasize its mass and presence. The head looks rather small, but the cloak would have passed over it, like a hood or veil. The maternal figure suggests a Demeter—a popular goddess in the western colonies.

126 There were no marble relief gravestones in Attica from early in the fifth century until about 430 BC. They began again at a time when Athens was going to war against fellow Greeks, and when much of the major sculptural work for Athens' new temples had been completed, but there must have been other reasons, and the start of a new series of gravestones is less remarkable than their absence earlier in the century. The new form was generally broader, in an architectural setting, often with a pediment, as here. It is as though the figures stand or sit before a doorway, either of their homes—since most of the scenes are calmly domestic—or of something beyond. The mother and child decorate a stone whose verse inscription reveals that it is for Ampharete and her grandchild. Idealization and rejuvenation go easily together, and the idealizing styles of Athenian sculpture well suit the quiet dignity of a funeral monument. The style is retained, little changed, for these reliefs (this is of about 410 BC) into the fourth century. The remains of paint in the background remind us of the realistic setting for these figures and groups.

124 Relief from balustrade of Nike temple (Athens, Acropolis Museum)

127 Idealization is also, of course, a natural condition for the representation of gods, and the Parthenon's expression of the Olympians was retained in many later monuments. Marble reliefs were common dedications in sanctuaries, often showing the gods, sometimes the worshippers also at reduced size. The identity of this assembly is unclear, but they are not mortals. The two goddesses at the centre may be Demeter and Kore, but there is nothing by way of attribute or singularity of appearance to reveal names, and these must have been apparent to the viewer from the setting or a lost inscription. The young male recalls Polyclitan figures [93]; the women, stocky precursors of the Caryatids [107 B]; the elder, the Parthenon frieze. An eclectic, high Classical style based on the forms

126 Gravestone of Ampharete (Athens, Kerameikos Museum)

reliefs that decorated the interior of the main room of the temple. How they were lit remains unclear. The vigorous style and chunky figures, carved around 400 BC or soon after, come as something of a surprise after what we have been looking at. The intense narrative vigour transcends a certain roughness of execution. The Greeks fighting centaurs and Amazons convey the verve of earlier work in south Greece, at Olympia, but expressed with the new command of realistic posture and a certain theatricality of gesture, with dress swirling in the background, a device long to be exploited by sculptors of narrative reliefs. The first of the two slabs shown [A] has the crossing bodies of Heracles and an Amazon, making the centrepiece to one short side of the frieze, in a prominent position at the end of the temple cella. The other [B] shows two rather dumpy girls seeking refuge at the statue of a goddess from the attentions of a centaur who has seized the dress of one, baring her, while trying to fight off a young Lapith. This is a more violent version of the subject of the west pediment at Olympia [82 A].

129 Pausanias states that there was a statue of Hermes carrying the infant Dionysus, by the Athenian sculptor Praxiteles, in the temple of Hera at Olympia. When excavators found this statue in the temple, it was naturally taken to be the original, and only later scholarship has entertained the suspicion that it might be an extremely fine copy or replacement, made in antiquity, perhaps after the original had been damaged. Praxiteles worked in the mid-fourth century and is one of the first of the new generation of sculptors who returned to marble for many prime works, including cult statues. The standing male had been a major sculptural type, from the four-square kouros [41, 43], through the relaxed but relatively static Early Classical figures [87], eventually lifting a heel [93], to figures in which the artist experiments with the effects of shifting a major part of the weight and balance of the figure on to another object. The excuse here is the weight of the divine child, part supported by the tree stump which is realistically draped with the god's cloak. The marble surface is highly polished, but this was probably true of many marbles after the Archaic, especially once the practice of painting flesh parts had been abandoned, and it would have been enhanced here by the attentions of temple cleaners. The group certainly looks more accomplished than most marbles of our period, more 'polished' in the broader sense of the word, yet there is a certain dullness of detail and expression which probably betrays the copyist.

130 Praxiteles made a marble Aphrodite for Cnidus, naked, as well as a clothed version, preferred by nearby Cos. Not surprisingly, it was the nude that was copied, and copied indefatigably for countless statues and statuettes as well as serving as the inspiration for a multitude of variants on the theme. The sculptor's successful exploitation of his

of the Parthenon period has evolved and determines the appearance of secondary products such as this for the next generation.

128 The temple of Apollo at Bassae eluded modern travellers for many years, deep in Arcadia. It was explored early in the last century (by Cockerell, the architect of the Ashmolean Museum in Oxford, on and in which many of its architectural features can be recognized) and its sculptures were brought to London. These were a series of

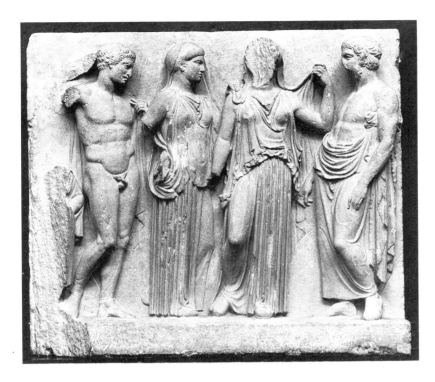

127 Votive relief: deities (Copenhagen, Ny Carlsberg Glyptotek)

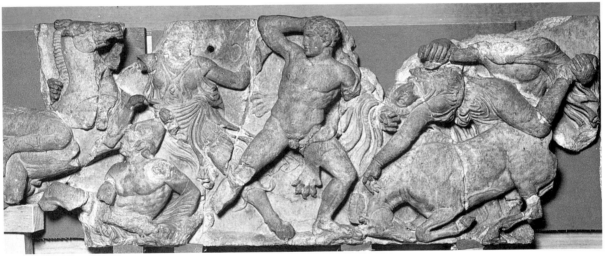

A

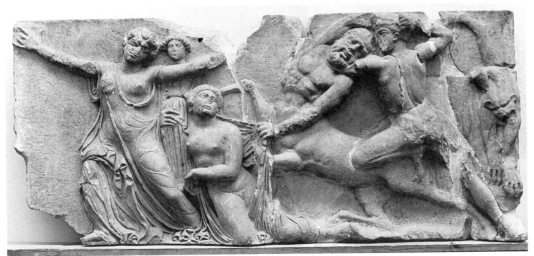

B

128 Frieze from temple of Apollo, Bassae: fights with Amazons and centaurs (London, British Museum)

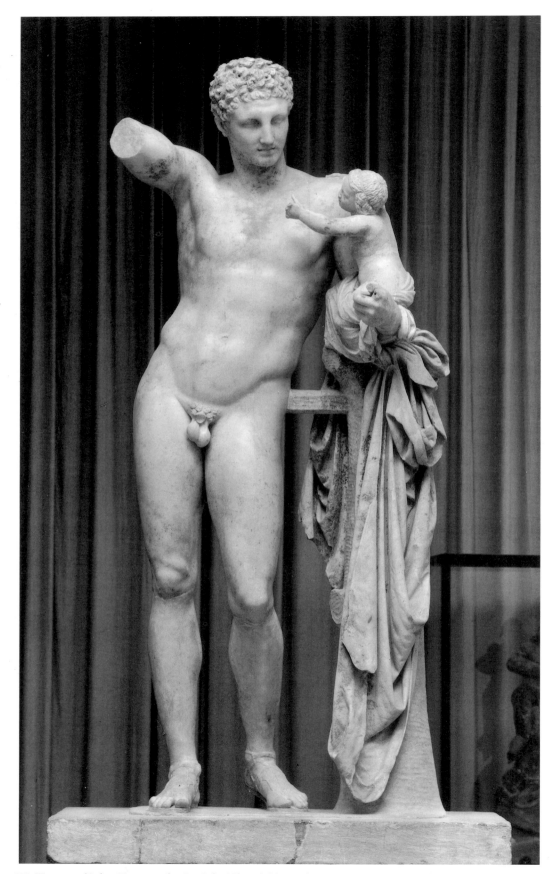

129 Hermes and infant Dionysus, after Praxiteles (Olympia Museum)

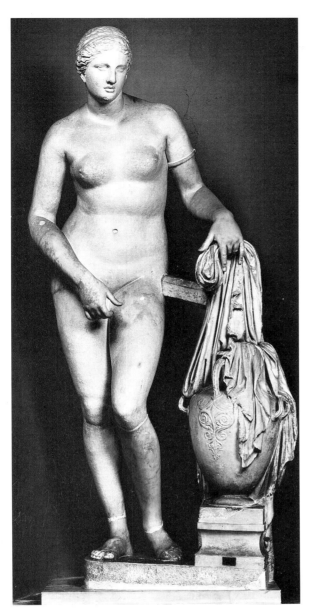

130 Aphrodite of Praxiteles, copy (Vatican Museum)

les' statue. The story of the clothed and nude versions reminds us how easy it would have been to create an original clay model for translation into marble as the nude, then to add dress for the second and, as it turned out, less popular figure.

131 It was said that four celebrated Greek sculptors had been commissioned to decorate the Mausoleum at Halicarnassus [113]. The truth of the story cannot be tested and all that can be said of the style of the surviving reliefs and statues is that it is purely Greek and of the highest quality. The best-preserved slabs of one of the friezes show a fight of Greeks and Amazons, a popular subject for monuments on both sides of the Aegean, with connotations of Graeco-oriental conflict. In contrast with the Bassae frieze [128] the figures are slimmer, more loosely disposed in the field, but no less subtly composed in fighting duels and threesomes. New figure types, like the twisting torso of the Amazon shown here [A], are often associated with another of the Greek sculptors named for his collaboration in the project—Scopas. Free-standing figures at more than life size were also set on the monument, probably between its columns. One which has survived near-complete has been called 'Mausolus' [B], but it is one of several such figures and the fine head is not so much a portrait as a good Greek characterization of a non-Greek, Carian prince, with his mane of hair and 'foreign' (to a Greek) features.

132 The seated goddess, probably Demeter, is from Cnidus, and thus a neighbour to the celebrated Aphrodite [130], and no less effective in its demonstration of the maternal dignity of this goddess than the Aphrodite was in demonstration of provocative sexuality. Moreover, it is an original. The head was made separately of a finer piece of marble than the body, in part because the surface quality was to be admired, enhanced by the painting of eyes and hair, some of which is still visible. There is a superficial similarity between the heads of the two goddesses, mainly because this sub-Classical treatment of women's features died hard in Greece, and there is no real parallel to the developing interests in portraiture and characterization apparent in many male heads. The heavy yet restless treatment of the dress gives it a value of its own without disguising the form of the body beneath. Sculptors are learning that dress can be used as effectively as anatomy or expression to evoke the desired mood of a figure. Leochares has been thought the sculptor, another name associated with the Mausoleum.

133 Leochares has also been associated with one of the most famous of Classical statues, the Apollo Belvedere, but the plausibility of the attribution is even flimsier than that for the Demeter [132]. The temptation to link known names to surviving statues, or copies of them, is strong but

material to counterfeit flesh made for a provocative figure which soon became a notable tourist attraction. The statue was exhibited in an open shrine, where she could be viewed all round. The goddess herself was said to have posed for it, but Praxiteles' favourite model Phryne is a more corporeal and plausible candidate. She is putting aside her dress, preparing to bathe. Or is she preparing, with her hand and dress, to protect herself from the gaze of an intruder—a popular motif in antiquity and not only in Greece (recall Susannah and the Elders)? It is difficult to believe that any of the many preserved copies (the one shown here is generally thought to be the best) do anything like justice to the original. Indeed, it may well be that the nineteenth-century version, with its sleek surface and realistic colour (see **Colour Plate** I), bring us closer to Praxite-

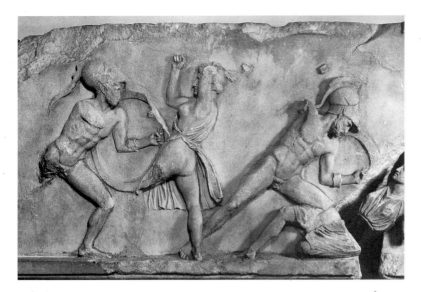

131 A Frieze from Mausoleum: fight with Amazons (London, British Museum)

131 B Carian prince from Mausoleum (London, British Museum)

132 Demeter from Cnidus (London, British Museum)

needs resisting given the poor survival rate of both texts and statues. The Apollo was found in the fifteenth century and thereafter often copied and adapted for other figures. It was hailed by one of the first serious connoisseurs of Classical art, Winckelmann, as 'the consummation of the best that nature, art and the human mind can produce'. Once the Parthenon sculptures were made known in the west it was dismissed as representative of the false view of Greek sculpture generated by the 'Graeco-Roman idols'. The marble copies a bronze of the later fourth century, and has the archer god striding forward, bow in (lost) left hand: or rather, not entirely 'lost left hand', since this statue had been cast in antiquity for the Roman copyists and a cast of the original hand has been found at Baiae (see on [81 B]). The pose might be taken to be advanced Poly-clitan but the slim rather effeminate body and head and the elaborate coiffure for the traditionally 'long-haired Apollo' introduce a new concept of the Olympian.

been composed for one main viewpoint, usually frontal, but now there is no prime view and the figure occupies his own space and environment which the viewer shares. Proportions have changed too, smaller-headed than the Polyclitan [93], and we may regard Lysippus as the last of the Classical theorists, harbinger of a new attitude to composition of figures and groups that is to be further developed in the Hellenistic period. He stands on the threshold of the New Order, when commissions are· for king-emperors rather than city-states, and it was said that Alexander the Great would allow no other to portray him in bronze.

135 Lysippus' treatment of Heracles was no less influential than his treatment of Alexander the Great. The hero personified the triumph of mortal courage over trials set by jealous gods. But he was himself the son of Zeus and allowed to enjoy eventual immortality. In the Classical period his role as a saviour of mankind was stressed as well as the human problems which his career posed, for he had mortal faults too, of lust and greed. He began to acquire a personality denied other figures of myth. They rode their winged horses or they decapitated demons with the help of magic and the active assistance of the gods, where Heracles relied on his native strength. Lysippus' treatment of him reflected on these aspects of his mortality and even gave him an individual image, a portrait, which was respected for the rest of antiquity. The Heracles Farnese is a colossal copy of a bronze original. It shows the weary hero at the end of his labours, resting on his club, his right hand holding behind his back the golden apples which will secure his immortality. But it is the mortal effort that is celebrated in the figure. The heavy musculature (rather exaggerated in this copy) abets the impression of exhausted power; and the head, with the tousled hair, tufty beard, and intense gaze, creates a recognizable 'likeness' that requires no further attribute for recognition.

136 Elements of the two Lysippan figures we have just been looking at [134–5] can be read in the athlete on this gravestone from Athens. Few such monuments reflect so well the new sculptural trends, but it is almost the last of the Attic series, which was cut short by an anti-luxury decree in about 307 BC. The young man looks out at the passer-by in a direct bid for his attention and sympathy, expressed more explicitly in the pose and gaze of the old man (his father?), while the sombre mood is more subtly expressed in the form of the sleeping slave. This type of gravestone would have been set more deeply in the doorway frame than was [126], a construction which allowed the figures sometimes to be cut wholly in the round.

137 Before Alexander the Great explicit portraiture was generally of the long or recently dead. The sculptor characterized his subject for what was known of his career and temperament and subordinated to this aim any know-

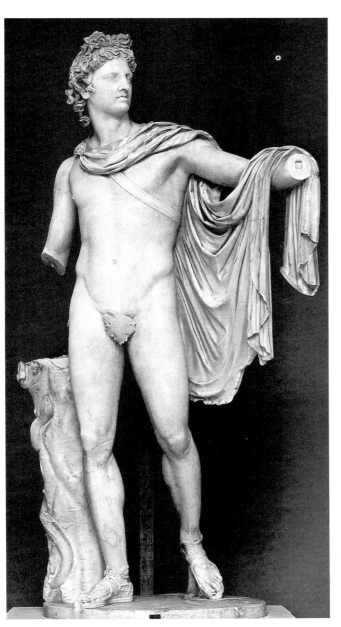

133 Apollo Belvedere, copy (Vatican Museum)

134 The long sequence of standing male nudes (see on [129]) is 'completed' in the later fourth century in the work of the sculptor Lysippus. This is a copy of his athlete scraping down his forearm with a strigil ('Apoxyomenus', removing the oil from his body after exercise). It was described in antiquity, so the attribution is secure. Instead of an exercise in subtleties of balance on feet or shifting of weight on to exterior supports, we have a figure whose ease of posture is expressed by a gently spiralling pose in which the set of the head, the body, the legs, the gestures, leads the eye and the viewer around the whole. Earlier statues had

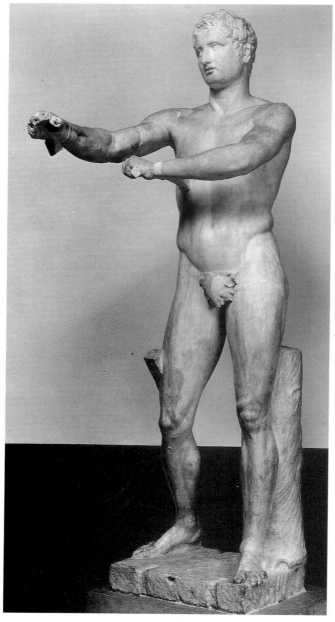

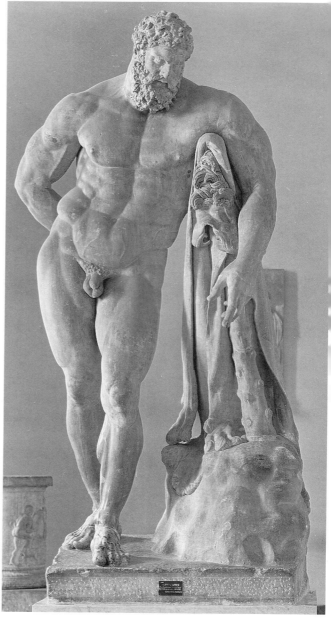

134 Apoxyomenus of Lysippus, copy (Vatican Museum)

135 Heracles Farnese, copy (Naples, National Museum)

ledge he might have had about details of appearance which, for the long dead, would have been only a matter of report. The philosopher Plato died in 347 BC. Several portraits of him are recorded, probably all posthumous. This copy of one is recognized from a version which bears his name. It is individual in that it does not resemble the portraits of other fourth-century philosophers. It blends, no doubt, some true likeness with qualities of almost Olympian introspection. The whole figure would have been dressed, standing or seated. Orators were shown standing, generals as warriors, their body types conforming to a fairly standard pattern and only the heads expressing any individuality. It was the heads that were most often copied for the Roman collector.

THE NEW PAINTING II

The revolution in Classical painting came towards the end of the fifth century. The style of the Polygnotan murals, described above [95], improved on the Archaic without carrying it into new territory in terms of technique and of the appearance of figures. Our evidence for the new styles, in which we may discern the beginnings of western painting as we know it from Rome and the Renaissance on, depends on text descriptions to which the contemporary monuments offered here can add little until well on into the fourth century [144–5]. Yet we can readily judge that the change was profound. There was a reversion to the

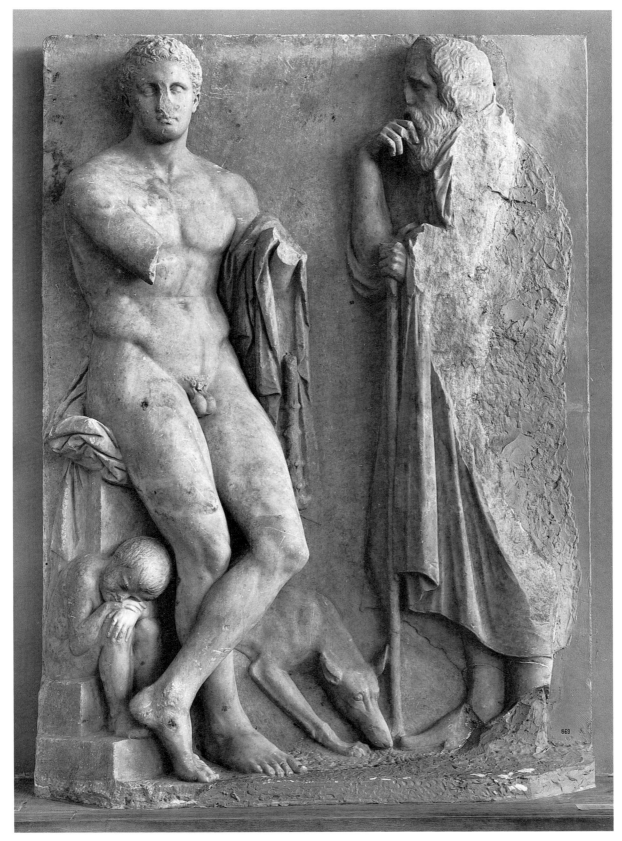

136 Gravestone from near the Ilissus (Athens, National Museum)

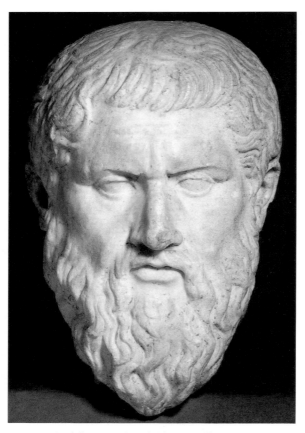

137 Portrait of Plato, copy (Cambridge, Fitzwilliam Museum)

138 Ivory plaque: Athena, Aphrodite (St Petersburg, Hermitage)

simple panel picture, even if multi-figured, and away from the multiplication of discrete groups seen on the big Polygnotan murals. Authors describe for us the characteristics of the new painting. In stage painting—the backdrops to the action which was still not on a raised stage but at the back of the *orchestra* or dancing area—there was an incipient understanding of perspective. This was not, it seems, applied to whole compositions with single vanishing points, but for separate objects or groups. This is, after all, the way the eye scans a scene, with a different focal point as the head moves. There is mention too of subtleties of shading and highlighting to suggest the rotundity of objects, which had been barely glimpsed in some earlier drawing on vases. Gradations of intensity of light and shade and of colour replaced the flat area-filling colour washes. Realism was sought and admired and there are anecdotes about the painter whose grapes were so realistic that they enticed down the birds; and of his colleague who painted a curtain that his rival asked to be drawn back. The latter was the acknowledged victor since he had deceived the human eye, the former only the birds—who had remained unalarmed even at the presence in the picture of human figures. All this is a world away from the cut-out figures of the best mid-fifth-century drawing, and

depends wholly on the acceptance of new techniques and new aspirations on the part of the artist. It was this deceptive realism that worried the philosophers. We would dearly like to be able to judge an example of it, but there are the faintest echoes only in vase-painting, where the uncompromising red-figure technique militated still against realism.

138 Although Classical painting on wooden panels has not survived, other media have, and we show part of an ivory plaque, which had been decorated with a scene of the Judgement of Paris (we have two of the rival goddesses, Athena holding her helmet and Aphrodite with Eros at her shoulder). This may have decorated furniture or have been part of a panel picture. It was found in a Scythian tomb near the north coast of the Black Sea, an important source for Classical jewellery and fine art, as we have seen, since the Scythians, unlike the Greeks, buried personal treasures with their dead, and they were a rich market for exotica from the Greek homeland. The outlines and details of the figures are lightly incised but we can see clear traces of the overlying colour and the effect must have resembled that of the white-ground vases of slightly earlier date [**98**]—the ivory is of about 400 BC—but executed with greater finesse and perhaps a wider palette of colours than we find on the vases.

139 (**Colour Plate** X) Athenian vase-painting of the later fifth century seems to have been inspired more by the appearance of contemporary relief sculpture than by any

of the new styles of major painting. Close-set lines emphasize the rotundity of limbs and do nothing to conceal the naked forms. The general style of many of the vases is languid, if not effete, however fine the drawing. This is by one of the masters of the period, the Meidias Painter. There was a tendency in his work and in the work of his circle to avoid the violent subjects of their predecessors, or to weaken them. For some time there had been a growing emphasis in the choice of subjects for vases on the life of women, with many scenes of them at home or preparing for marriage. This extends into an interest in the love life of the Goddess of Love herself, and there are several studies of Aphrodite with one of her mortal lovers, Adonis or, as here, Phaon. He was an ageing boatman to whom Aphrodite gave youth and beauty in return for a free ride. Thereafter the poetess Sappho was said to have fallen in love with him and been driven to suicide by frustration. The air of escapism which seems to pervade the scenes on many Athenian vases in these years, when Athens was ravaged by plagues, intermittently besieged, and fighting a losing war against most of the rest of the Greek world which had turned against her imperialist behaviour, may have been the craftsman's way of appeasing the mood of his fellow-citizens. The vases also become more ornate, with relief and gilt detail, while the drawing does not attempt to keep up with the experiments in shading and chiaroscuro practised by the major painters of the day.

140 Vase-painting has proved an important source of information about style and subjects because the medium is virtually indestructible and the painters found it a satisfactory one for a wide range of decoration. In homeland Greece, however, at the end of the fifth century, Athens still dominated the market in decorated vases and the volume of production was beginning to fall away. It may be that other types of vessel—plain black or in metal—were in more demand, and for the craft of vase-painting the impossibility of competing with the painting styles on wall or panel may have discouraged the finer artists from exercising their skills in the potters' quarter. There is a decreasing range of shapes decorated, and in some workshops an increasing interest in florid decoration and colour, and a great deal of simply sloppy work. By the end of the fourth century the genre had died. A few painters around the mid-century recall the earlier splendours of their craft by some fine drawing. This is generally better appreciated figure by figure than as assembled on a vase—never a wholly satisfactory field for pure drawing. The south Russian tombs of the Greek cities are a prime source for the best specimens, many of which are devoted to scenes of the life of women, such as the example shown, with women and Erotes preparing a bride for marriage.

141 Around the mid-fifth century Athens sent colonists to south Italy to people Thurii, a successor to the near-

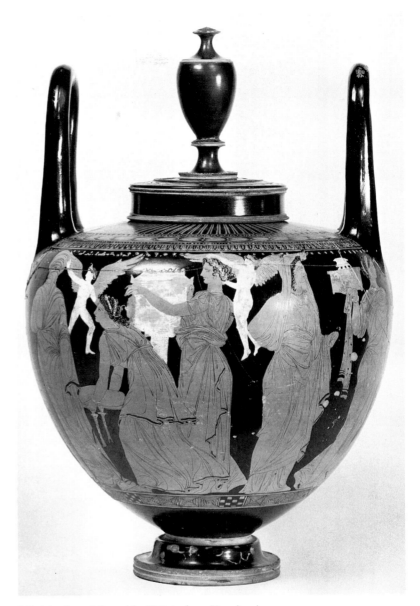

140 Athenian red-figure *lebes* (St Petersburg, Hermitage)

legendary Archaic Sybaris that had been destroyed by its neighbours. With them, no doubt, went potters. At all events, from about this time on there began to develop a number of south Italian schools of red-figure which owe their origins to Athenian styles (indeed, the first painters must have been immigrants) but which soon develop styles of their own. This is shown by emphasis on certain shapes and, especially in the fourth century, by interest in a range of subjects which by that date were being ignored in Athens itself. Some of the early painters were consummate artists. The Palermo Painter offers a delicacy of drawing which at least matches the Athenian, with some

141 Lucanian red-figure *skyphos*: Marsyas (New York, Metropolitan Museum)

painterly qualities (notice the satyr Marsyas' hair) and command of expression. He was probably working in Tarentum (Taranto) about 400 BC.

142 In the fourth century the Apulian potters of south Italy specialize in large, rather ornate vases of shapes that seem, to our eyes, almost a parody of classical forms. They admit much colour and are lavishly, and often most carefully, decorated with multi-figure scenes. Most of the vases seem to have been destined for the grave, and some graves were even constructed with separate compartments to house them. This use of the vases is reflected in the decoration of many of them. Otherwise, favourite subjects are mythological—both individual scenes and large complexes which seem to combine vignettes from various aspects of the action of a story, almost like playbills. The western Greeks' love of the theatre was well known and seems to have encouraged this type of decoration for the larger vases, but it is not always easy (or may sometimes seem too easy) to associate a picture with a particular play that has survived, and normally one that had been first performed in Athens a century before. The vase shown [A] is an oddly ornate and impractical version of a tall-necked amphora. The upper frieze on it [B] presents an episode in the story of Alcestis, who unselfishly gave her life for her husband, and was then rescued by Heracles. She is shown at home with her children, seated on her death-bed. (This is not a four-poster, but in an architectural setting common to many such scenes, here suggesting the palace.) Euripides wrote a play on the subject which was performed in 438 BC, a hundred years before the vase was painted, and we cannot safely postulate any connection between the two.

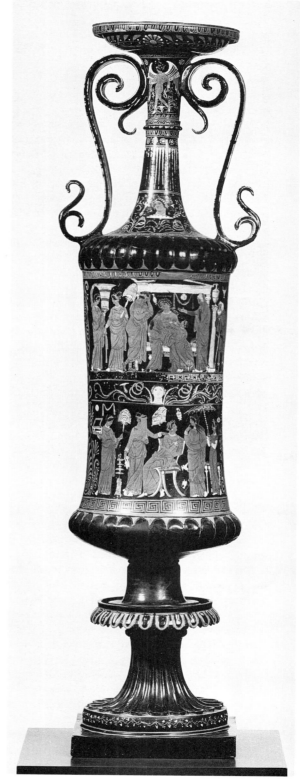

A

142 Apulian red-figure crater: Alcestis (Basle, Antikenmuseum)

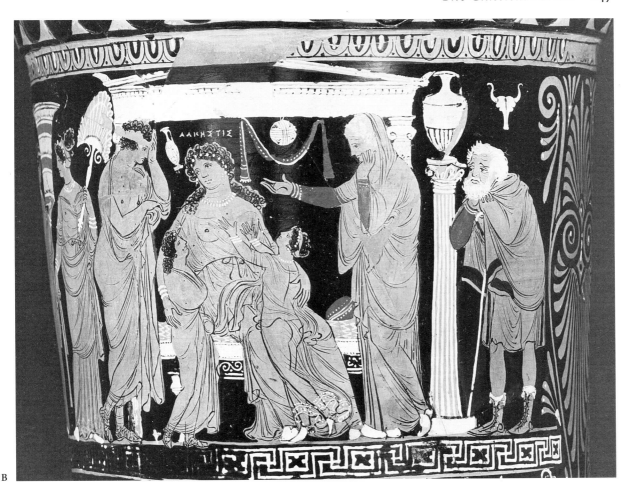

142 B

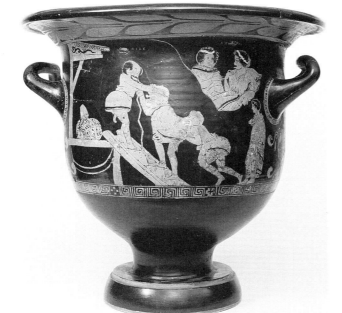

143 A number of south Italian vases show theatrical productions of a comic character which look like versions of Attic Old and Middle Comedy (the plays of Aristophanes and his followers), even to the costumes of the actors with their padded tunics, stage genitals, and grotesque masks. Many Greeks far from the homeland seem to have been devotees of Athenian theatre, and there were local productions, perhaps edited for the different audience, of the famous plays. It is odd that Athenian vase-painters generally avoided such explicit stage scenes. They are among the very few in Classical Greek art which seem as deliberately comic in their intention as were the performances that inspired them. On some of these vases we find a most effective humorous, if sketchy, cartoon style. The example shown has the comic actors helping up on to the low stage an old fellow, called Chiron (otherwise known to us as a dignified centaur), watched by two grotesque women in the wings (or stage box) and a neat, normally dressed stage producer.

143 Paestan red-figure vase (London, British Museum)

144 Painting from Tomb of Persephone, Vergina

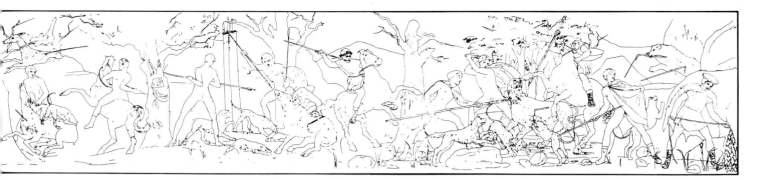

MACEDONIA

In the fourth century the centre of political power shifted to the north of Greece, to the kingdom of Macedonia. The new and wealthy court patronage, combined with royal burial customs that involved elaborately painted, built tombs and rich offerings, have, with no little good fortune and skill with the spade in recent years, made Macedonia a major source of knowledge for Greek art of the years before the inception of the 'Hellenistic' period. The royal cemetery at Vergina (ancient Aegae) has yielded the tomb of Alexander the Great's father Philip II, several finds from which are shown here [145–8], as well as other no less remarkable and instructive burials. Not least, they demonstrate to us for the first time what the new styles of Greek painting could achieve in the hands of masters.

144 A smaller tomb at Vergina, near that of Philip II, has been called the Tomb of Persephone for the painting of the rape of Persephone that decorated one of its inner walls, to the left of the entrance. Other walls showed the young goddess's sorrowing mother Demeter, Hermes, a distressed companion, and the Three Fates. The style is vivid, sometimes sketchy, but never less than totally assured in delineation of dress, gesture, and emotion. We show the main scene. The shaggy-haired god is leaping on to his chariot with the terrified Persephone grasped in his left arm, her body naked but for part of his cloak that covers her belly, her arms flung upwards and back towards her companion in despair, her hair wild, her expression distraught. Barely a century earlier such a scene of violence would have been shown with as much action but with no attempt at such deeply emotional depiction of features. The use of colour and the hatched shading of body contours lacks something of the precision that we might expect of the traditional 'Classical', but that precision was not an end in itself, and the artist's attempt to express the ethos of a scene, the pathos of a figure, is better served by these new painting techniques.

145 The painting of a hunt decorated the top frieze of the façade of Philip II's tomb at Vergina. The surface is sadly pitted but the composition can be recovered in all its detail and it reveals a frieze in which, for the first time in our knowledge of Greek art, landscape is admitted as a

145 Philip II tomb façade painting at Vergina

positive element in the scene, contributing to a real sense of depth. This was clearly an effect that could be even better exploited in a panel than in a frieze, but here the artist presents a panoramic view in which the eye moves from figure to figure effortlessly, held only by five focal points: the two figures at the left, one with the dead deer, the other galloping off into the background (an unthinkable pose for any realistic rendering in any earlier period); then two busy with dogs and boars; the centrepiece, a rather wild-eyed horseman, wreathed, perhaps the young Alexander; then three, one on horseback, attack a lion; and at the right there is one confronting a bear, another with hunting net. Philip died in 336 BC and the painting must have been done soon thereafter. The vase [140] is not much earlier; comparison shows how little by this date drawing on vases, even of quality, can tell us about the major art of painting. And the discovery of the tomb of Philip tells us how much we have still to learn of what the fourth-century painter could create.

146 The silver jug from Philip II's tomb was made with a separately cast rim and handle, and the satyr's head at the handle junction, a finely observed study of an only moder-

146 Silver jug from
tomb of Philip II
(Thessaloniki,
Museum)

ately animal humanoid. The manner of construction is the
usual one for metal vessels of the Classical period, as it had
been in the Archaic, but we know it better from bronzes
since more have survived. Silver was too precious to escape
frequent re-melting, even for coinage, in an age when the
artistic quality of works such as this was not as highly val-
ued (at least in monetary terms) as it is today. This is why
ancient silver plate was often inscribed with its weight, by
which it would be primarily judged. The most important
sources for our knowledge of Greek silver lie at the edges of
the Greek world in tombs such as this or around the Black
Sea, or beyond it in tombs and hoards of non-Greeks such
as Thracians and Scythians.

147 (**Colour Plate XII**) In the antechamber to Philip's
tomb there was the burial of a woman, her ashes in a gold
casket wrapped in two pieces of cloth, decorated with gold
thread and purple wool. The florals, birds, and wave pat-
terns are familiar enough from other media of the day, and
their appearance on this very rare survival of Classical tex-
tile demonstrates again the essential unity of the arts and
uses of decorative ornament in Greece. The design here
could have appeared as easily in painting, mosaic, or relief
in metal or stone (compare [**121**]), and can hardly be
judged especially suitable for textile. Our view of Greeks
dressed in the austere whiteness of their familiar statuary
should be tempered by this view of the appearance of finely
decorated cloth. In the Classical period the names of

painters associated with sculptors of marble are recorded;
we may judge that they had more than body make-up to
supply to the figures.

148 (**Colour Plate XII**) In the gold casket with the
woman's ashes and cloth was a gold diadem of unrivalled
intricacy. Its patterning is very like that of the cloth [**147**]
despite the totally different medium. The florals are not
naturalistic but use natural forms to describe symmetrical
arabesques, with the usual Greek disregard for nature
when pattern and proportion were the paramount con-
cern. Very close inspection reveals golden bees at work in
the florals, birds in the palmettes. The latter's flame leaves
had appeared before in Greek architectural and other dec-
oration and will become *de rigueur* in classicizing arts.
Colour is now admitted to set off the gold in the form of
glass inlays in some flowers and petals. The conceit of
adding insects to gold flowers goes back to the seventh
century in Greece.

149 Philip's tomb also yielded a series of ivory appliqués
that had decorated a couch—the precious counterparts to
the clay appliqués and reliefs already remarked [**115 A,
B**]—and there were gilt ivory reliefs on his shield. The dec-
oration from a couch was also found in another and
slightly later tomb at Vergina, the Prince's Tomb. We see a
bearded man holding a torch and looking tired though
merry, supported by a woman, whose Classical features
betray no sign of either sympathy or disgust, and preceded
by a young piping Pan. Hair and parts of the dress were
gilt, and there was once no doubt some painting, leaving
the bare ivory flesh. In Philip's tomb the couch stood
before the sarcophagus which contained a gold box with
Philip's ashes; and beside the couch was a table from which
the silver jug [**146**], with the rest of a drinking service, had
fallen. It is not often that Greek works of art are recovered
in conditions that make them no less valuable as evidence
for Greek burial practices.

149 Ivory group from Prince's Tomb, Vergina (Thessaloniki, Museum)

4 THE HELLENISTIC PERIOD

R. R. R. SMITH

THE golden age of Hellenistic art and culture was the third century BC. The new Macedonian kingdoms had emerged from the wars of Alexander and his Successors, and Rome had not yet appeared to darken Hellenism's western horizon. It was in this period, in the great capital cities like Alexandria and Pergamum, that the most striking and enduring artistic innovations were made. Many of the major innovations remain familiar today as central elements of the western art tradition: individualized portraiture, baroque figure style, genre realism, painted landscape. Extraordinary variety is a leading feature of the art of this period, but many of its products also share a distinctive appearance very much their own, broadly characterized by a strong, seductive realism and outstanding technical refinement.

Hellenistic artists inherited the forms of Classical art but transformed and vastly expanded its repertoire. New subjects were introduced and new styles evolved to represent their particular character. The wide range of expression of Hellenistic art—from thundering heroes to smiling nymphs—reflects the new ideas and concerns of new patrons that emerged in the wake of Alexander the Great's conquests. Artists and patrons after Alexander inhabited a world with hugely expanded frontiers. The conquest of the east, the new cities, and the courts of the Macedonian kings constituted a dynamo for far-reaching innovations in art.

Alexander's conquest of the Persian Empire gave him a kingdom stretching from Greece to Afghanistan. He died at Babylon in 323 BC at the age of 33 leaving no suitable heir. For the next forty years, his leading generals and their sons fought a series of intestine wars for control of all or parts of Alexander's empire. From these struggles there emerged in the early third century the three main Hellenistic dynasties, each with its separate territorial kingdom—the Ptolemies in Egypt, the Seleucids in Syria, and the Antigonids in Macedonia. These remained the three great powers in the Greek east until the arrival of the Romans in the second century BC. Several smaller kingdoms began to break away during the third century—the best known is that of Attalid Pergamum. Owing to accidents of survival and excavation we know more of the art and architecture of Pergamum than of those of any other Hellenistic capital. The later Hellenistic period saw the gradual elimination of the major dynasties by Rome. The last Ptolemaic ruler, Cleopatra VII, was removed in 30 BC.

In the period after Alexander, art and architecture came to be commissioned from a wider range of sources. The kings were the most important new patrons, and many significant new features of Hellenistic art can be traced to their initiative. Beside their steady demand for royal portraits, the kings also commissioned the best artists of the day to make great victory monuments, like the Attalid Gallic groups [200], and great battle paintings, like that preserved in the Alexander Mosaic [165]. The royal

courts also provided the richest markets for the finest in Hellenistic luxury arts, like silver and mosaic. The royal capitals set the fashions in such things for the wealthy everywhere.

Although the old world of the city-states was subordinated to Hellenistic monarchy, the *polis* continued to flourish as the main unit of Greek political and cultural life. The Greek cities remained, as in the Classical period, major patrons of the arts. Most conspicuous here was a new species of monument, the honorific statue. Kings, local leaders, eminent orators, and even star playwrights and philosophers could receive in return for outstanding service or benefactions to the community the prized honour of a public portrait statue in bronze. The hundreds of surviving inscribed decrees passed by city councils and assemblies attest to the rapidly increasing numbers of such benefactor statues. Public space in the Hellenistic cities soon came to be monopolized by these 'honours' in bronze.

In the Hellenistic period one can for the first time speak of a real middle class—a well-to-do bourgeoisie between rich aristocrats and the poor majority. The widening social range of patrons and private art commissions is seen, for example, in the greatly increased quantity and variety of small bronzes and terracotta figurines made as votives for the gods or to accompany relatives in the tomb. Funerary art was the most vigorous area of private patronage. City cemeteries and the tomb streets lining urban access roads were the most important context for the self-representation of the ordinary citizen with some money to spare. Marble monuments, statues, and reliefs were available in a full range of scales and quality to suit most middle-class pockets.

Hellenistic art cannot be studied through the careers of its great artists, not only because so much of their work is lost, but also because the surviving literary documentation is so poor. There was once a large body of Hellenistic art-historical literature, but the later sources on which we now depend—chiefly Pliny the Elder and Pausanias—were interested almost exclusively in the Classical period. Pliny's account of Greek art continues to the early third century and gives some valuable information about the sculptors and painters who worked for Alexander and the first generation of Hellenistic kings. And Pausanias describes a series of cult statues made by the sculptor Damophon of Messene in the early second century BC of which we have considerable remains [189]. For the most part, however, we cannot connect surviving works with well-known names. There is a notable increase in the number of sculptors' signatures that survive, and indeed the signing of all artefacts becomes more common in the Hellenistic period. Signatures on mosaics and silverware, for example, reflect the enhanced technical and artistic sophistication now applied to such media. Although we have few signatures that are still attached to major works, they can provide other, more general information.

Together literary sources and signatures suggest that the best Hellenistic painters and sculptors enjoyed a remarkably high social and economic status. Top artists like Lysippus and Apelles travelled widely and commanded greatly inflated prices for their works. Artists who enjoyed royal favour clearly had considerable social prestige: we hear of kings visiting painters in their studios, and anecdotes reveal artists dining at the Alexandrian court as nothing unusual. Many sculptors, like the Polycles of Athens, worked in a family business handed on from father to son, and in the major cities there was clearly an excellent living to be made from the manufacture of civic honorific statues. In the third century, a sculptor could charge 3,000 drachmas for a bronze portrait statue at a time when the average labourer's wage was one drachma a day.

Vitruvius, our only surviving architectural writer, was also most interested in the Classical past, and we therefore know few architects of our period. The creators of the new Hellenistic urban planning remain nameless. The architect whose work we know best, Hermogenes of Alabanda, was concerned with the theory and aesthetic refinement of the plans and orders of peripteral temples, in the manner of

Classical architects. Refined temple proportions, however, were not what attracted the most creative architectural thinking of the period.

The main challenge facing architects was the planning of new cities and sanctuaries in the east. There were royal capitals to design and build, as well as scores of lesser cities founded by the kings—the many Antiochs and Seleucias that populated Hellenistic Asia. It is natural, then, that some of the most important new features of Hellenistic architecture should lie in the realm of urbanism and planning. Ideas pioneered in the new foundations were soon imitated in older cities, many of which redesigned their urban centres during the Hellenistic period. Although based on the familiar principles of Hippodamian grid-planning, the major Hellenistic cities would have offered a Classical visitor a grander, more immediately impressive urban environment. The key differences lay in the careful integration of public buildings into the city grid and in their monumental treatment. Agora, theatre, gymnasia, and sanctuaries all received architecturally defined positions within the city plan. The small city of Priene provides the most complete example of this new rational urbanism [151]. The new planning achieved its ends with the adaptation and multiplication of quite simple architectural forms. The basic elements were terraces, stoas, and peristyles—these were flexible units capable of extensive variation and combination. In the planning of individual complexes, there are several new features of major importance. Most fundamental is the idea of combining the various components of a complex into a single architectural ensemble. Most striking perhaps is the swift emergence of the idea of axial symmetry in sanctuary plans, for example at Lindus in Rhodes [152] and at Magnesia.

Major temple projects, the pride of Classical Greece, were still undertaken in the Hellenistic period, but the innovative excitement that brought temple proportions to a theoretical 'perfection' was less keenly felt. The huge temples at Ephesus and Didyma, replacing Archaic predecessors, strove for a traditional effect of sheer scale and sumptuous ornament, while the more 'modern' sanctuaries at Cos and Lindus placed the main emphasis on the scenographic effect of the whole complex, paying little attention to the temple proper and to refined detail. At Pergamum, the sanctuary of the Great Altar omitted the temple altogether in favour of a colossal stepped altar that carried all the architectural trappings of a temple [155]. This is a good example of the way that Hellenistic designers liked to manipulate the traditional building repertoire for novel effects.

With the possible exception of royal palaces and tombs, Hellenistic architects were called on to provide few completely new building types. Generally, the religious, social, and cultural needs served by architecture did not suddenly change after Alexander. However, it is no accident that the most prominent, most characteristic examples of building types like the Greek theatre and stoa are Hellenistic. A whole range of buildings which to the Classical mind had not fully deserved a proper 'architectural' design now received one. It was in this monumental treatment of more or less secular public buildings that Hellenistic architecture most visibly transformed its Classical heritage. Most conspicuous and numerous were the stoas. Stoas might be architecturally unpretentious parts of a larger complex, but they could also be great buildings in their own right. The stoa of Attalus in Athens [156], for example, both defined the east edge of the old agora and was in terms of scale and careful design a building of near-temple quality.

In a period when city-state democracy was under threat, it was natural that buildings like the council house and theatre, which housed two of democracy's most cherished institutions, should also have been 'fixed' in monumental architectural form. The council house was the home of the *boule* or council, and the theatre, apart from accommodating the periodic dramatic festivals, also functioned as the regular meeting place for the *demos* or citizen assembly. The gymnasium was another key civic institution which

now received a defined architectural form—a large enclosed peristyle, with various alcoves (exedrae) and rooms that opened off the back of its porticoes.

The peristyle idea, of an open court surrounded by porticoes, was one of great potential and was applied simultaneously in palace architecture. Peristyles control the central design of palaces at Vergina [160 A], Pergamum, and Aï Khanoum (Afghanistan), and can be seen in flexible variation of scale and form in the great town mansions of the Macedonian nobility at Pella and in the rich middle-class housing of late Hellenistic Delos. Palaces and palatial houses deploy similar combinations of colonnaded peristyles and suites of rooms to the gymnasia. Their effect of open, half-open, and covered spaces was later applied with much architectural sophistication in Roman villas.

Previously, monumental tombs had been built by Greek architects only for Hellenized oriental potentates like Mausolus [113]. Now Macedonian kings and others followed their lead. Some tombs, like that at Belevi, adapted the recognized Mausoleum formula. Most common in Macedonia, however, were façade tombs with strong barrel-vaulted chambers behind that could carry the load of an earth tumulus. Their impressive façades [161] with engaged 'blind' orders, sometimes in two storeys, probably reflect the prestigious architecture of palace entrances.

The palaces and peristyle houses of the rich were the primary context for the many and varied arts of Hellenistic decorative craftsmanship—mosaic, furniture, silverware, wall-painting. In the early Hellenistic period, the stringent domestic morality of Classical democracy—the contemporaries of Alcibiades had affected outrage when he painted the walls of his house—gave way to the elaborate decoration of private life with all that fine craft could offer. Social change, the example of the Macedonian kings, and new wealth created an unprecedented demand for luxury arts. The greatly increased quantity of mosaic, silverware, and jewellery surviving from the Hellenistic period is testimony to this change. For demanding new patrons, Hellenistic craftsmen began to apply the repertoire of major art to decorative media. They also evolved a wealth of new ornamental motifs and made some technical innovations of lasting importance—for example, the cameo technique in gem-engraving and the tessera technique in mosaic.

Indeed, mosaic as we know it, that is, mosaic made of cubes of cut stone and glass (tesserae), was first developed in the Hellenistic period. The older technique of pebble mosaic, made from natural river pebbles, was brought to its greatest refinement in the later fourth century in the mansions of Pella [175] and then largely abandoned in the face of the self-evidently superior tessera technique, which was introduced in the early or middle third century. The advantages of the new technique were both practical and aesthetic. It offered a greater range of stones and colours; details could be rendered with ever finer grades of tesserae; straight lines in patterned borders were easier; and figure contours could be defined with a hard outline. Tessera mosaic both looked better and was more comfortable to walk on.

The designs of mosaic floors vary within quite narrow limits. Plain mosaics with simple borders were naturally very common. Prestige mosaics for reception rooms and dining rooms followed the basic format of their pebble counterparts, that is, a central pictorial *emblema* with its own frame, set in a larger plain field with an outer patterned border. The field and borders were usually of larger tesserae, while the figured *emblema* could be of extraordinarily fine tesserae. There was a clear division of work, and fine *emblemata* could be bought separately and set in a floor already made.

Domestic wall decoration, preserved on Delos for example, seems mostly to have consisted of moulded stucco and painted and polished plaster that imitate the expensive fine-channelled masonry and miniature engaged orders of marble walls. Only occasionally are there small figured friezes within the fictive masonry schemes. Elaborate architectural perspectives and figured panels painted directly on domestic walls both seem to have been a later, Roman phenomenon.

In the early Hellenistic period the regular use of silverware came within the reach of a much wider social group than before. Fine painted pottery all but disappears to be replaced at a lower level by a range of stamped and plain pottery wares. A great range of Hellenistic silver survives, designed mainly for the table and for drinking: buckets, jugs, plates, bowls, cups, strainers. These vessels display great technical finesse and elegance of design. The most elaborate cups usually consist of repoussé floral work on the exterior and separately attached figured *emblemata* inside. Other shapes concentrate on simplicity of form and sharp, highly detailed ornament.

Beside table silver, the liquid wealth of the well-to-do was also displayed in the gold jewellery worn by the women of their households. Hellenistic jewellers developed an extraordinary range of hair and body ornaments of gold: diadems, tiaras, medallions, bracelets, anklets, belts, necklaces, and, above all, a spectacular variety of extravagant ear-rings. New types, new shapes, and new techniques were introduced. Most striking perhaps are the novel polychrome effects of enamels and coloured stones like garnets and amethysts and the introduction of miniature figured elements—little Erotes play the leading role here. The overall effect of Hellenistic goldwork is one of sumptuous richness and exuberant virtuosity.

The Classical period had broken important ground in naturalistic pictorial representation. Its artists had discovered foreshortening, shading, highlights, and some idea of recession. The battle between proponents of line versus colour had already been fought. Hellenistic painters made great strides in linear perspective and added a great variety of new categories of painting: portraits, landscape, genre, still life. Perhaps their most important legacy that we can glimpse was a much greater sense of pictorial setting, of man in a real environment.

Although the great panel paintings of the Hellenistic period have all perished, we can at least outline their subjects and character from a combination of sources, written and material. Literary evidence is helpful in giving titles and descriptions of paintings, and names of painters and their patrons. We can thus form some idea of the repertoire of major painting and how it was affected by new patrons like the Macedonian kings. The surviving material evidence is more difficult to assess precisely. Hellenistic painting created a huge reservoir of pictures on which other arts drew for subjects and iconography, both during the Hellenistic period and for several centuries after. That original reservoir is now lost, but we have a great quantity of surviving reflections and imitations, contemporary and later. Contemporary reflections can be seen in tomb paintings, painted gravestones, and mosaic pictures, while the fresco and mosaic decoration of Roman houses, especially at Pompeii, preserves copies and versions of specific Hellenistic pictures. These two bodies of material are distinct: some of the Roman pictures are attempted reproductions but they are much later than our period and rarely of the best quality, while the surviving Hellenistic material consists only of loose imitations of major painting.

The focus of Classical painting had been city commissions for large panel pictures displayed in series in public buildings. Such commissions were now joined by those of Macedonian kings and rulers. These range from great historical set pieces, like battle or wedding pictures, to single-figure portraits. Much of this repertoire can be seen or at least glimpsed in the surviving record—for example hunt paintings at Vergina [145], battle pictures in the Alexander Mosaic [165], portrait figures at Levcadia [161].

The origins of the various forms of landscape painting found later in Roman wall-painting are much disputed. One distinctive and major branch, mythological landscape, in which small figures inhabit a vast landscape setting, is certainly Hellenistic. The finest example is the great Odyssey frieze [169], which copies and excerpts a longer Hellenistic original. It was probably in painted mythological friezes of this kind that Hellenistic artists evolved the technique of 'continuous narrative' in which the same figure can appear in successive parts of a single frieze or even in different parts of the same scene. Genre landscape,

featuring peasants and rustic shrines, may also have been Hellenistic in origin. Still life and erotic painting are both attested in literary sources as parts of the repertoire of some Hellenistic painters, and both categories are well represented in Roman frescoes and mosaics. Few of the Roman pictures of this kind, however, are of a standard of design and detail to suggest they rely on particular Hellenistic works rather than merely on a Hellenistic idea.

Several important and distinct species of painting were generated by the theatre. As branches of major artistic endeavour, some of these would be less familiar to modern eyes than, say, landscape or history painting. Most significant in terms of scale and regular commissions must have been scene-painting. The new stage buildings of the early Hellenistic theatre such as that at Priene required large painted panels (*pinakes*) for both the stage front and the stage wall behind. Vitruvius describes the main categories of Hellenistic scene-painting in general but clear terms. Satyr plays, which took place in the countryside, had landscape backdrops ('trees, caves, mountains'); the New Comedy required a bourgeois urban setting and so had townscapes or 'house-scapes', featuring 'the balconies and windows of apartment buildings'; and tragedy, which usually takes place in front of a royal palace, had grand palatial façades ('columns, pediments, statues'). It was probably only for the specific category of 'satyric' scene-painting that Hellenistic artists employed pure landscape in the modern sense with no human figures. And it was surely in the context of the large pictorial representations of towns and façade architecture demanded by comic and tragic sets that Hellenistic painters came to grips systematically with linear perspective. It is no accident that the regular Hellenistic term for perspective painting was *skenographia* or 'stage-painting'. The vocabulary of this architectural painting was adapted with great versatility and inventiveness by the domestic wall-decorators of late Republican Italy. Lesser categories of theatre painting included pictures of actors and musicians preparing themselves in the dressing room and pictures of famous stage scenes from well-known plays. Versions of stage-scene pictures are found already in late Hellenistic wall-paintings on Delos and are copied in mosaics at Pompeii.

There was one other, quite separate branch of Hellenistic painting of which we have no direct record but whose influence can be felt in various contexts—that of scientific illustration. The Museum at Alexandria was among other things a great research centre for the natural sciences. Here the Aristotelian programme of the empirical categorization of the natural world was carried on under royal patronage. Advanced botanical and zoological taxonomy naturally requires accomplished technical drawing. Precise, objective observation characterizes Hellenistic representation of animals and plants in general, but a more particular reflection of scientific illustration can be seen, for example, in the mosaic copies of Hellenistic fish compositions [173]. These were both detailed scientific inventories of marine life and brilliant pictorial designs. Literary sources refer to a related area of geographical painting as 'topography' (literally, place-painting) and 'chorography' (country-painting); and we hear of an Alexandrian painter known as Demetrius 'the topographer'. The famous Nile Mosaic at Palestrina [174] combines both taxonomical drawing of animals and some kind of 'chorography' of the Nile valley and delta. It no doubt reproduces a great Ptolemaic picture that promoted both these branches of scientific painting to the level of high art.

To a modern visitor returning to ancient times the role of architecture and painting in the Hellenistic world would be for the most part immediately comprehensible. The role of sculpture on the other hand might astound him. Statues, already numerous in Greek sanctuaries, multiply enormously in the public space of the Hellenistic city. Never before had so many of society's chief concerns been symbolized or embodied in statues. There was not only increased quantity but also an astonishing new variety of subjects and styles. Perhaps the most important feature of Hellenistic sculpture is the

representation in major statues of a whole range of figures that had previously only appeared in the minor arts: boisterous centaurs, decrepit peasants, demure middle-class ladies.

Most major statues were of bronze, and very few of these have survived. We have instead many marble figures that were mostly not the best works of their day and many later marble copies made in the Roman period. The copies supply examples of the prestige bronze dedications now lost, while the marble originals represent a much wider social range of sculpture, from near the best to more routine production.

Cult statues of major gods remained important commissions and, since they were very often of marble, some fine examples have survived. Later versions and copies give us others. Familiar gods of the Olympian pantheon like Zeus and Apollo were restyled by means of a more lifelike and immediate sculptural technique, while new deities like Serapis and Tyche were equipped with fresh and distinct divine 'portraits'. Many old but junior deities, like the Muses and Eros, were now promoted to the realm of major statuary. Broadly speaking, it was the repertoire of divine images as defined or redefined by Hellenistic sculptors that provided the accepted image types of the major gods for the rest of antiquity.

Portrait statues outstripped all others in terms of sheer quantity. They have also an impressive range in terms of expression and character. There was no doubt a connection at a general level between the swift rise of the honorific statue in the early Hellenistic city and the emergence and regular use of carefully differentiated, individualized portraiture. We have an astonishing series of portraits of rulers, philosophers, orators, generals, poets, and politicians. It was the sculptor's task both to define the public role of the subject—his character as politician or philosopher, for example—and, within that norm, to portray some identifying features of the person as an individual. In royal portraits the expression of a youthful, godlike character often left little room for real features, but most other categories achieve an extraordinary blend of the general and the particular, one that combines a strong sense of a real individual and a generalized statement about the sphere of excellence in which the sitter earned the honour of a public statue. The most remarkable and influential creations of this type are the philosopher portraits [214–17].

Athlete statues awarded, as before, for victories in games, often retained generic ideal features, but there is a striking new trend towards representing different kinds of athlete, often with remarkable realism. Classical athletes were mostly differentiated by pose or by attributes like a discus or spear. Hellenistic sculptors can distinguish boxers, sprinters, and wrestlers by closely observed distinctions of bodily form. The new range of body types seems to reflect the increased athletic professionalism of the period [211–12].

Mortal women also begin now to appear regularly in major statues for the first time. In massive imposing marble figures, sculptors invented a whole range of elaborate new drapery compositions to represent the fine dresses and shawls of the wealthy Hellenistic wife. Great quantities of these draped female statues survive from the Hellenistic east and reflect an enhanced social and economic role of women especially in the later Hellenistic period.

The great sculptured groups with historical and mythological subjects cannot have been frequent commissions, but they were probably the most prestigious ones. They are known almost exclusively in later copies and have little or no documentation. They were perhaps most often royal or state dedications set up as thank offerings for victories in war. It was probably in works like the Pasquino and the Gallic groups [199, 200] that the baroque style was born, a style of heightened dynamic idealism designed to represent the epic struggles and suffering of great heroes. The style is documented best at Attalid Pergamum, and it was perhaps in origin a 'royal' style—that is, first and most typically employed for heroic groups commissioned by kings.

Like baroque heroes, the figures from the world of Dionysus—the satyrs and centaurs—are among the most characteristic of Hellenistic creations [204–10]. Satyrs had appeared among Praxiteles' statues, but the full complement of the Dionysian thiasos now appears in statuary of the highest level. We have, mostly in later copies, an extraordinary array of statues of satyrs, centaurs, Bacchants, and nymphs. Other figures which now join the Dionysian realm, like Pan and Hermaphrodite, also appear in major statues. Many of the remarkable series of Hellenistic genre figures—the emaciated peasants, fishermen, and market women—wear Dionysian attributes like ivy wreaths and should also be considered part of the wider Dionysian landscape. Like the satyrs and nymphs, they are anonymous figures of the countryside, without true identity. The sinewy muscled satyrs and powerful centaurs have close formal relations to the baroque, but, whereas the baroque is a grand and serious style, the creatures of Dionysus are light, playful, smiling figures that express the benign care of the wine god. The highly inventive repertoire of Dionysian art was deployed in all Hellenistic media—painting, mosaic, silver, gems, jewellery—and remained of immense importance for the rest of antiquity. It is in the Dionysian realm that a Hellenistic love of the exotic, the sensual, and the extreme is most fully represented. Here the figures portrayed range from the very young to the very old, from the charming to the deliberately repellent, from the lustful goatish Pan to the beautiful, sexually ambivalent Hermaphrodite. It is here too that one can feel best the immediacy and sheer physicality for which Hellenistic sculptors strove. It was to represent the sense of living bodies of flesh and blood that their formidable panoply of realistic forms, styles, and techniques was designed.

The Hellenistic world bequeathed to its Roman conquerors a massive artistic legacy. The Hellenistic inventories of architectural planning, of individualized portraiture, of divine and mythological iconography, and of ornament of every kind provided the root ingredients and often the substance of Roman art. Perhaps the most important parts of this legacy were the unquestioned principle of the supremacy of realistic representation and the idea of appropriate styles for given subjects and contexts—senators' statues should be distinguished from those of heroes by more than their togas. On a purely practical level, the Hellenistic world also handed down an unbroken tradition of technical mastery in all the fine and applied arts. This continuity was not something abstract, but came in the form of the families, workshops, and individual artists that migrated or were forcibly taken from the Hellenistic east to Italy in the second and first centuries BC.

In their judgement and acquisition of Greek art, most Romans preferred what they regarded as the purer ideals of Classical Greece, and under Augustus it was the language of Classical art that was adapted for imperial monuments at Rome. Hellenistic art, however, remained permanently embedded in Rome's decorative art and in its architectural ornament.

ARCHITECTURE

150 Pergamum is the most thoroughly excavated of the Hellenistic capitals and provides the clearest picture of Hellenistic royal architecture and planning. The Attalids achieved recognized royal status only in the 230s BC, after their wars against the Gauls under Attalus I, and the period of their greatest power was under Eumenes II in the second century when loyal support of Rome earned them the control of much of western Asia Minor. Pergamum was thus a relative latecomer to the Hellenistic world stage, but sought to present itself as a model Hellenistic capital. The kings spent lavishly on cultural politics abroad, for example at Athens, and turned the Pergamene acropolis into a magnificent show-piece of 'modern' architectural design.

The acropolis rises abruptly out of the surrounding plain, and its descending terraces would have formed a striking ensemble and one that was visible from a great distance. A huge, steeply ramped theatre was built against the curving western side of the hill, and the main terraces of the acropolis radiate loosely from its curve. They are bounded and articulated by stoas, but remain open to the

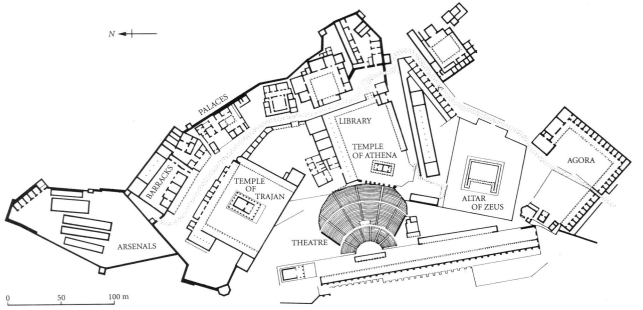

A

150 Acropolis of Pergamum (**B** model, Berlin, Pergamum Museum)

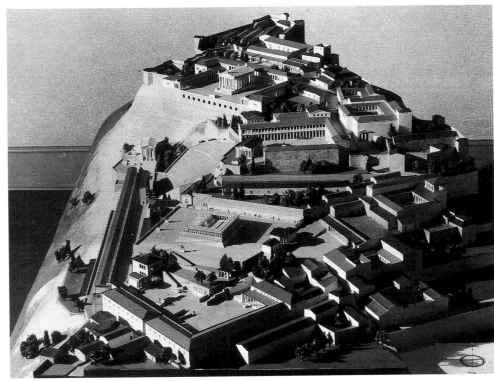

B

west, commanding superb views over the theatre to the plain below. The kings lived on the acropolis, and access to it was no doubt carefully controlled.

On the central terrace, roughly on the axis of the theatre, was the sanctuary of Athena, surrounded by a two-storey stoa. Its temple was an earlier, modest Doric structure, set obliquely near the edge of the terrace. This sanctuary was the religious and cultural heart of Attalid Pergamum. Here the kings set up their most prestigious statues and dedications from the Gallic wars, and they annexed to it a large library, presided over by a great statue of Athena, modelled after the Athena Parthenos of Phidias [106 B]. The next terrace below was the setting for the Great Altar, the grandest sculptural commission of its day. The lowest terrace was an *agora* with a small temple, while the uppermost terrace was built in its present form much later, for a temple to Trajan.

Disposed loosely behind the main terraces were various utilitarian and domestic buildings. The royal palace, comparatively small in this restricted space, was set modestly behind the sanctuary of Athena, but so close to it that a connection with the house of the goddess would inevitably suggest itself. The curving composition of the whole is closed below by the long theatre terrace, backed by an extended stoa and supported on an imposing buttressed wall.

Urbanism and ensemble planning constitute a major area of Hellenistic architectural innovation. Pergamum is the best example of a flexible scenographic urbanism that exploited the forms of a difficult site to create a varied and imposing display. The Attalids probably had in mind the Acropolis at Athens with its temple of Athena and theatre below. They aimed to outdo the prestigious Athenian model by deploying all the most advanced features of Hellenistic planning.

151 Priene offers a classic example of Hellenistic public planning for a small city-state. The site has been admirably excavated and its full plan recovered. In the later fourth century the Prienians moved their city to a more advantageous location. They chose a sloping site beneath a mountainous cliff near the mouth of the River Maeander. Across the estuary was the long-established city of Miletus, the home of Hippodamus, the famous urban theoretician of the fifth century BC. Miletus was a model of orthogonal planning, and the Prienians no doubt looked to its example. The new city was laid out in the late fourth century and built up over succeeding years. It is essentially a third-century town with some second-century improvements.

The housing grid was laid over the site with some imagination. Narrower streets with steps run up and down the hill, while the main access avenues run across the slope and in two minor valleys on either side of the temple ridge. The city wall, built of finely squared masonry, follows the land and rises behind to take in part of the clifftop above.

Classical 'new towns' like Olynthus [111] had similar housing grids, with spaces reserved for public building. What is new in Hellenistic planning is the handling of the public spaces. They are incorporated thoughtfully into various parts of the grid and are treated monumentally. Priene is a compact model version of this new urbanism. We see here how all the main institutions of Greek city life were given architectural definition: an agora with an expensive council house attached, a theatre built against the steepening slope, and a gymnasium in the lowest part of the town, terraced and buttressed above the city wall. These secular complexes all have a monumental aspect. The main temple, a fine Ionic peripteros, is raised effectively on a natural ridge, but in the townscape as a whole it has no more weight than the agora complex or the theatre.

The agora at Priene provides a good example of one of the driving ideas of Hellenistic architecture—the combining of the various components of the complex into a single ensemble. Unlike some contemporary sanctuary plans (e.g. Lindus [152]) the democratically inspired civic agora avoids the authority of a closed axial design, preferring a monumental rectangular space that has some symmetry but no commanding focus. The agora was laid out on a flat terrace and enclosed on three sides by stoa porticoes. Across the open fourth side runs one of the main city avenues, beyond which there is a separate, more imposing stoa, set back on its own terrace. In front of this stoa, street and agora space are fused ambivalently.

One consequence of such impressive agora architecture was that it tended to push out ordinary commerce to other locations, leaving the agora as a showcase for political and civic display. This function is strongly marked at Priene by the great line of bases for benefactor statues which turned this part of the agora into a kind of avenue of monuments.

Enough is known of the plans of other new cities in the Hellenistic east, for example Alexandria or Seleucid cities like Apamea on the Orontes, to see that they had rationally ordered housing grids within which major civic complexes were organized. Priene remains, however, the clearest and most fully documented case in which the controlling ideas of this new urbanism can be visualized.

152 When the citizens of Lindus in Rhodes undertook a major rebuilding of their famous sanctuary of Athena in the third century, they did not—as a Classical architect might have done—simply replace the small and old-fashioned temple of the goddess with a new and larger one. Instead, they constructed an impressively planned architectural setting for the old temple which was already perched dramatically on the edge of the acropolis cliff. The new design, essentially a grand terraced approach and gateway, combines rising terraces and axial symmetry to striking effect. Emphatic axiality was developed by Hellenistic architects in sanctuary complexes such as this where its evocation of an ordered higher authority was

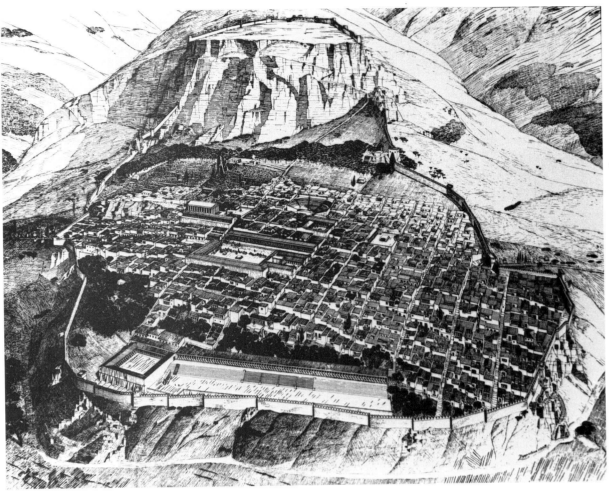

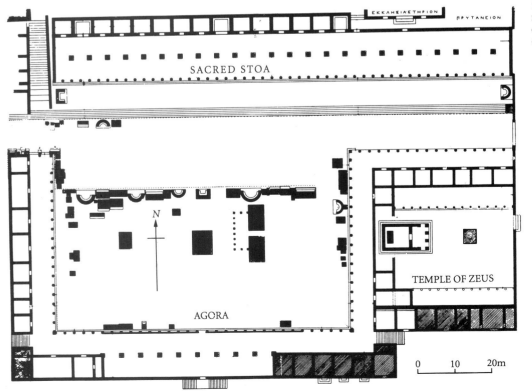

ΕΚΚΛΗΣΙΑΣΤΗΡΙΟΝ ΠΡΥΤΑΝΕΙΟΝ

SACRED STOA

151 Priene,
reconstruction
of city and plan
of central area

N

TEMPLE OF ZEUS

AGORA

0 10 20m

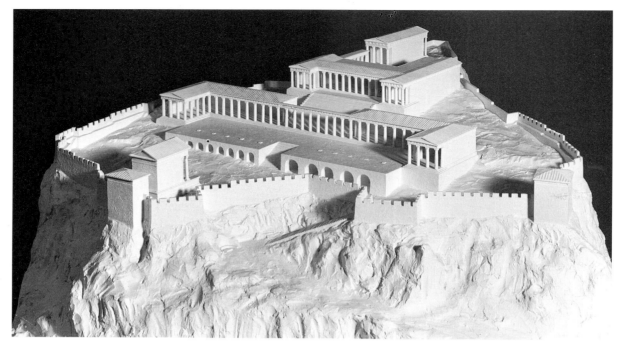

152 Sanctuary of Athena at Lindus, model (Copenhagen, National Museum)

where its evocation of an ordered higher authority was appropriate.

The Lindian acropolis offered a steep and restricted site. The first terrace is reached by a stairway cut through its centre and is framed behind by two L-shaped stoas that embraced the ends of the terrace. The two stoas are connected in the middle by a colonnade—an entirely non-functional columnar screen—behind which a wider stairway rises to another columnar front that repeats the scheme of the lower terrace on a smaller scale. From here one penetrated finally into the small sanctuary space proper, where the old temple stood off-axis and concealed.

The new sanctuary has an immediately effective and coherent plan. It also has considerable architectural sub-

tlety. For example, in elevation the lower colonnade rises to precisely the height of the narrow upper terrace; and in plan the wings of the stoas on both terraces project as far as the transverse line of the tops of their stairways. It is typical of Hellenistic architecture that such refinement be devoted as much to the planning of the whole as to its individual components.

153 The rebuilding of the temple of Apollo at Didyma was probably the biggest temple project of the early Hellenistic period. Begun in about 300 BC, its construction dragged on, funds permitting, for a couple of centuries. It was an Ionic colossus of conservative plan, intended to rival the recently rebuilt Artemisium at Ephesus. Its archi-

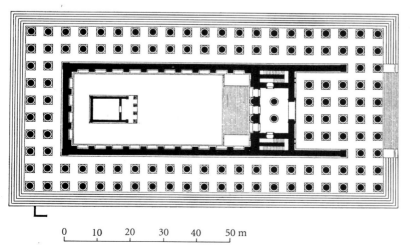

0 10 20 30 40 50 m

153 Temple of Apollo at Didyma

tecture was designed to impress by scale, columnar mass, and richness of ornament—here the old tradition of the temple as a sculptured marble monument continues. The plan is old-fashioned, an enlarged version of its Archaic predecessor, while the carved decoration is thoroughly 'modern'. The plan is dipteral, that is with double surrounding colonnades, and deploys ten by twenty-one columns around a huge walled court that was open to the sky (hypaethral). The front has a deep porch, filled with an impressive mass of three ranks of four columns.

The cella court is sunk below the level of the porch and contains a small separate temple for the cult statue. Access to the cella court was carefully restricted: one entered by two sloping, barrel-vaulted tunnels from the sides of the porch, not by the central 'door', which was raised high above the level of the porch. This doorway was really a high, stage-like window from which priests would have addressed the faithful. The temple housed a famous oracle, and the inner court was probably forbidden to the ordinary visitor.

The ornament and mouldings of the temple are varied and richly carved. The base mouldings of the cella wall, for example, have leaf-and-cable decoration, joined at the corners by inverted palmette designs. The low pedestals of the columns display a great variety of decoration and motifs. The inside of the cella court is articulated by massive pilasters with unusual sofa capitals, and at the top of the great interior stairway the imposing entrance is marked by two engaged columns with Corinthian capitals.

Recently a whole series of finely engraved lines, which were meant eventually to have been removed, were detected on the inside walls of the cella court. They seem to have been working drawings supplied by an architect for use by the masons. One set of drawings, for example, gives a scheme for laying out the entasis, or slight convexity, of the columns. The horizontal dimensions—the width of each column drum—are engraved at their full actual scale, while the (much larger) vertical dimensions are severely reduced for the sake of practicality. This is an early documented example of the use of a form of scale drawing in architecture.

154 The new temple of Artemis Leucophryene at Magnesia was very much a modern temple. It was designed, Vitruvius tells us, by the great Hermogenes of Alabanda (working about 200 BC), a noted theorist of Ionic temple architecture. Unlike the heavy Ionic colossi at Didyma and Sardis, the Magnesia temple employs a lighter design adapted from the purified rational Ionic of the late Classical architect Pytheus—of whom we know Hermogenes was a great admirer.

The Ionic colossi gained imposing effect from their dipteral plan—that is, with two rows of columns around the (narrow) cella instead of one. The Magnesia temple keeps a broad, eight-column façade and a narrow cella that

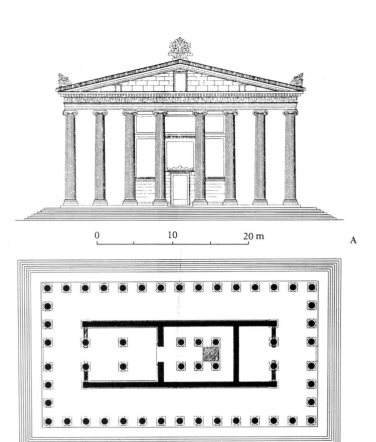

0 10 20 m A

B

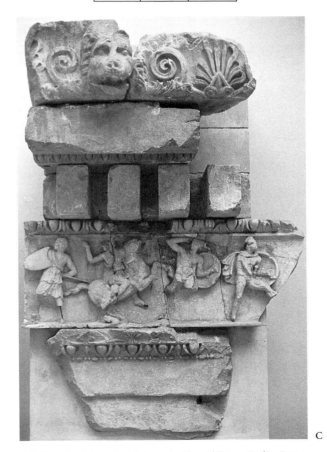

0 10 20 30 m B

C

154 Temple of Artemis at Magnesia (C entablature, Berlin, Pergamum Museum)

such a plan gives, but omits the inner ring of columns. The purpose of this pseudo-dipteral plan was to combine impressive scale and proportions with a lighter, more elegant effect. The omission of more than thirty columns was also no doubt a welcome saving. The narrow cella that results from such a plan was no disadvantage, since the cell's only practical function was to house the cult statue. It would also be easier to roof. The unseemly length of the cella was counteracted by a deep porch equal in length to the cella proper. The porch was closed by barriers and formed a separate hall. Inside the cella, the cult statue was framed within the tight embrace of two short internal colonnades that emphasize the very different characters of porch and cella.

The design of the façade order was canonical 'Pythean' Ionic except that the entablature included both dentils and a figured frieze. The subject of the frieze, an Amazonomachy, continues around all four sides of the building. The architectural sculpture of many Classical temples had been their crowning glory. Here the carving of the frieze is of deliberately mediocre quality. Perhaps, to the rationalist Hermogenes, fine work in this context (19 m. above the ground) seemed to little purpose. The frieze was designed to function not as a legible narrative but as a figured moulding. In the Hellenistic period, architects and masons adopted a much freer attitude to architectural ornament, concentrating less on the sculptural quality of carved marble decoration than on its overall effect.

155 The Great Altar at Pergamum is one of the central monuments of Hellenistic art. Its gigantomachy frieze is the finest example of the fully formed Hellenistic baroque and it was in some ways the *raison d'être* of the whole altar building. Fragments of the architrave inscription show that the monument was dedicated, for unspecified successes, in the second century BC, probably under Eumenes

II and most likely in the years after the Peace of Apamea (188 BC). Parts of the architecture and of the inner frieze were never finished.

The altar consists of a huge stepped platform, a podium crowned by an Ionic colonnade, and a monumental stairway framed by two projections. The altar proper was located in the enclosed court, reached from the stairway through a double columnar screen. Some of the motifs pioneered in the sanctuary at Lindus—stairway, colonnaded projections, and columnar screen—are here deployed on a single building and in more complex form.

Monumental altars, of which Pergamum's is only the biggest and the best known, provide good illustration of the way Hellenistic architects manipulated the Classical building repertoire. Large altars with stepped platforms had been built in the eastern Greek sanctuaries of the Archaic period (e.g. Samos), but are not found in the Classical period. Hellenistic architects revived the idea of colossal altars, but now designed them with the full vocabulary of a peripteral temple. A traditional Greek sanctuary had a large temple with a small sacrificial altar in front of it. At Pergamum, the temple is elided altogether and its impressive columnar architecture is transferred to the altar building.

The architectural form of the monument seems to have been shaped in large part by the colossal frieze which dominates its elevation. Classical temple sculpture was usually positioned too high up for its quality to be appreciated, and Hermogenes had drawn the obvious conclusion at Magnesia: mediocre friezes were adequate for temples. The altar of Pergamum, however, was designed with its frieze at the bottom, where its complex narrative and astonishing quality could be appreciated and experienced close up, like statuary in the round.

The gigantomachy frieze [B–D] was 110 m. long, and is carved on narrow panels 2.3 m. high (roughly one main

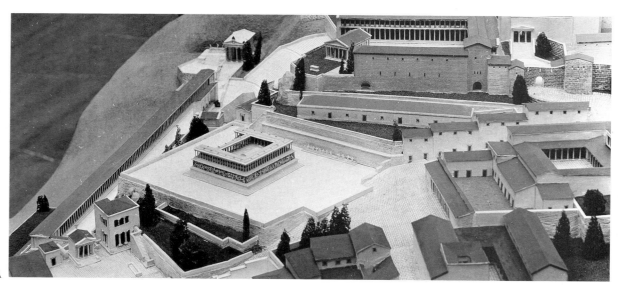

A

155 Great Altar at Pergamum (Berlin, Pergamum Museum).
A model; **B** north wing; **C** east frieze: Athena; **D** east frieze:
Artemis' dog bites giant; **E** Telephus frieze: Auge's boat

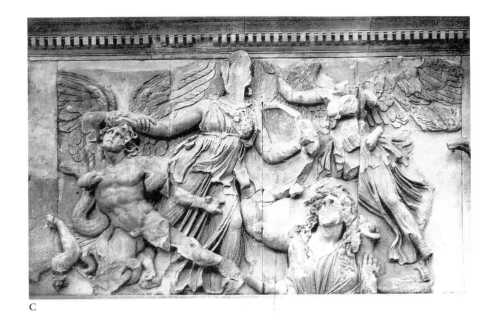

C

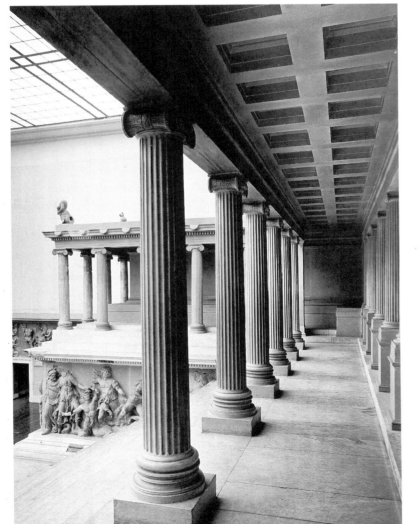

B

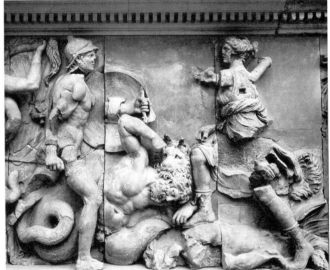

D

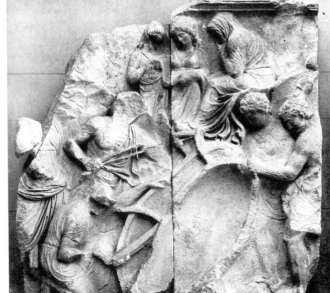

E

figure to each panel). The figures are carved in very high relief, and twist and turn like figures in the round, with little reference to the background. The style is a grand thunderous baroque, designed to represent the epic world of gods and heroes. The figures, which are carved with tremendous vigour and intensity, project frontally and threateningly into the world of the viewer—some giants even crawl out on to the real steps of the altar. Particulars of hair, wing feathers, animal skins, fish scales, and all manner of attributes and weapons are carved in astonishing detail. Such precision and elaboration was normal only on bronze statuary, and the virtuosity of the frieze lies in its reproduction in marble of the scale, quality, and surface detail of bronze statuary. The frieze would also have been painted—drapery and equipment in realistic colours and the background perhaps in a dark colour, against which the naked white figures would have stood out boldly.

The entire frieze was taken up with an endlessly varied battle composition of the gods repelling the monstrous giants from Olympus. The subject had been widely employed in classical Athens to allegorize Greek victory over barbarian enemies, and at Pergamum it would be understood as a broad allegory of Attalid struggles against the monstrous Gauls. The desire of Pergamum to be seen as a new Athens, however, was as important here as specific reference to Attalid deeds. The group of Zeus and Athena, which first confronted the viewer entering the sanctuary, clearly echoed a composition from the west pediment of the Parthenon.

The many figures and scenes of the frieze far exceed any classical models and were perhaps based on a lost epic poem. Some identities remain obscure to us, but the ancient viewer was provided with inscribed labels throughout. The name of each giant was inscribed on the footing course below the frieze, while the gods' names were inscribed in larger letters on the cornice above. Below the giants' names on the footing course were also inscribed the signatures of the sculptors responsible for each section of the frieze. Each signing master seems to have been responsible for about 3–6 m. of the frieze. The inscribed labels for the figures show how seriously the designers took the viewers' needs and how the frieze was designed for viewing at close quarters. The sculptors' signatures are most unusual in this context, and reflect the aesthetic value attached to the frieze.

In the section illustrated [C], Athena seizes a young winged giant by the hair, while Nike flies in to crown her from the side—she is Athena Nikephoros, bringer of victory. Below, sunk in the ground, is Ge or Earth, mother of the giants, begging for clemency for her son. On [D] Artemis' dog sinks his teeth into a giant's neck.

After the unrelieved epic thunder of the gigantomachy, the Telephus frieze [E] that ran round the inner wall of the altar court presented a varied world of tranquillity, adventure, and religious mystery. The frieze was meant to be

seen through the columns of a portico, like paintings on the back of a stoa, and clearly employed a number of pictorial devices—most obvious is the way in which the figures do not fill the full height of the frieze, leaving empty sky above. Many figures are located in various interior and outdoor settings.

Telephus was embraced by the Attalids as the founding hero of Pergamum, and his mythology, taken from a variety of epic and tragic sources, was welded into a complex new narrative that followed Telephus from his conception in Greece via many adventures to his death at Pergamum. In the panels illustrated, four workmen in short tunics are building the small round boat in which Telephus' mother Auge will be cast adrift from Greece. One worker uses a bow drill, shown with great accuracy; another wields a hammer. On the adjacent panel a cauldron of pitch for the boat's caulking is being heated. Auge sits above wearing a veil.

The Telephus frieze takes many liberties with the unities of place and time that normally reigned in classical narrative. It is composed in a series of scenes within which settings and time change frequently and abruptly, while the same protagonists appear in consecutive scenes. This technique of 'continuous narrative' had no doubt been pioneered in painted friezes (in the manner, for example, of the Odyssey frieze [169]). Thus, while the gigantomachy strove for the effect of monumental statuary, the Telephus frieze adapted techniques of contemporary painting.

156 The stoa was one of the most conspicuous secular building types of the Hellenistic city. Stoas might be plain porticoes defining the margins of larger complexes, but they might also be architectural monuments in their own right. The stoa of Attalus, given to Athens by Attalus II of Pergamum in the mid-second century BC, both acted as a prestigious monument and redefined the east side of the city's *agora*.

In plan, stoas could have one, two, or three aisles, with or without rooms behind; and in elevation, they could rise one or two storeys, and deployed the full range of columnar orders. The stoa of Attalus is one of the grandest surviving two-storey stoas and has been meticulously restored by its American excavators. It measures 116 × 19 m., and has two broad aisles with twenty-one large rooms behind them. The façade, more than 10 m. tall, has the usual combination of Doric below and Ionic above. Inside, the lower order is Ionic, as was normal in this position, while the upper storey employs an unusual palm capital, which seems to have been a kind of Pergamene signature motif. The building uses a wide variety of materials, from its noble white marble façade to dark marbles and more functional limestones behind. Stoas were multifunctional buildings which gave space and shade to a whole range of activities in Greek public life—business, retail, public offices, philosophy, art, gossip. The rooms in

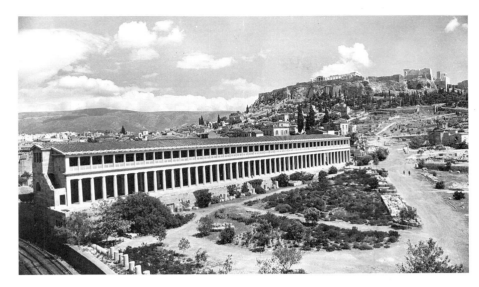

156 Stoa of Attalus at Athens

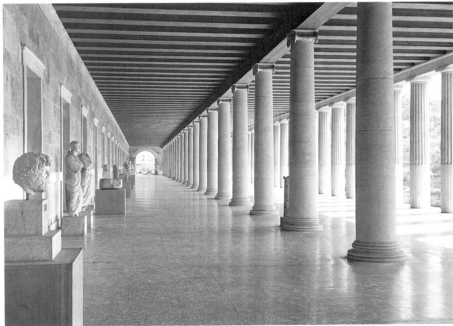

the stoa of Attalus must have been highly prestigious business or state offices.

The stoa of Attalus was the gift of a king, but belongs to royal architecture only in terms of its scale. It was a magnificent example of a building type that owed its evolution and popularity to the political circumstances of the democratic city-state. Stoas have no controlling architectural axis. They are capable, in theory, of infinite extension in length, and can be entered by anyone equally at any point along their façades. They have no interior focus or axis, no nave, since the inner colonnades nearly always divide the covered area into two equal spaces. There are few monumental building types less monarchic than a stoa.

157 This is the theatre at Epidaurus, built in the later fourth to third centuries BC. A large open-air theatre was an essential part of any self-respecting Hellenistic city and of any major Hellenistic sanctuary. Theatres were used not only for drama, but also for any kind of large citizen assembly. Tragedy and comedy had evolved in Athens in the fifth century, but the stone building we know as the Greek theatre was essentially of Hellenistic design. The theatre for which Euripides wrote had evolved organically and unsystematically. Early Hellenistic architects took this rough-hewn model and formed from it a new harmonious proportional design of the kind best experienced at Epidaurus. Its purpose was both aesthetic and acoustic refine-

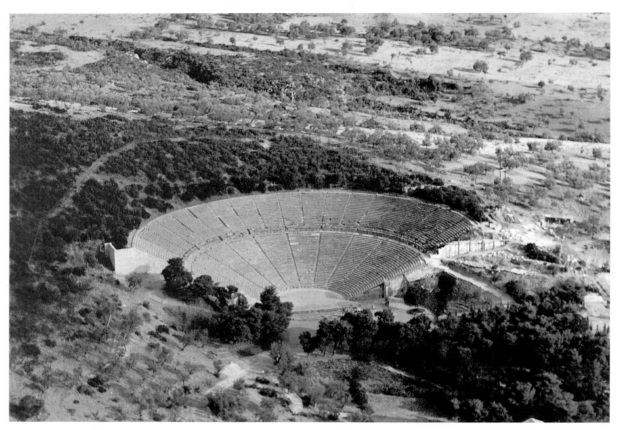

157 Theatre at Epidaurus

ment. This new type of theatre is found all over the Greek world, where it remained in use through the Roman period.

Of the three main elements—seating (*cavea*), circular orchestra, and stage building (*skene*)—only the orchestra, the centre of dramatic action for both chorus and actors in the Classical theatre, remained unchanged. (Classical tragedies remained part of the theatre repertoire—so the orchestra had to stay.) The seating, set against the side of a hill as before, was redesigned and divided neatly into sections and tiers. Special front seats were also supplied for dignitaries. The stage building, originally a simple backdrop and changing room (the literal meaning of *skene* is 'tent'), became an elaborate permanent structure with a proper stage (*logeion*). The new stage was probably designed to provide a suitable setting for the most popular kind of Hellenistic drama, New Comedy, which required more confined and intimate sets. New Comedy was a drama of romantic love and contemporary bourgeois life, pioneered by the immensely popular playwright Menander. Both the front of the stage (*proskenion*) and the back wall behind the stage (the *skene* proper) carried painted scenery and panels (*pinakes*) that could be changed according to the setting of the play. Loose reflections of this kind of theatre scenery may be seen in some Roman wall-paintings. Finally, gates were added across the entrances to the orchestra (*parodoi*), as at Epidaurus, in order to link the theatre and stage building architecturally.

158 Like the theatre, the gymnasium had long been a central institution of Greek city life—it was the focus of middle- and upper-class male life, functioning as a school for boys and a mens' club for their seniors. Large cities, like Pergamum, had several gymnasia for different age groups. Like the theatre, the gymnasium also took on a more fully defined architectural form in the Hellenistic period. The main buildings of the gymnasia at Priene and Olympia (the third-century building we see here) centred on large rectangular peristyles, enclosed courtyards surrounded by porticoes, behind which opened various rooms and exedrae. The open court was the palaestra, for exercise, especially wrestling. The exedrae—large halls entered through open colonnades—functioned as classrooms and lecture halls. The stadium, or running track, adjoined the main building. The architecture of the palaestra-schoolroom complex is a good example of the flexibility and practical effectiveness of Hellenistic peristyle planning. There were gymnasia wherever Greek city life flourished, from Alexandria to Aï Khanoum in Afghanistan.

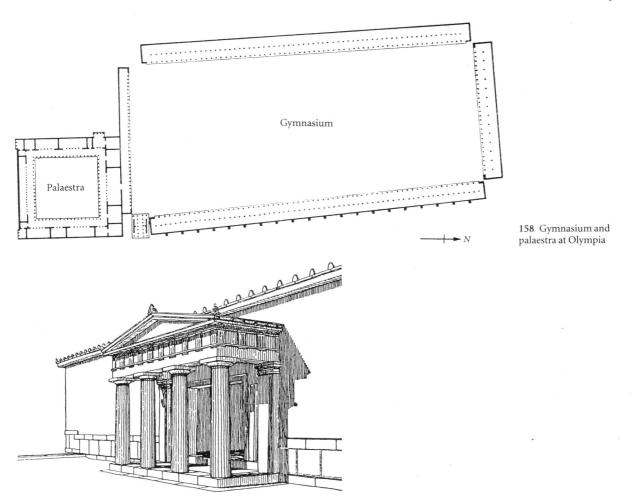

158 Gymnasium and palaestra at Olympia

Gymnasium

Palaestra

N

159 The city of Miletus was presented with a new self-contained *bouleuterion* (council house) complex by the Seleucid King Antiochus IV (175–164 BC). The roofed meeting chamber contained an artfully designed semi-circle of seats in imitation of the democratic theatre, while the exterior was articulated with an elegant engaged Doric order and decorated with shields and pierced by windows. The meeting hall proper is preceded by a colonnaded courtyard entered through a Corinthian propylon. The walls have an expensive tall and short (pseudo-isodomic) masonry pattern, and the marble ornament of both Doric and Corinthian capitals is delicately carved. The king's lavish architectural gift to a secular institution like the *boule* (city council) was intended to mark his deep respect for the civic democratic tradition.

160 The houses of the rich and powerful took on a new architectural splendour in the Hellenistic period. The palaces of the Macedonian nobility at Pella and Vergina show how domestic architecture could be transformed by the use of the peristyle.

[A] is the third-century palace at Vergina and [B] the second-century House of Cleopatra on Delos. These mansions deploy in a private context combinations of colonnaded courts with rooms behind similar to the gymnasia. The apparent simplicity of their plans belies the varied and pleasing effects of open, half-open, and closed spaces bathed in bright, shaded, or suffused light. Their thick walls indicate that these houses had upper storeys, now missing, for more private accommodation. The ground floor would contain the more public reception spaces. A suite of three connected rooms—a wide central exedra with closed side rooms opening off it—is a recurring feature on one side of the main peristyle. This was probably the main reception-dining suite of the house.

Floors of important rooms were decorated with figured mosaics, and walls would be stuccoed and painted in imitation of polished masonry patterns. Such mosaics and wall decorations are well preserved in some of the houses of late Hellenistic Delos. Here the prestigious architectural form of the peristyle is deployed even in the confined space of much smaller houses.

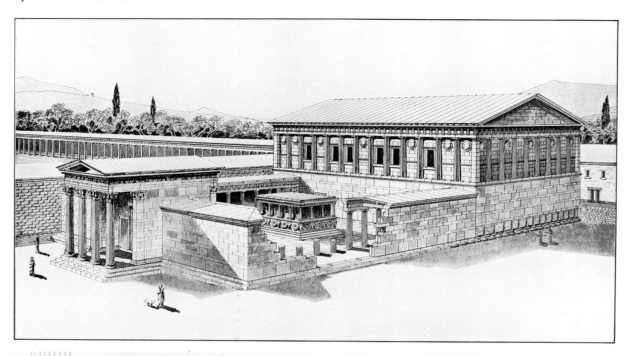

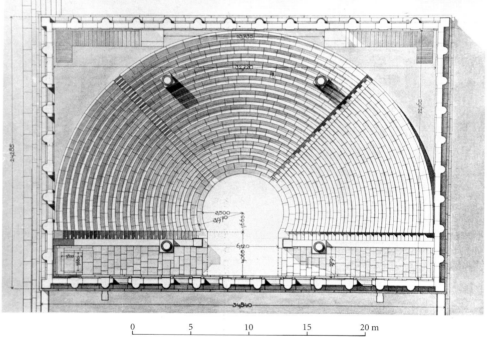

0 5 10 15 20 m

159 *Bouleuterion* at Miletus

161 The third-century Macedonian tomb at Levcadia presents an imposing two-storey façade with engaged orders, stuccoed white and painted in bright blue and red. On the panels between the lower columns four single figures are painted: on the left of the door, the dead nobleman in armour and Hermes who will lead him to Hades; on the right of the door, two of the judges of the Underworld both with their names inscribed, Aeacus seated and Rhadamanthys standing. The metopes contain curious monochrome paintings of a centauromachy, shaded to imitate high reliefs, while the attic zone is decorated with an Amazon frieze executed in moulded and coloured stucco. A series of fictive framed 'doors' decorates the upper Ionic order. These should be read as windows, closed by heavy nailed shutters. The two-storeyed façade and the windows have no architectural logic in a tomb,

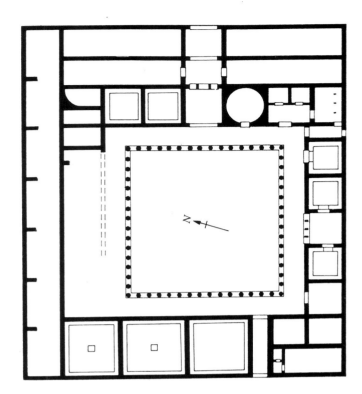

160 A Macedonian palace at Vergina (Aegae)

0 5 10 15 20 m

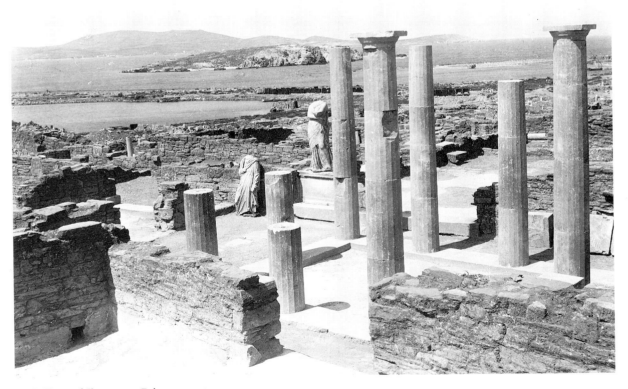

160 B House of Cleopatra on Delos

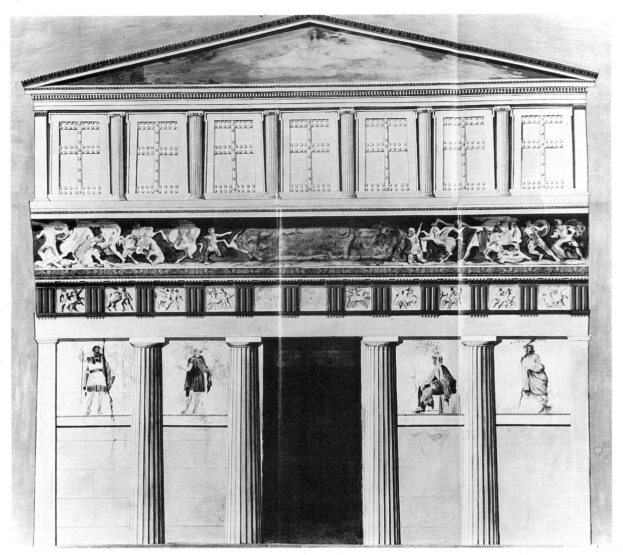

161 Tomb at Levcadia, façade

and probably reflect the architecture of a palace entrance with upstairs windows.

The tomb behind is architecturally unrelated to the façade. It consisted of two barrel-vaulted chambers, a wider entrance chamber and a deeper, narrower tomb chamber. Vaulted construction was well understood by Greek architects in the later fourth century, but vaults and arches were accorded low aesthetic value, being used chiefly in functional contexts, like cisterns and tunnels. Macedonian tombs were buried under a tumulus where barrel vaults were favoured for their strong vertical load-bearing properties.

162 (also **Colour Plate XIII**) The Alexander Sarcophagus is the finest, most elaborate funerary monument surviving from the Hellenistic period. Though not made for

Alexander, it was a royal commission—for one of the local rulers of Sidon in the late fourth century. These Phoenician kings, unlike their Macedonian contemporaries, preferred inhumation to cremation. They were strongly Hellenized and had employed Greek sculptors through the Classical period to carve their marble sarcophagi. A whole series of these sarcophagi was discovered in the royal necropolis at Sidon in 1887.

The Alexander Sarcophagus is the last and most sumptuous in the series. It was probably made for one Abdalonymus, whom Alexander confirmed on his throne after the battle of Issus in 333 BC (it is not known when he died). The sides of the chest are decorated with narrative scenes in high relief. On one long side Alexander is featured in battle against the Persians, no doubt at Issus. On the other, there is a hunt with Macedonians and Sido-

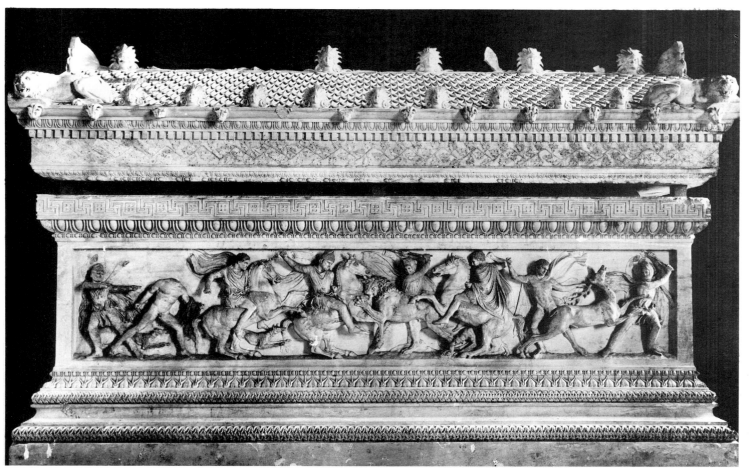

162 A Alexander Sarcophagus (Istanbul, Archaeological Museum)

nians, probably set in the great hunting park near Sidon. The local king thus displays the close association with Alexander that formed the basis and justification of his rule. The reliefs preserve much of their added colour and painted detail, and give the best impression of the enlivening effects of sculptural polychromy. The lid and chest of the sarcophagus are also decorated with a profusion of carved mouldings executed with refined metallic precision. They employ much of the repertoire of early Hellenistic architectural ornament—cable, leaf, double meander, and a rare vine twig decoration on the lower part of the lid. The quantity and richness of the ornament lend the sarcophagus the jewel-box splendour of a royal casket.

163 Hellenistic architects could be called on to design monuments and tombs that fell outside the normal repertoire. The Lysicrates Monument in Athens is an elegant, playful, and appealing structure. It was designed to display a tripod won by one Lysicrates in a theatre victory in 335–334 BC—he was the *choregos* or producer of the winning play. The monument consists of a square base and a tall cylinder with engaged Corinthian columns. Above, the frieze is carved with a humorous narrative of Dionysus and his satyrs at sea turning their pirate assailants into dolphins, while the roof carried an extraordinary three-branched acanthus finial on which the victory tripod rested. This was an architecturally precocious monument. The highly wrought capitals are the first example of the Corinthian order on the outside of a building. And the idea of a cylinder on a square base was one with a long future in memorial architecture.

164 The Hellenistic period was the great age of Greek science and technology—of observing, measuring, and calibrating. The Tower of the Winds in Athens was a highly unusual monument devoted to meteorology and chronometry. It was built, probably in the later second century BC, by one Andronicus of Cyrrhus (in Macedonia); it functioned on the outside as a monumental weathervane, and housed inside an elaborate waterclock. The building consists of an octagonal tower with two elegant columned porches facing the front and a kind of engaged drum

164 Tower of the Winds at Athens

163 Lysicrates Monument at Athens

behind which acted as the water tank for driving the clock's gears. The roof finial supported a revolving weathervane in the form of a Triton which pointed at the relevant wind—personified in an inscribed relief in the 'attic' zone on each of the eight sides. The tower was oriented due north so that the hour of the day could be read from the octagon at a glance, and for further detail each side carried a large engraved sundial. The attractive structure is built entirely of finely worked marble and had considerable influence in the later eighteenth century when it was included in Stuart and Revett's *Antiquities of Athens*. In England, it inspired several direct imitations.

PAINTING, MOSAIC, AND LUXURY ARTS

165 (also **Colour Plate XIII**) The Alexander Mosaic. Alexander charges from the left at the head of his cavalry Companions while Darius flees to the right in a huge chariot. In the centre a Persian nobleman has fallen, pierced by Alexander's long lance. It is to him that Darius gestures in dismay. Slanting spears and a barren tree provide a stark background setting. Alexander's Persian conquest is here condensed into a single dramatic moment—the turning-

165 Alexander Mosaic from Pompeii, copy (Naples, National Museum)

point of the crucial battle. The effect of heightened, emotional drama in bringing Darius and Alexander into virtual eye-contact is compensated by the precise historical realism of the arms and equipment on both sides. The authentic military equipment and more generally the extraordinary detail of the composition indicate that the mosaic was a careful copy of an earlier painting, probably of the late fourth century BC.

Several Alexander battle pictures feature in the literary record of early Hellenistic painting, but it is not known which one the mosaic copied. The mosaic painstakingly reproduces the painting's use of the austere four-colour technique—that is, a palette deliberately restricted to four earth colours (red, yellow, black, and white)—which had been practised by some of the greatest names of Classical painting, from Polygnotus to Apelles. Beside highlights, cast shadows, and recession in depth, which were standard by this time, the picture also employs more recent pictorial innovations mentioned by literary sources, for example, three-dimensional modelling in black (several of the horses) and the severe foreshortening of a horse seen directly from behind (compare [145]). Contemporary theoretical interest in the optical properties of reflecting surfaces is prominently displayed by the fallen Persian in

the centre foreground who is looking at the small reflection of himself in a polished convex shield. Similar reflecting shields recurred in other Hellenistic paintings.

The mosaic was made for a wealthy Hellenized Pompeian of around 100 BC and displayed in its own special exedra in his mansion (the House of the Faun). Although we may question the aesthetic wisdom of decorating a floor with a pictorial masterpiece, the value of the work to its owner probably lay in its startling and virtuoso translation of that picture into the infinitely more difficult medium of mosaic.

166 Around 40 BC the owner of a large villa at Boscoreale near Pompeii had the walls of his main reception room decorated with fresco copies of a cycle of early Hellenistic royal pictures. They give our best insight into another kind of court painting, far from the turbulent historical realism of the Alexander Mosaic, one that is static, allegorical, ceremonial. There are five panels, each with one or two figures set against a neutral background and connected by gesture, glance, and allusion rather than by narrative order.

Two panels of one wall show a standing philosopher and two allegorical figures. In the latter a personification

A

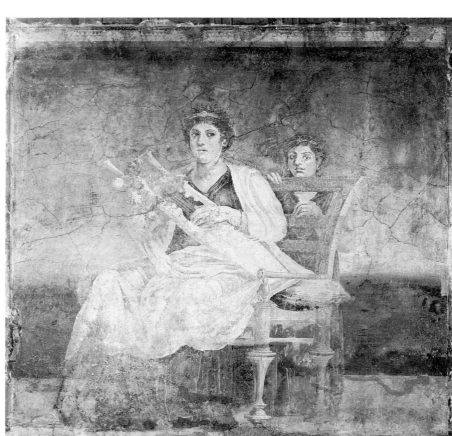

B

166 Frieze painting from
Boscoreale, copy (Naples,
National Museum).
A Macedonia and Asia;
B musician

of Macedonia is seated in a rocky landscape on the left above a contemplative figure of Asia. A large Macedonian shield stands between them. The subject of the picture is Macedonian rule over the east, a meaning that was made explicit in the following detail. The spear which Macedonia holds so firmly with both hands is planted firmly in the terrain on which Asia sits, and the blue-grey area between them is probably to be taken as the Hellespont, the narrow strip of water that divides Asia from Europe. Macedonia is sitting on the European side, planting her spear into the Asiatic side. The picture thus represents the specific idea of Asia as 'land won by the spear', a notion that was central to the Macedonians' claim to rule Asia by right of conquest. The idea of 'spear-won land' was the prevailing 'theory' or justification for Macedonian rule in the east.

The main occasion celebrated by the original cycle was probably the marriage of a Macedonian king and queen who are shown seated together in one of the panels. On one side of them is a woman playing a golden cithara, a large concert instrument [B]. She is a massive draped figure with a gold headband and sits on a fine lacquered red chair. She was probably a close relative of the king or queen, and the younger girl standing behind was perhaps her younger sister.

167 (**Colour Plate XIV**) The great picture of Telephus in Arcadia, a fresco copy from a public building in Herculaneum, has a formal grandeur similar to that of the Boscoreale cycle. We are here in the mythological realm, but it is clear that the original was a royal commission of the third to second centuries BC. The subject is Heracles' finding of his son Telephus, the hero whom the Attalids adopted as the founder of Pergamum. Father and son appear together in similar postures in the Telephus frieze of the Great Altar. At left sits the great, brooding figure of mountainous Arcadia, the location of the exposed infant's upbringing. Behind Arcadia is a young satyr with pipes, and at the right a youthful winged figure (Nike or Iris) points out to Heracles the wonder of Telephus being suckled by the hind. This narrative composition has been interspersed with some purely symbolic adjuncts of kingship—a heraldic eagle, king of birds; a lion, king of beasts; and a basket overflowing with fruit, symbol of royal plenty. The subject was intended to emphasize the pure mainland Greek origins of the Attalid dynasty. The intense stillness of Arcadia's massive figure is worthy of Ingres.

168 Deserted Ariadne lies in the foreground on a rocky beach. The young Dionysus appears at the left in sudden divine epiphany, standing with dynamic poise, cloak still billowing behind, looking down at the beautiful heroine. A small Eros raises her covering drape for the god to marvel at the body which the viewer can see only from behind. Dionysus' revelling thiasos emerges out of the misty back-

168 Painting from Pompeii: Dionysus and Ariadne, copy (Naples, National Museum)

ground—dancing dark-skinned satyrs, piping maenads, and an old Silenus helped by a younger fellow.

Most of the mythological panel pictures on Pompeian walls derive from late Classical and Hellenistic paintings, and their accuracy can often be confirmed or tested by other versions of the same composition (two other copies of this Ariadne picture are known), but few have the vivid fresh quality of this picture. Its light, dynamic effect and impressionistic style make a strong contrast with the measured style of the Boscoreale and Arcadia pictures [166–7]. Dionysian subjects pervade Hellenistic art, especially its sculpture. This Ariadne composition provides a rare counterpart in painting that can stand comparison with the statues.

169 Landscape, probably unknown to Classical painting, emerged in the Hellenistic period in the particular form of mythological landscape. The *Odyssey* frieze, a good copy after a Hellenistic original, is the most important representative of this species of painting. It decorated a wall in a house on the Esquiline hill in Rome of about 50 BC for which it was clearly not originally designed.

In the first preserved panel [A] Odysseus and his men

A

B

169 Odyssey paintings from Rome, copies (Vatican Museum). **A** arrival in Laestrygonia; **B** Laestrygonians attack Odysseus' men

arrive in the land of Laestrygonia and make enquiries of a woman who is on her way to fetch water. The setting is pastoral. In the next panel [B] mayhem breaks out as the giant Laestrygonian men brutalize Odysseus' companions with rocks and trees, on the shore and in the water, and drag them off for their 'unholy feast' (the primitive Laestrygonians were cannibals). The Laestrygonian episode takes up half of the preserved frieze, which was probably excerpted from a larger cycle. The frieze inverts the relationship of man to his surroundings that was usual in Greek art. The small figures are set in a vast, moody, romantic landscape in which man is dominated by nature and his surroundings—sea, cliffs, mountains, shore, lake, trees, livestock, and distant buildings. Mythological precision was maintained by adding inscribed labels for some of the figures and for topographic personifications such as the spring 'Krene' in the arrival scene.

170 Three musicians accompanied by a small slave boy perform on a narrow stage in front of a door. They are comic actors—the mask of the female flute-player is clearly shown as such. The highly skilled mosaic, proudly signed by its maker, Dioscurides of Samos, was made for a Pompeian client about 100 BC, copying a Hellenistic painting of the third century BC. The same composition is reproduced in a wall-painting from Stabiae. The mosaic carefully reproduces pictorial effects—the complex colour-shading of the clothes, and the different intensities of the cast shadow on the stage and back wall. The dark band above is the cast shadow of the eaves of the house in front of which the comedy takes place. At Pompeii the mosaic was paired with another mosaic which reproduces a scene from one of Menander's comedies.

Similar three-figure groups of actors appear in wall-paintings on Delos. The originals behind these pictures are probably what the literary sources call *comicae tabellae*, or 'small comedy panels'. Although their original function and context are not known, they represent one of the many levels of Hellenistic art that were permeated by theatre subjects.

171 This sensitive stucco panel from Herculaneum showing a tragic actor in a dressing room is one of the best of a series of wall-paintings and mosaics that reflect Hellenistic pictures representing actors offstage. They seem to have constituted a distinct species of theatre painting and were perhaps commemorative pictures of great performers. We are in the changing room before a tragic performance, and the door at the back is no doubt the entrance on to the stage. That is, we have the opposite viewpoint to that of the play's audience. A seated actor, the protagonist, has the dress and attributes of a king (sword and sceptre). A woman crouches in front of a female tragic mask which stands on a table in an open box surrounded by fillets. She is probably an assistant who will hand the mask to the

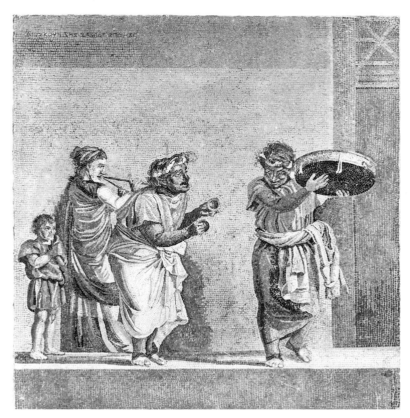

170 Mosaic from Pompeii: comic actor-musicians on stage, copy (Naples, National Museum)

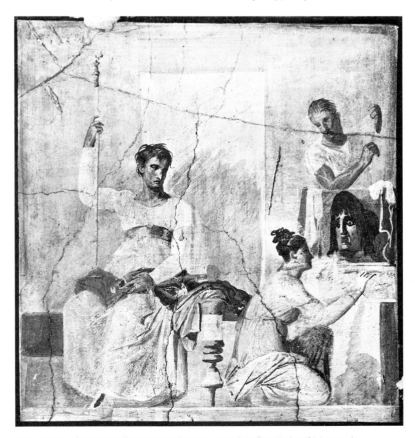

171 Painting from Herculaneum: tragic actor, copy (Naples, National Museum)

172 Gravestone of Hediste (Volos Museum)

actor who is changing behind (both male and female roles were played by male actors). This picture seems intended to convey the psychological tension between ordinary mortal actors and the lofty heroic roles they played.

172 Beside vast exterior landscapes, Hellenistic painters also devised interior settings for the intimate subjects of Greek mythology that involved heroines at home, such as Helen or Medea. The humble painted grave stele of Hediste from Demetrias in Thessaly shows a remarkable handling of a domestic interior combined with allusive narrative and pathos, which were also features of interest to contemporary (third-century) painters. Hediste lies in bed in the foreground. A woman carrying a baby appears from behind the screen wall, and another small figure appears in an open doorway further in the receding background. A common event of ancient life is portrayed with great clarity and simplicity: young Hediste has died in childbirth. The painting tells the story, like the epigrams on the same subject, with touching sentiment and an elegant economy of means.

173 Over twenty species of Mediterranean marine life are composed round a group of a struggling lobster and octopus, floating against a simple seascape. They include the following: sea bass, dogfish, red mullet, scorpion fish, sea bream, skate, conger eel, scallop, and oyster. The mosaic is the best of several later copies of a Hellenistic

composition. For their Roman buyers such mosaics were primarily decorative and artistic menus of prized table fish.

The origin and function of the Hellenistic composition was probably rather different. Still life is well attested as a branch of Hellenistic painting, and Hellenistic representations of animal and plant life are generally characterized by careful observation of nature. The extraordinary biological precision of the fish composition, however, probably reflects a more particular scientific interest. It seems to presume and to draw on a much larger repertoire of highly accurate taxonomical drawings. Not only does the picture seem to be based on such illustrations, it was also probably part of its purpose to display scientific learning.

174 The great Nile Mosaic from Palestrina (Praeneste) was made in the later second century BC to decorate the apse of a public building in the forum of the lower town there, below the famous sanctuary of Fortuna Primigenia. It was discovered in about 1600 and suffered badly in several trips to and from Rome. The subsequent extensive restorations can, however, be checked against early drawings made by Cassiano del Pozzo. As in the Alexander Mosaic, the subject-matter and extraordinary detail suggest the Nile Mosaic was intended as a virtuoso mosaic transcription of a Hellenistic, surely Alexandrian, painting.

The subject is the land of the Nile, represented from an experimental aerial or bird's-eye perspective that no doubt owes something to the arts of 'chorography' and 'topography', mentioned in literary sources. Most but not all of the elements within the bird's-eye landscape are shown in normal horizontal perspective. The Nile is in flood, and part of the picture's purpose was probably to present an allegory of Egyptian and Ptolemaic plenty provided by the annual inundation.

The top of the picture shows the wilds of upper Egypt with naked hunting parties tracking down exotic animals, each named in its accompanying label. There is a scientific interest in the animal kingdom similar to that of the fish compositions. The hunters are probably members of a royal expedition exploring the upper Nile, sent to bring back unusual animal species for the animal park of Alexandria. The middle zone features the pharaonic temples, obelisks, fortified estates, and native peasant huts typical of middle Egypt. The lower zone is taken up with native peasant life in the delta (canoes, fishing, reed huts) and with activities of the Alexandrian Greeks—there are a group at leisure under a bower, a party of Macedonian soldiers in front of a Greek temple, and a royal galley. The middle and lower zones are also interspersed with animal life typical of the delta. The species are here so familiar as to require no labels: crocodiles, hippopotami, ibises, ducks, cows.

This extraordinary picture, no doubt a Ptolemaic royal

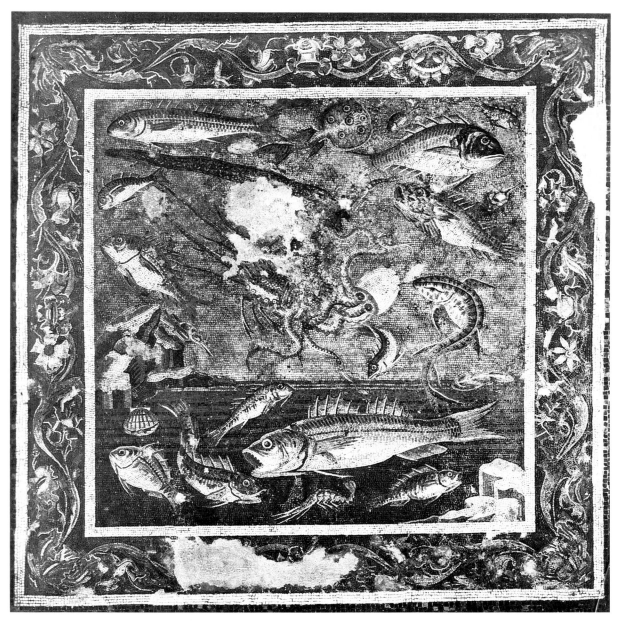

173 Mosaic from Pompeii, copy (Naples, National Museum)

commission, combined many novel features of Hellenistic painting—for example, genre landscape, topography, and perspective experiments. The picture also borrowed from and elevated to high art a new interest in natural science—included are elements of geography, ethnography, botany, and zoology.

175 (**Colour Plate XV**) This pebble mosaic from Pella, of about 300 BC, employs the combination of wide decorative frame and central picture panel (*emblema*) that was typical for fine Greek floor mosaics. In the central panel, two hunters, dressed in conventional Greek nudity, and

their dogs close in on a stag. The figures are set on a naturalistic rocky ground-line but against a black background on which their naked bodies stand out more clearly. A hat (*petasos*) floats at the upper right corner, interrupting the signature of the mosaicist: 'Gnosis made (it).' The field around the central picture is filled by superb flowering plant scrolls that grow from two acanthus calyces at opposite corners, while the outer border is framed by a cresting wave pattern. Figure-style and ornament are both typically early Hellenistic. The border and floral pattern function as flat floor decoration, while the central panel, with its carefully shaded figures, imitates contemporary paint-

A

B

174 Nile Mosaic from
Praeneste (Palestrina,
Archaeological
Museum). **A** scenes on
the Nile; **B** soldiers
before a temple

176 Dolphins Mosaic on Delos

ing. The composition was no doubt borrowed from contemporary paintings of royal hunts.

Pebble mosaics evolved in the Classical period and reached their greatest refinement around 300 BC in the mansions of Macedonian Pella. They deploy a restrained palette of natural river pebbles. Some contours and details are rendered by strips of clay or lead that provide sharper definition of, for example, hair or facial details. Shading is obtained by a pointillist technique of varied concentrations of darker pebbles. After the invention of tessera mosaics in the third century, pebble floors virtually disappeared.

176 The second-century Dolphins Mosaic from Delos consists of a round *emblema* surrounded by an elaborate border of two wave patterns, a perspective meander, and fine checks, all set within a square framed by a crenellated 'carpet' border. Pairs of dolphins fill the spandrel fields. They are harnessed in pairs, each of which is controlled by a miniature rider, each wearing a different coloured costume.

The practical advantages of cubed tesserae over round pebbles in mosaic construction are very clear in this detail. Tesserae cut to a single standard size could be laid quickly in lines and in multiples that made up controlling units of the decorative borders. In more complex figure designs—for example, the jockeys—much smaller tesserae were introduced to provide sharper contours, tonal gradation, and more colours. Tesserae provided greater control, greater flexibility, and much greater detail. Tesserae mosaics reached an extraordinary level of refinement in the second century BC at Pergamum, Delos, and then at

Pompeii where wealthy Italian patrons first commissioned copies of famous pictures in this medium.

177 The mosaic panel, signed by its maker Sophilus, depicts a female personification—a bust of a young woman wearing an unusual and elaborate crown on her head in the shape of a ship's stern which is held in place by a waving red-and-white striped fillet. She also holds a *stylus* or ship's yard-arm. Although the full-chinned and wide-eyed face is typical of Ptolemaic queens, it cannot have been intended in any sense as a portrait of a queen—naturally one could not walk on the queen's face. The mosaic comes from a site in the Nile delta (Thmuis), and the bust most probably personifies the great port city of Alexandria.

178 That even one mosaicist, Sosus of Pergamum, appears in the literary record is striking testimony to the new value brought to mosaic art by the tessera technique. Two of Sosus' works are recorded, the *Unswept Room* (*Asarotos Oikos*) and the *Doves*, and both can be recognized in later copies and imitations. They each represent a highly thoughtful design for the two main parts of a Hellenistic mosaic floor—the *emblema* and the surrounding field. It is possible but unsure that the two were part of a single floor composition.

The *Unswept Room* consisted of a continuous neutral field interspersed with representations of an array of dining debris: fish bones, chicken legs, shells, nuts, fruit stones, crustacea, and an occasional mouse nibbling at them. The mosaic contains several layers of reference—to the function of the mosaic (floor), to the function of the

177 Mosaic by Sophilus
(Alexandria, Graeco-Roman
Museum)

178 Mosaic by Sosus; *Unswept
Room*, copy (Vatican Museum)

room (dining), and to the 'dramatic time' of the subject (after dinner). There is a playful virtuosity of technique in the representation of the debris and mice as real things on the surface of a mosaic on which they cast shadows. It is fitting that the work of the one famous mosaicist recorded should be such a sophisticated and appropriate mosaic subject.

179 (Colour Plate XV) Four doves perch in an artful variety of postures on the rim of a fine bronze bowl filled with water. The composition, easily recognized as the *Doves* of Sosus of Pergamum, is known in a variety of versions, of which the earliest is a mosaic from Delos and the best this one from Hadrian's villa at Tivoli near Rome. In contrast to the floor aspect of the *Unswept Room*, the doves composition was clearly a show-piece *emblema* in which the artist displayed his extraordinary technical ability in the pictorial representation of a variety of difficult surfaces and textures: polished metal with diffuse highlights and hard detailed contours, soft bird feathers, still reflecting water, and a slab of marble on which the bowl stands. While the *Unswept Room* affirmed and played with the idea of mosaic as floor surface, the *Doves* was a brilliant chiaroscuro picture that denied its function and medium.

180 Two second-century drinking-bowls of similar shape and scale illustrate different trends in the decoration of Hellenistic silverware. The first [A] has a simple pattern in low relief of vertical fluting which frames panels of engraved vines that surround a slightly pointed leaf. Its style is precise, ordered, slightly mannered. The second [B] has a complex naturalistic floral pattern, based on a four-leaf acanthus and inhabited by Erotes, birds, and a butterfly. Its style is lively, exuberant.

The first bowl was hand-raised from a single sheet of silver, while the higher relief on the second bowl employs a new technique of an inner lining and an outer 'sleeve'. The rim and inside of the bowl form one piece (the lining), while the floral zone, beaten in repoussé from another piece, was fitted over the bowl as an outer sleeve, joined beneath the lip decoration. This technique later became popular for cups featuring extravagant figured scenes on the exterior. On Hellenistic cups like these, however, figured decoration was normally confined to the interior—a circular *emblema* set at the bottom of the bowl.

181 The gilt bronze crater from Derveni of the late fourth century BC is our finest surviving example of late Classical and early Hellenistic metalwork. It is a large virtuoso work (height 70 cm.) that deploys the full technical repertoire of contemporary bronze and silverware. The Dionysian frieze round the main body of the vase was raised in delicate low relief by the repoussé technique. The ornamental patterns were cast and chased, while the volutes, palmettes, and seated figures on the shoulders

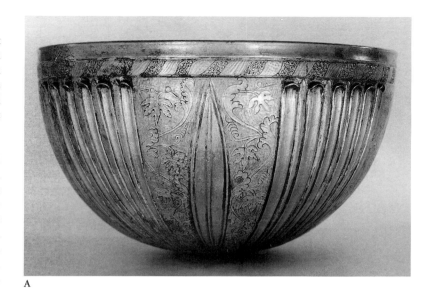

A

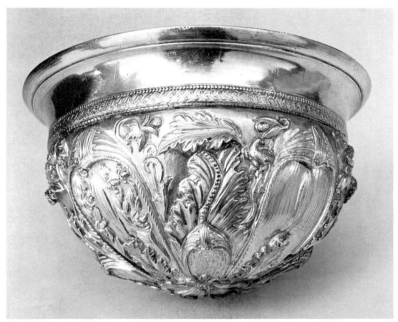

B

180 Silver bowls (Berlin, Staatliche Museen; Toledo Art Museum)

were attachments separately cast. The result is an extraordinarily rich decorative ensemble.

The crater was found in 1962 at Derveni in Macedonia in a tomb, where it served as an ash urn. The inscription of a previous owner on the lip—one Asteiounios son of Anaxagoras of Larissa—together with the shape and decorative themes of the vessel indicates a different original function. From the ivy wreaths on neck and body to the seated maenads on the shoulders and the dancing maenads on the main frieze, the themes are Dionysian. The shape of the vase, a volute-crater, had long been favoured for the most elaborate vessels for mixing wine and water at symposia. The original context of the crater should be

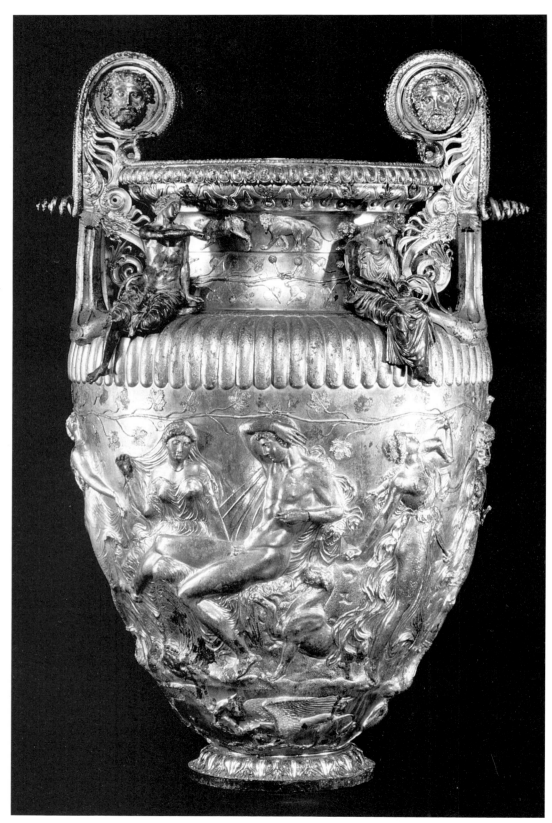

181 Gilt bronze crater from Derveni (Thessaloniki Museum)

182 A Gold ear-rings (New York, Metropolitan Museum)

182 B Gold necklace (Baltimore, Walters Art Gallery)

imagined among fine furniture in the main dining-room of a Pella mansion.

182 The gold ear-rings [A] display a formidable technical virtuosity. They consist of three main elements, an upper floral disc, an intermediary boat-shaped member, surrounded by rosettes below and palmettes above, and a variety of fine amphorae hanging on a plaited chain below. Fine third-century ear-rings like these have an inventive brilliance that sets them apart from the ear-rings of earlier and later periods.

The necklace [B] is a typically sumptuous example of Hellenistic personal ornament that well illustrates a new interest in more varied materials and colour effects. The central section of five large stones (actually blue and green glass), alternating square and oval, is held on a braided gold chain which terminates in golden lynx heads with pearl necks. The central stones have elaborate granulated settings from which hang the three pendants—an emerald-studded butterfly flanked by two tear-drop garnets. The design is bold, and the combination of pearl, emerald, garnet, and coloured glass has a striking effect.

Tombs from south Italy to south Russia have turned up an astonishing variety of Hellenistic gold jewellery. We see new types of ornament (diadems), new designs (especially for ear-rings), and technical innovation (e.g. in the use of filigree and polychrome materials). Jewellers also now began to make bold use of figured elements—human and animal heads and many Erotes appear beside the new repertoire of acanthus ornament. The overall effect of the new designs and techniques was one of richness and exuberance.

183 To the lively Classical tradition of gem-engraving Hellenistic engravers added new kinds of semi-precious stone, new subjects, and greater technical virtuosity. As in gold and silver work, there seems to be an increase in both production and creative daring. The increasing quantity of signed gems and the fame of Alexander's gem engraver Pyrgoteles indicate mounting prestige for the art. Royal patronage and royal subjects undoubtedly provided a new stimulus to gem engravers.

The examples illustrated show some of the range of Hellenistic gem-engraving. The Alexander head [A] on a nearly spherically faced stone wears the ram horns that assimilate him to Zeus Ammon, and may have been cut soon after his death in the eastern area of his empire, since a tiny Indian inscription appears below his neck. Other profile portrait heads show diverging tendencies in royal portraiture. The king [B] is impassioned and dynamic, while the queen [C] wears a heavy Classicism. Gods remained popular subjects. The slim goddess on [D] is typical of many such refined studies on large oval ring-stones. The nymph [E] is perhaps the most characteristically Hellenistic in subject and style. Instead of being cut into the flat undersurface of the stone, the design is carved boldly out of its convex upper surface (as on [A])—a technique that gives much higher relief and a bolder effect. The engaging rococo style and the back three-quarter view of the naked nymph are typical of a major strand in the art of the Hellenistic east.

184 (Colour Plate XVI) The Tazza Farnese, perhaps made in Alexandria for one of the later Ptolemies, is one of the largest surviving cameo works from antiquity. It is a

183 Engraved gem-stones (photographs of impressions and original: **A, D** Oxford, Ashmolean Museum; **B, C, E** St Petersburg, Hermitage). **A** head of Alexander, tourmaline; **B** Ptolemaic king, amethyst; **C** Ptolemaic queen, cornelian; **D** goddess, cornelian; **E** nymph on sea-monster, amethyst (original)

flat bowl cut from a single piece of banded Indian sardonyx. The white figures are carved on the inside of the bowl in the middle band of the triple-layered stone. Nile sits on the left with a cornucopia; below, Isis reclines on a sphinx; and across the centre strides her son Triptolemus-Horus with seedbag and plough. Two Horae or Seasons recline on the right, and two winds blow overhead. The theme—the abundance and fertility of the land of the Nile—is similar to that of the great Praeneste Mosaic [174], but here it is represented in a more allusive, stately allegory.

The cameo technique of carving semiprecious stones in relief, instead of intaglio, seems to have been invented in the third century BC, when banded sardonyx from India first became readily available. Some early examples survive from Hellenistic tombs in south Russia, and there are glass paste cameos imitating sardonyx which carry second-century royal portraits. Apart from the Tazza Farnese, however, no major examples of this new court art survive from the Hellenistic period. The successors of the Hellenistic engravers enjoyed a late golden age, in the service of the Julio-Claudian emperors at Rome in the first century AD [271].

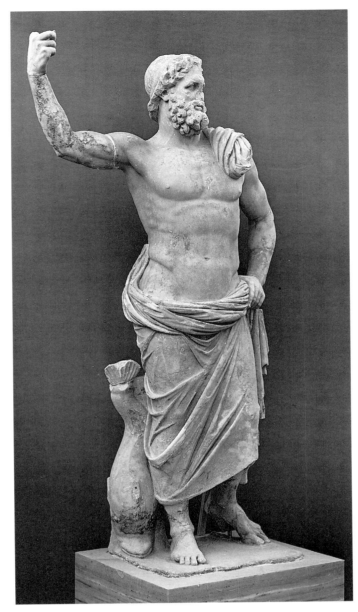

185 Apollo, from Tralles (Istanbul, Archaeological Museum)

186 Poseidon, from Melos (Athens, National Museum)

SCULPTURE

185 Originally the Apollo from Tralles was leaning on a support and held a lyre in his left hand, while his right arm rested languidly on top of his head. The arms and attributes of the figure were attached separately. Both Apollo and Dionysus take on this soft, youthful, almost effeminate aspect in the Hellenistic period. The highly charged naturalism of the body creates the impression of a real living god. The ideal long-haired head is Apollo's identifying 'portrait'. His soft musculature indicates both youth and a life devoted to the athletically unexacting arts of archery, music, and poetry. This is an image of cultural refinement that contrasts with that of the muscle-bound wrestler Her-

acles. There are other Roman versions of this statue type, indicating that the third-century Tralles Apollo was modelled on an already existing cult statue of Apollo. Hellenistic cult statues were quite often free versions of earlier, more famous statues of the deity.

186 Our second-century Poseidon stands in the pose of a divine ruler, holding a trident in his right hand and supported by a small dolphin at the side. As a senior Olympian, he has a powerful classical musculature, which is employed here less as a feature of the sculptor's style than as a simple means of evoking the god's majesty and superhuman status. That neo-classicism was not the sculptor's purpose is shown by the highly naturalistic drapery and the fully 'modern' treatment of the head.

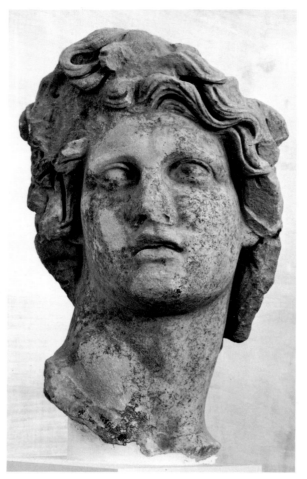

187 Helios, from Rhodes (Rhodes Museum)

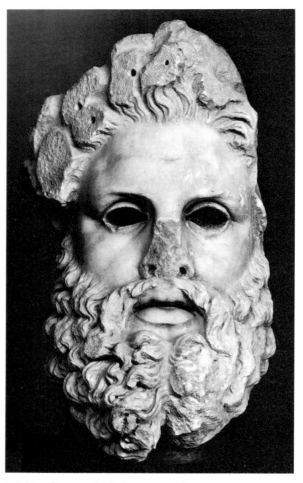

188 Zeus, from Aegeira (Athens, National Museum)

These indicate firmly that the god is part of the real world inhabited by the viewer.

187 Helios, the young sun god, twists his head upwards, his thick long hair falling back in artistic disarray. His lips are parted and reveal his upper teeth—he moves, lives, and breathes. The powerful upward turn, the diverging axes of head and neck, and the dynamic ideal are all features that occur in contemporary royal portraits—here used with much greater intensity. This Helios is a good example of the sometimes radical restyling of images of the gods in the early Hellenistic period. Helios was the patron deity of Rhodes and regularly appears on the city's coinage. The famous Colossus of Rhodes also represented him. It was a bronze figure over a hundred feet tall, made for the city in 305–304 BC by Chares, a follower of Lysippus.

188 This head is a good example of how the Classical portrait of a deity could be infused with a new power and vitality by the richer formal means of Hellenistic sculpture. The basic Phidian image of Zeus is animated by

baroque features, like the swelling lower brow and the thick dynamic hair brushed up from the forehead in separately added locks. The second-century head was excavated in the temple of Zeus at Aegeira in the northern Peloponnese (Achaea), where it had been seen by Pausanias, who gives the name of the sculptor—Euclides of Athens. The statue, like many colossal cult statues, was of acrolithic construction. In this technique, only the naked extremities (head, arms, feet) were of marble, the draped parts being of painted or gilded wood. One of the statue's marble arms was also recovered in the excavation—a massive veined forearm. The eyes would have been inlaid with naturalistically coloured glass and stone. The purpose of the whole image was to express the stern might of the chief Olympian.

189 Pausanias describes in some detail the cult statues made in the second century BC by the sculptor Damophon of Messene for a temple at Lycosura in the Arcadian mountains. The main parts of the statues were excavated at the site in the last century, and the group can be recon-

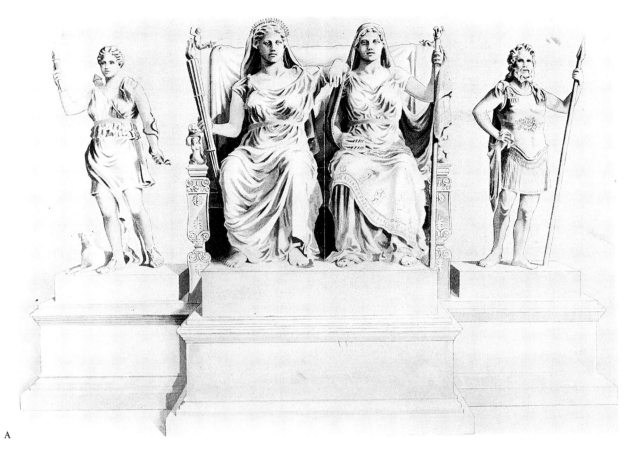

A

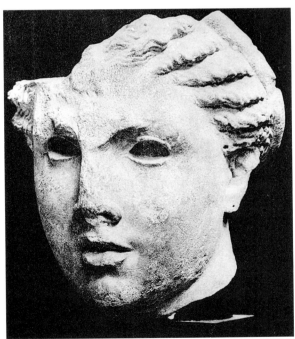

B

189 Cult group from Lycosura (B (head of Artemis): Athens, National Museum)

structed on paper with the aid of Pausanias' description and the image of the group on local coins. The temple was dedicated to Despoina (the Mistress), an ancient nature deity. She was seated on a double throne with Demeter. To the left was the young huntress Artemis, and to the right a local hero, Anytus, in military costume. The group combines several deities into a homogeneous local pantheon. The figures were constructed from many separate pieces of marble, probably over a wooden armature. The heads are hollowed out behind to reduce weight, and the throne was built in marble parts and 'planks' like a wooden seat. The drapery hanging from Demeter's sceptre has elaborate figured embroidery carved in low relief that follows the movement of the drapery. The heads are carved in a restrained Classical manner, a style that continued through the Hellenistic period to represent the grandeur of the old gods.

190 The goddess crouches to bathe herself. The body is mainly in profile, the left shoulder turned slightly, while the head turns sharply to the front, creating another axis. Aphrodite turns her head partly to the viewer and partly as a natural accompaniment to washing her shoulder and neck. Of the several naked Aphrodites that follow Praxiteles' Cnidia [130], this is perhaps the most successful in suggesting the goddess's sensual charm. The boldly modelled folds of the waist and the full thighs pressed together at diverging angles are a clear expression of voluptuousness that remained only potential in the Cnidia. She is the same goddess, with the same heavy bodily forms, but here in the third century, she becomes more of a living and moving figure—from the more fully modelled flesh to the

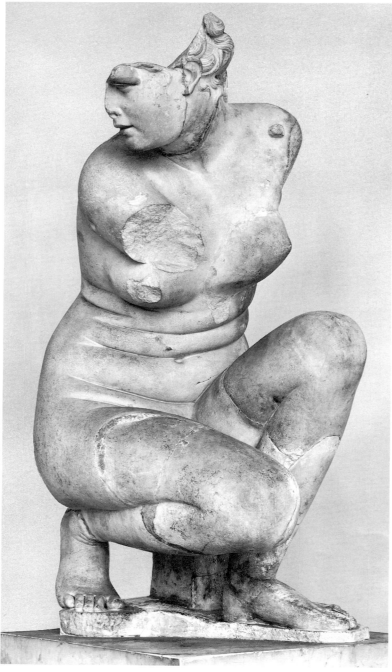

190 Crouching Aphrodite (Rome, National Museum)

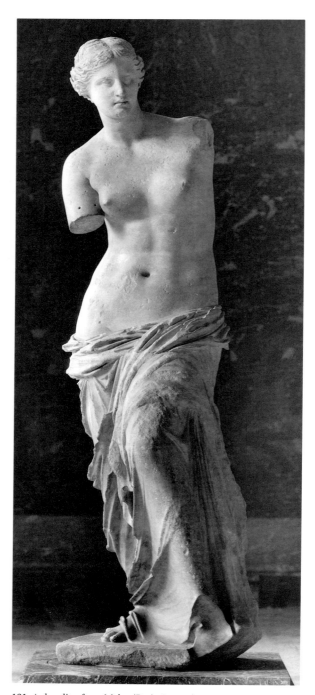

191 Aphrodite, from Melos (Paris, Louvre)

engaging turn of the head and the more openly appealing expression. The momentary action and genre posture suggest the original was a votive rather than a cult statue.

191 The 'Venus de Milo', second-century BC. The notorious lack of arms of the Aphrodite of Melos has invited many reconstructions. Available parallels suggest there was a support at one side on which she rested her left arm—perhaps holding the infant Eros—and on the base of which her slightly raised left foot would rest. The statue

was made in two main parts joined at the hips. The highly naturalistic drapery is carved in a casual, almost perfunctory manner, while the naked upper body is worked with great sensitivity. She has the soft massive forms of the canonical Aphrodite—broad hips that indicate sexual maturity and small breasts that indicate youthfulness. Unlike the engaging 'portrait' of the Crouching Aphrodite [190], the Melian's head is rather conservatively Classical in both expression and hairstyle. Her hair is plainly arranged without the extravagant bowknot on top of the

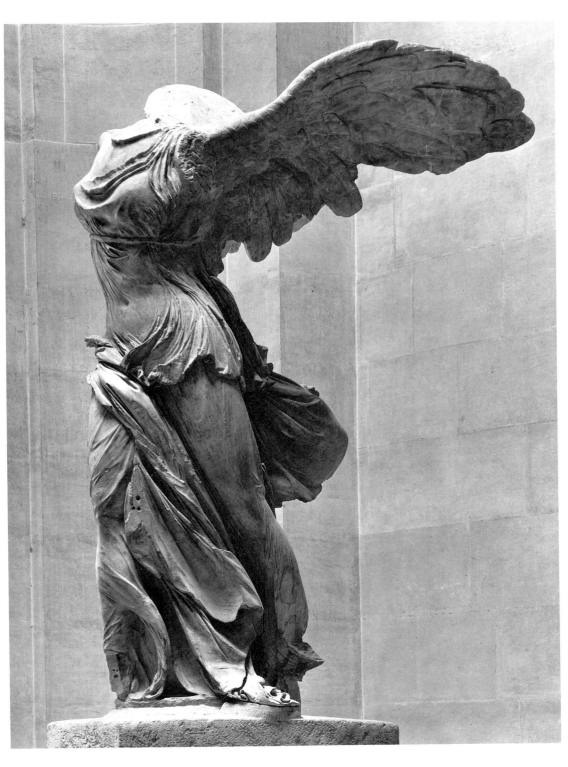

192 Nike, from Samothrace (Paris, Louvre)

head, and her features employ a rather heavy, severe ideal that gives the head an almost masculine expression.

The statue was found in 1820 and bought for the Louvre as the work of a Classical master. A part of the base that joined at the right was found with the statue, but then mysteriously lost. A drawing of this base shows that it was signed by one Hagesandrus from Antioch on the Maeander, in lettering of the Hellenistic period. In the nineteenth century a Hellenistic statue (especially one by an unknown sculptor) was considered *ipso facto* less fine than one of the Classical period.

192 The goddess Victory, with massive wings outstretched, lands in a rush of fine drapery on the prow of a warship. The statue was framed in its own precinct or exedra on a hill above the sanctuary on Samothrace. The

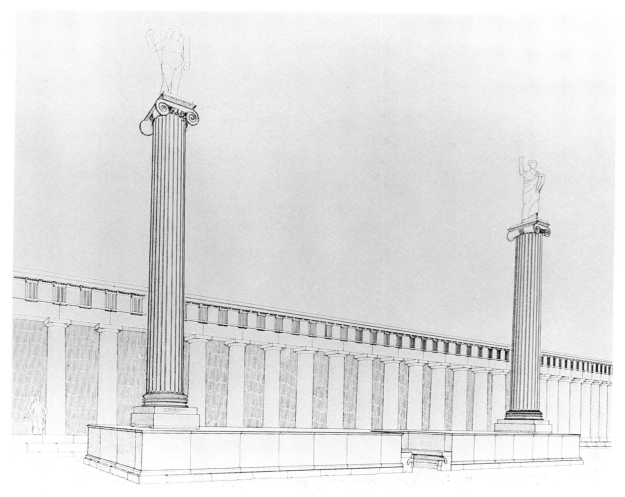

193 Ptolemaic statue monument at Olympia

ship's prow, carved in grey marble with full naval precision, was set obliquely in the exedra so that the statue presented a left three-quarter view—the view for which it was clearly designed. The twisting axes of hips and shoulders and the contours of wings and flying drapery are most telling from this viewpoint. The carving of the figure is virtuoso, its effect powerful. Landing Nikes and ruffled wind-blown drapery were already well known in the Classical period—for example, in the Nike of Paeonius at Olympia [123]. The Samothracian figure redraws these forms on a massive scale and adds torsion, vigour, and immediacy.

The statue no doubt commemorated a great naval victory, surely of a Hellenistic king. Samothrace was a favoured sanctuary for royal dedications and lay within the sphere of Antigonid Macedonia. One of the great Antigonid sea victories of the mid-third century (for example, the battle of Cos in the 250s BC) is the most likely context, although a later date, for a Rhodian victory in 190 BC, has also been favoured.

193 The Ptolemaic admiral Callicrates of Samos dedicated a great statue monument to Ptolemy II Philadelphus and his sister Queen Arsinoe II at Olympia sometime after their marriage in 274 BC. It was located on the east side of the sanctuary in front of the Echo Stoa, facing the front of the main temple of Zeus, and consisted of a long base with central bench-seat and two columns at either end carrying statues of the king and queen. The monument both expressed the admiral's loyalty to the king and advertised Ptolemaic power in the heart of old Greece. It also displayed the new importance of the queen as a royal partner in the Ptolemaic monarchy.

Royal statues abroad had to compete in civic and sanctuary spaces with other honorific statues, and this monument shows one simple and effective way of making the king's image more imposing. In such context, in a Panhellenic sanctuary of old Greece, other means of status enhancement—like colossal scale and costly materials—would be less appropriate.

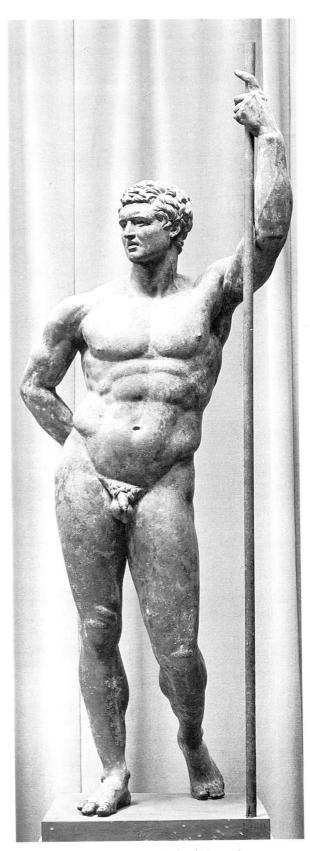

194 The powerfully muscled ruler stands in a tautly balanced posture with one arm raised holding a spear. The pose was probably first used for Alexander's statues, was common for royal statues after him, and soon came to mean simply 'ruler' or 'man of power' without necessary royal connotations. The Terme Ruler is the finest large-scale example of the type. The subject wears no royal diadem, and should be either a non-royal dynast or more likely a Macedonian prince. The naked body employs a heightened form of athletic musculature as an expression or metaphor of military-political power. The body has an impressive swagger accentuated by the unnaturally small head. The portrait features are treated with a tempered realism in which precise individuality is muted by an ideal expression of forceful energy and vigour. The portrait well expresses what ancient theoreticians of kingship called royal *deinotes*, a sense of awesome force. The statue was found in Rome, where it no doubt arrived from the Hellenistic east as booty in the late Republican period. (The 'Terme' are the Baths of Diocletian, part of which is now Rome's National Museum.)

195 Alexander's portraits created a new, youthful royal ideal by borrowing both from images of young heroes, like Achilles and Heracles, and from the king's own youthful

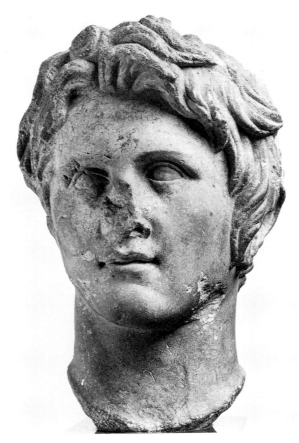

194 Terme Ruler, bronze (Rome, National Museum)

195 Alexander the Great (Dresden, Albertinum)

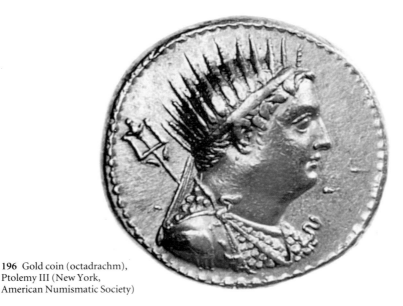

196 Gold coin (octadrachm),
Ptolemy III (New York,
American Numismatic Society)

appearance. Alexander has a powerful, deep-chinned face and a thick mane of hair with an upswept, off-centre parting. This head is one of two later copies probably after a major statue from Alexander's lifetime. When compared to the impassioned divinization of some of his later, posthumous images (as [183 A]), this portrait is decidedly restrained in expression. The upswept hair or *anastole* was a distinguishing personal sign of Alexander portraits. Many of his successors imitated the idealizing youthful image and its implied association with gods and heroes, but none appropriated his *anastole*.

All of Alexander's successors and their entourages followed the young king in the new fashion of being clean-shaven. This is a fact of central importance for both portraiture and social history, for many men in the Greek cities, especially intellectuals, chose to remain bearded. Greek and Roman rulers continued for the most part to be clean shaven until Hadrian.

196 Gold coins in large denominations were issued by the third-century Ptolemies at the start of a new king's reign, in the manner of accession medallions. They usually featured, as here, the deceased king. On this issue the rather plump, placid image of Ptolemy III Euergetes—a typically Ptolemaic royal image—is represented with an unusually wide array of divine apparel. His diadem carries a crown of long, light rays like the sun god Helios; his royal cloak (or chlamys) is in the form of Zeus' scaly aegis; and his sceptre has a triple prong like Poseidon's trident. The divine attributes are assimilated to their nearest royal equivalents—rays: diadem, aegis: cloak, trident: sceptre—and were intended, not to present the king as a composite Helios–Zeus–Poseidon, but rather to indicate the range of godlike powers he possessed. His presence had the brilliant effulgence of Helios; he commanded the sea like Poseidon; and he ruled justly, like Zeus, avenging himself on his enemies.

197 The bust of the founder of the Seleucid dynasty, Seleucus I Nicator, is a good example of the selective realism of early Hellenistic portraiture. It merges an individualizing presentation of the mature middle-aged king with normative elements of early Hellenistic royal appearance—the upward turn of the head, the thick wreath of 'royal' hair beneath the diadem, and an overriding expression of strength and vigour. Seleucus was one of Alexander's young generals who survived long after him and emerged from the wars of the successors to set up his own kingdom in 306 BC. On the eve of his assassination in 281 BC at the age of about 78, he had gathered much of Alexander's Asiatic empire into his hands. In an age spellbound by youthful charisma, his portrait may seem unusually 'honest', but since the original was probably made when Seleucus was already in his sixties, its realism was clearly heavily compromised.

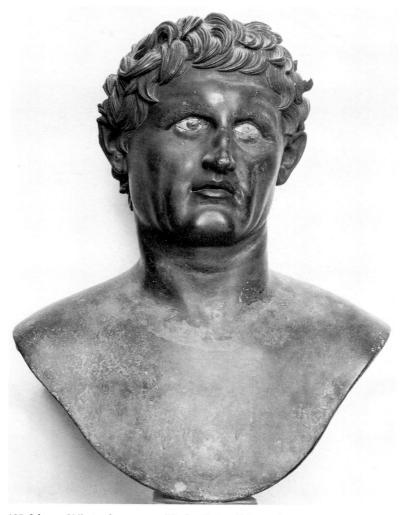

197 Seleucus I Nicator, bronze copy (Naples, National Museum)

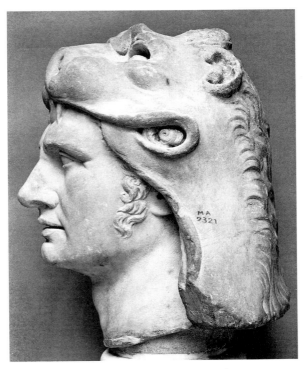

198 Mithradates VI of Pontus, copy (Paris, Louvre)

198 The king wears a lion-skin headdress over long curling hair. He has long sideburns, intense features, and an expression of heroic dynamism. The lion-skin was borrowed ultimately from Heracles, but in this context refers rather to Alexander, whose connection with the hero was universally recognized from his coinage, which had always featured a young Heracles in lion-skin. Mithradates VI of Pontus was the last independent Hellenistic monarch of any real standing, and he led a series of wars against the Romans in Asia Minor from 88 to 63 BC, posing as a new Alexander (from whom he claimed direct descent), come to save Asia from the Roman predator. He was finally defeated by Pompey and took his own life at the age of about 69. The youthful features of the portrait also aim to present the king as a new Alexander: they employ an intensified dynamic version of the Alexander ideal. Mithradates was already over 40 when this portrait type was created and continued to employ an even younger one on his coinage, unaltered until his death. Hellenistic royal portraits had more important things to communicate than the king's actual appearance.

199 The Hellenistic baroque, which we know best from the Great Altar at Pergamum in the second century, was probably formed in heroic groups of the third century like this one. The baroque was a grand, elevated style designed to represent the tumultuous world of epic heroes. The famous Pasquino group portrays the culminating episode

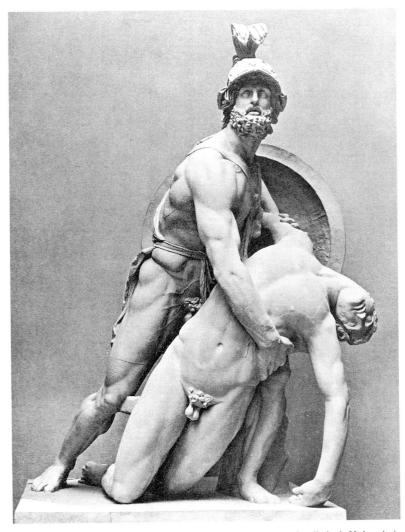

199 Menelaus and Patroclus (Pasquino group), plaster reconstruction (Leipzig University)

of *Iliad* books 16–17. The young Patroclus, having borrowed the sulking Achilles' armour in order to fight in his place, has been killed and stripped, and we see his body being rescued by the older hero Menelaus. Menelaus wears a tunic, belt, and baldric and is armed with sword, shield, and helmet. Patroclus' nudity is thus not merely 'heroic' but part of the narrative, that is, he is not 'nude' but stripped of his armour. His youthful body slumps with broken neck and trailing arm in a posture that combines great realism and pathos. The powerful figure of Menelaus stands astride the body, looking up with thunderous glance both at the viewer and at the surrounding enemy.

Sculptors of the early Hellenistic period experimented with action groups in the round as never before. They made groups of wrestlers, hunters, equestrian figures, and various mythological and historical subjects. The compact pyramidal design of the Menelaus and Patroclus is one of

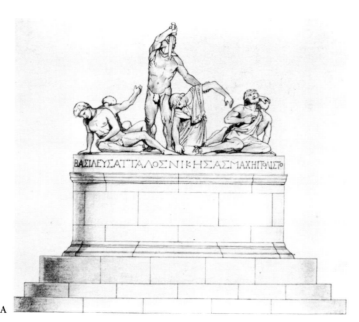

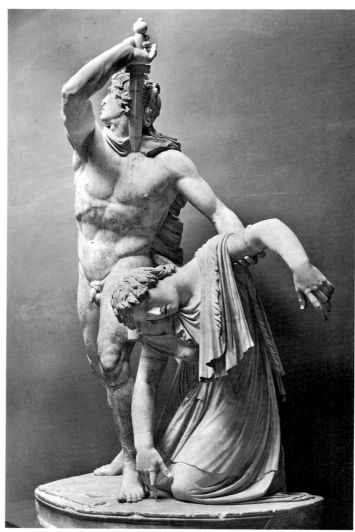

200 Attalid group of Gauls at Pergamum. A reconstruction; B chieftain and wife, copy (Ludovisi group) (Rome, National Museum); C Dying Gaul, copy (Rome, Capitoline Museum)

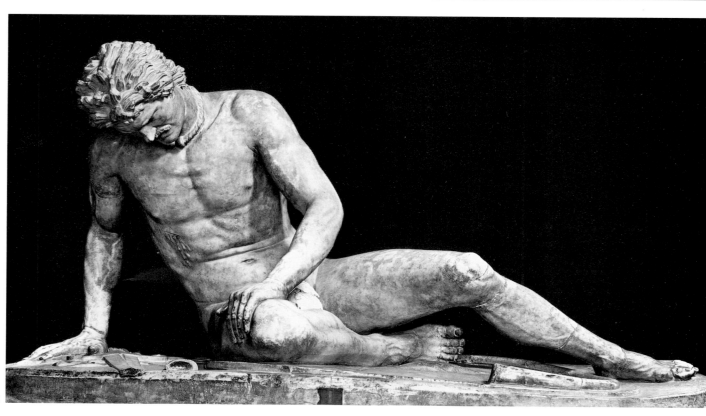

the most successful of the mythological groups. Historical battle groups of very similar kind are known to have been royal dedications, and their close connection to the mythological groups suggests these too may have been royal commissions.

200 Several tribes of Gauls crossed into Asia Minor in 278 BC, and in the middle years of the third century the Attalids of Pergamum fought a series of campaigns against them in defence of the Greek cities of the region. For their victories they set up in the 220s BC at least two great monuments on the acropolis at Pergamum of which the inscribed bases have been recovered. Statues from one of these monuments or another like them can be recognized by subject and appropriate date in a series of later marble copies. The most complete are the famous Ludovisi group and the Capitoline Dying Gaul. The Ludovisi group [B] is a loose pyramidal composition related to works like the Pasquino [199]. It represents a Gallic chieftain, distinguished by his (beardless) moustache and long hair, who has chosen noble suicide for himself and his wife to avoid capture. The Greek victors were probably not shown in this group. To place the defeated enemy on this exalted heroic plane rendered the unspoken powers of the victors self-evident.

The Capitoline Gaul [C] represents a younger figure with shorter hair and a more slender, wiry anatomy. He turns, struggling to support himself on his right arm, in order to look at the mortal spear-wound in his right flank from which blood flows. The blood is represented in relief on the copy and was perhaps inlaid in copper in the bronze original. Pain is suggested not so much by facial expression as by posture. He wears only a torque round his neck, emphasizing that his nudity is 'real'. The Greeks greatly admired the physical strength and bravery of the tall Gauls, who, it was said, fought naked and without armour.

In the Dying Gaul, the sculptor has achieved a fine combination of realistic anatomy and pleasing contour. The name of this sculptor may be known. The Gaul sits on a shield round which curls a long Celtic trumpet. If the trumpet could be taken as the figure's identifying feature, it might be identified as the Trumpeter by the sculptor Epigonus, a work listed in Pliny. Epigonus was an Attalid court sculptor who signed 'Works of Epigonus' on one of the large victory bases on the Pergamene acropolis, referring to the statues it carried. Unfortunately it is unclear to which base (if any) of those we know the surviving figures should be attributed.

201 The Laocoön group, with its anguished rhetorical suffering, remains one of the finest examples of the Hellenistic high baroque, made about 200 BC. It represents the Trojan priest Laocoön and his two sons attacked at an altar by two giant snakes. Ever since its discovery in Rome in 1506—Michelangelo was among the very first to see it—

the group has been convincingly connected with the marble Laocoön described by Pliny and attributed by him to three Rhodian sculptors, called Hagesandrus, Athanodorus, and Polydorus. From the recent discoveries at Sperlonga (see [202]) we now know more about these three Rhodians. They were high-class copyists who provided virtuoso marble reproductions for wealthy Roman buyers, probably in the later first century BC. The Laocoön, therefore, was most likely not their composition but a marble version of a mid-Hellenistic group, and indeed it has obvious connections in theme and style with the gigantomachy of the Great Altar of Pergamum.

The original group was probably concerned not with the epic version of the story in which Laocoön was killed by the snakes simply for opposing entry of the Wooden Horse into Troy (the version made famous by Vergil in *Aeneid* 2), but rather with the tragic version in which Laocoön was punished for breaking vows of priestly celibacy and related sensual crimes. The subject of the group, then, was one of mortal error and divine punishment. Like the heroes of tragedy, Laocoön is suffering intensely for defying the gods.

202 In 1953 the fragments of four Hellenistic baroque groups were found in a vast cave grotto on the Italian coast 60 miles south of Rome at Sperlonga. The cave, which was attached to a Roman seaside villa, functioned simultaneously as a fishpond and a spectacular dinner setting. The sculpture decorated the inside of the cave. There were two smaller groups, one a copy of the Menelaus and Patroclus [199], the other a copy of a group featuring the rape of the Palladium by Odysseus and Diomedes. The other two groups, each a colossal *tour de force*, continued the Odysseus theme. One is the great Polyphemus group, which was set in a subsidiary grotto at the back of the cave. The other was a Scylla group, now very fragmentary, which was set in the water in the middle of the cave and showed Odysseus' ship with the sea-monster Scylla alongside devouring several of his companions.

The Scylla group carried on the stern plate of the ship the signature of the same three Rhodians whom Pliny records as the sculptors of the Laocoön [201]. The signature also gives their fathers' names, which has allowed scholars to trace their family ties among the inscriptions of Rhodes and to place their activity with some certainty in the later first century BC. So although we know the Emperor Tiberius probably owned this villa, he more likely inherited than commissioned the sculptures. Parts of the Polyphemus group are known in other close copies which show that the three Rhodians specialized in highly accurate 'translations' of Hellenistic baroque originals.

The surviving parts of the Polyphemus group can be arranged in their original grouping with some confidence—a relief shows the same composition. Polyphemus is sprawled on his back in a drunken stupor, while two

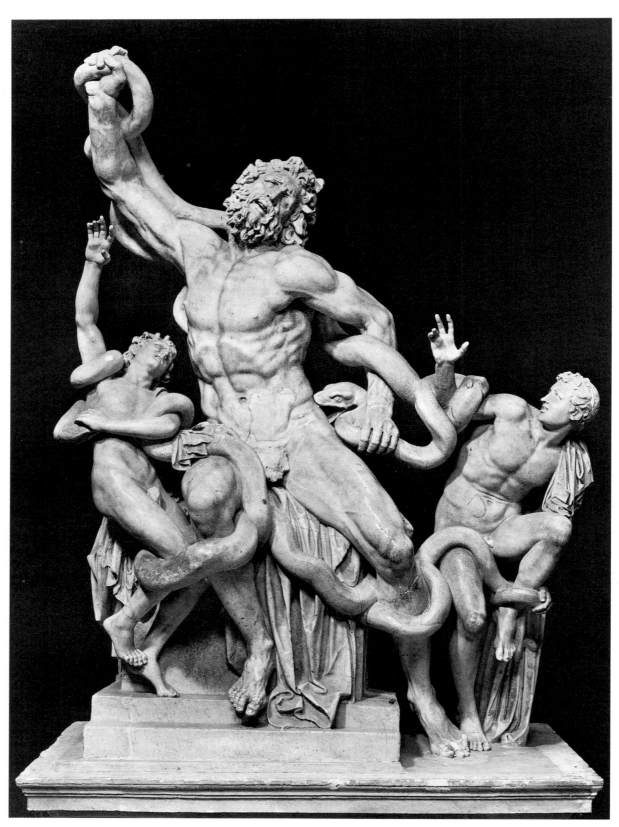

201 Laocoön (Vatican Museum)

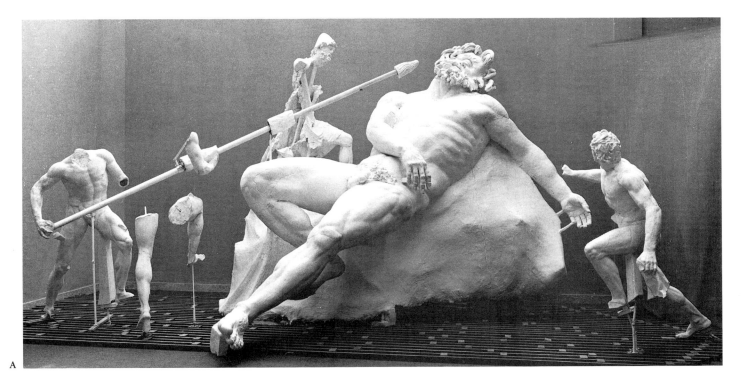

A

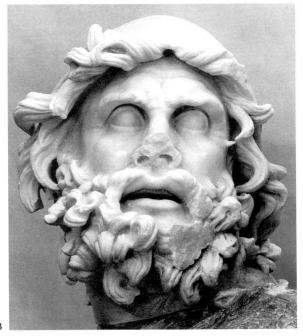

B

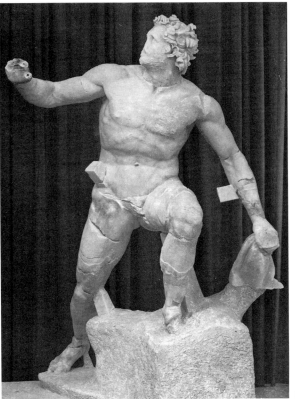

C

202 Polyphemus group at Sperlonga, copy. A plaster reconstruction;
B Odysseus; C wineskin carrier

of Odysseus' companions at left are about to plunge the
burning pole into his solitary eye. They are directed from
above by Odysseus [B], recognized by his conical hat; and
at right, a third companion charges in carrying a wineskin
[C], an allusion to how the Cyclops was put to sleep. The
sculptural technique is virtuoso, the style a full thundering
baroque. The figures combine powerful exaggeration of
muscles with a very refined surface finish that includes
details like the hair on Polyphemus' feet. The head of
Odysseus, with its foaming beard and wild undercut locks
of hair lashing round the forehead, has a wide-eyed heroic
fury not easily forgotten.

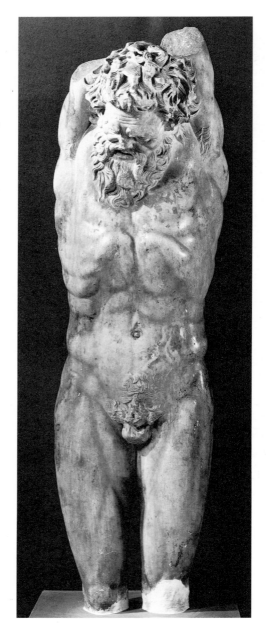

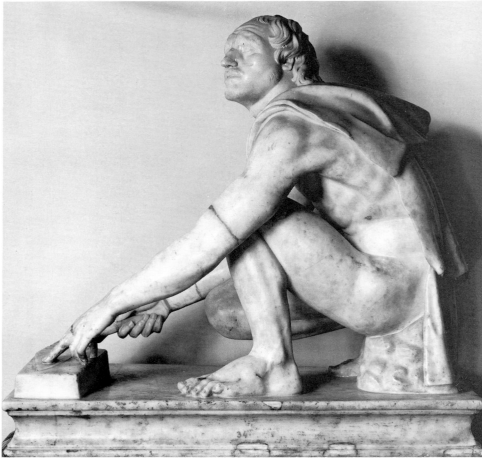

203 B Scythian knife-grinder, copy (Florence, Uffizi Gallery)

203 A Hanging Marsyas, copy (Istanbul, Archaeological Museum)

203 The satyr Marsyas [**A**], proud of his expertise on the rustic pipes, challenged lyre-playing Apollo to a musical contest, with his life as forfeit should he lose. While a fourth-century relief depicted the actual contest, the later third-century group represents the outcome: Apollo's terrible punishment of Marsyas' presumption or hubris. Two figures formed an open, disconnected composition. Marsyas is strung up from a tree by his wrists, while Apollo's Scythian slave crouches beneath, sharpening his knife in preparation for flaying him [**B**]. A seated Apollo may also have been included.

The Marsyas is a fine anatomical study with the skin stretched tight over his bare muscles and hollow rib cage by the hanging posture. His head is a powerful sympathetic study of stoic endurance—pain is expressed more through his body than his face. In this respect, one may contrast the Laocoön [**201**]. The Scythian, too, has a compact, realistic composition and an extraordinary 'genre' portrait—a flat brow with receding long hair and sharply defined features that all express a sinister air of cunning and cruelty. It is the Scythian, not Marsyas, who is the base, unthinking character. The stylistic elevation of Marsyas sets his error among those of tragic heroes.

204 The young satyr [**A**] is beating time with a foot clapper for a young nymph seated on a rock [**B**]. She is taking off her sandals in preparation for dancing. The same figures appear together on coins of Cyzicus which show they belong together in an open group. Dionysian figures—satyrs, nymphs, centaurs—were one of the most creative areas of Hellenistic sculpture. This group puts on display new editions of the satyr and his female partner. The young smiling satyr now has a distinctive taut, sinewy musculature—realistic but with animal traits. And in the female, the wild classical Bacchant has become a charming

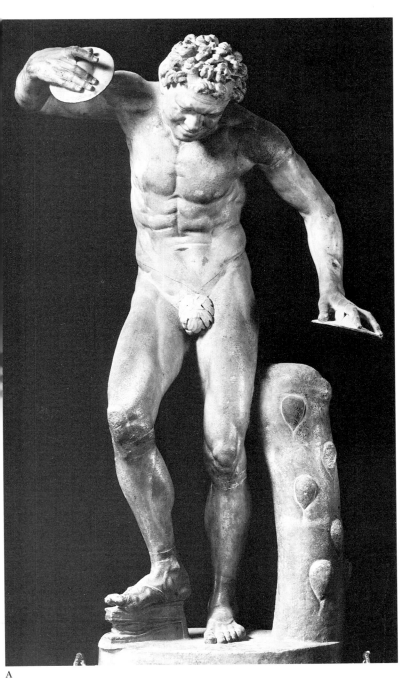

A

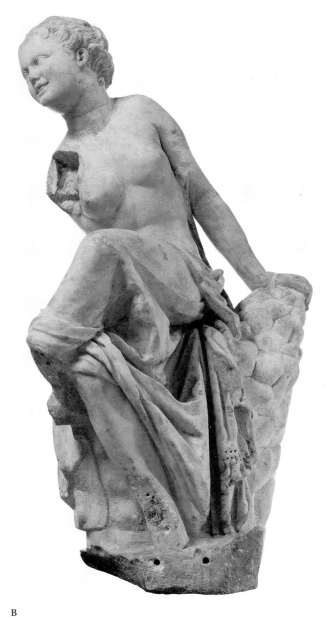

B

204 Invitation to the Dance group, copies (A Florence, Uffizi Gallery;
B Geneva, Musée d'Art et d'Histoire)

woodland nymph, designed explicitly as a smiling female counterpart to the satyr. The group represents the delightful carefree world of the Dionysian outdoors—it is a Hellenistic *fête-champêtre*.

205 An old centaur, his arms tied behind his back, turns in anguished pain to the baby Eros who rides on his back. The centaur is pierced by desire, but his hands are tied by age. The statue is one of a contrasting pair of which the other shows a young, smiling centaur snapping his fingers in the air—he represents youth, delighted by the stabs of Eros. Classical centaurs had been wild old creatures engaged in rustic battles with each other or with Lapiths. In the Hellenistic period (this is of about 200 BC) they joined the world of Dionysian art and are usually rendered in a lighter manner. The Old Centaur, while clearly of that world, reveals the close formal links such sculptures had with the grand and solemn world of the heroic baroque. The Dionysian and the heroic styles were different parts of the same stylistic or expressive spectrum.

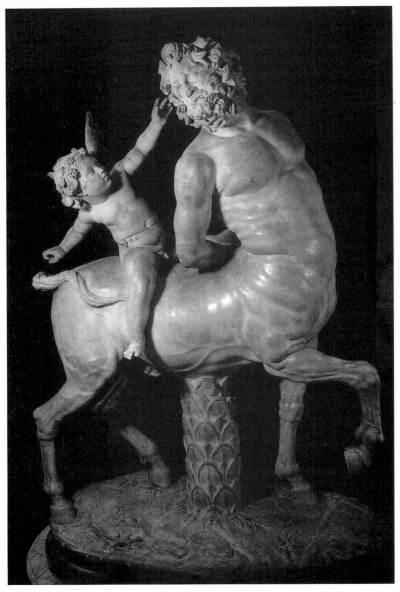

205 Old Centaur (Paris, Louvre)

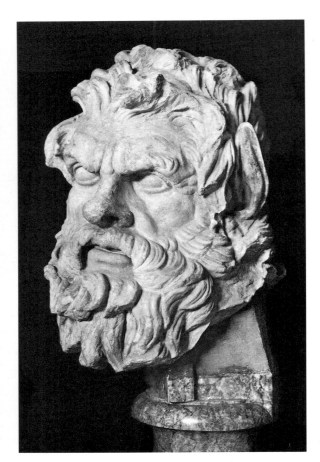

206 Centaur, copy (Rome, Conservatori Museum)

206 The head of an old centaur with large animal ears and thick beard turns sharply with a glowering expression of wild, intense ferocity. The carving is of exceptionally high quality and has a freshness lacking in most Roman copies. The head was probably a very fine reproduction of a Hellenistic work from a similar environment to that of the Sperlonga sculptures.

207 A long-legged elder satyr is vigorously fought off by a nymph-like hermaphrodite. The confused struggle of limbs creates an extraordinarily bold, explosive group composition, clearly designed for bronze. The viewer is intended to discover the true nature of the 'nymph' by proceeding round the group. Its double sexuality was intended as a surprise, certainly for the viewer and perhaps also for the satyr in the narrative of the group. This her-

maphrodite is neither the deity accorded cult since the fourth century BC, nor a particular character of mythology, but rather an androgynous 'genre' creature of Dionysian art. It has the round, smiling face of a Dionysian nymph, and the atmosphere is one of light, playful eroticism.

208 The sleeping figure lies in a long, sinuous pose of extraordinary elegance, clearly intended to be seen from behind. The spectator's approach to the statue from this view was probably carefully programmed in its setting, so that the discovery of its hermaphrodite sexuality would have come as a much greater surprise than in the Satyr and Hermaphrodite group [207]. There the laughing face revealed immediately the context of Dionysian play. Here the figure has the classic ideal head type and hairstyle of a divinity or heroine. Sleeping maenads spied on by satyrs had featured before in Classical paintings, but to a Hellenistic audience the best-known sleeping figure in this posture and style would have been rather the abandoned Ariadne—a famous Hellenistic painting showed her in a similar pose (see [168]). Thus the viewer was led to expect the unusual subject of a naked Ariadne in the round, but discovered instead an anonymous androgyne. The statue playfully engages a (male) viewer's ideas and assumptions about iconography and sexuality.

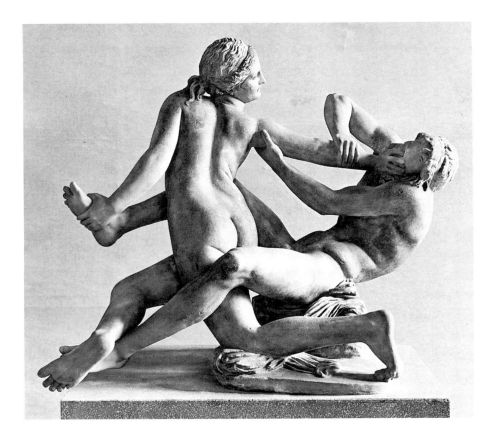

207 Satyr and Hermaphrodite,
copy (Dresden, Albertinum)

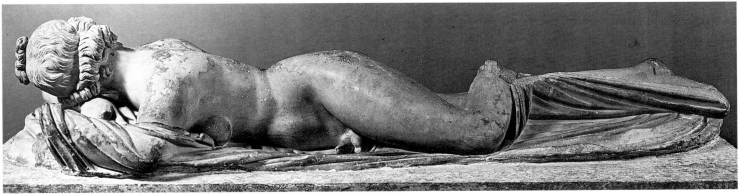

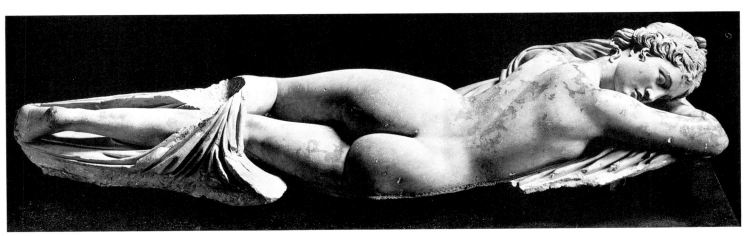

208 Sleeping Hermaphrodite, copy (Rome, National Museum)

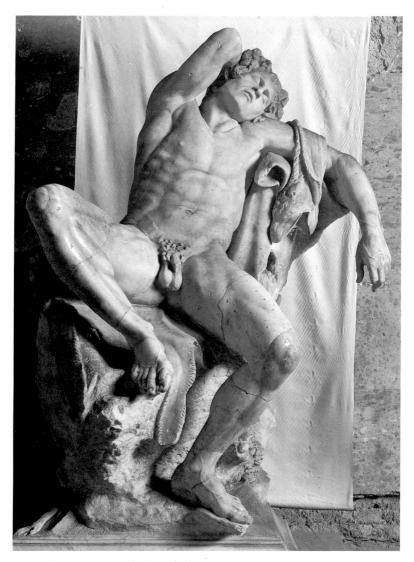

209 Barberini Faun (Munich, Glyptothek)

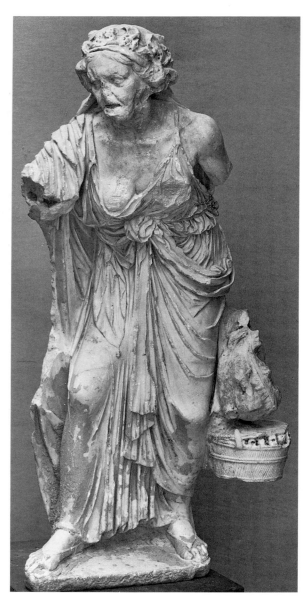

210 Old Market Woman, copy (New York, Metropolitan Museum)

209 The young male figure sprawls asleep on a rock. The viewer's first surprised impression of its openly erotic effect is only slowly modified by the realization that the subject is a satyr fallen asleep drunk in the wilds, not an athletic Greek youth sunbathing. The well-formed, muscular body has little of the distinctive sinewy satyr style, and the head reveals even on close inspection only a few animal-satyr traits—the ears and a small tuft of hair on the forehead. His identity is otherwise expressed only by the panther skin on which he lies. This is both an astonishing 'genre' portrait of a satyr in the tradition of the Scythian knife-grinder in the Marsyas group [203 B], and a provocative study in homoerotic voyeurism that is removed only a slight distance from reality by its Dionysian setting. The sculptor has captured most convincingly the abandoned relaxation and exposed pose of one who is sure he will not be observed. The figure is a copy (?) of a work of about 200 BC.

210 An old woman carrying some dead fowl and a basket full of live chickens walks forward awkwardly, her back bent by age and labour. She was no doubt using a stick. The head cloth, farm produce, and posture indicate a peasant woman. She wears, however, a fine long dress belted at the waist, a large mantle, and—most strikingly—a very elegant pair of thin-strapped sandals. These are of course not her daily farm clothes, rather she is wearing her very best because she is on her way to the city, to market, and surely to a festival, for she also wears a prominent wreath. The wreath is of ivy, and she is probably to be thought of as going to a Dionysian festival.

Hellenistic genre statues of peasant boys, old fishermen, and gnarled old women were a remarkable and entirely novel addition to the sculptural repertoire. On such lower-class beings Hellenistic sculptors turned their full powers

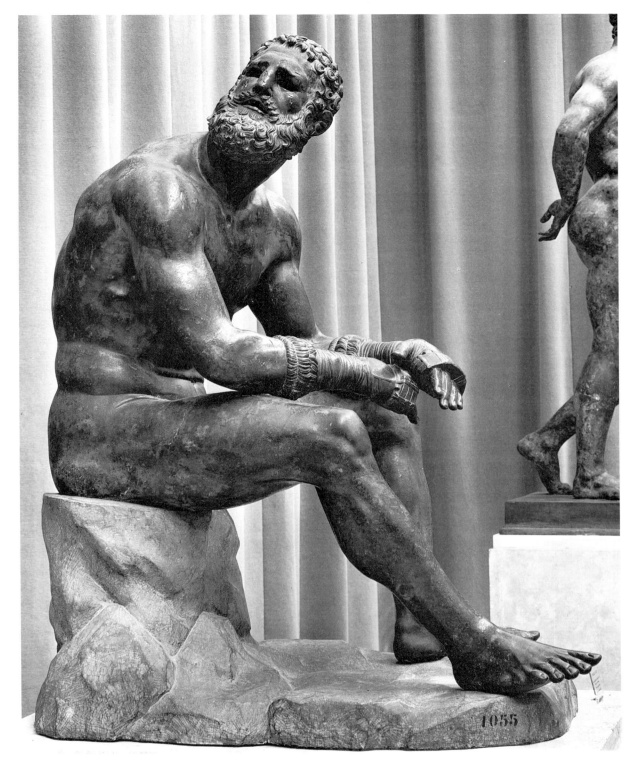

211 Terme Boxer, bronze (Rome, National Museum)

of withering observation and realistic representation. In the Market Woman, the decrepit face and neck are emphasized, while the bony chest and escaping right breast mock her vanished physical charms—the slipping dress is a familiar motif of Aphrodite and her circle. Such statues were naturally the votives of a wealthy and urban élite, for whom their aesthetic value lay in their acute contrast of pitiful subject and exquisite technique.

211 Athletic statues had been one of the major branches of Classical sculpture, in which theories of ideal proportion were forged. Prowess in particular sporting events

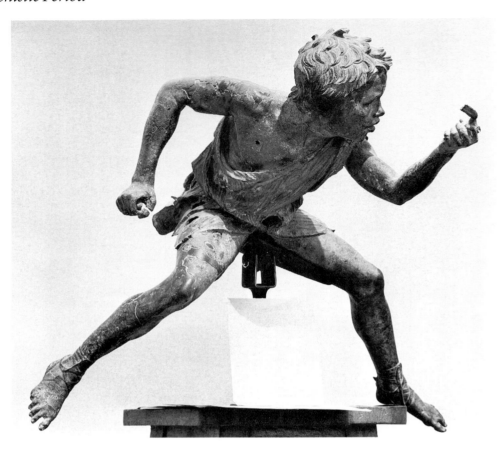

212 Jockey from
Artemisium, bronze
(Athens, National
Museum)

had been subordinated to the expression of a more gener-
alized norm of male excellence. In the Hellenistic period,
sculptors responded to the increasing specialization of
professional athletics with statues that carefully differenti-
ated the various kinds of athlete as sharply as they were in
life. The Terme Boxer and the Artemisium Jockey [212],
both original bronzes, are our finest examples.

The Terme figure represents a heavily muscled boxer
sitting with his head turned sharply up at the viewer. He
wears thick leather bindings, secured with thongs wrapped
round his forearms. Even without the bindings, he would
be immediately recognizable as a boxer or wrestler from
his battered and scarred face, broken nose, and thick
swollen ears. Indeed, although no doubt intended to rep-
resent a particular fighter, the head contains more generic
boxer traits than individual features. The immediacy of
the fight is indicated by the cuts on his face and ears, which
are represented in great detail by bright copper inlays.
These extraordinary bleeding gashes were revealed during
a recent recleaning and restoration of the statue.

212 A young boy jockey, wearing short tunic and san-
dals, leans forward on the mane of a racehorse. The sculp-
ture, found in a shipwreck off Cape Artemisium, has great
freshness and vigour. Although the boy's thick, tousled

hair and slightly African features are strikingly realistic,
this is clearly a generic portrait intended to represent more
his role and status as a jockey than his individuality. The
large bronze horse that belongs with the rider—it was
found in fragments with it—is a thoroughbred at full gal-
lop. The horse has classically 'noble' equine features which
indicate not a different date of manufacture from that of
the rider but the relative values in contemporary eyes of
fine horse and lowly jockey—he might have been a slave.
The vivid portrayal of the African jockey rendered the
whole monument true and immediate to the event that it
commemorated.

213 The orator and statesman Demosthenes, his hands
clasped in front, stands in a simple four-square posture
looking down. He wears sandals and a himation arranged
in the plainest manner and worn without undertunic. The
frowning portrait is a masterpiece combining effects of
individual physiognomy, intense interior character, and a
suggestion of mortal pathos. The head is known in more
than fifty marble copies of the Roman period, when
Demosthenes' speeches were regarded as the crowning
achievement of classical oratory.

The original statue, made by one Polyeuctus, is unusu-
ally well documented in our literary sources. It was set up

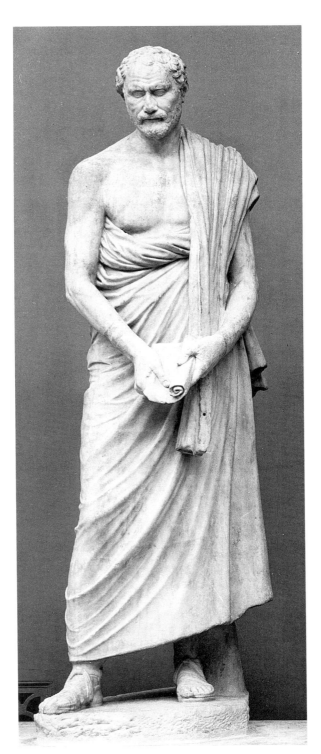

213 Demosthenes, copy (Copenhagen, Ny Carlsberg Glyptotek)

thrusting swagger of Macedonian ruler images like the Terme Ruler [**194**]. Much of the portrait's reflective, pensive attitude was borrowed from early Hellenistic philosopher portraits.

214 An ageing philosopher (third century BC) stands leaning back slightly in the posture of an elderly man. He wears sandals and a thick himation that falls casually off his left shoulder to reveal his sagging chest. He held a stick in his right hand and looks down, perhaps at something he is demonstrating—for example, a drawing on the ground. He was thus probably represented as engaged in teaching, the main public business of a philosopher.

Philosophers were prominent figures in Hellenistic society, especially at Athens, where the leading schools were located, and it was probably there that the philosopher's image evolved as an important and highly distinctive branch of Hellenistic portraiture. The statues represent unflinchingly the thinker's senescent mortal body, emphasizing his ascetic lack of concern for bodily appearance, which is redeemed by his unique intellectual insight, represented in the portrait head. It is these portraits' elevated inner character that distinguishes the realism of these statues from that, for example, of genre statues.

215 Although unidentified, the third-century head is one of the finest examples of a Hellenistic philosopher portrait that expresses unequivocally the idea that the subject's status derived from mind and moral character, rather than from physical or political power. In comparison with our many marble copies of such portraits, the head also reveals the much greater intensity and vitality of an original work in bronze. Its extraordinary variety, detail, and precision are characteristic of the best Hellenistic bronzework—from the finely engraved beard and dynamic tousled locks of hair to the inlaid eyes and sharply contoured lips.

This philosopher seems to have been part of a group of two or three similar figures, fragments of which were recovered from the same shipwreck off Anticythera—several feet and lower legs survive, all wearing the same kind of sandals and cloaks. Large lead tenons still protruded from the soles of the feet, indicating that they had been torn from their bases and were probably on their way to Rome as booty.

216 The portrait of Epicurus, known in over thirty copies, is identified by this inscribed example. The original, probably a seated statue, was most likely one set up in third-century Athens in his school, the Garden. The portrait has a distinctive long narrow face and rather fiercely knitted brows. The brows indicate the intensity of the master's intellectual concentration and commanding spirit, while the long face suggests asceticism. The founder of

in 280 BC in the Agora at Athens forty-two years after Demosthenes' death, as a symbol of Athenian opposition to and independence from the Macedonian kings, which Demosthenes had championed in his day. The statue's simplicity, restraint, and inward-looking character were no doubt to be read as a contrast and response to the

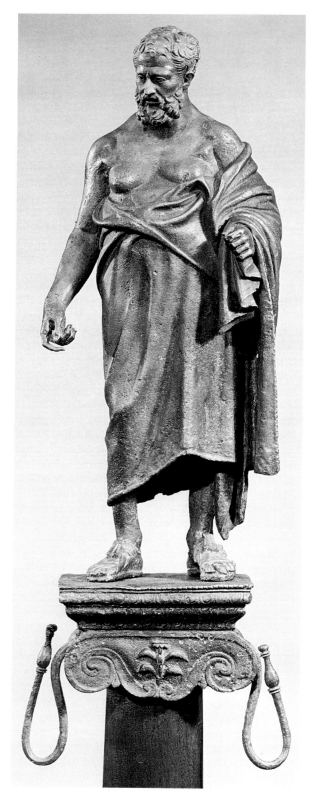

214 Philosopher, bronze statuette (New York, Metropolitan Museum)

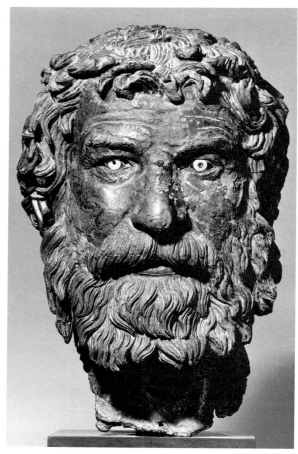

215 Philosopher, from Anticythera, bronze (Athens, National Museum)

Epicurean thought espoused pleasure only in the very special sense of the absence of pain. His goal was a state of unfettered tranquillity for the philosophical mind.

Unlike many of his decrepit, unkempt-looking rivals, Epicurus is shown at an ideal later middle age, with short, well-cut hair and a finely groomed long flowing beard. Indeed, ancient sources note that he had a more polished, worldly self-presentation than his philosophical peers. Although he taught retreat from public life and worldly commitment, Epicurus' portrait subtly subscribes to the old Greek belief—ostentatiously abandoned by the Cynics and Stoics—in the link between outer appearance and inner virtue.

217 The aged Stoic philosopher Chrysippus sits on a low stool, engaged in teaching, one hand extended in a gesture of explanation. He wears heavy sandals and a thick cloak wrapped round his stooping shoulders. The folds and surface of the cloak are rendered with great economy, while the portrait employs a wealth of realistic detail in the aged features and ill-growing, patchy beard. The figure has been reconstructed from a headless statue and a cast of one of

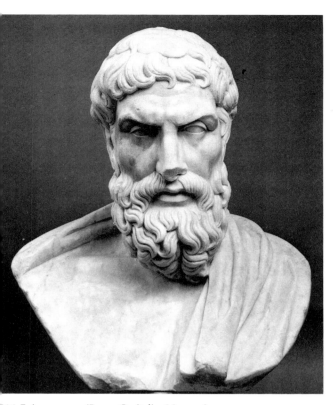

216 Epicurus, copy (Rome, Capitoline Museum)

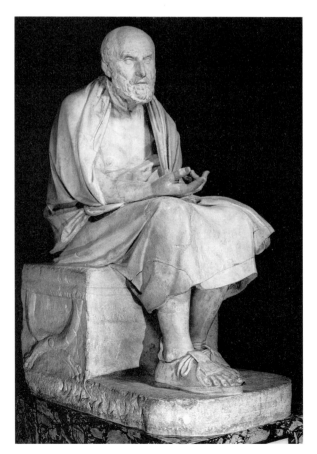

217 Chrysippus, copy (Paris, Louvre)

the many surviving copies of Chrysippus' portrait head. Chrysippus, who died about 207 BC, was the third head of the Stoic school founded by Zeno in Athens, and it was he who first systematized Stoic doctrine in a prodigious output of philosophical writings. The portrait is a classic representation of philosophical mind held temporarily in its senescent mortal frame.

218 The large statue of a draped woman, no doubt the wife or daughter of a wealthy citizen of Cos, was probably set up in the second century BC in recognition of some major benefaction to the community. The separately added head, like most portraits of Hellenistic women, is an entirely ideal construction, based on images of Aphrodite. The sense of a real or mortal image is represented rather by the statue's contemporary dress. She wears a long chiton and a very light mantle or shawl which is pulled tightly over her right arm and hip. This dress fashion had impelled sculptors to design a quite new form of carved drapery—the vertical folds of a thicker dress covered by and seen through a complicated play of transverse folds of a fine shawl. This 'transparent' drapery technique was quickly mastered in the third century and became part of the sculptor's stock in trade in the second century. It was sometimes combined, as here, with another sophisticated feature, namely the realistic 'press folds' or crease lines of the folded garment that follow the complicated contours of the figure.

Draped female marble statues of this kind survive in large numbers from the Hellenistic east and attest to a greatly increased social prominence of women of wealthy families in city life. The usually symbolic nature of this prominence, however, is strikingly represented in the almost complete lack of individual characterization. Differentiation extends little beyond elementary distinctions of age. Hellenistic society recognized the importance of some women but their principal attributes remained those of virtue and beauty. The heads of their honorific statues express beauty, the draped bodies virtuous modesty.

219 The veiled head, found in the sea off Smyrna (Izmir), has a modest downward glance that suggests a mortal woman more easily than a goddess—images of Hellenistic women rarely have strong portrait features. In its original context the subject would have been clear from its setting and inscribed base. The eyes were separately inlaid and the lips plated with copper. The different parts of her dress are clearly distinguished, and the drapery is handled with a convincing natural spontaneity. The piece is a rare surviving example of a major Hellenistic female figure in bronze, datable to the third century BC.

220 The charming statue represents a young girl seated on a stool in a slightly coquettish posture permitted to youth. She does not engage the viewer's gaze, but looks

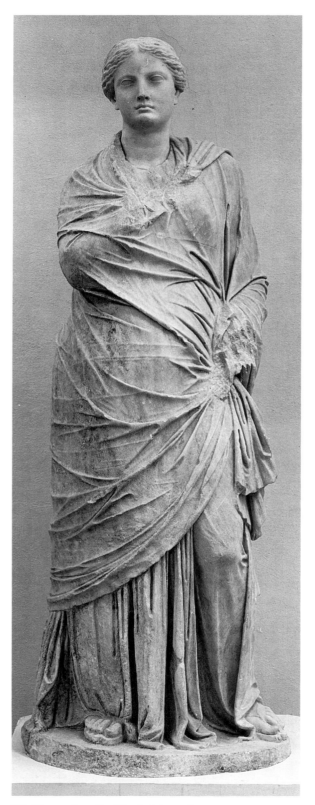

218 Woman, from Cos (Rhodes Museum)

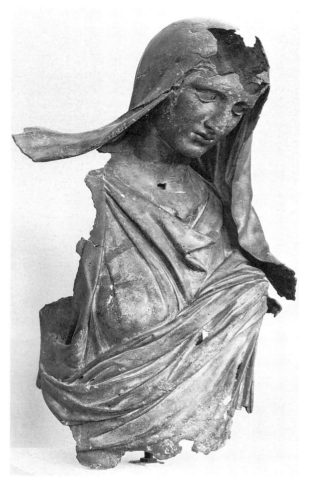

219 Lady from the Sea, bronze (Izmir, Archaeological Museum)

down at the ground—either in modesty or at something not included in the sculpture. Her adolescent or pre-marriage age is carefully defined in her fine features and perhaps also in the relative size of her body to the large stool on which she sits—her feet do not reach the ground. She wears a chiton fastened over her right shoulder with a mantle wound round her left elbow and shoulder. Her pose and drapery make up a complex and sophisticated design composed of irregular intersecting triangular shapes. The pose and emphatic three-dimensional quality of the statue—the viewer must go round the figure—are very similar to the famous Tyche of Antioch by Eutychides, a pupil of Lysippus, made about 300 BC. The original statue of the seated girl was perhaps a funerary monument of about the same date.

221 Terracotta statuettes of draped young women were made all over the Hellenistic world as inexpensive offerings for tombs and temples. The generic type ('Tanagra') is named after a cemetery near Thebes where large quantities were first discovered. The figures partly reproduce the

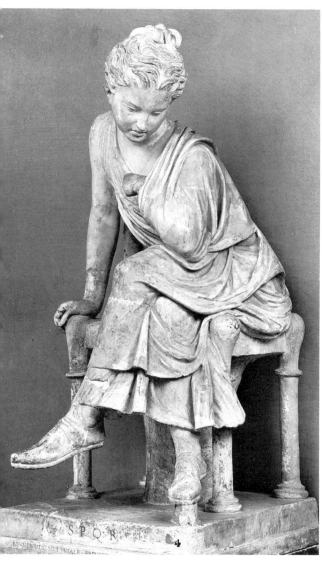

220 Seated girl, copy (Rome, Conservatori Museum)

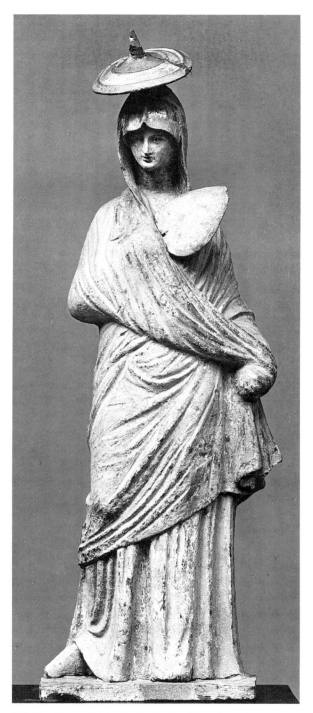

221 Clay 'Tanagra' statuette (Berlin, Staatliche Museen)

repertoire of major draped female statues—the respectable married wife—while others evoke a more spirited *demi-monde* of musicians, dancers, and gossipers. They often recall the middle-class ladies one encounters in the poems of Theocritus, strolling in the streets of Alexandria. The statuettes were brightly painted: the features of eyes and lips were picked out against white flesh, and the drapery was coloured in broad bands of blue, yellow, red, and pink, sometimes with gilded edging. Such vivid polychromy should be mentally transferred to the draped marble statues. This example was made about 300 BC.

222 The most common kind of grave monument in use in Hellenistic cemeteries was a tall marble gravestone decorated with many of the motifs of an architectural monu-

ment: podium, columns, entablature, attic, and pediment. Inscriptions and civic wreaths fill the attic, while the figures of the deceased are framed below, like statues in a *naiskos* or small shrine. Women have more personal weight here than in classical gravestones, appearing alone, often in their role as priestesses. Men are shown as public

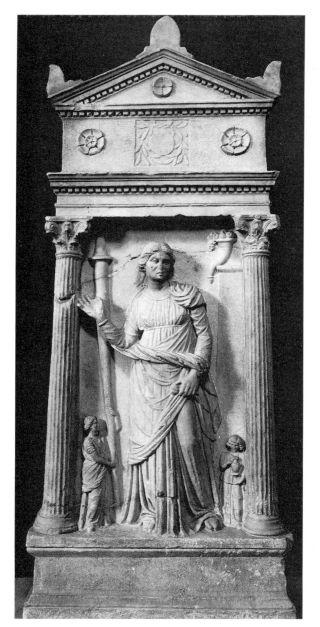

222 Grave relief, from Smyrna (Berlin, Pergamum Museum)

223 Portrait from Delos, bronze (Athens, National Museum)

figures in civic cloak or as heroic soldiers. Boys appear as young athletes. And even young children, shown playing with toys, sometimes received individual commemoration.

In this example from Smyrna, of the second century BC, an imposing figure of a priestess is accompanied by two diminutive attendants, one carrying a large torch (for nocturnal worship), the other a jug (for libations). The woman makes a gesture of salutation, directed towards her goddess rather than the viewer. The cornucopia in the background alludes to the wealth that explains and justifies her prominent position.

223 The bronze portrait represents a middle-aged man with short hair and soft, fleshy features, turning and looking up in a vigorous posture. Unlike philosopher or ruler portraits, it includes no elements that indicate unequivocally what category of person is represented. The head is typical of a large group of second-century Hellenistic portraits that emphasize the individual over his public role. These 'private' portraits do often represent private citizens, that is, wealthy men without public office. Their statues tend to express more who they were, than what they were. The realistic, individual features in this portrait are presented in the familiar framework of a dynamic upward turn and tilt of the head. This pose, the furrowed brow, and the parted lips express energy and sympathetic vitality. This mixture of realism and dynamism is characteristic of many private portraits of the late Hellenistic period.

224 The portrait head was found in 1974 fallen in front of the central niche of a *heroon* or cult room in the lower city at Pergamum. The room was most probably dedicated to the cult of one Diodoros Pasparos, a great civic benefactor and leader at Pergamum in the time of the Mithradatic wars (88–63 BC). Inscriptions tell of the extravagant statu-

PLATE XIII

162 B Alexander Sarcophagus
(Istanbul, Archaeological
Museum)

165 Alexander Mosaic from
Pompeii, copy (Naples,
National Museum)

PLATE XIV

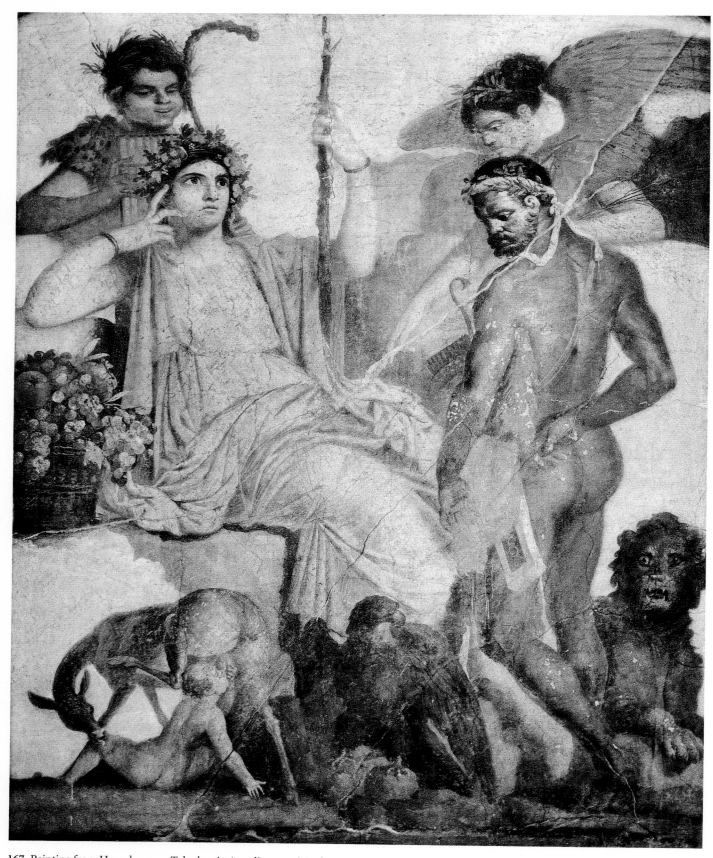

167 Painting from Herculaneum: Telephus in Arcadia, copy (Naples, National Museum)

PLATE XV

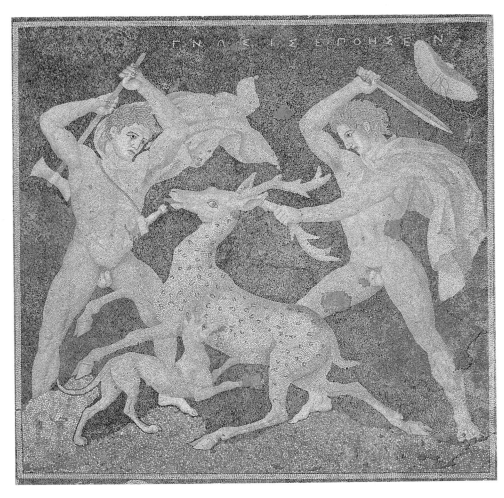

175 Pebble mosaic at Pella: stag hunt

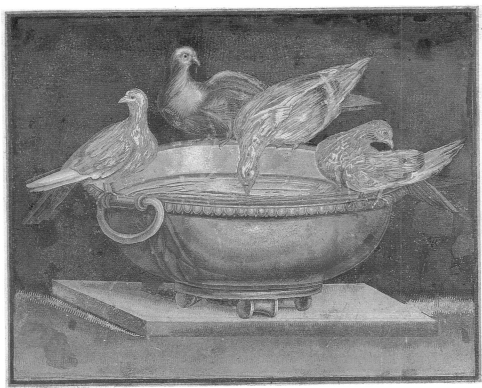

179 Mosaic by Sosus: *Doves*, copy (Rome, Capitoline Museum)

PLATE XVI

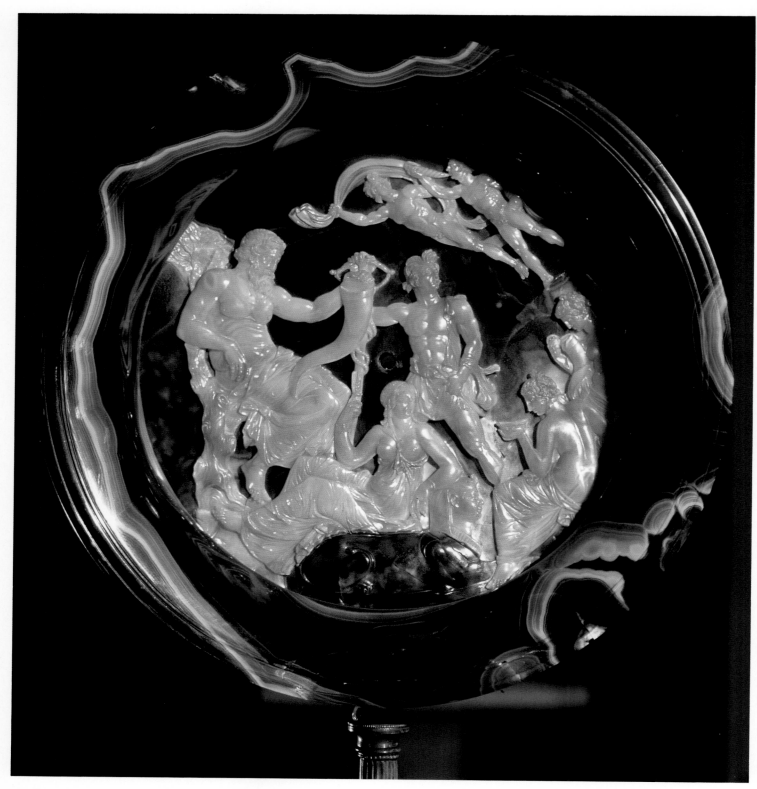

184 Tazza Farnese, sardonyx (Naples, National Museum)

224 Diodoros Pasparos, from Pergamum (Bergama Museum)

225 Italian businessman, from Delos (Athens, National Museum)

ary honours voted to Pasparos for securing important concessions from Rome, where he evidently had well-connected friends. The head is very finely carved and shows the sitter as middle-aged, with short-cropped hair receding above the temples. It combines a highly particular rendering of individual physiognomy with a soft, refined sculptural treatment.

While the technique remains Hellenistic, the portrait seems to have borrowed something in conception from contemporary Roman portraiture, namely the objective individuality of the head structure, the physiognomical detail, and, most obviously, the short-cropped, receding hair. Unlike many contemporary Roman heads, the portrait also lays claim to a mildness, a sense of beneficent humanity. It belongs with a group of similar portraits of local rulers and dynasts of the first century BC who held sway through the good graces of Rome. This public self-image seems to have been designed to express a Roman political allegiance. Men like Pasparos mediated politically

between Rome and the cities of the late Hellenistic east, and their portraits also span these two worlds.

225 This statue was found in the main reception room of a large house on Delos. It is sometimes nicknamed the 'Pseudo-Athlete' because it has the body of a classical athlete but the head of an Italian businessman, who probably spent little time at the running track. In the later second and early first centuries BC Delos was a free port that played a key role in the transfer of wealth, especially slaves, from the Hellenistic east to Italy. The island provides for us the best cross-section of late Hellenistic art that was now

available to Roman patrons. The statue represents probably one of the great financiers and slave traders who organized this transfer of men, goods, and culture to Italy. It is an arresting figure that highlights some marked changes that Roman patronage brought to Hellenistic art.

First, in the portrait head there is an intensification of the individual realism of Hellenistic portraits into an uncompromising, hard-headed, almost aggressive style that appears distinctively 'Roman'. This was how Romans liked to see themselves, and many of their friends in the Greek east (like Diodoros Pasparos [224]) followed this portrait manner in a lighter key.

Secondly, the statue makes no attempt to convince us that it represents the real athletic body of the sitter, in the way Hellenistic ruler statues did; rather it is styled in an obviously classical and 'unreal' manner. The statue employs the prestigious vocabulary of a Polyclitan athlete in order to suggest some elevated but unspecified status for the sitter. Classic body types with realistic portrait heads had a long future in Roman art.

And finally, the style of the body also points to a wider or more general Roman preference for the Classical style over contemporary Hellenistic styles. In the same house on Delos, the owner displayed a copy of the Diadumenus by Polyclitus—our earliest example of a precise marble replica of a Classical statue that was intended to be recognized as such. Although the story of much late Republican art in Italy is of the re-creation and redeployment of Hellenistic art in Roman settings, these statues illustrate that the Romans also made some important choices of their own—in portraiture and in preferred art-styles of the past.

5 ROME: THE REPUBLIC AND EARLY EMPIRE

J. J. POLLITT

WHEN we speak of 'Roman' art we mean something quite different from what we usually mean when we speak of Greek art. The latter, at least before the Hellenistic period, generally refers to the art of a single ethnic and cultural group created in regions—Greece, Asia Minor, Magna Graecia, and a few colonial cities—where the Greeks lived. Mature Roman art, by contrast, refers to a tradition of styles, genres, and iconography which served the political needs of a vast multi-cultural and polyethnic state and which satisfied the changing tastes of a society that was stratified primarily on the basis of wealth. It was designed, disseminated, and appreciated throughout an empire that extended in longitude from the European coast of the Atlantic ocean to Mesopotamia and in latitude from the borders of Scotland to northern Africa. Although the administrative centre of this far-flung state was in Rome, the natives of the city, by the first century after Christ, played only a small role in its affairs, and even the Italian population of the Roman municipalities of Italy, while still an important base of the aristocratic class that controlled the Empire, began to share political power with Roman citizens from the provinces. Within its far-flung borders, the Roman Empire encompassed a wide array of national groups, cultural traditions, and languages, and as people of such diverse ethnic backgrounds as Celts, Greeks, and Semites (to name only a few) attained Roman citizenship and began to be active in public affairs, their role in shaping Roman political, intellectual, and artistic life became increasingly important. Even the emperors, in time, came from outside Italy. Hadrian, for example, was from Spain.

Roman art, then, was no more the product of a single people than was the Roman culture as a whole. Some known architects and painters were clearly Italians, and a few were probably even Romans. The surviving evidence from inscriptions and literary sources suggests, however, that most 'Roman' sculptors, and many 'Roman' architects and painters, were Greeks and that others hailed from the Near East and Europe. Their art is referred to as Roman because its inspiration and source of patronage was the Roman political and social system, not because its creators were Romans in an ethnic sense.

A distinctively Roman art (as opposed to versions of Etruscan or Italo-Hellenistic art in Rome) did not begin to take shape until the first century BC and did not develop fully until the establishment of the imperial principate by Augustus towards the end of that century. It was formed from a fusion of Italic traditions (including Etruscan) on the one hand and of Greek (at first mainly Hellenistic) traditions on the other. Much of the stylistic development of official Roman art up to the end of the second century AD can be seen, in fact, as a reflection of how changing needs and predilections at any given time impelled the imperial government to stress the importance to either Rome's Greek or its Italic artistic heritage. Preferences for one or the other of these two artistic strains also typified, in the view of many scholars, the tastes of different social classes within the Empire. The Italic tradition, the evidence seems

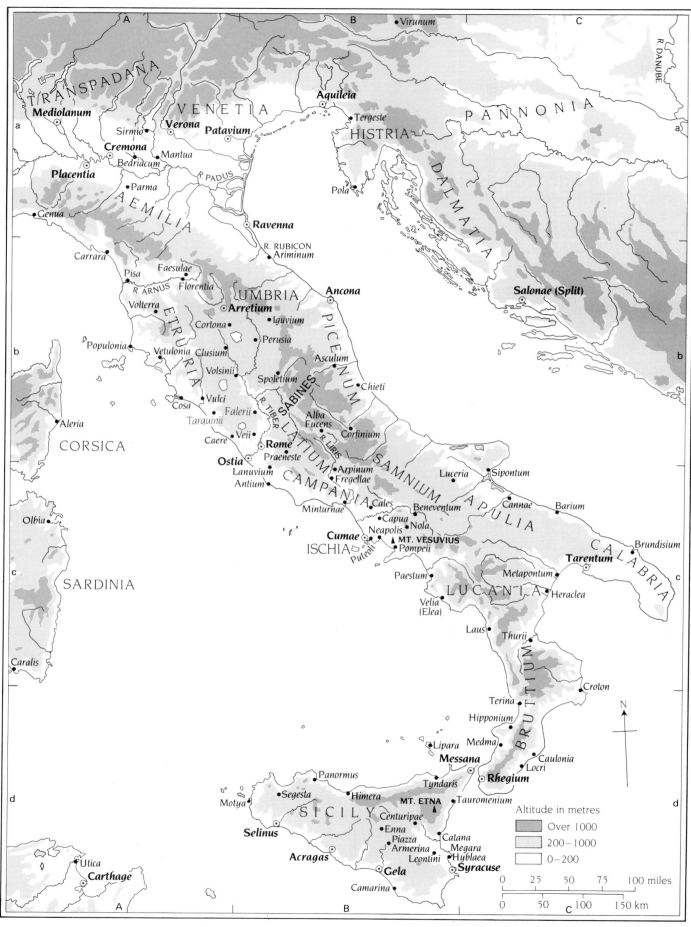

A
B
C

• Virunum

TRANSPADANA

Mediolanum ⊙ **Aquileia**
 • Tergeste P A N N O N I A
 • Sirmio **Verona** H I S T R I A
Cremona ⊙ **Patavium** V E N E T I A
 • Mantua
 • Bedriacum • Pola
Placentia ⊙ D A L M A T I A
 • Parma
 A E M I L I A R. PADUS
• Genua

 Ravenna ⊙
• Carrara R. RUBICON
 • Ariminum
 • Pisa • Faesulae
 R. ARNUS • Florentia **Salonae (Split)** ⊙
 • Volterra U M B R I A • Ancona
 Arretium ⊙ **Ancona**
 • Populonia • Cortona • Iguvium
 • Vetulonia Clusium • Perusia P I C E N U M
 • Cosa • Volsinii • Asculum
 • Vulci Spoletium **SABINES** • Chieti
 Tarquinii Falerii Alba
 E T R U R I A R. TIBER Fucens
 • Caere • Veii • Corfinium
C O R S I C A **Rome** ⊙ R. LIRIS S A M N I U M
 • Praeneste **L A T I U M**
 Ostia ⊙
 • Lanuvium • Arpinum • Luceria • Sipontum
 • Antium **C A M P A N I A** • Fregellae
 • Beneventum A P U L I A
 • Minturnae • Cales • Cannae • Barium
 • Capua • Nola
• Olbia • Neapolis
 Cumae • Puteoli ▲ **MT. VESUVIUS**
 I S C H I A • Pompeii **Brundisium** •
 C A L A B R I A
S A R D I N I A • Paestum • Metapontum **Tarentum** •
 • Velia L U C A N I A • Heraclea
 (Elea)
 • Laus
• Caralis • Thurii

 • Croton

 • Terina
 • Hipponium N
 • Lipara • Medma B R U T T I U M
 • Caulonia
 Messana • Locri
 • Panormus • Tyndaris
 Rhegium ⊙
 • Motya • Segesta • Himera **MT. ETNA** • Tauromenium Altitude in metres
 ▓ Over 1000
Selinus S I C I L Y • Centuripae ░ 200–1000
 • Enna • Catana □ 0–200
 • Piazza • Megara
 Armerina • Leontini Hyblaea
Acragas **Gela** ⊙ **Syracuse** ⊙

 • Utica • Camarina 0 25 50 75 100 miles
 Carthage ⊙ 0 50 100 150 km

MAP 2. ITALY

to suggest, was favoured in the 'popular' or 'plebeian' art of the lower classes and the Hellenistic tradition in works of art created for the aristocratic senatorial class.

Etruscan, Italic, and Greek artistic forms and styles, like the cultures that produced them, had interacted in Italy for centuries before the founding of the Roman Empire, and their formal incorporation into Roman art was the culmination of a long period of synthesis. A brief history of how this synthesis came about over a period of eight centuries will help to explain how many of the most distinctive features of mature Roman art came into being. This long period can for the sake of clarity be divided into three phases: an 'Etruscan phase' dating to the seventh and sixth centuries BC and coinciding mainly with the 'Regal Period' in Rome's early history; an 'Italic phase' dating to the fifth and fourth centuries BC and coinciding with the formative stages of the Roman Republic; and a 'Greek phase' dating to the third and second centuries BC and coinciding with Rome's expansion into and domination of the Hellenistic world. It must be remembered, however, that these phases are not sealed compartments and that features of one can be found in the others. The influence of Greek art, for example, permeated Etruscan art and the Italic art of central Italy, and Etruscan art continued to exist for centuries after the decline of Etruscan cultural and political dominance.

The details of the Regal Period of Rome's history were codified in the second and first centuries BC by Varro, Livy, and other writers, who combined popular legends with ancient annals preserved in the form of priestly records. According to their reconstruction of their own past, the city was founded (traditionally in 753 BC) by Romulus, who came from the neighbouring town of Alba Longa in Latium and was a distant descendant of the Trojan hero Aeneas. Romulus and the Latin kings who were his immediate successors slowly expanded the city from its simple birthplace on the Palatine hill and as they did so instituted many of the religious, governmental, and military institutions that would typify Rome throughout its history. Towards the end of the seventh century BC (traditionally in 616 BC) an Etruscan dynasty was established in Rome by a settler from Etruria, Tarquinius Priscus, who was the son of a Greek exile and an Etruscan mother. The first Tarquin was credited with expanding both the political prestige and the physical amenities of the city, the latter through its first major building programme, and this expansion was portrayed as continuing until the arrogance of the last of the Etruscan kings, Tarquinius Superbus, led to the expulsion of the dynasty and the founding of a republican form of government (traditionally 510–509 BC). Power then came to be vested in a group of popular assemblies and in the Senate, a council of wealthy, aristocratic citizens who had previously been advisers to the kings, and also in an array of elected magistrates, the chief of whom were the two consuls.

Although some of these details are undoubtedly products of patriotic and antiquarian imagination and although some archaeologists would like to lower the traditional chronology by forty to fifty years, the picture of early Rome drawn by the ancient annalists accords reasonably well with archaeological evidence. Thatched huts, pottery, bronze pins, etc. from the eighth century BC excavated on the Palatine fit well with the Romulian founding of the city. Draining of the lowlands between the hills of Rome and their conversion from a cemetery into the forum of the city (about 575 BC) may well accord with the expansion of the city under the Etruscans. The foundation of a large 'Tuscan-style' (see [252]) temple on the Capitoline hill with extensive decoration in terracotta fits well with the tradition that the Tarquins built such a temple and that an Etruscan artist named Vulca executed its sculptures. Finally, the end, around 475 BC, of a building programme that led to the construction of several important Tuscan-style temples may reflect the decline of the influence of the Etruscans at Rome and elsewhere following their defeat at the hands of an alliance of south Italian Greek cities in 474 BC.

The Etruscan heritage in Roman art stemmed mainly from Etruscan religious institutions. Familiar figures in later Roman relief sculpture, for example the lictors with *fasces* who accompany the emperor

[**228 B**], were Etruscan in origin. It was in architecture, however, that an Etruscan feeling was most deep and enduring. Etruscan religion seems to have had an obsession with divination, that is, reading the will of the gods through signs. One form of divination involved reading the meaning of portents in the sky such as lightning and the flights of birds, and in order to do this an augur, standing in a place of worship, had to position himself in a very precise way with regard to the surrounding horizon so that he could clearly determine what occurred to his left and to his right. When temples came to be constructed they were set on a tall podium so that they would dominate the carefully defined space (called the *templum*, or 'cut-off space', from which 'temple' derives) in which the augurs would make their observations. Their relationship to a strictly determined ritual space also meant that the front of Etruscan temples was of paramount importance and that architectural decoration should be concentrated on its façade. This was in contrast to most Greek temples, which were designed as sculptural forms to be viewed from all sides. The 'Tuscan temple', as Vitruvius later termed this Etruscan form, remained in the Roman architectural repertoire for over a thousand years, and its omnipresence and familiarity in Rome undoubtedly helped to shape the taste for axial spacing, bilateral symmetry, and emphasis on a single façade that we find in even the most mature Roman architectural planning, such as the great imperial fora [**255**].

The political and social background of the succeeding 'Italic' phase in the evolution of Roman art is characterized by two themes. One is internal social strife between the landowning, wealthy class of families (the patricians) and the poorer tradesmen, servants, and peasants (the *plebs*). These two original groups accommodated one another over a period of centuries and eventually merged to the point of being indistinguishable. In later times, however, slaves, immigrants, and foreigners inherited the place of the original *plebs*, and the disparity of their status with that of the 'patrician' senatorial class remained the same. The adjectives 'patrician' and 'plebeian' have consequently been perpetuated by modern historians to express a continuing antithesis in the social order of the late Republic and of the Empire that is also a characteristic of their art.

The second theme is military expansion. By 396 BC, when the Romans conquered and sacked the powerful Etruscan city of Veii, they had subdued most of the surrounding peoples in Latium and Tuscany and guaranteed their control of the Tiber. In the middle of the fourth century BC a call for help from friendly Latin cities to the south brought them into conflict with an aggressive group of mountain peoples in central Italy known as the Samnites. A protracted series of wars with the Samnites (343–290 BC), followed by a mopping-up operation to punish Etruscan cities that had allied themselves with the Samnites, resulted in 280 BC in the Romans assuming control of all of central Italy south of the Po. This led in short order to political and commercial conflict with Tarentum, the foremost of the Greek cities of southern Italy. In the resulting 'Tarentine war' the Romans wore down the armies of the Hellenistic royal adventurer Pyrrhus of Epirus, who had come to the aid of the Tarentines and eventually took Tarentum (272 BC). By 270 BC, having shown that they could match the military prowess of the Hellenistic Greeks, they had taken control the Greek cities of south Italy and dominated the whole of the Italian peninsula.

A significant aspect of the Roman conquest of Italy, both for political history and for the history of art, is that the conquered cities and people were not simply held in subjugation by brute force. The citizens of some of them gained Roman citizenship, and others became *Socii*, allies with rights guaranteed by treaty. This network of relationships, with its active interchange of ideas and cultural traditions, not only helped to stabilize Rome's base of power in Italy but also served to widen the Romans' cultural horizons. Their previous experience of the Etruscan tradition was now augmented by contact with the extensively Hellenized art of central Italy, in which the changing styles and techniques

of Greek art had been adapted to native forms and institutions, and artists from cities like Praeneste began to benefit from Roman patronage. The result was that splendidly elegant works like the Ficoroni *cista* [358] came to be made in Rome.

Contact with the Hellenized Italic art of central Italy also seems to have stimulated the further development of two genres of sculpture and painting that run throughout the history of Roman art and are to some extent its hallmarks—triumphal art and portraiture. Both of these genres exemplify what at this early stage became and thereafter remained the primary function of public art in the Roman world: the commemoration of historical events and personalities.

The triumph was a ritualized procession of Etruscan origin in which a victorious general, accompanied by magistrates and senators, proceeded along a prescribed route from the gates of Rome to the temple of Jupiter on the Capitoline. Exhibited in such processions, in addition to captives from the defeated army and wagon-loads of booty, were paintings that recorded scenes from battles in the triumphant general's campaign. Such paintings appear to have received a good deal of attention from the Roman public and to have played a role in promoting the political careers of those who commissioned them. Pliny records that the future consul L. Hostilius Mancinus not only exhibited a painting or paintings of his assault on Carthage in 146 BC but stood by to explain pictorial details to curious onlookers, and Livy cites a painting set up by Tiberius Sempronius Gracchus after subduing a revolt in Sardinia in 177 BC in which battle scenes were somehow superimposed on a depiction of the topography of the entire island. While nothing so elaborate is preserved in surviving monuments, a sense of what the earliest of these historical paintings were probably like can be gleaned from a fragmentary mural painting found in a tomb on the Esquiline hill which illustrates scenes from a Roman general's campaign against the Samnites [278]. It seems likely that this early tradition of historical paintings inspired by military campaigns was one of the principal elements that went into the creation of the familiar genre of Roman historical reliefs during the first century BC, when sculpture in stone, under Greek influence, became common in Rome and features of painting were transferred to this more enduring medium.

Although the form of portraiture that is most familiarly associated with Roman art today did not develop until the first century BC (out of a fusion of Italic and Greek traditions), portrait statuary had in fact existed in Rome at least as early as the time of Tarquinius Superbus, and Roman writers record the dedication of many portrait statues in Rome throughout the history of the Republic. These early public portraits seem mostly to have been cast in bronze and invariably commemorated persons who had played a prominent role in Roman politics or military affairs. The earliest examples were presumably rather standardized images in the Etruscan archaic style, but no very early example of such portraits survives. Several bronze portraits dating from later centuries of the Republic, however, like the famous Capitoline Brutus [236], probably preserve the effect that most public portraits of the Italic phase were intended to achieve. Although the influence of the technical skills of Greek sculptors pervades these works, their creators seem to have been inclined to attenuate Hellenistic elegance in favour of a matter-of-fact, business-like sobriety that was appropriate for men who were forging an empire.

The third or 'Greek' phase in the evolution of early Roman art was already presaged in the triumph that followed the defeat of Pyrrhus and the surrender of Tarentum in 275–272 BC in which, the historian Florus records, the Romans had their first close look at purely Greek art in the form of 'richly adorned statues and charming Tarentine painted panels'. These were the forerunners of an avalanche of captured works of art from the Greek world that would shortly begin to inundate Rome.

The subjugation of Italy soon brought the Romans into commercial rivalry and conflict with the Carthaginians, who controlled much of Sicily as well as the coast of North Africa, and led to a series of

costly wars that lasted into the middle of the next century. By 227 BC Sicily as well as Sardinia had been wrested from the Carthaginians and established as the first Roman 'provinces', that is, conquered regions that were henceforth to be governed by Roman magistrates and to pay taxes to the Roman treasury. At first, the venerable and culturally rich Greek cities of Sicily and south Italy, like Syracuse, usually retained the status of largely independent and respected allies within this new political system; but during the long Carthaginian counter-offensive in Italy led by the general Hannibal, who posed a serious threat to Rome's survival between 217 and 203 BC, a number of Greek cities, Syracuse among them, went over to the Carthaginian side. When the Romans with dogged tenacity managed to reassert control over these defectors, their punishment was severe. Syracuse was thoroughly sacked by the Roman general Marcellus in 211 BC, an event that marked not only the end of the heyday of Greek culture in Sicily but also the beginning of a period of intellectual ferment in Rome that would last for a century and revolutionize the city's artistic life.

The artistic treasures from the city that Marcellus brought back to Rome as spoils had a dazzling effect on some Romans and caused others to recoil in conservative outrage. 'Prior to this, Rome neither had nor even knew of these exquisite and refined things . . . rather it was full of barbaric weapons and bloody spoils,' says Plutarch, in a famous passage that undoubtedly exaggerates Rome's lack of culture but captures the essence of a cultural confrontation that had begun in earnest. 'The Romans blamed Marcellus . . . because he had filled the Roman people, who had hitherto been accustomed to fighting or farming and had no experience with a life of softness and ease . . . with a taste for leisure and idle talk, affecting urbane opinions about the arts and about artists, even to the point of wasting the better part of a day on such things. But Marcellus, far from sharing this opinion, proclaimed proudly, even before the Greeks, that he had taught the Romans . . . to respect and marvel at the beautiful and wondrous works of Greece.'

Roman armies appeared in Greece itself at the beginning of the second century BC to punish King Philip V of Macedonia for having been an ally of Hannibal. Within little more than half a century Macedonia had become a Roman province and southern Greece, with the exception of Athens and a few other cities, was ruled by Roman governors. While the details of the diplomatic manœuvres and military campaigns through which the Romans were drawn into, and ultimately assumed control of, Greece need not concern us here, a few crucial events in the process deserve mention because of the important role they played in the Hellenization of Roman art.

In the triumphal procession following the battle of Pydna in 168 BC, a conflict that put an end to the Macedonian monarchy, a whole day, according to Plutarch, was 'just barely sufficient to see the statues that had been seized, and the paintings, and colossal images' that Aemilius Paullus put on display. One of these, we are told, was an Athena by Phidias. For this procession Paullus also retained a well-known Greek painter, Metrodorus, to execute new historical paintings to illustrate details of his victory, and he subsequently hired Metrodorus, who also had a reputation as a philosopher, to become his sons' tutor. He thus became the first Greek artist to create works of art that fulfilled a fundamentally Roman need and taste and was presumably also one of the first to migrate to Rome in order to take advantage of Roman patronage.

Another important landmark (literally) in the Hellenization of the city of Rome was the architectural complex erected in Rome by Quintus Metellus 'Macedonicus' to commemorate his final conquest of Macedonia in 148 BC. In an area of the Campus Martius Metellus constructed a four-sided portico, known as the Porticus Metelli, within which he incorporated a temple of Juno and also built a new temple of Jupiter. This was apparently the first temple in Rome made of marble. Its architect was a Greek named Hermodorus of Salamis, and it may have been Hermodorus who first introduced a

thoroughgoing use of the Greek architectural orders into Rome. Exactly what the temples in the Porticus Metelli looked like is not certain, but it is probable that they combined a 'Tuscan' ground plan with a Greek decorative system and thus presented a form something like that of the surviving temple of Fortuna Virilis [253]. To execute cult images for the temples of Jupiter and Juno Metellus hired and brought to Rome a family of versatile Athenian sculptors, Timarchides and his sons Dionysius and Polycles; and inside the portico he set up, among other Greek sculptures, the famous 'Granicus Monument', a large group of equestrian sculptures in bronze by the famous sculptor Lysippus that had been dedicated at Dion in Macedonia by Alexander the Great after his first major victory over the Persians. The Porticus Metelli complex was thus both a museum for renowned masterpieces of earlier Greek art and also a display piece designed to show what living Greek architects and sculptors could still do.

Two additional moments in the Hellenization of Roman artistic sensibilities require comment: the devasting sack of the ancient city of Corinth in 146 BC (which ended the resistance of southern Greece and put a virtual end to the city's existence for over a hundred years) and the bequest to Rome in 133 BC of the city and kingdom of Pergamum by its last ruler, Attalus III. Strabo says 'the best of the public monuments of Rome' came from the destruction of Corinth, but the legacy of the sack mentioned most often by ancient writers concerns the decorative arts. It resulted in a flood of small bronze objects, known collectively as 'Corinthian bronzes', into the burgeoning art market of Rome, and these continued to obsess Roman art collectors for centuries. Taking possession of Pergamum, by contrast, did not result in still another inundation of Rome with the spoils of war, but it did give some Romans an opportunity to experience the feeling of what it was like to live in one of the most artistically refined cities of the Hellenistic world.

By the first century BC the impact of the Romans' collision with Greek culture had been largely absorbed, and Rome became a sophisticated and influential centre of late Hellenistic art. It was now intellectually respectable to admire Greek art, and possessing an art collection seems to have become something of a status symbol for upper-class Romans. In the wake of a new mania for collecting, the spirit of which is tellingly preserved in the letters of Cicero, there developed a network of dealers, restorers, copyists, and even forgers that resembled in many respects today's 'art world'. To meet the new demand, a number of prominent Greek sculptors established studios in Rome and began to produce both copies of earlier masterpieces and also original works in a variety of styles. Some of them, like Pasiteles and Arcesilaus, became prominent figures. Not only did they receive major public commissions, such as the creation of cult images for important temples, but they were also able to sell their works, sometimes for huge sums, to wealthy private collectors.

In spite of the intensity of the period of Hellenization, however, the art of Rome did not become, entirely and in perpetuity, a regional version of the art of Greece. In the course of the first century BC we first begin to see the emergence of genres of art that were expressions of peculiarly Roman cultural institutions, and even though these show the influence of Greek style and technique, they have no precise Greek precedents. It is above all in the portraiture, commemorative relief sculpture, and architecture of the period that the unfolding of a truly Roman art is most clearly revealed.

Around the time of the dictatorship of Sulla, when there was a recrudescence of the power and influence of the conservative senatorial order, we begin to see the first examples of a sternly realistic type of portrait that seems to have been specially created to meet the needs of the patrician class [237–8]. In part, these Republican patrician portraits fall into a tradition of realistic portraiture that had been developing for more than two centuries in Hellenistic art and that had already had an influence, as we have seen, on earlier art in Italy [236]. But a new element has been added to the tradition. According to

the Greek historian Polybius (about 202–120 BC), who lived for a number of years in Rome and understood Roman culture, upper-class Roman families had the custom of making death masks of their ancestors in plaster or wax and of preserving them in shrines in their houses. These were 'wrought with the utmost attention being paid to preserving a likeness in regard to both shape and contour'. When a member of the family died, the masks were carried, and sometimes worn, by surviving members of the family in a funeral procession that proceeded from the family's house to the Rostra in the Forum, where a eulogy was delivered. Thus the prominent ancestors of the deceased were physically present at the funeral ceremony, in an eerie but historically vivid way, to celebrate the distinction of his family line.

In the first century BC Roman aristocrats began to commission sculptors, most of whom were undoubtedly Greeks, to make more durable versions of these masks, and since the masks consisted, of course, only of heads, the sculptors converted them to portrait busts. To render the effect of the ancestor masks in stone the sculptors naturally used technical mannerisms that were common in late Hellenistic sculpture, but the wrinkled, sombre, at times even emaciated quality of these heads, spurning Greek elegance in favour of uncompromising toughness, is distinctive. The portrait bust, a new and characteristically Roman form (Greek portraits normally represented the entire body of the subject), was to have a very long life in Roman art and so also would the portrait type for which it was created. The 'Republican portrait', as it is frequently called, lived on into the Empire and enjoyed periods of renewed popularity when respect for the traditions of the senatorial class was in political vogue. Other styles of portraiture coexisted with it—basically Hellenistic types, like the portraits of Pompey [239] and Cicero, and the neo-classical portraits preferred by the Julio-Claudian emperors—but its influence never vanished entirely.

The historical relief, that distinctive form of Roman sculpture that celebrated important public rituals and events and was used throughout the Empire to adorn public monuments, emerged in the first century BC out of a coalescence of diverse sources—earlier Roman triumphal painting, Greek historical painting, and Etruscan ritual and funereal art. More than any other type of monument these reliefs embody the commemorative urge and historical self-consciousness of Roman culture. Through a combination of symbol and realistic narrative they were intended to capture both the reality of a historical moment and also that moment's continuing religious and cultural meaning. The arrival of the genre on the Roman scene and its distinctiveness when compared to contemporary Hellenistic decorative relief are most vividly illustrated by the friezes of the so-called altar of Domitius Ahenobarbus [226], where an elegant procession of Tritons, Nereids, and sea creatures celebrating the wedding of Poseidon and Amphitrite is contrasted with a detailed illustration of the practical and ritual actions and actors involved in a Roman census.

Mature Roman imperial architecture with its soaring concrete domes and vaults, its majestic arcades, and its complex ground-plans was the Roman world's most dynamic and original, and arguably most profound, creation. From the very beginning, as we have seen, Roman architecture had a distinctive character that set it apart from architecture in the Greek world, and as time went on this difference was to become even greater. Although the Tuscan-type temple, with surface decoration adapted from Greece, continued to be the most common form of Roman architecture in the late Republic and well into the early Empire, there were already buildings in the first century BC which in their materials, method of construction, and new conceptions of space turned away from both the Greek and Etruscan traditions towards a highly innovative future. In these structures Roman architects began to realize the potential of vaulted spaces and arcades, formed from a combination of stone and poured concrete (a technique of construction that the Romans had begun to use as early as the first half of the second century BC for practical buildings like warehouses), to create new architectural rhythms and

above all a new world of interior architectural space. The most impressive example of the new architecture is the great temple of Fortuna Primigenia at Praeneste [**254**], laid out in a series of connected terraces defined by vaulted passageways and tunnels through which the worshipper was led along a tightly controlled route to a climactic architectural and cosmic 'vision'.

Realization of the full potential of this revolutionary, and essentially anti-Greek, movement in Roman architecture would have to wait until the second half of the first century AD. From the end of the Republic until the time of Nero it was not so much suppressed as masked by the classicism that the Emperor Augustus encouraged in all branches of art for ideological reasons.

The political background against which these new forms of Roman art emerged was one of continual tumult in which social strife and civil war led ultimately to the collapse of the Republic. By the end of the second century the complex effects of warfare and foreign conquest had driven many small farmers in Italy off their lands and into the cities. At the same time the aristocratic class centred in the Senate began to control vast plantations run by slave labour. The gulf between the haves and have-nots in Roman Italy, once expressed by the distinction between patrician and plebeian and now recast as the opposition of *Optimates* and *Populares*, was greater than ever. After the failure of the social reform movement led by Tiberius and Gaius Gracchus (133–122 BC), the landless lower classes had little hope of changing their status except through military service. To meet the demands imposed by conquered territories around the Mediterranean, the early Republic's temporary armies made up of farmer-soldiers, ordered in ranks stratified by wealth, no longer sufficed. The Romans needed well-trained professional armies, and a series of reforms instituted at the beginning of the century by the general Marius made it possible for men at the lower end of the economic scale to serve in the army regardless of their financial condition. The welfare of these soldiers while they were in service was the responsibility of their commander, and at the end of a long period of service they were normally settled on small farms in newly acquired land. Since under these circumstances a soldier's prospects and prosperity depended entirely on the fortunes of his commander, his loyalty quite naturally went to that individual rather than to a more abstract concept of 'the state'. Armies thus became bases of power for those who aspired to political leadership, enabling them to intimidate the Senate, manipulate the governmental machinery of the Republic to their own end, and to fight with one another. So it was with strong men such as Sulla, Pompey, Julius Caesar, Mark Antony, and ultimately Caesar's youthful nephew Octavian.

When Octavian emerged from his victory over Antony and Cleopatra at Actium in 31 BC and proceeded in the next decade to transform the political atmosphere of the previous hundred years by transforming himself into 'Augustus', he seems to have realized from the beginning that art could be an effective weapon in his efforts to establish order and stability in Roman society after a century of turmoil. Rejecting and suppressing the political past that had brought him to power, Augustus chose to cultivate an image of himself as the moderate and pious First Citizen of the state, the upholder of the most respected traditions of the Republic, and the guarantor of peace and prosperity in the Roman world. The official art that he encouraged by his personal patronage was undeniably propagandistic and ideological, but the pejorative connotation that often attaches to those words today does not seem justified in the case of Augustan art. Its aim was to encourage in the Roman citizenry a new respect for the moral virtues embodied by the heroes of Rome's early history (particularly its farmer-soldiers), an appreciation of the benefits of moderation in personal behaviour, and an awareness that both of these virtues were essential if the era of peace and prosperity which Augustus' political settlement had brought about was to be perpetuated.

The theme of respect for Rome's historical traditions, and by extrapolation for the new government that had rescued these traditions from an era of political chaos, underlies, of course, some of the great

literary creations that were fostered by Augustus' patronage, the Aeneid, for example, and Livy's history. In the visual arts, the images of early heroes installed in the wings of Forum Augusti, the frieze of the reconstructed Basilica Aemilia [227], and the Aeneas panel on the Ara Pacis [228] were designed to convey the same message. Even Augustus' own tomb, designed many years before his death, was covered by a circular earthen mound that evoked the ancient tumuli of the early Etruscans.

Moderation in personal behaviour, the antidote to the need for personal aggrandizement that had led in the preceding decades to civil war, was expressed not only through historical exemplars like 'pious' Aeneas but also in the creation of a cool neo-classical style that evoked Greek art of the Classical period, which the Romans had come to view as a kind of golden age. It was in the balance, simplicity, and dignity of the art of Phidias and Polyclitus, rather than the sumptuousness and realism of Hellenistic art, that artists of the Augustan period found a language of forms that could convey Augustus' vision of himself as a new Pericles and of Augustan Rome as a new Athens. The wrinkled, hard-bitten, and occasionally tormented look of late Republican portraiture was replaced by the smooth, imperturbable visages, seemingly impervious to age, of Augustus and his family and associates [240–2], and a quiet balance was infused into their stance and movement, as in the stately processions of the Ara Pacis [228] and in the Polyclitan pose of the emperor's portrait from Prima Porta [240].

The message that peace and abundance are the fruits of moderation and the sort of honest labour that had typified the Romans' early ancestors—an underlying theme of Virgil's *Georgics*, written in part to inspire and instruct veterans who were returning to the land to pursue a new life as productive farmers—was conveyed in Augustan art by a pervasive use of elegant floral ornament in sculpture [228 C], painting, and the decorative arts but above all in architectural ornament. To reinforce in a tangible way the idea that his political settlement had ushered in a new golden age, Augustus oversaw, over the more than four decades during which he guided and set the tone for the Roman state, a thorough rebuilding of Rome. In building new temples and reconstructing most of the old ones, his architects employed, with few exceptions, the Corinthian order, undoubtedly because its lush combination of acanthus leaves, vines, and flowers was perceived to have a meaning. Looking about them, the citizens of Rome would have seen not only a city that, as Augustus boasted, had been transformed from one of brick to one of marble but also an architectural landscape that appeared to have burst into bloom.

The crisp, polished, classicizing elegance of official Augustan art was also the dominant artistic style of the private art of the period that was produced for aristocratic circles. Beautiful examples of it survive in gems, pottery, silverware, and the wall-paintings of houses and villas. At the same time, however, a strikingly different artistic tradition, which had its roots in early Italic art and was distinctly un-Greek, throve among the lower classes of Roman society. It is found primarily in the portraits and relief sculptures that adorned the tombs of freedmen, former slaves who had obtained freedom and had gone into trade, usually with the blessing of an aristocratic patron. Many of these freedmen became quite wealthy, came to constitute a solid middle class, and could afford to hire skilful artists and to build quite elaborate, if at times eccentric, tombs, like that of the baker Eurysaces [234]. Although the artists whom they employed occasionally toyed with the prevailing aristocratic style, their commission most often was to adhere to a style that favoured an austere Republican look [234–5] and eschewed both the elegant poses and the naturalistic representation of figures in space that were typical of Greek art. The natural appearance of things in such monuments is subordinated to the message of the relief. Symbol prevails over optical experience.

Because of its association with the non-aristocratic classes of the Roman world, scholars have termed this style 'plebeian' or 'popular', but these terms should not be taken to imply that it was

somehow primitive or inept. Plebeian art had both rules and an expressive power of its own and was used as a result of conscious choice. It always lurked in the background of the official art of the early Empire, and beginning at least as early as the time of Trajan features of it began to be incorporated into important imperial reliefs. By the third century the symbolic space and scale of the plebeian style and its blocky forms had become dominating factors in Roman art.

For about half a century after Augustus's death the classicistic style that he had created was perpetuated in both the official public art and the private court art of the Julio-Claudian dynasty, but as time went on it became more a mannerism than an expression of conviction. Augustus had had the inner qualities that had enabled him to take all the real power of the state into his hands and yet maintain the outer appearance of the modest citizen and benign father who respected tradition and did his duty, through a series of constitutional offices, for the benefit of all. This was a role for which his morose successor Tiberius was unsuited. Tiberius seems to have been most comfortable in splendid isolation, removed from the risks that the subtle obligations of Augustus' principate had required, and the most tangible outward expression of this is that he abandoned the modest house in which Augustus had lived on the Palatine hill and built on it instead the first imperial palace (the Domus Tiberiana). In doing so he inaugurated a pattern, both political and architectural, that would gradually remove the emperor from daily contact with the citizenry into a setting that endowed him with godlike splendour. The strong, business-like emperors such as Vespasian and Trajan tended to view trappings of imperial splendour as a part of the job and took them in their stride. But for weaker, more impressionable, less secure emperors—the demented Caligula, the hedonistic Nero, and the megalomaniac Domitian—the removal of the principate to an isolated palatial setting provided an opportunity for the indulgence of personal fantasy in a way that inevitably brought disaster.

Cracks in the cool façade of Augustan classicism can already be detected in the outwardly workman-like and dutiful face of Claudius (AD 41–54) [243], but a determined abandonment of it had to wait until the later years of Nero's principate, when a great fire in Rome in AD 64 destroyed much of the city, including much of the imperial palace. The devastation caused by the fire gave Nero, lately freed from the constraints urged upon him by his tutor Seneca and others to live like a philosopher-emperor, the chance to expropriate much of the centre of the city and to create the palace of his fantasies, the Domus Aurea ('Golden House') [262]. Here the emperor's architects, Severus and Celer, first exploited the full potential of cast concrete to create, with vaults, apses, and domes, a fantasy-fulfilling interior world. Its surfaces, covered with lush, extravagant, and fantastic decoration in painting and stucco, usher in a style in both the figurative arts and architecture that is often described as baroque and which would dominate much of the art patronized by the succeeding Flavian dynasty despite the fact that they had consigned Nero's memory to formal damnation.

T. Flavius Vespasianus ('Vespasian'), who was elevated to the principate in AD 70 after a year of turmoil in which other claimants sorted themselves out, was the antithesis of Nero. He came from a modest family of equestrian rank and his no-nonsense, hard-headed, unpretentious view of himself and his position had an 'old Roman' quality about it. While neither he nor anyone else seriously considered a restoration of the Republic, he made a point, in his image and in his acts, of contrasting the Republican virtues of his government with the luxury and self-indulgence of the Neronian court. In Flavian portraits, official and private, the austere Republican type of the first century BC enjoyed a come-back [244].

Vespasian's building projects were even more pointedly anti-Neronian. The great Flavian amphitheatre, now known as the Colosseum, was built on the site of what had been a lake (drained and filled with concrete by the Flavian architects) within the pleasure-park of the Domus Aurea. He also

restored the venerable temple of Jupiter on the Capitoline and built, adjacent to the old Forum Romanum and the Forum of Augustus, a new complex known as the Templum Pacis (Temple of Peace). This was considered by Pliny and others to have been one of the most beautiful buildings in Rome, and it incorporated, in addition to facilities for public business and religious rites, a library and also exhibition space for works of art. Vespasian's architecture, in short, was state architecture.

When an explicit political message was not involved, however, the baroque trend in Roman art initiated in the time of Nero was still allowed to have full sway. The late Fourth-Style paintings of Pompeii and Herculaneum [283–91], presumably as always echoing the art of the capital city, are, if anything, more 'stagy' and dream-like than the paintings of the Domus Aurea. In Flavian relief sculpture, about which much has been written, scholars have also seen an attempt not so much to create a tangible, plastic embodiment of the physical reality of objects as to create an illusion or impression of their reality through an essentially decorative pattern made up of smooth surfaces and dark shadows. This 'chiaroscuro effect' of monuments of the period, achieved by outlining forms with deeply drilled areas, was at first a device to enhance baroque ornamentation. In time, however, it seems to have taken on an existential significance of its own, and in later Roman art it was used to convey the feeling that the outer world of appearances was in some sense a fleeting illusion masking a different, underlying reality.

When Vespasian's younger son Domitian succeeded to the principate in AD 81 after the brief reign of his elder brother Titus, the baroque and grandiloquent current in Flavian art began to outweigh its neo-Republican theme. Although he oversaw important public building projects—a new area for public business between the Forum of Augustus and the Templum Pacis called the Forum Transitorium, the famous Arch of Titus [229], and a major rebuilding of the Capitoline after a second great fire (in AD 80)—Domitian's most obsessive commitment was to the construction of a huge new imperial residence on the Palatine. With its great vaulted audience hall and its baroque gardens and fountains, the vast complex of the Domus Flavia (later, with subsequent accretions, called the Domus Augustana) became synonymous with imperial splendour and represented the culmination of that urge in some emperors to be regarded as a superior being endowed with godlike qualities (*Dominus et Deus* was the title Domitian stipulated for himself) and to dwell in a setting, already aspired to in the palaces of Tiberius and Nero, appropriate for such an exalted personage.

Domitian's vision of himself was no protection against the hostility and consequent conspiracies that his personality engendered, and in AD 96, with the connivance of his own family, he was assassinated in his magnificent palace by officers of his own palace guard. The Senate immediately proclaimed one of its respected senior members, M. Cocceius Nerva, as the new emperor, and to cement a sincere but tenuous reversion to a constitutional rather than absolutist view of the principate, Nerva quickly adopted a powerful general, M. Ulpius Traianus, as his successor. Trajan, who succeeded in AD 98, was a formidable military leader and completely committed to the enforcement of Roman authority in Europe, Asia, and Africa, but personally he was humane, courteous, respectful of tradition, and sincerely committed to a constitutional form of the principate in which he was as much a servant of the state as a beneficiary of its power and wealth. When the Senate some years later conferred upon him the title *Optimus Princeps* it was with the genuine conviction that he was everything an emperor should be.

Just as it marks the high point of the geographical extent, prestige, prosperity, and social stability of the Empire, the principate of Trajan marks the supreme moment of integration, order, and unambiguous purpose in Roman imperial art. In the great monuments of the Trajanic era all the diverse strands in Roman art that we have traced up to this point were preserved and harmonized. Augustan classicism and all that it connoted for the first emperor is echoed in the emperor's crisp, smooth portraits. In the great cycles of relief sculpture from his forum [231] compositional forms that had their

roots in Greek art are blended with the baroque style of carving that evolved in the Flavian period and are often presented in a partly symbolic spatial setting that derives from 'plebeian art'. All of these stylistic features, moreover, were brought to the service of a triumphal art that had deep roots in the Republican past and showed the emperor, like a new Scipio or Metellus, serving the state by subduing its enemies and expanding its realm. The same unifying comprehensiveness can be seen in the architectural projects designed and carried out by Apollodorus of Damascus, an Asiatic Greek architect who seems to have been Trajan's adviser on matters ranging from iconography to military engineering. Foremost among these projects were the new Forum of Trajan (which conjured up and perpetuated on a grand scale architectural forms that had first been developed in the Forum Romanum and in the Forum of Augustus) and the adjacent Markets of Trajan [267], which took the fruits of what the Neronian and Flavian architectural revolution had achieved with poured concrete and applied them, sheathed in sober Roman brick, to the public good.

When Trajan died in AD 117 on his way home from a difficult campaign against the Parthians he was succeeded by a distant relative who was his ward and adopted successor, P. Aelius Hadrianus. The change in style that Hadrian quickly brought to both the imperial government and the arts that served it is striking. He abandoned military expansion, and devoted most of his energy to stabilizing the borders of the Empire and improving the economic and legal aspects of administration in the provinces. Much of his principate was spent travelling from one province to another, and as he did so he became, if he was not already, the most cosmopolitan of emperors, perhaps more at home among the troops in Britain, the priests in Egypt, or the teachers of philosophy in Greece than among senators in Rome. Although he was a very able administrator, Hadrian was by predisposition an intellectual and an aesthete who wrote poetry, dabbled in the arts, explored religious mysteries, and pondered philosophical questions. His travels, in addition to stimulating an appreciation of the diverse cultures contained within the imperial borders, had instilled in him a sense of history, and these aspects of his personality strongly coloured the art that he patronized and sometimes even designed. In the villa at Tivoli, for example [263], where he spent most of his time towards the end of his career, amid some of the most daringly 'modern' structures of the age, he re-created, in a playful, even capricious way, venerable buildings that he had visited in the provinces such as the Painted Stoa in Athens and an Egyptian temple on the Canopic branch of the Nile. Even in his greatest public monument in Rome, the Pantheon, a virtual symbol of the cosmos of which imperial Rome was the temporal centre, he 'quoted' the past by re-creating an old-fashioned porch with the dedicatory inscription of the builder of the original Pantheon, Marcus Agrippa [268].

If his temporal ambitions and achievements belonged to Rome, Hadrian's soul, so to speak, belonged to Greece, and his detractors, who for the first time began to see portraits of an emperor who had grown a beard like a Greek philosopher, were not unperceptive when they nicknamed him the *Graeculus* ('Greekling'). [245]. Not surprisingly it was Hadrian's patronage that brought about the last major revival of the Greek tradition in Roman art. In Hadrianic sculpture the splendid but violent art of the Trajanic period with its baroque and plebeian stylistic traits, its triumphal tone, and its overtly political message is all but forgotten. In his public monuments we see scenes of hunting and religious offerings [232] or elegant personifications of the provinces; in semi-public monuments like the portraits of his lover Antinous [246] we encounter a refined play with venerable Greek images of ephebes and gods; and in his villa at Tivoli we find overt copies, as well as adaptations, of famous sculptures of Classical Greece.

Classicism in Augustan art had been driven by ideology. In Hadrianic art its motivating force was nostalgia, the desire to recapture or re-create an age when, it was thought, love of beauty and the pursuit of understanding were valued more highly than the struggle for power. As anyone familiar with the

history of Classical Greece could have confirmed, this was a utopian vision. But in the essentially peaceful and prosperous era of Hadrian and his successor Antoninus Pius, it was an appropriate, sustaining vision, evoking as it did the very idea of 'civilization'. During the four centuries since Marcellus had urged the Romans 'to respect and marvel at the beautiful and wondrous works of Greece' the artists who created the official art of the Roman world had periodically returned to Classical Greek art in order to recapture a certain sense of measure, balance, and calm. Hadrian's artists were the last to do so in a serious way. When towards the end of the second century barbarian tribes began to push through the borders that Hadrian had laboured to solidify, the Greek vision became a luxury that the embattled Empire could no longer afford.

HISTORICAL RELIEFS

226 Art historians are virtually unanimous in agreeing that these reliefs, which contrast a newly developed and peculiarly Roman genre, the historical relief, with an elegant mythological scene that is purely Hellenistic in style, constitute one of the most important monuments of the Roman Republic. The date, function, and history of the monument are, however, highly controversial. The use of the word 'altar' to describe the monument is conventional, but it is probable that the reliefs originally decorated a large statue base.

The two sets of reliefs were discovered in the seventeenth century and are now divided between Munich and Paris. Those in Munich, which make up three of the four

and on the right a group of soldiers in armour is shown to emphasize the importance of the census for the military. The centre is concerned with the sacrifice. The tall armed figure of the god Mars stands to the left of a central altar, and a figure in a toga, probably the censor, is placed to the right. They are flanked by musicians on the left and by assistants who bring forward animals for a form of sacrifice known as the *suovetaurilia* (the offering of a bull, a sheep, and a pig).

It was once generally believed that these sculptures came from the site of a temple of Neptune in the Circus Flaminius constructed about 42–30 BC by the military commander and provincial governor Cn. Domitius Ahenobarbus (hence the traditional name of the relief). The marine scene has often been thought to reflect a group by the Greek sculptor Scopas which Pliny says was set up in

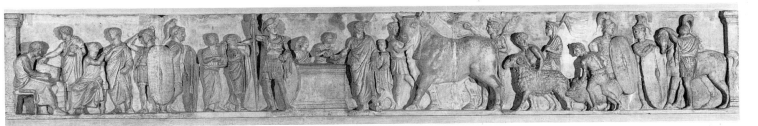

226 Altar of Domitius Ahenobarbus (Munich, Glyptothek; Paris, Louvre)

sides of the monument, depict a marine procession celebrating the wedding of Poseidon (Neptune) and Amphitrite, who are seated in a chariot in the centre of the long panel. Around them cavort the sinuous, flowing, elegant figures of Nereids riding sea creatures, Tritons, and Cupids.

By contrast the reliefs in Paris preserve a sober, detailed, and essentially realistic record of an important Roman public ritual, the census. Although the precise date of the event that is commemorated here is debated, there is no doubt that function of the relief was to record a specific historical event. A periodic census of citizens was taken (usually every five years) by the consuls to confirm the assignment of individuals to particular classes, and since it was viewed as a religious as well as a political institution, the census regularly concluded with a purificatory sacrifice (*lustrum*). On the left of the relief a group of citizens are seen making declarations to a scribe and an assessor,

the Circus Flaminius by Domitius Ahenobarbus, but whether this group was by the famous sculptor of the fourth century BC or by a later Scopas is debated. Current opinion favours an earlier date, connected perhaps with a census that took place between 115 and 97 BC.

227 The Basilica Aemilia, originally built in 179 BC, was one of the major civic buildings of the Roman Forum, and was periodically refurbished and restored. The frieze illustrated here, which seems to have decorated the interior of the basilica, most probably dates from 14 BC, when Augustus had the building reconstructed after a fire. Like the early chapters of Livy's history of Rome, also created under the patronage of Augustus, the frieze was part of a programme designed to foster a sense of veneration for virtues that were held to be part of Rome's ancient cultural heritage, and hence it commemorates the legends about the city's earliest days from which moral 'lessons' might be

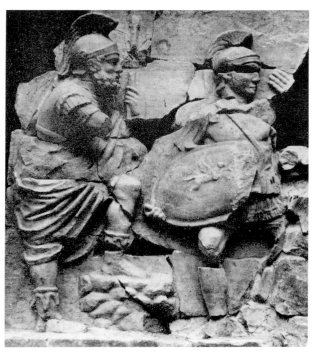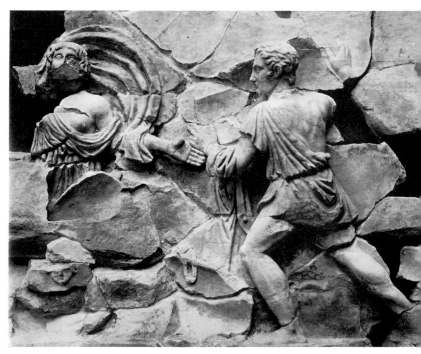

227 Frieze of Basilica Aemilia, Rome: punishment of Tarpeia (Rome, Antiquarium of Forum)

drawn. Shown here is the punishment of the Vestal Virgin Tarpeia, who in the time of Romulus betrayed the city by opening its gates to an invading Sabine army. Instead of rewarding her with gold bracelets, as she had anticipated, the Sabines condemned her as a traitor and executed her by crushing her with their shields. Tarpeia, in the centre, gestures dramatically as the soldiers begin to pile on the shields, while on the far right the dignified bearded figure of the Sabine king, Titus Tatius, sternly looks on.

The liveliness of the frieze, with its blowing drapery and animated movements, and its slightly blocky proportions, may have been intended to recall certain Greek architectural friezes, like that of the temple of Apollo at Bassae.

228 The 'Altar of the Augustan Peace' (Ara Pacis Augustae) was inaugurated on 4 July 13 BC and dedicated after its completion on 30 January 9 BC. Although its immediate purpose was to celebrate Augustus' successful pacification, through diplomatic means, of the provinces of Spain and Gaul, its imagery, as already discussed (p. 226), transcends this specific event and alludes to all the major themes in Augustan ideology.

Some of the surviving components of the altar were discovered as early as the sixteenth century, but the monument as a whole was not reconstructed until the late 1930s. It now stands near its original site on the eastern side of the Campus Martius just off the Via Flaminia (modern Via del Corso), in an area where Augustus' mausoleum and *ustrinum* (precinct for cremation) were also laid out. The

altar was set in a walled enclosure with doorways on its east and west sides, and the major sculptural decoration of the monument was placed on the outer walls of this enclosure. The altar itself was decorated with griffins, floral ornaments, and a simple frieze depicting animals being led to sacrifice, and the reliefs on the inside walls of the enclosure simulate what seems to be a fence supported by pilasters above which are hung lush garlands of fruit.

On the outside of the long sides of the enclosure (the north and south sides) the decoration is divided into an upper set of panels that depict the imperial family and prominent Roman officials participating in a religious procession, probably the one held at the time of the inauguration of the altar. Below these are large rectangular panels decorated with a lush growth of acanthus plants that form themselves into calligraphic scrolls dotted with blossoms and fruits. Snakes and lizards slither through this dense but orderly foliage, and swans flutter their wings above it. The feeling of the fertility of the earth that is conveyed by this elegant acanthus jungle (a motif that continues on the pilasters of the building and also on the lower panels of the east and west side) evokes in turn the idea of the abundance and prosperity that peace makes possible. This was an important theme, as already noted, of Augustan poetry, especially of the Fourth Eclogue of Virgil, which, whatever the original impetus for its composition, was interpreted as a prophecy of the golden age that Augustus' settlement of Rome's political turmoil had brought about.

A

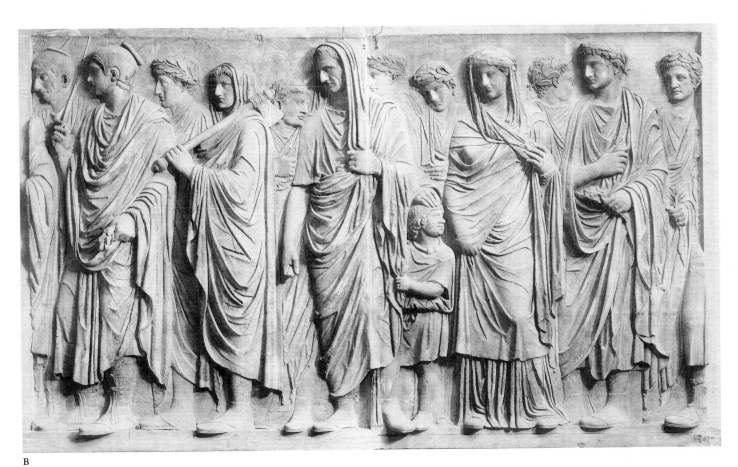

B

228 Ara Pacis Augustae, Rome. **A** general view; **B** imperial family and attendants

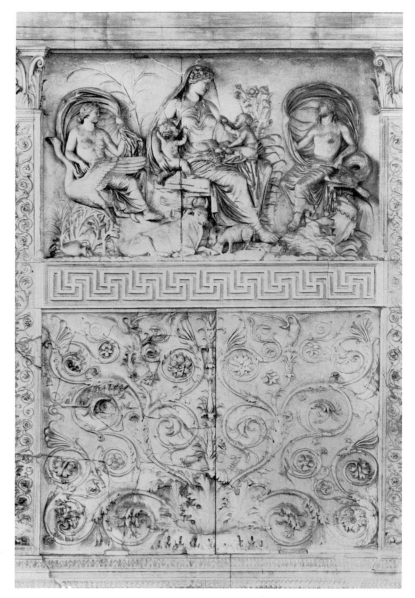

228 C Ara Pacis Augustae, Rome. Tellus or Italia

the political tone and meaning of the frieze can be appreci-ated simply by citing a few. On the left side of the south panel, for example [B], Augustus himself was shown, probably in the act of performing a sacrifice, surrounded by imperial attendants (lictors bearing *fasces* and *flamines*, with their distinctive caps) and assistants in the sacri-ficial rite. The majestic, veiled man with the craggy face seen at the centre is Marcus Agrippa, Augustus' loyal general and later his son-in-law, who, prior to his death in 12 BC, was the designated successor to the principate. The veiled woman to the right of Agrippa is the Empress Livia, and the man to her right is probably her son, the future Emperor Tiberius. Many of the other figures on the frieze no doubt depicted members of the imperial family, including the several children placed at the feet of these imposing adults.

The purpose of this historical frieze was no doubt to commemorate the presence of various dignitaries at the inauguration of the Ara Pacis, but it almost certainly also had a broader propaganda purpose. Augustus' social legis-lation condemned profligacy and encouraged family life. Here the Julio-Claudian family is shown as a family ought to be—pious, dignified, and well ordered.

On the east and west ends of the enclosure, on either side of the doors, another group of decorative reliefs con-tinued the themes of fertility, piety, reverence for tradi-tion, and cultural pride. Of two of these only fragments survive: Mars with Romulus and Remus on the north-west and the goddess Roma on the north-east. The other two, however, are well preserved and are masterful adaptations of the style of Hellenistic pictorial reliefs to the spirit of the Augustan age. In the panel on the south-west Aeneas, with his cloak drawn over his head in priestly fashion, thus echoing the figure of Augustus on the south long frieze, offers sacrifice (probably the sacrifice offered by the Tro-jans at Lanuvium when they first reached Italy) in the pres-ence of his son Iulus-Ascanius.

Finally, on the south-east panel, a majestic seated god-dess, most often identified as the earth goddess Tellus or as Italia, the personification of Italy, embraces two children [C]. Fruits are spread out on her lap. Flanking her are two female figures, one riding a swan and the other a sea-mon-ster, who are probably Aurae, Breezes. Beneath them are a reclining cow and a sheep, lush vegetation culminating in flowers, and an overturned urn indicating a spring. This allegorical scene, with primal elements of earth, air, and water harmonized and thriving in the wake of the Augus-tan peace, has with justice often been seen as a visual pro-jection of the spirit of Augustan poetry.

229 The Arch of Titus was erected by Domitian some time after Titus' death in AD 81 and served a dual purpose of memorializing both Titus' deification and also the tri-umph celebrated in AD 71 by Titus and Vespasian after their victory in the Jewish Wars. It stands on the low hill

The, crisp rhythmic pattern of the togas and the calm, aloof faces of the stately religious procession depicted in the upper panels of the long sides evoke, in a general way, a variety of Classical Greek models, such as the frieze of the Parthenon (also a religious procession depicted on the sides of a building) and later Greek votive reliefs. In typ-ically Roman fashion, however, many of the classicized faces on the frieze of the Ara Pacis represented specific his-torical figures. Most of those on the north side were restored in the Renaissance, but on the south side the por-traits of prominent figures in the imperial circle are unmistakable. While the identification of all of these por-traits is too complicated and controversial to explore here,

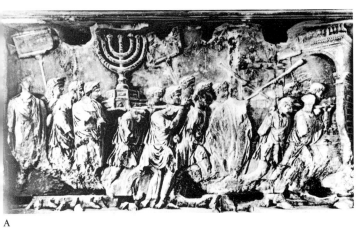
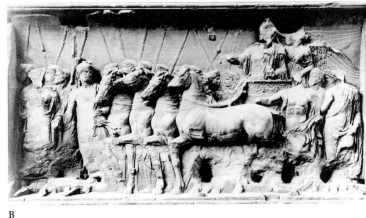

A B

229 Arch of Titus, Rome. **A** spoils from Jerusalem; **B** Titus in triumph

known as the Velia, along the path of the Via Sacra leading into the Forum and towards the temple of Jupiter on the Capitoline. The arch was partially dismantled in the Middle Ages, and much of what one sees today is a restoration of the early nineteenth century. The central passageway, however, with its dedicatory inscription, figures of Victory decorating the spandrels, and famous triumphal reliefs in the interior of the passageway, remains intact.

Because of their historical vividness, their iconographical complexity, and their style, the reliefs were highly influential in antiquity, and in spite of their damaged and heavily weathered condition they continue to be an active subject of discussion in modern scholarship. On the southern interior face of the arch participants in the triumphal procession of AD 71 are shown carrying the seven-branched candelabrum and other objects taken from the temple in Jerusalem [**A**]. The procession seems to emerge from the background of the relief on the left, curve out toward the viewer, and then plunge back inward through an arch on the right end. The sense of spatial depth that this movement evokes is enhanced by the varied levels of the relief itself, some of the figures being carved nearly in the round and others only slightly raised from the background. The 'illusionism' thus created must certainly reflect the technique of contemporary painters and be related to a long tradition of triumphal paintings. At one time it was thought to be a general distinguishing characteristic of Roman, as opposed to Greek, art; and although it is now recognized that there were precedents for the depiction of levels of spatial depth in Hellenistic relief sculpture, it remains true that this sort of illusionism is a typical feature of many imperial reliefs.

The same stylistic features are found in the panel on the north side of the passageway, which depicts Titus riding in a triumphal chariot, crowned by Victory and escorted by both human figures and quasi-divinities [**B**]. Leading the horses that draw the chariot is a female figure in a helmet who is probably Roma, but possibly Virtus. Standing in

front of the chariot behind the horses are two figures who are probably the Genius of the Roman People (nude to the waist) and the Genius of the Roman Senate. This blending of personifications with human figures, which was to become a vital part of the expressive language of Roman historical reliefs, was anticipated in representations on Roman coins (see [**250 G, H**]), but the Arch of Titus was the first major public monument to use it.

230 With the Arch of Trajan at Beneventum, one of the best preserved of all Roman public monuments, the architectural form and sculptural decoration of the Roman triumphal arch reached maturity. As the usefulness of these monuments not only to celebrate military exploits but also to disseminate imperial ideas and policies came to be appreciated, it became normal to cover most of their exterior as well as interior surface with sculptural decoration.

The arch at Beneventum was begun by AD 114 and perhaps completed during the early years of the principate of Hadrian (who appears on some of its reliefs). In addition to two large panels in the archway, each exterior façade is decorated with six major relief panels (two between the engaged columns and two flanking the inscription on the attic) as well as with minor friezes and the usual Victories in the spandrels. Their style and their mixture of personifications, deities, and humans derive from the reliefs of the Arch of Titus, but their subjects focus not so much on specific historical events as on the emperor's benign and constructive policies. The two large panels on the interior of the archway, for example, depict Trajan offering sacrifice and overseeing policies that provided food and other forms of aid for the children of poor families. The side that faced towards the portion of the Via Appia that led to Rome (usually called the 'city side') dealt with domestic policies relating to Rome and Italy; and the side facing the road to the port of Brundisium (Brindisi) and the east (the 'country side') illustrated policies relating to the

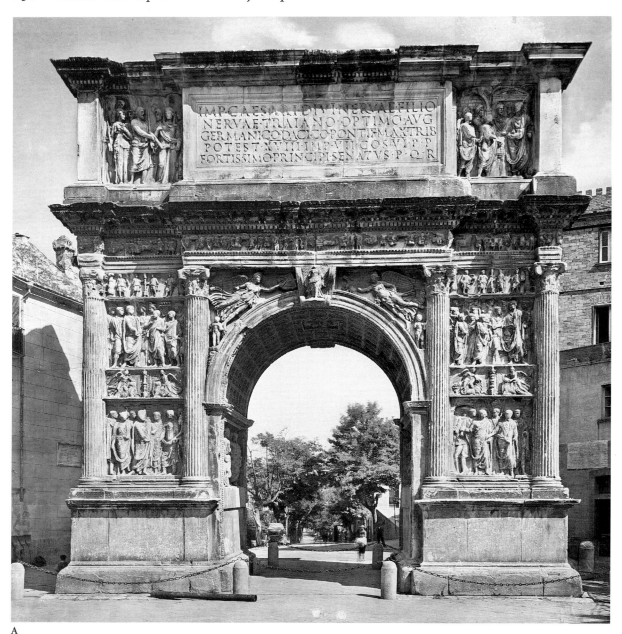

A

230 Arch of Trajan at Beneventum. **A** general view; **B** Trajan with Tellus and Mars; **C** Trajan and businessmen

provinces. Trajan's austere and serious portrait, with its smooth surface planes and its characteristic bangs over the forehead (a kind of new-Augustan face, cultivated, perhaps, in reaction to the realism of the Flavians), is preserved and easily recognizable in many of the panels.

A relief from each side is illustrated here. In [**B**] from the country side, Trajan, clad in a tunic and soldier's cloak, stands to the right facing the stately figure of the goddess Tellus (Earth), on the far left, and, next to her, the familiar armed figure of the god Mars, who was both the patron god of military men and, as the father of Romulus and

Remus, an ancestor of the Roman people. Tellus has just drawn a plough through the earth and out of the furrow children emerge. In the background, between Mars and Trajan, stands the personification of Abundance, holding a cornucopia. What seems to be referred to here is the Trajanic policy of encouraging citizens of the Empire, through subsidies of various types, to have large families so that in the future there would be a generous supply of soldiers for the Roman army.

[**C**], a panel from the city side, most probably refers to Trajan's construction of a great new harbour at Ostia and

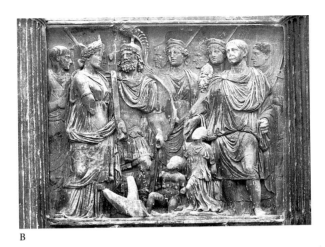

B

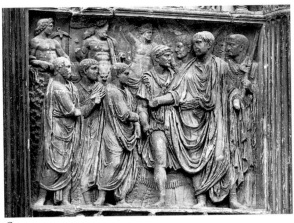

C

to the importance of that project for the efficient functioning of the *Annona Augusti*, the imperial grain supply system. Trajan, clad in a toga and flanked by attendants, receives three citizens who are probably businessmen connected in some way with the grain trade and are represented as if they were only about three-quarters the size of the emperor. Behind them, in an upper zone whose spatial relationship to the rest of the scene is uncertain, sit the figures of Portunus, god of the harbour, and of Hercules and Apollo, whose temples were situated in the principal business district of Rome. This panel provides one of the earliest examples on an official state monument of a formal device that would gradually become all-pervasive as the late antique style of Roman art developed: the use of scale to distinguish figures of great importance (Trajan) from figures of lesser significance (the businessmen). Precedents for this device can be found, as already noted, in earlier Roman 'plebeian' art (see [234–5]) and also in the art of the ancient Near East (much of which Trajan had conquered or aspired to conquer), and its use may have been intended to evoke both traditions.

231 The Column of Trajan, erected in Trajan's Forum between two libraries behind the Basilica Ulpia (see [255 C]), was dedicated in AD 113. It served in part as a sepulchre—Trajan's cremated remains were placed in the chamber at its base—but its principal function, like the forum as a whole, was to celebrate Trajan's two successful campaigns against the Dacians (the inhabitants of ancient Romania) in AD 101–2 and 105–6. It did this by means of an extraordinary cycle of reliefs designed to resemble a great scroll which winds around the column in an ascending spiral for more than 200 m.

The story of the Dacian campaigns is told in 155 scenes which are separated by architectural and topographical features but not by distinct borders, and one thus has the sense of a continuous but shifting landscape unfolding in the background and linking all the events depicted. Within these changing scenes Trajan appears again and again, and

other figures, notably the Dacian King Decebalus, also reappear. Although the matter is controversial, it seems likely that the continuous narrative (the term is appropriate even though the same figure never reappears in the same scene) thus created may have been influenced by illustrated scrolls, examples of which must have been kept in the adjacent libraries.

The scenes record not only military engagements but also all the routine matters that went with a campaign—crossing rivers, marches, constructing forts and towns, sacrifices, the emperor addressing the troops, the reception of ambassadors, and so on. In spite of a certain amount of formulaic repetition the artists were clearly concerned with preserving a minutely detailed record of things that had actually happened on the campaigns. Often the space in which the action takes place is rendered in 'bird's-eye perspective', so that one can see the interior of forts and cities; and details of architectural and engineering projects, military equipment, and landscape are rendered in considerable detail.

[A] illustrates portions of the four lower spirals of the relief. At the bottom a large figure of a god, personifying the Danube, rises out of the water and watches the Roman army as it crosses the river into Dacia on a pontoon bridge. To the left we see some of the fortifications on the Roman side of the Danube. In the band above Roman soldiers are seen laying bricks or masonry and carrying timbers as they build a fortified camp. In the third spiral this camp is finished, and we see Roman cavalry and infantry preparing to leave it and go on campaign. Above this we see the aftermath of the first Roman attack in which Trajan, standing on a platform faced by Roman soldiers with their legionary standards, prepares to receive Dacian ambassadors.

Much of the narrative power of the frieze stems from its depiction of the Dacians' dogged but futile resistance to the Romans' well-organized and relentless war machine. The designer or designers of the frieze were careful to represent the Dacians and their king, Decebalus, as barbaric (in one scene their women are shown torturing a Roman

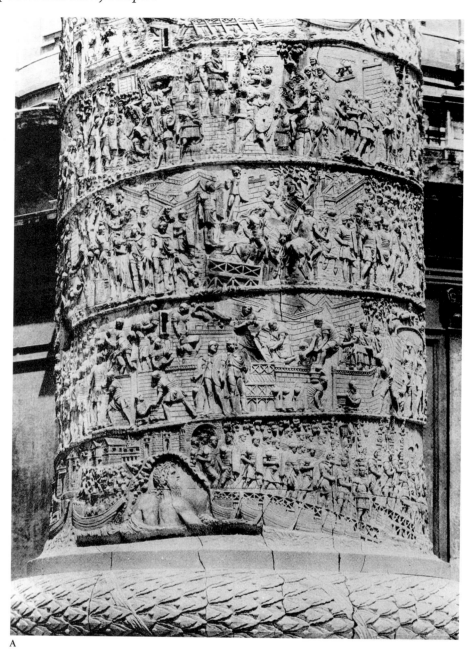

231 Column of Trajan, Rome.
A Dacian campaign;
B Trajan with prisoners and a
Dacian town; **C** Dacians in
despair

A

prisoner) and ill-disciplined, and to contrast these qualities with the orderly self-control of Trajan and his soldiers. They also strove to make it clear, however, that the Romans had not overcome an insignificant opponent, and hence at times the Dacians are portrayed, with a certain amount of sympathy, as brave fighters endowed with perverse nobility. Decebalus, for example, retains an aloof dignity even when he is forced to submit to Trajan at the end of the first campaign, and near the end of the narrative he is shown committing suicide rather than be taken prisoner by the Romans.

[**B**] shows a junction of two scenes connected with early battles in Trajan's first campaign. To the left, in a setting dotted with trees, we see Decebalus, recognizable by his characteristic floppy headdress, surrounded by wounded Dacians who are being helped by their comrades. (Further to the left, not visible here, Roman and Dacian soldiers are shown still locked in combat.) To the right Trajan and his officers calmly survey the ramparts of a Dacian town. Below them Roman soldiers with torches are setting fire to Dacian houses. [**C**] is a scene from the last stages of the war, when the Romans had laid siege to the Dacian capital

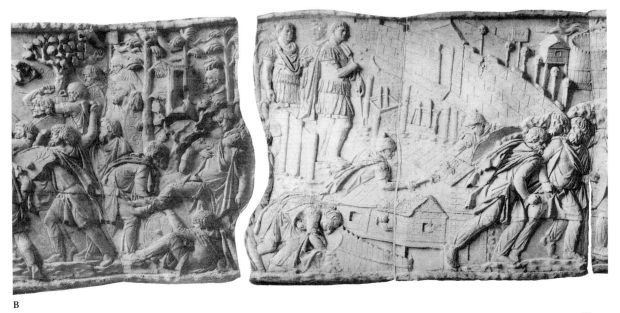

B

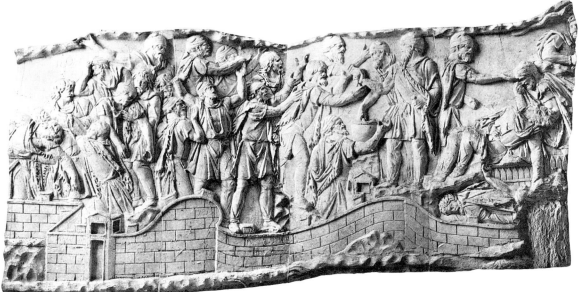

C

and were starving it into submission. The scene is set inside the Dacian fortifications. To the left a Dacian leader has dipped a goblet into a bowl and is distributing the liquid to a group of gesticulating soldiers. Some interpret this as a mass suicide in which the Dacians drink poison rather than surrender to the Romans; others feel that they are simply sharing their dwindling supply of water. Either way it is a dramatic scene, and its poignancy is enhanced by the figures to the right where, among the Dacian dead, an older man is seen weeping over the body of a younger one, perhaps his son.

232 Eight circular reliefs depicting Hadrian and members of his retinue engaged in hunting and offering sacrifices were incorporated in the early fourth century into the decoration of the Arch of Constantine (see p. 299). There is no evidence as to the nature of the Hadrianic monument from which they were taken, but the lack of such evidence has naturally not discouraged speculative suggestions (e.g. a four-sided gateway, an arch, a private monument of some sort, a temple tomb for Antinous). In the example shown here, Hadrian (whose face has been recut to represent a later ruler, probably Constantius Chlorus), to the left of a central altar, is shown offering sacrifice to Apollo. On a base behind the altar stands a hip-shot, smooth image of the god that calls to mind the images of Antinous and crystallizes that peculiarly Hadrianic vision of Classical Greek art. In his left hand Apollo holds a cithara, supported by a serpent-entwined tripod; behind the statue is a tree, probably the sacred laurel of Delphi. To the left and

232 Arch of Constantine, Rome: Hadrian at sacrifice

right of Hadrian stand two companions, one of whom holds the emperor's horse. The companion on the left has been identified as the future emperor Antoninus Pius.

The absence of military subject-matter has suggested to some that the eight tondi belonged to a monument made for Hadrian's private enjoyment, but it is more likely that they belonged to a public monument that was modelled, in keeping with Hadrian's cosmopolitan taste, on the royal iconography of the ancient Near East, where the motifs of the royal hunt and sacrifice had a long history.

233 In addition to documenting military campaigns and triumphs, rites of the state religion, and acts relating to governmental policies, the historical reliefs were some-times also used to commemorate the final event of the emperors' careers—their death and deification. From the very beginning of the Empire, the Romans adopted the practice, probably derived from the Hellenistic world, of deifying deceased rulers. Whether such deification was taken seriously in a religious sense, or whether it was essentially a political ritual designed in part to put the stamp of legitimacy on the succeeding emperor, is debated, but in any case a series of ritual acts, priestly offices, and an artistic iconography were quickly devel-oped to serve the needs of the imperial cult.

The Column of Antoninus and Faustina, commis-sioned by Marcus Aurelius to commemorate the deifica-tion of Antoninus Pius and his wife Faustina the Elder

(who had died twenty years before Antoninus), was erected as a cenotaph on the spot in the Campus Martius where Antoninus had been cremated. It consisted of a base decorated with relief sculptures and a red granite column surmounted by a portrait of Antoninus. The portrait is lost, and the column was substantially damaged in the eighteenth century, but the base, 2.47 m. high, survives in good condition.

On the principal façade of the base is a striking scene in which a youthful winged male figure carries the deceased emperor and his wife to their heavenly destination. Two eagles, traditionally associated with Jupiter, hover over his broad wings, and Antoninus holds a eagle-topped sceptre. The message would seem to be that Antoninus and Faustina have become a new Jupiter and Juno. The iden-tity of the winged male has been a matter for speculation; he may be the Genius of the Golden Age or possibly Aeon, the embodiment of cycles of time. Below to the right sits the goddess Roma, a martial figure who wears a helmet and has one breast bared like an Amazon. Armour is piled in front of her, and she leans on a shield bearing a depic-tion of Romulus and Remus suckled by the wolf. Opposite her on the left is a personification of the Campus Martius holding an obelisk. Both figures seem to look towards the ascending emperor and empress.

On the sides of the base are nearly identical reliefs depicting the military parade, the *decursio*, that took place at the time of the cremation. The stylistic distinction between the apotheosis relief and the parade reliefs has often been noted and seems to bring us to a borderline between the classicism of the early Empire and the style which was to be characteristic of the later Empire. The sol-diers of the parade relief seem squat and schematized when compared with the elongated and elegantly posed and draped figures of the apotheosis scene. The spatial set-ting of the parade scene, moreover, has become essentially symbolic. Thin terrain lines underlie some of the riders and the foot soldiers in the centre, but essentially the design is a geometric pattern, a circle with a centre. As in earlier Italic and plebeian art, the idea behind the scene has become more important than the naturalistic proportions and spatial relationships of its figures, and what we seem to be seeing here is the raising of these venerable popular modes of Roman art to the level of official commemora-tive monuments.

PLEBEIAN RELIEFS

234 The plebeian tradition in Roman sculpture involved not only style but also subject-matter. When contrasted with the elegant and learned mythological subject-matter of patrician sarcophagi [349–52] or decorative panels like the stucco reliefs from the Villa of the Farnesina [277 A],

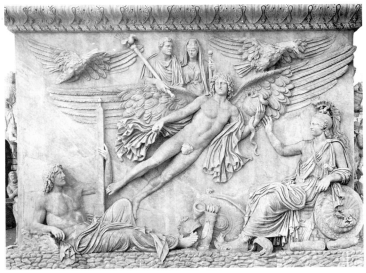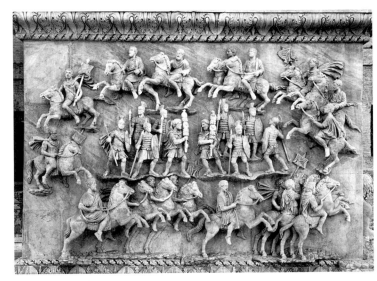

233 Base of Column of Antoninus Pius: apotheosis of Antoninus and Faustina; decursio (Vatican Museum)

the reliefs from the tomb of the wealthy baker M. Vergileus Eurysaces (see [258]) might seem to belong to another society altogether. Much of the art of this sort was made for customers who belonged to the freedman class, that is, former slaves and their descendants. Far from being a revolutionary group, the freedmen were usually intensely loyal to the imperial system, prospered under imperial patronage, and formed an enterprising, mercantile, lower and middle class. Unlike upper-class Romans, their status put no restrictions on the type of commercial activity in which they could engage, and some of them, like Eurysaces and the fictional Trimalchio in the *Satyricon* of Petronius, became very wealthy. Burdened neither by Greek intellectual traditions nor by the iconography that went with political power, they were free to commission scenes of what interested them most—their own lives. In the south frieze (above) of the tomb of Eurysaces we see workers, presumably in his bakery, sorting, sifting, and grinding grain; on the north frieze (below) dough is being prepared in a kneading machine at the right, rolled into loaves on the tables in the centre, and baked in an oven on the left.

235 While the sophisticated classicism of the Hadrianic period significantly altered the tone of official art and aristocratic private art, the underground tradition of plebeian art went on as if Hadrian had never existed.

Chariot races, held in Rome's most extensive place of entertainment, the long racecourse known as the Circus Maximus, were wildly popular with the Roman populace. This relief marked the tomb of a magistrate who was responsible for oversight of events that took place in the circus and is of interest both for its funereal iconography and for its plebeian rendition of the races. At the left, characteristically on a larger scale than the other figures, we see

the magistrate and his wife with their right hands joined. This gesture, the *dextrarum iunctio*, was a symbol of union in marriage and probably means that husband and wife have been reunited in an afterlife. The wife stands on a base, as if she were a statue, which may mean that she had died before her husband. His short haircut with bangs is in the style that was in vogue during the time of Trajan, which was perhaps the period when he served as a magistrate. His creased, severe face also evokes an older tradition—the sobriety of Republican portraits.

As in other plebeian reliefs, the sculptor is primarily interested in conveying information and disregards natural spatial and temporal relationships. The scene to the right is a strangely jumbled yet vivid depiction of the races in the circus. If it is the same charioteer who is seen racing in the foreground and again holding the palm of victory in the background, the scene is an example of continuous narrative within a single scene. Depicted at the far right are the entrance gate of the circus and an inside wall, turned on its end to fit into the frame of the relief, with herms in front of it (perhaps the starting-gate facility known as the *carceres*). Other topographical features that are known to have existed in the circus are also represented. The statues standing on columns and the obelisk all stood on a long earthen embankment known as the *spina* (spine) that ran down the centre of the racecourse; the bundles of conical objects are probably the *metae*, wooden posts at each end of the *spina* that marked perilous turns for the charioteers; and the object with figures of dolphins on top was a score-keeping device.

The bird's-eye perspective that we see here is a feature of the scenes on the Column of Trajan [231] as is, in a modified form, continuous narrative, and it is a matter of speculation as to whether the circus relief was influenced by the

234 Tomb of Eurysaces, reliefs, Rome

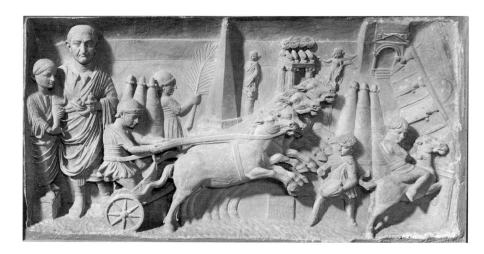

235 Relief with circus scenes
(Vatican Museum)

reliefs of the column, or whether the column was in-
fluenced by the plebeian tradition that the circus relief
perpetuates. Both may be true.

PORTRAITS

236 This bronze head was discovered in Rome in the six-
teenth century and quickly, although fancifully, associated
with L. Junius Brutus, the first consul of the Republic.
Commentators have seen in the spare, cubic construction
of the head, the linear rather than plastic elaboration of its
surface, and its serious, business-like mien a truly Italic
(hence un-Greek) ethos. It does, however, contain formal
details, especially in the hair, that derive from techniques
of bronzeworking that were developed in Greece and
adopted in Etruscan and mid-Italic sculpture. Suggestions

for the date of the head range from the fourth to the first
centuries BC. In both style and technique it relates most
closely to Etruscan and Italic sculpture of the mid-Repub-
lic, and Otto Brendel's suggestion that it belonged to an
over-life-size equestrian statue, commissioned by the gov-
ernment of Rome and executed about 300 BC by Etruscan
craftsmen, may well be correct.

237 The emaciated quality of the head, with its sunken
cheeks, deep wrinkles, and grim expression, place it in the
'veristic' tradition of the early first century BC, when fea-
tures of Roman aristocratic ancestor portraits and the tra-
ditional sobriety of Italic sculpture were being adapted by
immigrant Greek artists to monumental portrait sculp-
ture in stone.

 The 'capite velato' head originally belonged to a full-
length statue of a Roman noble clad in a toga. The nose and
part of the neck are restored. Part of the toga, now broken

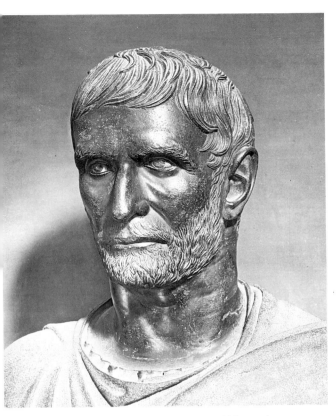

236 Capitoline Brutus, bronze (Rome, Conservatori Museum)

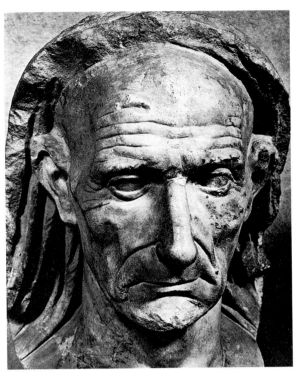

237 Veiled Head (Vatican Museum)

at the edges, was drawn up over his head, possibly indicating that he held a priestly office.

238 A Roman noble carries the busts of his ancestors. The style of the toga suggests that the statue belongs to the time of Augustus, but the busts of the two ancestors are depicted in styles that were prevalent in about 50–25 BC. (The head now on the statue itself is ancient but does not belong to it; the original, one suspects, was a classicizing portrait in the Augustan tradition.) The statue alludes to the custom of carrying ancestral death masks to the funeral ceremonies for Roman aristocrats (see p. 224), but in a broader way it also celebrates the importance that family connections had for political aspirations and social standing within the senatorial class. The purpose of the statue was most probably to commemorate the public career of its subject and the distinction of his lineage, and the sculptor has accordingly rejected the emaciated look that must have been a feature of the early funereal masks in favour of the sober but vigorous look of late Republican public portrait sculpture.

239 Pompey 'the Great' (106–48 BC) rose to prominence in Rome by virtue of a distinguished military career, shifting political alliances, and prudent political marriages. Early in his career he helped to subdue various enemies of the Roman state, the most notorious and dangerous of whom was Mithradates of Pontus, the rebellious Hellenistic king who saw himself as a new Alexander the Great and struggled to expel the Romans from Asia just as Alexander had expelled the Persians two and a half centuries earlier. After a great triumph in 62 BC to celebrate his victory in the Mithradatic wars, Pompey soon entered into an alliance with Julius Caesar and M. Crassus (the First Triumvirate), married Caesar's daughter, and throughout the 50s was one of the most powerful figures in the Roman world. His gradual falling out with Caesar led ultimately to his defeat at the battle of Pharsalus in 48 BC, soon after which he was murdered. During the Empire he continued to be remembered as a man of integrity who, in spite of his unhappy end, had won great victories for the Roman state and had played a major organizational role in its system of provincial government.

The head in Copenhagen is identified as Pompey on the basis of coin portraits issued shortly after his death and was found in a tomb on the outskirts of Rome that seems to have belonged to his family line. It is probably a copy, made by Pompey's descendants in the time of Claudius, of an original created about 55 BC, when he held the consulship and had oversight of artistic projects in Rome, including the dedication of a great theatre.

The portrait is an early and interesting fusion of the essential realism of Republican portraiture with mannerisms derived from the Hellenistic 'heroic portrait', a type

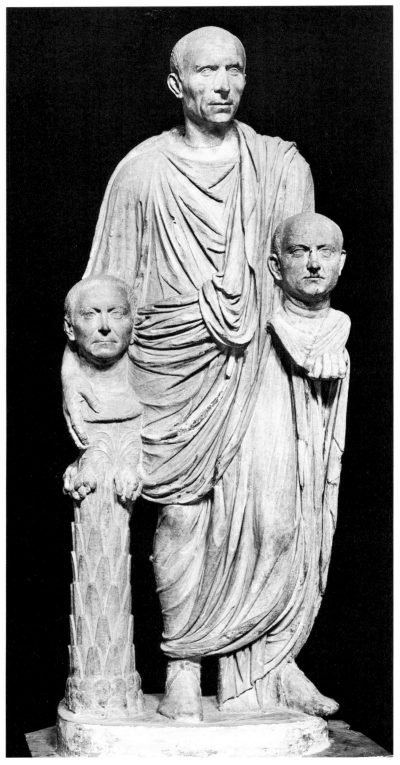

238 Barberini Togatus (Rome, Conservatori Museum)

first developed for Alexander the Great and often favoured by subsequent Hellenistic kings, including Mithradates. The portrait's small eyes, bulbous nose, lined brow, and rather puffy face presumably reflect Pompey's real physiognomy and would have reassured the public that they

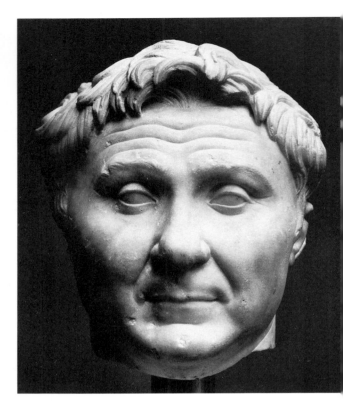

239 Pompey the Great (Copenhagen, Ny Carlsberg Glyptotek)

were dealing with a hard-headed Roman general and statesman who could prevail in the pragmatic world of Roman politics. On the other hand, the way the portrait's thick and somewhat tousled crop of hair stands up over the centre of the forehead (a feature called an *anastole* in Greek) is an allusion to a feature of the famous portraits of Alexander by his court sculptor Lysippus (see [195]). Plutarch confirms that Pompey liked to affect both the hairstyle and the dramatic glance that were features of Alexander's portraits and that some Romans (probably his political opponents) took to calling him 'Alexander' in a mocking way. It is probable, however, that there was more than vanity and affectation behind these sculptural quotations. Pompey, like Alexander before him, was a victorious general who had conquered in the east and left behind him a new military settlement, and he wanted to impress that fact on the Roman populace. He, not Mithradates, the portrait announced, was the new Alexander.

240 Dissemination of the emperor's portrait, in the city of Rome, in Italy, and in the provinces, was one of the principal ways in which imperial administrations conveyed his personality, outlook, and policies to the population of the Empire. As each new emperor came to power an official portrait bust was normally created in Rome, and copies of it were distributed far and wide. If an emperor ruled for an extended period of time, the official portrait was some-

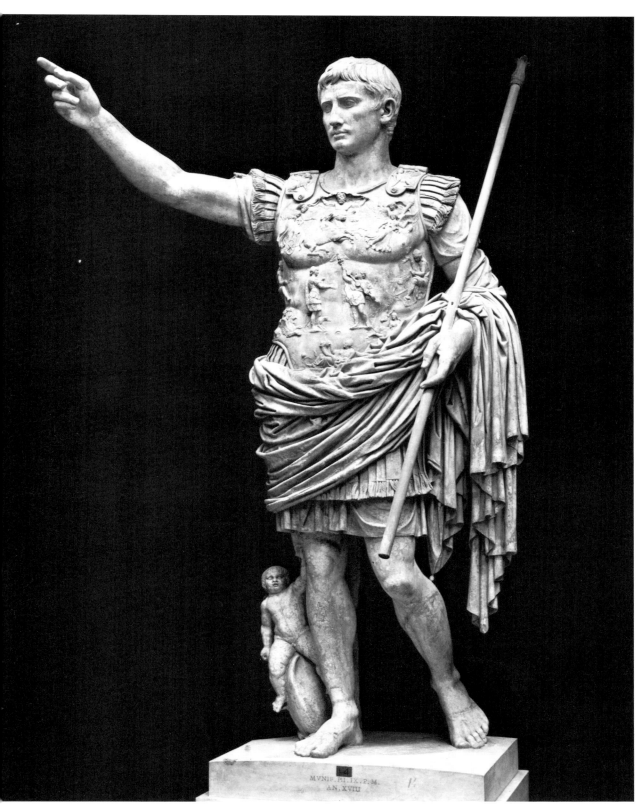

240 Prima Porta Augustus (Vatican Museum)

times modified to reflect his age or changing self-image. Such portrait heads could be affixed to a variety of body types (e.g. dressed in a toga, or in armour), depending on what aspect of the emperor's role was to be emphasized in the statue—for example, leader of the army, consul, or priest of the state religion.

This famous portrait depicting Augustus in military dress and hence in his role as *Imperator*, leader of the Roman army, was found in a villa at Prima Porta, just out-side Rome, that once belonged to the Empress Livia. The statue was clearly designed to express a variety of political ideas and yet, although it has been studied and discussed perhaps more than any other Roman portrait, the mean-ing of many of its details remains controversial.

Even the *contrapposto* composition of the statue, which echoes that of the Doryphorus of Polyclitus [93] and sim-ilar Greek representations of youthful athletes, can, as already noted be said to be part of its meaning, since pro-moting reverence for the Classical past was a part of Augustus' cultural programme. Strict Classical balance is violated, however, by the dominating gesture of the right arm, which is sometimes associated with the *adlocutio*, the formal address by the emperor to the army and the citi-zenry. The small figure of Cupid riding on a dolphin next to Augustus' right leg served the practical function of pro-viding an additional support for the statue but was also probably an allusion to the official genealogy of the im-perial family and therefore part of the statue's message. Cupid was the son of Venus, as was Aeneas, from whom the Julian line claimed descent. The dolphin was probably intended to call to mind Augustus' naval victory over Cleopatra and Antony at Actium.

On the emperor's elaborate breastplate we encounter the same blend of mythical and religious figures, personi-fications, and historical personalities that also appear on historical reliefs and gems (see [250–1, 272]). At the top the bearded figure of Caelus, the Sky, spreads his mantle across the heavens. Beneath this, to the left, the Sun (Greek Helios or Latin Sol) rises in a four-horse chariot. To the right, Dawn (Aurora), riding on a winged female figure, looks back towards the sun. These figures were probably intended to convey a feeling of universality and perhaps also of the dawning of a new age. At the bottom of the breastplate, in the centre, is the goddess Tellus, Earth. To her left and right respectively are Apollo riding a griffin, and Diana riding a stag, and above them are seated female figures who may represent conquered provinces. The two standing figures in the centre are generally agreed to allude to an important historical event, the return in 20 BC of the Roman legionary standards that had been captured by the Parthians thirty-three years earlier. Their loss had been a severe blow to Roman pride, and their recovery was a diplomatic triumph for Augustus. The figure on the right is identified by his baggy trousers as a Parthian. He is handing over a legionary standard to a figure in Roman

armour who is accompanied by a dog, or perhaps a wolf. The identity of this latter figure remains an enigma for modern interpreters. Augustus himself, Tiberius (who was the official deputy sent to receive the standards), Romulus, or a personification of the Roman army have all been suggested.

Still another puzzle about the statue is its bare feet. Gen-erals normally wore boots, and Augustus's barefootedness has been thought by some to mean that he is represented as a god, which would mean that he has already been deified, and that the statue must therefore be posthumous. If this is true, the Prima Porta statue may be a copy or variant, cre-ated for Tiberius and Livia shortly after Augustus' death, of an earlier bronze statue, perhaps one set up in Perga-mum shortly after the recovery of the legionary standards.

The most widespread version of Augustus' portrait head gets its name from this statue (the 'Prima Porta type'). Over 150 examples of it exist.

241 This serene portrait, found in the Via Labicana in Rome, is one of the finest realizations in portraiture of the formal and conceptual artistic aims of Augustan art. It is also one of the most sensitive renderings of the Prima Porta type, the distinctive features of which are a broad forehead, delicately tapering jaw, aquiline nose, largely uncreased, youthful-looking surfaces, and a rich but orderly hair-do, characterized by a distinctive separation of three locks at the centre-right of the forehead. Here Augustus wears the toga, the official ceremonial dress for state business and rituals. (The toga was essentially a large shawl, often as much as 5–6 m. long, that had a curved edge as well as a straight edge.) Its fine, delicate long lines enhance the serene dignity of the statue. The fact that the toga is pulled over his head, a practice normal for someone carrying out priestly duties, suggests that Augustus may be represented here as Pontifex Maximus, the chief priest of the state, a title and role that he accepted in 12 BC. In any case, the statue was clearly designed to embody the virtue of *pietas*, dutiful reverence for traditional religious and cultural values, that Augustus wished both to exemplify in person and to inculcate into his fellow Romans.

242 The women of the Julio-Claudian line were por-trayed in the same calm, neo-classical style that was used for images of the emperors. Agrippina the Elder (14 BC–AD 33) was the daughter of Marcus Agrippa and Augustus' daughter Julia. She married Germanicus, the popular gen-eral who was a grandson of Augustus' sister Octavia on one side, and of his wife Livia on the other. After her husband's mysterious death while on campaign in the east, a death which she blamed on Tiberius, she carried on a protracted quarrel with the emperor, was eventually banished from Rome, and is said to have starved to death in exile. After her death her memory was revered by the emperors Caligula, who was her son, and Claudius, who was a

PLATE XVII

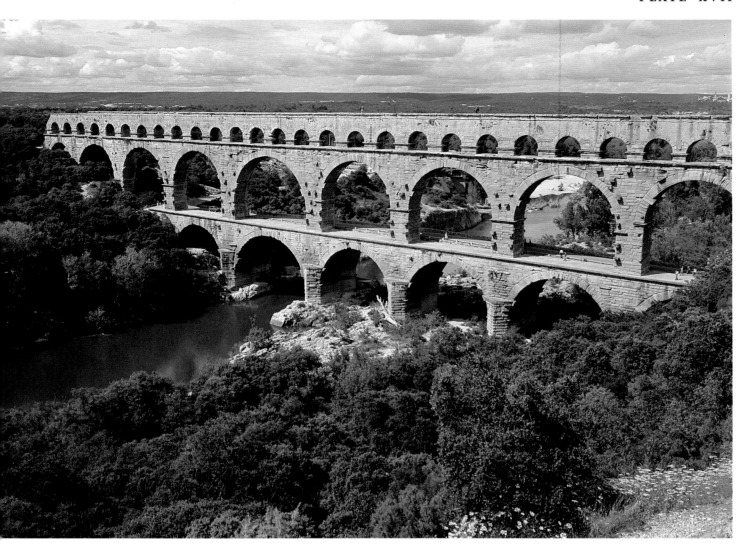

257 Pont du Gard, Nîmes

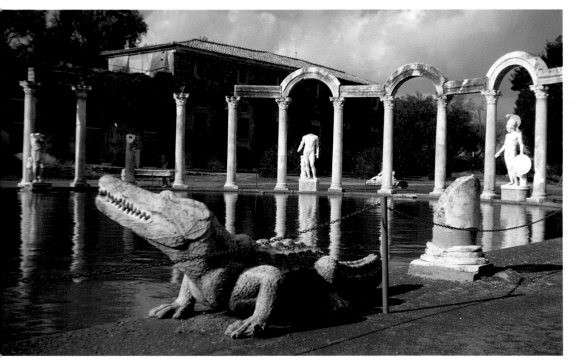

263 B Hadrian's villa at Tivoli, the Serapeum-Canopus

PLATE XVIII

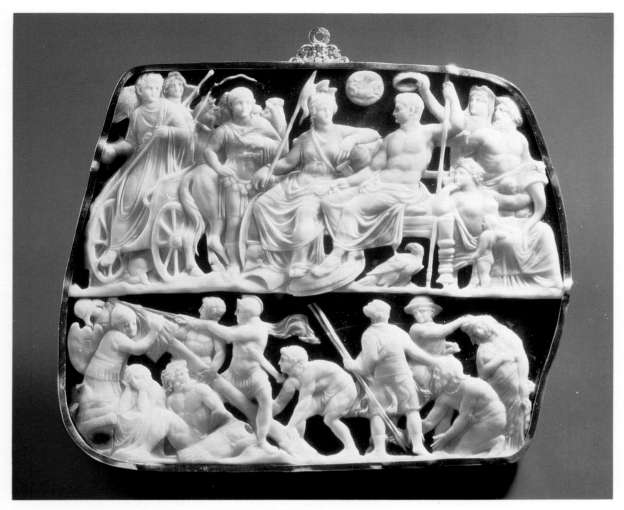

271 Gemma Augustea, sardonyx (Vienna, Kunsthistorisches Museum)

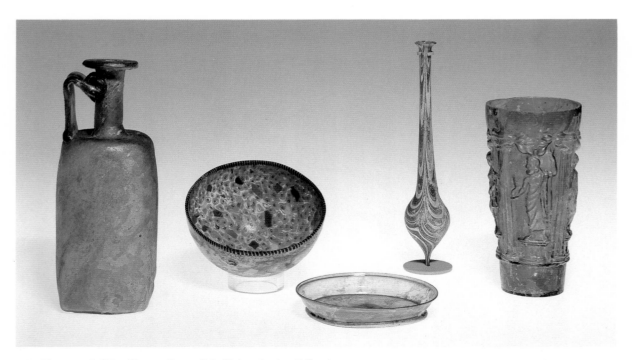

274 Glass vessels (New Haven, Conn., Yale University Art Gallery)

PLATE XIX

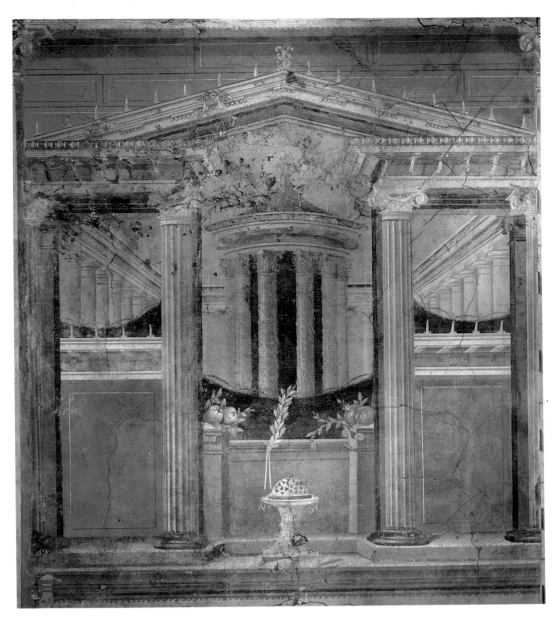

279 Painted room from Boscoreale (New York, Metropolitan Museum)

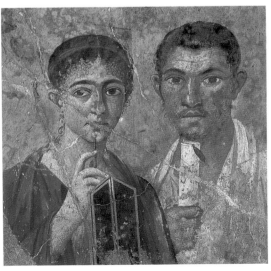

289 Portraits, from Pompeii (Naples, National Museum)

PLATE XX

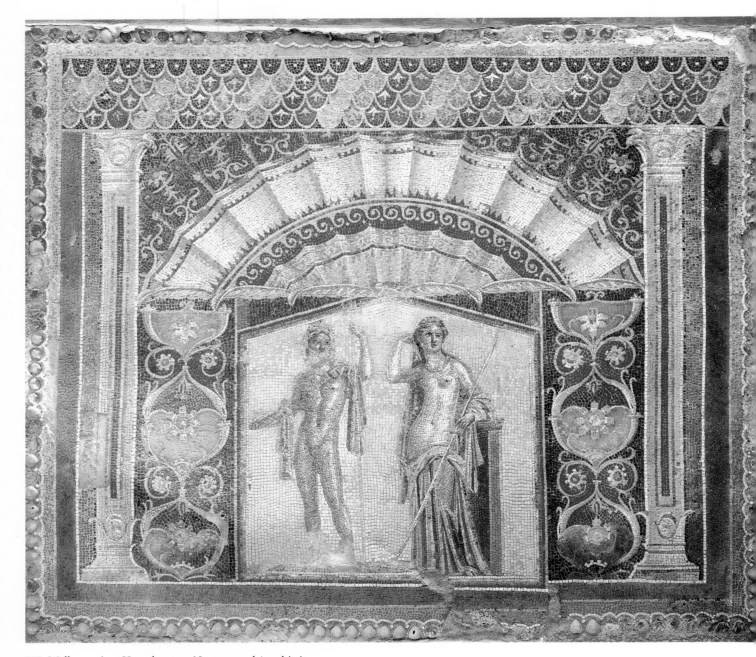

297 Wall-mosaic at Herculaneum: Neptune and Amphitrite

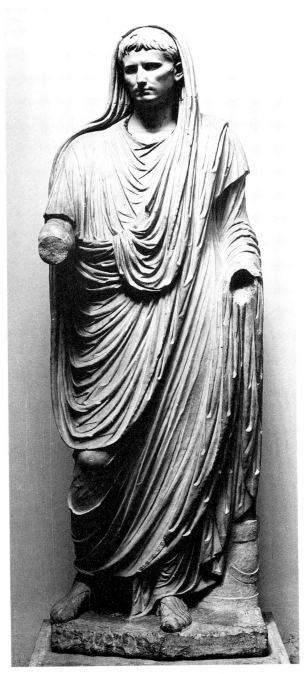

241 Augustus as priest (Rome, National Museum)

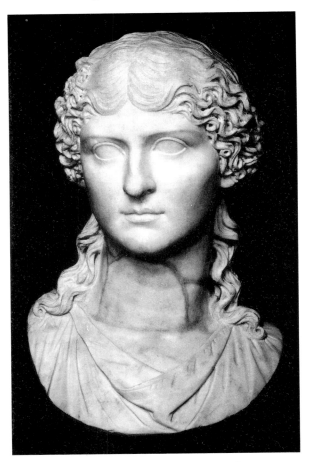

242 Agrippina the Elder (Rome, Capitoline Museum)

brother of Germanicus, and portraits of her became widespread (see also [251 A]). The example illustrated here was probably made at this time but was probably derived from a prototype created in the later reign of Augustus or early in the reign of Tiberius. The smooth planes of the face and the configuration of the eyes and mouth are reminiscent of the portraits of both Augustus and Caligula.

Roman portraits, especially portraits of women, are often dated by their hairstyles, which changed from generation to generation. The modest style of Agrippina's hair—parted in the middle and tied into four folded braids at the back, with two separate locks falling along the side of the neck to the shoulders—has a simplicity that contrasts significantly with the hair-dos of later periods (e.g. [344]).

243 This colossal portrait statue (height 2.54 m.) of the Emperor Claudius was found in Lanuvium in 1865 and probably originally stood in a public building in that city. A dedicatory inscription, now lost, seems to have indicated that it was dedicated in AD 42–3, shortly after Claudius' accession. The statue perpetuates a tradition, going back to the later Hellenistic period, of combining the portrait busts of prominent Roman citizens with the idealized, youthful bodies that were typical of Greek statues of athletes and gods. These body types, along with the attributes that frequently accompanied them, were part of a conventional artistic language used to convey political and social messages about the person portrayed. The effect of combining what are often matter-of-fact,

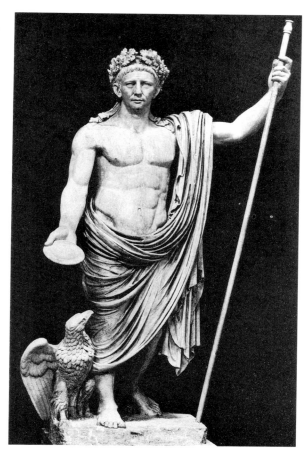

243 Claudius as Jupiter (Vatican Museum)

unglamorous Roman faces with muscular, youthful, and sometimes sensuous bodies often seems incongruous, sometimes even comical, to modern eyes, but in the Roman world the convention seems to have been so well accepted that it did not seem abnormal.

Claudius, according to ancient sources, was a scholarly, retiring type of man who stammered, was not physically robust, and was even suspected by some of being mentally retarded. When he was catapulted into the principate at the age of 55 after the assassination of Caligula, he turned out to be a competent, meticulous ruler, but it would have been difficult, without considerable help from the propaganda centres in Rome that were responsible for generating imperial imagery, to view him as a dominating, heroic figure in the tradition of Julius Caesar and Augustus.

The statue was undoubtedly, in a non-pejorative sense, propagandistic, that is, its various features were intended to convey a message about the ruler whom it represented. Any educated Roman viewer would have been prepared to read the massive, muscular body with an eagle at its feet and a sceptre (restored) in the left hand as an image of Jupiter (the Roman equivalent of the Greek Zeus) and to conclude that Claudius, like the supreme Olympian god, was a powerful, world-dominating figure. The head of the statue, on the other hand, would have conveyed the simul-

taneous message that Claudius was a real man who as First Citizen presided over the rites of the state. Hence the oak wreath and what was probably a sacrificial offering bowl in his right hand. (The existing bowl is a questionable restoration.) The face, with its crescent-shaped locks of hair over the broad forehead, slightly projecting ears, and tapering jaw, clearly conveyed a still subtler message. It evoked the portraits of Augustus and confirmed Claudius' position in the Julio-Claudian dynasty, but it did so with a significant difference. In place of the smooth, eternally youthful appearance of Augustus, the sculptor was permitted to render the lined, pouchy face of an older man. This variation from Augustan classicism evokes, of course, the realistic portraits of Republican Rome, and was probably intended to reassure the Roman public that Claudius was committed to restoring respect for traditional Roman values after the excesses of Caligula.

244 With the advent of Vespasian there came a powerful reassertion of the values, attitudes, and appearances of the Roman Republic, the memory of which was increasingly romanticized as a golden age of constitutional government by the senatorial class. A tough, pragmatic soldier with old-fashioned values had come to power, and through portraits like this one that message went out to the Roman world. The head's broad, heavily lined face, its balding head, and its small, shrewd eyes effectively combine to convey Vespasian's amply documented 'no-nonsense' personality. Gone is the cool, idealistic classicism of Augustan art that, by the time of Nero, had come to be associated with despotism and degenerate pretentiousness. The vivid, almost intimate, glimpse of Vespasian's personality captured by the Copenhagen portrait has led some to speculate that it was a private rather than a public portrait, although there is no compelling reason to think that this was the case. Others see the portrait as one made at the very end of Vespasian's life, and perhaps it does capture the sardonic spirit of a man who could joke about the Roman custom of posthumous deification by declaring, when he knew he was dying, that he was 'about to become a god'.

245 Hadrian was a patron of the arts and understood the power of visual imagery. This, and the fact that the essential peacefulness of his principate gave ample opportunity for the propagation of his image, perhaps explain why there are hundreds of surviving portraits of him. Hadrian seems to have had naturally curly hair which was often arranged, as here, in waves on the crown of his head and in neatly curled locks framing forehead and temples. It is above all on the basis of subtle variations in his hair-do, complemented by variations in the configuration of his face, and by details of drapery or armour on the bust, that at least six types have been identified within the large corpus of his portraits.

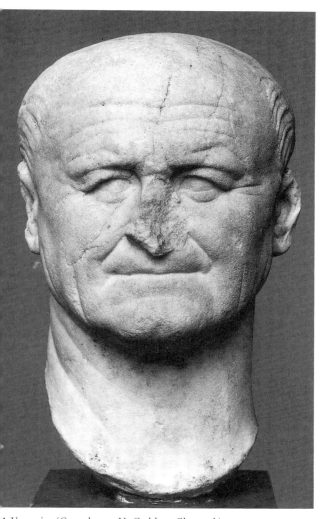

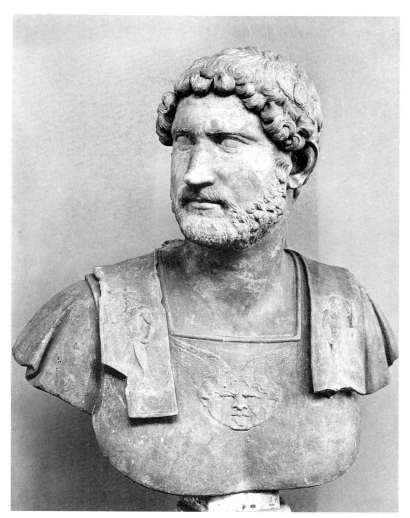

244 Vespasian (Copenhagen, Ny Carlsberg Glyptotek)

245 Hadrian (Rome, Capitoline Museum)

The type shown here is thought to have been developed in Hadrian's later years, but all of Hadrian's portraits, early or late, seem to represent him in early middle age, still vigorous but mature. His face is always smooth and unlined, and he always wears his characteristic close-cut beard. As already noted (p. 229), the beard seems to have been a deliberate outward expression of his philhellenism. After centuries of smooth-shaven Republican statesmen and emperors, Hadrian decided to change the imperial image and chose to present the face of a Greek philosopher. His choice was highly influential; not until the fourth century would the Romans again see an emperor who was not bearded.

Roman portrait busts had originally encompassed only the head, neck, and just a hint of the shoulders of the subject. Late in the first century AD, however, sculptors began to expand the bust to include more of the shoulders and chest. This made it possible to include some of the attributes that had traditionally gone with full-body portraits, like the cuirass that Hadrian wears in the bust illustrated here. Although military prowess was not something that

Hadrian stressed in connection with his personal image, Roman politics required that his subjects be reminded of his role as commander-in-chief of the Empire's far-flung armies. It has been suggested that the two enigmatic figures on the shoulder flaps may represent, or be related to, Jupiter, and that the armour may thus also be an allusion to Hadrian's assumption of the title *Olympios* in AD 128.

246 The portraits of the Bithynian youth Antinous, Hadrian's companion and lover, make up one of the most characteristic, if somewhat bizarre, aspects of Hadrianic art. After Antinous drowned in the Nile during a visit to Egypt with the emperor in AD 130, Hadrian saw to it that the youth was deified and that cults were established to honour him and perpetuate his memory. According to Dio Cassius, 'He also set up statues of him, or more properly, cult images of him, throughout what one might almost call the entire inhabited world.' Surviving sculptures confirm what the historian records. Antinous' smooth face with its full cheeks, aquiline nose, and pout-

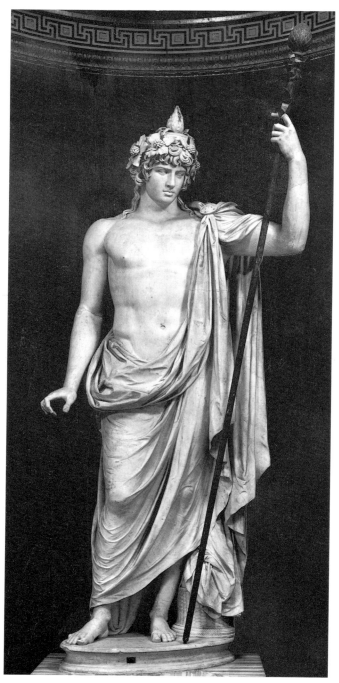

246 Antinous as Bacchus (Vatican Museum)

ing expression now confronts us in the guise, for example, of Apollo, Bacchus, Hermes, Vertumnus, and Osiris.

The over-life-size (height 3.46 m.) statue of Antinous-Bacchus illustrated here was probably originally set up in Hadrian's villa at Tivoli. He wears a wreath of vines and grapes on his head, and a chest associated with the Bacchic mysteries is placed at his feet. The restored Bacchic wand

(thyrsus) that he now holds in his left hand is probably close to the original.

In addition to documenting Hadrian's love for the cultures and images of the various regions of the Empire, his fondness for the motif of the ideal youth in Greek art, and his general interest in the exotic, the images of Antinous are of importance because their stylistic features influenced the style of later Antonine sculpture.

247 This relief probably once adorned a tomb on the outskirts of Rome and shows how the plebeian tradition in Roman portraiture was perpetuated among ordinary Romans even when the elegance of Greek art pervaded both the official and the private art of the imperial circle. Features such as the frontal composition of L. Vibius and his wife, their large hands, and their dour expressions, which call to mind ancestral death masks, would seem to connect this relief with a pre-imperial, Italic tradition in Roman art. Yet the hairstyle of the woman makes it virtually certain that the relief was made during the time of Augustus. What seems to be the funeral mask of a boy, perhaps a deceased child of the principal figures, floats between them.

248 The study of Roman sculpture tends to focus, understandably, on genres that are distinctively Roman, like portraits and historical reliefs; yet much of the sculpture that one would have encountered every day in the Roman world—in public spaces like temples, gymnasia, and baths and in villas and houses—was of a different character. Both in style and in subject-matter this sculpture perpetuated the Greek sculptural tradition. Even as early as the second century BC Roman aristocrats had become enthusiastic collectors of Greek art, amd when the supply of Greek originals began to dry up, Roman patrons frequently commissioned new works that carried on both the forms and the feeling of Greek sculpture. Sometimes these were reasonably faithful copies of Greek originals; sometimes they were variants on well-known Greek types; and sometimes they were wholly new creations which echoed a variety of Greek prototypes.

The 'Ildefonso group', a classicistic creation that fuses Polyclitan and Praxitelean stylistic features, belongs in the last of these categories. Details of its workmanship suggest that it was probably made in the second quarter of the first century AD, but it is clearly in the tradition made popular by Pasiteles and his school in the first century BC.

The figure on the right, who holds two torches and wears a crown of laurel, is supported by a small archaistic kore, to his left, and by an altar in the centre that he touches with a lowered torch. The torch-bearer is essentially an amalgam of features derived from the sculpture of the fifth-century Greek sculptor Polyclitus—the torso is based on the Westmacott athlete type, the left arm on the Diadumenus, and the head on the Doryphorus [93]—but

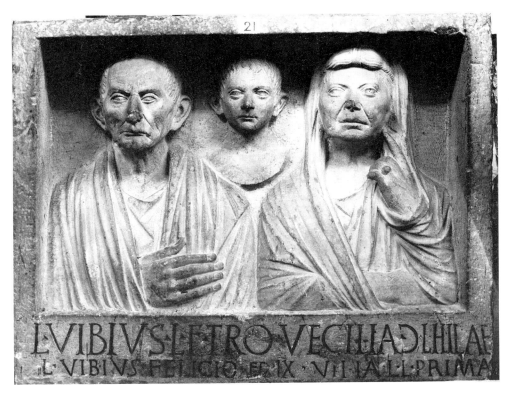

247 Grave relief of
L. Vibius and family
(Vatican Museum)

all are made softer and more boyish than the prototypes. The torso of the figure on the left who leans against the torch-bearer is closely modelled, on the other hand, on the Apollo Sauroktonos of the fourth-century sculptor Prax-iteles. The head of this figure may also have originally been a Praxitelean type, but it was replaced in the Hadrianic period by a portrait of Antinous (cf. [246]). Since the statue was found in the early seventeenth century in the area of the ancient Gardens of Sallust, which belonged to the emperors, it is not impossible that this substitution was made by Hadrian himself.

Although outwardly the Ildefonso group might look like a work of Hellenistic art, its casual eclecticism (quoting features of various famous prototypes but not worrying too much about their organic relationships) and its adaptability (sticking on a new head when the occasion called for it) are more typical of a certain type of Roman art. The meaning of the group is enigmatic, and this too may be a Roman feature. The lowered torch is a motif often associated with death, but the figures do not necessarily belong to a funeral monument. If, in fact, the group was produced in multiple versions for the Roman art market, like the sculptures of the school of Pasiteles, it may have had no single, fixed meaning. Among the many identifications that have been proposed over the centuries since its discovery, the most popular have been Castor and Pollux or Orestes and Pylades (the latter first suggested by Winckelmann).

249 This colossal (3.58 m. high) image of Hercules in green basalt originally stood in a niche in the great reception hall and throne room of the Domus Augustana. It was

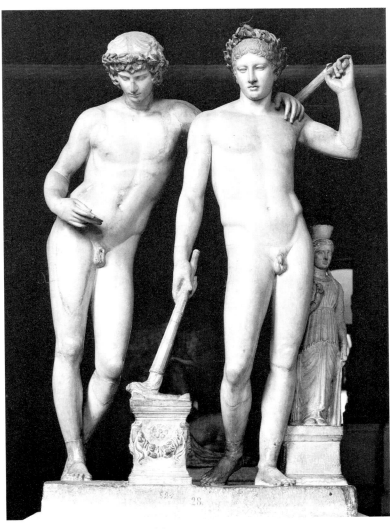

248 Ildefonso group (Madrid, Prado)

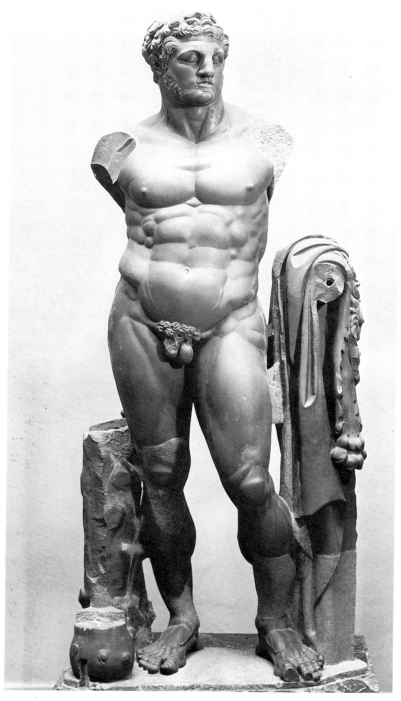

249 Hercules (Parma, National Museum)

discovered in 1722 on property belonging to the Farnese family, was eventually used to decorate the Farnese palace in Parma, and is now exhibited in the Museo Nazionale in Parma.

As a work commissioned by Domitian's artistic planners to decorate the imperial palace, it must have been recognized in its time as a sculpture of the highest possible quality. The style that the sculptor adopted, as well as the

stone from which it was carved, were in keeping with the opulent, baroque style of the building in which the statue stood. The shadows and impression of restless movement created by the deep contrasts in the bulging muscles of Hercules' chest would have harmonized with the engaged columns and niches of the room's rich and variegated façade.

COINS

Roman coins are valued not only for what they can tell us about monetary history but also for their aesthetic appeal and for the information that they provide for the iconography of Roman official art. The designs on the best coins of the late Republic and the Empire rival those of the finest Roman gems; numismatic portraits have long played a key role in helping scholars to determine the identity of sculptured portraits; and inscriptions on coins often provide clues to the identity of subjects in relief sculpture which would otherwise remain obscure.

The designs on most Roman coins were produced by striking blanks made of various metals (copper, brass, silver, and gold) with engraved dies. These were essentially a product of the gem-maker's art, and like gems they were prepared with gravers, small punches, and drills by highly skilled designers. Two types of dies were prepared for any coin issue, one of which would be fixed in an anvil and the other attached to a punch. When a heated blank was then placed on the anvil die and hammered with the die set into the punch, the side of the resulting coins that faced the anvil was usually flat while the side struck with the punch was slightly concave and had edges that curved slightly upward. In the study of numismatics, the anvil-die side is usually referred to as the obverse, and the punch-die side as the reverse.

Since coins reached every part of the Empire and were looked at and handled every day by hundreds of thousands of people, they were a powerful medium for the dissemination of government propaganda, and it is clear that the overseers of the Roman mints devoted a good deal of thought to what their coins should say. On the obverse of most Roman coins there was a head in profile. At first these represented gods and mythical heroes. By the beginning of the first century BC, however, portraits of earlier Roman statesmen and generals, some of them only recently deceased, began to appear, and shortly before his assassination Julius Caesar established a new tradition by putting his own portrait on an issue of coins, a practice which other political leaders of the late Republic soon followed. During the Empire it became normal practice to place a portrait of the emperor (or, occasionally, another member of the imperial family) on the obverse of all coins. The reverse of Roman coins was normally reserved for figures

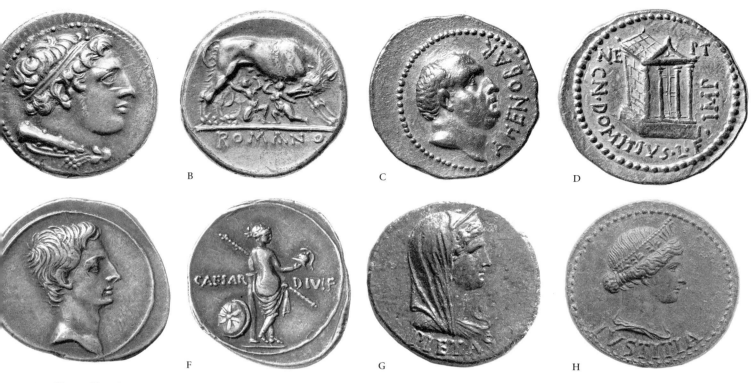

250 Silver, gold, and brass coins

and scenes that conveyed messages about the policies, achievements, alliances, or dynastic associations of political leaders: buildings, localities, personifications of places and ideas, representations or symbols of public acts (e.g. funerals, imperial donations, battles), portraits of relatives and ancestors, and representations of gods who were thought to be ancestors or patrons or who had been recipients of pious service.

In the early Republic Roman money took the form of uncoined bronze and stamped bronze bars. As the Romans began to take control of the whole of Italy and their interaction with the Greeks of south Italy (where coinage had a long tradition) increased, their need for a flexible, lightweight form of currency became obvious, and in the first half of the third century BC they took steps to develop their own coinage. At first these were modelled on, and issued in accordance with the weight standards of, Greek coins [250 A], but by the end of the third century the Romans had developed their own bimetallic system featuring a silver coin called the denarius and bronze coins that were subdivisions of it. Although intrinsic and relative values of these coins fluctuated over the next two centuries, this system lasted until the end of the Republic. A mint was established in Rome in the temple of Juno Moneta (the origin of the word 'money') and was supervised by a board of magistrates who issued coins on the authority of the Senate. At the beginning of the Empire Augustus reformed this system by establishing clear relative values for a gold coin called the aureus, which weighed between 7 and 8 g., for the silver denarius, which weighed over 3 g., and a series of brass and copper coins, the most important of which was the brass sestertius. Although these coins were later devalued and even debased from time to time, and new multiples of them were created, the system remained essentially intact until late antiquity.

250 A, B Silver didrachm, about 269 BC. This is one of the earlier Roman coins, issued on a Greek standard. On the obverse is Hercules, who was worshipped in Rome, with the skin of the Nemean lion around his neck and his club on his shoulder. On the reverse Romulus and Remus suckled by the wolf are depicted. The inscription in the exergue beneath them is an archaic Latin form meaning 'of the Romans'.

250 C, D Aureus of Cn. Domitius Ahenobarbus, 41 BC. Ahenobarbus was an admiral who, after the assassination of Julius Caesar, fought with Brutus against Antony but later came to terms with both Antony and Octavian. He was consul in 32 BC, and generally prospered, as both a politician and soldier. The portrait of a balding and somewhat overweight man on the obverse of the coin shown here is probably Ahenobarbus himself, although it might be one of his ancestors. It is, in either case, an interesting

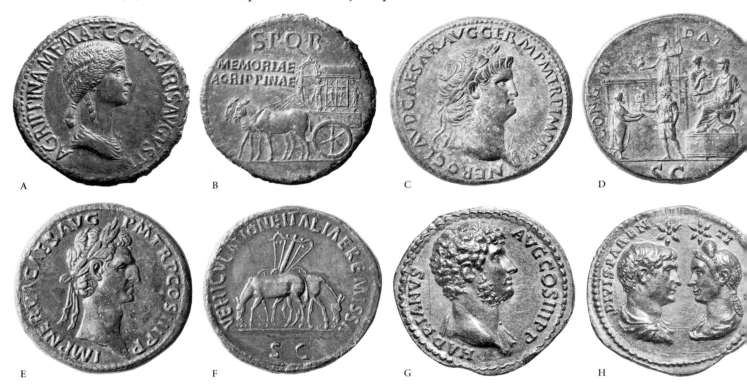

251 Brass and gold coins

example of the realistic portrait style of the late Republic. On the reverse a temple is depicted, behind which is the inscription NEPT. This is undoubtedly the temple of Neptune in the Circus Flaminius that was either built by or restored by Ahenobarbus. Whether rightly or wrongly, the famous sculptured reliefs known as the altar of Domitius Ahenobarbus [226] have often been associated with this temple.

250 E, F Silver denarius of Octavian, 31 BC. On the obverse is a finely engraved portrait of Octavian, issued shortly before or after Actium and not long before he became Augustus. On the reverse is Venus Victrix holding a sceptre and a helmet. She rests one arm on a column, which has a shield leaning against it. Venus was honoured both as a divine ancestor of the Julian line and as the deity who supported Caesar in his battles. A temple to her, begun by Caesar and completed by Augustus, stood in Caesar's Forum (see [255]), and Caesar had used her image on his own coinage. The figure of Venus thus conveys the idea that divine forces are supporting Octavian and that he is the rightful heir of Caesar, and if this meaning was at first not entirely clear, the inscription, 'son of the deified Caesar', would have made it so.

250 G, H Personified virtues on Tiberian coins. The elegant but hard-edged and austere classicism of the Julio-Claudian period suffuses these personifications of Piety (*Pietas*) and Justice (*Iustitia*) which appeared on the reverse sides of two brass coins (*dupondii*) issued in AD 22–3. The latter was issued by Tiberius; the former by his son Drusus. Personifications were a useful artistic convention for conveying to the general public qualities which the people could expect to find in the emperor, the imperial family, and the administration, and which the government would like to see in its citizenry. The attitude underlying these coins may have stemmed from the influence of Livia, the widow of Augustus and mother of Tiberius, who, whatever her behind-the-scenes role may have been, was outwardly respected for her dignity, propriety, and old-fashioned virtues.

251 A, B Brass sestertius issued by Caligula, with a portrait of Agrippina, about AD 38. On the obverse is a portrait of Agrippina the Elder, the granddaughter of Augustus and mother of Caligula, who died in AD 33 after being banished from Rome by Tiberius. The coin was issued as part of Caligula's effort to resurrect public honours for his mother. A comparison of this coin with the fine sculptured portrait of Agrippina already discussed [242] will make it clear how useful coin portraits can be to scholars in their effort to determine the identity of sculptured portraits. On the reverse is (probably) the funeral wagon (*carpentum*) of Agrippina drawn by two mules. The vehicle seems to have

sculptured or painted side panels and to be supported by statues at its four corners. Beneath the abbreviation for the 'senate and people of Rome' (SPQR) the inscription reads: 'to the memory of Agrippina.'

251 C, D Brass sestertius of Nero, AD 64–6. On the obverse is Nero, at his most grandiose, crowned with a laurel wreath and with what seems to be an aegis over his left shoulder. The reverse has a depiction, resembling those on sculptured reliefs [230 C], of an imperial *congiarium*, a gift of food or money to the Roman populace whereby the emperors sought to achieve both social stability and popularity. Nero is seated on a dais to the right. An attendant stands by him, and a second attendant holds out a symbol of *liberalitas* (it can be so identified from representations on other coins) to a Roman citizen whose arms are wrapped in his toga (part of the protocol, apparently, of receiving an imperial gift). Behind these figures is a statue of Minerva (Athena), holding a sceptre and an owl (one of her attributes); and behind the statue is a building or doorway with four columns.

251 E, F Brass sestertius of Nerva, AD 97. One of several reforms undertaken by Nerva to win popular support for his administration and to distance his own policies from the perceived iniquities of Domitian was to relieve the inhabitants of Italy from an obligation to pay the cost of the Roman postal service. This sestertius provides a remarkably down-to-earth example of how coins were used to remind the Roman populace of such changes. On the reverse we see two mules grazing in front of a cart (presumably a *vehiculum* of the postal service) from which they have been unyoked. The wheels of the cart are seen in three-quarter perspective, and its yoke is tipped upward. The inscription around the design, 'the postal service of Italy remitted', makes its significance clear. Were it not for the laurel crown of the emperor, Nerva's craggy portrait on the obverse might be taken for that of an austere senator of the Republic, and that, of course, was the image he wanted to convey.

251 G, H Aureus of Hadrian, probably AD 138. Trajan died while on military campaign, and there was some doubt as to whether or not he had officially adopted Hadrian and designated him as his successor. It was perhaps because of this doubt, and the use of it made by his political enemies, that Hadrian frequently emphasized his ties to Trajan, and hence the legitimacy of his principate, on his coins. On this gold coin, generally thought to have been issued in the last year of his life, Hadrian's own portrait is paired with those of Trajan and Trajan's wife Plotina, who are identified by the inscription as 'the deified parents'. (Plotina had supported Hadrian's candidacy after Trajan died and was honoured on other Hadrianic coins as well.) It has been suggested that this coin was actu-

ally issued by Antoninus Pius shortly after Hadrian's death and before his deification. The youthful, deity-like appearance of Hadrian in this portrait is indeed striking, but the artist may have chosen this form in order to make the portrait harmonize with those of Trajan and Plotina.

ARCHITECTURE

252 The earliest Roman temples, like the first temple of Jupiter on the Capitoline, were adapted from Etruscan architecture and hence, following a tradition established by the later Roman architect Vitruvius, are usually called Tuscan. Their distinguishing features were a high podium, a deep porch supported by widely spaced columns, one or more chambers for cult images behind the porch, and a gabled roof with thick overhanging eaves. The superstructure was normally made of wood, with columns in the Tuscan-Doric style, and the roof was sheathed in a rich assortment of terracotta tiles, revetments, and mouldings, the most distinctive of which were large antefixes which held the tiles in place along the edge of the roof. The outer surfaces of these were sometimes worked in relief and always colourfully painted. The ridge pole and gables were also frequently decorated with painted terracotta sculptures.

As already noted, the front of Tuscan temples, facing the precinct of the god or gods to whom they were dedicated, played a role in Etrusco-Roman religious ritual and was of the utmost importance. This was in distinct contrast to Greek temples, which, with their peripteral colonnades, were designed to be seen from all sides. In the Hellenistic period, when the forms of Greek architecture became fashionable in the Roman world, one of the chief challenges of Roman temple builders was finding a way to fuse Greek forms with the basic Tuscan groundplan.

253 This small architectural gem, dating from about 125 BC and miraculously well preserved in the Forum Boarium (a major business section of ancient Rome on the banks of the Tiber), is a good example of the fusion of Greek and Tuscan traditions. It has the usual podium and deep porch, but the columns and entablature are in the Ionic order, and the architect has created the impression of a Greek peripteral temple by attaching engaged columns to the sides and back of the cella.

Ancient sources mention a number of temples in this region, but there is no indisputable evidence as to which deity was worshipped in this temple. Portunus, the god of the harbour, is one serious possibility, but in view of the uncertainty, the designation Fortuna Virilis is a commonly used scholarly convention.

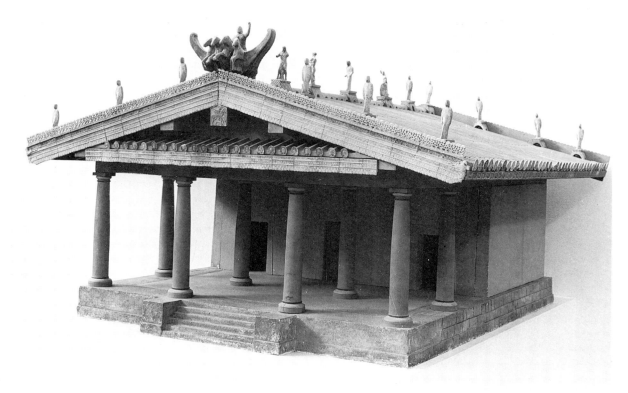

252 Reconstruction
of a Tuscan temple

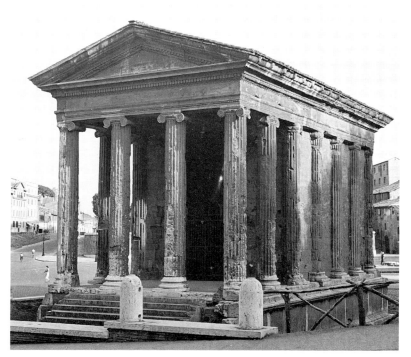

253 Temple of Fortuna Virilis, Rome

254 This great temple complex, laid out on a steep hill-side in Praeneste (modern Palestrina), a hill town in Latium about 36 km. east of Rome, was one of the great architectural creations of the Republic. Its exact date has been debated by archaeologists, with some favouring the

second half of the second century BC and others putting it in the time of the dictator Sulla (about 80 BC), who sacked the town during his struggle with the followers of Marius but later re-established and rebuilt it as a colony for his veterans.

The shrine was an oracular one in which worshippers were able to approach the goddess of Fortune and, through the drawing of lots, to learn about what the future held for them as individuals. The architects, however, seem to have envisaged the role of the goddess in grander terms, that is, as the force that guides the destiny of nations and empires, and designed the temple on a scale which would express this idea.

The temple complex consisted of two sanctuaries. A lower one contained a temple, a basilica, and a meeting house, behind which were two caves, one of which contained the well-known Hellenistic mosaic with scenes along the Nile [174]. It was perhaps in this area that the consultation of the oracle took place. But if the future of individuals was descried in the lower sanctuary, the future of Roman architecture was moulded and cast in the upper sanctuary.

The upper sanctuary was shaped almost entirely from concrete faced with small tile-like pieces of tufa and outlined with tufa arches and corner blocks. Originally most of these surfaces were probably covered with marble stucco. One approached the sanctuary by steep stairways at the end of a lower terrace (level II in the reconstruction); these led to two narrow rising porticoes, closed on the outside and covered with vaults supported by Doric columns,

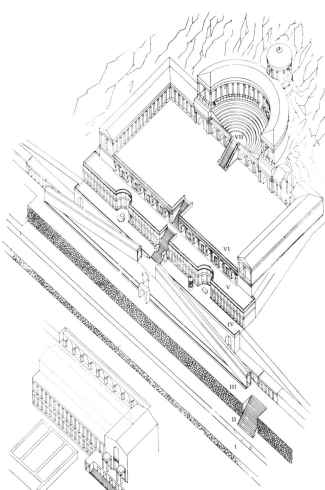

which channelled one's movement towards a series of stairways at the centre. Emerging from these tunnel-like passageways at level IV one found oneself before a long portico of shops or offices punctuated by two hemicycles with Ionic columns on their façades and ceilings consisting of coffered barrel vaults. From this level one ascended to another shallow terrace on which the new style of arcuated, vaulted niches was deliberately contrasted with older rectangular forms (level V), and then to a deep and spacious terrace with vaulted openings flanked on both sides by Corinthian porticoes (level VI). From here one ascended up a theatre-like exedra capped by a semicircular Corinthian portico with a ceiling in the form of double barrel vaults; and finally, through this, one reached, at the summit of the sanctuary, the open circular temple of Fortuna herself.

The ascending plan of the sanctuary was probably understood in psychological as well as topographical terms. The architects seem to have been intent on controlling and guiding visitors' movements through the complex, leading them from initially dark passageways to an increased level of light and to a greater breadth of vision, until, standing at the peak of the hill in the presence of the goddess, they were challenged to participate in a grand vision of an unfolding destiny.

254 Temple of Fortuna, Praeneste: reconstruction and view of upper terrace

255 In 51 BC Julius Caesar came to the conclusion that the old Forum Romanum was no longer sufficient to serve as the setting for the many public functions (official public assemblies, law courts, the reception of ambassadors, etc.) of the now huge Roman state, and he inaugurated an expansion programme that would be carried on for nearly two centuries. In 46 BC in an area to the north-east of the old Forum, behind the Curia (Senate House), he began construction of the Forum Iulium, which was essentially a rectangular space flanked by colonnades on its long sides, entered through an elaborate gateway, and dominated at its far end by a temple to Venus Genetrix. This complex, which was completed by Augustus after Caesar's death, set a pattern which, with interesting variations, would be repeated as the spaces collectively known as the Imperial Fora continued to develop.

The Forum of Augustus was planned as early as 42 BC, when Octavian, during the battle of Philippi, vowed to build the temple to Mars Ultor which dominates the main axis of the space. The entire structure was finally dedicated in 2 BC. The temple is in the lush Augustan Corinthian style, with capitals and ceiling coffers that seem to be bursting into flower. The attic storey of the flanking colonnades of the forum had as part of its decoration copies (on a reduced scale) of the Caryatids of the Erechtheum in Athens [107 B]; and behind these colonnades were two hemicycle-shaped bays adorned with niches containing statues of mythical ancestors of the Julian line and early heroes of the Roman state. All the elements of the complex were thus designed by the architects to express the major themes of Augustan art—prosperity, Classical balance, and reverence for tradition.

In AD 71, after the establishment of the Flavian dynasty and the conclusion of the campaign in Judaea, Vespasian undertook the construction, to the south of the Forum Augusti, of a spacious park surrounded by colonnades and dominated on its southern axis by a temple of Peace. This space, which later came to be known as the Forum Pacis (Forum of Peace), is said by ancient writers to have been one of the most sumptuous in the city, but aside from its plan, which survives on an ancient map of the city of Rome that is engraved on stone and was once exhibited in the building, very little evidence about its architectural forms survives. Vespasian may also have begun the narrow complex which lay between the Forum of Augustus and the Forum Pacis, although most of the work on it seems to have been overseen by Domitian. After Domitian's assassination and the official condemnation of his memory, however, the space was officially designated as the Forum of Nerva. In a sense, the Forum Nervae was simply a monumental setting for a portion of the Argiletum, a major roadway that ran from the old Forum to the eastern part of the city, but its plan was nevertheless designed to harmonize with those of the Forum Iulium and the Forum Augusti. A Corinthian temple of Minerva dominated its

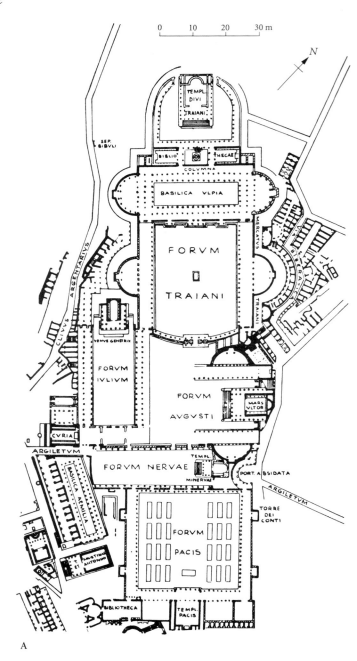

255 Imperial Fora, Rome. **A** plan; **B** Forum of Augustus; **C** Forum of Trajan

long axis, and its sides were flanked by a colonnade. Because of the narrowness of the space, there was not enough room for an actual portico, and the columns, surmounted by an attic and a frieze, simply served as an ornamental screen for the side walls. Such façade architecture became a distinctive feature of the Roman baroque style that was developed in particular by Domitian's architects. A portion of the colonnade, with a figure of Minerva in the attic and a frieze depicting stories relating to the domestic crafts and virtues of which Minerva was the patron, still survives.

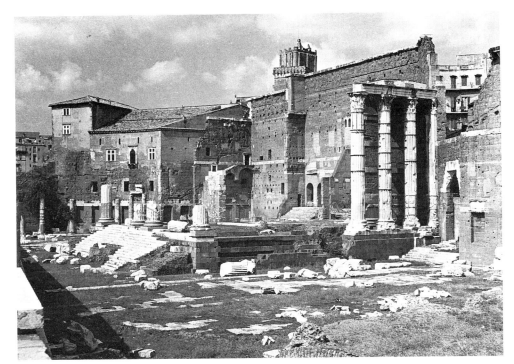

B

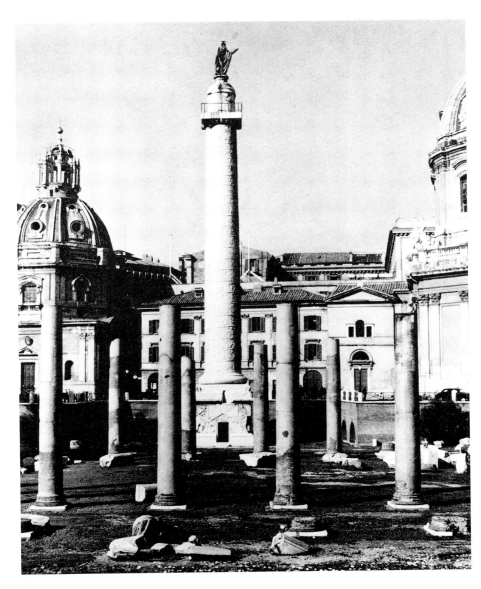

C

The last, largest, and most splendid of the Imperial Fora was that of Trajan, built by the architect Apollodorus of Damascus, and dedicated in AD 112. It was financed, at least in part, with spoils from the emperor's campaign against the Dacians and in many ways commemorated that triumph. The vast space of the forum, measuring approximately 300 m. in length, was entered from the Forum of Augustus through a triumphal arch (depicted on contemporary coins) which was capped by a bronze statue of Trajan in a six-horse chariot. The great open space to the north of the arch was flanked, like the Forum of Augustus, by colonnades which masked semicircular exedrae and were decorated in their attic storey with statues of captured Dacians. A huge equestrian statue of Trajan stood in the centre. The northern perimeter of this space was closed by the external façade of a huge (170 m. in length) basilica, the Basilica Ulpia, the axis of which ran transversely across the main axis of the forum. On the slope behind the eastern exedra a vast complex of markets was built [267] which, although technically not part of the forum, was clearly part of a unified architectural plan.

Behind the basilica, to the north, stood the great Column of Trajan, with its famous ascending scroll of relief sculptures depicting the emperor's Dacian campaigns [231]. On either side of the column there were two libraries, one for Greek and one for Latin texts. Facing these, further to the north, stood a temple to the deified Trajan, built by Hadrian after Trajan's death.

Our [B] shows a view of the Forum of Augustus; and [C] that of Trajan. In the foreground are columns of the Basilica Ulpia, behind which stands the Column of Trajan. On the slope to the right are the remains of the Markets of Trajan.

256 In this, one of the best preserved of all Roman temples, we see the beginning of an effort to broadcast the characteristic forms and themes of Augustan art in the provinces. Nîmes, ancient Nemausus, in Gaul (southern France) was a Gallic city that became increasingly Romanized during the first century BC and was finally given the status of a Roman colony (for the settlement of military veterans) in 28 BC.

Once again, as in the temple of Fortuna Virilis, the effect of a Greek peripteral colonnade is combined with the now venerable plan of a Tuscan temple. In the Maison Carrée, however, lush Corinthian columns and acanthus scrolls on the frieze above were used to convey the aims and ideals of Augustus' principate. Traces of an inscription suggest that the temple was constructed about 20 BC by Marcus Agrippa and originally dedicated to Augustus and Rome. Later it appears to have been rededicated, possibly to Gaius and Lucius Caesar, Augustus' grandsons, who were at one time designated as his heirs but who died before him.

257 (Colour Plate XVII) Roman aqueducts, with their great stately procession of arches spanning the plains and valleys of various European countries, are to the average traveller perhaps the most familiar and evocative monuments of the ancient Roman world. Aqueducts were gravity-driven water systems that carried water from springs and lakes at high elevations into urban centres, where it was channelled over arches, along walls, and through pipes to fountains, pools, and baths. Much of the course of any aqueduct actually consisted of tunnels and ground-level watercourses which were not highly visible. The great arched structures like the Pont du Gard were only required to preserve the gentle slope of the aqueduct when a valley or river had to be traversed. The impressive engineering skill that made them possible, and their aesthetic appeal, which evokes a sense of order, control, and the ability to overcome obstacles, made them effective symbols of the presence of Roman authority throughout the Empire.

The Pont du Gard, which carried water for 269 m. over the Gardon River to Nemausus, was built by Marcus Agrippa between 20 and 16 BC. Its three series of superimposed arches, 69 m. high, are built entirely of stone. A simple proportional relationship between the arches (the small arches at the top represent one unit, the central arches below four units, and the lateral arches three units) helps to create the pervading sense of harmony and dignity.

258 This impressive double arch was incorporated into the defensive city wall with which the Emperor Aurelian surrounded Rome in the later third century AD and thus became a gateway, the Porta Praenestina. Although the term Porta continues to be applied to it (its modern name is the Porta Maggiore), the structure was originally a bridge rather than a gate, designed in the time of Claudius (about AD 45–50) to carry two important aqueducts, the Aqua Claudia and the Aqua Anio Novus, over two major roads, the Via Praenestina and the Via Labicana, that led eastward out of the city. Channels for the aqueducts can still be seen above the arches. The rusticated masonry that frames the arches and forms the engaged columns of the *aediculae* is a distinctive feature of Claudian architecture, perhaps a reflection of the emperor's antiquarian sensibility, and had an important influence on architects during the Italian Renaissance.

The strange-looking monument that stands outside the arch to the east is the tomb of a prosperous baker, M. Vergileus Eurysaces, who lived in the later first century BC. When constructed it stood outside the official perimeter of the city, as religious custom required, but it was respected by later builders, including those of the aqueducts, as the city expanded. The tomb was decorated with reliefs in the plebeian style illustrating activities involved in the preparation of dough and the baking of bread [234]. Such down-to-earth subjects were common in the sepulchral

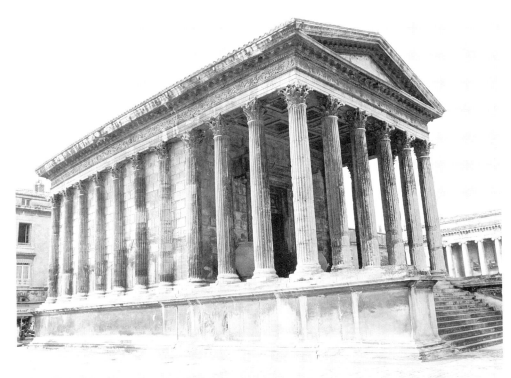

256 Maison Carrée,
Nimes

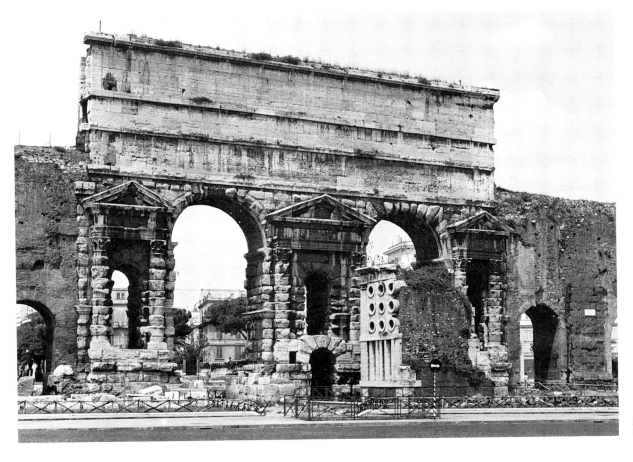

258 Porta
Praenestina, Rome

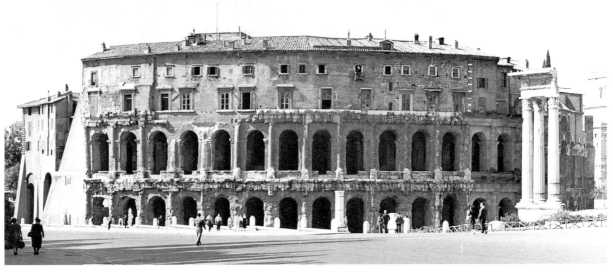

259 Theatre of Marcellus, Rome

art of the freedman class, even on expensive tombs such as this. The unique and enigmatic form of the tomb was perhaps designed to represent measures of grain stacked horizontally and vertically.

259 Romans theatres evolved out of ancient Greek theatres, which in most cases had approximately semicircular banks of seats for the audience and, by the Hellenistic period, a stage with a colonnaded front and a back wall equipped with doors [157]. In the first century BC, however, when the new technology of arches and concrete vaults made it possible to support a sloping auditorium without the need for a hillside, the Romans began to develop a form of theatre architecture which was distinctly their own.

The Roman theatre was essentially a half-cylinder, open at the top but usually covered with an awning, with arched entrances on the curving section of its exterior and a high wall at the back of the stage (called the *scaenae frons* or 'the façade of the stage') that joined with, and reached to the top of, the auditorium. This closed-in form, intensely focused on the stage, was much closer than its Greek prototypes to modern opera houses and theatres and is probably ancestral to them.

The first permanent theatre in this form (there appear to have been predecessors in temporary materials) was built by Pompey in 55 BC in the Campus Martius, but only a few traces of it survive. Better preserved and also very early in the sequence of Roman theatres is the one dedicated to Marcellus, Augustus' nephew and intended heir who died in 23 BC which the emperor built and dedicated some time between 13 and 11 BC. The stage of the Theatre of Marcellus is now encased in later buildings, but the exterior of its auditorium is still an impressive example of

what was to become one of the most pervasive urban architectural forms of the Roman world. The network of arches, corridors, tunnels, and ramps that gave access to the interiors of such Roman theatres was normally ornamented with a screen of engaged columns in the traditional Greek orders, Doric at base, Ionic in the middle, and Corinthian above. Here the Doric and Ionic can still be seen, but the third storey has not been preserved and its form is conjectural.

260 Sabratha in the province of Tripolitania (present-day Libya) was a Phoenician and Carthaginian city that gradually became Romanized after the Roman defeat of Carthage, and finally became, during the Empire, a fully fledged Roman city with a number of impressive architectural monuments. The desert conditions that currently prevail in this part of Libya (now more harsh than in antiquity) have helped to preserve the impressive remains not only here but also in neighbouring cities like Leptis Magna. The theatre, which dates from the last quarter of the second century, was substantially restored, using mostly original materials, by Italian archaeologists before the Second World War. As a result of this restoration, it now provides the most illuminating preserved example of the *scaenae frons* of a Roman theatre.

The *scaenae frons* of developed Roman theatres was normally equipped with three doors which were screened and framed by an elaborate façade of columns arranged in two or three storeys. Here at Sabratha the doorways are set into apses. The columns of the first two storeys of the colonnade are made of coloured marble, while those of the upper storey are of dark granite. They have Corinthian capitals, but their shafts vary in form, some with flutes in the traditional (i.e. vertical) form, some with spiral flutes,

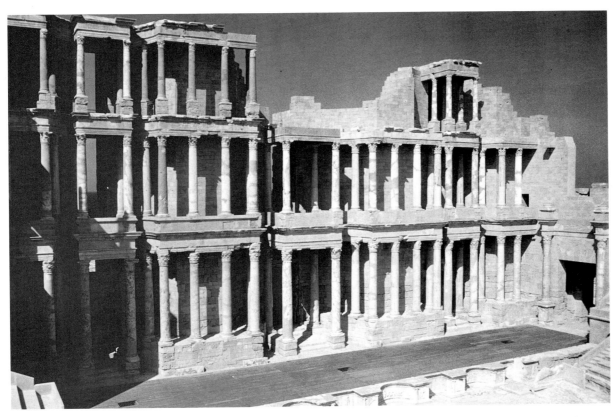

260 Theatre at Sabratha

and some unfluted. The central door of the *scaenae frons* was traditionally known as the 'royal door' (*valva* or *porta regia*), and it may be that stage backgrounds of this sort were intended to reproduce the façades of palatial buildings like the Domus Augustana, where the emperors, like kings in traditional dramas, made their entrances and exits.

Also visible in this photograph is the semicircular area, called the orchestra, which separated the seats of the theatre from the stage, and the proscenium, the low front of the stage that separated it from the orchestra. The proscenium was often, as here, designed with niches and decorated with relief sculpture.

261 Roman amphitheatres, the large oval-shaped structures in which a variety of spectacles such as gladiatorial combats, hunts, and even naval battles were held, were one of those typical and massive architectural forms which, along with basilicas, baths, and theatres, announced the existence of the Roman way of life in a city.

Gladiatorial games probably had their origin in Etruscan funeral rites which sanctioned bloody death in order to appease the potentially menacing deities of the Underworld, and although their religious associations were gradually forgotten, they became an increasingly popular form of public entertainment in Italy. At first they

were held in the forum of various cities (including Rome, at least as early as the third century BC), but eventually separate structures had to be devised to contain the violence of both the spectators and the combatants. The well-preserved amphitheatre at Pompeii, dating from 78 BC, is one of the earliest. Although Augustus built an amphitheatre in the Campus Martius as early as 29 BC, Rome did not have a major structure of this sort until the Flavian amphitheatre now known as the Colosseum was built to eradicate the memory of Nero's Domus Aurea [262].

In today's world most people share the view of the Greeks that the spectacles in amphitheatres were cruel and primitive, and yet the buildings themselves remain remarkable examples of complicated engineering, blending harmony of design with efficiency of function. Their architectural development was similar to that of theatres. At first, as in the example at Pompeii, they were partly excavated, so that their rows of seats could be supported by earthen embankments, but eventually free-standing structures, supported by a network of arches and vaulted corridors, were created. Their exteriors were sometimes faced with stone and usually screened with engaged columns and entablatures in the traditional Greek orders.

Exactly when the amphitheatre at Verona was built is uncertain, but certain technical details suggest a late Julio-Claudian or Flavian date, and it probably belongs to the

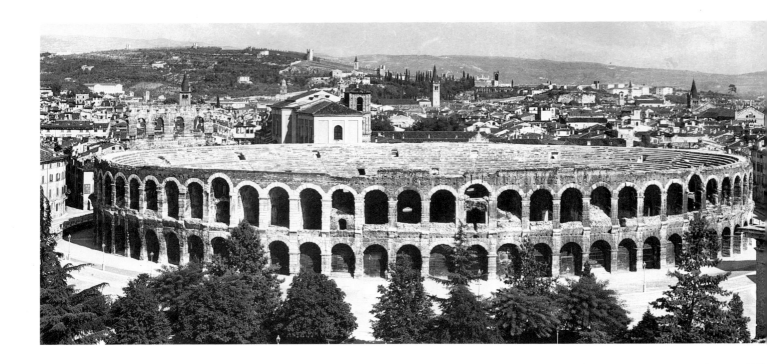

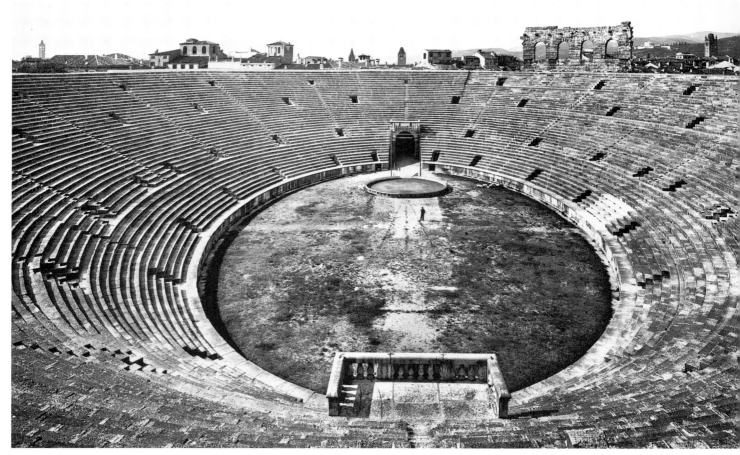

261 Amphitheatre at Verona

middle or second half of the first century. Because it has been used by the city for public functions since at least the twelfth century (operatic performances being one of the most common uses today), its interior, although in part restored, is in a remarkably good state of preservation. Its seats are reached through vaulted tunnels leading from the exterior arches, with stairways leading to the upper levels. The large tunnel at the end of the long axis was originally for the entrance and exit of the combatants. The parapet around the floor of the arena was designed to protect the spectators from animals and other hazards.

Only one section of the exterior of the amphitheatre at Verona is preserved (most of what one sees today was originally an inner ring of arches). The arches of its two lower levels were framed with a screen of pilasters, but the uppermost level was simply an arcuated masonry screen, one of the functions of which was probably to anchor a large awning.

262 The great fire in AD 64 which destroyed much of the centre of Rome gave Nero and his architects Severus and Celer an opportunity to create a vast new imperial residence, known as the Domus Aurea or Golden House, in the centre of the city. Beginning from a vestibule in the old Forum the complex extended across the Palatine hill eastward to the Velia and northward to the Esquiline and its principal spur, the Mons Oppius. In the low area between these hills was a lake and a vestibule containing a colossal statue of the emperor. (After Nero's death the colossus was converted into a statue of the sun god and became the source of the popular name of the Flavian amphitheatre that was built on the site of Nero's lake, the Colosseum.) A famous description by the ancient biographer Suetonius, written in the time of Hadrian, preserves a vision of the Golden House that archaeology cannot rival: 'It had a vestibule, in which stood a statue of Nero himself, 120 feet high; the area that the palace covered was so vast that it had a mile-long portico with three colonnades; it also had a pool that was like the sea and was surrounded by buildings that created the impression of cities; beside this there were rural areas with ploughed fields, vineyards, pastures, and woodlands and filled with all sorts of domesticated animals and wild beasts. All the structures in the other parts of the palace were overlaid with gold and were highlighted with gems and mother of pearl; there were dining-rooms whose ceilings were equipped with rotating ivory panels and with pipes so that flowers could be strewn and unguents sprayed on those below; the main dining room was a rotunda, which rotated day and night like the heavens; there were also baths through which flowed sea water and medicinal spring water. When the palace was completed in the manner described, Nero dedicated it and expressed his satisfaction only by noting that he was 'at last beginning to live like a human being'.

After Nero's death most of the Domus Aurea was oblit-

erated or converted to other uses. A substantial portion of the lower storey of the main residential building on the Mons Oppius was left intact, however, when it was covered by a large public bath building in the time of Trajan, and can still be studied. These remains are of enormous importance in the history of Roman architecture because in them the great Roman tradition of shaping soaring interior spaces with concrete vaults and domes, a tradition which was to influence religious and public architecture in Europe and the Near East for many centuries, reached its early maturity. Illustrated here are a high vaulted corridor of the palace [B] and a domed octagonal room [A], one of the earliest concrete domes known. The domed room may be the rotunda mentioned by Suetonius. The corridor is decorated with paintings in the Fourth Style, which may have been invented here and later adopted as a fashion in smaller cities like Pompeii.

263 (B = Colour Plate XVII) Hadrian's sprawling villa at Tibur (Tivoli), about 28 kilometres north-east of Rome, was probably the official summer residence of the emperor during those periods when he was not travelling in the provinces. Brick-stamps on the villa's many structures indicate that the periods when most of the work on it was done coincide with periods when Hadrian was in Rome (rather than travelling in the provinces), that is, AD 118–21 and 125–30.

According to the *Historia Augusta* Hadrian named sections of his villa after famous places in the provinces (e.g. the Academy of Plato), and he may have intended to evoke the appearance of these sites in some of the villa's structures. While there were precedents in earlier Roman villas for whimsical associations of this sort and while the eccentricity of Hadrian's ideas may have been exaggerated, there can be no doubt that the villa gave him an opportunity to indulge the cosmopolitanism, wide range of learning, and artistic nature that ancient writers ascribe to him and that its vast array of buildings (there are at least eighteen separate architectural complexes spread over half a square mile) bear the stamp of his personality and taste. Among them were palaces, baths, gardens, shrines, theatres, and areas for exercise, dining, and contemplation, which exhibit not only novel and interesting curvilinear plans but also an innovative, even daring, use of vaults and domes.

The complex illustrated here [B] is usually referred to as the Serapeum-Canopus, because it is thought to have evoked the general appearance of a temple of the god Serapis at Alexandria, which was situated at the end of a channel off the Canopic branch of the Nile. The Serapeum is a semi-domed apse formed with alternating flat and concave sections. A long barrel-vaulted, cave-like room off the centre of this apse was decorated with mosaics and contained a water channel connected with an aqueduct. In the six semicircular and rectangular niches in this vaulted

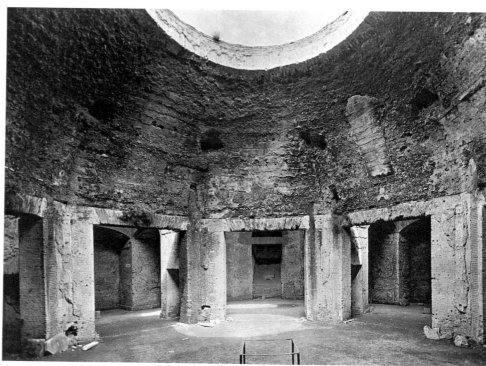

262 Golden House of Nero, Rome. A octagon room; B corridor with paintings

A

B

room there were fountains and sculptures. The apse faced a rectangular pool which was flanked by other, smaller apsidal structures at right angles. The use of the 'Serapeum' has been much debated, but most probably it was a dining pavilion for the emperor and his guests. This very avant-garde architectural design faced out on to a water-course about 120 m. long which was surrounded with sculptures intended to evoke Greece and the Classical past, among them four replicas of the Caryatids of the Erechtheum in Athens [107 B] and versions of Amazon types that are often associated with Phidias and Kresilas [94]. The full range of Hadrian's complex artistic sensibilities, in other words, are captured in the Serapeum-Canopus area's combination of architectural innovation and nostalgic classicism.

264 The remains of Pompeii and Herculaneum make it possible to trace the development of the ordinary Roman house over several centuries and to observe, in particular, how a venerable Italic house plan whose distinctive feature was an atrium was slowly supplemented, and eventually supplanted, by a plan, mainly Greek in origin, that focused on a colonnaded courtyard.

The elements of the basic Italic plan are described by the Roman architect Vitruvius and clearly preserved in some of the earliest houses at Pompeii, like the House of the Surgeon [A], built in the fourth or third century BC. It was essentially a rectangle entered through a passageway (called the *fauces*) on its central long axis which led to a central atrium consisting of pool (the impluvium) below and an open rectangle in the roof above (the compluvium) which allowed for the entrance of light, air, and at times rain. The atrium was surrounded by a symmetrical arrangement of chambers and spaces which were dominated, at the far end of the central axis, by a large room known as the tablinum. Although this may at first have been a master bedroom, it quickly evolved into an admin-

263 A Hadrian's villa at Tivoli, model (German Institute, Rome)

istrative office and reception room for the master of the house. On either side of the atrium just before one came to the tablinum there were two open wings (alae) which may have been intended for the display of ancestor portraits and for shrines honouring protective household deities. Behind the tablinum there was sometimes a hallway and a small garden.

In the second century BC, when larger and more sumptuous houses came to be constructed, the Italic plan continued to serve as a kind of ritual nucleus, but substantial peristyle courtyards were added to it, and the social life of the house seems to have shifted to these courtyards, which were often equipped with elegant dining-rooms. In the wealthy House of the Faun [B] (named after a statue found in the house), which took up an entire city block, there were two such courtyards and also a second atrium (the second being what Vitruvius calls a tetrastyle atrium, i.e.

one supported by four columns). The floor of one of the richly decorated dining-rooms that faced the first courtyard was decorated with the famous Alexander Mosaic [165].

As the nature of the population at Pompeii changed over the centuries, and an old Italian aristocracy was gradually supplanted by retired Roman soldiers and freedmen, the formality of the atrium seems to have become less important, and one sometimes finds it in a truncated form, as in the House of the Vettii [C], where the tablinum has been eliminated and the atrium serves essentially as a vestibule to the courtyard. See [265].

In two large seaside houses at Herculaneum [D], which date to some time between AD 50 and 79 and anticipate the direction Roman domestic architecture would take in the next century, we find the atrium seemingly tacked on for the sake of nostalgia in one and eliminated altogether in

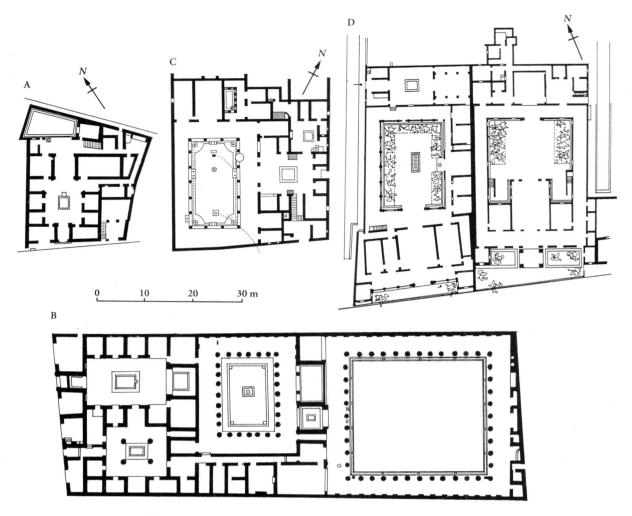

264 Plans of houses at Pompeii (A–C) and Herculaneum (D)

the other. In the House of the Mosaic Atrium the atrium, instead of determining the main axis of the house, is placed at right angles to it. The alae are eliminated and the tablinum is converted into a dining-room with internal piers supporting walls pierced by windows, a type which Vitruvius says resembled basilicas and which he calls an 'Egyptian *Oecus*'. At this point the atrium had clearly become an architect's caprice rather than a social or ritual necessity. In the House of the Stags (named after a decorative sculpture found in it) the atrium is really simply a lobby, without a compluvium, and the first important room that one encounters is a large dining-room which faces the courtyard and determines the main axis of the house. See also [266]. In both of these houses the elaborately equipped courtyard, leading out to dining-rooms and pergolas that faced the sea, was the focal point of the design, and the social life of the houses clearly centred on these courtyards.

265 Because it was rehabilitated and redecorated after the earthquake of AD 62, the House of the Vettii was in good condition at the time of the destruction of Pompeii,

and even now its brightly painted walls continue to impress visitors. In its final phase the house belonged to two freedmen, Aulus Vettius Restitutus and Aulus Vettius Conviva. The exact relationship between the two men (e.g. brothers, cousins) is not known, but Conviva is recorded to have been an *Augustalis*, that is, a priest of the cult of the emperor, a position reserved for freedmen. The small garden sculptures, stone tables, and basins for fountains were presumably typical of most Pompeian courtyards but have survived in only a few. On the elaborate Fourth-Style paintings of the house, see [283], and for the plan [264 C].

266 In the foreground, atop the sea wall of Herculanuem, are the pergola (centre) and summer dining-rooms, behind which is the courtyard. The large opening of the main dining-room is visible at the far end of the courtyard. For the plan see [264 D].

267 On the slopes of the Quirinal behind the east hemicycle of Trajan's Forum [255] Apollodorus of Damascus designed a vast market complex consisting of about 170 shops and offices linked by three streets and laid out on six

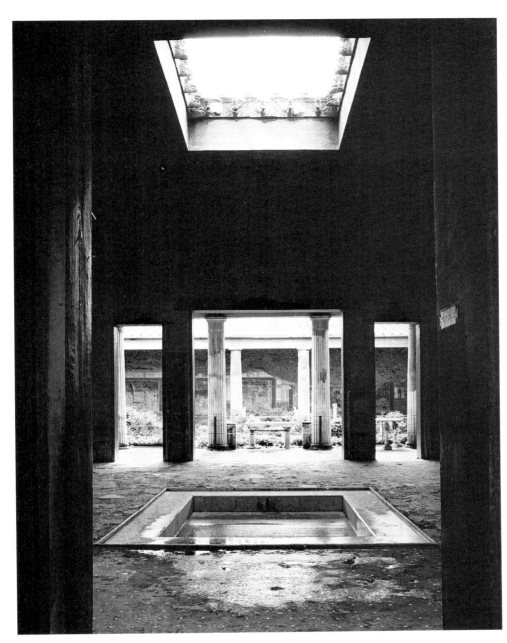

265 House of the
Vettii, Pompeii

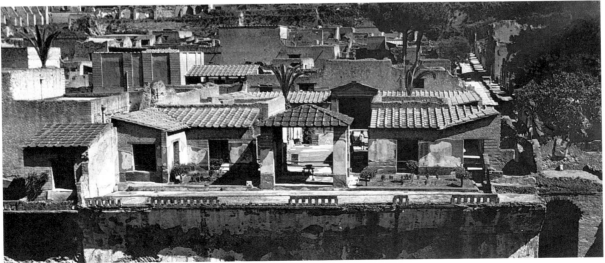

266 House of the Stags, Herculaneum

A

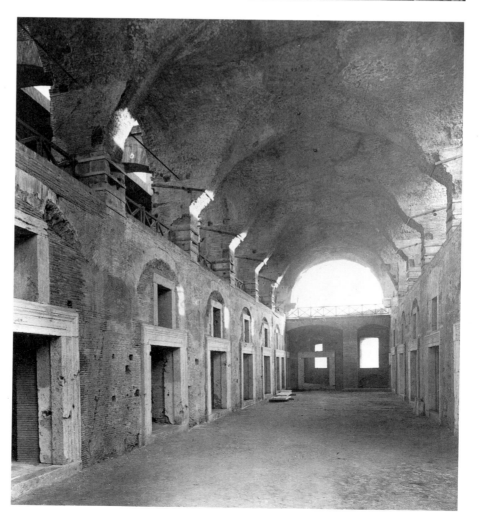

B

levels which were connected by stairways. The markets were constructed entirely of brick-faced concrete, with a few details like the frames of doorways outlined in travertine limestone. In some areas, particularly on the lowest level behind the east hemicycle of Trajan's Forum, stucco decoration may have been added to the brickwork. The precise function of all these rooms cannot, of course, be determined, but it has been plausibly suggested that some of them were devoted to the offices of magistrates whom the emperor appointed to oversee the *Annona*, the public grain supply.

Compared to the lavish marble surfaces and classical architectural orders of the forum below, which looked back to Augustan art and beyond that to Greece, the stark brickwork and moulded shapes of the markets must have made a startling contrast. In texture and form they reflected not the sumptuous world of imperial ceremony but rather the day-to-day world in which most Romans lived. The surface of much of Rome, if the surviving apartment houses of Ostia are reliable indicators, must have looked like this, and it was this look and these forms, more than those of the forum, that Rome would transmit to the Middle Ages.

The plan of the first three levels of the markets was established by the semicircle of the forum, behind which there was a firewall and then a semicircular street. The first level of shops was entered directly off this street, and its curving pattern was punctuated at either end by semicircular and semi-domed rooms. The second level of shops followed the plan of the lowest level, and access to them was through a vaulted corridor reached by stairs. At the third level, atop the main hemicycle, ran a street known in the Middle Ages as the Via Biberatica [A], at the northern end of which, on its east side, is an impressive and well-preserved market building. The lowest level of the shops connected with this structure faces out on to the Via Biberatica, but its middle and upper levels are encompassed in a great cross-vaulted hall [B]. The vault was supported by arch buttresses which enabled the architect to leave the hall open at the sides and thus admit air and light both to the shops at the middle level and to the upper shops, which were reached from a kind of clerestory gallery. Utilitarian, relatively unadorned, yet majestic, the Markets of Trajan remain one of the Empire's most imaginative architectural creations. In them the aesthetic effects of the architectural revolution became part of the daily life of Rome.

268 The Pantheon of Hadrian, begun about AD 118 and dedicated about ten years later, is one of the greatest, and certainly one of the most influential, buildings in the history of European architecture. Its construction was prompted in part by a need to recreate one of Rome's more venerable temples. An earlier structure called the Pantheon had been built on the same site in the Campus Martius by Marcus Agrippa around 27 BC. Agrippa's building had been restored and rededicated by Domitian after an extensive fire in Rome in AD 80, but the refurbished building had again burned down in AD 110 after being struck by lightning. The need to restore the Pantheon, however, also gave Hadrian and his architects an opportunity to harness new architectural forms and building techniques to express both the emperor's sophisticated religious sensitivities and also a feeling of cosmic order which mirrored the order of the Roman Empire at its high point. Although the details of the building clearly reflect the skills and training of professional architects and engineers, it is not impossible that Hadrian, who is known to have been an amateur artist and had strong views about architecture, played a role in its design.

The structure consists of two quite distinct parts: a traditional-looking colonnaded porch with Corinthian columns surmounted by an entablature and a high pediment, and a vast domed rotunda 43.2 m. in both diameter and height. The junction of these two units has an awkward appearance today, but in antiquity it would have been largely masked by a three-sided portico that surrounded the building's large rectangular forecourt. Hadrian's sophisticated admiration for the past is well documented, and although the unfluted columns of Egyptian granite (12.5 m. high) and other architectural details are unmistakably products of his own era, he clearly made an effort in the rectilinear forms of the porch to echo the architecture of an earlier time. This interest in nostalgic evocation even led to the retention or re-creation of Marcus Agrippa's dedicatory inscription for the original Pantheon.

It is unlikely that worshippers who first passed through this old-fashioned-looking porch, like visitors who pass through it for the first time in our own era, were prepared for the dazzling experience of light, colour, and soaring space that confronted them when they entered the rotunda. The concrete drum that formed the walls of this chamber was 20 feet thick and extended upward for half of its total height. A group of semicircular and rectangular recesses in this drum had the practical virtue of enabling its concrete to dry more evenly and quickly, and they presumably served as chapels, or at least niches for sculptures, when the Pantheon was completed and in use. The great coffered dome which sprang from the top of the drum and made up the upper half of the building was poured from increasingly lighter concrete which diminished in thickness and terminated in a great circular opening (usually called the *oculus*) 30 feet in diameter.

The religious meaning and function of the Pantheon are not entirely clear and continue to be subjects of speculation. 'Pantheon' is in origin a Greek word, but it is uncertain whether the Latin term is derived from the Greek genitive plural ('of all the gods') or a neuter singular ('the all holy'). Perhaps it was both. The ancient historian Dio Cassius records that the earlier Pantheon of Agrippa con-

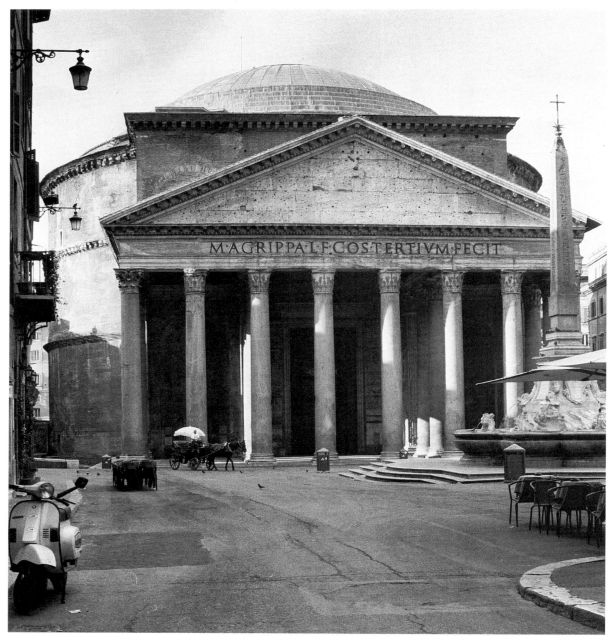

268 Pantheon, Rome

tained the statues of many gods, and this was presumably also true of Hadrian's building, but which particular gods were enshrined within it and in what order is simply not known. In any case, the fusion of measured geometry in the Pantheon with the feeling of infinity conveyed by its vast dome and the sky beyond may have conveyed more than the separate definable powers of particular gods. As they looked from the niches with their statues, adorned with coloured marble and gilding, upward towards the dome with its geometric pattern of coffers, diminishing as

they recede towards the top, and finally at the pure white light of the *oculus*, the worshippers' consciousness must have been drawn from specific deities and cults to an idea of the divine essence that was the underlying power of all of them. Such a transcendental and syncretistic conception is in keeping with the religious atmosphere of the mature Roman Empire and with what is known about Hadrian's personal religious inclinations. And as the seasons progressed and the great beam of light from the *oculus* illuminated, at different times of day and different

periods of the year, the shrines below, worshippers may have sensed a single divine intelligence guiding the orderly movements of the cosmos.

Whether or not it embodied a divine essence, the Pantheon in many ways embodies the essence of mature Roman architecture. It was, of course, by the standards of its time, a spectacular piece of engineering. But above all it is distinctively Roman in its use of curvilinear forms, cast in concrete, to create an interior space that was a world in itself and that had the power to affect and shape human consciousness.

THE DECORATIVE ARTS

269 Decorated silver vessels were expensive items designed for a sophisticated aristocracy in the Roman world, and some surviving examples are masterpieces of technical skill and design. The example shown here is one of several cups found in a wealthy villa buried by Vesuvius, and its political subject-matter, resembling a sculptured

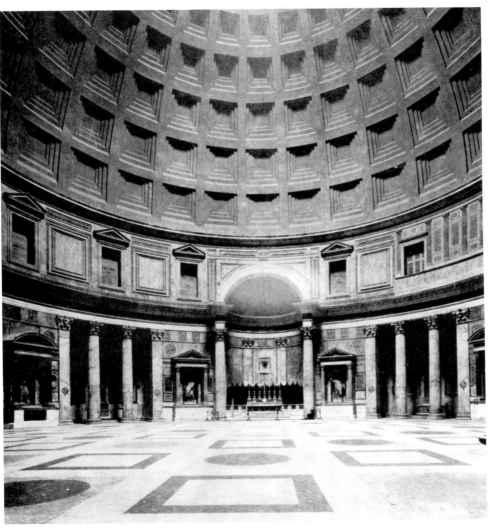

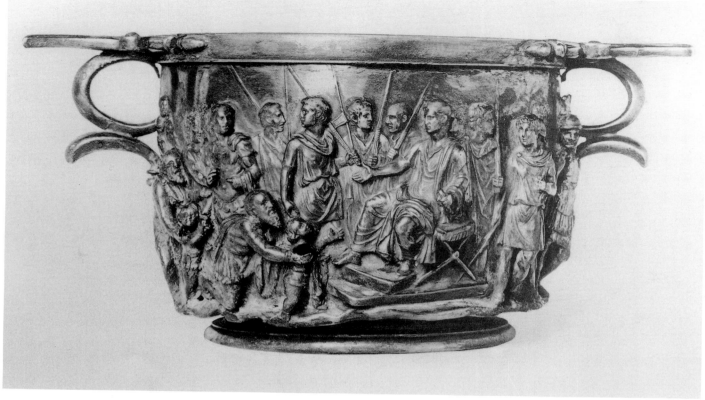

269 Silver cup from Boscoreale (Paris, Louvre)

historical relief, suggests that it may have been made for a member of the imperial court, about AD 10–20. The Emperor Augustus, seated in the centre amidst his military officers, is shown receiving the submission of a group of conquered barbarians who approach from the left and kneel before him.

270 Even when working under the programmatic strictures of official art, as on the Ara Pacis [228], Roman designers showed a remarkable sensitivity to the forms and the feeling of nature. In private art this sensitivity could be given full play, as on Arretine ware [273], in sacro-idyllic landscape paintings [288], and on the silver goblets depicted here, which are decorated with scenes of cranes hunting for lizards, butterflies, and other creatures in a field of wheat and poppies. The crisp, restrained and elegant draughtsmanship of the decoration points to the Julio-Claudian period, and it is likely that the cups date from around the middle of the first century. Other examples of the motif of feeding cranes survive on both silverware and pottery, and these goblets thus seem to be examples of a widespread decorative genre.

271 (**Colour Plate XVIII**) Cameo gems, produced by carving relief design into gem-stones with multicoloured

layers, thus setting off one colour against another, first appeared in the classical world in the Hellenistic period (see [184]) and were popular among the Romans. Some spectacular examples with imperial portraits and complex political iconography, like the famous example illustrated here, may have originally belonged to the imperial family. In the tradition of the Ara Pacis and other Augustan public monuments, the Gemma Augustea celebrates Augustus' pacification of the Roman world and the importance of the Julio-Claudian family line. In the upper register, Augustus is depicted seated next to the goddess Roma. Beneath his throne is the eagle of Jupiter, and above him is his birth sign, Capricorn. To the right are three allegorical figures. Seated and holding a cornucopia is Tellus, Earth, with two children. The standing female is Oecumene, 'the inabited world', who crowns the emperor with a wreath. The bearded male between them is probably Oceanus. On the far left the future emperor Tiberius alights from a chariot driven by a winged Victory. The identity of the youth in armour between Augustus and Tiberius is debated, but he is probably Germanicus, the nephew of Tiberius. The scene almost certainly commemorates one of Tiberius' military victories in the northern provinces between AD 7 and 12. In the lower register Roman soldiers set up a trophy in the presence of captured barbarians.

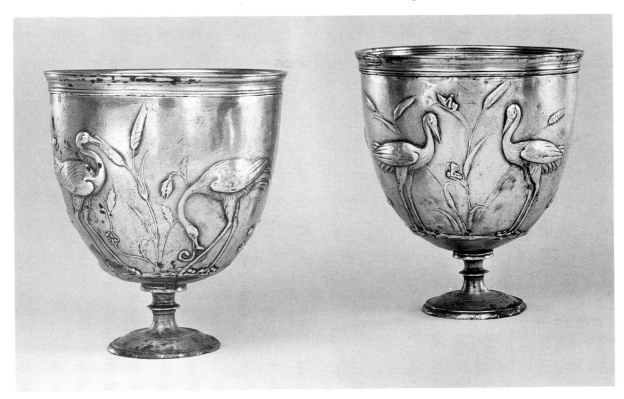

270 Silver cups (New York, Pierpont Morgan Library)

272 In addition to extraordinary, almost monumental cameos like the Gemma Augustea [**271**], a great variety of smaller gems survives from the Roman world, and the subjects depicted on them—portraits, deities, mythological narratives, decorative motifs from nature, and philosophical symbols—are as varied as they are in sculpture and painting. Some gems were decorated with figures that were thought to have the power either to attract good fortune (for example, portraits of Alexander the Great) or to avert bad luck, as was probably the case with [**A**]; others, like portraits of members of the imperial family, clearly had a political and patriotic character; still others, like [**B**], seem to have had a philosophical significance; but many were undoubtedly valued mainly for the beauty of their materials and workmanship. Unless there is some specific historical evidence (e.g. the signature of a known artist or an identifiable portrait) Roman gems are extremely difficult to date, since their style tended to remain remarkably uniform over several centuries. Only one gem cutter, Dioscurides, [**C**], who lived in the time of Augustus, is mentioned by ancient writers, but the names of others appear on the gems themselves. Almost all of them, as was the case with sculptors of the Roman period, are Greek.

In [**A**] the precise lines of the faces and finely carved details of Medusa's snaky hair point, perhaps, to an Augustan date. The signature of the artist, Solon, written in Greek letters, runs along the back of the head. In early

Greek art fearsome images of the head of the Gorgon Medusa were thought to have the power to ward off evil influences, and a similar apotropaic power may have been attributed to a gem of this sort. But unlike his archaic Greek predecessors, Solon follows the Hellenistic tradition of depicting Medusa as ominously beautiful. This gem, sometimes referred to as the Strozzi Medusa, was found in Rome in the early eighteenth century and was known to Winckelmann. The small gem [**B**] (14 × 11 mm.) was probably the bezel of a ring and is probably datable to the first century BC. The head of Epicurus, which also occurs on other gems, where it is identified by inscriptions, is based on a popular sculptured portrait of the early Hellenistic period [**216**]. The philosophy of Epicurus had many followers among Roman intellectuals of the late Republic, and Cicero records that they often put the philosopher's image 'on their drinking cups and rings'.

[**C**] Dioscurides, according to Suetonius and the Elder Pliny, created, at Augustus' request, an imperial seal bearing the emperor's portrait. To have received such an important commission he must have been the most prestigious gem cutter of his time. The story alluded to in this scene [**C**] is the theft of the Palladium (an ancient image of Athena set up in Troy) by Diomedes and Odysseus. The Greeks had been told that as long as the image remained at Troy, the city could not be taken. Diomedes, holding the Palladium in one hand and a sword in the other, appears to

A

B

C

272 Engraved gem-stones. **A** Medusa, chalcedony (London, British Museum); **B** Epicurus, red jasper (London, British Museum); **C** Diomedes, by Dioscurides, cornelian (Chatsworth House)

be stepping or jumping over an altar which is draped with a garland. At his feet is a fallen figure, probably a priest who has been slain by Odysseus. A column surmounted by a statue of a youth stands in the background. This gem is one of several that represent excerpts from a larger rendition of the story in which Odysseus and the walls of Troy were also depicted. (The full version occurs on a somewhat larger,

oval-shaped gem in the Ashmolean Museum, Oxford.) It seems likely that the gems were inspired by a larger work of art, perhaps a painting. The story was best known from a Greek epic (now lost), the *Sack of Troy*, and the owners of the gems may have valued them for their learned, philhellenic literary content. It is always possible, however, that the subject had some special symbolic or political significance for the Romans that now eludes us. There was, it might be noted, a Roman version of the legend which maintained that the Palladium stolen by Diomedes was only a copy and that the real one was brought to Italy by Aeneas.

273 *Terra sigillata* ('clay decorated with small images') is a Latin term used by modern scholars to designate a class of decorated red-gloss pottery that was first made in Italy in the late first century BC and was gradually adopted and manufactured in other parts of the Empire over a period of four centuries. The principal centre of production in Italy was Arretium (modern Arezzo), and hence the Italian ware, which was produced between about 30 BC and AD 40, is known as Arretine. The first provincial versions of *terra sigillata* were produced in southern Gaul (France) and in Asia Minor by the middle of the first century AD. *Terra sigillata* was decorated with a variety of human and animal figures and floral designs, which were sometimes incised but more often either attached separately or produced by shaping the entire vessel in a mould. (It should be noted that not all red-gloss ware was decorated, and hence the

273 Arretine cup (New York, Metropolitan Museum)

more inclusive term 'Samian ware' is sometimes used to characterize all varieties of it.) Arretine ware was produced under the influence of Augustan classicism, and some of the most refined and elegant examples of Roman decorative art belong to this class. The conical vase illustrated here is from the workshop of the artisan Cn. Ateius. Its decoration of floral designs, candelabra, and birds has the same calligraphic elegance and feeling for nature that is found on the Ara Pacis [228].

274 (Colour Plate XVIII) Prior to the middle of the first century BC glass vessels were made either by casting glass in a mould or by winding it around an earthen core attached to a rod, and the usually colourful glass vessels so produced seem to have been regarded as luxury ware. With the discovery, around 50 BC, of the technique of blowing glass, the glass industry underwent a revolution in the Roman world. Glassware could now be produced cheaply, quickly, in a wide variety of shapes, and in great quantities, with the result that the use of glass tableware spread rapidly. Blown glass was sometimes free-blown and sometime blown into moulds, but it was inevitably thinner than cast glass. Although varieties of coloured glass continued to be made, the thinness of blown glass added to its transparency, and transparency, without colour, soon became a prized quality among Roman glassmakers and their clients. (Transparent blown-glass shapes often appear, for example, in the still-life paintings from Pompeii [290].)

Shown here is an assortment of Roman glass vessels from the first century AD. [A] is a mould-blown blue-green square jug. The square form facilitated packing in

275 Bronze tripod brazier, from Pompeii (Naples, National Museum)

variety of bronze furniture, vessels, untensils, armour, etc., and some of it is of extraordinary quality. The tripod brazier illustrated here, found in an elaborate temple compound at Pompeii dedicated to the Egyptian goddess Isis, dates from the first century BC or AD and exemplifies the virtuosity of Roman bronzework. The three supports, the lower parts of which are given the form of the legs and paws of a large feline, are linked by elaborate floral scroll-work and are surmounted by winged sphinxes. Flowering stalks connect the sphinxes with the brazier above, which is ornamented with garlands and bucrania (the skulls of sacrificial animals). The detailing of the sphinxes and floral ornament is on a level with the finest Roman bronze sculpture.

276 Around the middle of the first century BC Roman coroplasts developed a genre of small terracotta plaques (ranging in height from 22 to 50 cm. and in width from 27 to 48 cm.) for use as decorative elements in architecture. They are generally referred to as 'Campana reliefs', the name being derived from the scholar who first studied them as a group. The type continued in use until about the middle of the second century AD and seems to have been most popular during the Julio-Claudian period. Decorative reliefs in terracotta had long been used in Etruscan architecture to sheath wooden rafters, the ends of wooden beams, etc., and it is likely that the Campana reliefs developed out of this Etruscan tradition. Not only do they bear some formal similarity to the older terracottas but their use also seems to have been confined to the areas once dominated by Etruscan culture—Tuscany, Latium, and Campania as far south as Naples. Like the Etruscan prototypes they were at first used to decorate the exterior of small temples, but in time their use was extended to decorate the interior of houses, villas, baths, theatres, and tombs. In these settings their association with wooden architecture was forgotten, and they became purely decorative elements, often embedded in masonry walls. The subjects of the Campana reliefs seem to have been drawn exclusively from Greek mythology, and their style is derived mainly from the neo-classical tradition in late Hellenistic sculpture. Thus, like other works originating in and round Rome in the first century BC, they represent an adaptation of Greek and Italic forms to Roman taste and usage. The two examples illustrated here form a diptych depicting the chariot race of Pelops and Oinomaus: [A] Pelops carrying off Hippodamea, and [B] Oinomaus and his charioteer Myrtilus. The decorative function of the two panels was clearly more important to their designer than their content. If the story had been important, Oinomaus would have been shown in pursuit of Pelops, but the direction of movement in each relief makes such an arrangement impossible, and they give the impression of being designed as framing motifs rather than as parts of a narrative frieze.

crates, an example of which has been found at Pompeii. [B] is a free-blown dish. A typical piece of utilitarian, essentially transparent tableware. [C] is a cast mosaic glass bowl. This effect was produced by heating and thus fusing pieces of glass rods in a two-part mould. [D] is a free-blown alabastron. Glass blowing made possible this elegant, attenuated elaboration on the traditional shape of the ancient unguent vase. [E] is a mould-blown beaker with representations of Neptune, Bacchus, and two Seasons, probably Autumn and Summer. This is an example of a large class of such vessels found in various parts of the Empire.

275 The volcanic destruction of Pompeii and Herculaneum made possible the preservation of a considerable

A

B

276 Campana reliefs
(New York, Metropoli-
tan Museum)

277 Decoration of walls and ceilings with figured reliefs in stucco began to be used in the Roman world early in the first century BC and continued for approximately four centuries. Stucco reliefs are found in a variety of settings—houses, theatres, basilicas, and vaulted tombs—but were especially favoured in baths, perhaps because they were more resistant to moisture than fresco painting. While recognizable mythological narratives do occur, the main emphasis in such reliefs was on single decorative motifs. When used to decorate vaults these were often set in a geometric pattern made up of circles, rectangles, hexagons, etc.; on walls they are often set into fantastic architectural settings analogous to those of the Third and Fourth Styles of Romano-Campanian painting.

[A] is one of a group of reliefs that decorated the ceilings of three bedrooms in a Roman house discovered in 1879 in the grounds of the sixteenth-century villa known as 'La Farnesina'. The house dates to the last quarter of the first century BC and may have been the residence of Marcus Agrippa and his wife Julia, the daughter of Augustus. In the example shown here, from cubiculum B, the central scene depicts what seems to be a Bacchic initiation rite in an open air sanctuary. A child with a veil over his or her head is led before an old Silenus by two women, one of whom rests her hand (now missing) on the child's head while the other brings forward a tambourine. The Silenus is about to unveil an object related to the rites of Bacchus, probably the image of a phallus. The child holds a Bacchic wand, the *thyrus*. Between the women is a *liknon*, a winnowing basket used in the mysteries of Bacchus. The figure of a third woman, kneeling behind the *liknon*, is mostly broken away but her outline is still faintly discernible. At the left is a free-standing column or pillar, behind which is a tree. On the right is another pillar decorated with a fillet, or perhaps a wall draped with a curtain. The elegant border below depicts Victories and griffins in a network of tendrils. At the left of the upper border are Arimasps and another pattern of vines. As the fantastic quality of these border designs and the wispy landscape elements of the central scene indicate, the design of these stuccoes is similar to that of the Third Style of Romano-Campanian painting, and it is not surprising that this house was also decorated with imaginative frescoes that are transitional between the Second and Third Styles.

[B], a relief from the west lunette of the *apodyterium* (dressing room) of the Stabian baths at Pompeii, was presumably finished shortly before the destruction of Pompeii in AD 79, and its composition and whimsical figures resemble those of a Fourth-Style wall painting. The figure of a satyr holding a shepherd's crook and a plate of fruit stands on a base within a triangular *aedicula*. To the left an Eros, fluttering beneath the coffered ceiling of a pergola, drapes a garland on a slender leafy column, while above a winged female figure holds one end of a cloth or awning that is draped over the *aedicula*.

PAINTING

Most of the surviving examples of Roman painting are wall-paintings in tombs and houses, particularly, of course, the houses of Pompeii, Herculaneum, and other sites in Campania that were buried by the eruption of Mount Vesuvius in AD 79. Panel paintings on wood are known to have existed from literary sources, and some of the most renowned paintings in antiquity were in this form; but only very small fragments of paintings on wood survive. The mural paintings were basically done in the fresco technique, that is, the paint was applied to wet plaster, but a certain amount of overpainting after the plaster had dried was not uncommon.

Unlike sculpture, which was primarily practised by Greeks within the Roman world and seems to have been regarded as a menial craft by the Romans, painting appears to have been looked upon as a socially acceptable occupation, and a number of Roman painters, beginning with Fabius Pictor (active about 300 BC), are mentioned by ancient writers.

Because of the many gaps in our evidence, it is difficult to trace an overall stylistic development in Roman painting similar to that which one can follow, for example, in Greek vase-painting. At Pompeii and Herculaneum, however, where the surviving paintings are abundant, scholars have been able to identify four distinct styles of mural decoration, which also seem to be applicable to the less plentiful examples of wall-painting found in Rome and elsewhere. The four Pompeian styles, it should be emphasized, refer to principles of design for decorating the entire space of a wall and not to styles of figure painting. The First Style (about 200–80 BC) simply involved the painting of stucco panels which were moulded in relief to simulate marble revetments. A similar practice is found in Greek houses of the Hellenistic period, and the Roman version of the style differs from its Greek counterpart only in being less logical in its simulation of architectural forms and more capricious in its use of colour. The Second Style (about 80–20 BC) was the first truly representational style and was most often used to create the illusion of receding space seen through a screen of columns or pilasters set on a substantial dado. In a few famous examples human figures either inhabit the spatial vista or are set on the dado, as if it were a shallow stage. The Third Style, which began to appear early in the principate of Augustus and lasted until around the middle of the first century AD, was created in reaction to the perspectival illusionism of the Second Style. Although a basic architectural division of dado, columnar screen, and entablature or attic is preserved, the earlier spatial vistas are now closed by dark panels and the architecture itself is depicted in flimsy, fantastic forms. The panels sometimes have pictorial scenes painted on them, or set into them, creating the illusion of

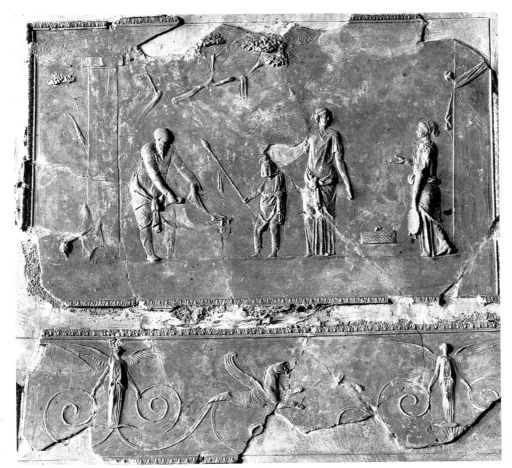

277 A Stucco relief, from Rome (Rome, National Museum)

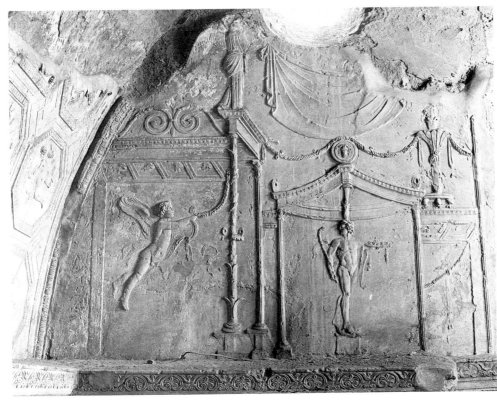

277 B Stucco relief at Pompeii

hung pictures. Finally, beginning towards the middle of the first century but mainly in vogue during the period between the great earthquake at Pompeii in AD 62 or 63 and the destruction of the city in 79, a Fourth Style was devised to combine the spatial vistas of the Second Style with the fantastic architecture of the Third. Because of its ornateness and flamboyance, the Fourth Style, which may imitate the stage settings of Roman theatres, is sometimes referred to as 'baroque'.

From the period between the destruction of Pompeii and the time of Hadrian the evidence is far more limited, but painted tombs and traces of domestic wall-paintings at Ostia, at Hadrian's villa at Tivoli, and in the northern provinces suggest that there was a reversion to anti-illusionistic designs, similar to the Third Pompeian Style.

278 This fragment, from the wall of a tomb on the Esquiline, Rome, is probably the oldest surviving example of Roman painting. It preserves traces of narrative scenes arranged in four superimposed bands. In the uppermost we see only traces of the leg of a warrior, and in the lowest a battle scene. In the upper of the two bands in the middle two figures, an armed warrior wearing a crested helmet to the left and a man dressed in a toga and holding a spear on the right, meet outside the fortification walls of a city. In the band below the same two figures, who are identified by inscriptions as Fannius and Fabius, meet again, this time flanked by smaller figures of soldiers. It has been suggested that Fabius is Quintus Fabius Maximus Rullianus and that the fragment depicts incidents from the Second Samnite War (326–322 BC), in which Fabius was a cavalry commander. The paintings in the tomb from which this fragment comes (perhaps a tomb of the Fabian family) were probably influenced by Roman triumphal paintings; in any case they document, at an early date, that preoccupation with historical commemoration which is one of the earliest distinctive feature of Roman art. The fragment also provides an early example of stylistic features that typify the plebeian tradition in Roman art (see p. 226–7), that is, the disparity in scale between the various figures, with the more important commanders depicted on a larger scale than the surrounding soldiers, and the 'ladder perspective' in which the soldiers are arranged.

279 (**Colour Plate XIX**) Some of the finest examples of Second-Style mural decoration come from a villa at Boscoreale, about a mile from Pompeii. Shown here is a section of the architectural landscape decoration that covered three walls of a bedroom off the main courtyard of the house. This and other paintings from the villa were acquired by the Metropolitan Museum in New York shortly after their discovery in 1900, and the bedroom has now been reconstructed within the museum. These walls were conceived as a series of illusionistic vistas showing city-scapes, shrines, and the countryside. Through the

278 Painting from the Esquiline, Rome (Rome, Conservatori Museum)

columns and open pediment of a gateway in a masonry wall, behind which are two inner walls, we see a circular temple surrounded by a colonnade on three sides, set against the vista of the blue sky. Perspectival diminution of these elements along a central axis has led some scholars to conclude that Roman painters knew about, and occasionally used, a system of one-point perspective. The elaborate details of the scene are essentially realistic—an incense burner stands before the entrance; the outer columns are of yellow marble with composite Ionic-Corinthian capitals of white marble; offerings of fruits are placed on the jambs of doorway in the first inner wall; and bronze and marble details of the inner temple are carefully rendered.

280 The most remarkable example of figure painting in the context of Second-Style mural decoration is the frieze from a large chamber in a villa on the outskirts of Pompeii. The building gets its modern name, the Villa of the Mysteries, from the subject of the frieze. The villa was built in the late third or early second century BC and was expanded and refurbished from time to time up until the destruction of Pompeii. Its heyday seems to have come towards the middle of the first century BC, when the impressive Second-Style paintings which decorate several of its rooms

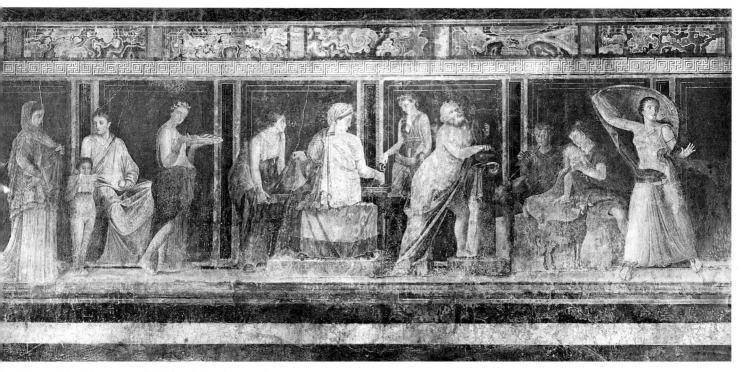

80 'Mystery Frieze', from Pompeii (Naples, National Museum)

were commissioned. The frieze forms what seems to be a continuous composition that ran around all four walls of the room, and its twenty-eight large figures provide some of the finest examples of draughtsmanship, shading, modulation of colour, and emotional expression in extant Roman painting. They are represented as standing and sitting on a shallow socle of green stone, at the back of which are large red panels that imitate stone revetment. These are separated by black pilaster-like panels lined with an egg-and-dart moulding. The classicizing drapery of several figures is reminiscent of terracotta statuettes and other sculptures of the fourth century BC, and this as well as other details such as the melon coiffure of the frightened woman (see below), have led a number of commentators to suggest that the frieze is based, at least in part, on lost Greek paintings of the late Classical or early Hellenistic period.

Throughout the frieze human women are interspersed with figures of religious mythology—Bacchus and Ariadne, satyrs, Sileni, a maenad, Erotes, and a formidable winged female with a whip, who seems to be flogging an initiate. The exact interpretation of the many details of the frieze have been much debated. Most scholars would agree that they deal with the initiation of a woman, or several women, into rites connected with sexual maturity, and probably marriage. Since Bacchus and related figures are represented so prominently in the scene, most also feel that the frieze is related in some way to the mysteries of

Bacchus, but even this is not certain. (There were other mystery cults that were concerned with the life and experience of women, e.g. those of the Bona Dea.) The subjects shown may, in fact, be eclectic to some degree. It is not likely that the painter of this frieze would have revealed the secret details of a particular mystery cult in a domestic room that seems not to have been a closed shrine.

Shown here is the longest uninterrupted stretch of the frieze, on the wall adjacent to the entrance to the room. At the far left a stately woman, perhaps the presiding matron of the rites, seems to be listening to a naked boy who is reading from a scroll and is encouraged by a seated woman who holds another scroll. To the right another group of four women seem to be engaged in a sacrificial or lustral rite. A woman with a tray, who has her mantle wound around her hips in a manner that signifies an acolyte, approaches three women grouped around a table. The seated woman with a headdress who has her back to the viewer may be a priestess. She has apparently taken something from a basket held by the woman to her left and is washing it under a cloth with water poured by the girl to her right. All except the figure holding the basket, who may be a servant, wear wreaths on their heads. From here we are unexpectedly transported to the world of mythical figures. An old Silenus, leaning against a pillar, is playing a lyre. To his left, and seemingly unrelated to him, is a pastoral scene which may seem bizarre to modern eyes. Seated on a rock behind a goat in the foreground, a boy satyr plays

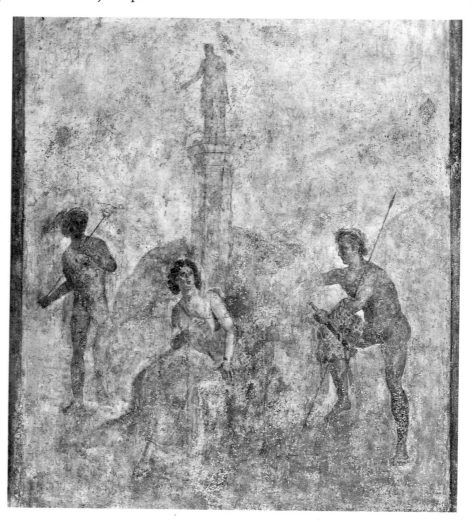

281 Painting in House of Livia, Rome

the pipes while a girl satyr suckles a kid. Finally at the far right, and again seemingly unrelated to the figures to the left, is the striking figure of an excited woman who stretches her cloak out behind her head and seems to gesture in fear. Exactly what has provoked her fear is not certain, but it is probably the flagellation scene or the unveiling of the phallic image that are depicted on the adjacent wall.

281 The House of Livia is part of a complex of houses on the Palatine hill, Rome, that were most probably the residence of Augustus. Seen here on one wall of the tablinum of the house, is a good example of the late Second Style, probably painted soon after Augustus became emperor. The central panel of the wall gives the impression of a large window through which one sees, in the distance as it were, a mythological scene, the story of the Argive priestess Io. She sits on a rock behind which is a column surmounted by a statue and, in the distance, a tree. To the right, Argus keeps watch on Io. Emerging from behind the rock to the

left is Hermes, who will set her free. The statuesque mythical figures are probably based on prototypes derived from Greek painting, but the misty landscape setting in which the figures move gives the painting a distinctively Roman character.

282 Third-Style wall in the tablinum of the House of Marcus Lucretius Fronto, Pompeii. In front of the dado the illusion of small fenced-in gardens is created. The three-part division of the main section of the wall, also common in the Second Style, is preserved, but the dark panels all but close off any sense of spatial recession. On the side panels two harbour-scapes, executed in a quick impressionistic style, seem somehow suspended on spindly candelabra. In the Second Style the upper level of the wall, above the main colonnade, was usually capped by a 'rational' entablature with a central gable or arch, through which one could, so to speak, look into the distance. Here the upper section of the wall is divided up into a fantastic series of *aediculae*, doors, and niches punctu-

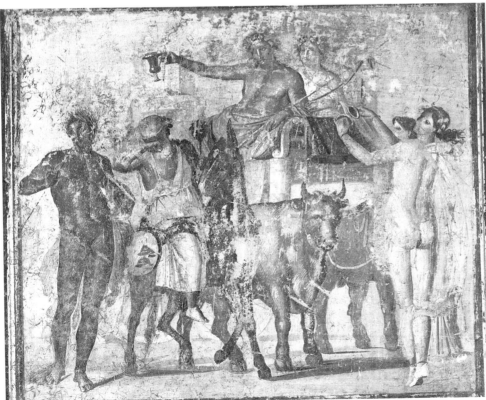

282 Wall and painting
(Bacchus and Ariadne)
in House of M. Lucretius
Fronto, Pompeii

283 Painting in House of the Vettii, Pompeii

ated at various points with vessels, theatrical masks, a tripod, and a still-life painting. The inset picture in the central panel depicts a Bacchic procession and is executed in what is basically a Greek style (see under [284]). Bacchus and Ariadne are seen riding in a wagon drawn by bulls. To the right a naked maenad, clanging cymbals, dances in ecstasy, while to the far left a satyr plays the double flutes. An old man with a bald head rides on a mule alongside the wagon of Bacchus, and the god appears to pour wine on his head.

283 The House of the Vettii, Pompeii, was rebuilt and elaborately decorated after the great earthquake of AD 62–3 by two prosperous merchants named Vettius (see [264 C, 265]). The room shown here is a full-blown example of the Fourth Style. The divisions of the wall remain essentially as they were in the previous styles, but the side panels of the main section of the wall as well as the *aediculae* and windows of the attic now open up into imaginative vistas in which we glimpse additional elements of fantastic architectural constructions. The columns and mouldings have a spindly, ornate quality, as in the Third Style.

Depicted in the large painted panels in the middle of each of the two walls shown here are Daedalus in the presence of Pasiphae and Hermes overseeing the punishment of Ixion.

284 As we have seen in the House of the Vettii, large narrative paintings with subjects drawn from Greek mythology and epic poetry were often set into the central sections of Fourth-Style wall designs. It is thought that many of these paintings were based on famous Greek originals, and that the painters at Pompeii were familiar with them, or at least their basic compositions, through pattern-books. This seems to be confirmed by the discovery at Pompeii of multiple versions of a single composition, with varying colours and with widely differing backgrounds. In these Greek-inspired paintings large-scale human and animal figures, painted with clear sculptural contours, usually dominate the scene. Their mass and corporeality are conveyed through subtle shading (a skill already highly developed in Greek painting in the fourth century BC), and the surrounding space is rendered in a minimal way. The painting illustrated here from the House of the Tragic Poet, Pompeii, is one of the finest of these narrative paint-

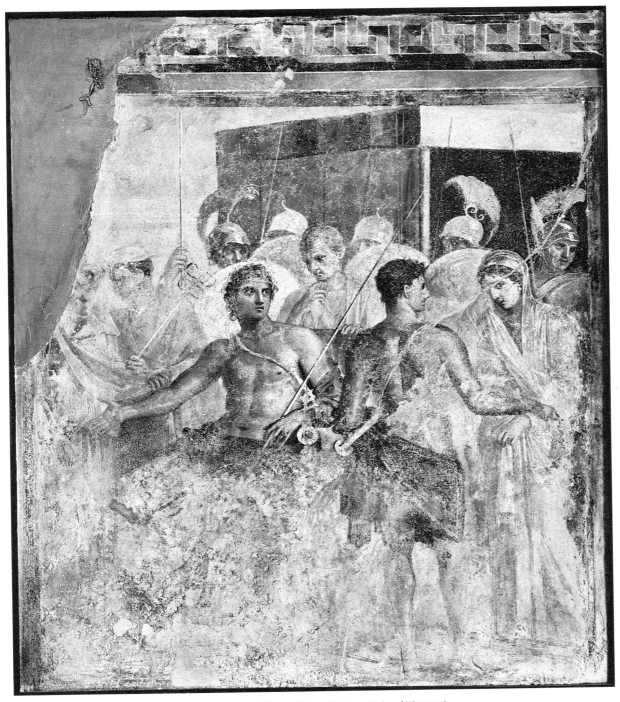

284 Painting from House of the Tragic Poet, Pompeii: Achilles and Briseis (Naples, National Museum)

ings. Its subject is the incident in the first book of the *Iliad* which led to the anger of Achilles. Seated in his tent, an angry Achilles with glinting eyes stares to his left where Patroclus, with his back turned to the viewer, is about to lead Briseis away to Agamemnon. In the background, between Achilles and Patroclus, a worried-looking old man, probably Phoenix, ponders Achilles' anger, while still further back armed soldiers mill about nervously.

285 Compared to the large mythological paintings that served as centrepieces at Pompeii, like the one discussed above, this scene is an example of the many small paintings which played only minor roles in the decorative schemes of Pompeian walls. To modern eyes the sketchy, impressionistic style of these paintings, done with quick brushstrokes which suggest more than they actually depict, has a spontaneity that is often more appealing than the laboured

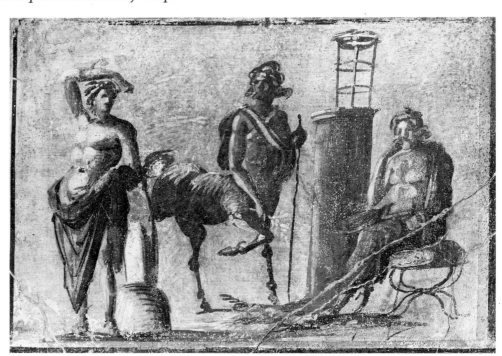

285 Painting of three
deities, from Pompeii
(Naples, National
Museum)

details of the larger paintings. The subject-matter of these impressionistic scenes is sometimes, as here, derived from the Greek tradition, but the style is essentially a native creation of Romano-Campanian painters. The three figures shown here are perhaps *dii salutares*, deities to whom one could pray for the blessing of health. To the left is Apollo leaning on an *omphalos*, in a pose made famous in a statue by the Greek sculptor Praxiteles. The seated figure to the right is apparently the god Asclepius (Roman Aesculapius). Between them is a centaur holding a staff, probably the centaur-sage Chiron, who was skilled in medicine and was thought to have attained immortality. The painting is from a house in Pompeii, possibly the House of Adonis.

286 This remarkable scene from the Villa of Livia at Prima Porta, Rome, in which, behind a trellis and a low wall, birds fly about and perch in a garden of shrubs and small trees that are lush with fruits and flowers and stand out against the blue sky in the distance, is unique in ancient painting and would appear to represent a fundamentally Roman sensibility. Hellenistic painters had been developing elements of landscape paintings for three centuries, and when working for Roman patrons, as in the case of the *Odyssey* landscapes [**169**], had brought them to a high level of complexity and sophistication. This painting, however, in which human figures are entirely absent, and nature, in and of itself, is the subject, has no Greek prototype. It evokes the same appreciation of nature's power to provide an escape from human cares that one finds in the poetry of Horace and Virgil and was probably painted when the two poets were still living.

287 This interesting Fourth-Style painting from the House of Pinarius Cerialis, Pompeii, combines figures of the Greek heroes Orestes and Pylades (apparently derived from a pattern-book, since similar versions of them turn up in other paintings at Pompeii) with what seems to be a purely Roman setting. The heroes appear as actors on a stage, which looks very much like a real Roman stage with its characteristic *scaenae frons* [**260**], and are part of a performance of Euripides' *Iphigenia in Tauris* (or a Roman adaptation of it). Iphigenia with her attendants appears as a priestess in the central *aedicula*. To the left is the seated figure of Thoas, the Taurian king who planned to sacrifice Orestes and Pylades. The latter appear on the right as prisoners with their hands bound.

288 Many examples of small, wispy, impressionistic landscape paintings survive from Pompeii. Some have identifiable mythological subjects, but many seem to be generic in character. Most have a rural atmosphere, with a rocky terrain dotted with grottoes, trees, and inhabited by diminutive human and animal figures who move among small shrines, columns, and statues. A few show harbours, porticoes, and villas. All are rendered with quick brushstrokes that create a shadowy, impressionistic style. On Third-Style walls such scenes were often made the centrepieces of solid-colour wall panels; in the Second and Fourth Styles, they are normally side-decorations. In the scene illustrated here a single-arch bridge leads over a stream in the foreground to a precinct of small shrines, amid which grows a large tree. Cattle graze in what seems to be a green field to the right, a herdsman and a goat cross

286 Garden painting from Villa of Livia, Rome (Rome, National Museum)

287 Painting of theatrical scene at Pompeii

the bridge, and rocky crags loom in the background. In the centre foreground we see a statue holding torches (Hecate or Diana?) standing on a pillar set into a protruding rock. The feeling of lunar light suffuses the whole scene.

289 (**Colour Plate XIX**) As we have seen in the case of plebeian-style sculptured portraits, the Romans used the art of portraiture not only to commemorate great leaders and famous thinkers (which had been the Greek tradition) but also to preserve the likeness of ordinary citizens. The same was true in painting. The example shown here, from a Fourth-Style setting, probably represents a Pompeian lawyer named Terentius Neo and his wife. She holds a tablet lined with wax (the ancient equivalent of a note-

288 Sacro-idyllic landscape painting, from Pompeii (Naples, National Museum)

290 Still-life painting from House of Julia Felix, Pompeii (Naples, National Museum)

pad) in her left hand, and in her right hand a stylus for writing on it. He holds a rolled-up papyrus scroll. Both, but especially she, have carefully prepared for a formal portrait and are well dressed and carefully coiffed. The exceptionally large eyes are a characteristic of many Roman painted portraits.

290 The interest of Roman artists in humble, familiar, everyday details of life that we have seen in plebeian-style reliefs [234–5] and in paintings of gardens [286] is also

reflected in still-life scenes. The most common examples from Pompeii depict food and tableware, but others also show writing implements, musical instruments, and religious objects. Most still-life paintings were minor elements in the decorative systems described above but were removed from their original settings in the eighteenth and nineteenth centuries and are now exhibited as separate panels in the Naples Museum. In the scene from the House of Julia Felix illustrated here we see, set out on what seems to be a stone shelf or table, a large glass bowl filled with

pomegranates, apples, pears, and grapes. To the left of the bowl is a single pomegranate, broken open; on the right a sealed amphora rests against a clay jar filled with grapes.

291 A Pompeian bread-seller seated on what seems to be a wooden stall or kiosk piled high with baskets and circular loaves of bread transacts business with three customers. In spite of the painting's modest subject and sketchiness its creator was clearly familiar with the techniques of shading that we have encountered in the heroic, Greek-style paintings at Pompeii. Romano-Campanian painters, it would seem, were prepared to provide whatever their clientele demanded—epic scenes, still-life scenes, or commercial advertisements.

MOSAICS

Roman mosaics constitute a direct continuation of the Hellenistic Greek tradition, and in the second and first centuries BC it is really not possible to make a distinction between Roman and Greek mosaics. The early polychrome mosaics from Pompeii, for example, are most appropriately described as Italo-Hellenistic. During the Empire, however, there were technical and stylistic variations, such as the elaboration of a distinctive genre of black and white mosaics and the use of mosaic decoration on walls as well as pavements, that were special developments of Roman art.

292 This small scene, dating to the second century BC, was part of an extensive programme of floor-mosaics which decorated a particularly sumptuous house at Pompeii, the House of the Faun [**264**]. Its fine polychrome, *opus vermiculatum* technique is on a level with that of the best Hellenistic mosaics found at sites like Delos and Pergamum. The subject anticipates the still-life scenes that were later popular in Roman painting [**290**], although here the life is not entirely still. Above, on what may be the shelf of a larder, an excited cat, with eyes dilated, mauls a dead dove. Below, two ducks, seemingly quite alive, sit quietly behind an assortment of fish and shellfish. The different elements of the scene were perhaps composed from designs in a mosaicist's pattern-book, a fact which would explain its naturalistic incongruities.

293 Although less common than in Romano-Campanian painting, familiar Greek myths were also a part of the Roman mosaicist's repertoire. This panel, found in a villa in Stabiae and dating from the mid-first century AD, depicts the story of Phrixus and Helle. In the centre the miraculous golden ram, with Phrixus seated on its back, is shown flying through the air, while below, Helle, who has just fallen into the sea that would eventually be named

291 Painting of a baker's shop, from Pompeii (Naples, National Museum)

292 Mosaic from House of the Faun, Pompeii (Naples, National Museum)

293 Mosaic from Stabiae: Phrixus and Helle (Naples, National Museum)

after her (the Hellespont), gestures for help. The rocky shores on either side are reminiscent of the fantastic terrain found in sacro-idyllic landscape paintings [288].

294 This panel, found in 1897 in a villa at Torre Annunziata near Pompeii and dating from the first century AD, depicts a colloquy of seven philosophers. The five figures in the centre are seated in a stone exedra decorated with supports in the form of lions' feet. In front of them is a globe which has been placed in an open chest. To the left is another open chest which was probably for the scrolls which are held by the second and seventh figures from the right. The philosopher on the far right is looking at the globe and seems to be explaining it. The seated figure third from the right points to the globe with a staff, while the seventh figure from the right seems to be turning away from it with an air of scepticism. Behind the group, in the centre, is a column surmounted by a sundial. In the upper right, apparently in the distance, is a fortified citadel, and to the left are a tree and a gateway, features which were often used in Hellenistic art to indicate a rural sanctuary. The gateway is surmounted with what are probably votive vessels.

The exact subject of the mosaic has been a subject of scholarly speculation since its discovery. Many have supported the view that it depicts the Seven Sages of antiquity. Another plausible interpretation, mostly recently elaborated in detail by Konrad Gaiser, is that it represents the Academy of Plato. According to this view, the citadel on the right is the Athenian Acropolis, and the gate and tree are an allusion to the grounds of the Academy; the figure on the far right is Heraclides of Pontus engaged in explaining his astronomical theories; the seated figure pointing with the staff is Plato; and the sceptical figure on the far left is Aristotle. Whatever its exact meaning, the mosaic exem-

plifies the serious intellectual life that was cultivated in the aristocratic villas that surrounded the Bay of Naples.

295 The Romans' preoccupation with portraiture even extended to floor-mosaics. This sober and dignified picture of a Roman matron, carefully groomed and wearing golden ear-rings, comes from the floor of the tablinum of a Pompeian house.

296 Emblems that served as reminders of the transience of human life and of the consequent need to enjoy it while there is still time were familiar fixtures in Roman popular philosophy. This small panel apparently once decorated the triclinium of a Pompeian house that was later converted into a tannery. Its imagery probably had some appeal for the residents of both establishments. In the centre is a human skull, symbolizing death, beneath which are a butterfly, probably an allusion to the soul taking wing, and a wheel, an attribute of the goddesses Tyche and Nemesis, both of whom were regarded as overseers of the mutability of human affairs. Above the skull is a carpenter's level with a plumb line suspended from its centre. This instrument is supported on the right by a shepherd's crook to which a leather sack is attached, both of which apparently allude to a life of simplicity and poverty, like that endorsed by Cynic and other mendicant philosophers. The support on the left, on the other hand, seems to be a sceptre adorned with a purple cloth, both symbols of royalty. The basic idea conveyed by the mosaic is, then, that death brings all, rich or poor, powerful or humble, to the same level.

297 (**Colour Plate XX**) The Greeks seem to have used mosaic work only for pavements. Some of the houses of Pompeii and Herculaneum attest, however, that the

294 Mosaic from Torre Annunziata: philosophers (Naples, National Museum)

296 *Memento mori* mosaic, from Pompeii (Naples, National Museum)

295 Mosaic portrait, from Pompeii (Naples, National Museum)

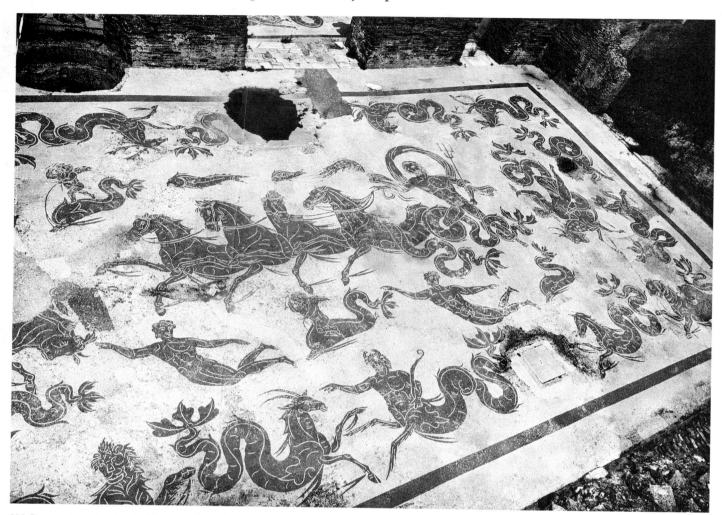

298　Pavement mosaic, at Ostia: Neptune and Amphitrite

Romans also used it to decorate walls, thus inaugurating a tradition that would eventually lead to the great church mosaics of the early Christian and Byzantine periods. In this, the finest of the Campanian wall-mosaics, we see the gods Neptune and his consort Amphitrite (also called Salacia) set against a gold background within a shell-shaped niche flanked by pilasters. The mosaic decorated part of the walls of a summer dining-room that also contained a fountain. As the god who presided over waters, Neptune and his entourage were often incorporated into the decoration of fountains and baths (see [298]).

298 Mosaics made exclusively of black and white tesserae began to appear in the late first century BC and were widely used throughout the first three centuries of the Empire. They were particularly useful for decorating the great expanses of pavement in large vaulted buildings, especially baths, and their designs and subjects often complement the plan of particular rooms as well as whole buildings. The public and commercial buildings of Ostia, the harbour town of Rome, preserve hundreds of examples of the black and white style. One of the most admired is this large composition that decorates the entrance hall of the Baths of Neptune, a Hadrianic building, completed in AD 139, just after the emperor's death. The figures are all rendered in black silhouette with anatomical details picked out in white. The success of the design thus depends on excellence in draughtsmanship rather than chromatic effects. In the centre Neptune, with his cape billowing over his head, is drawn rapidly along by four hippocamps. Amphitrite, seated on another hippocamp, trails behind. Around them Tritons, winged putti on dolphins, human swimmers, and diverse sea creatures form an encircling pattern that, unlike the central scene, has no obvious top or bottom and was designed to give bathers something to look at from any vantage point in the room.

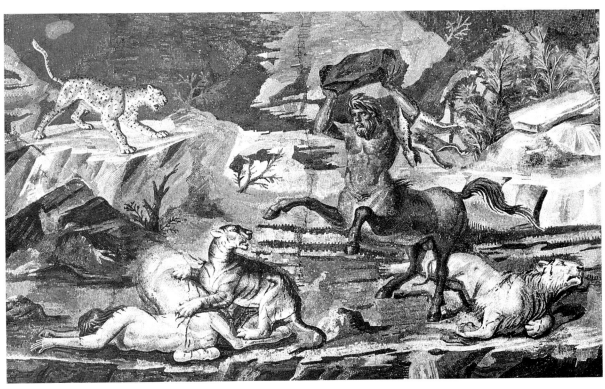

299 Mosaic from Hadrian's villa at Tivoli: centaurs attacked by wild animals (Berlin, Staatliche Museen)

299 Technically this is one of the finest of all Roman mosaics, an indication of the level of workmanship that was required when the patron was the emperor. The scene seems to be a descendant of a famous painting, described by Lucian, of a family of centaurs done by the Greek painter Zeuxis in the fourth century BC, but whereas that painting had been quietly humorous, the Hadrianic mosaic is full of pathos. In a rocky landscape the heroic figure of a male centaur is about to hurl a large boulder at a tiger who is clawing the centaur's fallen mate. A defeated lion lies prostrate at the left, while a leopard snarls from a ledge on the upper right. One wonders if this fanciful conception was not Hadrian's own, a reminiscence of both the art and the exotic fauna that he had seen on his travels in the eastern provinces. It is from his villa at Tivoli [263].

6 THE LATER ROMAN PERIOD

JANET HUSKINSON

A NEW chapter in the book presupposes a new chapter in art and some kind of break with what went before. Yet in art it is not a sudden or decisive division since forces for change are counterbalanced by conservative traditions; and the boundaries of this 'later Roman period' in time and place are not easy to define.

For its chronology there is a choice of points at which to start and end. Two external events provide possible endings for the Western half of the Empire at least: the Sack of Rome in AD 410 by the Visigothic king, Alaric, or the deposition of the last emperor of the West in AD 476. (This chapter will go down to the fifth century.) The beginning of the period is harder to identify; but a broad historical view suggests that the reign of Antoninus Pius (AD 138–61) formed a gentle but decisive watershed. When he succeeded Hadrian the Empire was arguably at its peak and had already reached its geographical limits; its borders could be defended with relative ease, while within them imperial policy worked to impart a sense of unity and coherence through a state which by and large lived in peace. When he was succeeded in turn by Marcus Aurelius and Lucius Verus (acting as joint emperors until the death of the latter) this gentle stagnation was disturbed by increasing difficulties. Internal problems in the economy and in recruitment for the army were exacerbated by wars on the eastern and northern borders. These difficulties, and some of their consequences, in terms of an increased emphasis on the military and on the person of the emperor as potentially consolidating force, belong to the other side of the watershed.

The accession of Septimius Severus (in AD 193) is sometimes taken as an alternative start to the 'later' Empire, and it is true that many of the features just described developed with greater momentum during his reign. As a provincial, from Leptis Magna, who had come to power through the army, Septimius Severus is often credited with an increase of foreign and military influences which changed the character of the Empire irreversibly. With further defensive campaigns to wage on the borders he reorganized the army, improving the social and legal status of soldiers and giving military command to professionals. At the same time more of the important administrative jobs were given to knights, rather than to the old senatorial class; while specifically foreign influences, particularly in oriental religions, were ascribed to Severus' own family (his wife Julia Domna came from Syria), and to the many foreign recruits to the army.

Whenever we choose to start the 'later Empire'—sooner or later—the features which develop in the period are the same. We see a society which becomes increasingly structured as a defence against military threats from without, and against civil war, economic collapse, and demoralization from within. At its head is the emperor, who often identifies himself with some divine source of help (as Hercules for Commodus, Sol for Aurelian); administering it is a bureaucracy of increasing complexity.

To set geographical boundaries to the cultural concerns of this chapter is also difficult. Used in this context 'Roman' is an ambiguous word, even more so, perhaps than in the early Empire: during these later centuries the creativity of the metropolis declined and some of the major artistic initiatives were taken in provinces where local influences emerged to reinterpret the Graeco-Roman tradition. Such artistic differences were set within other, greater divisions in the Empire: the fundamental cultural divide between Latin-speaking west and Greek east, and the political partitioning of the third and fourth centuries. This began with Diocletian's reorganization of the Empire into four parts, each with its own capital; the fourth century saw the founding of Constantinople as a capital of a reunited empire, followed by new divisions alternating with reunification as the result of military and political pressures. Yet despite these forces for fragmentation, something of a common culture lived on, fostered by the regular movement of soldiers, administrators, and craftsmen. What is so often 'Roman' about its art is the subject-matter, particularly in official contexts; this is reproduced across the Empire, often following the local stylistic traditions.

Within these boundaries, temporal and spatial, works of art were commissioned and made for a range of contexts which was wide, but probably not substantially different from that of the early Empire—that is to say, for the purposes of state and religion, and for the use and enjoyment of wealthy and cultivated individuals. The different requirements of these contexts, as well as different circumstances of manufacture, affected the choice of style and subject-matter; and this provides a key to understanding some of the developments that can be traced in art over the period. These relate to changes in style so fundamental that they have been the subject of much scholarly analysis, particularly over the last century; they demand an evaluation not only of their own qualities, but also those of the classical style which they appear to reject.

One monument in particular sums up these changes (which are individually documented in many of the illustrations which follow). This is the Arch of Constantine in Rome. It was erected to commemorate Constantine's victory at the battle of Milvian Bridge in AD 312—as the inscription records in some high-minded phraseology—and was dedicated in AD 315. It is an imposing monument, to convey the importance of the event; but what is surprising at least to twentieth-century expectations is the mixture of material and styles in its decoration. Reused reliefs from monuments of Trajan, Hadrian [232], and Marcus Aurelius supplement contemporary work in the friezes and in the figures on the bases and in the spandrels. There is continuity in their common theme, which is imperial virtue and triumph, but a contrast in its treatment which clearly illustrates these changes in style.

Two panels on the arch depict the distribution of imperial largesse to the people after a victorious campaign. They are of different date: the earlier is one of eight panels reused on the arch from a triumphal monument of Marcus Aurelius. Stylistically it follows the 'Grand Tradition' of Roman historical relief with the figures well proportioned and idealized, and shown in statuesque (though informal) poses. Set lower down is the Constantinian version, created for the arch some 140 years later. Its frieze-like shape meant that the composition was extended laterally, but it has the same basic components as the earlier scene with officialdom elevated above the people. The figure of the emperor, frontally enthroned, fills the whole width of the panel at its very centre. The people below appear as a uniform mass, turned towards their emperor with uplifted hands.

The style of this relief is so obviously different from the classicism of the earlier panel. Rather than building up a harmonious and integrated composition in which external details are pleasingly depicted, it lays bare the inner significance of the scene. Realistic sizing and grouping of figures are rejected for a non-naturalistic approach where important features are disproportionately large and figures arranged according to the social hierarchy. There is an almost relentless sense of symmetry and patterning,

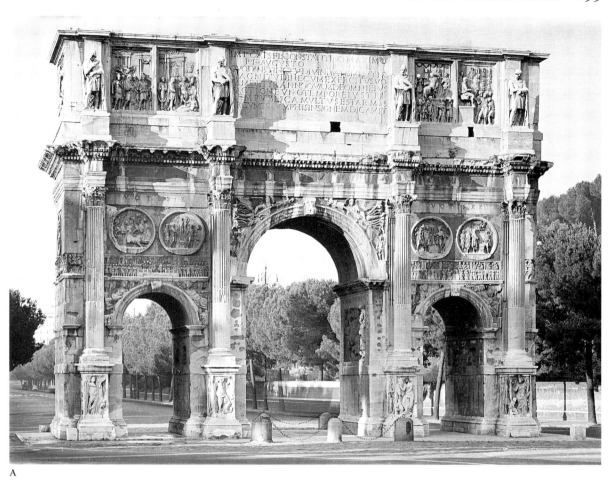

A

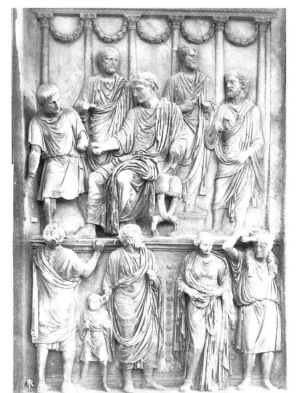

B

The Arch of Constantine, Rome. **A** view; **B** Marcus Aurelius
giving money

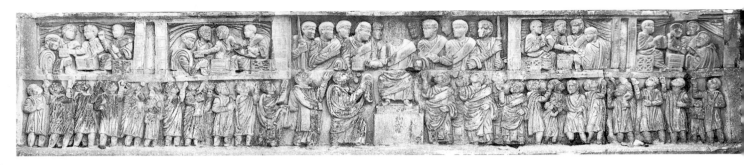

C The Arch of Constantine, Rome. Constantine giving money

emphasized by the stumpy figure-style and low relief-work. Whereas the earlier panel expressed an enjoyment of individuality and movement, here the specific has been converted to the generic, and the dynamic to the static.

These developments typify many of the changes found in late antique art, and in particular the tension between continuity (as here, in theme) and new directions (stylistic change). What we are looking at, then, is art in transition, the classical style moving towards the early medieval and Byzantine. Yet, as we shall see, the transition is not a straight line of evolution but a series of zigzags, which moves backwards and forwards from versions of one style to another. Indeed, it will be clear from the last chapter that many of these non-classical features were in fact present in earlier Roman art even from the time of the Republic, where they are linked with that trend which is variously described as 'non-classical', 'popular', or 'plebeian'. In these earlier examples they occur mainly in representations of Roman subjects, rather than in established Hellenistic mythological compositions or in the 'Grand Tradition' of state art. However, from the later first century onwards they appear more frequently, even in official imperial monuments, where, at the start of our period, we find examples on the base of the Column of Antoninus Pius and in scenes on the Column of Marcus Aurelius [334]. They coexist on the base, as on this arch, with classical styles (just as they had done on the so-called Altar of Domitius Ahenobarbus [226] in the first century BC), implying a facility on the part of the viewer to appreciate both of them.

Alongside these shifts in style were some important developments in technique which altered the representation of form. In sculpture the increased use of the running drill from the mid-second century onwards offered opportunities for exploring chiaroscuro effects, and for indicating volume without actually modelling it. Mosaic is another medium which increasingly abandoned interest in the third dimension, evolving flat, all-over designs for floors, and introducing gold, then silver, tesserae as backgrounds of ethereal light in wall- and vault-mosaics.

At this point one must ask why non-classical features came to be used so prevalently in later Roman art. Different answers have been given to this at different times. One argument is that they are a symptom of a decadent art: in response to the shortage of skilled craftsmen, art developed a simpler, corner-cutting style, which in turn reflected society in decline. Certainly the effects of such a shortage can be seen at times, as in the city of Rome at the turn of the third and fourth centuries; the declining demand for commissions in the uncertain days of the mid-third century led to a situation where the craftsmen who decorated run-of-the-mill sarcophagi also worked on monuments of state, notably the Arch of Constantine. Certainly, too, there are the usual examples of work by incompetent craftsmen, some of whom may have been copying classical compositions which meant little to them. Yet despite such cases, the shortage of skills cannot be a major factor in these changes of style which, as we have seen,

appeared on much earlier monuments, sometimes even alongside a competently executed 'classical' scene.

A second answer argues for influences from outside the Graeco-Roman world. In particular the art of the east was held by some late-nineteenth-century scholars to be a probable source for hieratic features, like frontal positioning, and for bold, flat forms characteristic of the later Roman style. Dura-Europos, within the confines of the Roman Empire, shows what these oriental elements were like; but many of these have parallels in the indigenous art forms of other regions of the Empire.

A third suggestion is that Christianity played a major part in the preference for a 'non-classical' approach. Some secular art of the third century, notably portraiture, suggests a heightened sense of spirituality, which has been ascribed to the general *Angst* of the age, or more specifically to the influence of Neoplatonic philosophy. What Christianity allegedly added to this was its urgent need for an iconography and a style which could be didactic and to the point. However, this need cannot have been a decisive factor in the preference of this non-classical style, on chronological grounds and also because of the way in which Christian art developed, sharing as it did in the traditions of existing secular art from a position of dependency. It made use of both classical and non-classical styles, as they came and went in contemporary art, and shared the services of craftsmen—sculptors and glass-gilders, for instance—with pagan (and sometimes Jewish) customers.

These arguments have been rather baldly stated here. Although they are all inadequate as total explanations, they contain some truth and can all be accommodated within the explanation which seems perhaps the most convincing. That is that the non-classical element in Roman art came to the forefront in the later Empire because it was better suited than the classical style to the changed priorities which art was trying to express. As the panels on the Arch of Constantine showed, while the classical showed forms in natural, even if idealized, terms and was concerned with the harmonious representation of external appearances, the non-classical approach tended to concentrate on expressing the intrinsic qualities of its subject-matter and on setting it within the total scheme of things. The style which resulted was spare yet powerful in its ability to convey ideas by emphasis on significant details. It thus married well with the need of many sectors of later Roman society to convey messages in terms intelligible to the visual readers. It also came close to the aesthetic philosophy of Plotinus, which saw art as the representation of concept rather than perceptions.

Yet saying this is not to imply that the changes which occurred in art over this period resulted solely from a conscious, organized direction, or from the stimulus of external situations. Certainly there were times and places in which a specific style was apparently chosen in order to make a deliberate statement about an external social issue; but essentially we are talking about a much more intimate relationship between artistic style and the attitudes which foster it. There is a sense of this even if we look in a general way at the development of monumental sculpture over the period. What begins with Antoninus as a competent classicism, cold but not dead, shifts into the Severan period with a break-up of surfaces, structures, and compositions, somehow expressive of the insecurities that threatened society. In the later third century the increasing influence of the military can be felt in the hard, uncompromising portrait style, and in the tendency towards consolidated compositions. This particular trend is most conspicuous in the art of the Tetrarchy when the administration of the Empire, divided and subdivided, relied upon a firmly controlled and controlling social structure. Some loosening-up can be detected in the more organic, modelled forms of mid-fourth-century art, but the same structuring is retained in those Christian sarcophagi which depict the hierarchy of Christ and his apostles in heavenly society.

The interaction of the styles also varies from region to region. In the Greek east the traditions of Hellenistic art held strong in most fields at least until the late third century. The prosperous cities of Asia

Minor provided an environment in which art could flourish, encouraged by wealthy patrons with a tradition of public commissions which went back to Hellenistic times. Even in the context of official art in the area the themes and motifs came in the main from metropolitan Rome, but their treatment remained Greek; a magnificently Hellenistic example of this is the Great Antonine Altar at Ephesus, which shares many of the qualities of earlier Pergamene baroque. Furthermore, Asiatic artistic influence was exported, both by its travelling sculptors (like those who apparently worked at Leptis) and by artefacts like sarcophagi [302 and 348].

Something of a similar relationship between Rome and local interests can be seen in other provinces where, by contrast, existing local traditions of representational art were limited. In the earlier days of Roman Britain, works of art and craftsmen were imported to make up for the deficiency of local experience; but by the end of the second century it would seem that native artists were quite capable of reproducing classical subjects, though often with local traits of their own. Yet beyond this increased facility it is difficult to see much development in the Romano-British art of this period (and this is true of other provinces with a similar cultural history).

North Africa offers a case of a different kind, where an established Graeco-Roman tradition was challenged through local interests: the decoration of floor-mosaics there shows a movement away from Hellenistic mythological subjects and their familiar compositions to themes which were more relevant to contemporary life. The stylistic and compositional changes that these involved seem to have influenced mosaics in neighbouring regions, notably Sicily (Piazza Armerina).

The case of these North African mosaics highlights two considerations which are important for any period in art, but especially for later Roman art because of the tension which it displays between forces of tradition and change. These are the respective roles of the patron and of the artist-craftsman.

Of influential patrons the most prominent was the emperor: as we have seen, political needs worked closely with the development of a 'non-classical' style, while imperial iconography came to be used extensively in other spheres of art. 'Official art' used almost every medium—monumental sculpture in an architectural context, free-standing statues and portraits, metalware, coins and engraved gemstones, and painting. Architectural enterprises reflected some of the same themes in a different way, providing the spatial context for the exhibition of imperial qualities in the form of palaces, and in the creation of new capitals for the court. Nor was it simply new artistic creations which expressed these virtues; the recycling of earlier material had a positive function in restating links with the past (as on the Arch of Constantine).

Most official art is concerned with propaganda, especially around the figure of the emperor. Some important monuments recorded specific imperial achievements in documentary fashion [334–7]; but the major trend was towards commemoration of generic, timeless qualities rather than individual happenings. Thus it is the status of the emperor and not his personal characteristics that is constantly reinforced by his image in art, often in terms that are found in contemporary literary panegyric; and even when the figure-style is able to stress the humanity of an emperor (as in the Aurelian panels on the Arch of Constantine: p. 299), the activity portrayed is often generic.

Similar aims and processes can be seen in imperial portraits: they come to emphasize more and more the transcendental qualities of the emperor, often using a sophisticated language of detail and allusion to do so. Costume, gesture, attributes, companion figures, and, on coins and medallions, legends combine to spell out the particular message, as is well illustrated by the famous bust in the Palazzo dei Conservatori of the Emperor Commodus. Divine attributes play a major role in this: they may be modest like Septimius Severus' imitation of the forelocks of the god Serapis, or they may be part of an intricate range of cross-references like the imagery related to Sol, which comes to involve not only

the sun god and the emperor but Christ. Septimius Severus is one emperor who worked hard to consolidate his image by establishing different recognizable portrait types of himself. Others, such as Alexander Severus, used styles which harked back to earlier emperors (in this case to the Julio-Claudians), but it is sometimes unclear whether such visual references were conscious or not. Certainly one can see human qualities of one sort or another surfacing in imperial portraits of the mid-third century: a hard-edged realism colours portraits of soldier emperors like Maximinus Thrax [339] and Philip the Arab, which are then followed by the softer 'aesthetic' image of the philhellenic Gallienus.

Private patronage also had a conspicuous effect on public art and architecture: mindful of obligations or ambitions, or simply motivated by civic pride, wealthy individuals provided their cities with decorations and amenities. As well as such monuments for use by the community, they also built large and conspicuous tombs, and made votive donations, in the form of silverware or mosaic pavements, for instance to their places of worship. Christians followed pagans in this.

However, it is the art which the private patron had for his personal use which offers most insight into the possible power of patronage; yet more often than not it is impossible to determine whether the use of a particular style or subject reflects positive choice or passive toleration on the patron's part. With sarcophagi, for instance, a few may have been especially commissioned, but many more would have been purchased from stock, and a similar distinction presumably holds good for all the other 'private art' forms where money could buy the best available. Transportable goods—including sarcophagi and also metalwork, jewellery, and textiles—might be exported from specialized production centres, thus extending the customers' potential choice. For other crafts the patron would have to make do with what was on local offer, influencing it as best he could. Some powerful influences seem to lie behind the major shift in subject-matter found in North African mosaics. Replacing the traditional (and stale?) repertoire of Hellenistic mythological scenes, designs are developed which represent contemporary life on the estate or favourite recreations like the games and theatre. Even when these give an idealized version of local life as lived, they represent the aspirations of the patrons who ordered them [310]. More traditional cultural interests may be reflected in some fourth-century British mosaics which specifically allude to the *Aeneid*: they indicate, if nothing else, that these provincial patrons had an awareness of their classical literary heritage. Surviving collections of sculpture [318–19] and silverware [320–2] give an insight into the range of subjects which could, for some reason, be acceptable together, as well as into background social circumstances.

Religious interests also affected consumer demand, as is evident from a comparison of Christian art before and after the Peace of the Church. Before the Edict of Milan in AD 313 gave freedom of worship to all and restored certain property rights to Christians, Christian religious art was limited in effect to funerary contexts—catacombs and sarcophagi—and Christian patrons and artists had to make do with decorative motifs from the common stock by which to symbolize particular truths. The Peace of the Church opened the way not only for new themes and representations (which lie beyond the limits of this book), but also for wider and more influential patronage, so that Christian subjects are soon to be found in luxury goods, like ivory and silverware. A particularly interesting insight into the use which influential patrons could make of art is provided by late-fourth-century Rome, where some leading pagan families seem specifically to have chosen classical themes and styles to advertise their own standpoint and interest in their cultural and religious traditions [323]. A further twist comes when conventional subjects reappear in pagan art, refurbished as it were by use in a specifically Christian artistic context.

The other major figure was the artist-craftsman. His skills, or otherwise, have already been adduced as a possible (though unlikely) factor in the transformation of art in the later Roman period.

The status of artists was probably little changed from the earlier Empire. By and large they were craftsmen rather than artists in the sense in which we tend to use the word, although the designations used for mosaicists and glass-workers (where there is some information) suggest that there were different classifications according to skills. Certainly there are many mosaic pavements which show a clear distinction between a master's hand and that of an assistant. Workers in luxury goods would most often be found in large cities where demand for their services was likely to be concentrated. Many other craftsmen worked from small local centres, but may have travelled beyond their own province to work: in fourth-century Britain, for example, we can identify several local schools of mosaicists, and can also trace the use of motifs from abroad. Sometimes a high degree of inventiveness was required of craftsmen, in the evolution of new compositions in North African mosaics for instance, or in the adaptation of existing models for new subjects (as early Christian art required); but often they must have been reproducing designs which were fairly well known, if not to them personally, then to generations of their fellow-craftsmen.

Such craftsmen, therefore, played a major role in what is one of the central features of later Roman art—the transmission of motifs long established in the repertoires of Graeco-Roman art. Thus we encounter compositions which are repeated virtually unchanged across centuries: the scene of Bellerophon and the Chimaera in the mosaic of the mid-fourth century AD from Hinton St Mary (Dorset) echoes that from third-century BC Olynthus. Other scenes were widespread in a geographical sense, like Orpheus and the beasts, which appears in painting, mosaic, and sculpture in sites across the Empire (see [312 B, 319]). Some of this continuity may be explained by the physical movement of travelling artists and of artefacts which carried the designs. Another influence may have been 'copybooks', or design manuals from which artists took their reproductions, but (not surprisingly) no direct evidence of these has remained. What have survived, however, are many instances of the transmission of a motif from one medium to another, sometimes involving some minor adaptations *en route*, but nevertheless providing a cumulatively enriching effect.

The relationship between patron and artist is an important dynamic in the development of later Roman art, since it contributes to that tension between creativity and tradition which is such a major characteristic. This is easier to understand, perhaps, from a distance than from a close examination of a particular artefact, when it can be hard to evaluate the factors which may have conditioned its appearance. In an art form which was both conservative and significative any deviations from the iconographical norm pose a puzzle. Are the changes accidental, mere mistakes, or were they for some reason intended? And if intended, why? To attempt an appropriate interpretation these questions need to be asked, even though they may be impossible to answer. Similar difficulties arise with those motifs which are transferred from one medium to another: how much do they retain of their original significance? Yet there is real historical value in our inability to be too precise: for although the art of this period has a fondness for allusion and has such a wealth of earlier artistic and literary themes on which to draw, it also seems to have enjoyed symbols that were open to a number of possible interpretations. The representation of the successful hunt on the sarcophagus [354] may look back to past achievements of the deceased, or forward to eternal recreation in the afterlife; it may be a statement about the mores of his social class, or express a belief in the ability of virtue to overcome the forces of death. The image contains all these possibilities at once, but does not force us to choose just one of them: the totality is acceptable.

That in effect sums up the potency of later Roman art: its vigour is linked to the multiplicity of ways in which it expresses the interests of a society in transition.

ARCHITECTURE

Urban architecture is a good starting-point for exploring the interaction of Roman requirements and local traditions. Across the Empire Roman settlements and cities reproduced the same types of public building—fora, basilica, temples, baths—but with many variations that reflect local building styles and practices.

300 The provision of water was an essential amenity in any city, and fountains and baths were popular forms of benefactions by the wealthy who wished to make their presence felt. Inscriptions, or as here—and in many comparable public buildings in Greece and Asia Minor—portrait sculpture identified the donors, who gained further reflected glory from the richness of the architecture. In this case Herodes Atticus linked the imperial family to his own

through the honorific statues which decorated this elaborate fountain-place (*nymphaeum*) erected in the later second century in the sanctuary at Olympia.

301 Large bath complexes came to symbolize the qualities of urban life and were a social centre in many cities. These imposing baths were built between AD 212 and 216, following the style of baths donated to Rome by earlier emperors; they remained in use at least until the sixth century, and even today their ruins continue as a place of public entertainment, as an open-air auditorium. This plan shows clearly the symmetrical design. Two identical blocks flanked the central axis along which were placed the principal bathing halls: the *caldarium* (hot room) in a large circular room, the *tepidarium* (warm room), the *frigidarium* (cold room) in a vaulted chamber, and the *natatio* (swimming pool) at the northern end. Each block contained a porticoed exercise yard (*palaestra*), and smaller

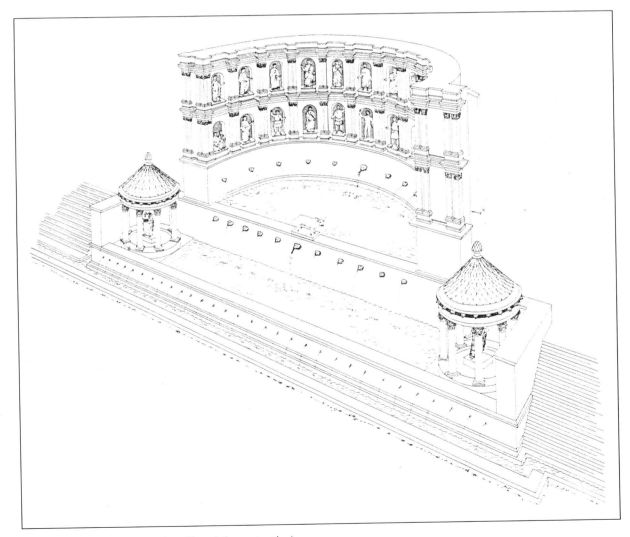

300 Nymphaeum of Herodes Atticus, Olympia (reconstruction)

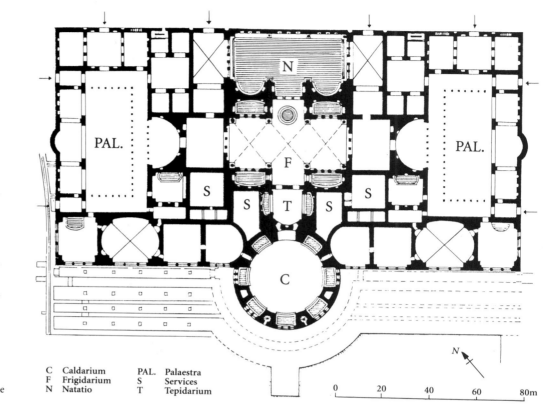

301 Baths of
Caracalla, Rome

C Caldarium
F Frigidarium
N Natatio

PAL. Palaestra
S Services
T Tepidarium

bath- and changing rooms. The surrounding enclosure accommodated other recreation facilities and the furnaces and reservoirs for the baths. What this plan can only hint at are the exciting spatial effects created by the sheer size of the place, by its vaulted ceilings, and by its decoration. Although little of this survives—fragments of wall-mosaics and floor-mosaics from the palaestra areas showing athletes—it is clear that here, as in other bath complexes, decoration played an important part in articulating architectural space and in creating an atmosphere of luxury and recreation. The sculpture which was displayed in various halls included some colossal copies of Hellenistic masterpieces which must have been especially made for this colossal building.

302 Septimius Severus honoured his birthplace of Leptis Magna in Tripolitania with some major building projects which include this new forum and basilica, dedicated in AD 216. In concept and layout they follow Roman precedents, but adopt features taken from various parts of the Greek world; thus they show the local resilience of the Hellenistic tradition which could outstrip the influence of metropolitan Rome, even in an imperial commission. The forum porticoes were unusual for their time in that the columns supported arches in a way that is familiar later (see [**304**]). At one end was a temple to the imperial family, and facing this at the other end was a row of shops

which backed on to the great aisled basilica. This lay at a slight angle to the short axis of the forum, to which it was essentially an indoor equivalent as a public meeting-place. The architectural decoration of forum and basilica was lavish, with features which suggest Asia Minor as a source of inspiration, and probably also of technical skill. Most striking are these pilasters from the apses at each end of the basilica. They are decorated luxuriantly with a foliage frieze which frames small figures within its scrolls. These relate principally to the patron gods of Leptis—Bacchus (in vine scroll) and Hercules (in acanthus) with a variety of other divine figures and groups. The sculptural technique, with its heavy undercutting, exploited the strong sunlight of Africa to give depth to the rather flat reliefs.

303 By contrast the early fourth-century basilica at Trier was a simple brick-built hall, rectangular apart from the projecting apse and with little external ornamentation other than the lines of arcading. It also served a different purpose from that at Leptis, most probably as the audience hall of Constantine's palace in the city. The austerity of the building's design offset the elaborate court ceremonial which focused upon the figure of the emperor, who would have appeared enthroned in the apse. We have in the *missorium* of Theodosius [**322**] an illustration of imperial ceremony related to an architectural setting. The marble panelling on the walls, mosaics, and the generous supply

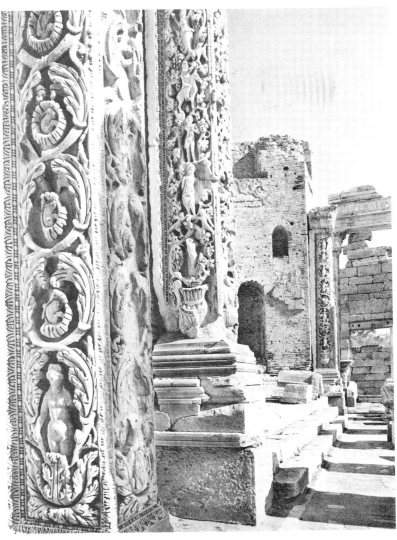

302 Pilasters in Severan Basilica,
Leptis Magna

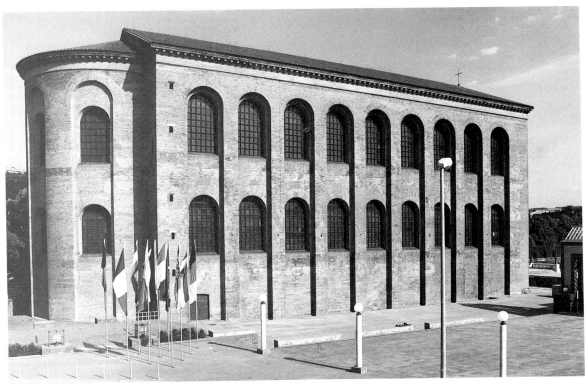

303 Basilica, Trier

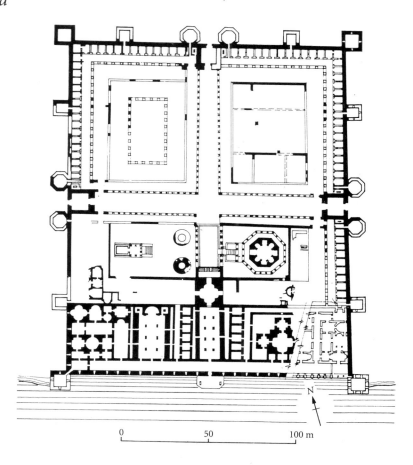

304 Palace of Diocletian, Split

0 50 100 m

of natural light through the windows must have served, as it were, to reflect his glory. Galleries once ran around the interior and the hall was centrally heated for the comfort of participants.

Although the development of Christian architecture has to remain outside the scope of this book, it is important to record that it found a model for larger church buildings in the basilica. Simple in their design (whether aisled or not), Roman basilicas had traditionally been meeting-places which offered a focal point for the enactment of ceremonial in the apse, or rectangular bay, at the end of the nave; their familiarity as essentially secular buildings of flexible usage made them conceptually more acceptable for Christians to adopt.

304 In AD 305 the Emperor Diocletian abdicated and retired to a seaside palace at Split in his homeland of Dalmatia. The grandeur of this building can still be sensed from its substantial remains, which later came to enclose much of the medieval city of Spalato. Its basically rectangular plan combined the traditional design of the Roman military camp or *castrum* (seen in the two intersecting thoroughfares) with rooms that were typically palatial. This colonnaded court near the centre of the complex led to the emperor's apartments on the southern side. These

included a central hall flanked by an aisled audience chamber and a dining suite; linking them was a portico which overlooked the sea and terminated in two projecting towers. To the side of this entrance court lay a small temple and the imperial mausoleum. These, and the residential blocks to the north of them, must have given this section of the palace the feeling of a small town.

305 The villa at Piazza Armerina in Sicily is a fascinating site, rich in figured floor-mosaics, and controversial in terms of date and ownership. The villa comprises several distinct areas which are interconnected, at some points more loosely than at others. The twists and turns which the visitor must make to cross the house heighten the impression of distance and variety, already given by the different levels of the land. From the entrance in the side of a horse-shoe-shaped colonnade the chief axis of the building lies ahead; a vestibule leads on to a porticoed garden, and beyond that a corridor and large apsidal audience hall. To the south of this is a suite of private rooms, and at the side of this main complex, at an angle to the peristyle, is a magnificent three-apsed reception room which opens from an oval portico. The villa's baths fill the angle between the main peristyle and the entrance. In its expansiveness the villa may look back to the designs of earlier Italian country

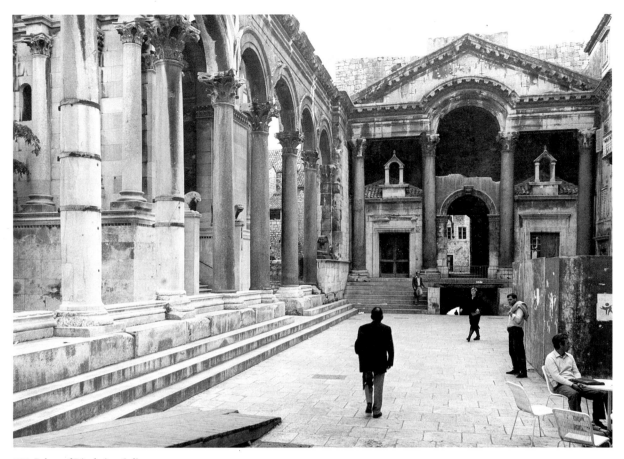

304 Palace of Diocletian, Split

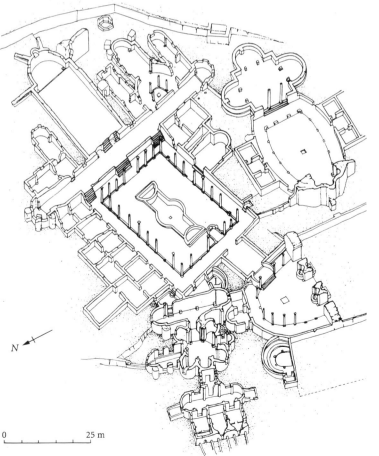

305 Villa at Piazza Armerina, Sicily

N

0 25 m

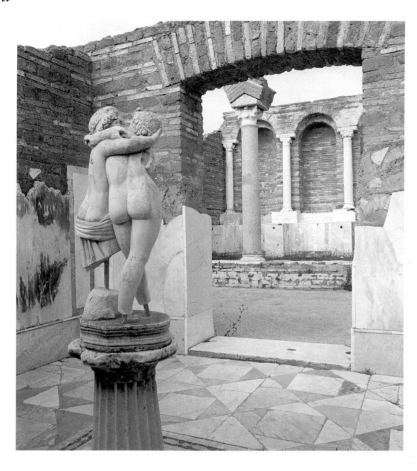

306 House of Cupid and Psyche, Ostia

houses; but certain rooms—the prominent dining-room, for example—reflect an influence from wealthy villas of contemporary North Africa. This is visible too in the themes and style of the floor-mosaics.

Certain aspects of its architecture and decoration have suggested that the villa may have been an imperial residence belonging to the Tetrarch Maximian. So specific a link would place its construction in the first few years of the fourth century. However, it would be more realistic to assign this to a longer period and probably later into the century. More convincing perhaps than the imperial connection is the interpretation of the villa as the house of a wealthy and aspiring landowner.

306 Fourth-century Ostia has some attractive townhouses which provided more spacious accommodation than the apartment blocks of the preceding centuries had done. This house, which is named after the statue of Cupid and Psyche discovered there, is one of the smaller of the group, but includes many typical features. The plan is quite simple. On the west are four small rooms opening on to a wide central corridor, at the northern end of which lies the main reception room. As in several of these late houses this is centrally heated, and is decorated with an opulent floor of coloured marbles [311], and marble panelling on the walls. A major feature of the house is its courtyard garden, separated from the corridor by a screen of arches; and the elaborate niched fountain set against its far wall must have added sparkle to the elegant architecture, as this view suggests.

INTERIOR DECORATION

Developments in architecture which created buildings that were essentially introspective led to an increasing emphasis on the decoration of interiors. This exploited various artistic media, combined where appropriate with natural effects from light and water.

FLOOR-MOSAICS

The central issue in the design of floor-mosaics in this period is, as it had always been, how to treat the surface of the floor. Is it to be seen as a finite flat surface bounded physically by the walls of the room and conceptually by the need for solidity under foot? Or may it be used—like a wall

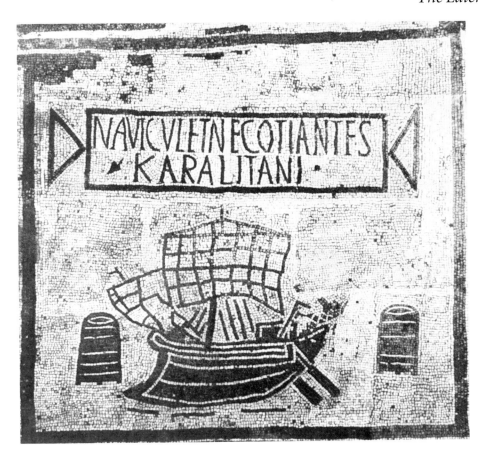

307 Floor-mosaic in Forum of the Corporations, Ostia: merchantman

decorated with pictures—as a place to display scenes which have spatial interest of their own? In short, should it, or could it, accommodate the third dimension in its design?

Differences in solution to this dilemma relate to contemporary developments in architecture and in the decoration of the walls: the curving space produced by vaults, for example, inevitably required something different from the floor, whereas flat ceilings did not. They also relate, as these examples show, to different regional traditions in mosaic and pictorial technique.

307 Rome and Ostia begin this period still committed to black and white mosaic, and then move gradually back towards the polychrome style which had continued in use elsewhere in the Empire. The effectiveness of black and white mosaic lies in its ability to convey essentials whilst preserving its integrity as an art form independent of painting. Although it perhaps lost out to polychrome in the rendering of mythological subjects which needed more pictorial support, it could produce designs of surprising power, either as simple statements, or as large, all-over designs. A wide range of examples is to be found at Ostia, where polychrome does not appear until the later second century. The Forum of the Corporations was a large colonnaded square housing the individual offices of traders who worked out of Ostia. These small rooms are paved with black and white mosaics which allude to the particular line of business. This is a typical example of the late second century: the inscription refers to the shipowners and merchants of Cagliari (in Sardinia). A merchant vessel is shown below; and flanking this are two cylindrical corn-measures. The forms are two-dimensional, with the minimum of extra markings (three lines for the sea). This economical design is so effective because it captures the concept and does not waste time elaborating it further.

308 In the eastern provinces the tradition of Hellenistic pictorialism prevailed, continuing with mythological subjects set as panels within a border. The mosaics from Philippopolis (Syria) were influenced by these traditions; and their high quality suggests that skilled craftsmen were attracted there from other parts of the region soon after its foundation as a Roman colony in AD 244. This mosaic is a lively example. The subject—the goddess surprised by the hunter Actaeon as she bathes—was originally developed in the Hellenistic period; and artistic features like the all-enveloping landscape, the statuary prototype for the figure of the goddess, the Greek inscriptions, and the luxuriant garlands in the border belong to a similar background.

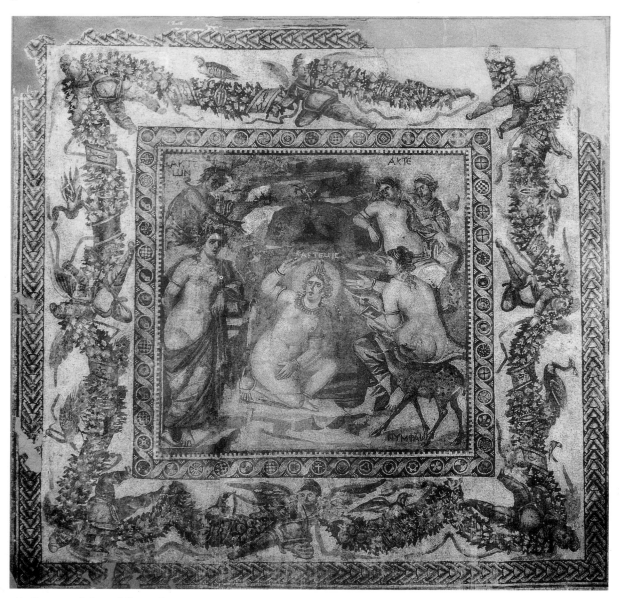

308 Floor-mosaic from Philippopolis, Syria: Diana (Artemis) and Actaeon

The vivid pictorial quality of the composition and the modelling of the figures by shading and highlight are notable when compared with the flatter, less integrated figure-styles developing elsewhere at this time. Yet even so, there is a slightly provincial clumsiness about the figures; while the goddess's ornate jewellery is very much a late Roman touch.

309 One solution to the problem of integrating pictures into an all-over design is illustrated in this pavement from Cologne; like other mosaics from third-century Germany it suggests a local fascination with intricate geometric designs to carpet the floor with rows of square and half-square panels. Each of these contains a figured scene set within a frame of lozenges and triangles, which are interlinked by borders of plait motif. (The exception is the central scene of the drunken Bacchus being supported by a satyr, which is set within a simpler frame and is thus larger.) Furthermore, the subjects in these scenes are interlinked by the themes of wine, food, dance, and love. Individual figures are well modelled, and often smaller cubes of stone (tesserae) are used to give some shading to the colours. However, the way in which they 'float' on a light background prevents this pictorial quality from threatening the all-over treatment of the floor; and they appear securely enmeshed in the heavier network of borders. In this particular mosaic the geometric shapes which form these borders are still used to form a flat pattern, although

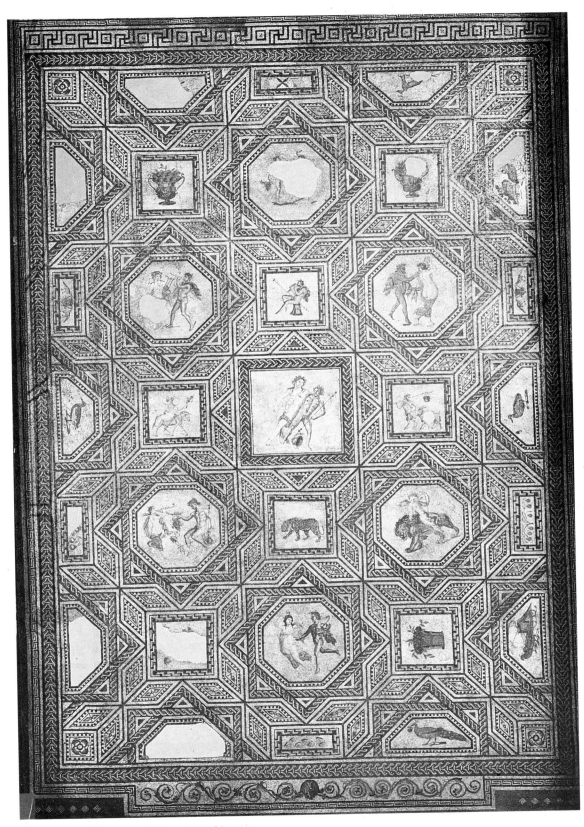

309 Floor-mosaic in a house in Cologne: Bacchic scenes

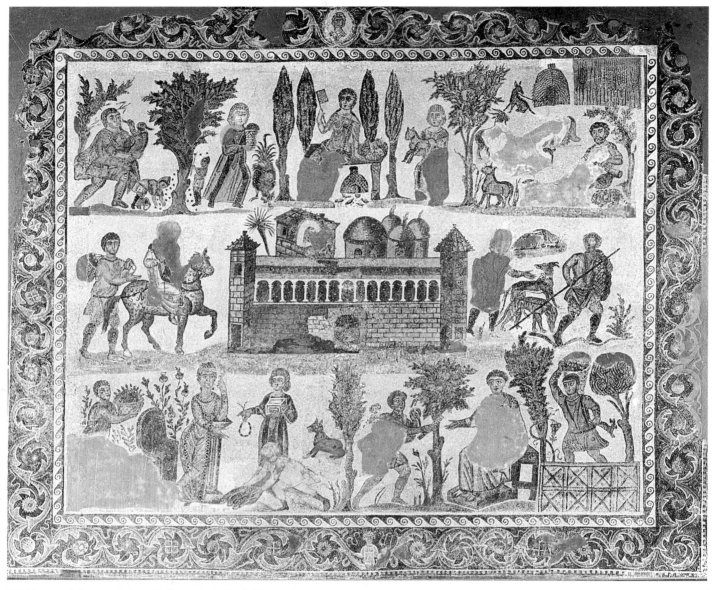

310 Dominus Iulius mosaic from Carthage (Tunis, Bardo Museum)

the arrangement of the square and lozenges at the very corner of the pavement hints at the possibility of illusionistic tricks.

310 From the late second century AD onwards mosaics in North Africa developed new compositions which accommodated figures within a design that addressed the whole floor surface. One impetus for this may have been the patrons' desire to portray some of their own interests instead of the old mythological pictures. At first these changes happened largely in isolation from other provinces, but early in the fourth century similar designs appeared in Sicily; and after that many of the non-classical

elements which they included began to affect mosaics elsewhere.

Many of these North African mosaics build up their decoration in a structured design, often by arranging motifs from a stock repertoire around a significant focal point. In this late-fourth-century pavement the villa building appears as the centre of the different activities on the estate of Dominus Iulius. These are shown in idealized terms—the lady, for instance, poses as Venus—and with an obvious interest in decorative appeal. This, and the all-over arrangement of the design, with its limited interest in depth, are characteristic of this creative local development.

311 *Opus sectile* pavement, House of Cupid and Psyche, Ostia

311 As in other contemporary houses in Ostia, the principal room in the House of Cupid and Psyche (see [306]) boasted a floor of specially shaped marble tiles. Different marbles were used to produce a subtle polychrome effect, with pink and beige as the predominant colours. It is a particularly sophisticated example of a type of pavement which had precedents in early imperial Rome, but gained popularity later, perhaps because of fashions in the eastern Empire. It was often complemented by marble decoration on the walls, whether as simple panels (as in this room; compare [317] imitated in paint) or as complex pictures worked in the *opus sectile* technique (as in [314]).

312 These 'animal-catalogue' mosaics illustrate some of the practicalities of the art. The mosaicists have drawn on the stock repertoire (possibly from some pattern-book) in an almost modular approach to composition. The different birds and animals are usually shown as free-standing individuals and often without a consistent overall scale or any interaction. This is clear in the Ostian example [A], of the late second century where the varied treatments of ground-line and shadow also suggest different sources for the figures. (Perhaps the business which occupied the premises was concerned with the import of animals into Italy for the games or hunt.) The introduction of a central

human figure or an activity (such as hunting or amphitheatre games) provides a *raison d'être* for the animals. The best-known figure is Orpheus, and this large mosaic [B] illustrates not only the heyday of Cypriot mosaic pavements, but also a popular design for Orpheus pavements across the Empire. The combination in the late fourth-century North African mosaic [C] of Bacchus with highly active quadrupeds all associated with the games may symbolize his mastery of the forces of life, through the magical gesture of the dangling lizard. Christian mosaics incorporated the Good Shepherd, Adam, or even Noah's Ark as the 'explanatory' feature, and later used the 'animal catalogue' alone to depict peaceful coexistence in paradise.

The Greek inscription at the top of panel [B] (late second–third centuries) records that Gaius (or Titus) Pinnius Restitutus 'made it'; this could refer to the mosaicist or to the owner of the house, but either way is interesting for the conspicuous placing of such a personal pronouncement.

WALL- AND VAULT-MOSAICS

In this period walls and vaulted ceilings grow in importance as areas for mosaic decoration. These could include fragile or luxurious materials (impractical for the floor) to create extra effects of light and grandeur.

313 The present-day church of Sta Costanza was probably designed as the mausoleum for Constantina, the daughter of Constantine (died AD 354), and as such it uses the circular form developed by the Tetrarchs. The original mosaic decoration only survives in the vault of the ambulatory, together with small apse mosaics showing Christian religious themes, which were added later in the fourth century.

These vault-mosaics are lively and varied in design, and, perhaps surprisingly, lack any specific Christian subject-matter. In fact most of the sections into which the surface of the vault is divided are decorated with motifs conventional in floor-mosaic: geometric panels containing individual figures or objects, a random decoration of birds, foliage, and drinking-vessels, and a vine-scroll design which has scenes of grape-harvesting and a central bust of a young woman (Constantina?). Gold is used in the drinking-vessels, and for reflections of light on the foliage.

314 (**Colour Plate XXI**) Later drawings suggest that the wall decoration in this mid-fourth-century basilica was complex in design; and the four surviving panels all have a certain opulence, being worked in this technique of *opus sectile*. This used pieces of marble or other precious stones which were specially shaped to form patterns or pictures; along with other types of marble decoration it enjoyed a particular vogue in late antiquity. Richness rather than successful figure-style is the effect of this panel, which shows the seduction of Hylas by the nymphs. The scene

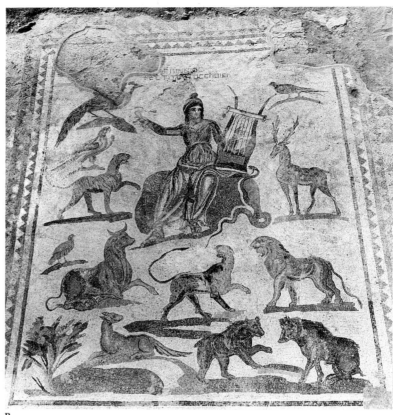

A

B

312 Animal catalogue mosaics (**A** Ostia; **B** Nea Paphos, Cyprus; **C** El Djem, Tunisia)

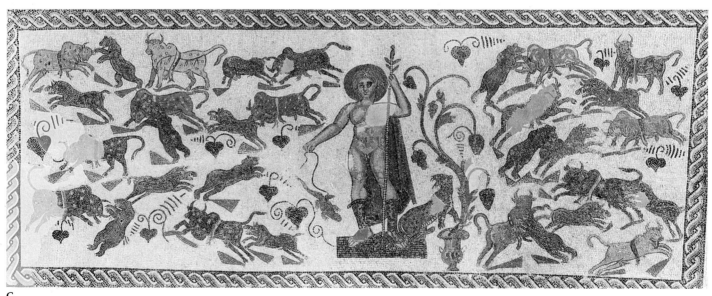

C

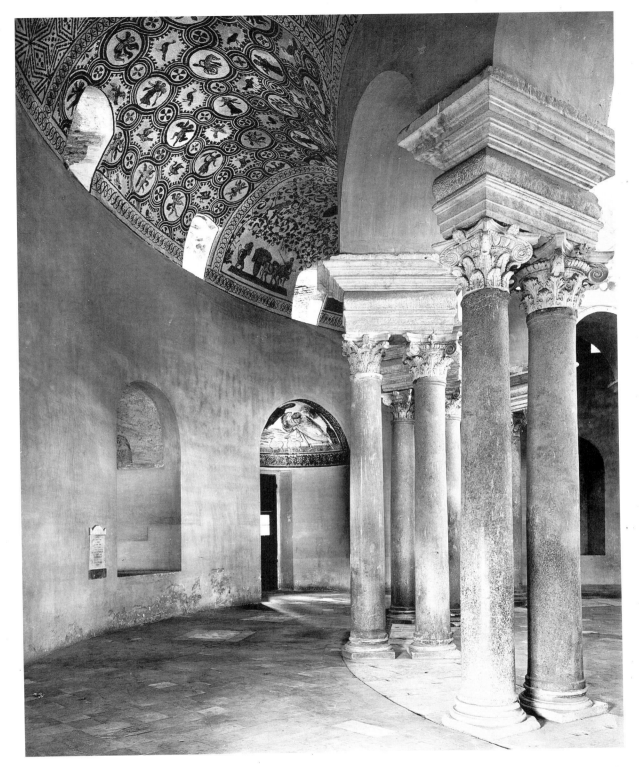

313 Church of Sta Constanza, Rome

uses a well-established composition, but the medium gives the figures a spiky and awkward style. However, the materials are rich and subtly coloured, including pieces of cameo and mother-of-pearl. An exotic effect is added by setting the scene so that it appears like a motif on a swag of drapery (worked in porphyry), which has a decorative frieze of Egyptian figures and a geometric border on the underside.

315 Wall and ceiling, Catacomb of San Sebastiano, Rome

316 Painting in Via Latina Catacomb, Rome: Return of Alcestis

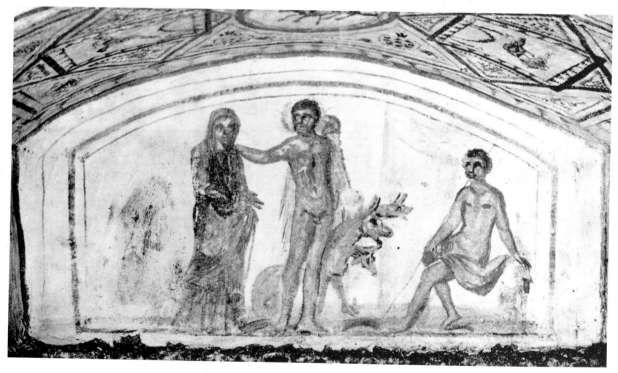

WALL-PAINTING

315 These paintings of about AD 230 show how the light-ground architectural style of wall decoration developed in the early decades of the third century. Thick lines and borders articulate the edges of the vaulted ceiling, while red lines divide the background into panels which contain some free-floating motifs and—a new development

here—green lines used as filling ornament. The overall effect is light but architecturally rather incoherent.

316 The style of painting illustrates the much heavier approach of a century later. Not only are the real architectural forms of the chamber articulated by motifs which relate to their actual shape, but the figures in the decorative panels are strong and substantial. They are well modelled

by the use of highlights and shading within a clear outline; here, and in the other Hercules panels in this *cubiculum* (N), they have a statuesque quality which reflects the long popularity of the scenes in classical sculpture. Classicism is also apparent in the symmetry and balance with which the subsidiary decoration is arranged; it prevents their elaboration from becoming too florid. The paintings in this catacomb (which may be dated between AD 320 and 360) are particularly interesting for their range of subject-matter. In this one chamber the walls are decorated with mythological scenes which represent the redemptive powers of the pagan hero Hercules—here leading Alcestis back from death to meet her husband Admetus. They form a parallel to the biblical scenes in other rooms which impart a Christian message of salvation.

317 This painting of about AD 300 decorated a main reception room in a hillside house on the street known as Embolos at Ephesus. It reflects the fashion for real marble panelling, seen in contemporary buildings like the House of Cupid and Psyche at Ostia [**306**], and it also looks back to the heavily architectural designs of the so-called Second Pompeian Style of wall-painting [**279**], but without their interest in spatial illusionism. Above a dado of real marble is a painted colonnade set on a continuous base. Between the columns (or pilasters) are painted panels imitating cut shapes of inlaid marble, and the area above the frieze was also decorated with imitation marble inlay, in bold circular designs. The colour scheme is restrained and co-ordinated—reddish brown, ochre, and black—with clear distinctions made between the different marbles imitated, and an effective alternation of light- and dark-ground panels. Colour variation in the flutes and bases of the columns gives a limited sense of volume; but their thick black outline and the flatness of the capitals make the design as a whole two-dimensional.

DECORATIVE SCULPTURE

In the later Empire free-standing sculpture played a diminishing role in the decoration of houses and villas. Where it was used it could be of great effect, when, as in the House of Cupid and Psyche (see [**306**]), it was displayed as a three-dimensional marble work against a background of marble walls and floor.

318 Such statues represent the latest stages in the long Roman tradition of collecting copies (and originals) of earlier Greek works to display in houses. Large-scale copying dwindled after the Antonine period, but pieces continued to be collected and displayed in wealthy houses. In the villa at Libourne near Bordeaux from which this marble statue of Venus comes there was also found a companion figure of Diana, and fragments belonging to figures of Meleager, Juno, and Apollo.

317 Painting in a town house, Ephesus

The statue stands 75 cm. high and is well proportioned and smoothly modelled. The type which it copies is a long-established Hellenistic one, but the stockiness of the figure and the treatment of the features indicate its early-fourth-century date.

319 A number of similar reliefs survive, but their actual function is unclear. The main scene, in this case of Orpheus and the beasts, is supported by a rectangular base with a cylindrical pilaster running up the back to project above in the form of a hollow tree trunk. This cavity may have contained some form of liquid, depending on the sculpture's use—oil, if it were a lamp, or water if it were some kind of fountain ornament. This particular example was apparently found in a suite of baths—and, indeed, there are many other occasions which associate this scene of Orpheus and the beasts with fountains or pools. Whatever its precise purpose, this relief must have looked very decorative set in a niche. Behind the seated figure of Orpheus the background has been cut away to produce an openwork effect; this, and the use of drill holes to mark the leaves, makes dramatic patterns of light and shade. The

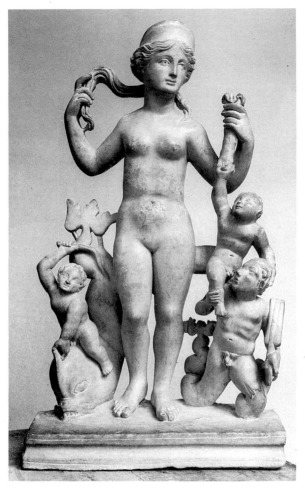

318 Venus, from a villa near Narbonne (Paris, Louvre)

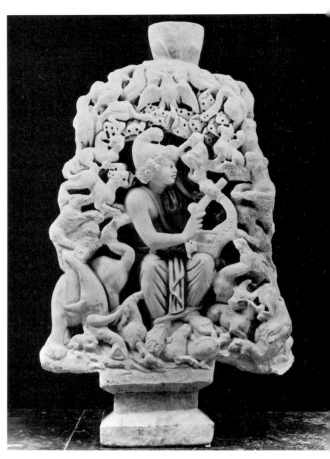

319 Orpheus and the beasts (Sabratha, Archaeological Museum)

soft modelling of the forms and the way in which the animals are shown all around Orpheus, some perched in the tree, give the scene a pleasant intimacy. The sculpture, with its contrasts of light and textures, is reminiscent of the reliefs at Leptis [**302**], and like them may be the work of craftsmen from Asia Minor.

LUXURY GOODS

Some of the most attractive work of this period is in the arts and crafts of the fourth century. The relative peace and prosperity stimulated demand for luxury objects; and the variety of decorative motifs—mythological, political, and the newly emergent Christian—reflects the patrons' different interests.

SILVERWARE

The large number of hoards which date from this period means that it is particularly well documented. Some of these collections represent 'family silver', buried for safe-keeping at the time of an emergency; others are pirate's loot ready to be melted down, while the Water Newton Treasure came from a church. Many of these hoards have been discovered on the edge of the Empire (several in Britain), nearer perhaps to the source of threat, but far from the centres of manufacture, which are likely to have been the great imperial cities with their privileged markets. By and large, most of the surviving silver comprises tableware, toilet-goods (flasks and containers), and votive offerings.

320 This dish is a masterpiece by any standards, although the most striking feature is its size: it is 60.5 cm. in diameter and weighs 8.256 kg. The decoration is worked in relief and details are engraved, providing textural contrasts with the smoothness of the silver. Further visual satisfaction comes from the arrangement of the figured scenes in concentric bands: the eye is drawn out from the central head of Oceanus, through the narrow band packed with horizontal swimming figures, to the outer circle of Bacchic figures where the emphasis is vertical and there is more surrounding space. Each section has a different decorative border. The mobility of the figures in the outer frieze and their obvious classical source obscure at first some oddities in their style. It looks as if the skill of the silversmith was not up to coping with some of the twisted

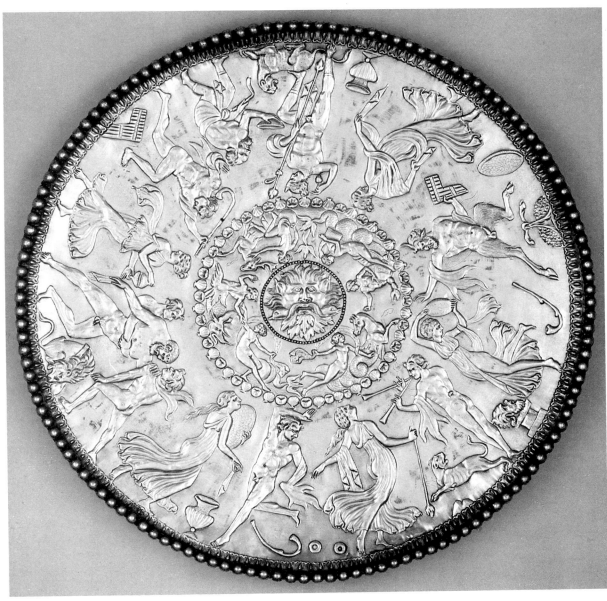

320 Great Dish from Mildenhall Treasure (London, British Museum)

poses of the dancers, and the women in particular turn out flat and narrow. More amazing, given the quality of the dish, is that the satyr supporting Hercules lacks a lower body. Features of this kind recur in other expensive silverware of the time—as does the contemporary hair-do given to one of the dancers. The figures are all well known in the repertoire of Greek and Roman decorative art, and are used symbolically in other contexts. This raises a question about their cumulative significance here, which is compounded by the fact that the Treasure includes two other Bacchic plates and items with specifically Christian decoration. There is an implicit challenge to draw some religious conclusions. Yet whether the Treasure as a whole was originally pagan or Christian in background cannot be established; what is more certain is that it represented wealth, hidden for safety some time in the mid-fourth century.

321 This is one of four silver-gilt statuettes in the Esquiline Treasure personifying four major cities of the Empire, the others being Rome, Constantinople, and Alexandria; measuring about 14 cm. high they were most probably a set of decorative finials for a piece of furniture. The seated female figures which they represent have similar draperies and facial features, but distinctive headdresses and attributes specify their city. Apart from the

flesh parts the figures are gilded, with surface decoration engraved. This figure is easily identified as the personification of Antioch since the statuette follows the iconography of the famous Hellenistic sculpture of the Tyche (or Fortune) of Antioch. The woman wears the characteristic high mural crown and holds attributes of fruit and corn. From below her emerges the nude figure of a youth who personifies the River Orontes on which the city of Antioch stands. Despite the existence of this particular earlier model the statuette and its companions are very much of their time, as expressions of the interest in the identity and status of major imperial cities.

The 'Esquiline Treasure' gained its name from the part of Rome where it was discovered in 1793. It represents domestic silverware of a wealthy family. Inscriptions identify them as the Turcii, a leading family, which had some Christian members; for the marriage of two of them, Turcius Secundus and Projecta, was made a beautiful toilet-box with its combination of Christian and pagan decoration. The family seems to have acquired the silver from Roman workshops over a few decades in the middle of the fourth century, and then hid it for safety in the face of the impending Sack of Rome by the Visigoths in AD 410.

322 This imposing plate (known as a *missorium*) is nearly 75 cm. in diameter. It is a lavish example of the kind of plate distributed by emperors on the occasion of imperial anniversaries. Here the inscription refers to the tenth anniversary (*decennalia*) of Theodosius I, which occurred in AD 388. As in earlier dishes of this kind, the decoration is dedicated to the expression of imperial status. This is powerfully effected through the use of a whole range of non-naturalistic schemata which suggest the concept, rather than the man. Against a stylized architectural background which evokes the arcades of palatial courts (see [304]) the figures of the emperor and two Augusti are positioned and scaled according to their status. All three imperial figures have little physical individuality, and are shown nimbed and enthroned in a rigidly frontal position, with appropriate regalia. Most significant of all these features is the emperor's forward gaze as he hands a document to the figure who kneels at his feet: there is no relationship between them in human emotional terms, but the situation is heavily symbolic. Also symbolic, but reflecting a different artistic tradition, is the personification of Earth in the lower segment of the dish; looking admiringly up at the emperor and surrounded by symbols of abundance which are offered up to him by Cupids, she represents the natural world at his disposal. Although there are awkwardnesses in the rendering of this figure, it clearly relates to the other classically inspired mythological figures which appear—often with similar gawkiness—on other fourth-century silverware ([320] for example). The

321 Furniture ornament from Esquiline Treasure: Tyche of Antioch (London, British Museum)

322 Commemorative plate of Theodosius I (Madrid, Real Academia de la Historia)

soft, almost sensuous pose and the fluid drapery suggest a fully three-dimensional form in contrast to the flatness of the scene above, which finds its own parallels in the reliefs on the base of the obelisk erected by Theodosius in Constantinople [337]. Most probably this dish too was made there, or in Salonica where the anniversary was celebrated.

IVORY

From the mid-fourth century onwards ivory seems to have become a popular material for luxury goods, particularly for small boxes and for writing tablets (diptychs) made for commemorative purposes. Subject-matter and style tend to remain classical in source, although Christian themes appear from the mid-fourth century onwards.

323 A few surviving diptychs seem to have been commissioned by individuals to commemorate a private event. This panel and its companion ('Nicomachorum', in the Musée de Cluny, Paris) formed a diptych, possibly made to celebrate a marriage between the two great Roman senatorial families some time in the 380s or 390s. Each panel depicts in classical style a pagan priestess before a shrine: in this case the attributes suggest dedication to

323 Ivory diptych leaf of the Symmachi (London, Victoria and Albert Museum)

Bacchus and to Jupiter. The facial features, hairstyle, and drapery seem to make a deliberate reference back to the classical Greek art forms favoured by Romans in the early Empire. Yet there are problems, particularly in perspective, which reflect the late antique date. The overt classicism of this piece, and of other ivories attributed to the same workshop, suggests that patrons may have deliberately opted for this style to convey their devotion to the

traditional religion and culture. However, such archaism is also to be found in contemporary Christian pieces, as the cameo of Honorius and Maria [325 C] shows.

324 As well as marking important private events such as marriages, ivory diptychs were also commissioned as gifts to record the assumption of public office. This diptych depicts Probianus, deputy (*vicarius*) of the city of Rome, and was made about AD 400 possibly by the same workshop as the Symmachi relief, with which it shares a classical figure-style and an interest in spatial effects. The two leaves of this diptych are very similar in their design, and the variations are specifically intended to represent different facets—public and private—of Probianus' life. In each case he is shown in the upper panel, enthroned and flanked by two secretaries; in the lower panel two men standing by a small table point up to him in greeting. One leaf, however, portrays him in his official capacity, wearing the uniform cloak and holding the unrolled scroll of office; the other shows him as a private person wearing the senatorial toga. This difference is picked up in the inscription at the top of each panel, and in the costume change of the other figures. Comparison with the similar scene on the near contemporary *missorium* of Theodosius [322] shows how well the artist here has managed to combine an indication of status with a sense of the official's humanity.

JEWELLERY

325 (A = Colour Plate XXII) At the start of this period, jewellery in gold predominated; and this remained important in new developments such as the setting of imperial coins and medallions to be worn as jewellery, and in the fretwork technique of *opus interrasile*. There was also a growing interest in the use of stones for their own decorative effects. Hair ornaments of the type seen in [A] are known from portrait sculpture (which provides useful corroborative evidence about jewellery fashions in this period); they were worn down the middle of the head so that the three pendants—in this case a sapphire and pearls—hung down on the forehead. This particular example was found with an attractive bracelet of a matching style, and a cameo brooch; it dates from the third century.

The scenes of hunting and vintage on the fourth-century gold bracelet [B] are worked in the *opus interrasile* technique.

Cameo was an art form revived in late antiquity, particularly as gifts from the imperial family whose qualities were extolled, usually in heavily allegorical compositions. Here, however, this is done by deliberate evocation of an earlier age of Rome's greatness. Honorius and Maria, as they are usually identified on [C], are each given a hairstyle which links them back with the Julio-Claudian impe-

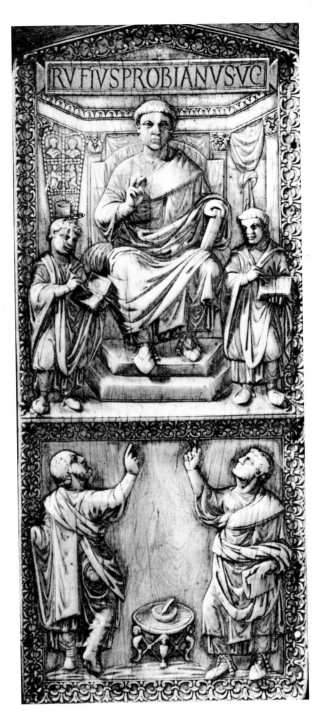

324 Ivory diptych of Probianus (Berlin, Staatsbibliothek)

rial family, and so to its virtues, although the diadem with Christian monogram hints at a new religious dimension to their rule.

TERRACOTTA

326 Elaborate terracotta dishes of this type were produced in North Africa during the late fourth and early fifth centuries in imitation of more expensive silverware. This fragment illustrates well how decoration was built up from a stock repertory of mythological, secular, and Christian motifs, which were repeated in different combinations on the dishes. Here the subject of the central scene (Priam seeking to ransom Hector's body from Achilles) links up with scenes from Achilles' earlier life on the rim. The statuesque figures in the main scene look back to some Hellenistic prototype; but the abbreviated forms on the rim must have had a narrative origin, possibly in some

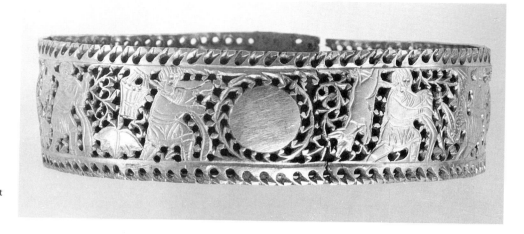

325 B Gold bracelet (London, British Museum)

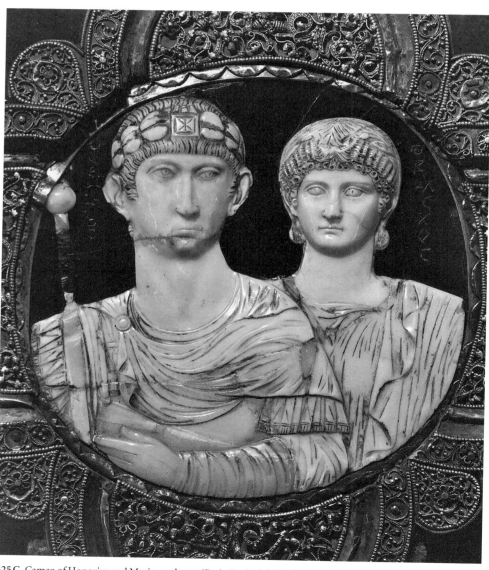

325 C Cameo of Honorius and Maria, sardonyx (Paris, Rothschild Collection)

PLATE XXI

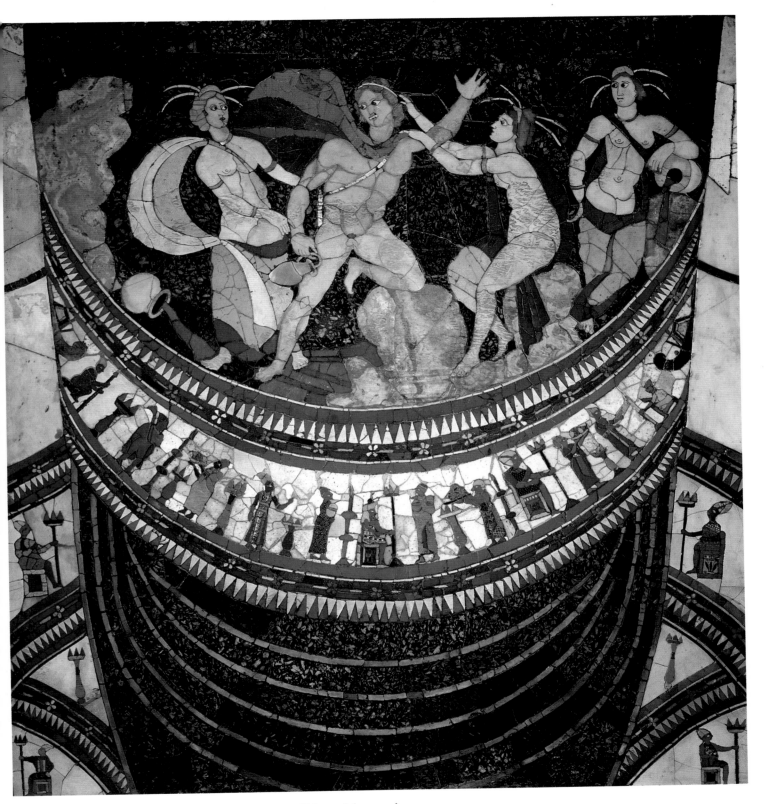

314 *Opus sectile* panel from Basilica of Junius Bassus, Rome: Hylas and the nymphs

PLATE XXII

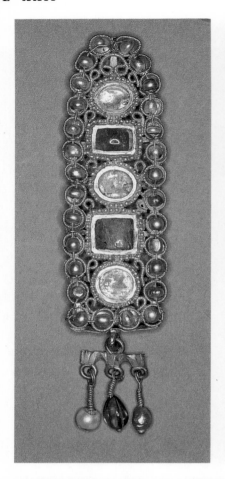

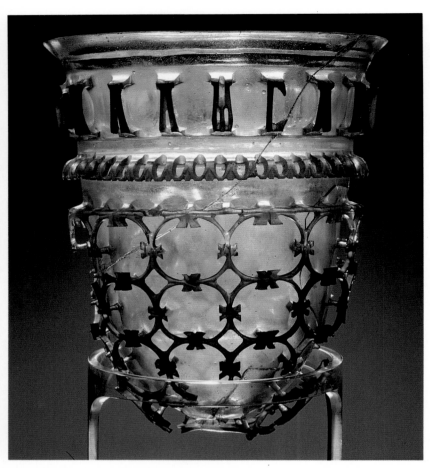

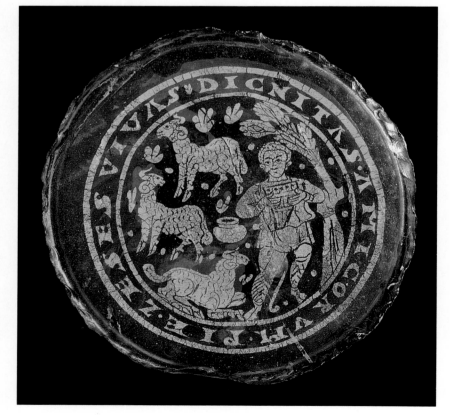

325 A Gold hair ornament from Tunis (London, British Museum)

329 Glass cage-cup (Cologne, Römisch-Germanisches Museum)

331 Gold-glass plate (Corning Museum of Glass)

PLATE XXIII

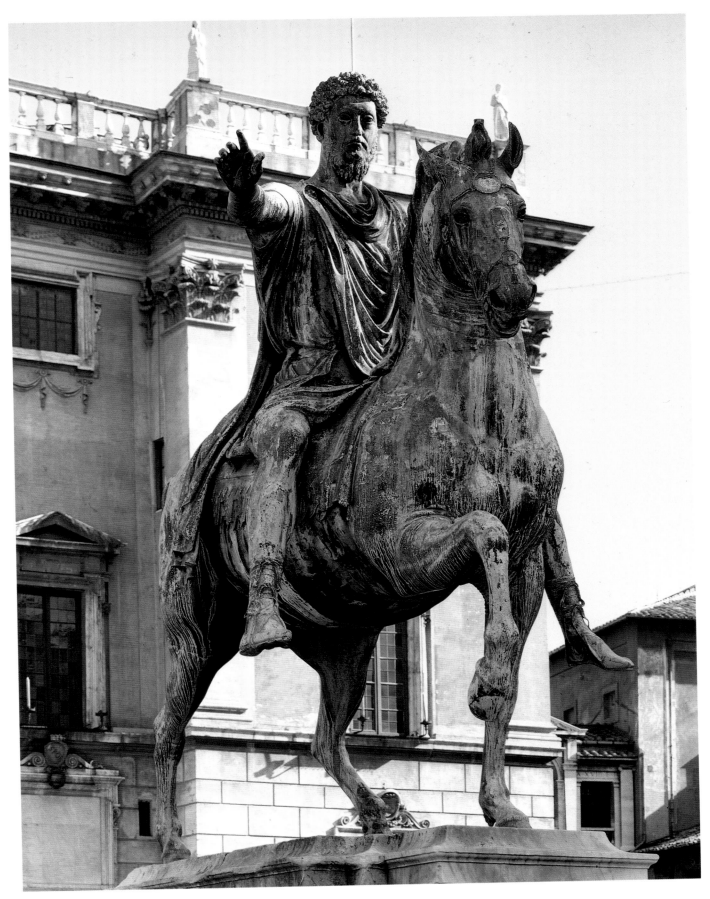

338 Marcus Aurelius, bronze (Rome, Capitoline Museum)

PLATE XXIV

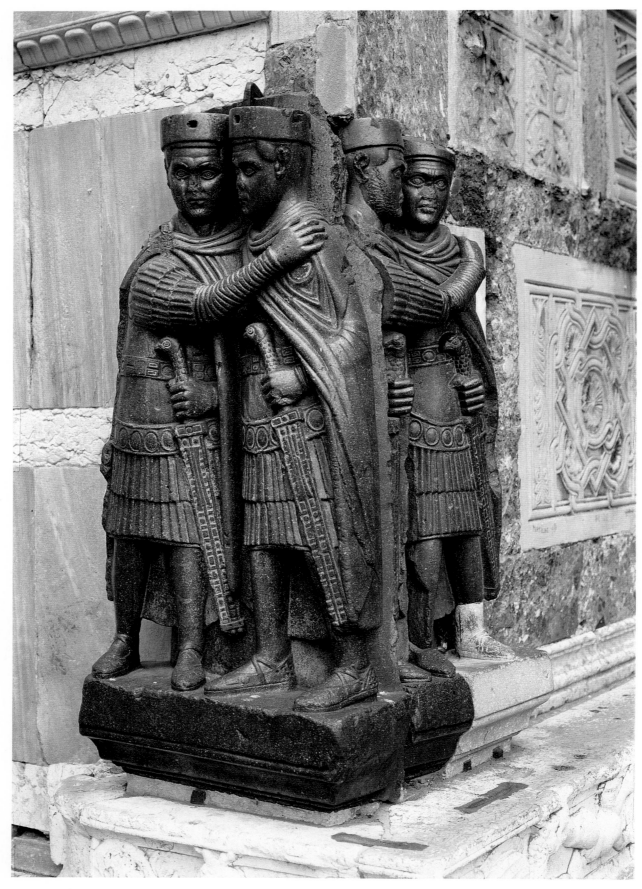

340 Tetrarchs (Venice, St Mark's)

illustrated text (see [327]). They are certainly part of a cycle, which does not appear in art until late antiquity. The inner border of medallions has a different history: although its origin must be numismatic devices, it is immediately derived from friezes on decorative bronze-work. This is a good example of the range of decorative material which the craftsman was able to synthesize and use for the dish, which itself imitated work in another medium.

ILLUSTRATED BOOKS

327 Although so little original material survives there is evidence from literature, from later copies of lost manuscripts, and, less directly, from the composition and content of other contemporary works of art to show that this was a formative period in the art of the illustrated text. The major reason for this is that by the fourth century AD the codex (formed of flat, folded sheets of parchment) had come to replace the papyrus roll as the usual type of book. Many rolls had been illustrated, but probably with this type of minimal scene, inserted at a relevant point in the column of text. This would represent the bare bones of the episode as narrated, and could be followed by a series of similar illustrations as the text moved on. This abbreviated style has an obvious counterpart in the designs used on coins, and seems to have influenced compositions in other branches of art. The poem in this third-century fragment concerns Hercules' killing of the Nemean lion; and the three surviving illustrations show different episodes. It represents the most popular type of subject-matter—epic stories of the gods and heroes. Even when a poem has not itself survived we can often postulate its existence from the repetition of the same illustrations (often in an abbreviated form) in many works of art (see [326]).

328 The codex allowed book illustration to become closer to other pictorial arts, particularly in terms of composition. A single scene could be enlarged, to suit the space on the new page, and given a more detailed composition and a frame to separate it from the text. The quality of the painting which these flat pages allowed could be rich and highly decorative, as it is in some of the codices made in the fifth century. Books of this quality were made for presentation, to individuals and churches, as well as being prized by their own patrons. In fact the earliest dated codex with full-page illustrations to survive—the so-called 'Calendar of 354'—seems to have been made as a New Year gift for a Roman aristocrat, Valentinus. Although its illustrations are known only through Renaissance drawings of an early medieval copy they show well the complex range of iconographical sources on which the designers drew. The contents too are heterogeneous, combining Christian information with an otherwise pagan calendar. This title-page expresses hopes for the prosperity of Valentinus in

326 Terracotta dish: life of Achilles (Berlin, Staatliche Museen)

327 Papyrus roll: Hercules and lion (Oxford, Bodleian Library)

328 Frontispiece of Calendar of AD 354, copy

an accumulation of standard phrases; the wish *Valentine, Floreas in Deo* is repeated as a striking monogram. The name of the scribe is hidden in the complex monogram, and reappears in full in the handles of the inscribed panel. He was Furius Dionysius Filocalus, who is known later to have cut inscriptions for Pope Damasus (AD 366–84).

GLASS

329 (**Colour Plate XXII**) Delicacy of decoration and colouring is superb in this small (12 cm.) glass beaker. It is an example of a 'cage-cup', in which decorative features have been cut out to stand almost free of the main vessel.

Here they are arranged with an elegant proportion. Under a simple rim runs a Greek inscription which exhorts the user to drink and always live life well. This classicism is carried below into the border of 'egg-and-dart', which stands above the lacy network of oval designs that covers the lower part of the beaker. Red, gold, and green distinguish the different areas of patterning. Cologne was a major glass-making centre. Such 'cage-cups' must have been luxury items as they were the work of craftsmen of recognized skill, and were often buried (as this one was) as grave goods. Most were made in the late third and early fourth centuries.

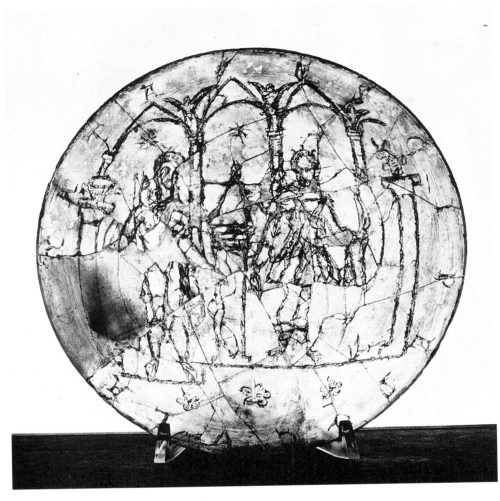

330 Engraved glass dish (Cologne, Römisch-Germanisches Museum)

330 Engraving was a popular technique for figured glassware in the fourth century. This piece was made in Cologne during the 320s by a workshop which produced other dishes similarly inscribed and decorated with mythological, biblical, or secular subjects. It measures 18 cm. in diameter and shows Apollo (left) and Diana (right) in an architectural setting which must represent a shrine. The inscription at the edge recommends the diner to take up the welcome cup.

331 (**Colour Plate XXII**) Glassware decorated with gold and painted scenes like this was manufactured in the third and fourth centuries. Many of the scenes survived as decoration in the Roman catacombs, although they depict a wide range of conventional as well as religious themes. Such dishes were usually made in two layers, fused together to secure the decorated discs. Here, within a circular border inscribed with an exhortation to drink, live, and be the pride of one's friends, is depicted a shepherd tending his flock. Fertility and abundance are suggested by the heavy fleeces of the sheep, the circular bowl (presum-

ably for milking), and the tree and small plants which are dotted around the field. The image of the shepherd and his sheep is a popular one in Greek and Roman art which idealizes the delights and tranquillity of the natural world. In the Christian period it may be interpreted further, as an allusion to the Christian Good Shepherd and his pastoral paradise. This combination of popular 'everyday' subjects, idealized treatment, and a possible religious dimension is typical of much of the multi-layered symbolism in late antique art. A similar example is the scene of the hunt, illustrated by mosaics and by sarcophagi [354].

TEXTILES

Panels for clothing and wall-hangings are the most common textiles to survive. Many were found in Egypt, and their decoration shows a tension between traditional Hellenistic designs and a local, more abstract style.

332 A typical long-sleeved tunic was made of linen or wool. It was decorated at the front and back with long

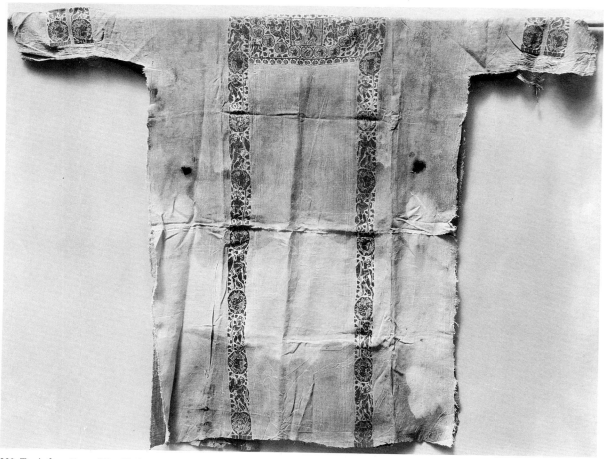

332 Tunic from Egypt (New York, Metropolitan Museum)

strips (*clavi*) and with borders around the neck. These panels were woven, usually in a mixture of wool and linen, and might be polychrome or worked in a single colour on white. The scenes which they contained were taken from the traditional Hellenistic repertory of mythological topics, and sometimes achieved pictorial effects that were remarkable considering the limitations of size and technique. Later on, however, these came to be replaced by non-classical features which characterized the local, so-called 'Coptic' art, with figures and natural forms rendered in an abstract style. This fourth-century example seems to lie somewhere in between: the figure-style is rather cuboid, but the subjects well established, with a Triton and Nereid shown at the neck along with a warrior and dancer, and on the *clavi* more warriors separated by animals in medallions.

333 Substantial fragments (measuring just over 2 m. × 1.5 m.) survive and suggest that the original hanging showed Meleager and Atalanta standing side by side each in a niche formed by a pedimented arcade. The figures are each identified by a Greek inscription, and seem to have

been three-quarters life size. This scale, the highly decorated architecture, and the subtly modulated colouring make this an imposing example of its kind. The hanging is woven from a mixture of linen and dyed wools. A wide range of colours is used which, for the figures, produces a pictorial modelling that gives them some substance. This style, and indeed the mythological subject-matter, places the hanging in the Hellenistic tradition of Egyptian textile design, in contrast to other less classical compositions which it also produced. Nevertheless, it does contain many features which are typically late antique, and which suggest that the hanging was made around AD 400. The idea of abstracting mythological figures from their narrative context and depicting them with their attributes almost like icons is something which recurs in contemporary art (as in [312 C]); as does the architectural background (see [322, 349]). Here too, as in many other late antique representations of mythological characters, their costume is contemporary rather than classical: Meleager wears the cloak and decorated long-sleeved tunic of other fourth-century huntsmen (see [310]), while the diadem—rather impractical in the hunt—is an adornment which Atalanta shares

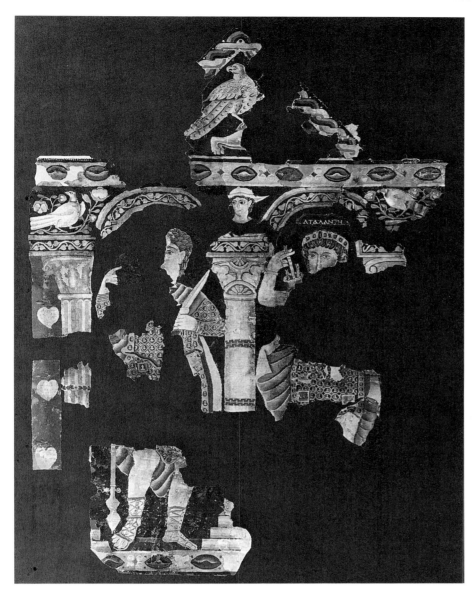

333 Wall-hanging from Egypt: Meleager and Atalanta (Berne, Abegg-Stiftung)

with other late antique goddesses. Meleager and Atalanta were in fact popular subjects in the mythological repertoire of later Roman art, perhaps through a combination of interests.

IMPERIAL MONUMENTS

334 Completed some time after his death, this column commemorated the successful campaigns waged by Marcus Aurelius in the Danube area between AD 172 and 175. It took over from Trajan's Column (erected in AD 113 [231]) the idea of recording events in a continuous spiral band of sculpted reliefs, but its final effect was somewhat different. Whereas the earlier column might be said to have aimed at objectivity of expression, with careful editing of the scenes and a dry, unemotional attention to detail, its successor offers a more subjective view of events. Scenes of desperate violence and grief—like the sack of a German village shown here on the top band—convey human suffering in war; while others—like the rain miracle on the right side of the central band—hint at a cosmic dimension through the dramatic intervention of the personified elements. The sense of drama is heightened by the figure-style; individuals often have disproportionately large heads, and some of the group compositions seem almost thrown apart by the actions which they are trying to contain. By contrast the emperor is usually made to stand out as detached and authoritative, often in a frontal

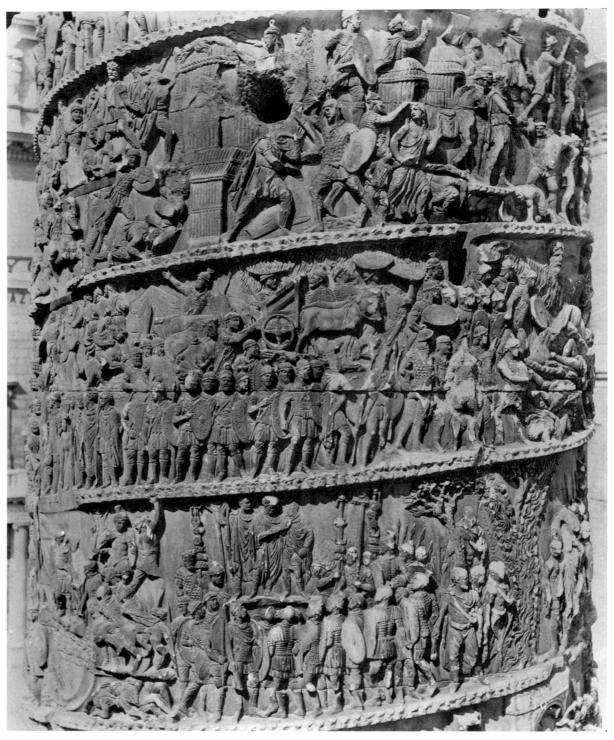

334 Column of Marcus Aurelius, Rome

position. The arrangement employed on Trajan's Column, whereby the emperor was usually shown slightly but not conspicuously separate from crowds and flanked by two officers now becomes an exaggerated formula—as in the lowest band here. This device not only implies transcendental qualities of leadership, but provides visual help to the long-distance viewer in picking out the protagonists. All in all this column is more 'user-friendly' than Trajan's: the scenes unfold in a looser spiral and there are fewer of them to sort out. The increased use of the drill creates dramatic patterns of light and shade and visual accentuation. This type of column with a continuous spiral of reliefs was resurrected nearly 200 years later in Constantinople when Theodosius I (in AD 386) and Arcadius (AD 403) each erected a column to commemorate campaigns against the Goths.

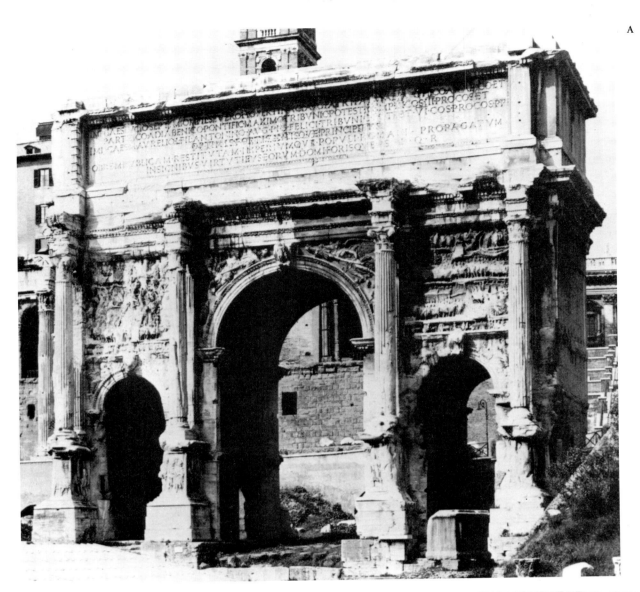

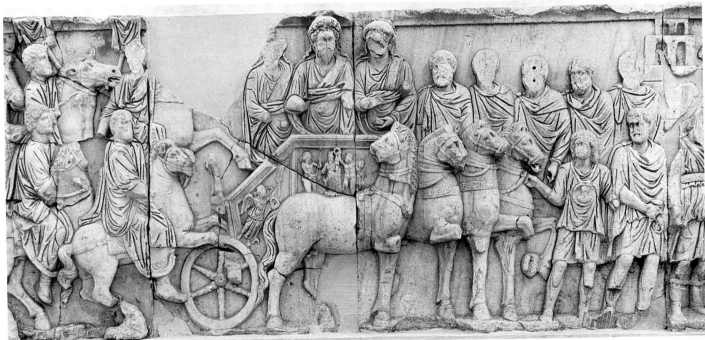

335 Commemorative arches of Septimius Severus. **A** in Forum, Rome; **B** at Leptis Magna: triumphal procession

335 Throughout this period emperors continued the practice of erecting arches, in Rome and in the provinces, to commemorate their victories. Interestingly for us they include some major and distinctive monuments. Two arches are associated with the Emperor Septimius Severus, one erected in the Roman Forum in AD 203 after his Parthian triumph [**A**], and the other set up in his home town of Leptis Magna a little later [**B**]; both make innovations. The Roman example is one of the grandest versions of a long-established type, but is curious in the way it introduces some small-scale narrative scenes into the four main decorative panels. These combine several episodes in a single panel, using non-naturalistic scale and perspective to accommodate all the details, just as Roman triumphal paintings must have done. The figures are small and squat with crude drill-work used to model them.

The four-way arch at Leptis [**B**] was less conventional in form. As with other Severan monuments in the city [**302**], the marble and craftsmen most probably came from Asia Minor, and the themes from the repertoire of Roman official art. What is striking about the reliefs on the attic of the arch is the static, almost formulaic, style of their compositions. This may be partly due to a desire for clarity of form, given their high position, but surely reflects changed ideas about the emperor and his status. Artistic tendencies observed already in the Column of Marcus Aurelius are developed one stage further. As on the column the emperor appears here as the central and slightly larger figure in a discrete group of three (the other two being his sons). Their position is strictly frontal, facing out of the relief and not towards the crowd of onlookers as reality would dictate. Schematization extends—inevitably—to the crowds, who are lined up in two tiers, with the higher row of half-figures representing those further away.

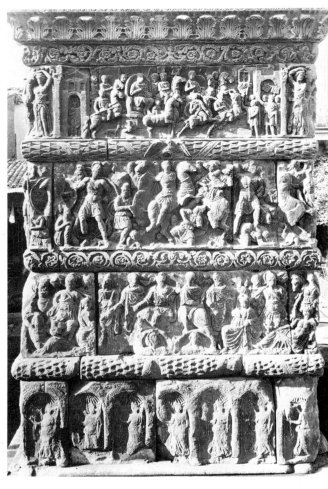

336 Arch of Galerius, Salonica

336 This four-way arch was built around AD 300 at the heart of the complex of buildings which formed Galerius' residence in his capital city. The reliefs suggest that its purpose was to commemorate victory over the Persians by the Tetrarchs. They are shown in the next to bottom panel on this south side, with the senior emperors enthroned and the juniors standing, in the company of various suitable personifications. The composition of this particular panel demonstrates well the particular artistic interest of these reliefs: we see motifs from a centralized imperial repertoire receiving a 'local' treatment from east Greek craftsmen. This is responsible for the heavily ornamental borders, and for the architectural setting in the lowest panel where the conch-shaped niches in which the Victories stand are reminiscent of contemporary Asiatic sarcophagi. The figured scenes themselves are arranged in superimposed rows, and are quite varied in their composition and style. The overall effect is a lively, almost florid patterning of well-rounded forms, unlike anything produced in contemporary Rome.

337 Theodosius I erected a number of monuments in Constantinople including an obelisk in the *spina* (central 'island') of the hippodrome. The obelisk itself was Egyptian, but the base (dated to AD 390) was decorated on all four sides with figured reliefs and triumphal inscriptions. The hippodrome, or circus, had become one of the most important sites in an imperial city, as major spectacles involving the emperor's public appearance were staged there. The four different factions which raced in the games acquired a potent mixture of political and religious symbolism on the theme of imperial victory; and the crowds of spectators played their part in acclaiming the emperor's triumph. These values are spelled out on the base where reliefs depict Theodosius appearing in his box in the hippodrome on various occasions—with his court, receiving homage from barbarians, and at a victory ceremony. These events are shown in very structured terms with figures all subordinated to the emperor and graded in size according to their social importance (some of the spectators are merely heads). Almost all are frontal, so that they

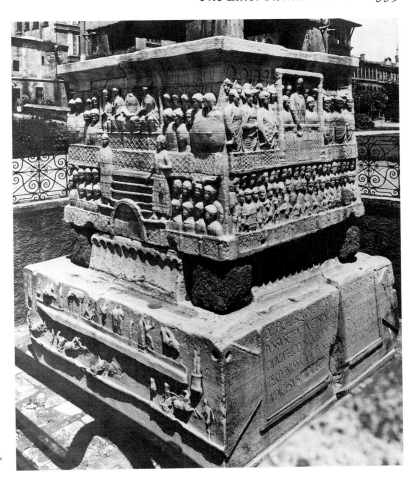

337 Base of Obelisk of Theodosius, Constantinople

do not appear to relate to each other. Although the modelling of the drapery is soft, and individual heads well rounded, the relentless organization of the composition is the outstanding feature. Below the main panels are set the inscriptions (on two sides), and reliefs in a spontaneous and informal style which record the erection of the obelisk and a horse race.

IMPERIAL PORTRAITS

As in the early Empire the chief aim of imperial portraiture was to convey ideas about the emperor—his moral qualities, the nature of his authority, the significance of his achievements—rather than to reproduce his physical likeness. This is as true for free-standing sculpted portraits as it is for representations on coins or in historical reliefs where the monument gives a specific context. In later imperial art this image-making is even stronger: status and generic action marginalize considerations of the individual, and many of the standard ways of representing the emperor have become heavily formulaic.

338 (**Colour Plate XXIII**) This is a unique example of a type of statue which must have adorned cities throughout the Roman Empire—the victorious emperor mounted on horseback, in gilt bronze. As in many such full-figure portraits the total ensemble gives the immediate effect. Here the emperor, dressed in a tunic and heavy military cloak, salutes the onlooker from his horse with raised right hand. This distinctive gesture of authority had been used in the earlier bronze equestrian statues of Sulla and Domitian, and becomes characteristic of later representations where command, courage, or triumph is the essential theme. Part of the same image is the conquered victim lying under the horse's feet, and it is possible, but not certain, that this group too once included the figure of a barbarian lying below the horse's right hoof. Victory would have been the primary message, if, as the portrait style suggests, the statue was erected around AD 165 at the end of the Parthian Wars.

339 Maximinus the Thracian was the first of the so-called soldier emperors, and had come to power after the assassination of Alexander Severus. Hugeness of size and brute strength were allegedly his chief characteristics.

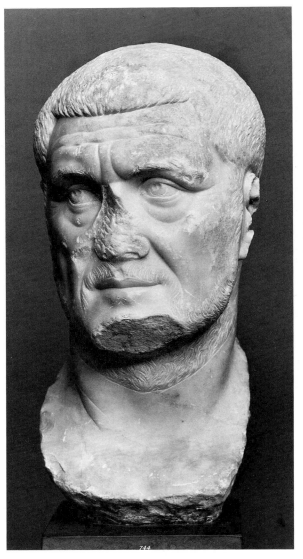

339 Maximinus Thrax (Copenhagen, Ny Carlsberg Glyptotek)

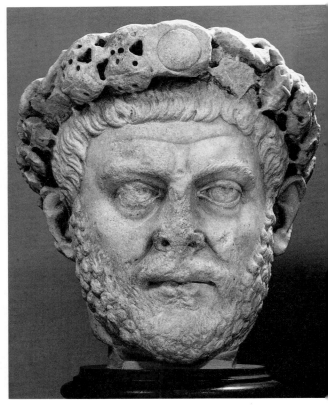

341 Diocletian, from Nicomedia (Istanbul, Archaeological Museum)

These are well conveyed by this head: in fact, the direct gaze suggests that they have already been turned upon a target. The effectiveness of the portrait derives from a combination of powerfully modelled volumes and a detailed linear treatment of the eyes, hair, and beard. There is a contrast between the heavy flesh which sags a little around the eyes and at the back of the neck, and the hard lines of the wrinkles and hair-line which bite into it. Although this uncompromising style breaks with the softer images of his predecessors it is not entirely new: it draws on those features of Republican and Flavian portraiture which produce a hard-boiled 'realism' and which appear also in the portraiture of Septimius' son Caracalla, who cultivated an intimidating frown. Such shifts in style recur in imperial portraiture in the second

quarter of the third century. They are easier to see than to understand: retrospective allusions may be unconscious rather than intended.

340 (**Colour Plate XXIV**) This famous group portrays not so much the men but their status: it expresses solidarity and not individual characteristics. Similarities in height, dress, and gesture assert the supremacy of group over individual identity; and the pairs of figures are literally bound together by embrace. This group, which is carved in porphyry, a material much used for imperial monuments in late antiquity, was probably made in the eastern Empire, possibly Egypt, about AD 300. A comparable, though less accomplished, piece is now in the Vatican Library. It is also interesting to look at contemporary portraits of the individual tetrarchs worked in similar materials which do attempt some characterization. Here too is the tendency to abstraction, reinforced by a hard style which relies on linear detail rather than modelling.

341 This marble head, which has been identified as Diocletian, probably belonged to an over-life-size statue. Stylistically it provides a striking contrast with the severity of the tetrarchic group [**340**], and is evidence for the continued strength of the Hellenistic sculptural tradition in

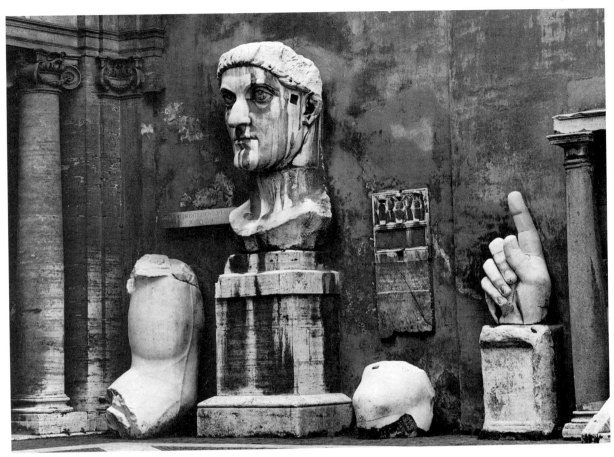

342 Colossal head of Constantine (Rome, Conservatori Museum)

Asia Minor at this date. Here features are modelled as volume—witness the individual locks of hair and distinctive folds of the cheeks—rather than delineated. There is a good deal of interest in contrasting textures and in lively detail despite a restricted use of the drill.

342 The sheer size of this head (2.6 m. high)—and indeed of the other limbs which survive from this colossal seated statue—makes it still awe-inspiring. We are able to appreciate at close quarters the architectonic quality of its design and the careful balance needed in such large-scale work to prevent the enlargement of distinctive features from producing a caricature. Yet viewed in its original setting (which was presumably the apse of the Basilica of Maxentius which Constantine rededicated in AD 313 and where the fragments were found), the statue would have relied on its total impact for effect: it would have expressed superhuman power and transcendent majesty, and only minimal interest in the emperor as an individual. The portrait features are over-simplified, with more interest in significant expression of eyes and lips than in surface texture; but comparison with later coins of Constantine shows the same long nose and jaw. There are several other colossal statues of Constantine and his successors which are less well known. Their fashion goes hand in hand with colossal architectural settings, and with the concept of emperor as more than mortal man.

343 The two sides of this gold medallion illustrate the theme of imperial victory in contrasting styles. The obverse portrays Constantius II as Augustus in a style which is relatively relaxed and realistic (note for instance the delicacy of his fingers). Power and triumph are suggested by attributes and gestures—the raised right hand, the orb surmounted by a wreath-bearing Victory, and the rich diadem and costume. The reverse spells out the same message by symbols of victory in the lower segment, and above, a highly formulaic image of Constantius standing in his six-horse chariot. There is no sense here of an individual personality; rather a message, built up from a series of visual details (nimbus, orb, over-sized right hand raised, crowning Victories), and verbalized in the surrounding inscription CONSTANTIUS VICTOR SEMPER AUG[ustus]. However, it is the composition itself which is most emphatic, and particularly forceful is the symmetrical arrangement of the figures around the frontal iconic

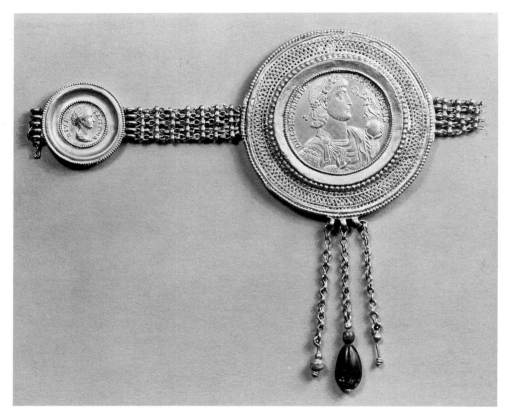
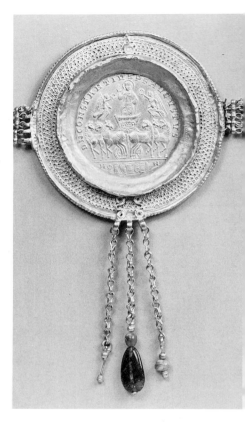

343 Gold medallion of Constantius II (Baltimore, Walters Art Gallery)

figure of Constantius. Medallions like this were minted in small numbers, probably for distribution as gifts by the emperor. Many of their motifs resemble those on contemporary coins, but tend to be more sophisticated in their propaganda content.

PRIVATE PORTRAITS

344 Goddess and mortal, this statue exemplifies a combination which is found in many Roman portraits, whether made for a funerary or an official context. (The fact that this statue was found in the forum of the town of Praeneste has suggested that it might represent a lady of the imperial house.) Sometimes the juxtaposition of these characteristics appears incongruous. Here the figure depicts Venus, with typical posture and attributes; but the sharp portrait features of the head are those of a Roman matron of the early third century. In this way the mortal woman gains immortality—or at least a more flattering image than a more worldly portrait might have given her.

345 As in the early Empire private portraiture tended to follow imperial developments and this piece shows a private patron feeling his way, as it were, between changing imperial styles. The shape and smooth surface of the face, the treatment of the beard, and the expression of the eyes follow Severan styles; yet the close-cropped hair and furrowed brow look towards the harder realism of Maximinus Thrax (see [**339**]). Although we might see it as rather a compromise, the portrait does have an integrity of its own: there is an overall crispness of form and wistfulness of expression. About AD 230.

346 This elderly man is portrayed in the 'philosopher-type' developed in the mid-third century, and was carved shortly after this period. The significance of this type is reinforced by the appearance of the philosopher figure on contemporary sarcophagi: just as Republican portraits had tended to concentrate upon the worldly experience of their subjects, so these representations value wisdom and reflectiveness. The best-known portrait head of this type has been identified as the Neoplatonist philosopher Plotinus. This 'anonymous' version, with its pinched cheeks and distant rheumy gaze, portrays the other-worldliness of an elderly ascetic.

347 Portraits were also executed in small-scale, 'luxury' media such as engraved gems, cameos (see [**325 C**]), and gilded glass; and this particularly fine example has been reset, with ancient gems and medallions, in an early

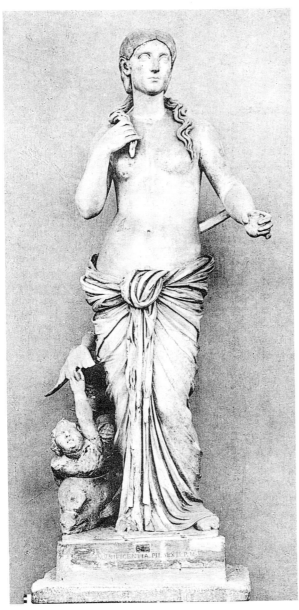

344 Portrait of a woman as Venus (Vatican Museum)

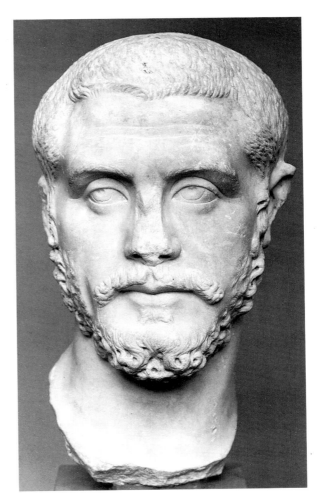

345 Portrait of a man (Copenhagen, Ny Carlsberg Glyptotek)

medieval processional cross. The naturalistic depiction of the figures with their elongated faces and dark luminous eyes suggests that it was made in Alexandria, probably in the late third century.

SARCOPHAGI

Italian sarcophagi were intended to be set against the wall of a tomb, and are decorated only on three sides (the side panels being in lower relief than the front). The lid is low and terminates in a flat face at the front; this is usually decorated and often contains the inscription panel. Over the course of our period fashions change in the relative dimensions of lid and trough, and in the arrangement of the sculpture on the front: this might be in a single frieze of figures, or set within an arcade of columns, or in panels separated by panels of curving lines (strigils).

Supplies of local marble and skilled craftsmen to work with it drew Athens and Asia Minor into the trade. Sarcophagi, finished to varying degrees, were exported from these centres to be sold or completed by local craftsmen; and their secondary artistic influence was considerable. Both of these areas produced sarcophagi which were decorated on all four sides. The Attic examples frequently depict mythological scenes in a well-rounded naturalistic figure-style, and have rich architectural mouldings. Asiatic sarcophagi are usually much larger and have a more ornate, less classical treatment of figures, with deep drilled ornament. One of the best-known types uses an elaborate architectural background of columns and niches for its figures.

ASIATIC SARCOPHAGI

348 This type of sarcophagus was exported in considerable numbers from the marble quarries on the island of Proconnesus (in the Sea of Marmara). The decoration on the back is only blocked out for completion once the sar-

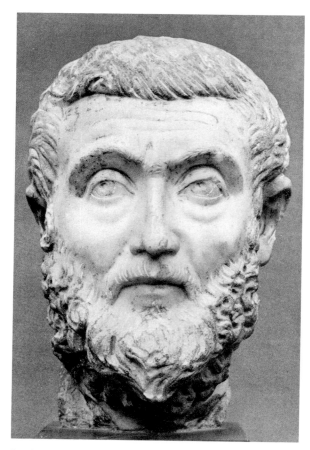

346 Portrait of an old man (Frankfurt, Liebighaus)

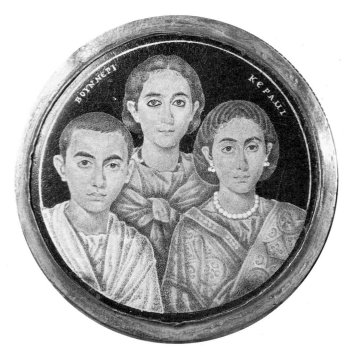

347 Portrait of a woman and children, painted glass, reset (Brescia, Civic Museum)

cophagus had reached its destination. (This example was found in Tarsus, in eastern Turkey.) Clearly it would have repeated the design of three garlands supported by Cupids and winged Victories which appears on the front. The heavy gabled lid is also characteristic of this type of Asiatic sarcophagus; and here too the pattern of 'leaf tiles' had been left unfinished. Figures of mourning Cupids fill the acroteria at the front and scenes from the myth of Cupid and Psyche occupy the gables at the side. A particularly decorative feature of this sarcophagus is the narrow frieze of Cupids hunting wild animals which runs along the edge of the lid and offsets some of its severity.

349 Typically Asiatic features on this massive sarcophagus are the rich architectural background which is used on the front and sides and the choice of figured decoration. The figures are dignified and statuesque with plenty of space around them. On the front (where they stand against rather than under the colonnade) they are from a traditional repertoire: the Dioscuri, guardians of the soul on its journey, stand at each end. Sitting slightly elevated in the centre is a bearded philosopher-type man who seems to be reading to the veiled woman in front of him. Behind him stands another woman, resembling in her pose the goddess Artemis. The motif of figures standing in a rich architectural setting continues on to the left side where a veiled woman takes offerings of fruit to the small table which is

visible in the open central doorway of the tomb; a man watches on its other side. The back of the sarcophagus and its right side also share a theme—the hunt; on the back there are no architectural features, but vestiges remain in the niches above the side. The monumentality of the piece is shown by the other friezes—of animal combat, below the lid, and of Cupid hunters, charioteers, and athletes on the base at the back and sides. The lid was designed like a *kline* (couch) for the deceased, but in this case the figures are missing. The sarcophagus, and others of this type, combine the idea of the sarcophagus as a house (expressed in the architectural decoration and open door at the side) with the concept of it as a bed.

ATTIC SARCOPHAGI

350 This is a particularly grand example of an Attic *kline* sarcophagus of about AD 180. Here the couch-form is not just limited to the lid, but is carried through to the base, which is carved with a swag of fruit and foliage on three sides, and to the caryatids and herms which are the support figures. The front and two sides show fighting between the Amazons and Greeks, with Achilles and the dying Penthesilea on the left side. The figures are heroic in style and there is a good deal of vigorous action, with many of the engagements depicted according to well-established models. The back has a lively design of griffins prancing above garlands supported by an eagle. In contrast to the smooth classical forms in the friezes the figures on the lid appear gaunt and uncompromising. In fact they are unfinished in part, and it has been suggested that their carving could be the work of a local craftsman, finishing off the imported piece.

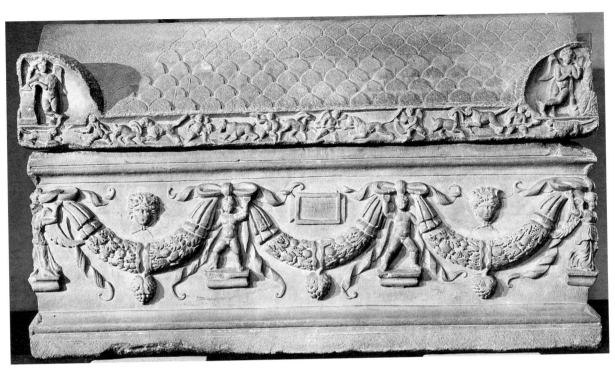

348 Garland sarcophagus (New York, Metropolitan Museum)

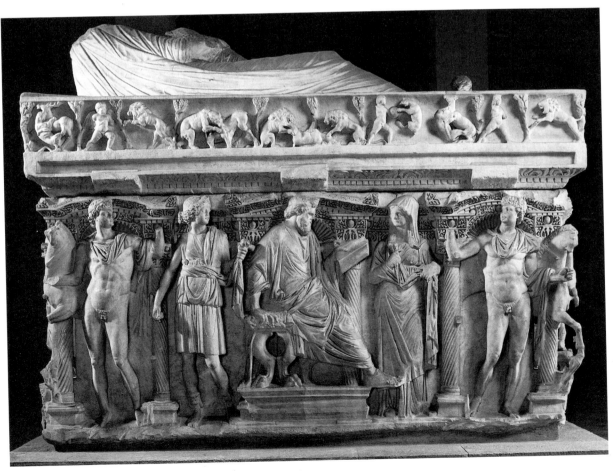

349 Sarcophagus from Sidamara (Istanbul, Archaeological Museum)

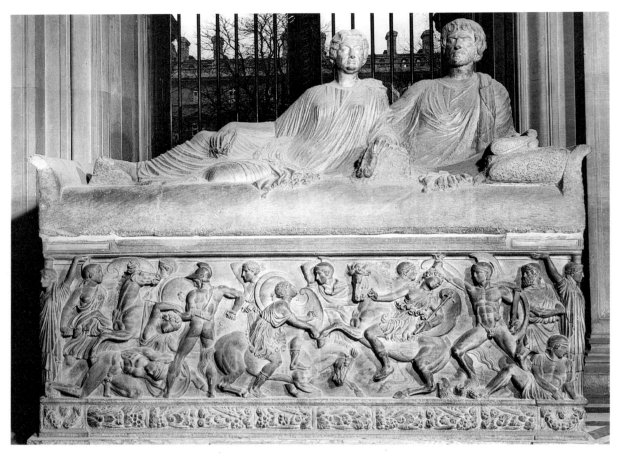

350 Sarcophagus: Greeks fighting Amazons (Paris, Louvre)

SARCOPHAGUS THEMES

Sarcophagi are also interesting for the content of their decoration. Although one may argue about the nature and extent of some of the symbolism, there are clear patterns in the development of themes and compositions. Some of these were taken from mythology, where a range of stories offered opportunities for significant narrative; others used generic scenes and figures like the Seasons; and another group developed themes from the life of this world. Practicalities affected the choice of some decoration; sarcophagi were expensive to produce, and some designs were clearly evolved to maximize customer appeal. Personalized touches, like portrait details, could be added on purchase to heads that had been roughly sketched out. The following examples were made in Rome.

351 The myth of Endymion was an obvious choice for the decoration of sarcophagi as it deals with themes of eternal rest and of the enduring power of love. The episode depicted shows the goddess of the moon coming upon the shepherd as he sleeps; she kisses him, and he forthwith enjoys eternal sleep and youth. Earlier examples like this narrate the event in relatively simple pictorial terms with a limited number of supporting figures: Aura (the personification of the breeze) holds the horses while the winged figure of Sleep pours a sleeping draught upon

Endymion. There are a few small figures which must personify the location, while winged Cupids indicate the romance of the depicted myth and—in the larger mourning figures at the corners—its funerary aspect.

This was made about AD 150–60. Later versions of the episode tend to be more ornate and packed with action and additional figures. A few other Endymion sarcophagi which focus on a centralized sleeping figure illustrate a further development in the treatment of myth on sarcophagi. This is the change from a narrative to a conceptual approach: it becomes more urgent to show underlying ideas rather than a sequence of events, so that the chief figures are shown abstracted from their natural narrative context. This process also occurs on sarcophagi which depict scenes from human life, as well as in other art forms like mosaic [312C].

352 The figures here combine two of the most popular subjects in the decoration of Roman sarcophagi—the god Bacchus and the Seasons. Together they express ideas about renewal and rebirth into the richness of life through union with the god. In this case the symbolism is even continued by the form of the sarcophagus, which is round-ended to resemble a wine-vat (*lenos*). Bacchic motifs were always common in Roman funerary art, but mythological scenes featuring the god appear with great frequency during the third century; this was made in the mid-century.

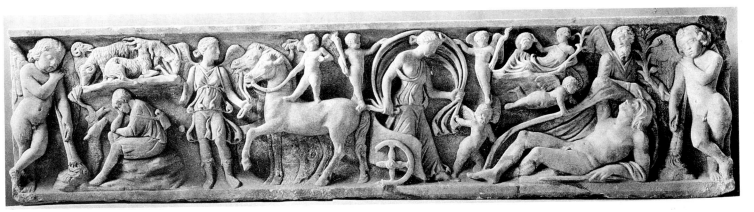

351 Endymion
sarcophagus (New
York, Metropolitan
Museum)

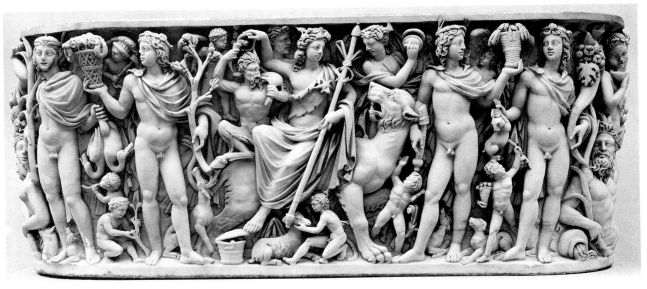

352 Badminton
sarcophagus:
Bacchus and the
Seasons (New York,
Metropolitan
Museum)

Their consistent imagery reflects a developed theology; in funerary terms many of the themes relate somehow to the idea of union of a mortal with the god, through a particular event (his union with Ariadne) or through the ecstasy which his followers experience in their festivities. This idea of apotheosis was sometimes emphasized by including a portrait figure or head. Here the element of mythological narrative has been eliminated so that Bacchus appears as an emblematic figure, seated on his leopard and flanked by the Seasons and the personifications of Earth and Ocean, who complete the concept of universality. This sarcophagus is justly famous for its elegance and the quality of its finish. Smooth, polished surfaces contrast with the deep undercutting of the background and with the drilling of rougher textures like hair. The figures seem ethereal, partly because they are elongated to suit the fashionably deep trough of the sarcophagus, and also because they appear remote from worldly concerns: the Seasons, for instance, hold out their produce at arm's length, as if to detach themselves from agricultural realities. Above and below the main figures the spaces are filled by busy Cupids and by larger figures (or part-figures) of followers of Bacchus. In short, this is very much a 'luxury' product—a sarcophagus for an aesthete.

353 Military victory, which formed a major theme in the official art of Marcus Aurelius, was the subject of a series of imposing 'battle sarcophagi' made in the last quarter of the second century AD. Their size—and here they also drew on the contemporary fashion for higher, larger reliefs—and the detailing and quality of the sculpture suggest that they were probably special commissions, rather than part of the general stock-in-trade. This splendid example may have been made for a general in the German campaigns. The lid shows episodes of his family life and of life in the field, while the main body of the sarcophagus depicts him on horseback at the centre of the throng. Although the whole of this relief is full of figures, twisted, tumbling, moving in all directions, it is possible to detect a main diagonal thrust in the action as the Romans move in from the left and the Germans collapse before them. Details are carefully indicated in an almost documentary fashion; although these

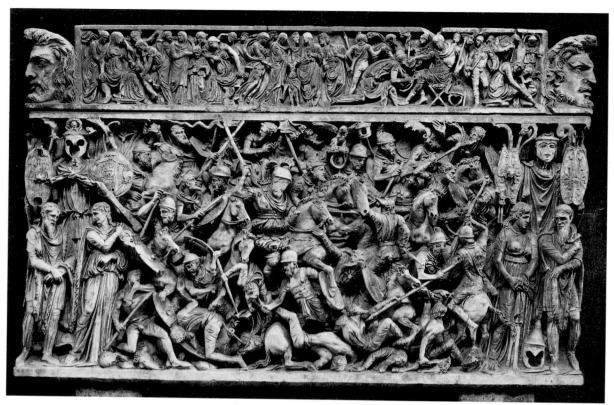

353 Battle sarcophagus, from Portonaccio (Rome, National Museum)

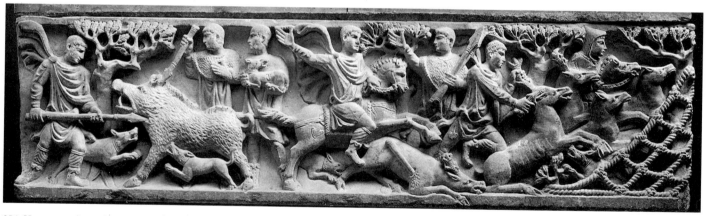

354 Hunt sarcophagus (Rome, Conservatori Museum)

reliefs follow in the Hellenistic tradition of dramatic battle compositions, they owe something to the approach of the imperial columns. Yet even if much of this decoration refers to the particular, it is lifted away into a wider perspective: the lid seems to be saying that there are other things in life than military victory, while the trophies of standing prisoners at each side show that there can be dignity in defeat.

354 The hunt is a popular theme on sarcophagi (as it is in other media); the qualities of courage and magnanimity which it extols in earthly life are given a new context in man's battle with death. It is a theme capable of containing more than one level of meaning and drawing on a range of artistic sources. The lion-hunt, in particular, is invested with special idealization: the hunter engages with the king of beasts, often witnessed by the personification of Virtus. The boar-hunt is often treated with greater realism, and with many of the same pictorial touches that occur in hunt mosaics. This example shows how effectively so many elements can be fused together in one powerful image: there are mythological echoes in the scenes of that boar-hunt on the left (modelled on Meleager and the Calydonian boar) and the capture of the stag at centre right (modelled on Hercules and the Cerynian hind), but the figure at the centre, with his upraised right hand, and conquered beast lying underfoot, has all the potency of a triumphant emperor (see [338]).

7 THE DIFFUSION OF CLASSICAL ART

JOHN BOARDMAN

THE history of classical art is far more than an account of the arts and crafts of the Greek and Roman world. At all periods the styles, techniques, and subjects of the craftsmen, through whose work we have defined and described the classical tradition, had an influence which went far beyond the borders of the Greek city-states and their colonies, far beyond even the yet broader boundaries of the Roman Empire. This chapter is devoted to some account of the effects of this diffusion within the period considered in this volume. In these years the effect is observed on peoples whose own record in the arts ranges from the high sophistication of the Egyptians, based on a tradition far longer than that of the Greeks, to the relative simplicity of, say, Etruscans and Europeans. Within this compass classical art had often to serve very different purposes from those for which it had been created. Some are purely decorative or narrative, many are religious. The mode of translation tells us something about both teachers and taught, and about the way in which styles and motifs pass between cultures. Our terminus is about AD 400, but this does not mark the end of the process. Already classical art, essentially 'pagan' in its outlook and purposes, had been recruited to serve the very different message of Christianity. It says much for its quality that such a different message could be successfully conveyed through the formulas and idioms created for a totally alien mode of thought and belief. The survival of classical art through the Middle Ages, its renaissance and subsequent rediscovery in neo-classicism, are subjects of other books, of many other books. And its continuing presence at the end of the second millennium AD is apparent to all who have learned something of its history, who can recognize its idiom and can use their eyes. The heritage is a live one, however little it may still hold of those principles which governed classical art in the centuries during which it evolved, and which we have tried to explain and illustrate in the previous chapters.

Greek arts were carried far from the shores of the Aegean in years very soon after their first Iron Age styles had been determined, in the Geometric period of the eighth century BC. Pressures of population and the opportunities for trade led to the establishment of colonies on the shores of south Italy and Sicily before 700 BC, and in the succeeding century these were reinforced, and the area of colonization spread into the Black Sea, along the North African coast, and, for a trading port, into Egypt. The demand for familiar objects guaranteed a flow of manufactured goods from the homeland, but a proportion of the emigrant population must have been craftsmen, and in their new homes the manner of their work changed gradually in response to local needs and sometimes in response to the taste of their new neighbours. Colonial styles were not always 'provincial' in the modern sense. There were areas of high achievement, most of them noticed in preceding chapters since they are essentially 'Greek', and the wealth of many of the colonies guaranteed ambitious patronage.

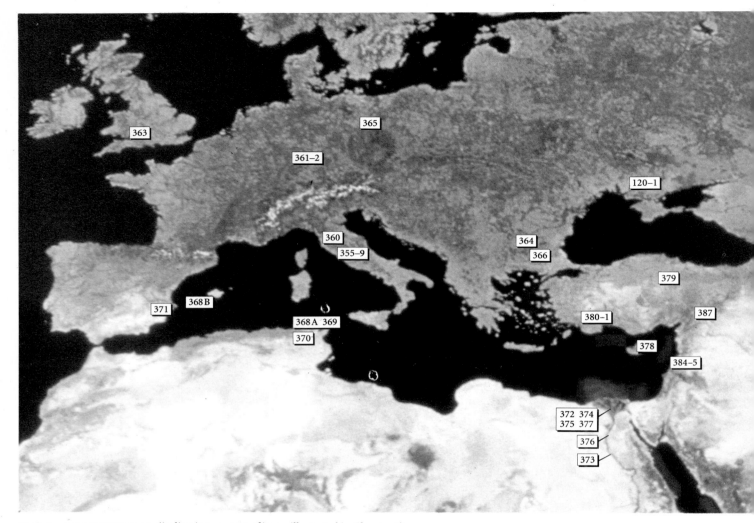

MAP 3. SATELLITE MAP (indicating sources of items illustrated in Chapter 7)

It is the effect of all this on non-Greek neighbours that is part of our quest in this chapter, but there were areas where foreign powers were themselves influential patrons. The Persian Empire had spread to the shores of the Aegean, embracing Greek cities on what is now the western coast of Turkey, by the end of the sixth century BC. For two centuries thereafter the Greeks were much involved with the Persians. Greek craftsmen and Greek loot went to Persia itself, while in Asia Minor the local vassal kingdoms and Persian governors were ready patrons for Greek arts. The most obvious example is the construction and decoration of the Mausoleum [113] for the Carian king.

Exchange and trade with neighbours could produce more interesting results, where the customer might either affect the nature of the product he received, or encourage his own craftsmen to imitate or to adjust native styles to the favoured Greek idiom. This is the process that is mainly responsible for the creation of Etruscan art, but the effect was less dramatic in other parts of Europe and western Asia.

The process did not stop with the period of Greek colonization and the city-states. When Alexander the Great marched to India a whole new chapter of superficial Hellenization of eastern arts began that was to be felt as far away as China and eventually Japan, but it was strictly superficial and owed nothing to the personal intervention of Mediterranean craftsmen rather than to shrewd and selective observation of their products by local artists. Much of this story belongs to the period of the Roman Empire, which embraced all the Greek world and spread its borders far beyond it in all directions (except the east).

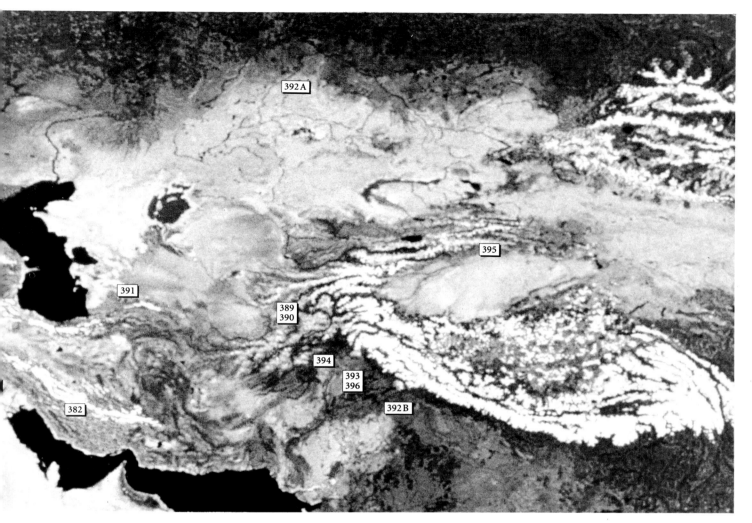

With the Roman Empire real 'provincial' classical arts become more clearly apparent. Non-Greek and non-Roman peoples were absorbed as citizens into the network of a single administration that ran from the Atlantic to Mesopotamia, from the Danube to the Nile. In some areas the quality and originality of work was high—we think of all the arts of the Greek homeland, of the sarcophagi of Asia Minor, of the colourful mosaics of North Africa and Syria. In the main cities of the richer western provinces life-style and art-style could be virtually metropolitan, but in Britannia, for example, few works of merit were imported and the local craftsmen offer at best interesting blends of Roman and native styles.

For non-classical peoples what is bought or borrowable in classical art is determined both by what is available and by what may seem required or usable. The choice and the medium of transmission both raise interesting questions about classical art and about the character of the receptive cultures.

How can 'art' or 'artistic influence' travel? Sophisticated new techniques of production, for fine jewellery or the working of difficult materials, have to be taught and cannot be learned from observation alone. In some areas, then, the presence of craftsmen has to be assumed, at least in initial stages. Decorative styles, forms, and motifs can travel readily enough on portable objects, provided that the objects themselves are of sufficient interest to generate demand, or serve desired functions. Architecture cannot travel, and major sculpture seldom travelled, but architects and sculptors can and did travel freely within the classical world and potentially outside it where there was patronage. St (Doubting)

Thomas was thought to have ended his architectural career in India. When the figures and subjects of narrative art travelled they would normally not be accompanied by labels, nor would their recipients have the texts which help us to recognize and understand subjects. This means that they could be either misinterpreted or, as was more often the case, reinterpreted to suit different needs. This could also happen when the original meaning was familiar, as in the use of pagan motifs by Christian artists, turning a Heracles, Hesperid maiden, and her tree with the apples and sacred snake into an Adam and Eve, or a group of the Seven Sages of Greece into Christ with his disciples. There is even a return of motifs from Christian art—the group of the Virgin and child serving as model for Hermes with the infant Dionysus.

The identity of the artists responsible for the diffusion usually escapes us, though their new patrons can more easily be located or imagined. Ancient texts tell us far too little about such matters and signatures on the relevant monuments are exceptional. The essential anonymity of so much classical art is even more apparent here. The decorative arts of the modern world are such a strange amalgam of the past, of new media, and of innovation for innovation's sake that it is not easy, even for archaeologists who have as it were lived with the past, to imagine the visual character of a culture whose arts enjoyed the overall unity of style and forms that obtained in classical antiquity, and the effect that such a unified scheme might have on contemporaries and on successors. Yet our understanding of the strong heritage of classicism must depend on our recognition of the power of such a unity. What we have tried to define and illustrate in other chapters we here see carried into other places and other times (some rather later than the limits set for earlier chapters).

ETRURIA

When the first Greek colonies were founded in central Italy in the eighth century BC, one of the attractions must have been the proximity of the metal-rich land of Etruria. It was populated by peoples known in the historic period as Tyrrhenoi to the Greeks, Tusci or Etrusci to the Romans. There had been contact with Greece before, in the Bronze Age, but any continuity there may have been thereafter was slight. By the eighth century the Etruscans had formed a loose confederation of states, north of Rome, which at that time shared their culture. They enjoyed considerable prosperity from their natural resources, but their arts were relatively unambitious, admitting only minor figurative or decorative pattern, and related more to those of European cultures to the north. The arrival of the Greeks introduced influential new styles by both objects imported and the presence of craftsmen, some of whom worked in Etruria itself. The only competing style was that of the Phoenicians, whose influence was profound but relatively short-lived and confined largely to the luxury arts. From the eighth century down through the Hellenistic period, to the rise of Rome, Etruscan art otherwise echoed Greek art. The artists, native and Greek, did not merely copy, but translated Greek forms and themes to suit the taste of a people temperamentally as unlike the Greeks as they could be. Without Greek art there would be no Etruscan art (or it would have been vastly different), but although it was wholly derivative it achieved an individuality that often appeals more directly to modern taste than the more controlled, 'classic' achievements of the Greeks. The products were generally looser in composition than the Greek, and sometimes thus appear the more vigorous. In craft techniques, notably in jewellery, they were supreme. If we judge their work more colourful than Greek, this may be simply because of the nature of what has survived from each culture—Etruscan wall-paintings against Greek stone statuary, bleached by time. But this is an area in which the diffusion of Greek art can truly be said to have been wholly responsible for the creation of a new art.

355 Greeks from Euboea were the first to settle near the Etruscans, on the island of Ischia, off the Bay of Naples, and then on the mainland. Their products were the first to be influential, but in pottery the pervasive influence of Corinthian wares determined the appearance of most figure-decorated Etruscan pottery for some two centuries. The Corinthian animal style in black-figure, for example, becomes strangely transmuted. On the vase shown here, copying a Corinthian shape of around 600 BC, the animal and human figures have acquired new, unrealistic proportions and unrealistic patterns which remove them a stage further away from the eastern arts which had inspired the

355 Etruscan black-figure vase (London, British Museum)

Greek. In the sixth century, when Athenian vases take over markets formerly dominated by the Corinthian, it is Athenian styles that are copied, but there is an important influx of artists also from east Greece, especially in and after the mid-century. These are part of the diaspora of Ionians, probably displaced by the Persians, which is also responsible for new trends in the arts of Athens itself, mainly in sculpture. But this east Greek incursion is to have a more profound effect on the appearance of the arts in Etruria and goes far beyond pottery styles.

356 (A = **Colour Plate XXV**) A Corinthian noble, Demaratus, was said to have emigrated to Etruria, to Tarquinia, in the mid-seventh century, there to develop a prosperous business and become father of the fifth king of Rome. He took with him a painter and three clay-modellers who 'introduced modelling to Italy'. In a country innocent of statuary marble (the Carrara quarries to the north were first exploited much later) major works of sculpture, in the round or as architectural decoration in

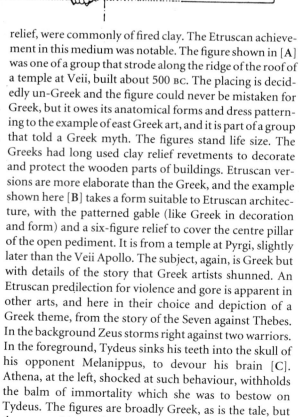

B

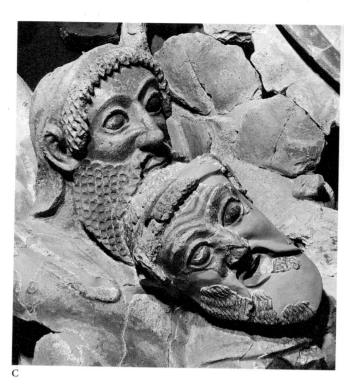

C

356 B, C Etruscan clay group from temple at Pyrgi (Rome, Villa Giulia)

relief, were commonly of fired clay. The Etruscan achievement in this medium was notable. The figure shown in [A] was one of a group that strode along the ridge of the roof of a temple at Veii, built about 500 BC. The placing is decidedly un-Greek and the figure could never be mistaken for Greek, but it owes its anatomical forms and dress patterning to the example of east Greek art, and it is part of a group that told a Greek myth. The figures stand life size. The Greeks had long used clay relief revetments to decorate and protect the wooden parts of buildings. Etruscan versions are more elaborate than the Greek, and the example shown here [B] takes a form suitable to Etruscan architecture, with the patterned gable (like Greek in decoration and form) and a six-figure relief to cover the centre pillar of the open pediment. It is from a temple at Pyrgi, slightly later than the Veii Apollo. The subject, again, is Greek but with details of the story that Greek artists shunned. An Etruscan predilection for violence and gore is apparent in other arts, and here in their choice and depiction of a Greek theme, from the story of the Seven against Thebes. In the background Zeus storms right against two warriors. In the foreground, Tydeus sinks his teeth into the skull of his opponent Melanippus, to devour his brain [C]. Athena, at the left, shocked at such behaviour, withholds the balm of immortality which she was to bestow on Tydeus. The figures are broadly Greek, as is the tale, but the composition and treatment are not.

357 The arts of gem-engraving were brought to Etruria from east Greece at the end of the sixth century. It was to prove a craft that captivated the Etruscans, who had already shown their skills in fine jewellery, far more elaborate than the Greek, and owing much to Phoenician example in both techniques and forms. For their gems the Etruscans held to the scarab shape right into the Hellenistic period, while the Greeks changed their preferred shapes and styles [117]. They elaborated the scarab backs far more than the Greeks, making them more like jewels and often setting them in precious metal mounts of equal elaboration. They also especially favoured the use of a deep red carnelian (perhaps the colour was artificially heightened) where the Greeks were more eclectic with their materials. The late Archaic Greek styles of cutting were adopted and died hard, but were slowly replaced by Classicizing works closer to the contemporary Greek. There is a sharpness and almost ostentatious miniaturist quality about Etruscan scarabs which makes them among the most prized examples of ancient art. The example shown is little over half an inch high (1.42 cm.). The athlete scraping himself with a strigil is a Greek subject, given a mythical identity by the inscription, which identifies the figure as Tydeus (Tute)—in an alphabet, notice, derived from Greek. This is the same Tydeus as on [356 B, C], more pleasantly occupied. The Etruscans knew Greek art well, and Greek myth comparatively well; at least they had their own translations

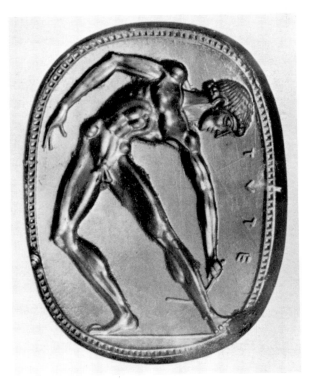

357 Etruscan scarab (Berlin, Staatliche Museen)

for most Greek myth names. They were not, however, always applied appropriately and although Tydeus (in common with most Greek heroes) had a good athletic record, we are not bound to think that the Etruscans had a special regard for him in this light, rather than that the artist enhanced a stock Greek motif with a prestigious and familiar name. The fine delineation of the youth's musculature and pose is as late Archaic Greek, probably cut within the first quarter of the fifth century.

358 Etruscan mirrors like Etruscan scarabs are prime media for Etruscan art, the mirrors decorated with the finest linear incision and again deriving from Greek types. This style of decoration was not, however, confined to mirrors but enjoyed a larger field on cylindrical boxes (*cistae*) such as the one shown here, one of the most famous—the Ficoroni *cista*. The finest *cistae* were made in Praeneste, a Latin state related to Etruria rather as was early Rome. Indeed this piece was, as its inscription tells us, made in Rome by one Novios Plautios, apparently an Italian freedman of the Plautii family, to be given by a Praenestine to his daughter. The subject is Greek, the athletic contest with King Amykos in the course of the Argonaut expedition [A], and it is executed in a purely Greek Classical style of the later fourth century. Many scholars have thought that it derives from a panel painting, perhaps a Greek import to Rome which would account for the unexpected information offered in the inscription. The lid handle takes the form of three bronze figures [B]. These little bronzes are another Etruscan speciality, used as handles, or as supports and attachments to other pieces of furniture such as lampstands and bronze vessels. Their styles and subjects

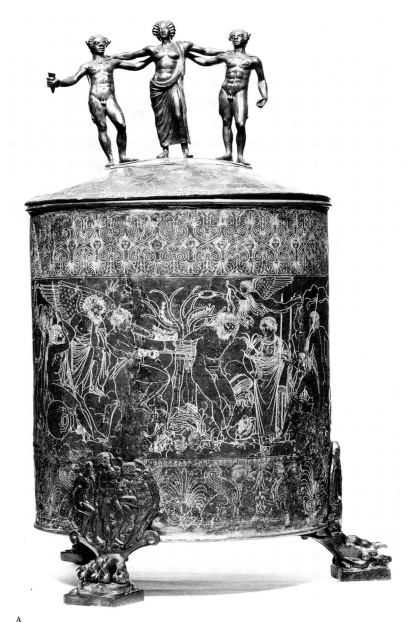

A

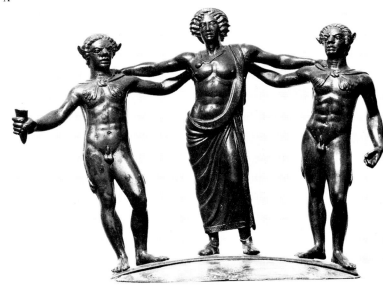

B

358 Etruscan (Praenestine) bronze box, the Ficoroni *cista* (Rome, Villa Giulia)

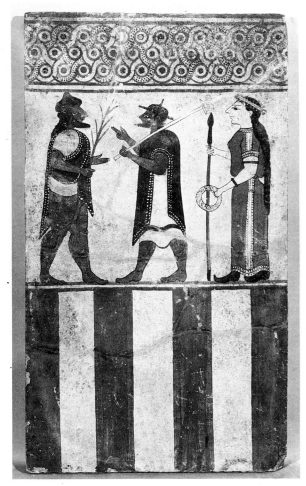

359 A Etruscan clay 'Boccanera slab' (London, British Museum)

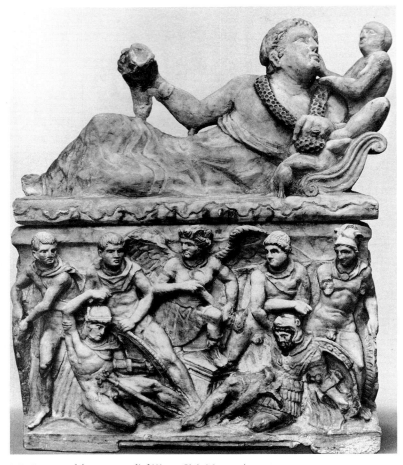

360 Etruscan alabaster urn relief (Siena, Civic Museum)

are generally Greek, rendered with that sharp polish and detail, often with a certain flourish in the dress, which seem hallmarks of Etruscan art.

359 (B = **Colour Plate XXVI**) The major burials of many Etruscan cemeteries were in built tombs of a type unknown in Greece before the Hellenistic period, although they have their kin in Asia Minor. They attracted elaborate wall-paintings and have thus preserved for us the record of an art of which little enough survives in Greece for the Archaic and Classical periods. The styles of the paintings, which begin by about 650 BC, soon come to follow Greek styles and often copy Greek subjects, but adding peculiarly Etruscan demons. The scale of the paintings makes them a better demonstration of the vivacity of Etruscan art than the smaller vases or finer miniaturist arts. For a while in the sixth century painted clay slabs are used, and one shown here [A], of about the mid-century, is from a series (the 'Boccanera slabs') from Cerveteri. The relationship of the style to that of contemporary Greek vase-painting is clear, yet these figures are equally clearly not by Greek hands. The general style is east Greek, as is the

fine cable pattern over the figures. By the end of the Archaic period far more elaborate compositions spread over the tomb walls. [B] shows dancers from the Tomb of the Banquet at Tarquinia of about 470 BC. They clearly derive from Greek models but show no heart for current Greek interests in anatomical plausibility in figure and movement, and instead offer supple but boneless figures dancing with a flourish of fingers, limbs, and dress in a grove of emaciated, jewel-like trees, which are quite un-Greek. The tomb paintings of Etruria continue through the Hellenistic period, sometimes showing some awareness of new Greek styles of drawing, with shading and highlighting of detail, though never approaching the more significant new styles which we first glimpse in the Macedonian graves of the fourth century [144–5].

360 Stone and clay sculptures, in the round and in relief, continue to serve Etruscan burials into the Hellenistic period in Classical styles applied to monuments of types barely matched in Greece itself. Ash urns with relief-decorated fronts, and sometimes a portrait of the dead shown reclining on the lid, are a characteristic form. A special

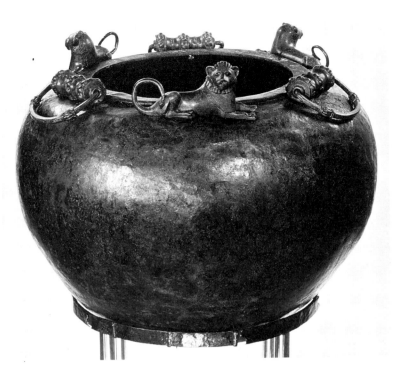

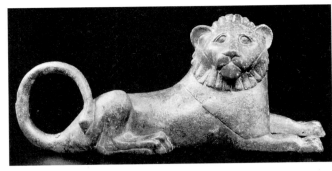

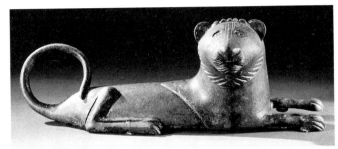

361 Greek bronze cauldron from Hochdorf (Stuttgart, Württemberg. Landesmuseum)

group, made of alabaster, come from Volterra. The second-century example shown here carries a Greek mythological scene, involving the Seven against Thebes, but the figures are disposed in a manner which seems to presage the Roman historical reliefs [231]. In this respect, as in some aspects of portraiture, we find the Etruscan treatment of borrowed arts making an original contribution to the development of classical art in the hands of others—the Romans.

EUROPE

Central Europe, beyond the shorelines colonized by Greeks, was the home of an austere but by no means backward society in the years when Greek goods first made their way over the Alps or up the Rhône. Arts were relatively unsophisticated, and decorative styles owed most to that community of style that flowed from the steppes of Asia across Europe, and which emerges as an 'Animal Style' or varieties of Celtic or Nordic art. The massive Greek cauldrons [59] and other luxury goods that travelled, by gift or exchange, into Europe in the sixth century BC found their way into graves otherwise equipped with cast and hammered metalwork of forms quite different from the Greek. The largest are bronze buckets as large as dustbins, which perhaps encouraged the taste for the outsize in Greek bronzework. There was occasional response to the Greek forms in the sixth and fifth centuries, and

some of the bronzework accommodated translations of Greek decorative patterns. Around the north Adriatic there was some finer decorative metalwork with figure subjects in the so-called Situla Art of the sixth to fourth centuries BC. This, inevitably, was not unaffected by the proximity of the Hellenized styles of Etruria.

With the Rhine and the Danube (and Hadrian's Wall) as its northern frontiers, the Roman Empire brought to the outlying provinces classical crafts that were locally practised with varying degrees of assimilation to local taste, and frequently with a degree of impoverishment in style and understanding of subject. The presence of these arts in areas which were to become dominant even on Mediterranean shores in later centuries was influential for the further development of European arts, but not a subject for this volume.

361 In 1978–9 a new princely burial was discovered at the site at Hochdorf (between Stuttgart and Karlsruhe). The majority of the finds, of gold and bronze, were of local manufacture, but with them was a bronze cauldron which is clearly Greek. Though of barely half the capacity of the Vix crater [59] it is still enormous, holding some 500 litres. Its shoulder is decorated with three figures of reclining lions of a familiar Greek sixth-century type. Two of them (one shown here) are pure Greek, though slightly differing one from the other. The third adopts the same pose as his companions but is completely different in style. It must be a replacement for a damaged Greek original, made by a local craftsman who declined simply to cast from the

362 Satyr heads, **A** Greek and **B, C** Celtic derivatives
A · B · C

Greek beasts or even to attempt to copy anything more than the posture and features of their manes. Instead he created a figure in an idiom to which he was accustomed, and which is very far removed from the broadly orientalizing style of the Greek. The forms are smooth and undefined, the proportions unreal, yet the result is strong and individual, not a mere pastiche; a good example of borrowed Greek form but total independence of style.

362 The Celtic art of Europe from the fifth century BC on displays an amalgam of animal and floral decoration not unrelated to the Animal Style of the eastern nomads, but tending more to the purely abstract. Greek and Etruscan works were becoming well known to Celtic artists, and they borrowed a small range of decorative details, very rapidly translating them so effectively that it takes some pains to rediscover their classical origins. Unlike Etruscan artists, they succeeded in translating classical motifs and absorbing them into a brilliant and wholly individual new style that survived to serve Christian art in Europe with no loss of vigour. In both Greece and Etruria it was not uncommon to use a satyr's head as the decorative attachment to the lower end of a jar handle [**A**]. Celtic artists used the motif in the same or comparable positions. On a Celtic flagon from Kleinaspergle, not far from Hochdorf [**B**], the device shows its origins clearly enough for all that the parts, moustaches, hair, and beard, have become detached and reincorporated as a form of floral embellishment. Later, on a gold finger ring from Rodenbach [**C**], further disintegration of the motif and some additional features from classical scroll patterns have left the classical original far behind though still discernible. Meanwhile, in the Greek world, the motif had simply been upgraded to a fully classical rendering [**146**].

363 The decoration of the façade pediment of the temple at Bath demonstrates very well how much classical art and

iconography had penetrated even to Roman Britain, and how it could be adjusted to local needs. The temple was dedicated to Sulis Minerva, a conflation of Roman Minerva (Athena) with the local goddess of the spring. In the first century AD a temple and bath buildings were erected north and south of the spring, and in about AD 200 the temple was enlarged and given a striking new façade. The great head in the central disc represents, in classical terms, the sea god Oceanus (compare [**320**]), but he is translated here by being given attributes of the Gorgon-head Medusa—wings in the hair and knotted snakes at the neck. There may be some specific Celtic identity intended, but the general implication of water and terror would suit a motif which is intended to protect the temple and the waters of the spring, an apotropaic function sometimes exercised by images in this position. But if this is so, it is surprising to see it supported in a multiple wreath by two winged Victories. This is a scheme which, in the Mediterranean world, is used especially on sarcophagi to support a wreath or shield, sometimes including the bust of the dead, and the whole pediment at Bath is almost like an adjusted relief from a sarcophagus. We shall find a yet stranger application of the Victories and wreath motif more than 5,000 miles away [**395**].

THE BLACK SEA

The Greeks were planting colonies on the shores of the Black Sea in the seventh century BC, generally near the mouths of the great rivers that gave access to the peoples of the hinterland—the Danube, Dniester, Dnieper, Don, and Phasis, with a cluster along the Hellespont and around the straits at the east of the Crimea. To the west lay the Thracians of the upper Balkans, an area rich in metals and metal technology and occupied by warrior kingdoms which

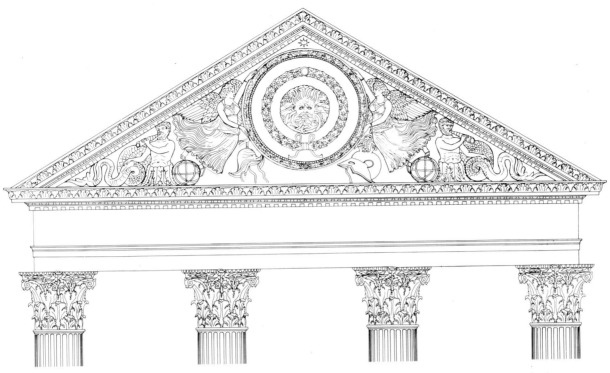

363 Pediment and head from temple at Bath, England

acquired in their wanderings elements of Mesopotamian arts that they had wedded to their own superb expression of the Animal Style arts of the steppes, their original home. It was a style that tended to translate natural forms into animal bodies or limbs, combined with a great flair for pattern. It was best expressed on the small objects that a nomad life would require, notably horse harness. Fine Greek works were sold or given to the Scythians, and were manufactured for them in the colonies [120–1], where an attempt was made to assimilate the precision and near-naturalism of Greek forms to the more impressionistic and illogical forms of the Animal Style. The results are admirable in terms of ingenuity and technique but in terms of style succeed only in losing the essence of both. No compromise seemed possible between two such strong and incompatible formal idioms: it makes the Celtic achievement the more admirable. In the Classical and Hellenistic periods Greek forms became more dominant in the coastal areas, but neither the arms nor the arts of the Roman world made much impact in an area where eastern peoples and interests began again to play a leading role.

364 The kingdoms of Thrace in the fifth and fourth centuries seem to have attracted rich objects from both the Greek and the Persian worlds. These are known principally from hoards of silver vessels, several found in recent years. From them we can see that the local craftsmen could adapt the foreign shapes and motifs to their own ends, so

were intolerant of Greek (and Persian) interference and where Greek goods and styles penetrated with some difficulty. To the north the Scythians, a formerly nomad people who had settled in the plains of the Ukraine and south Russia and to the east of the Crimea, had already

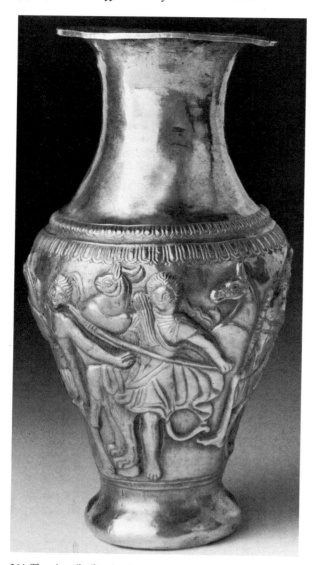

364 Thracian gilt silver jug (Rogozen Museum)

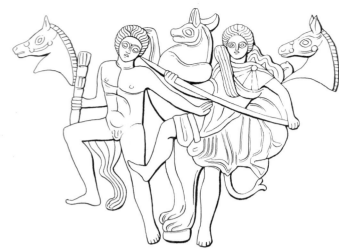

that although forms and figures can be understood in terms of Greek art, their new functions require a different explanation. The Rogozen hoard of 165 vessels (weighing some 20 kg.) was found in 1986; it had been buried in the fourth century BC. The shape of the jug shown here is Greek in origin. The thrice-repeated group on the body shows, in Greek terms, Heracles fighting an Amazon. But he is young, his lion-skin reduced to a leg dangling meaninglessly from behind one thigh, and he seems likely to be killed. She seems assisted by a rearing horned lion between them—an eastern monster that Greeks too would associate with Amazons, though the horse head behind her was a commoner attribute. And although the group is broadly Greek in the posture of the figures it does not copy any common Greek scheme for the scene. The subject that in Greece could be used to demonstrate Greek success over

orientals seems here to have been deliberately inverted: the medium and the significance of the figures may be the same but the message is quite changed.

365 The introduction to this section remarked the characteristic Animal Style and Scythian treatment of animal bodies, repeating parts, and translating members into other animal forms with utter disregard for anatomical plausibility but a superb sense of pattern. When Greeks made precious objects for Scythians they could go only half-way to satisfying the different aesthetic; they applied the right surgery but ignored the compositional idiom. The gold fish shown here is a piece of decoration from horse harness of Scythian type, found in a grave or hoard of Scythian objects, rather far from the Scythian homeland, in west Poland (Witaszkovo/Vettersfelde). It was made by a Greek craftsman, probably in one of the Black Sea colonies, in the later sixth century BC. The form of the fish's tail is echoed by the spread wings of a flying eagle and the tail-tips turned into rams' heads. Otherwise the body is simply used as a field for the conventional display of Archaic Greek groups of fighting animals and, below, a merman in a shoal of fish.

366 The great tomb paintings of Macedonia of the later fourth and third centuries BC offer the best of contemporary Greek styles [144–5]. Thracian neighbours also sometimes made built tombs, suitable for mural decoration, such as the one at Kazanlak in south Bulgaria, from which this detail is taken. The quality hardly matches Vergina but the techniques, with bold contouring, linear hatching, and some highlighting to indicate rotundity, are in the Greek manner, and if this is not the work of a Greek artist he was surely Greek-trained.

367 Ancient Colchis, south of the Caucasus and abutting the eastern shores of the Black Sea, was rich in metals and had a long history of advanced metal technology. To

365 Graeco-Scythian gold horse harness
(Berlin, Staatliche Museen)

366 Thracian tomb painting at Kazanlak

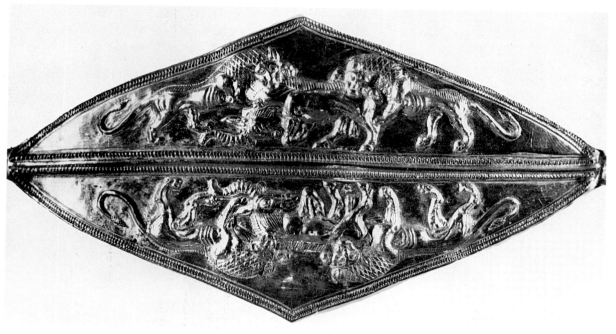

367 Graeco-Colchian gold diadem (Tbilisi Museum)

the Greeks it was the goal of their hero Jason's search for the Golden Fleece, and they visited and probably settled in Colchis at the time of their further exploration of the Black Sea shores. Native crafts, related to both the Scythian and Persian, display a strong individuality and absorbed Greek forms, rather as the Thracians had, but without developing any new, local figure style. From the fifth century BC there are finds in graves, notably at Vani, about sixty miles from the sea, which suggest that east Greek artists were making jewellery for Colchians. The pieces are not Greek in form (and not always certainly Colchian) but the styles of decoration were native to those parts of the east Greek world in touch with Lydia and, by this time, its heavily Persianized arts. The gold diadem of which a detail is shown here is of a shape met only in Colchis. The decoration of animal fights on the diamond-shaped plaque is an old eastern one, but the composition, poses, and execution betray Greek hands.

THE WESTERN MEDITERRANEAN

Greek ships and goods penetrated west and south of the Italian peninsula, but most of the coasts and islands, and therefore shipping lanes, were dominated by others, notably the Phoenicians. The latter had voyaged west as soon as the Greeks and were as quick to trade, slower to settle. Although the Greeks placed colonies on the northeastern coast of Spain and in south France (whence the Greek goods that passed on into Europe and which we

have already discussed), these carried little to prove influential in local crafts. The Phoenicians settled Carthage (near Tunis) at about the time the Greeks started settling in Italy. The culture they carried from their eastern homeland (the Lebanon–Israel coast) was heavily Egyptianizing, but the routes and interests they shared with the Greeks meant some mixture also of culture, which becomes more apparent in the fifth century and later. Greek artists could be employed for special commissions in Phoenician cities, such as perhaps the Motya marble [88]. A geographer tells us that Phoenician ships carried Athenian pottery down the Morocco coast, which is a tribute to the quality of the merchandise as well as being a commentary on command of trade routes. Carthage challenged and was overwhelmed by Rome in 146 BC. The new North African provinces of the Roman Empire were rich and graced by imperial architecture and mosaic decoration as good as most in the homeland, but there were lingering traces of the Carthaginian past and even the nomad Berber neighbours were not untouched by the arts of the classical world.

368 To the archaeologist, the most characteristic items of Phoenician trade are trinkets and jewellery, bazaar goods. In the fifth and fourth centuries these Phoenician products take on Greek features more readily than do their more substantial religious monuments. Thus, a gold ring from Utica, just north of Carthage, is of the native form but carries a Greek satyr [A]. A large number of green stone scarabs are common finds on Phoenician sites and these bear motifs which derive from Greece, as well as

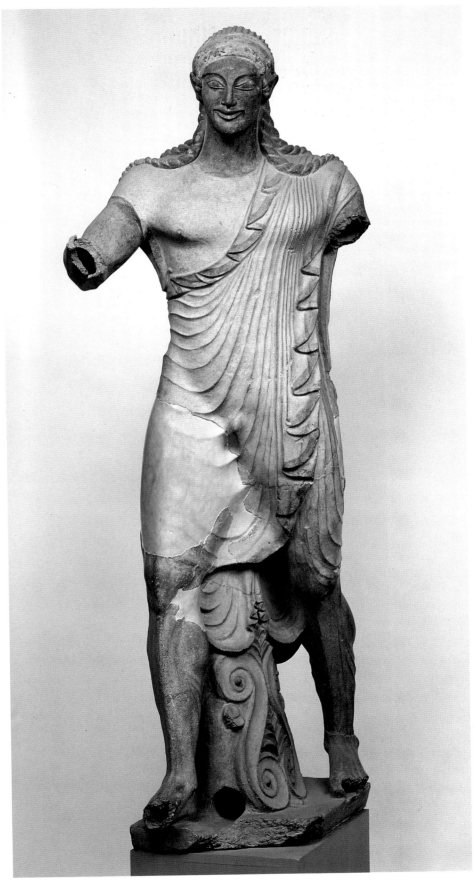

PLATE XXV

356A Etruscan clay Apollo from temple at Veii (Rome, Villa Giulia)

PLATE XXVI

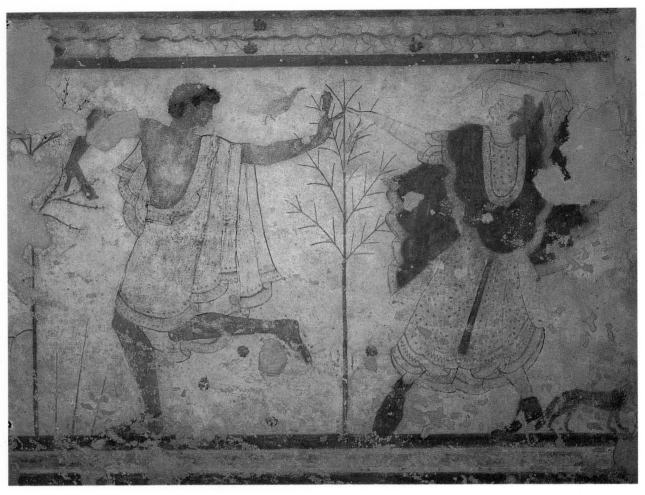

359 B Etruscan painting from the Tomb of the Banquet at Tarquinia

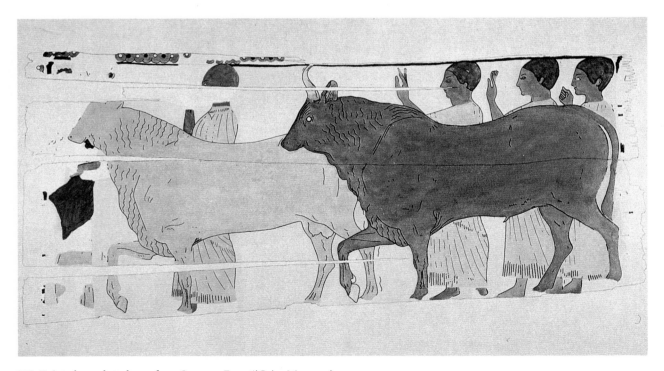

372 Painted wooden plaque from Saqqara, Egypt (Cairo Museum)

PLATE XXVII

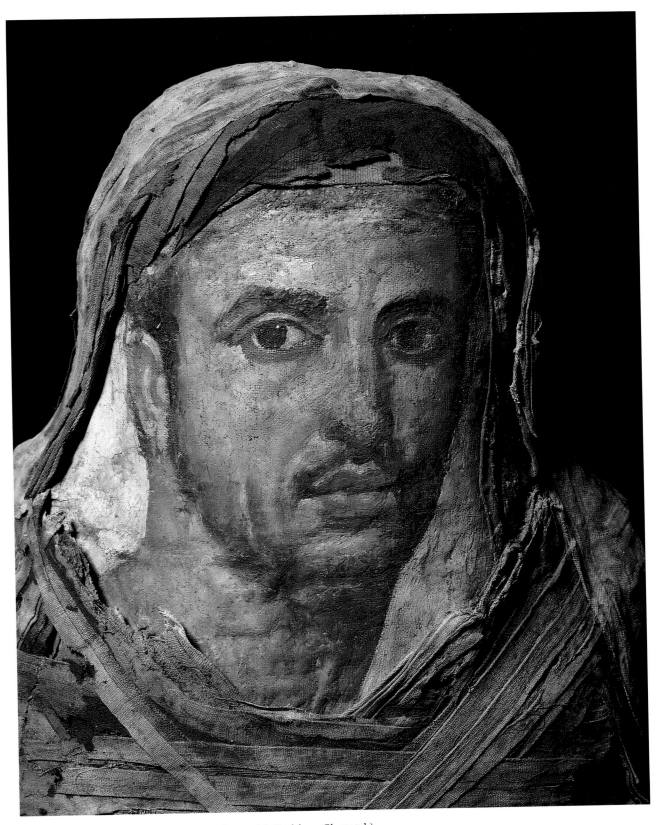

376 Painting from a mummy-case (Copenhagen, Ny Carlsberg Glyptotek)

PLATE XXVIII

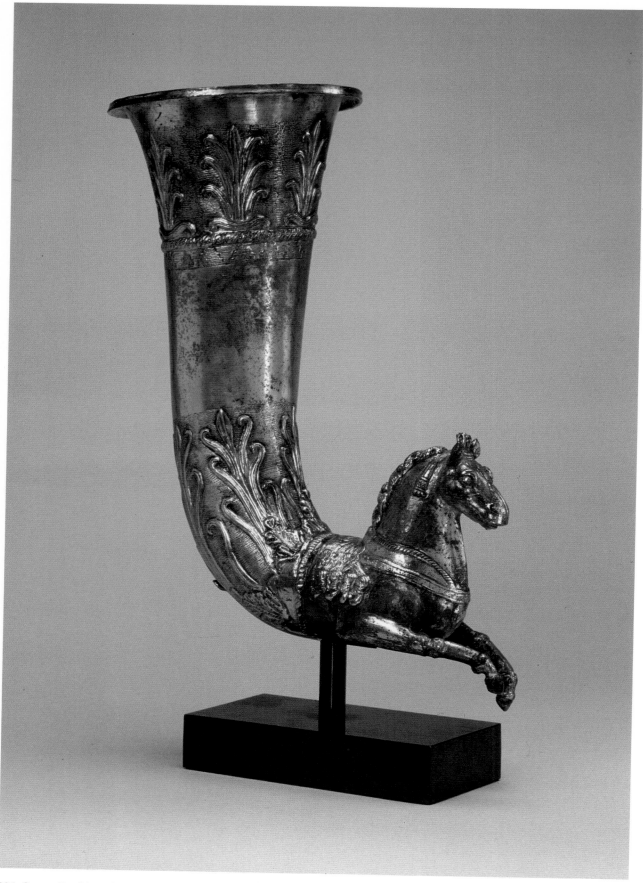

386 Graeco-Parthian silver-gilt rhyton (New York, Shelby White Collection)

A

B

from Egypt and the Levant. The device on one shown here [B] is from Ibiza, which was an important Phoenician settlement, and similar pieces are well known in Spain, Sardinia, and Carthage, as well as in the eastern Mediterranean. The subject, a horseman, warrior, and his dog, is essentially Greek in mood and detail, though it might well have been cut by a non-Greek hand.

369 Carthage was slow to accept more than the superficialities of Greek art—architectural detail, the forms of mass-produced classical clay figurines, little more. But by the Hellenistic period the pervasive effect of classical art had a more profound effect. There had always been some measure of assimilation of local gods to Greek, and it proved possible to accept the Greek goddess Demeter virtually as a native. The monument shown here takes a Greek form in terms of its architectural detail, though mixing Doric (capitals) and Ionic, and of the figure of the goddess shown upon it. It was dedicated to Persephone, Demeter's daughter and partner at Eleusis, by the Carthaginian joint-king ('suffete') Milkyaton, probably in the third century BC.

370 The architectural patterns of the classical world were not borrowed only to embellish minor monuments, although major architecture in the classical style in Carthaginian lands had to await the rule of Romans. This monument, however, at Dougga (Tunisia) is composed of classical architectural orders and statuary, in the round and in relief, of fully classical style. The form, with its pyramidal roof and stepped outline, is a monumental version (21 m. high) of smaller Punic tomb markers. Inscriptions

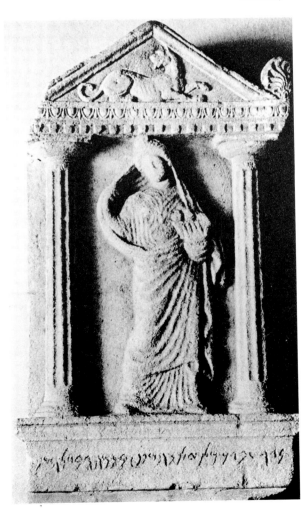

369 Punic votive
stele from Carthage
(Turin, Antiquities
Museum)

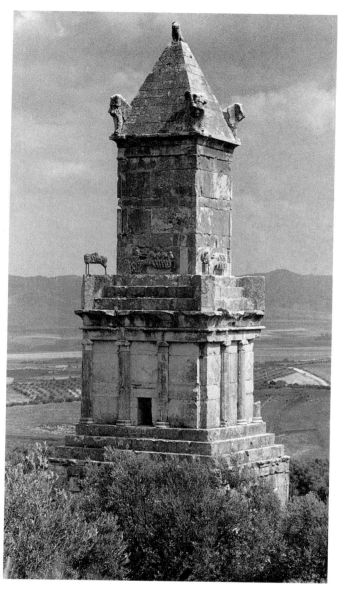

370 Tomb at Dougga (Tunisia)

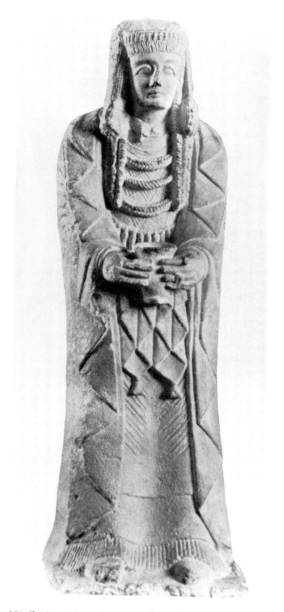

371 Iberian statue of a woman from Cerro de los Santos (Madrid, National Archaeological Museum)

on it (in Libyan and Punic) show that it was the tomb of a local ruler of the second or first century BC, but its architect was Punic, Abarish, son of Abdashart, as well as his assistants and the masons. Even for monumental architectural essays in the classical manner the presence of Greek or Roman architects was not indispensable.

371 This stone statue of a woman holding an offering bowl is one of a rich series found at Cerro de los Santos in south-east Spain. At first sight the staring eyes, zigzag pattern of folds, and the fringe of the undergarment over the feet recall Archaic Greek statuary (as [48]), and this must be the ultimate source for these forms, although it is commonly thought that it was not carved before the fourth century BC and some have argued for an even later date. The way in which Archaic or Classical Greek fashions can

linger and re-emerge in places regularly exposed to Greek and other foreign influence is not easily explained. The south-west of Spain had nourished a rich and distinctive culture, the 'Tartessian', fed on the silver-rich valleys north of Cadiz. This had been sought out by Phoenicians from the later eighth century on, and the easterners had a more profound effect on local styles in stone sculpture than did anything Greek. But although Greeks had been excluded from this trading area, Greek art had its effect as soon and decisively as it had in the Phoenician colonies. However, the effect is haphazard, and we find strongly Hellenizing works such as this, or the famous classicizing bust of the Lady of Elche (in Madrid), beside crude but exciting and original works of 'Iberian' art, and both styles can be traced down into the period of Roman domination.

EGYPT

In the seventh century BC Greek mercenaries came to Egypt to fight for the Pharaohs in civil wars and in the Levant. Some were permitted to settle, and by the end of the century one site in the Nile valley, Naucratis, was occupied and destined to be designated by the Egyptians as the sole entry for trade from the Greek world. In Egypt the Greeks, mainly from the eastern shores of the Aegean, encountered an old civilization, rich and introspective in its society and arts. From it they were soon to learn lessons that would profoundly affect their own arts of sculpture and architecture, as we have seen. From them Egypt had nothing of note to learn although immigrant artists absorbed something of Egyptian styles and media. In the fifth and fourth centuries the land was part of the Persian Empire.

Only with Alexander the Great did the Greek presence become influential. He annexed the country, founded a new capital on the coast at Alexandria, where he was to be buried, visited the oracle site of Amun (Ammon to the Greeks) in the western desert, and declared himself a god. His successors, the family of Ptolemy, adopted Egyptian court manners, even to marrying their sisters, but were of Macedonian blood, and the Hellenistic culture of Egypt made in its arts few compromises with the traditional styles which were still practised. Yet on this foreign soil were established significant new Greek studios which made important contributions to the development of Greek art.

372 (Colour Plate XXVI) The diaspora of the Ionians in the sixth century, which carried their artists to mainland Greece (especially Attica) and to Italy, also touched Egypt. This wooden plaque is from Sakkara, a Nile delta site well supplied with Greek goods. The technique and, to a degree, the subject-matter—a sacrificial procession—are Egyptian but the style is purely Greek. It is very closely related to the style of the 'Caeretan hydriae' [71] which were made at about this time or earlier (late sixth century) in Etruria in the more familiar Greek vase-painting technique. The wooden plaque, well preserved in the dry conditions of Egypt which are friendly to such materials, offers a view of a Greek painting style on wood which must have been common enough in the homeland also.

373 Petosiris was a priest of Thoth and local dignitary at Hermopolis in Middle Egypt, 250 miles south of Alexandria. He had lived, and complained, under Persian rule, but lived to see and, it appears, profit from Greek rule before his death somewhere around 300 BC or soon afterwards. The decoration of his tomb betrays an interesting and, for Egypt, uncharacteristic degree of Greek artistic influence which may reflect the Hellenizing life-style of its occupant. The ritual reliefs are in the pure Egyptian man-

ner; others have figures and poses which go beyond the canonical Egyptian types and for their realism suggest close knowledge of Greek works; and the painted relief shown here, with the family at worship and sacrifice at the entrance to the tomb(?), presents them in a version of Greek dress, which they perhaps affected in life, and in essentially Greek behaviour (the style of sacrifice) and poses (e.g. the woman leaning on a pillar). The work is clearly not from Greek hands, but other reliefs in the tomb show craftsmen making gold and silver vessels of what must be judged Graeco-Persian type—animal-protome rhytons and an incense burner with an Eros atop. This remains an isolated phenomenon for Ptolemaic Egypt, in which the traditional Greek and Egyptian styles in art had the slightest real influence on each other. For the most part Greek kings and Roman emperors continued to be represented either in a pure classical style or as Pharaohs had been for centuries before.

374 The arts of portraiture had enjoyed a longer career in Egypt than in Greece, with varying degrees of attention to realistic presentation of features. The Egyptian sculptor shared the Greek interest in idealization but his aim was to create an image that expressed aspirations to eternal life rather than a quintessence of mortality. Under the Ptolemies we find works in Egyptian material and often with the Egyptian trappings of royalty which the Greek rulers had adopted. This is a black diorite head of the eighth Ptolemy (Physkon), who died in 116 BC. It is not quite a 'real' portrait in the Greek manner, recognizable from the king's coins, where he is shown without the Egyptian royal headdress; here his puffy features and bulging eyes are rather highly stylized.

375 Once Egypt had become a Roman province the classicizing styles of Augustan Rome are more apparent. The diorite head is from a figure posed frontally, a pillar at his back in the Egyptian manner (the top of it appearing at his neck; the head [374] was also pillared), originally inscribed in hieroglyphs with the man's name and rank. He was probably a priest or high official, possibly a military commander. His features are realistic, and the treatment of eyes, lips, and hair may owe as much to the example of Greek classical statuary as to the man's true physiognomy. The colour contrast is achieved through the difference between the polished black stone for the face and the rougher finish to the locks of hair and pillar. Diorite was a popular material for sculpture in Egypt, harder than Greek white marbles, and occasionally used in the Roman period for copies of bronze figures because the surface resembled the darkly patinated bronze of older statuary.

376 (Colour Plate XXVII) Mummification of the dead was an Egyptian practice adopted by some of the immi-

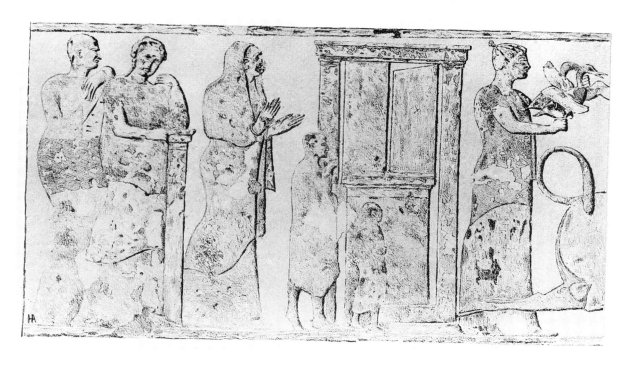

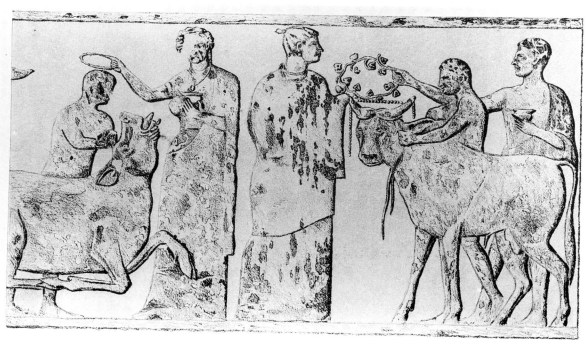

373 Painted relief from Tomb of Petosiris, Hermopolis

grant community. The Egyptian mummy cases had stylized sculpted heads, Greek versions of which had been made for Phoenician notables [384]. In Hellenistic Egypt the faces were modelled plaster masks. Under Rome, and in a restricted area of the Fayoum, some 60 miles south of Cairo, portraits painted on wood or linen were set in the mummy wrappings, executed in the encaustic technique, with heated wax, or in tempera. Some are stunningly realistic, among the best examples of classical portraiture to have survived from the Roman period.

374 Portrait of a Ptolemy (Brussels, Musées Royaux)

375 Portrait of an Egyptian (Brooklyn Museum)

377 The Copts were Egyptian Christians. Their art, mainly of the fifth to seventh centuries AD, is best known to us from relief sculpture, jewellery, and textiles. Despite their Christian faith a high proportion of the subject-matter of their works is pagan, sometimes closely following classical models of the Roman period, sometimes mis-understanding or even reinterpreting. The style, however, owes very little to the classical tradition and seems to express a form of folk art limply copying styles and subjects which no longer held any relevance to their society. The poses of the figures on this limestone relief derive from Greek art, and so presumably does the central group of a lady (perhaps Leda) defending herself from the importunate advances of a swan. This is rather like classical myth being played by puppets.

THE EAST BEFORE ALEXANDER

Greek enterprise in the east, perhaps as early as 1000 BC, brought about the orientalizing revolution in Greek art described in Chapter 2. In early years Greek influence in the east was minimal, and the easterner seemed mainly indifferent even to Greek decorated pottery. Only Cyprus, with its Greek Bronze Age heritage, gives evidence for the presence both of Greeks and of crafts influenced by Greek example. But the island was no less dependent culturally on its nearer neighbours, the Phoenicians who had also settled on Cyprus in the ninth century, and, for a while, Egypt.

Anatolia (Asia Minor of the Romans), homeland of the Bronze Age Hittite Empire, was a different matter. The Aegean is, in its way, a Greek sea, and its eastern shores (now west Turkey) had been well visited and perhaps fought over (Troy) in early times. By about 1000 BC new settlement from the Greek homeland (the so-called Ionian

377 Egyptian, Coptic relief (Oxford, Ashmolean Museum)

Migration) led to the establishment of wealthy new Greek cities—Smyrna, Ephesus, Miletus, and others—and settling of the offshore islands—Lesbos, Chios, Samos, Dorian Rhodes. Their story and their art form part of the history of the Greek world, but they were closer to powerful and sophisticated neighbours than were the Balkan Greeks. The empires of Phrygia in the eighth–seventh and of Lydia in the seventh–sixth centuries were oriental in character, forcing the Greeks to build cities that might withstand attacks of imperial Assyrian proportions, not the mere border raids of neighbours and nomads. The intermingling of the Lydian and Greek Ionian cultures in the sixth century produced a mainly luxury art in which the different elements are difficult to separate, but which was to make its mark in the Greek homeland and even Etruria. King Croesus of Lydia, from his capital at Sardis with the golden River Pactolus flowing by, made rich offerings to Greek temples. The poetess Sappho, on Lesbos, commented on the attractions of Lydian life. But the contribution of the oriental to the Greek, the Greek to the oriental, only became a live issue again when Croesus was defeated by the Persians, and the new empire of the east began to intrude on the life of the Greek Aegean world.

Though the Greek homeland repulsed the Persian invaders, at the battles of Marathon, then Salamis and Plataea, and even carried the fight across the Aegean itself, the eastern Greeks (Ionians and others) had fared less well, or sometimes accommodated themselves more readily to their new rulers. Ionian-Lydian masons and probably other craftsmen were taken to Persia itself to help form the

imperial arts of a people who had to rely on borrowed traditions for works of substance and show. Mesopotamian example was closer at hand and dominant, but the Greek contribution was distinctive and long influential. The western areas of the Persian Empire enjoyed a degree of independence, and their rulers freely employed Greeks. Some special genres which depend on Greek idiom but eastern patronage begin to appear. They are most apparent in the west, in Anatolia, Cyprus, or Phoenicia, but their penetration east marks the beginning of the most distant imposition of classical styles on local taste, brought about in the first place by Persian acquisitions in the west, consummated by Alexander's conquests in the east.

378 We think of Cyprus as a Greek island. Although it is unhappily divided today it had been dominantly Greek from the Hellenistic period on, and intermittently so before, beginning with immigration from Greece at the end of the Bronze Age. There was a strong indigenous population with a distinctive if often rather repetitive taste in the decorative arts, and linked more to the mainland to the east than to the Greek Aegean. The island's culture had been enlivened by the presence of Phoenicians from the ninth century on, and thereafter by a growing Greek presence. Archaic Greek styles were as readily adopted as Phoenician and Egyptian, and often oddly blended. Greek scenes of myth could be copied, but quite often with an odd twist to the narrative which must be due to the imagination or lack of comprehension of native craftsmen rather than to expatriates who had become out of touch.

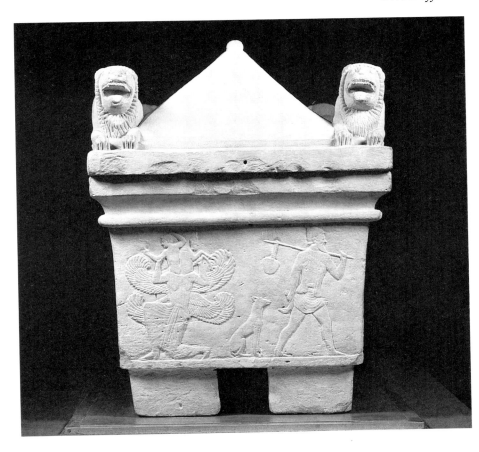

378 Cypriot sarcophagus from Golgoi: Perseus and Medusa (New York, Metropolitan Museum)

We show the end view of a stone sarcophagus carved in relief with scenes in a rather flat, Hellenizing style, sub-Archaic of the first half of the fifth century BC. The subject is a Greek one: the Gorgon Medusa is collapsing at the left, decapitated, and from her severed neck spring, literally, her child Chrysaor and the winged horse Pegasus. In Greek scenes Perseus makes his escape, wearing his magic cap and boots, with the Gorgon head in a bag under his arm. The Perseus here has been translated into a local hunter, the Gorgon head suspended in a bag over his shoulder, like his dinner, holding his sickle (a proper implement also in Greek art for beheading Gorgons), and his impassive dog at his heels. The horror of the mutilated monster and the urgency of flight have been effectively eliminated from the image, which is more that of a casual rustic encounter.

379 The kingdom of Phrygia occupied the territory of the Bronze Age Hittite Empire, neighbour to the Greek states of the eastern Aegean. There was a sound Anatolian tradition in the arts, including painting and fine metal-work, but Greek forms and patterns were readily admitted. This strange limestone goddess is from the old Hittite capital at Bogazkoy and probably represents the Anatolian goddess whom the Greeks adopted as Cybele, with two musician attendants. The very idea of such a cult image probably owes much to Greek example even if the expressions on the faces do not, but the overall form and pose, as well as the way the dress is patterned to suggest folds swept away to one side, are somewhat inept versions of common Greek Archaic forms, as [50].

380 The kingdom of Lydia centred on Sardis, even closer to the Ionian Greeks than Phrygia. King Croesus' reputation for wealth was based not only on the gold-bearing river that flowed past his capital but on the lavishness of his gifts to the Greek cities. The homeland sanctuaries, mainly Delphi, were the main beneficiaries, since many of the eastern Greeks had already been reduced to acknowledging Lydian overlordship. The poetess Sappho, on offshore Lesbos, could sing of the brilliant high society of the Lydian court, and the Greeks were suspiciously receptive of the possibly enervating luxury of these oriental neighbours. The arts and culture of Ionia were soon inextricably mingled with those of Lydia to form virtually a *koine*. The little silver vase shown here demonstrates the amalgam of styles and influences. The shape is Egyptian, the alabastron, normally of alabaster. The little lug handles have been stylized into duck heads, an oriental touch. But the

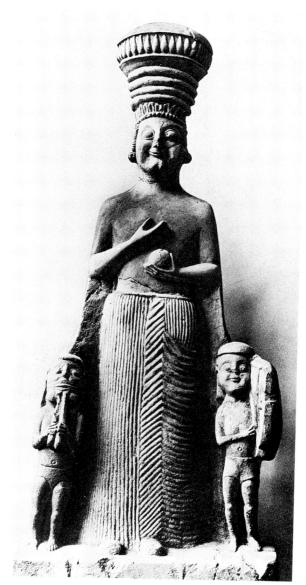

379 Phrygian statue of the goddess Cybele (Ankara Museum)

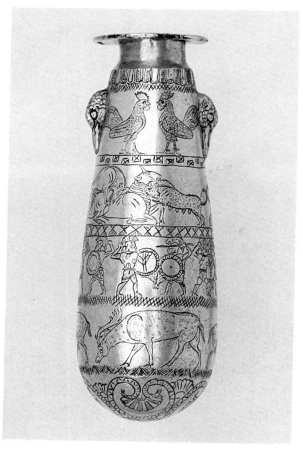

380 Graeco-Lydian silver vase (New York, Metropolitan Museum)

body has been covered with incised decoration, rendered in friezes, and filled with warrior and animal figures in the Greek orientalizing style. It is not easy to say whether this was made before or after Croesus' kingdom fell to the Persians (in the mid-sixth century), but there are many silver vessels of later in the century which attest the same blend of styles and show that the Ionian-Lydian reputation for luxury and luxury goods survived the arrival of new overlords.

381 Anatolian traditions in wall-painting are a little better documented now for the sixth century by finds at the Phrygian capital Gordium. After the mainland had been overrun by the Persians, local dynasts were still allowed a considerable degree of independence and there was no imposition of foreign arts rather than foreign bureaucracy. In the south-west, in ancient Lycia, above-ground tomb monuments are decorated with reliefs cut in the Greek style, while tomb chambers could bear paintings on their walls. These are precious indications of styles and techniques of the period, and there is so much Greek in both the style and subject-matter of the decoration that we may take them as at least an intimation of contemporary Greek painting, otherwise so elusive. Here, on a tomb wall at Elmali of the early fifth century, the warriors in their chariot are dressed as Greeks, and the same tomb has Greek myth subjects as well as a funerary feast which is Anatolian both in inspiration and in the equipment depicted.

382 When the Persian King Darius built his palace at Susa in the late sixth century he recorded the many nations from all over his empire, stretching from the Aegean to India, whose forced labour had contributed to the construction. His comparatively young empire had no long tradition in the monumental arts and had to borrow from

381 Lycian wall-painting at Elmali

others. Mesopotamia (the Babylonians) and Egypt were prominent contributors, but men of Ionia and Sardis too are recorded, as masons. In the great palatial buildings of the Persians of this date, and into the fifth century at Persepolis, there is plentiful evidence for the influence of Greek masonry techniques in the finishing and joining of blocks. The wide range of sources of the craftsmen did not hinder the creation of a homogeneous Court art of Persia which was long influential in the east. The Greek contribution was not confined to masonry. The figure arts of the Persian Court Style owe most to Mesopotamia, in their friezes of guards and tribute-bearers, but in some important particulars it is Greek pattern that is adopted and that

survived in the east long after the passing of the empire of the Medes and Persians. On the figures shown here from one of the Persepolis friezes, the dress is carved with splaying, overlapping folds that can only derive from the familiar Greek late Archaic treatment of clothing (as [**48, 73, 75**]). For the east this is a novelty. In Greece it soon serves to help express and articulate the forms of the body beneath, a mission that the east ignored, clinging to this convenient and decorative formula and unmoved by the rapid changes in style that the full Classical period had brought to Greek lands. Only later, and without the Persian intermediary, did the new message of fifth-century Greek art invade the east, as we shall see.

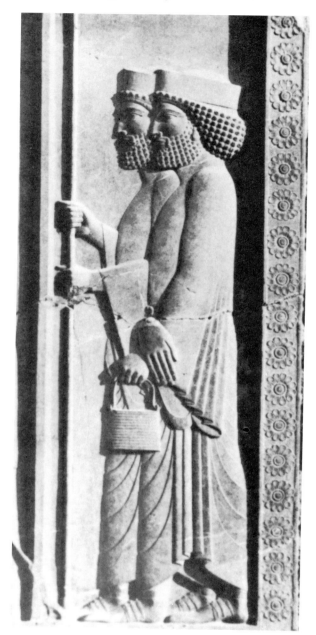

382 Persian frieze detail at Persepolis

383 The intrusion of Greek arts into the western provinces of the Persian Empire was not confined to painting and sculpture. The Greeks had learned the cutting of hardstone seals and gems from the east and in the late Archaic period perfected it as a high art [62]. In the fifth and fourth centuries a school of gem-cutting can be distinguished that owes most to Greek example but that worked for the Persian or Persianized courts of the west. The source and nationality of the makers of these 'Graeco-Persian' gems are not clear, but they exhibit subjects which are purely Persian in dress or behaviour (some exotic hunts) but with a number of relaxed and domestic scenes that could only derive from Greek example, since they are quite foreign to the court arts of the east. On [A] the Persian prince with his wife, who serves him unguent, offer an image far removed from the usual eastern repertory of scenes of domination or court ritual. There are also scenes on stamp seals and on cylinders—the eastern seal shape—of Persians fighting Greeks, where the Greeks are worsted but the style and poses of the figures are purely Greek [B]. Multi-faced seals can juxtapose Greek nudes and Persian archers [C].

384 The kings of Phoenicia enjoyed much the same independence under Persia as did the dynasts of Anatolia, and they were no less ready to look to Greek artists for monuments, which local crafts could not readily create, to match the new standards and styles which the Greek world had already begun to impose on its neighbours. The royal cemetery at Sidon—a complex of underground chambers—offers good examples of this. The Egyptian style of sarcophagus, shaped to the body and with the head rendered in paint or in the round in the Egyptian manner, was redesigned to accommodate heads in Greek style, however incongruous their setting. More imposing were the relief-decorated sarcophagi, a genre not unknown in the Greek world but best represented in the finest Greek styles of the fifth and fourth centuries here, and, of course, to enjoy renewed popularity in the Roman period. One of the latest, post-Alexander but also commemorating him in its decoration, is the Alexander Sarcophagus, which we have already seen [162].

385 A more unusual monument demonstrating the employment of Greek sculptors by the kings of Sidon is the so-called Tribune which was excavated in the sanctuary of the god Echmoun in 1972. It overlooked an approach to the sanctuary but it is by no means clear what its function could have been. Its architectural detail and mouldings are Greek but the form of the monument is not. The sculptural style is purely Greek, fourth-century, possibly not far in date from the rule of the phil-Athenian King Straton, though some scholars have wondered whether it is not rather classicizing of later date. While the subject-matter of the Greek-made sarcophagi in Sidon (as [162]) is intelligible in terms of the interests of the patrons, that of the Tribune is puzzling and almost aggressively Greek in mood. The upper frieze has an assembly of the Greek gods, with no apparent attempt to identify any of them with Semitic gods, least of all with the god of the sanctuary where it was erected. The lower frieze has a dance of nymphs which includes a satyr and two woman musicians, with cithara and pipes. The dancing figures relate closely to classical types that have a long history in the west.

383 Graeco-Persian seal impressions (**A** Oxford,
Ashmolean Museum; **B** New York, Rosen Collection;
C St Petersburg, Hermitage)

A

B

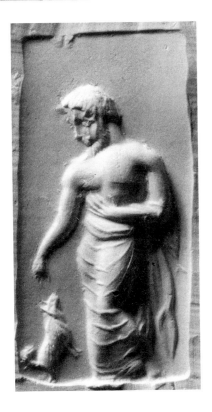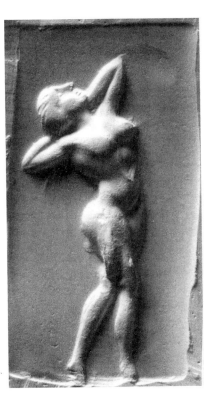

C

384 Graeco-Phoenician anthropoid sarcophagus (Istanbul, Archaeological Museum)

THE EAST AFTER ALEXANDER

In the east Alexander's armies went beyond even the bounds of the Persian Empire, into north-west India (north Pakistan), and crossed the River Oxus into what is now Turkestan. His successors' grip on the area gradually faltered, but a breakaway Greek kingdom in Bactria (roughly the Oxus valley) created a Hellenistic enclave in central Asia which lasted over a century and which sent its

princes to rule even in India. The Persian homeland, meanwhile, fell to the Parthians, a military power strong enough to defeat the Roman legions and keep them at bay beyond Mesopotamia. Within a century of the start of the Christian era the tribes that had driven the Greeks from Bactria moved into India to establish the Kushan Empire, which itself spread over Bactria and into central Asia (Chinese Turkestan, Sinkiang province) towards their original home. The early centuries AD see the creation of Buddhist art within the Kushan realm and its spread north and north-east along the Silk Routes that had opened China and the Mediterranean world to each other.

What of Greeks and Greek or Roman art in this dramatic story of the ebb and flow of power, impossibly compressed in the last paragraph? In Parthia the legacy appears slight and superficial. Hellenistic Bactria seems somehow to have kept in touch with the east Mediterranean and its fashions, for all that its religious architecture owed more to local or earlier Persian manners. Contact with local crafts is slight in these years. The Buddhist art of the Kushans in north Pakistan and east Afghanistan (Gandhara) has much classical in it. Some of this derives from the Bactrian heritage, and most from new contacts with the Mediterranean through new sea routes which were being regularly travelled from the first century AD on. These ran from Alexandria, down the Red Sea, along the Arabian coast, and, with the helpful monsoons, across to central India, serving the trade in spices and other luxuries that Rome coveted.

The Hellenistic arts of Bactria seem to have promoted various mixed classical styles which borrowed pattern and figure motifs, generally with little understanding of their function, and mainly in India rather than in Bactria. And in the north the nomad styles, related to the Scythian which we have already discussed, were just as impervious to Greek fashion. The civilization of the Indus valley was as old as that of the Nile or Mesopotamia, but with less continuity of style. Buddhist art, however, may have looked to the west for the means of portraying a man-god, his life, and his adventures. It also accepted many elements, both decorative and figurative, that could play a role in the adornment of religious structures. There was no native idiom to meet this need, and the nature and associations (let alone the date) of the earliest stone sculpture in the relevant areas remain obscure, so there is a danger of attributing too much to the west. But this is the remotest example of the borrowing and re-employment of Classical art by non-Greeks, and, with the religion it served, it was to carry a touch of the Mediterranean even beyond the China seas.

386 (**Colour Plate XXVIII**) This silver rhyton with its gilt detail is a good example of the lingering Hellenism in Parthian Persia after Alexander's successors had lost their grip on the country. It is an apt expression of the give and

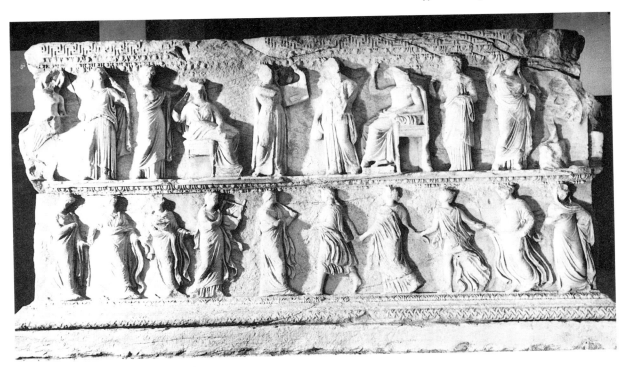

385 Relief basis at Sidon (Beirut Museum)

take of motifs and forms between east and west. The
drinking-horn is a utensil of the greatest antiquity, easy to
sling at your belt or saddle. Easterners translated the shape
into various materials and commonly drank from it
through a hole in its base rather than the open top: it was
thus more like a pourer—Greek rhyton. The terminal or
spout might take the form of an animal head or forepart.
The Greeks adopted the type but often preferred to give it
a foot of some sort, being more used to putting their
crockery and plate on flat-topped tables. But they made
fine silver rhytons of eastern type for their neighbours in
Thrace and Scythia, while in Achaemenid Persia these ves-
sels were produced, in local styles, also in precious mater-
ials. However, as in so much else, Greek forms came to
prevail, and even when the animal motifs for the spouts
were of eastern type (lion-griffins or the like) the style was
Greek, Hellenistic, and the types had themselves been
adopted throughout the Greek world as fashionably Per-
sianizing. We see them, for instance, in the hands of the
heroized dead on Greek grave reliefs. This example must
have been made in Persia, probably in the early Parthian
period of the second century BC. The horse is the round-
muzzled eastern type familiar from the Persian palace
reliefs, with dressed mane and forelock and tasselled
saddle-cloth. The style is purely Greek, with the acanthus
and palmette decoration on the horn. But notice, just
below the palmettes at the neck, the stepped battlement
pattern, an old Mesopotamian motif that became some-
thing of a trademark of Persian art.

387 The kings of Commagene, in the Taurus mountains
of south-east Turkey, were as much dependent on the
good will of the Parthians to their east as on that of the
Romans to their south and west. They cultivated a strange
blend of classical and oriental in their arts, in this 'political
and cultural backwater'. The great first-century BC relief
shown here, at Arsameia, carries figures nearly twice life
size. King Antiochos, dressed as an oriental, shakes hands
with a Heracles who is Greek in his nakedness, bareheaded
and barefooted. The sculptor has abjured any classicizing
of the style, however, beyond the general pose, and the
Greek hero has been assimilated to the Persian Artagnes.
Here and to the east, across Parthia, classical subjects were
more readily remembered than classical styles, and there
seems to have been a deliberate reversion to a distinctive
orientalism, dependent no little on the artistic traditions
of the old Achaemenid Persian Empire, which were them-
selves syncretic. The contrast with the record yet further
east, in Bactria and Gandhara, is striking.

388 Here is a gracious young woman, made of stone and
stucco with plentiful colour, standing in a relaxed classical
pose, yet with a strange formality about her. She was found
in Seleucia on the River Tigris, the Hellenistic capital that
was founded to replace ancient Babylon. She was probably
made early in our era, when her home was already a
Parthian city but living still culturally on its Hellenistic
past. The round, proudly set head and somewhat aggres-
sive stance recall far earlier Babylonian works, but her fea-

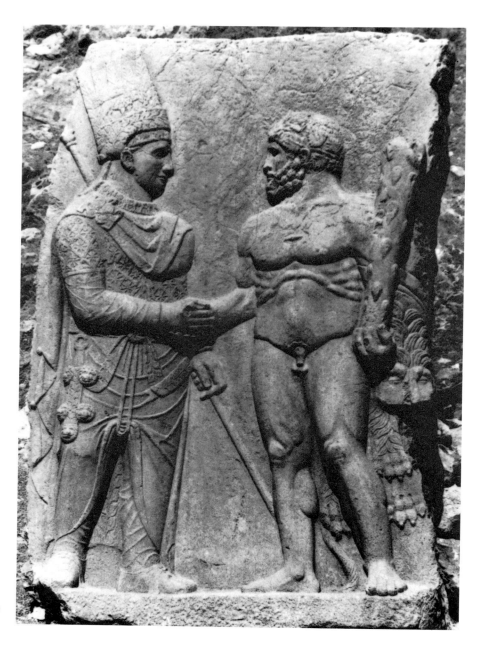

387 Relief at Arsameia: Heracles and local king

tures, the disposition of her dress, and its patterning owe everything to Greek art.

389 The wholly Greek character of the Bactrian kingdom is in no way better demonstrated than by the quality of its coinage and the vigorous portraiture of the kings. One example shown [A] is a silver coin of King Antimachus, of the early second century BC. He is wearing the flat cap or *kausia*, a regal version of a Macedonian headdress. The other [B] is a near contemporary coin of King Demetrios wearing the elephant scalp which had appeared on coins showing Alexander and which reflected his Indian conquests. Both therefore hark back to symbols of Macedonian kingship and government which the break-

away state of Bactria had rejected, such was the propagandist power of Alexander's record and reputation in the east. The Bactrians' pride in their coinage is demonstrated also by the fact that they struck the largest gold and silver coins of the Greek world.

390 The site at Aï Khanoum, on the south bank of the River Oxus, has revealed a Hellenistic Bactrian city which flourished until the mid-second century BC. Much of its architectural detail (though not plans) and figurative arts are purely Greek, or at worst provincial. Some reveal their exotic origin from their techniques (stucco sculpture) rather than their appearance, and some betray more clearly some distancing from their Mediterranean models.

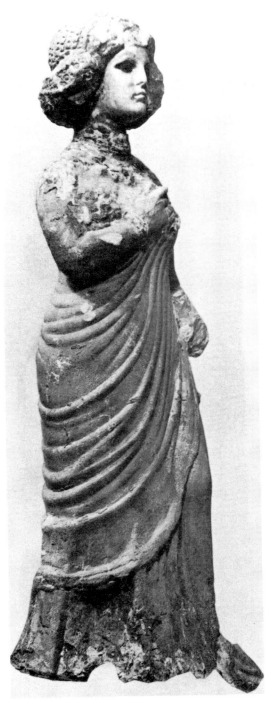

388 Statuette of a woman from Seleucia (Baghdad Museum)

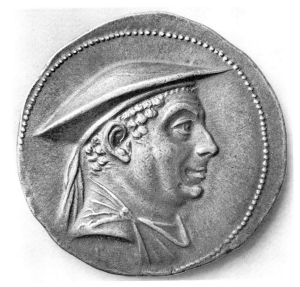

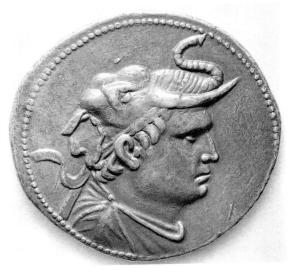

B

389 Bactrian silver coins. **A** of Antimachus; **B** of Demetrios (London, British Museum)

Thus, the limestone figure shown here, little over half life size, offers a typical Hellenistic pose for a lady or goddess, and typical high-girt dress, but the carving is flat and totally lacking in the plasticity usually apparent in even the most cursory homeland Greek work.

391 At Nisa in Parthia a hoard of ivory vessels seems to represent booty from a campaign, or possibly tribute. The vessels are pourers (rhytons) with animal or monster foreparts at the spouts and relief figures and heads at their lips. We have seen [386] that the general type is oriental, deriving from elaborated drinking-horns, but this is the form as it had been developed in Greece and the style and subject-matter is so Greek that we should imagine that these are of Greek manufacture too. If so, it is most probable that they are a Bactrian Greek product. The forepart of a similar vessel has recently been found on one of the Bactrian sites on the River Oxus itself.

392 Some of the most elegant expressions of the blend of classical and oriental appear on silverware and jewellery, generally using western forms but with a mixture of decorative styles. The problems they pose are matters of date

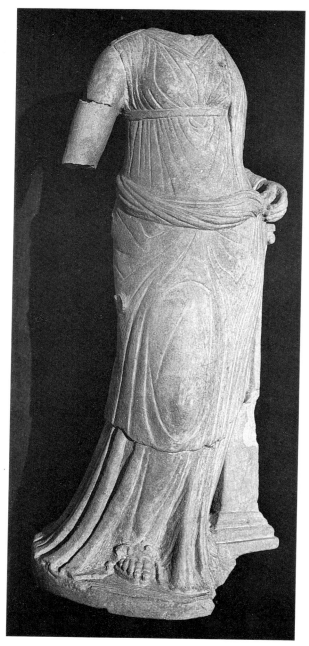

390 Statue from Aï Khanoum (Kabul Museum)

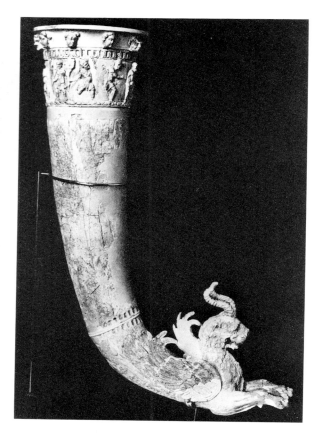

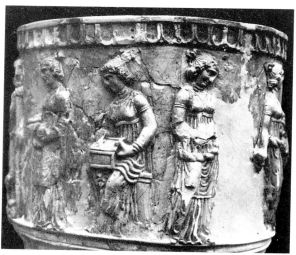

391 Bactrian ivory vases from Nisa

and origin, since such precious objects moved about readily in antiquity. The silver medallion shown here [A] was found in southern Siberia, between Omsk and Tobolsk, and carries a bust of the goddess Artemis/Diana, with her bow and quiver, executed in a near-classical style. Such relief medallions are a common feature of late Hellenistic and Roman plate, and there are other borrowed forms found in the east, widely distributed, even into China. Several hemispherical bowls with relief scenes on the outside carry translated but, it seems, misunderstood classical

figures and groups beside figures of Persian or Indian type. These are all probably the product of studios whose origins lay in Greek Bactria but where native craftsmen combined various traditions, local or more distantly inspired. Jewellery tells the same tale, with eastern forms carrying classical figures and groups, Aphrodites or an Eros and Psyche, rendered in gold and often embellished with

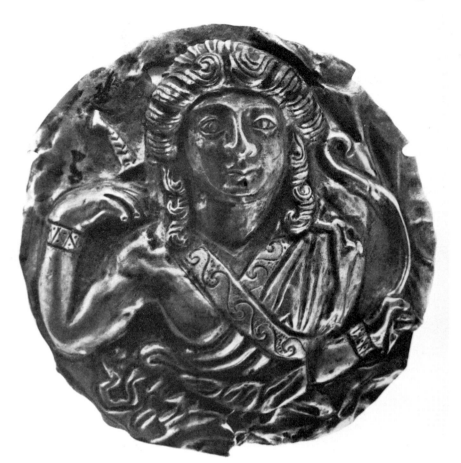

392 B Gold ornament from Kashmir (private collection)

turquoise, a stone readily available in Bactria. Much of this, however, belongs to the early centuries AD, in Gandhara, and is well represented in the Indo-Greek and later Kushan city at Taxila. Far more remarkable is the earlier gold jewel [B], only 3.8 cm. high. It was found in Kashmir. Its form is not Greek but may be restored with a pin mount to serve as ornament to dress, perhaps a turban since similar decoration for turbans can be seen in Indian sculpture. It is in the form of the forepart of a sphinx (only one animal leg surviving), a type employed for Hellenistic earrings but here adapted for other use. It is highly elaborate, with cloisons for stone or enamel in the wings and ivy wreath, and fine granulation including the cross-straps on the naked body, a type of feminine ornament much favoured in India (as in Greece, but not for monsters). But the sphinx also has human arms, holding a scroll (not an eastern style for reading) on which is inscribed in gold granules the Greek word *thea*, 'goddess' or 'divine'. A Greek craftsman has created his jewel and adjusted its subject to the needs of an easterner, and proclaims its function in his own language.

393 The Bactrian Greeks introduced many Greek architectural features to the east, and it is not always clear, when they reappear in India, whether the source of inspiration is Bactrian or fresh from the west. The Corinthian capital was enthusiastically adopted, sometimes in its full architectural function, often given figure groups between its acanthus leaves. More often it serves as a framing device on the stone reliefs depicting the life and works of Buddha, which appear to owe so much to classical narrative in both composition and individual figures. One of the more unusual applications of the Corinthian capital was in the design of the clay model stupa (a sacred Buddhist monument, essentially a dome housing a reliquary) shown here and found at Taxila. The whole base of the dome takes the form of a capital, over the Indian lotus (a Buddhist symbol) and a sub-classical colonnade on the lowest member. Floral patterns from the west, other than these capitals, were long influential, especially the vine and other leafy *rinceaux* which become common features of Indian and then central Asian ornament, eventually adjusted to the different flora of China, the peony.

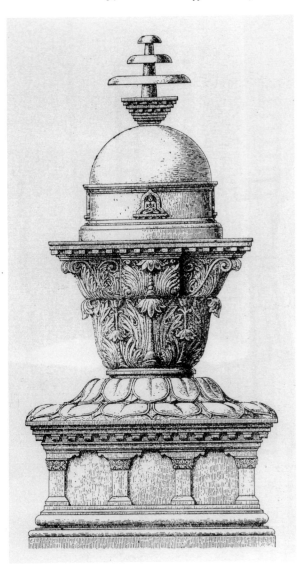

393 Buddhist stupa at Taxila, Pakistan

394 Clay figure at Hadda, Afghanistan

394 Classical art provided the east with figure-types which could be assimilated to local heroes and divinities. Heracles, the most popular of Greek heroes, had been the model for Greek and Roman rulers at least since Alexander, but in the east was especially associated with the Persian Artagnes [387] and the Indian Vajrapani. The Greek hero's posture and physique were copied, with his lion-skin and club, but other symbols and attributes appropriate to his new identity were added. Hadda, the Buddhist centre in western Afghanistan (destroyed in the recent fighting), has proved a major source for substantial sculptural expression of these classicizing eastern deities, ex-

ecuted in clay or stucco and often on a monumental scale. Although the date may be relatively late (even into the fifth century AD) the artist of the Heracles-Vajrapani shown here has remained faithful to a pose created by Lysippus in the fourth century BC, and seems even not to have lost much of the feeling for corporeality which was characteristic of Greek sculpture but which was generally lost as the subjects were adapted or copied in later centuries and far from their homes. Only the club has been exchanged for the Indian thunderbolt. Many such works look most like provincial late Hellenistic rather than the product of such a distant studio up to half a millennium later. In areas

395 Buddhist wall-painting from Qizil, China

where there is no great incentive for change in the rendering of forms, and especially where the forms were themselves in the first place foreign, a continuity of treatment is perhaps more readily understood; at this distance and date, however, it is phenomenal.

395 For reasons hard to fathom some classical figure groups won especial favour in the east and were often repeated and adapted. We may assume that they were borrowed because they could serve a new identity, though this is less easy to name than the Heracles-Vajrapani of [394]. The common Mediterranean sarcophagus motif of Cupids holding swags and garlands was often copied, apparently simply for its decorative effect. The classical sea-monster (*ketos*) is accepted and affects the appearance of his local kin, the *makara*. One adopted motif with a long and unusual career started in the west as the group of two winged Cupids or Victories, dress aflutter, flying towards each other and holding jointly a wreath or medallion. The group is carried with Buddhist art into central Asia, where it reappears, in the painting shown here, at the Buddhist cave site of Qizil, at the north of the Taklamakan desert on the northern arm of the Silk Route. The sex of the figures is indeterminate and the wings now just flying cloaks. These may be fifth century. Much later and further east, in Buddhist China, such figures contribute much, if not all, to the forms of the popular flying spirits, the *apsaras*, of the Dun Huang caves, still in a Buddhist context.

396 A major aesthetic and cultural invention of Greek art had been the creation of anthropomorphic images of divinity. These had not relied on sheer size or costliness of material or demonstrations of supernatural power. In the fifth century BC their potency lay in the idealization of the human form (first male, in the next century also female) and its demonstration in a realistically relaxed posture that expressed immanent godhead, almost introspectively, accessible for its humanity of form but clearly removed from mere mortality. Both the spirit and form of this invention seem to have been very largely responsible for the adoption in northern India of a standing figure for their man-god, Buddha. His pose is classical, relaxed,

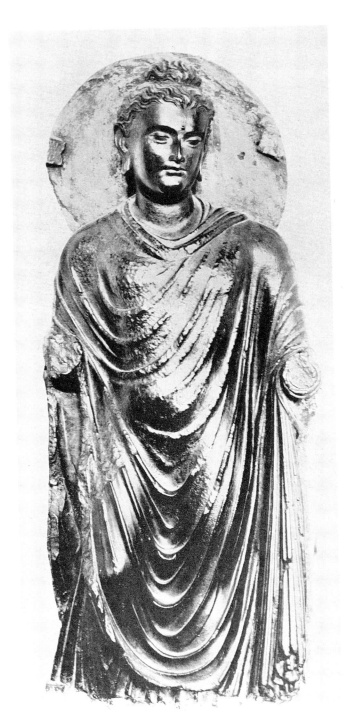

396 Statue of Buddha (once Hoti-Mardan)

obviously a descendant of the Polyclitan male with the gently flexed leg, so very different from the eastern postures which find no mean between the frontally rigid and the vigorously active, except in such borrowings from the west. The dress enhances the body forms, using the pattern of fold and contour rather than imposing the divine regalia of an eastern deity or monarch. In detail, even the stylization of the hair-knob (*ushnisha*, a symbol of high birth) is Hellenized into Hellenistic locks. And on other, older figures, a yet older Greek pattern of zigzag folds per-

sists with the Buddhist imagery even into China and eventually Japan; but this is a Greek feature possibly derived from Persia (as in the Achaemenid [382]) rather than more directly from the west. The forms and spirit of the arts of the Mediterranean took their passage east in the hands of many different craftsmen, with different purposes and skills. That they could survive recognizably such distances in time and space is a testimony to their efficacy, even for purposes for which they had not been devised.

FURTHER READING

General Background

J. Boardman, J. Griffin, and O. Murray (eds.), *The Oxford History of the Classical World* (Oxford, 1986), contains essays on most aspects of the culture of the period covered in this volume.

General Art

GREEK

M. Robertson, *A History of Greek Art* (Cambridge, 1986), gives the fullest treatment. In smaller format are R. M. Cook, *Greek Art* (London, 1972); J. Boardman, *Greek Art* (London, 1985); S. Woodford, *An Introduction to Greek Art* (London, 1986); and a review of recent finds and interpretations in B. A. Sparkes, *Greek Art* (Greece and Rome, New Surveys in the Classics no. 22, Oxford, 1991). Literary sources in translation in J. J. Pollitt, *The Art of Ancient Greece* (Cambridge, 1990) with *The Ancient View of Greek Art* (New Haven, Conn., 1974). G. M. A. Richter, *Perspective in Greek and Roman Art* (London, 1970). C. Habicht, *Pausanias' Guide to Ancient Greece* (Berkeley, Calif., 1985).

ROMAN

B. Andreae, *The Art of Rome* (New York, 1977), is the best general text, extensively illustrated. G. M. A. Hanfmann, *Roman Art* (New York, 1964). M. Henig (ed.), *A Handbook of Roman Art* (Oxford, 1983), with good bibliography. H. Kähler, *The Art of Rome and her Empire* (New York, 1963). Literary sources in translation in J. J. Pollitt, *The Art of Rome* c.753 BC–AD 337 (Cambridge, 1983).

Period Studies

PRE-CLASSICAL GREEK

J. N. Coldstream, *Geometric Greece* (London, 1977). B. Schweitzer, *Greek Geometric Art* (London, 1971). A. M. Snodgrass, *Archaic Greece* (London, 1980). J. M. Hurwit, *The Art and Culture of Early Greece* (Ithaca, NY, 1983). J. Charbonneaux, R. Martin, and F. Villard, *Archaic Greek Art* (London, 1971), with profuse illustration. A. W. Johnston, *The Emergence of Greece* (Oxford, 1976). J. Boardman, *Preclassical Style and Civilization* (Harmondsworth, 1967), and *The Greeks Overseas* (London, 1980), for foreign influences.

CLASSICAL GREEK

J. J. Pollitt, *Art and Experience in Classical Greece* (Cambridge, 1972). J. Charbonneaux, R. Martin, and F. Villard, *Classical Greece* (London, 1973).

HELLENISTIC

J. J. Pollitt, *Art in the Hellenistic Age* (Cambridge, 1986), the best general work. C. M. Havelock, *Hellenistic Art* (London, 1971), more idiosyncratic. B. H. Fowler, *The Hellenistic Aesthetic* (Madison, Wis., 1989), for interesting

analogies with literature. J. Onians, *Art and Thought in the Hellenistic Age* (London, 1979), a stimulating account of the art in its broader cultural context. J. Charbonneaux, R. Martin, and F. Villard, *Hellenistic Art* (London, 1973), with excellent illustrations.

REPUBLIC AND EARLY ROMAN EMPIRE

R. Bianchi Bandinelli, *Rome: The Centre of Power* (New York, 1970). P. Zanker, *The Power of Images in the Age of Augustus* (Ann Arbor, Mich., 1988). M. T. Boatwright, *Hadrian and the City of Rome* (Princeton, NJ, 1987).

LATER ROMAN EMPIRE

K. Weitzmann (ed.), *The Age of Spirituality* (New York, 1979), the extensive catalogue of an exhibition. R. Bianchi Bandinelli, *Rome, the Late Empire: Roman Art AD 200–400* (London, 1971), generously illustrated and particularly useful for regional development. C. C. Vermeule, *Roman Imperial Art in Greece and Asia Minor* (Cambridge, Mass., 1968). H. P. L'Orange, *Art Forms and Civic Life in the Late Roman Empire* (Princeton, NJ, 1965). E. Kitzinger, *Byzantine Art in the Making* (London, 1977).

Subjects

ARCHITECTURE

E. D. Owens, *The City in the Greek and Roman World* (London, 1991), a useful résumé. J. B. Ward-Perkins, *Cities of Ancient Greece and Italy* (New York, 1974).

GREEK

A. W. Lawrence, *Greek Architecture* (revised by R. A. Tomlinson, Harmondsworth, 1983). W. B. Dinsmoor, *The Architecture of Ancient Greece* (London, 1952), somewhat dated. H. Berve, G. Gruben, and M. Hirmer, *Greek Temples, Theatres and Shrines* (London, 1963), for full studies of individual buildings. J. J. Coulton, *Greek Architects at Work* (London, 1977), for planning and techniques, and *The Architectural Development of the Greek Stoa* (Oxford, 1976). R. E. Wycherley, *How the Greeks Built Cities* (London, 1962). H. Lauter, *Die Architektur des Hellenismus* (Darmstadt, 1986), the essential synthetic work.

ROMAN

A. Boethius, *Etruscan and Early Roman Architecture* (Harmondsworth, 1978). F. E. Brown, *Roman Architecture* (New York, 1961). W. L. MacDonald, *The Architecture of the Roman Empire*, i, ii (New Haven, Conn., 1965, 1986) and *The Pantheon* (Cambridge, Mass., 1976). J. B. Ward-Perkins, *Roman Imperial Architecture* (Harmondsworth, 1981), a clear and comprehensive survey. A. G. McKay, *Houses, Villas and Palaces in the Roman World* (Ithaca, NY, 1975). G. Picard, *Living Architecture: Roman* (London, 1965). E. Nash, *Pictorial Dictionary of Ancient Rome* (New York, 1968).

SCULPTURE

GREEK

A. Stewart, *Greek Sculpture; An Exploration* (New Haven, Conn., 1990). C. Rolley, *Greek Bronzes* (London, 1986). R. A. Higgins, *Greek Terracottas* (London, 1967). G. M. A. Richter, *Portraits of the Greeks* (Oxford, 1984). R. Lullies and M. Hirmer, *Greek Sculpture* (London, 1960) and E. Langlotz and M. Hirmer, *Ancient Greek Sculpture of South Italy and Sicily* (London, 1965). B. S. Ridgway, *Roman Copies of Greek Sculpture* (Ann Arbor, Mich., 1984).

Pre-Classical

G. M. A. Richter, *Kouroi* (London, 1960), *Korai* (London, 1968), and *Archaic Attic Gravestones* (London, 1944). H. G. G. Payne and G. Mackworth Young, *Archaic Marble Sculpture from the Acropolis* (London, 1936, 1950). J. Boardman, *Greek Sculpture, Archaic Period* (London, 1978), fully illustrated handbook. J. Floren, *Die geometrische und archäische Plastik* (Munich, 1987), fully documented handbook.

Classical

B. Ashmole and N. Yalouris, *Olympia* (London, 1967). J. Boardman and D. Finn, *The Parthenon and its Sculptures* (London, 1985). B. Ashmole, *Architect and Sculptor in Ancient Greece* (London, 1972), for Olympia, Parthenon,

Mausoleum. O. Palagia, *The Pediments of the Parthenon* (Leiden, 1993). J. Boardman, *Greek Sculpture, Classical Period* (London, 1985), fully illustrated handbook.

Hellenistic

M. Bieber, *The Sculpture of the Hellenistic Age* (New York, 1961), the standard work. B. S. Ridgway, *Hellenistic Sculpture: The Styles of ca.331–200* (Madison, Wis., 1991), much concerned with chronology. R. R. R. Smith, *Hellenistic Royal Portraits* (Oxford, 1988); and *Hellenistic Sculpture* (London, 1991), fully illustrated handbook. A. F. Stewart, *Attika: Studies in Athenian Sculpture of the Hellenistic Age* (London, 1979). E. Hansen, *The Attalids of Pergamon* (Ithaca, NY, 1971), on the Great Altar. R. A. Higgins, *Tanagra and the Figurines* (Princeton, NJ, 1986).

ROMAN

D. E. E. Kleiner, *Roman Sculpture* (New Haven, Conn., 1992), the standard handbook. D. Strong, *Roman Imperial Sculpture* (Harmondsworth, 1961). N. Hannestad, *Roman Art and Imperial Policy* (Aarhus, 1986). M. Torelli, *Typology and Structure of Roman Historical Reliefs* (Ann Arbor, Mich., 1982). J. D. Breckenridge, *Likeness: A Conceptual History of Ancient Portraiture* (Evanston, Ill., 1969). S. Wood, *Roman Portrait Sculpture 217–260* (Leiden, 1986). G. Koch and H. Sichtermann, *Römische Sarkophage* (Munich, 1982), the standard handbook. S. Walker, *Catalogue of Roman Sarcophagi in the British Museum* (London, 1990), for a useful range. G. M. A. Hanfmann, *The Season Sarcophagus at Dumbarton Oaks* (Washington, DC, 1951). Late antique attitudes to decorative sculpture: D. M. Brinkerhoff, *A Collection of Sculpture in Classical and Early Christian Antioch* (New York, 1970) and C. C. Vermeule, *Greek Sculpture and Roman Taste* (Ann Arbor, Mich., 1977).

POTTERY

GREEK

R. M. Cook, *Greek Painted Pottery* (London, 1972). Fully illustrated handbooks: J. Boardman, *Athenian Black Figure Vases* (London, 1974), *Athenian Red Figure Vases: The Archaic Period* (London, 1973), and *Athenian Red Figure Vases: The Classical Period* (London, 1989); A. D. Trendall, *Red Figure Vases of South Italy and Sicily* (London, 1989). P. Arias, M. Hirmer, and B. B. Shefton, *History of Greek Vases* (London, 1961), commentary on fine pictures. T. B. L. Webster, *Potter and Patron in Ancient Athens* (London, 1972). B. A. Sparkes, *Greek Pottery: An Introduction* (Manchester, 1991). J. D. Beazley, *The Development of Attic Black Figure* (Berkeley, Calif., 1951), and *Greek Vases: Lectures*, ed. D. C. Kurtz (Oxford, 1989). M. Robertson, *The Art of Vase Painting in Classical Athens* (Cambridge, 1992).

ROMAN

R. J. Charleston, *Roman Pottery* (London, 1955). C. Johns, *Arretine and Samian Pottery* (London, 1971).

PAINTING AND MOSAIC

GREEK

Full discussion in M. Robertson, *A History of Greek Art* (Cambridge, 1986), chs. 4–5. V. J. Bruno, *Form and Color in Greek Painting* (New York, 1977). B. B. Brown, *Ptolemaic Paintings and Mosaics and the Alexandrian Style* (Cambridge, Mass., 1957). J. White, *Perspective in Ancient Drawing and Painting* (London, 1956). M. Andronikos, *Vergina* (Athens, 1984).

ROMAN

A. Maiuri, *Roman Painting* (Geneva, 1953). R. Ling, *Roman Painting* (Cambridge, 1991), the authoritative monograph. A. Stenico, *Roman and Etruscan Painting* (Amsterdam, 1963), for illustrations. W. Dorigo, *Late Roman Painting* (London, 1971). J. R. Clarke, *Roman Black and White Figural Mosaics* (New York, 1979). Some regional studies: K. M. D. Dunbabin, *The Mosaics of Roman North Africa* (Oxford, 1978); D. Levi, *Antioch Mosaic Pavements* (London, 1947); D. Neal, *Roman Mosaics in Britain* (London, 1981).

GEMS, JEWELLERY, COINAGE

J. Boardman, *Greek Gems and Finger Rings* (London, 1970). G. M. A. Richter, *The Engraved Gems of the Greeks and Etruscans* (London, 1968) and *The Engraved Gems of the Romans* (London, 1971). O. Neverov, *Antique Intaglios in the Hermitage Collection* (Leningrad, 1976) and *Antique Cameos in the Hermitage Museum* (Leningrad, 1971).

R. A. Higgins, *Greek and Roman Jewellery* (London, 1980). H. Hoffmann and P. F. Davidson, *Greek Gold* (New York, 1966). *The Search for Alexander: An Exhibition* (Washington, DC, 1980). C. M. Kraay and M. Hirmer, *Greek Coins* (London, 1966). J. P. C. Kent and M. Hirmer, *Roman Coins* (London, 1978).

LUXURY CRAFTS

D. Strong, *Greek and Roman Gold and Silver Plate* (London, 1966). J. P. C. Kent, *Wealth of the Roman World: Gold and Silver AD 300–700* (London, 1977); and D. B. Harden, *Glass of the Caesars* (London, 1987), exhibition catalogues with general survey. G. M. A. Richter, *The Furniture of the Greeks and Romans* (London, 1966). D. Strong, D. Brown, *et al.*, *Roman Crafts* (London, 1976). V. Spinazzola, *Le arti decorative in Pompeii* (Rome, 1928). K. Weitzmann, *Late Antique and Early Christian Book Illustration* (London, 1977), with fine illustrations of masterpieces of the period.

OTHER ASPECTS

Lexicon iconographicum mythologiae classicae i– (1981–), a fully illustrated encyclopaedia of Greek and Roman myth scenes. T. H. Carpenter, *Art and Myth in Ancient Greece* (London, 1991), a fully illustrated handbook. T. B. L. Webster and A. D. Trendall, *Illustrations of Greek Drama* (London, 1971). D. C. Kurtz and J. Boardman, *Greek Burial Customs* (London, 1971) and J. M. C. Toynbee, *Death and Burial in the Roman World* (London, 1971). H. A. Shapiro, *Art and Cult under the Tyrants in Athens* (Mainz, 1989). R. Brilliant, *Gesture and Rank in Roman Art* (New Haven, Conn., 1963). S. G. MacCormack, *Art and Ceremony in Late Antiquity* (Berkeley, Calif., 1981).

OTHER AREAS

J. Boardman, *The Greeks Overseas* (London, 1980), for the Archaic period. E. Porada, *The Art of Ancient Iran* (London, 1965). O. Brendel, *Etruscan Art* (Harmondsworth, 1975). D. B. Harden, *The Phoenicians* (London, 1962). T. T. Rice, *The Scythians* (London, 1957). B. Piotrovsky *et al.*, *Scythian Art* (Oxford, 1988). R. and V. Megaw, *Celtic Art* (London, 1989). T. T. Rice, *The Ancient Arts of Central Asia* (London, 1965). J. Boardman, *The Diffusion of Classical Art in Antiquity* (London and Princeton, NJ, forthcoming).

LIST OF ILLUSTRATIONS

The publisher, editor, and authors are grateful to the museums, collectors, and scholars named below for photographs and permission to use them in this volume.

DAI Deutsches Archäologisches Institut
Fot. Fototeca Unione
Gruben H. Berve and G. Gruben, *Griechische Tempel und Heiligtümer* (Munich, 1961)

BLACK-AND-WHITE ILLUSTRATIONS

GENERAL INDEX